The Idea of the
Avant Garde

MANCHESTER
1824

Manchester University Press

The Idea of the
Avant Garde
And What It Means Today

Edited by Marc James Léger

Manchester University Press
Manchester and New York

Left Curve
Oakland, CA

distributed exclusively in the US by Palgrave Macmillan

Manchester University Press
Altrincham Street, Manchester M1 7JA
and Room 400, 175 Fifth Avenue, New York, NY 10010, USA
www.manchesteruniversitypress.co.uk

with
Left Curve Publications
www.leftcurve.org

Distributed in the United States exclusively by
Palgrave Macmillan, 175 Fifth Avenue, New York,
NY 10010, USA

Distributed in Canada exclusively by
UBC Press, University of British Columbia, 2029 West Mall,
Vancouver, BC, Canada V6T 1Z2

British Library Cataloguing-in-Publication Data
A catalogue record for this book is available from the British Library

Library of Congress Cataloging-in-Publication Data applied for

ISBN 978 07190 96914 hardback

First published 2014

Designed
by Csaba Polony
Typeset
by Left Curve Publications and Servis Filmsetting Ltd, Stockport, Cheshire
Printed in Great Britain
by TJ International Ltd, Padstow

This book is dedicated to
Amiri Baraka, Chris Marker and Lebbeus Woods

• "Innovation enters art by revolution. Reality reveals itself in art in much the same way as gravity reveals itself when a ceiling collapses on its owner's head. New art searches for the new word, the new expression. The poet suffers in attempts to break down the barrier between the word and reality. We can already feel the new word on his lips, but tradition puts forward the old concept." – *Viktor Shklovsky* • "This means that in the psychology and ideology of avant-garde art, historically considered (from the viewpoint of what Hegelians and Marxists would call the historic dialectic), the futurist manifestation represents, so to speak, a prophetic and utopian phase, the arena of agitation and preparation for the announced revolution, if not the revolution itself." – *Renato Poggioli* • "Through the commercial mechanisms that control cultural activity, avant-garde tendencies are cut off from the constituencies that might support them, constituencies that are always limited by the entirety of social conditions. People from these tendencies who have been noticed are generally admitted on an individual basis, at the price of a vital repudiation; the fundamental point of debate is always the renunciation of comprehensive demands and the acceptance of a fragmented work, open to multiple readings. This is what makes the very term avant-garde, which when all is said and done is wielded by the bourgeoisie, somewhat suspicious and ridiculous." – *Guy Debord* • "In so far as the historical avant-garde movements respond to the developmental stage of autonomous art epitomized by aestheticism, they are part of modernism; in so far as they call the institution of art into question, they constitute a break with modernism. The history of the avant-gardes, each with its own special historical conditions, arises out of this contradiction." – *Peter Bürger* • "The dream of reconciling political vanguardism and avant-gardism in matters of art and the art of living in a sort of summation of all revolutions – social, sexual, artistic – is undoubtedly a constant of literary and artistic avant-gardes." – *Pierre Bourdieu* • "To write a history of the avant-garde is already to contain it: obviously within a narrative structure and thus inevitably within a certain ideological regime, a certain formation of (pre)judgments. Every history is to some extent an attempt to determine (to comprehend and to control) the avant-garde's currency, its demise, or its survival today." – *Paul Mann* • "Avant-garde art has become the official art of our time. It occupies this place because, like any official art, it is ideologically useful. But to be so used, its meaning must be constantly and carefully mediated." – *Carol Duncan* • "The 'time' of the cultural avant-garde is not the same as that of the vanguard party. These artists' practices interrupted the continuity of perceptions and estranged the familiar, severing historical tradition through the force of their fantasy." – *Susan Buck-Morss* • "The encounter between Leninist politics and modernist art (exemplified in the fantasy of Lenin meeting Dadaists in the Cabaret Voltaire in Zurich) cannot structurally take place; more radically, revolutionary politics and revolutionary art move in different temporalities – although they are linked, they are two sides of the same phenomenon which, precisely as two sides, can never meet." – *Slavoj Žižek* •

This Is Not an Introduction

Marc James Léger

The Idea of the Avant Garde is premised on the assumption that the concept of the avant garde has a particular purchase on our thinking in these times of global political crisis. The idea for the book emerged as a displacement of a previous wish I had, which was to organize a cultural festival dedicated to avant-garde cultural expression and politics. The city of Montreal where I live hosts countless cultural festivals and has a regular roster of challenging artistic presentations. On the whole, however, the spectacular nature of cultural events makes of art production a keystone to tourism and populist entertainment. As global capitalism and post-welfare state governments work to administer and/or censor the various forms of radical cultural practice, critical thinking, autonomous production and progressive ideologization are typically earmarked for budget cuts or some other kind of rightist pressure. In this context, cultural production depends on and facilitates the extension of neoliberal control.

When I started this project, it seemed to me that in this era of disaster capitalism it is all the more vital to address the interest, pleasure and radical potential of the avant garde. Rather than accept the postmodern attitude that considers all talk of avant-gardism as so much canonical boilerplate, or as business marketing, I thought to conceive a project that would facilitate a cross-generational transmission of ideas that have little to do with creative innovation, nor with any artist's or art movement's apotheosis, but that instead thinks critically about what we do as artists and theorists. In *The Rules of Art*, the French sociologist Pierre Bourdieu argued that struggles over what is important in art and culture are determined by sanctions outside the field of art, often related to the struggle for rewards, some of them political.[1] In this sense the value of art is considered less in terms of its internal structure than in terms of what it does in the world. Avant-garde work, I would argue, is work that is concerned first and foremost with how art interacts with the world around it, how it contributes to society and how its own immanent unfolding is designed to interact with outside forces. Much cultural production today is shaped by a biopolitics that ideologically construes all creative and knowledge production in terms of capital accumulation. In this context, the radical ambition of avant-garde work is substituted for various forms of networked practice that make cultural production a matter of participation and life styling. Those who make compromises with the external forms of biopower contribute to the ageing of the avant garde. In this process, there is a contradictory double movement in which the classification of older work brings it into the orbit of younger people who rediscover those products once they are out of fashion and access its rarity, renewing potentially with its heretical strategies. The new avant garde, Bourdieu says, will access that position by invoking a return to its purity, obscurity and even the poverty of its beginnings, against orthodoxy.

In conceiving this project my goal was to create a forum in which contemporary views on the avant garde idea could mix and mingle, clash, conspire and inspire. For this to happen I didn't think it would be necessary for me to put forward my own version of the conditions of possibility for avant-garde praxis.[2] It seemed to me, rather, that a collection of writings and works by some of the most respected practitioners and astute commentators on matters avant garde would create its own horizon of meanings. In the process of preparing the manuscript, however, I did select one or two ideas that I thought could serve as a preamble. These are derived from one of the first prominent books on the subject, Renato Poggioli's *The Theory of the Avant Garde*.[3] The first historical reference that Poggioli gives for the idea of the avant garde comes from *De la mission de l'art et du rôle des artistes* by Gabriel-Désiré Laverdant. Writing before the 1848 Revolution, the French Fourierist argued that art has a mission of social reform and that it can agitate for change through the production of revolutionary propaganda. Writing in 1960s U.S.A., in the context of the Cold War, Poggioli attempted to bring the anti-traditional tradition of the avant garde up to date by considering how it manages to live and work in the present, how it can reconcile itself to the culture of the times by collaborating with parts of the public.[4] Political changes in society lead to a corresponding change in the kinds of publics that exist. Poggioli distinguished in this regard an art that is made for an intelligentsia and an art that creates a public for itself—an art for an intellectual elite.

Poggioli argues that the concept of the intelligentsia comes from nineteenth-century Russia. Such intellectuals tended to have lower-class backgrounds. The aim of the "intellectual proletariat," or intelligentsia, he says, was to modernise and radicalize a society of workers and peasants. While the "historical" avant gardes may have identified with the goals

of the proletarian intelligentsia, they were for the most part linked to the bourgeoisie.[5] The anti-bourgeois stance of the avant garde, he argues, is not a mere pose, but part of the dialectic of alienation that projects its particular crisis in universal terms. The work of the postwar "neo-avant garde," then, according to Poggioli, is made for a public that forms itself outside of class distinctions. Intellectuals, he argues, do not form a new class. Unlike the intelligentsia, intellectuals accept the relative autonomy of art and respond positively to changes in taste and fashion. The intelligentsia, in contrast, derides aesthetic speculation and looks for ideological adhesion in works that are focused on the correct content. According to Poggioli, the bureaucratic intelligentsia of postwar America had detached itself from the revolutionary attitude and had dedicated itself instead to serving state ideology. Against this, the only possibility for a truly progressive association of political and aesthetic avant gardes would come from the intellectual elite, constituted as it is through elective affinity rather than class interests.[6]

In the current context, after the pluralist 70s, the postmodern 80s, and the thanatophilic 90s, and now that the Fukuyaman proclamation of the "end of history" has lost all plausibility, the politics of anarchism and communism, and more generally, of anti-capitalism, have allowed for a rethinking of the role of the intelligentsia in this age of so-called post-Fordist, post-political multitudes. *The Idea of the Avant Garde* mediates the stakes of a contemporary intelligentsia that is not only cognizant of the different temporalities of radical art and politics, but that tempers revolutionary negativity with a measure of distance from even the avant garde.[7] My goal here has been to draw on those cultural strands that bridge the aesthetic, the intellectual and the radical and to see what is even imaginable at this present time.

All of the contributors to this volume are distinct and challenging voices. Rather that attempting a synoptic summary of these, the reader of the present volume is invited to make their own way through this compendium of ideas, propositions, and provocations. Anything new having to do with the avant garde is already inscribed within an artistic genealogy that dates back to the previous two centuries. Whatever ruptures and continuities one finds here, their inscription within an avant garde configuration makes it such that the cultural practices and artworks in question represent a finitude that displays its own organizing principles within a truth that is infinitely multiple. This truth corresponds to the event of the avant garde.[8]

I wish to thank all of the contributors for their commitment to what they do and for generously sharing their thoughts on the idea of the avant garde. Thanks to the artists who either contributed an entry to the book or who contributed the visuals that illuminate the texts. Thanks also to all of those who for some reason or other could not participate

in the book but who nevertheless responded with interest. Special thanks go to the editor of Left Curve Publications, Csaba Polony, who believed in this project from the start. Finally, thanks to those sources that have allowed reprints of essays and who are acknowledged here:

Adrian Piper's "Political Art and the Paradigm of Innovation" was first published in Diarmuid Costello and Dominic Willsdon, eds. *The Life and Times of Images: Ethics and Aesthetics* (Ithaca: Cornell University Press, 2008) 119-33; Andrea Fraser's "From the Critique of Institutions to an Institution of Critique," was published in *Artforum* (September 2005) 278-83; David Tomas' "Dead End, Sophisticated Endgame Strategy, or a Third Way?" is modified from a version that was published in *Etc* (Spring 2012) 23-7; Hal Foster's "Precarious" was published in *Artforum* (December 2009) 207-9; Laura Mulvey's essay on Mary Kelly was published in Dominique Heyes-Moore and Maria Bashaw, eds. *Mary Kelly: Projects, 1973-2010* (Manchester: The Whitworth Art Gallery and University of Manchester, 2011); Bruce LaBruce's piece was first published in two parts as "Wondering... Don't Get Your Rosaries in a Bunch, Madrid," in *Vice* magazine online (February 2012)—it is reprinted here courtesy of Vice magazine; "Richard Kostelanetz and Michael Butterworth in Conversation" was edited by Derek Horton and first published in *Soanyway* online magazine Issue #13, "Before or Since," available at: http:www.soanyway.org.uk/beforeorsince.htm; Wu Ming 2's "How to Tell a Revolution from Everything Else" was first presented as a lecture at the University of North Carolina, April 5, 2011, it is a Creative Commons text available online at http://www.wuming-foundation.com/WM2_UNC_talk_on_revolution.pdf; Nikolaus Müller-Schöll's "Poverty of Experience: Performance Practices After the Fall" was first published in Danish as "Erfaringsfattigdom. Om visse sceniske praksisser "efter faldet," *Peripeti. Tidsskrift for dramaturgiske studier* #14 (2010) 7-16; Judith Malina's essay was published as an afterword in Judith Malina, *The Piscator Notebook* (New York: Routledge, 2012); the original text-script by Etcetera/Errorist International for *The Errorist Kabaret* (2009) was first presented at the 11th Istanbul Biennial and made available by Federiko Zukerfeld; Travis Wilkerson's "Creative Agitation" manifesto was first published in *Cineaste* 37:1 (Winter 2011); the conversation between Alexander Kluge and Oskar Negt is excerpted from the Kluge film *News from Ideological Antiquity. Marx—Eisenstein—Das Kapital / Nachrichten aus der ideologischen Antike. Marx—Eisenstein—Das Kapital* (Alexander Kluge, Germany, 2008); Evan Mauro's "The Death and Life of the Avant Garde" was first published in *Mediations* 26:1-2 (Fall 2012-Spring 2013) 119-42; Mikkel Bolt Rasmussen's essay is a first-time translation of the first chapter of his book *Avantgardens selvmord* (Copenhagen: 28/6, 2009) 7-39; Gene Ray's "Towards a Critical Art Theory" was first published in Gerald Raunig and Gene Ray, eds. *Art and Contemporary Critical Practice: Reinventing Institutional*

Critique (London: MayFly Books, 2009) 79-91; John Roberts' "Revolutionary Pathos, Negation, and the Suspensive Avant-Garde," was first published in *New Literary History* 41:4 (Autumn 2010) 717-30; Zanny Begg and Dmitry Vilensky's "On the Possibility of Avant-Garde Compositions in Contemporary Art" was first presented in *Newspaper of the Platform "Chto Delat?/What Is to Be Done?"* #17 Debates on the Avant-Garde (August 2007), available at: http://www.chtodelat.org/images/pdfs/17_vanguard.pdf; a version of Beatriz Colomina's text was pblished in Germano Celant, ed. *The Small Utopia: Ars Multiplicata* (Milan: Progretto Prada Arte, 2012); BAVO's essay was originally published in Belgian as "Waarom kunstenaars niet fascistisch genoeg zijn" in the online journal *rekto:verso* #49 (November-December 2011), it is presented here in English for the first time; lastly, Chris Culter's "Thoughts on Music and the Avant Garde" was first published in Hans Werner Heister, Wolfgang Martin Stroh and Peter Wicke, eds. *Musik-Avantgarde Zur Dialektik von Vohut und Nachhut—Eine Gedankensammlung fur Gunther Mayer* (Oldenberg: Bis Verlag der Carl von Ossietzky University, 2006).

Notes

1. Pierre Bourdieu, *The Rules of Art: Genesis and Structure of the Literary Field*, trans. Susan Emanuel (Stanford: Stanford University Press, [1992] 1995) 252-5.
2. See Marc James Léger, *Brave New Avant Garde: Essays on Contemporary Art and Politics* (Winchester, UK: Zero Books, 2012).
3. Renato Poggioli, *The Theory of the Avant-Garde*, trans. Gerald Fitzgerald (Cambridge: Harvard University Press, [1962] 1968).
4. Poggioli, *The Theory of the Avant-Garde*, 79.
5. The periodizing qualifiers "bohemian," "historical" and "neo" are of course derived from Peter Bürger's *Theory of the Avant Garde*, trans. Michael Shaw (Minneapolis: University of Minnesota Press, [1974] 1984).
6. Poggioli, *The Theory of the Avant-Garde*, 91. This process is given an updated treatment by David Cottington who argues that a leftist partisan view of the avant garde not only ignores the conservative political affiliations of some of its members, but more importantly, the development of an "alternative professionalism" through which the emergence, formation, and institutional consolidation of the interwar avant garde led its networked members away from the entrenched confrontation between capitalism and communism—a strategy that makes Cottington's book amenable to the predominant culturalization of politics that has been at the core of left-liberal pluralism since at least the 1960s. Cottington's effort to provide a seemingly more complete account of the formation of an avant garde network tends to depoliticize the theoretical advances of Peter Bürger's concept of the "institution art," which not only accounts for the separation of cultural production from mainstream society, a process that makes avant garde more difficult to distinguish from modernism, but also the class character of its political effort to reintegrate art into social processes. Whereas Cottington wishes to see the productive aspects of false sublation—a kind of 'resistance is futile' approach to contradiction and overdetermination with no outside to capitalism—Bürger operated with a Marxist notion of the social totality that opened up the kinds of possibilities that we see enacted in today's engaged art practices. One needs therefore to distinguish the concrete universal, the hegemony of capitalism, from the social totality. While the "cultural contradictions of capitalim" contain avant-garde art, this is not to say that avant-garde art is capitalist. As Guy Debord understood better than most contemporary cultural historians, whatever contradictions exist in society, these can only be resolved in history and not in artworks. The relevance of avant-gardism for today's practices is thus not a question of legacy, but is subtracted, as Badiou would put it, from the norms of evaluation that separate being from its topographical links to the event of the avant garde. Avant-garde praxis is that which is subtracted from the opposition art and politics, social formation and ideology. The named singularities in Cottington's book—among them Gavin Grindon, Yes Men, Reverend Billy, Etcetera, Laboratory of Insurrectionary Imagination, Centre for Tactical Magic, Julian Stallabrass, Michael [sic: Steve] Kurtz, Huit Facettes, Okwui Enwezor, Elizabeth Harney, Blake Stimson and Gregory Sholette, and John Roberts—appear thus as contemporary instances in which the term avant garde loses its ability to provide a total understanding of society and reveal what Bürger elsewhere refers to as its "unrealized extravagance." See David Cottington, *The Avant-Garde: A Very Short Introduction* (Oxford: Oxford University Press, 2013). See also Peter Bürger, "Avant-Garde and Neo-Avant-Garde: An Attempt to Answer Certain Critics of *Theory of the Avant-Garde*," *New Literary History* 41:4 (Autumn 2010) 695-715.
7. On this, see my essay "For the De-Incapacitation of Community Art Practice," *Journal of Aesthetics and Protest* #6 (2008) 286-99.
8. See Alain Badiou, *Handbook of Inaesthetics*, trans. Alberto Toscano (Stanford: Stanford University Press, [1998] 2000).

Political Art and the Paradigm of Innovation

Adrian Piper

Post-modernism claimed that originality is no longer possible, and that the artist is merely a scavenger who rearranges prefabricated materials, images and ideas—call this the anti-originality thesis. This thesis was itself original, and therefore self-defeating. But quite aside from its self-contradiction, the anti-originality thesis was objectionable for several reasons. First, it rationalized the long-standing mainstream Euroethnic practice of using without attribution and exploiting for personal profit the creative products of marginalized cultures, while those marginalized cultures themselves continued to labor under conditions of obscurity and deprivation. Second, the creative products of marginalized cultures express meanings that can only be understood by understanding the culture in question. The anti-originality thesis decontextualized and resituated them in such a way as to discourage cross-cultural communication and reinforce mainstream tendencies to ignorance and self-congratulation. Third, the anti-originality thesis began to gain currency in the United States in the late 1980s—at the very moment when, as the result of the increasing popularity of the concept of 'otherness' bequeathed us by post-structuralist anthropology, the innovative contributions of artists from those marginalized cultures began to gain recognition. The anti-originality thesis enabled mainstream artists, who had risen to prominence on the basis of aesthetic innovation now clearly familiar from the work of formerly unacknowledged minority artists, to dismiss the value of originality in any case—thereby cementing the art-historical significance of the mainstream group while denying it to those on the margins. The anti-originality thesis thus served an urgent function at an important historical moment. It was an ideological fiction that provided an institutional bulwark against the marginalized outsiders who were beginning to storm the barricades.

A further shortcoming of the anti-originality thesis was the shallow conception of originality it presupposed. According to this conception, true originality does not depend on materials, images or ideas already present in the culture at large, but rather contributes entirely novel ones. It does not synthesize or reconfigure any such previously existing elements, but rather creates new ones from scratch—as though these were mutually exclusive alternatives; and as though any entirely novel entity could be cognized in the first place. In order to speak to us, a work of art must use languages we can recognize.

If works of art in any field really had to expunge all familiar images, ideas, media and materials in order to meet such criteria of originality, none of the major art historical figures we consensually recognize as original would pass the test. Should we then have gone back and re-evaluated whether Picasso made too great a use of African art to count as innovative according to this criterion? And if so, should we then have valorized Picasso's cubism even more highly because of its unoriginality? And should we now valorize more highly works of art that are more derivative, and disparage works that are insufficiently derivative? These are some of the *reductio ad absurda* to which the anti-originality thesis leads.

Finally, the impotence of the anti-originality thesis was demonstrated by the long-standing art world practices of selecting, exhibiting, marketing and canonizing modern art. Regardless of conflicting opinions about quality, all parties to these practices converge on the essentials of how to bring work to the attention of a larger audience and how to keep it there. Whether the audience in question is the artist who first makes the work, the dealer who first shows it, the viewer who first sees it, the critic who first writes about it, the collector who first buys it, or the institution that first legitimates it, the language of innovation functions in the same way. It frames the work as 'cutting edge,' as something that, in some important respect, has not been done before: as breaking new ground, pushing the envelope, challenging received notions, framing the debate in a new way, rejecting cherished principles, violating conventional thinking, and so on. Most of us have been deploying these familiar clichés to suit our art professional promotional roles since the onset of industrialization. And sometimes they are even warranted by the work in question. For all of these reasons, it is very difficult to take the anti-originality thesis seriously, as original as it originally seemed to be.

Indeed, the promotional fervor with which the concept of originality is invoked to market and canonize modern art finds its parallel in the fervor with which the anti-originality thesis itself was marketed as original. The enthusiasm that greeted this novel thesis when it first appeared, the heat with which its advocates elaborated upon and proselytized about it, and the seriousness with which it was taken up in extended discussion—all were sound indicators of its originality. Then began the gradual process of dogmatic

Adrian Piper, *Avdiya* (2012). Custom-designed silkscreen wallpaper, dimensions variable. Collection and © Adrian Piper Research Archive Foundation Berlin.

hardening by which this new idea became old—its canonization in the art-critical literature, the creation of academic chairs for its proponents, the generations of graduate students pressed into service to spread the gospel, the incorporation of this gospel into academic syllabi, and finally the new generations of graduate students who sought to meet the requirement of dissertation originality by calling the anti-originality thesis itself into question. This cyclical, essentially self-cannibalizing process—it's new, it's old, it's new because it's old, it's old because it's new, etc.—characterizes the historical shelf-life of the anti-originality thesis as well as that of modern art.

But this process is not confined to art or academia. It typifies a culture that more generally perpetuates itself by creating desires for 'new and improved' commodities, consuming them, digesting them, spitting them out, and moving on to the next ones—i.e. the culture of unrestrained free-market capitalism. The following observations are based in my experience of American culture and politics. But to the extent that you permit the globalization of American culture to invade your own, you may find them relevant there as well.

The culture of unrestrained free-market capitalism feeds on the shared and foundational experience of incompleteness, inferiority—of generalized insufficiency, or *want*. The experience of generalized want is created by media fabulations of a fantasy world of perpetual happiness that sharply contrasts with our complex and often painful social reality, plus the promise that this fantasy world can be realized through the acquisition of those material goods that serve as props within it. For those who have the wealth to acquire such props, this promise is broken on a daily basis, and the hollow dissatisfaction at the core of perpetual acquisition is a constant reminder that something is missing. Unfortunately, this dissatisfaction only rarely leads to the interrogation of the basic premise of the fantasy itself—i.e. that the acquisition of material props can realize it in the first place. Usually the conclusion is, rather, that more props are needed to do the trick.

This is the function of the globalized advertainment industry. Based in the American myth of acquisition and consumption, it offers tantalizing desire-satisfaction events as palliatives to the agonies of conscience caused by America's historical crimes against humanity and their present consequences. And it is nourished internationally by comparable agonies in other countries: the fall of the Austro-Hungarian Empire, of the British Empire, the Second World War in Germany and Japan, the Soviet regime in Russia, the Cultural Revolution in China, to name only a few. The globalized advertainment industry exploits our shared need to escape from the morally unbearable present of those consequences, by producing 'new and improved' goods and services that deaden their pain and divert our attention. And it expends enormous

resources convincing us to want them. That is, the advertainment industry creates interminable and insatiable desire for the new that narcotizes the ugly realities and moral self-dislike inherited from our past atrocities; it promises an end to that self-dislike in repetitive infusions of desire-satisfaction. The enduring themes of originality and innovation that characterize the discourse of modern art—indeed, contemporary culture more generally—is merely one example of that dynamic.

However, as for other such examples, there are limits on the extent of acceptable innovation in modern art. I have already suggested that no art object can be original in every respect, if it hopes to gain cognitive recognition from its viewers. A concrete particular that is not recognizable relative to the pre-existing concepts and categories by which we make sense of experience can form no part of that experience. But the limits of acceptability are much narrower than this. Unrestrained free-market capitalism depends on the rhetoric of innovation to drive consumption of the objects, events and services that perpetuate it. To the extent that a work of art undermines such consumption itself, it sacrifices acceptability, approval and status within that economy—no matter how innovative it may be in other respects—and is marginalized accordingly.

A work of art can innovate in many ways that thus conflict with the foundations of unrestrained free-market capitalism. Here are a few of them, in no particular order: First, it can critique irrationally unequal distributions of power and resources that impede the level playing field that democratic social institutions theoretically presuppose. Art that critiques racism, sexism, homophobia, anti-Semitism and other forms of xenophobia would exemplify such work. Second, it can interrogate the commodity production that is the currency of unrestrained free-market capitalism. Art that, through its form or its content calls into question the value of material embodiment, of refined techniques of production or of the use of expensive materials would exemplify such work. Third, it can call attention to the exchange relations among agents that drive an unrestrained free-market economy. Art that examines the transactions between artist and critic, dealer and collector, art and exhibition venue, promotional visibility and sales or profitability and institutional canonization would exemplify such work. Fourth, it can subvert the act or process of consumption itself. Art that disintegrates, or rots, or self-destructs, or evaporates after a fixed period of time, or that, through viewer participation, continually alters and expands its own form, or that elicits distancing, or self-critique, or intellectual reflection, or anger, or disgust rather than desire, or that rejects materiality thwarts the normal process of commodity consumption that links such objects with desire-satisfaction. Fifth, it can call into question the fundamental values of consumption. Art that satirizes desire or sexuality or wealth or technology, or that calls attention to alterna-

tive value systems that oppose or reject these, or that requires criteria of aesthetic evaluation that are incompatible with them, or that invokes utopian social ideals of fairness and equality would exemplify such work.

These brief descriptions identify some of the kinds of work we typically call 'avant-garde,' or 'cutting edge.' They are only a few of the ways in which a work of art can come into conflict with the conditions required by the smooth functioning of an unrestrained free-market economy. Such works have in common a genesis in culturally transgressive ideas or concepts that drive artists to actualize them, despite their incompatibility with the norms and ideology of capitalism. By resisting conformity to the social and economic status quo, they function primarily as paradigms of artistic self-expression. Thus two concepts—avant-garde or cutting-edge art on the one hand, and self-expression on the other—are linked in art that defies the cultural conventions of unrestrained free-market capitalism, by expressing a part of the self that exists beyond the limiting boundaries of desire. Cutting-edge paradigms of self-expression, in turn, frustrate the conventional economic function of art as a high-end currency of exchange in an unrestrained free market.

This kind of art thus embodies a tension between two central ideas assumed to be entwined in most modern democracies: free expression and free-market consumption. Capitalism typically defends free-market consumption as the most meaningful exercise of free expression in a modern democracy: to quote a particularly compelling recent ad, 'I want to break free-e-e!'—while drinking Coke. In this paradigm, freedom of expression equals freedom to consume, to satisfy desire. Hence freedom of the self, in this narrative, is in fact equivalent to enslavement by desire; and non-equivalent to autonomous self-regulation. Rather than being moved by principled internal dispositions that define and structure the self independently of the external influences on it, the self under unrestrained free-market capitalism is driven by its pursuit of objects external to it. Rather than controlling its desires and deferring their gratification in light of such principles, the self is controlled and defined by its desires, and so is at the mercy of the external stimuli that drive it. Unrestrained free-market consumption thus transforms the self into a marionette jerked here and there by the strings that attach it to external sources of self-gratification. Unrestrained free-market capitalism's version of freedom of expression thus presupposes what Kant would call a heteronymous self that is defined by the external objects it appropriates and digests. This is precisely the opposite of the originality and innovation that unrestrained free-market capitalism claims to nurture. Commodities that actually satisfy these desiderata would thus seem to stunt their growth in those who consume them.

Cutting-edge art of the kind described earlier demonstrates that there is no necessary connection between freedom of expression and free-market consumption. The two are antithetical where freedom of expression transgresses the habitual desires that market consumption inculcates. Such work serves to remind us that there are other capacities within the self—curiosity, wonder, intellect, reason, self-awareness, for example—and may even awaken those capacities within some viewers. By stimulating alternative capacities within the self and eliciting alternative responses that outcompete the demands of desire, such work also may inspire new possibilities of creative self-expression in its viewers. If it can be dismissed by the incurious with the comment that 'I could do that if I tried,' it can also be embraced by the curious with exactly the same thought.

To the extent that such work frustrates market exchange and consumption, it tends to exist at the margins of an unrestrained free-market economy, if at all. And it receives less of the financial support or institutional legitimation than does work which functions more smoothly within the constraints of free-market capitalism. It denies such work an audience at any or all levels of entry into the nerve centre of contemporary art: dealers decline to make studio visits to see it, or decline to show it on grounds of its unmarketability; or, should the work pass that hurdle, critics, mindful of the conservative publishing interests that ultimately ensure their own marketability, decline to write about it; or, should the work pass that hurdle, curators, mindful of the conservative administrative interests that ultimately determine museum policy (including staff hiring), decline to accord it the stamp of institutional canonization; or, should the work pass that hurdle, conservative institutions and collectors, mindful of the contradiction to their own values such work expresses, decline to purchase it. In direct proportion to the threat to such values that this type of cutting-edge art represents, it is immediately or gradually eliminated from public awareness and from the historical record by those conservative capitalist interests themselves. Cutting-edge art thereby exposes the ideological deception by which unrestrained capitalism claims the mantle of freedom for purposes of self-legitimation. Unrestrained free-market capitalism in fact restricts quite narrowly the freedom to express oneself in works of art that subvert the market transactions through which such works are supposed to be consumed.

By excluding from institutional legitimation those works of art that thus call into question the foundations of this system, the system of free-market capitalism itself thereby ensures a permanent supply of innovative but perpetually marginalized art works that do, in fact, 'break new ground,' 'push the envelope,' 'challenge received notions,' 'frame the debate in a new way,' 'reject cherished principles' or 'violate conventional thinking'—to the detriment of their

creators' livelihoods. Typically, these judgements are applied approvingly to those innovations that respect the highly circumscribed limits of unrestrained free-market capitalism: the rhetoric of the margin is most effectively manipulated by those most firmly ensconced at the center. But they are withheld from innovations that actually do most strongly interrogate or subvert market forces. Instead, such art typically receives either heavy blasts of unfocused hostility, or little if any recognition at all. Because such work destabilizes the power relations constitutive of unrestrained free-market capitalism, I shall bring all of it under the rubric of *explicitly political art*.

By contrast, *implicitly political art* is often preoccupied with abstraction, or pure form, or perception, or beauty. Its content avoids topical, politically divisive subject matter; and its form extends and celebrates accepted materials, techniques and modes of production. It may serve to inspire or delight us, or provide an escape or asylum from the painful social realities that surround us. As such, implicitly political art is no less culturally necessary, significant or valuable than explicitly political art. A healthy and well-functioning society makes room for both. Most artists who produce implicitly political art are extremely fortunate to have the luxury of an inner, creative sanctuary in which the drive to produce such work can be nurtured. They are fortunate to be spared the necessity of grappling consciously and always, at all levels of their being, with the urgent social problems that often drive explicitly political art. Most producers of implicitly political art have reason to be grateful for the creative solace from such problems they are privileged to enjoy.

However, some who produce implicitly political art do not escape such problems, but rather are ensnared by them. Motivated by self-censorship, and by the strategic understanding that making explicitly political art lessens the chances and the magnitude of professional success, this kind of implicitly political art is an expression of imprisonment within the bounds of political conflict, rather than an escape from it. These artists make a reasoned decision that voluntarily cramping their own scope of self-expression and confining their investigations within free-market capitalist conventions is well worth the trade-off in professional success. They thereby sacrifice freedom of expression for the material rewards of institutional legitimacy. They knowingly subordinate the self-expressive function of their work to its function as a currency of market exchange, and, like artists and writers in the former eastern European countries under Communism, they exchange clarity for 'subtlety,' forthrightness for 'understatement,' and political protest for 'irony.' The authoritarian extremes of capitalism and socialism thus dovetail in the artistic evasions and self-protective camouflage they force professionally ambitious artists to adopt.

Regardless of the background determinants of implicitly political art, it qualifies as political because—like all events, actions and choices embedded in a social context—it has political preconditions and political consequences. Whatever its other benefits—and there are many—implicitly political art reinforces and exploits the conditions required by unrestrained free-market capitalism. Implicitly political art tacitly endorses the status quo by taking advantage of it, presupposing it, and declining to interrogate it. This would include art that purports to contain no political content, or contains political content so masked and subdued under layers of irony, esoteric allusions and insider jokes that it is perceptually invisible; or art that requires the expensive and sophisticated production techniques of any high-end commodity; or that diverts the viewer's attention away from her own compromised location within the matrix of power relations that constitute a free-market economy; or that celebrates or reinforces the addictive habits of commodity consumption and desire-satisfaction themselves. A healthy market economy, embedded within the constraints of a stable and well-functioning democracy, would accommodate both art that celebrates it and art that interrogates it.

Obviously all of these different characteristics identify a multi-dimensional sliding scale of degrees according to which a work of art may be explicitly or implicitly political. No work of art is well served by all-or-nothing judgements at either extreme, and to call a work either implicitly or explicitly political is not to pass judgement on its quality or value. Nevertheless, these two possibilities, together with the continuum of degrees between them, are exhaustive. The concept of 'non-political art'—i.e. art that is political neither in its content, nor its form, nor its social or economic presuppositions, is another ideological fiction of unrestrained free-market capitalism that has been used for propaganda purposes just as effectively as explicitly political art has.

To see why explicitly political art is systematically marginalized in an unrestrained free-market capitalist art world, consider the instrumentalizing function that transforms all objects, events and relationships into tools of desire-satisfaction in an unrestrained free-market economy more generally. This function consists in a disposition to view all such objects, events and relationships as potential instruments of personal profit, and to appraise and rank them accordingly. Here the archetypal question is, 'How much mileage can I get out of this?' The question can be posed of any object, event, relationship or condition. It is in essence a question as to how the maximum possible personal profit, i.e. satisfaction of personal desire, can be wrung from it. Unrestrained free-market capitalism thus subordinates all such states of affairs to the satisfaction of personal desire. I describe it as *unrestrained* because it

imposes no constraints of custom, policy or principle on the pursuit of desire-satisfaction.

For among the states of affairs thus subordinated are, of course, political relationships. After all, the 'free' in 'free-market' refers to a market unregulated and unrestrained by government interference. Advocates of free-market capitalism like to claim that government interference is unnecessary to a society in which all consumers are rational profit-seekers whose patterns of individual consumption conduce to the well-being of all. But this sunny view ignores the instrumentalizing function that defines unrestrained free-market capitalism, which encourages forming temporary alliances and monopolies that maximize profit by reducing competition. It also encourages unethical free riding when this is an effective means to the same end. It now seems clear that the combination of monopoly with free rider corporate practices is a lethal one that demands governmental regulation rather than refutes the need for it; and that such monopolies are incapable of policing themselves.

However, the drive for personal profit and desire-satisfaction is at odds with political regulation designed to secure the stability of all transactions within a society. Social stability requires three basic conditions. First, it requires mutual trust, and so an embedded convention of honoring contracts, or promise-keeping. Second, it requires a fair distribution of economic resources, so as to minimize conflict over those resources. These two conditions, in turn, require a third: an enforcement mechanism that distributes rewards for honoring contracts and economic fairness, and punishments for violating them. The machinery of government—of legislation, administration and adjudication—is predicated on these basic social requirements.

In a healthy and well-functioning society, individual odysseys of desire-satisfaction are constrained by these requirements. Those that conflict with them are systematically discouraged by the society's entrenched customs, as well as by its penal system. In such a society, government functions not only as a constraint but also as a counterweight to the pull of uncontrolled profit-seeking. Such a government consistently protects the rights of free speech when these are in jeopardy. It consistently inflicts punishments for criminal behavior. It passes and consistently enforces policies, procedures and regulations that ensure fairness in all contractual transactions, even where these policies may thwart individual advantage. And it consistently advocates on behalf of the powerless, in order that their voices and their claims receive the same attention as those of the powerful or eloquent. However, we have already seen that in an unregulated free-market capitalist society, government performs none of these functions consistently because it is, in reality, a subordinate instrument

of capital accumulation that acts only when and where it serves corporate interests to allow this.

A society driven by unregulated free-market capitalism is unhealthy and dysfunctional because in it, the basic structural requirement of social stability itself is subordinated to individual odysseys of desire-satisfaction, rather than the other way around. Unregulated free-market capitalism satisfies the conditions of social stability—i.e. trust and fairness—only to the extent that these are compatible with the accumulation of personal instruments of desire-satisfaction. Thus contracts are honored only if it is profitable to do so, but violated if this would be more cost-effective. Resources are distributed fairly only when inequitable but self-aggrandizing distributions would be too costly—for example, when the risk of public disclosure, potential social disruption, expensive litigation, falling revenues or stock prices, a tarnished reputation and the like would be too high. More generally, in an unregulated capitalist society, social stability is a worthwhile investment only to the extent that one's gated and guarded residential community cannot be sufficiently fortified against the danger of riots outside it; or to the extent that financial resources cannot be protected in anonymous off-shore bank accounts.

However, unregulated free-market capitalism does not merely subordinate transactional stability to maximizing personal desire-satisfaction at the tactical level. It ensures the compliance of those whose job it is to secure social stability itself—i.e. the legislative, executive and judicial branches of government—by purchasing their allegiance to personal profitability instead. By rewarding government officials with gifts, bribes, campaign contributions, personal favours, capital resources, high-status official appointments and high-paying jobs in the private sector, corporations condition those officials to reciprocate by creating and implementing public policies that are advantageous to corporate goals. In a society overtaken entirely by unregulated free-market capitalism, what may look from the outside—and, indeed, even to a naïve insider—like a serendipitous partnership between business and government is in fact a corporate business relationship between an employer and the government officials employed to protect and promote the corporation's best interests. Government is thereby similarly instrumentalized as a tool by which the powerful may maximize desire-satisfaction and personal profit.

For example, the American Republican party enacted a hostile takeover of the 2000 Presidential election through its five corporate employees on the Supreme Court. Their decision to hand the Presidency to a candidate who had lost the popular vote flaunted their power in the face of a politically disabled electorate, and irreparably defiled the legitimacy and judicial authority of the Supreme Court itself. These five Supreme Court Justices were more than

willing to trade their personal integrity, moral authority, the dignity of their office and the very idea of a democratically elected President for personal gain. Once these salaried rewards of capital are established conventions of governance, the desire for justice or a commitment to the ideals of democracy and freedom become irrelevant to the function of political office. Corporate profit and political profit become mutually reinforcing variants on the same theme.

And once the bond of trust between a citizenry and its government is decisively broken by this kind of corruption, that government can no longer motivate the democratic participation of its citizenry, because its claims to embody democratic values and represent fairly its citizens' best interests are no longer credible. However, at this stage such a government does not need the democratic participation of its citizenry to survive. On the contrary: its survival is secured by the same corporate profits it is now reconfigured to protect, and the democratic participation of its citizenry is little more than an irritant and an obstacle to that goal. The society's best interests that government now cynically purports to represent in staged and scripted public relations events are at best an afterthought.

Then the best hope for such a citizenry is simply to wait for the inevitable squabbles over power and resources to develop into wars between the major players in business and government, and wait for them to turn back to the citizenry to forge alliances that can leverage their respective positions relative to their enemies. But an informed and sophisticated citizenry in such a society will not mistake such transient, tactical alliances of power for the relations of fair representation that identify a true democracy. Nor will it depend on that government to represent fairly citizens' best interests where they can offer government no incentives of power or profit to do so. So, for example, a community or subculture that is powerful neither in numbers nor in capital resources should not expect acts of magnanimity from its elected representatives, even where these are required by considerations of fairness. In unregulated free-market capitalism, political representation is just another instrument for maximizing personal profit, and is as transient and unstable as the desires that profit satisfies. Talk of fairness is cause for mockery.

Now we can see more easily why, in a society driven by unregulated free-market capitalism, explicitly political art that undermines its foundations is relegated to the margins, while implicitly political art that depends on and reinforces those foundations is rewarded. Those of us in whom the acculturated commitment to democracy runs deep may naturally think that free exchange in Mill's marketplace of ideas is far more essential to a well-functioning democracy than unregulated exchange in the marketplace of goods and services; and therefore that artistic expression is a paradigm of democracy rather than of consumption. However, in an unregulated free-market society, expression itself is nothing more than a subordinate instrument of profit and desire-satisfaction. Speech, including artistic production, is a tool for achieving a desired end, whether or not its content refers to any matter of fact. A person who says what he thinks you want to hear rather than what he believes; or makes statements that are at odds with her actions; or deliberately misrepresents policies or matters of political fact; or uses speech to threaten, intimidate or deceive, or fill valuable air time, or placate his constituents or 'spin' a publicity disaster is a familiar spectacle in American political life, as well as outside it.

Only the gullible take such instrumentalized speech seriously. An audience that recognizes such speech as the tool of manipulation and self-aggrandizement it is simply tunes out. A public figure who engages in instrumentalized speech, knowing that no one believes it, knowingly uses such speech as a cynical and arrogant display of force that taunts its audiences with its inability to fight back; and debases it by the force-feeding of lies. Thus, reminding a disenfranchised citizenry of its powerlessness to set rational and honest terms of public dialogue is the demoralizing role of an advertainment media industry under unregulated capitalism.

Under these circumstances, cutting-edge artistic self-expression can find no protection because it violates the instrumentalization of speech on which unregulated capitalism feeds. On the contrary: such self-expression is a threat to its smooth functioning that must be marginalized and disabled as efficiently as possible; and so is, under these circumstances, a form of self-endangerment, indeed career suicide, for its creator. Where government is merely an instrument of capital accumulation, there can be no genuine alternative economic support system to sustain and encourage works of art that contribute to public dialogue by interrogating, criticizing or undermining the political status quo in the ways earlier described. There can be no deeply embedded social arrangements relative to which interrogation, criticism or the presentation of alternatives can be publicly acknowledged as valuable; and no social framework within which these values can find consistent and concerted defence. That is, such a society has no room for a 'loyal opposition'—of the sort that the BBC, for example, frequently provides to the British government—and no incentive to supply the basic social preconditions in which art as a paradigm of self-expression can flourish. All it can be—all it is permitted to be—is an instrumental, high-end currency of market transaction.

Consider an actual case. In the 1990s in the United States, the Philip Morris corporation (now renamed Altria) backed

both reactionary politicians who opposed governmental funding for avant-garde art, and also artists and major art institutions that exhibited it. On the surface, it seemed inconsistent to support both political representatives such as Senator Jesse Helms who opposed such work on the one hand, and also art institutions that encouraged it on the other. But at a deeper level there was no inconsistency. Since Philip Morris sells drug addiction and death for profit, it was and remains clearly very vulnerable to political and moral criticism. And, as both Philip Morris and Senator Jesse Helms were fully aware, avant-garde art can be an extremely powerful and potent voice of moral criticism and political protest. So it was in Philip Morris's interests to control the content of such art, to restrict it to the critically innocuous and politically inoffensive. It attempted to accomplish this, first, by helping Senator Helms eliminate public funding for avant-garde art. Second, Philip Morris simultaneously established itself as the major source of private corporate funding in the arts. Thus, in essence, artworks and exhibitions could receive funding either from Philip Morris and corporations like it, or not at all.

By refusing to fund explicitly political art that criticized, protested or undermined its corporate interests, and choking off alternative sources of funding in the public sector, Philip Morris successfully discouraged the making, exhibiting and performance of such work. Having already bought the complicity of elected representatives in eliminating government support for works of contemporary art, it then bought the silence both of artists who wanted those professional opportunities, and also of the art institutions that otherwise would have offered them. Both censored themselves, and subordinated contemporary art to the demands of unregulated free-market capitalism, by producing and exhibiting commodities it could easily digest.

This example illustrates the truism that in a society in which government is a tool of business interests, we can hardly expect it to be a beacon of democracy in the arts. In such a society, adherence to the ideology of unregulated free-market capitalism is a primary objective of content programming in the advertainment industry, as well as of acculturation throughout the society more generally. Such ideological adherence is strictly incompatible with an unconditional commitment to freedom of expression. So, far from being celebrated as an expression of the democratic exchange of ideas, artwork that interrogates, criticizes or offers alternatives is discouraged by the withholding of political as well as financial support. Through such negative reinforcement consistently applied, the scope of thought and imagination themselves are diminished to minor variations on the actual—at the same time that desire, consumption and impulse shopping are magnified into fantasy retreats from it; and we gradually lose the capacity to conceive a world in which our lives, our experiences and our selves can be any better or any different than they are now. This is how a purportedly democratic form of government can be complicit in the suppression of reason when this conflicts with the profit motive.

Now one very great achievement of explicitly political art is to demonstrate, at a concrete perceptual level, what alternatives to the status quo actually look like. That is why it often makes its viewers so viscerally uncomfortable. Explicitly political art does not always, or necessarily, present its viewers with alternatives to the status quo that are genuine improvements on it: explicitly political art can be politically reactionary as well. Nevertheless, some explicitly political art does give form and reality to dreams of betterment—of more humane attitudes towards others who are different, more considerate treatment of natural resources and materials, more judicious forms of social organization, or more reflective and sophisticated approaches to our own psychological dispositions—and may stand as a back-handed reproach to the excesses of unregulated free-market capitalism for this reason alone. Seen from within the framework of such a society, explicitly political art may well seem to push the envelope a bit too far; to violate so many cherished assumptions and break so much new ground that the ground itself may seem to tremble beneath our feet. In these cases, explicitly political art may well transgress currently acceptable norms of innovation. But it does not violate the demands of human progress.

From the Critique of Institutions to an Institution of Critique

Andrea Fraser

Nearly forty years after their first appearance, the practices now associated with "institutional critique" have for many come to seem, well, institutionalized. In the Spring of 2005, for example, Daniel Buren returned with a major installation to the Guggenheim Museum (which famously censored both his and Hans Haacke's work in 1971); Buren and Olafur Eliasson discussed the problem of "the institution" in the pages of *Artforum*; and the LA County Museum of Art hosted a conference called "Institutional Critique and After." More symposia planned for the Getty and the College Art Association's annual conference, along with a special issue of *Texte zur Kunst*, may very well see the further reduction of institutional critique to its acronym: IC. Ick.

In the context of museum exhibitions and art history symposia such as these, one increasingly finds institutional critique accorded the unquestioning respect often granted artistic phenomena that have achieved a certain historical status. That recognition, however, quickly becomes an occasion to dismiss the critical claims associated with it, as resentment of its perceived exclusivity and high-handedness rushes to the surface. How can artists who have become art-historical institutions themselves claim to critique the institution of art? Michael Kimmelman provided a ready example of such skepticism in his critical *New York Times* review of Buren's Guggenheim show. While the "critique of the institution of the museum" and the "commodity status of art" were "counterestablishment ideas when, like Mr. Buren, they emerged forty or so years ago," Kimmelman contends, Buren is now an "official artist of France, a role that does not seem to trouble some of his once-radical fans. Nor, apparently, does the fact that his brand of institutional analysis ... invariably depends on the largesse of institutions like the Guggenheim." Kimmelman goes on to compare Buren unfavorably to Christo and Jeanne-Claude, who "operate, for the most part, outside traditional institutions, with fiscal independence, in a public sphere beyond the legislative control of art experts."[1]

Further doubts about the historic and present-day efficacy of institutional critique arise with laments over how bad things have become in an art world in which the Museum of Modern Art opens its new temporary exhibition galleries with a corporate collection, and art hedge funds sell shares of single paintings. In these discussions, one finds a certain nostalgia for institutional critique as a now-anachronistic artifact of an era before the corporate mega-museum and the 24/7 global art market, a time when artists could still conceivably take up a critical position against or outside the institution. Today, the argument goes, there no longer is an outside. How, then, can we imagine, much less accomplish, a critique of art institutions when museum and market have grown into an all-encompassing apparatus of cultural reification? Now, when we need it most, institutional critique is dead, a victim of its own success or failure, swallowed up by the institution it stood against.

But assessments of the institutionalization of institutional critique and charges of its obsolescence in an era of mega-museums and global markets founders on a basic misconception of what institutional critique is, at least in light of the practices that have come to define it. They necessitate a reexamination of its history and aims, and a restatement of its urgent stakes in the present.

I recently discovered that none of the half-dozen people often considered the "founders" of "institutional critique" claim to use the term. I first used it in print in a 1985 essay on Louise Lawler, "In and Out of Place," when I ran off the now-familiar list of Michael Asher, Marcel Broodthaers, Daniel Buren, and Hans Haacke, adding that, "while very different, all these artists engage(d) in institutional critique."[2]

I probably first encountered that list of names coupled with the term "institution" in Benjamin H. D. Buchloh's 1982 essay "Allegorical Procedures," where he describes "Buren's and Asher's analysis of the historical place and function of aesthetic constructs within institutions, or Haacke's and Broodthaers' operations revealing the material conditions of those institutions as ideological."[3] The essay continues with references to "institutionalized language," "institutional frameworks," "institutional exhibition topics," and describes one of the "essential features of Modernism" as the "impulse to criticize itself from within, to question its institutionalization." But the term "institutional critique" never appears.

By 1985, I had also read Peter Bürger's *Theory of the Avant-Garde*, which was published in Germany in 1974 and finally appeared in English translation in 1984. One of Bürger's

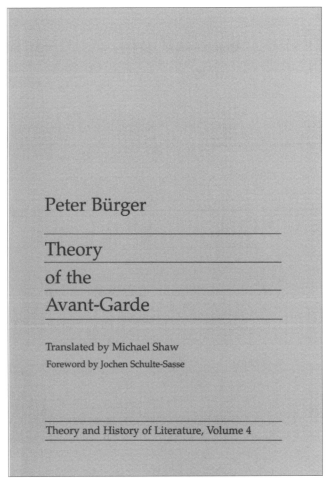

Peter Bürger

Theory
of the
Avant-Garde

Translated by Michael Shaw
Foreword by Jochen Schulte-Sasse

Theory and History of Literature, Volume 4

Peter Bürger's *Theory of the Avant-Garde*, 1974. English edition by
University of Minnesota Press, 1984.

central theses is that "with the historical avant-garde movements, the social subsystem that is art enters the stage of self-criticism. Dadaism ... no longer criticizes schools that preceded it, but criticizes art as an institution, and the course its development took in bourgeois society."[4]

Having studied with Buchloh as well as Craig Owens, who edited my essay on Lawler, I think it's quite possible that one of them let "institutional critique" slip out. It's also possible that their students in the mid-80s at the School of Visual Arts and the Whitney Independent Study Program (where Hans Haacke and Martha Rosler also lectured)—including Gregg Bordowitz, Joshua Decter, Mark Dion, and me—just started using the terms as shorthand for "the critique of institutions" in our after-class debates. Not having found an earlier published appearance of the term, it is curious to consider that the established canon we thought we were receiving may have just been forming at the time. It could even be that our very reception of ten- or fifteen-year-old works, printed texts, and tardy translations (by the likes of Douglas Crimp, Asher, Buren, Haacke, Rosler, Buchloh, and Bürger), and our perception of those works and texts as canonical, was a central moment in the process of institutional critique's so-called institutionalization. And so I find myself enmeshed in the contradictions and com-

plicities, ambitions and ambivalence that institutional critique is often accused of, caught between the self-flattering possibility that I was the first person to put the term in print, and the critically shameful prospect of having played a role in the reduction of certain radical practices to a pithy catch-phrase, packaged for co-optation.

If, indeed, the term "institutional critique" emerged as shorthand for "the critique of institutions," today that catchphrase has been even further reduced by restrictive interpretations of its constituent parts: "institution" and "critique." The practice of institutional critique is generally defined by its apparent objects: "the institution," which is, in turn, taken to refer primarily to established, organized sites for the presentation of art. As the flyer for the symposium at LACMA put it, institutional critique is art that exposes "the structures and logic of museums and art galleries." "Critique" appears even less specific than "institution," vacillating between a rather timid "exposing," "reflecting," or "revealing," on the one hand, and visions of the revolutionary overthrow of the existing museological order on the other, with the institutional critic as a guerrilla fighter engaging in acts of subversion and sabotage, breaking through walls and floors and doors, provoking censorship, bringing down the powers that be. In either case, "art" and "artist" generally figure as antagonistically opposed to an "institution" that incorporates, co-opts, commodifies, and otherwise misappropriates once-radical—and institutionalized—practices.

These representations can admittedly be found in the texts of critics associated with institutional critique. However, the idea that institutional critique opposes art to institution, or supposes that radical artistic practices can or ever did exist outside of the institution of art before being "institutionalized" by museums, is contradicted at every turn by the writings and work of Asher, Broodthaers, Buren, and Haacke. From Broodthaers' announcement of his first gallery exhibition in 1964—which he begins by confiding that "the idea of inventing something insincere finally crossed my mind" and then informing us that his dealer will "take thirty percent"—the critique of the apparatus that distributes, presents, and collects art has been inseparable from a critique of artistic practice itself.[5] As Buren put it in "The Function of the Museum" in 1970, if "the Museum makes its 'mark,' imposes its 'frame' ... on everything that is exhibited in it, in a deep and indelible way," it does so easily because "everything that the Museum shows is only considered and produced in view of being in it."[6] In "The Function of the Studio" from the following year, he couldn't be more clear, arguing that the "analysis of the art system must inevitably be carried on" by investigating both the studio and the museum "as customs, the ossifying customs of art."[7]

Indeed, the critique most consistently in evidence in the post-studio work of Buren and Asher is aimed at artistic

practice itself (a point that may not have been lost on other artists in the Sixth Guggenheim International Exhibition, since it was they, not the museum officials or trustees, who demanded the removal of Buren's work in 1971). As their writings make clear, the institutionalization of art in museums or its commodification in galleries cannot be conceived of as the co-optation or misappropriation of studio art, whose portable form predestines it to a life of circulation and exchange, market and museological incorporation. Their rigorously site-specific interventions developed as a means not only to reflect on these and other institutional conditions but also to resist the very forms of appropriation on which they reflect. As transitory, these works further acknowledge the historical specificity of any critical interventions, whose effectiveness will always be limited to a particular time and place. Broodthaers, however, was the supreme master of performing critical obsolescence in his gestures of melancholic complicity. Just three years after founding the *Musée d'Art Moderne, Département des Aigles* in his Brussels studio in 1968, he put his "museum fiction" up for sale, "for reasons of bankruptcy," in a prospectus that served as a wrapper for the catalogue of the Cologne Art Fair—with a limited edition sold through Galerie Michael Werner. Finally, the most explicit statement of the elemental role of artists in the institution of art may have been made by Haacke: "Artists," he wrote in 1974, "as much as their supporters and their enemies, no matter of what ideological coloration, are unwitting partners ... They participate jointly in the maintenance and/or development of the ideological make-up of their society. They work within that frame, set the frame and are being framed."[8]

From 1969 on, a conception of the "institution of art" begins to emerge that includes not just the museum, nor even only the sites of production, distribution, and reception of art, but the entire field of art as a social universe. In the works of artists associated with institutional critique, it came to encompass all the sites in which art is shown—from museums and galleries to corporate offices and collectors' homes, and even public space when art is installed there. It also includes the sites of the production of art, studio as well as office, and the sites of the production of art discourse: art magazines, catalogues, art columns in the popular press, symposia, and lectures. And it also includes the sites of the production of the producers of art and art discourse: studio art, art history and, now, curatorial studies programs. And finally, as Rosler put it in the title of her seminal 1979 essay, it also includes all the "lookers, buyers, dealers and makers" themselves.

This conception of "institution" can be seen most clearly in the work of Haacke, who came to institutional critique through a turn from physical and environmental systems in the 1960s to social systems, starting with his gallery-visitor polls of 1969-73. Beyond the most encompassing list of substantive spaces, places, people and things, the "institution" engaged by Haacke can best be defined as the net-work of social and economic relationships between them. Like his *Condensation Cube* (1963-65), and his *MoMA-Poll* (1970), the gallery and museum figure less as objects of critique themselves than as containers in which the largely abstract and invisible forces and relations that traverse particular social spaces can be made visible.[9]

Moving from a substantive understanding of "the institution" as specific places, organizations, and individuals to a conception of it as a social field, the question of what is inside and what is outside becomes much more complex. Engaging those boundaries has been a consistent concern of artists associated with institutional critique. Beginning in 1969 with a *travail in situ* at Wide White Space in Antwerp, Buren realized many works that bridged interior and exterior, artistic and non-artistic sites, revealing how the perception of the same material, the same sign, can change radically depending on where it is viewed.

However, it was Asher who may have realized with the greatest precision Buren's early understanding that even a concept, as soon as it "is announced, and especially when it is 'exhibited as art' ...becomes an ideal-object, which brings us once again to art."[10] With his *Installation Münster (Caravan)*, Asher demonstrated that the institutionalization of art as art depends not on its location in the physical frame of an institution, but in conceptual or perceptual frames. First presented in the 1977 edition of Skulptur Projekte in Münster, the work consisted of a rented recreational trailer, or caravan, parked in different parts of the city each week during the exhibition. At the museum serving as a reference point for the show, visitors could find information about where the caravan could be viewed *in situ* that week. At the site itself, however, nothing indicated that the caravan was art or had any connection to the exhibition. To casual passersby, it was nothing but a caravan.

Asher took Duchamp one step further. Art is not art because it is signed by an artist or shown in a museum or any other "institutional" site. Art is art when it exists for discourses and practices that recognize it as art, value and evaluate it as art, and consume it as art, whether as object, gesture, representation, or only idea. The institution of art is not something external to any work of art but the irreducible condition of its existence as art. No matter how public in placement, immaterial, transitory, relational, everyday, or even invisible, what is announced and perceived as art is always already institutionalized, simply because it exists within the perception of participants in the field of art as art, a perception not necessarily aesthetic but fundamentally social in its determination.

What Asher thus demonstrated is that the institution of art is not only "institutionalized" in organizations like museums and objectified in art objects. It is also internalized and embodied in people. It is internalized in the competencies, conceptual models, and modes of perception that allow us

Daniel Buren, *Papiers collés blanc et vert*, work *in situ*, on the invitation of the Apollinaire Gallery (Milan) for "Prospect 1968: Zeitung zur Internationalen Vorschau auf die Kunst in den Galerien der Avantgarde," Städtische Kunsthalle Düsseldorf, September 1968. Detail. © D.B-ADAGP Paris.

to produce, write about, and understand art, or simply to recognize art as art, whether as artists, critics, curators, art historians, dealers, collectors, or museum visitors. And above all, it exists in the interests, aspirations, and criteria of value that orient our actions and define our sense of worth. These competencies and dispositions determine our own institutionalization as members of the field of art. They make up what Pierre Bourdieu called *habitus*: the "social made body," the institution made mind.

There is, of course, an "outside" of the institution, but it has no fixed, substantive characteristics. It is only what, at any given moment, does not exist as an object of artistic discourses and practices. But just as art cannot exist outside the field of art, we cannot exist outside the field of art, at least not as artists, critics, curators, etc. And what we do outside the field, to the extent that it remains outside, can have no effect within it. So if there is no outside for us, it is not because the institution is perfectly closed, or exists as an apparatus in a "totally administered society," or has grown all-encompassing in size and scope. It is because the institution is inside of us, and we can't get outside of ourselves.

Has institutional critique been institutionalized? Institutional critique has always been institutionalized. It could only have emerged within and, like all art, can only function within the institution art. The insistence of institutional critique on the inescapability of institutional determination may, in fact, be what distinguishes it most precisely from other legacies of the historical avant garde. It may be unique among those legacies in its recognition of the failure of avant-garde movements and the consequences of that failure; that is, not the destruction of the institution of art, but its explosion beyond the traditional boundaries of specifically artistic objects and aesthetic criteria. The institutionalization of Duchamp's negation of artistic competence with the readymade transformed that negation into a supreme affirmation of the omnipotence of the artistic gaze and its limitless incorporative power. It opened the way for the artistic conceptualization—and commodification—of everything. As Bürger could already write in 1974, "If an artist today signs a stove pipe and exhibits it, that artist certainly does not denounce the art market but adapts to it. Such adaptation does not eradicate the idea of individual creativity, it affirms it, and the reason is the failure of the avant-garde."[11]

It is artists—as much as museums or the market—who, in their very efforts to escape the institution of art, have driven its expansion. With each attempt to evade the limits of institutional determination, to embrace an outside, to redefine art or integrate it into everyday life, to reach "everyday" people and work in the "real" world, we expand our frame and bring more of the world into it. But we never escape it.

Of course, that frame has also been transformed in the process. The question is how? Discussions of that transformation have tended to revolve around oppositions like inside and outside, public and private, elitism and populism. But when these arguments are used to assign political value to substantive conditions, they often fail to account for the underlying distributions of power that are reproduced even as conditions change, and they thus end up serving to legitimate that reproduction. To give the most obvious example, the enormous expansion of museum audiences, celebrated under the banner of populism, has proceeded hand in hand with the continuous rise of entrance fees, excluding more and more lower-income visitors, and the creation of new forms of elite participation with increasingly differentiated hierarchies of membership, viewings, and galas, the exclusivity of which is broadly advertised in fashion magazines and society pages. Far from becoming less elitist, ever-more popular museums have become vehicles for the mass-marketing of elite tastes and practices that, while perhaps less rarefied in terms of the aesthetic competencies they demand, are ever more rarefied economically as prices rise. All of which also increases the demand for the products and services of art professionals.

However, the fact that we are trapped in our field does not mean that we have no effect on, and are not affected by, what takes place beyond its boundaries. Once again, Haacke may have been the first to understand and represent the full extent of the interplay between what is inside and outside the field of art. While Asher and Buren examined how an object or sign is transformed as it traverses physical and conceptual boundaries, Haacke engaged in the "institution" as a network of social and economic relationships, making visible the complicities among the apparently opposed spheres of art, the state, and corporations. It may be Haacke, above all, who evokes characterizations of the institutional critic as an heroic challenger, fearlessly speaking truth to power—and justifiably so, as his work has been subject to vandalism, censorship, and parliamentary showdowns. However, anyone familiar with his work should recognize that, far from trying to tear down the museum, Haacke's project has been an attempt to *defend* the institution of art from institutionalization by political and economic interests.

That the art world, now a global multibillion-dollar industry, is not part of the "real world" is one of the most absurd fictions of art discourse. The current market boom, to mention only the most obvious example, is a direct product of neoliberal economic policies. It belongs, first of all, to the luxury consumption boom that has gone along with growing income disparities and concentrations of wealth—the beneficiaries of Bush's tax cuts are our patrons—and, secondly, to the same economic forces that have created the global real-estate bubble: lack of confidence in the stock market due to falling prices and corporate accounting scandals, lack of confidence in the bond market due to the rising national debt, low interest rates, and regressive tax cuts. And the art market is not the only art world site where the growing economic disparities of our society are reproduced. They can also be seen in what are now only nominally "nonprofit" organizations like universities—where MFA programs rely on cheap adjunct labor—and museums, where anti-union policies have produced compensation ratios between the highest- and lowest-paid employees that now surpass forty to one.

Representations of the "art world" as wholly distinct from the "real world," like representations of the "institution" as discrete and separate from "us," serve specific functions in art discourse. They maintain an imaginary distance between the social and economic interests we invest in through our activities and the euphemized artistic, intellectual, and even political "interests" (or disinterest) that provide those activities with content and justify their existence. And with these representations, we also reproduce the mythologies of volunteerist freedom and creative omnipotence that have made art and artists such attractive emblems for neoliberalism's entrepreneurial "ownership-society" optimism. That such optimism has found perfect artistic expression in neo-Fluxus practices like relational aesthetics, which are now in perpetual vogue, demonstrates the degree to which what Bürger called the avant-garde's aim to integrate "art into life praxis" has evolved into a highly ideological form of escapism. But this is not just about ideology. We are not only symbols of the rewards of the current regime: In this art market, we are its direct material beneficiaries.

Every time we speak of the "institution" as other than "us," we disavow our role in the creation and perpetuation of its conditions. We avoid responsibility for, or action against, the everyday complicities, compromises, and censorship—above all, self-censorship—which are driven by our own interests in the field and the benefits we derive from it. It's not a question of inside or outside, or the number and scale of various organized sites for the production, presentation, and distribution of art. It's not a question of being against the institution: We are the institution. It's a question of what kind of values we institutionalize, what forms of practice we reward, and what kinds of rewards we aspire to. Because the institution of art is internalized, embodied, and performed by individuals, these are the questions that institutional critique demands we ask, above all, of ourselves.

Finally, it is this self-questioning—more than a thematic like "the institution," no matter how broadly conceived—that defines institutional critique as a practice. If, as Bürger put it, the self-criticism of the historical avant garde intended "the abolition of autonomous art" and its integration "into the praxis of life," it failed in both its aims and strategies.[12] However, the very institutionalization that marked this failure became the condition of institutional critique. Recognizing that failure and its consequences, institutional critique turned from the increasingly bad-faith efforts of neo-avant gardes at dismantling or escaping the institution of art and aimed instead to *defend* the very institution that the institutionalization of the avant garde's "self-criticism" had created the potential for: an institution of critique. And it may be this very institutionalization that allows institutional critique to judge the institution of art against the critical claims of its legitimizing discourses, against its self-representation as a site of resistance and contestation, and against its mythologies of radicality and symbolic revolution.

Notes

1. Michael Kimmelman, "Tall French Visitor Takes up Residence in the Guggenheim," *New York Times* (March 25, 2005).
2. Andrea Fraser, "In and Out of Place," *Art in America* (June 1985) 124.
3. Benjamin H.D. Buchloh, "Allegorical Procedures: Appropriation and Montage in Contemporary Art," *Artforum* (September 1982) 48.
4. Peter Bürger, *Theory of the Avant-Garde*, trans. Michael Shaw (Minneapolis: University of Minnesota Press, 1984) 22.
5. Marcel Broodthaers quoted in Benjamin Buchloh, "Open Letters, Industrial Poems," *October* #42 (Fall 1987) 71.
6. Daniel Buren, "The Function of the Museum," in A.A. Bronson and Peggy Gale, eds. *Museums by Artists* (Toronto: Art Metropole, 1983) 58.
7. Daniel Buren, "The Function of the Studio," in *Museums by Artists*, 61.
8. Hans Haacke, "All the Art That's Fit to Show," in *Museums by Artists*, 152.
9. In this, Haacke's work parallels the theory of art as a social field developed by Pierre Bourdieu.
10. Daniel Buren, "Beware!" *Studio International* (March 1970) 101.
11. Bürger, *Theory of the Avant-Garde*, 52-3.
12. Bürger, *Theory of the Avant-Garde*, 54.

Dead End, Sophisticated Endgame Strategy, or a Third Way? Institutional Critique's Academic Paradoxes *&* Their Consequences for the Development of Post-Avant-Garde Practices

David Tomas

In 2006, John C. Welchman published an edited anthology entitled *Institutional Critique and After*. This was followed in 2009 by another anthology titled *Institutional Critique: An Anthology of Artists' Writings*, edited by Alexander Alberro and Blake Stimson. These important collections of historical and contemporary articles represent the academic consolidation of a sub-discipline—an assimilation that highlights an important set of paradoxes and contradictions concerning institutional critique's institutionalization since the 1960s.

The "Preface" to the Alberro and Stimson anthology cautions:

> Needless to say, we are well aware that to put together an anthology of institutional critique is to *institutionalize* institutional critique and therefore is fraught with self-contradictions from the beginning. To a certain extent, many of the criticisms articulated in these writings and projects could be leveled at this very volume, and we bear full responsibility for our selections and organization.[1]

It also acknowledges, "our primary ambition has been to give as rich a sense as possible of the breadth and depth of institutional critique rather than imposing a narrow outline. We have felt it particularly important to plan the volume as a guide, a resource, a base for further work and reading, as well as a self-contained book."[2] These sentences point to the existence of a new institutional, if implicit, *academic* frame of reference that links editors, publisher and audience. The first sign of this frame is the publisher's name: MIT Press, one of the most powerful and influential academic presses in the world. The second and third signs are the titles and the systems of references that bolster the observations and arguments presented in the anthology's introductory essays.[3] Welchman's preface and introduction have no references at all, but the information they supply leads to the same conclusion concerning the JRP | Ringier anthology's built-in audience profile and its connections to the university system.

What's In a Name?

The neutral title of the MIT anthology places the editors, their observations and comments at a comfortable distance from the contradictions and double binds of institutional critique's achievements, failures and defeats 'on the ground.' This detachment is publicized by the titles of the two introductions: "Institutions, Critique, and Institutional Critique" (Alberro's critical overview) and "What Was Institutional Critique?" (Stimson's ironically toned, philosophically based historical review).

Titular neutrality is synchronized with the editors' "primary ambition … to give as rich a sense as possible of the breadth and depth of institutional critique rather than imposing a narrow outline," and it tends, conveniently, to neutralize the candidly acknowledged possibility that their anthology could also easily be subject to an alternative form of institutional critique. Distance provides the necessary objectivity that is promoted by a panoramic point of view, a measure of the anthology's authenticity that is rooted in the volume's comprehensive assessment of institutional critique's history and range of activities. Objectivity produces, in its turn, the illusion that the editors' mandate exists beyond any moral or historico-critical imperative to address the anthology's own invisible institutional framework. This neutrality and the editors' confession that "we bear full responsibility for our selections and organization" tend to neutralize the political and ideological implications of the hierarchy between those that choose (under the guidance of acknowledged advisors) and those that have been chosen to be included in the book (or those that have been excluded).[4] These implicit contradictions suggest, moreover, that the MIT anthology functions as a compact, mobile emissary of a new and for the most part invisible institutional authority—a power that has not been previously acknowledged by the artists engaged in traditional museum or gallery-directed forms of institutional critique.

In the Name of the University

The university occupies a central—and openly acknowledged—position in the production and publication of *Institutional Critique and After*. The preface and introduction to this book turn out to be rich sources of information on the events leading up to this anthology's publication and their academic frame of reference. What is inadvertently or unconsciously occluded in the case of the MIT publication is clearly and innocently acknowledged in the case of the JRP|Ringier volume.[5]

The Southern California Consortium of Art Schools (SoCCAS) symposium that served as the foundation for the JRP|Ringier publication is the product of an academic culture. The range of speakers presented in *Institutional Critique and After*—the artists, scholars and museum professionals that described their positions and exchanged their ideas—is a testimony not only to the diversity of professional interest in this topic, but it is also an example of the synergy between academic and artistic cultures that exists in the art world today. As this case suggests, there is an intellectual cohesion between the various representatives of an institutionalized art world where the distinction between artists and traditional academics is blurred by the fact that they both work in a common environment and, increasingly, refer to common theories and sources of information. Undergraduate and graduate students are the raw materials that are processed by the university system to become, in the case of the art world, the next generation of art professionals.[6] While it is easy to retort that there are a significant number of art schools in the SoCCAS consortium, the fact that they are associated in a common project to produce academic symposia and books is a sign of their collective desire to explore prestigious, academically sanctioned topics related to the visual arts. This type of consolidation illustrates the way visual practices are being increasingly framed by academic topics of inquiry that include not only the history of art but, increasingly, a contemporary art history that is almost in synchronicity with the present—an extraordinarily audacious and defiant academic tour de force.

Institutional Critique and After's historical frame of reference stretches from the 1960s to 2005, but its later decades were considered from the optic of a "contemporary reassessment."[7] As Welchman points out, "Institutional Critique has been vigorously reoriented in recent years to address issues such as site-specificity, globalization, and the relation of visual culture to urban and metropolitan environments."[8] His list does not include the university or education. However, if one considers the book itself as an extension not only of an academic styled symposium but also of the university system that created the economic conditions for the symposium's existence, as well as supplying most of its intellectual raw material in the form of speakers, then the book can also be considered, as I have already suggested in the case of the MIT anthology, an autonomous institutional site in itself, and thus worthy of critical investigation in these terms.

Dead End or Sophisticated Endgame Strategy?

The dissemination, reformulation or subversion of the practice of institutional critique (it depends on how one views the changes) has important consequences on its meaning, strategies and targets. This raises an interesting question: Is it possible that there is considerable real and symbolic capital invested in the ongoing viability and 'critical health' of this practice because it has been perceived by artists, curators and academics to be an indispensable extension of the socio-political project of social transformation that was pursued in various ways by the avant garde throughout the twentieth century? Clearly, as Michael Asher's, Daniel Buren's and Hans Haacke's works suggest, early practitioners of institutional critique had no real intention of stepping outside of the boundaries and contradictions of the art world. Their objective was to point to these contradictions—to raise consciousness—and in doing so to produce difficult, sometimes complex and contradictory work. Thus the informal movement's principal historical achievement is linked to its longevity—its ability to continue to exist in a perpetual condition of articulating practices in double-bind situations vis-à-vis its own logical/utopian conditions of existence. No longer interested in the most radical and dangerous of the early twentieth-century avant garde's socio-political projects—revolutionary change in the case of the constructivists, for example—60s and 70s practitioners (of what would later be recognized as work belonging to a tradition of institutional critique) were more interested in probing the art world's institutional limits, which they managed to strategically define in terms of architectural, socio-economic and political contradictions.[9] This allowed them to simultaneously redefine the nature and functions of the artist and artwork while astutely sidestepping the dangerous questions of co-optation or long-term versus short-term cultural change.[10] In their place, the one month window of opportunity promoted by conventional exhibition cycles, proved, and continues to prove, the most efficient way of maximizing short-term analysis. Indeed, analysis—an academic custom par excellence—became the dominant *modus operandi* for these early practitioners of institutional critique. In this sense, the window of opportunity provided by the exhibition was never really questioned and therefore the exhibition economy escaped critical investigation. Fixed cycles of varying length are at the foundation of the art world's exhibition economy and they continue to dictate the way that information is presented by artists as well as the pace of change that the art world is willing to tolerate. The useful and clever approaches developed by artists like Buren ensured that they were able to continue to produce work indefinitely without facing the possibility of exclusion, early retirement, self-effacement, or even occlusion,

since the phenomena of institutional paradoxes and blatant contradictions (whether they existed in a museum, public or private gallery) was a subject matter that was inexhaustible. It was only a question of choosing one's object of analysis and ensuring that one was well integrated into the exhibition cycle from one season to another.[11]

Tacit Relationships and Continuous Possibilities

If one accepts the institutional paradoxes of contemporary art at face value, one can exit from an exhibition just as one emerges from a confessional: relatively free of guilt. However, if one probes those paradoxes in terms of the relationship between the work of art, the art world's economy, and the positions that the work and its author occupy within this economy, then the story is more complex and disturbing—at least for the viewer who is interested in pursuing institutional critique's analytical possibilities to their paradoxical and self-neutralizing ends. A critical, institutionally-directed artistic gesture can, therefore, be judged, in this context, to represent a theoretical and practical dead end, or, it can be accepted as the product of a sophisticated endgame strategy. However, in each case, one is confronted with the continuous possibility of institutional critique's extinction, a demise that is perpetually deferred through the tacit parasitic agreement that exists between institution and artist. In contrast, there is another alternative, another vantage point that might provide a different and more promising perspective on this paradox.

Third Way

The two anthologies are useful and definitive, but they also function as bookends to a marginal tradition in the visual arts. Although they do not contain the totality of knowledge about institutional critique, they conveniently signal its practical end by providing enough information to expose its unacknowledged, terminal—if perpetual—institutional paradoxes. However, they also point to a new site of investigation that is already intellectually and economically invested in institutional critique's future transformation in terms of what its members consider to be a 'realistic' theoretical and historical afterlife. If one accepts the practice's logical end (as opposed to its ongoing parasitic existence), then, in theory, this should also point to the atrophy of the unhealthy relationship between institution and artist, and the eventual institutional loss of control over the visibility and circulation of artworks, the careers of their authors, and what the public understands as contemporary art or advanced culture. This is clearly not the case—hence, the tacit theoretical/practical acceptance of the perpetual incoherence created by the parasitic coexistence of institutional critique's dead end/sophisticated endgame alternatives. In spite of this ongoing incoherence, the two volumes provide another way out by inadvertently pointing to an invisible yet ubiquitous institution that artists have not acknowledged and critically addressed in terms of the guerrilla tactics that they have adopted in their investigations of, and confrontations with, the monolithic, increasingly inventive and aesthetically challenging institutions that contain or frame their works and practices. This other institution is the university, with its intellectual class system and increasingly 'hip' and therefore fashion-conscious ideas, and, in the case of art, its array of disciplines and sub-disciplines.

The opening paragraph of Alberro's introduction to the MIT anthology inadvertently exposes the university's ambiguous historical position and relationship to power, knowledge, the public archive and the art institution:

> Like the institutions of the university and the library or public archive, the art institution was advanced by Enlightenment philosophy as dualistic. The aesthetic, discursively realized in salons and museums through the process of critique, was coupled with a promise: the production of public exchange, of a public sphere, of a public subject. It also functioned as a form of self-imagining, as an integral element in the constitution of bourgeois identity.[12]

This would have been a perfect introduction to a thorough and critical assessment of the tradition of institutional critique. It could also have served as an initial frame of reference for a self-reflexive analysis of the publication's relationship to the university: the institution that educated Alberro and Stimson as well most of the artists, curators and museum directors, etc., that operate in the art world today.[13] Alberro was not, however, really conscious of the radical implications of his opening paragraph. He goes on to provide the reader with a critical overview of the transformations in institutional critique from the 1960s to the present. His historically justified focus on the museum, and his distinction between immanent and prescriptive facets of institutional critique's engagements with that institution, provide the reader with important information and tools of analysis. One should perhaps ask for nothing more in the introduction to an anthology of artists' writings of this kind. However, one can argue that the question of the viability and/or contradictions of the tradition of institutional critique has lost all meaning in the current context of art production, and that this neutralization is the product of the absence of a critical perspective in relation to the contemporary artist's academic education.

The first and most important context for the development of strategies and tactics related to the analysis and criticism of the institutions subtending art production and reception, the economies which bind them together and through them to society at large, is no longer the museum or the art gallery (although they remain major players in the art world, along with auction houses). Because it serves as the site for the production of artists, art historians and critics, their visual works, practices, theories, histories, book manuscripts and articles, the new context is the university.

As measured by the number of artists who pass through its system, the university is now the principal institution for

the schooling of the contemporary artist in the western art world. It is also the primary institution for the education of historians and theorists. Thus, the separation between content and context, relative to the university, should be considered more significant and central to the creative process than it appears to be, although questions of research and education have recently become important topics of debate.[14] Perhaps one of the reasons for this paradoxical historical occlusion can be traced to the university's deceptive illusion of transparency. The university seems to have been relegated to a benign unconscious presence in the art world, when in fact it has always had the disturbing—and destructive—potential to serve as a *measure of progress* (and ultimately of *viability*) against which to pass judgement on the archaic models of creativity that still dominate the art world's culture, economy, and socio-institutional organization. Although the university governs, and increasingly regiments, the intellectual framework of contemporary artistic production, its formative presence has been eclipsed, notwithstanding the fact that academic methods of conceiving and compartmentalizing knowledge are deeply implicated in how artworks are visualized, produced, and received today. This occlusion has been reinforced by the ubiquitous and uncritical use of academic tools (the conventionally—that is, academically—formatted book) and methods of presentation (predictable academic layout conventions) that artists have unconsciously adopted by way of their reading practices in order to communicate information to their intellectual peers in the most efficient and democratic manner. What is at issue here, of course, is the way artworks are conceived so as to function in relation to specific bodies of information and disciplines of knowledge.

A Question of Context

Since the late 1950s there has been a progressive transformation in the art world's institutional foundations, its relationship to academic disciplines and its handling of different forms of knowledge. Paradoxically, the major categories of subject matter in the visual arts have survived such fundamental epistemological revisions. This has created, and perhaps even facilitated, a gradual epistemological transformation, thereby ensuring that its effects have not been readily detectable precisely because of the continued presence of centuries-old categories of subject matter like the human body (in almost every sphere of contemporary art) or genre painting (whose persistence serves as a reassuring historical filter in advanced post-1980s large-scale photography). In contrast, the best barometer of these changes and the most efficient measure of their significance is to be found in late 1960s and early 1970s text-based conceptual art with its focus on words, ideas, language, and its interest in other disciplinary forms of knowledge such as philosophy (Joseph Kosuth) or physics and the social sciences (Bernar Venet, Hans Haacke). While most art-related activities have ignored their conceptual roots in the

university, conceptual art did in fact produce work that could not exist without an implicit acknowledgement of the role of university-based knowledge in both its production and reception.

Artists are university-integrated intellectuals to the extent that they pursue PhDs in practice, compete for grants in the social sciences, and actively pursue collaborations with colleagues from other disciplines including anthropology, cultural studies, communication studies, computer science, and mechanical and electrical engineering. Given this new multi-disciplinary institutional environment, one would expect that the question of knowledge construction, transfer, use, and dissemination would occupy a central—and reflexive—position in artistic production and, by extension, in the core cultural matrix of each product since it can now easily be considered a purely *academic* product. While art's discursive systems have now attained a degree of academic respectability, artists still avoid engaging with the university in the same way they critically engage with the gallery or museum. The academic institutionalization of "artistic creation" should also be factored into the way contemporary art histories are constructed, since they too are invariably the product of an academic environment, its disciplinary structure, and its methodological models. Although their effects have had a ubiquitous impact on the art world and its products, it is relatively easy to conclude that these new academic conditions of production are, for the most part, rarely, if ever, acknowledged by the majority of contemporary artists and other art world protagonists (theorists, critics, curators, gallery owners, museum directors, boards of trustees and so on) as important or significant frames of reference in the production and reception of artworks.

What would happen to our understanding of contemporary art, its history and theory, or media-based visual practices (and most art practices today are media-based), if one took account of the university as a specific context for the production of knowledge and used this context as a foundation for the development of an alternative art/media history and theory as well as using the university and its disciplinary matrix as the basis for the development of innovative forms of counter-practices that are nevertheless still—and paradoxically—predicated on them? Is it even possible to deprogram the university-trained artist and the institutional milieux in which he or she functions today? And if it is possible to deprogram the artist, where would this lead when considered in terms of new methodologies and practices, as well as new models of reception, in a world that has been dominated over the past fifty years by successive waves of advanced academic theories?

When one considers the contributions, over the last fifty years, of cybernetics, semiotics, structuralism, post-structuralism, psychoanalysis, anthropology, communication studies, film studies, gender studies, postcolonial and visual studies—as well as, more generally, a trans-disciplinary pol-

itics of representation or a collective acknowledgement of the multiple and contradictory composition of social identities—one is confronted with the broad success that these key movements and ideas have had in transforming not only the social sciences but also the visual arts. This success is compounded by the death of the author and the unlimited extension of textual practices across disciplines and cultures. Today, however, these compounded academically based upheavals no longer seem to have the radical potential and specialized progressive appeal that they had fifty or even fifteen years ago. Moreover, if the questions of knowledge and education are now being raised, paradoxically, this is taking place against the invisible background of the university itself. So questions remain concerning the role of art and the artist in a world not only governed by academic theories but also framed by the ongoing operations of a post-1990s political, economic and cultural frame of reference provided by a New World Order and its proponents: What does it mean to begin to reference all contemporary artistic practices in the West in terms of the university considered as a meta-medium for the conception and production of artworks? How do socio-political and economic transformations in this medium impact on the nature and function of the artist and artwork? Is it possible to de- and re-program the academically trained artist, and where would this lead from the viewpoints of post-disciplinary methodologies, practices, and models of reception in a world that valorizes managerial order and ubiquitous visibility over the dis-order of localized transient practices? These are not easy questions to answer.

Instead of treating the university as a new meta-medium that should be factored into the material foundations of the creative process, most artists continue to produce work as if they are still operating in a traditional craft- and object-based art economy (a situation that seems to be actively promoted by art departments, galleries, museums, and auction houses). What would happen to the concepts of creative content or aesthetic experience if the university was treated as a (new) technology and/or as an advanced meta-medium and that medium became the site of critique and open-ended experimentation?

In reality, there can never be a clean break with the old. The old and new are now interlaced and networked together with a precise institutional model of how knowledge is created, archived and transmitted. Within this context, it is now of paramount importance to create micro-passageways for the clandestine transfer of 'deviant' forms of information, methodologies (or their fragments), and ideas that can result in eddies composed of un-, anti- or counter-disciplinary micro-dialogues. These eddies have the status of "liquid knowledge" (fluid and quixotic knowledge that has no immediate relationship to an origin). They are free to circulate around more sedentary forms of "hard knowledge" ("architectural" configurations of information that are cast in stable spatio-temporal form) or "softer knowl-

edge" (malleable and flexible "architectural" arrangements of information).[15] The definition, function, and context of knowledge thus becomes a site of historical contestation.

The university is the next post-avant-garde battlefield with contestants promoting different visions of the most appropriate form and function of knowledge associated with various academic disciplines when approached from the perspective of democratically supported and socially productive forms of applied research and forms of practice. Words and phrases like "appropriate," "function," "knowledge," "democratic," "research," "democratically supported," "socially productive" and "applied forms of knowledge" can become the sites of conflicting interpretations as various political factions attempt to redefine the university's function under the guidance of progressive, neoliberal, or conservative socio-economic paradigms. Increasingly, the university's traditional (if fictional) secular neutrality and its nominal educational independence is subject to covert political pressures and more or less direct exterior economic controls in the name of an amalgamated form of socio-economic rationality framed by a populist democratic ideology. The advocates of this ideology have held the university accountable to the socio-economic expectations of the majority, as opposed to answering to the long-term educational needs of a progressive society and its evolving culture. Their will has been gradually imposed on the university over the last few decades through the introduction of various regimes of bureaucratic efficiency. Conceived as a utopian space of free thought and the site of multiple forms of independent research, the university is now under scrutiny in the name of new norms of productivity and democratic accessibility and new socio-economic standards of accountability that are used to determine the nature, intellectual and practical parameters, and social value of research. These criteria have transformed the university into a site of contestation in which the role of free thought, free speech, and open-minded or "disinterested" experimentation are the battlegrounds for alternative interpretations of their social roles and functions.

Insofar as the traditional function of the university must be defended as essential to the healthy development of a society and culture, and insofar as Art is now a university-based academic discipline in the western world, Art must now play an essential—if eccentric, perhaps counter-productive, and even destructive—critical, reflexive role in defending progressive values and practices as well as defending its own vision of the latter's visual and aesthetic dimensions and functions as motors of social progress and cultural regeneration. But this is not all. Since Art is not a form of scientific, technological or economic knowledge, nor a coherent discipline, it must remain conscious of its own radical history in order to critically re-evaluate its relationship with the university and the latter's rapidly transforming social purpose. The artist must again become acutely conscious of Art's progressive avant-garde roots—

its often marginal utopian political aspirations and experiments—under the present global geopolitical regime and its new institutional—neoliberal and neoconservative—conditions of existence. Faced with these conditions, it is these aspirations and experiments that give Art the necessary historical leverage for it to claim to be a viable *contemporary* (post-avant-garde) site for the generation of alternative models and forms of knowledge.

Notes

1. "Preface" in Alexander Alberro and Blake Stimson, eds. *Institutional Critique: An Anthology of Artists' Writings* (Cambridge: The MIT Press, 2009) no pages.
2. "Preface" in Alexander Alberro and Blake Stimson, eds. *Institutional Critique*, no pages.
3. Alberro and Stimson, eds. *Institutional Critique*, 18-19, 40-42.
4. Preface to Alberro and Stimson, eds. *Institutional Critique*. The advisors include: Nora M. Alter, Uta Meta Bauer, Sabine Breitweiser, Ron Clark, Andrea Giunta, Isabelle Graw, James Meyer, Andrzej Przywara, and Stephen Wright.
5. John C. Welchman, "Preface" in *Institutional Critique and After* (Zurich: JRP|Ringier, 2006) 8-9. *Institutional Critique and After* was the product of a Southern California Consortium of Art Schools (SoCCAS) symposium that was held on May 21, 2005, at the Los Angeles County Museum of Art. The publication was the second in the SoCCAS symposia series. John C. Welchman's preface presents information on the symposium's multifaceted institutional infrastructure and the range of people involved in its development and presentation. He lists the symposium's SoCCAS funding sources and notes that the symposium was hosted by the Los Angeles County Museum of Art. The major funding source was the SoCCAS consortium itself. It was composed of the following institutions: Art Center College of Art and Design, Pasadena; California Institute of the Arts, Valencia; Claremont Graduate School; Otis College of Art and Design; University of California, Irvine; University of California, Los Angeles; University of California, San Diego; and the University of Southern California. Another source of funding was the Fellows of Contemporary Art, Los Angeles.
6. Welchman, "Preface," *Institutional Critique and After*, 9.
7. Welchman, "Preface," *Institutional Critique and After*, 11.
8. Welchman, "Preface," *Institutional Critique and After*, 11.
9. See, for example, the canonical works of three of the founding figures of institutional critique: Asher, Buren and Haacke.
10. For examples from a later generation, see Andrea Fraser, Fred Wilson, and Mark Dion.
11. The careers of Haacke and Buren are wonderful examples of the kinds of useful careers that sophisticated and politically attuned artists can pursue in the art world's densely populated institutional environment.
12. Alberro, "Institutions, Critique, and Institutional Critique," *Institutional Critique*, 3.

13. Alberro obtained his Ph.D. at Northwestern University in 1996 and his M.A. degree in Art History from the University of British Columbia in 1990, as well as a B.A. from the same university. Stimson obtained his Ph.D. from Cornell University in 1998, an M.F.A. in Sculpture from Tufts University and the School of the Museum of Fine Arts, Boston, in 1992. He was a Fellow in Studio Art at the Whitney Independent Study Program, New York, in 1990-91, and he obtained a B.A. in Religious Studies from Middlebury College in 1982. Although Stimson's education is dualist in form, his affiliations are clearly academic.
14. See for example the *Texte Zur Kunst* theme issue on *Artistic Research*, and its network of references, June 2011, available at http://www.textezurkunst.de/82/.
15. The question of what constitutes knowledge is complex and has been widely debated in every discipline from philosophy to visual art. For the purposes of this book, knowledge is defined as a systemic configuration or agglomeration of specifically organized information—a meta-informational matrix that embodies a point of view of the world—that is capable of retaining its stability across time and space, however short the extension or expanse might be. Knowledge codifies the world and is used to probe and speculate about its nature. From an anthropological viewpoint all human artifacts and systems of ideas are configurations of knowledge about the world and humanity's position in it. Societies and cultures are large-scale meta-informational matrices whose economies, customs, and systems of belief model the world and organize human activities according to those models. From the university's viewpoint, knowledge can take the form of a discipline, it can be transmitted orally, or it can be conveyed by a book, slide, or PowerPoint presentation (or similar mobile storage medium). In each case, the form is in itself a specific knowledge matrix. The question of the reception of knowledge adds a layer of ambiguity to its interpretation and gives it an essential elasticity that allows for its productive mutation in the hands of groups and individuals, a phenomenon that is essential for a society and a culture's ecological health.

In this article, knowledge can be understood to take three basic forms: 1) Hard knowledge: Within the university, knowledge has traditionally been transmitted by way of books, which stabilizes it and allows it to voyage across space and time in a permanent, coherent fashion. For the artist, hard knowledge has been traditionally transmitted via paintings, drawings, or sculpture. Today it can be transmitted via single and multiple channel films and videotapes, installations, etc. 2) Soft knowledge: This term refers to knowledge that has been transmitted orally through the medium of lectures and seminars within the university but is also recorded and codified in the form of notes, diagrams and sketches. 3) Liquid knowledge: While it retains its kinships to information and data, liquid knowledge is mobile and its affiliation to hard and soft knowledge is simply based on it being spatio-temporally disenfranchised and therefore nomadic. It moves along disciplinary fault lines and cracks. It fills the gaps that might exist between the more stable architectural forms of hard and soft knowledge. It moves along invisible trajectories and it can appear in very different hard and soft formations. Liquid knowledge from different disciplines can form trans-disciplinary "eddies" between these disciplines under the right circumstances. Under other circumstances, it can take an un-, anti- or counter-disciplinary form.

•　　•　　•

There is a growing consensus that the contemporary artist must not only acknowledge, but should also learn to function positively under the current socio-institutional and neoliberal regimes of production and dissemination in the art world, since these follow closely, if not mirror, the dominant market forces of society in general. For many, this capitulation is based on the perception that there is no viable way to avoid the seductive embrace of global capitalism. There is, in other words, no way out. While one cannot deny that these regimes extend to the art world and that they increasingly control its intellectual and material economies, one must be wary of such prescriptions for they automatically neutralize or invalidate the operational and critical-historical functions of the artist's century-old avant-garde mandate of exploring society's margins, its cultural boundaries, as well as the possibilities and limits of the discipline of art understood as a reflexive social practice that can focus on what art is, what its social role is, and what it can and cannot do. If one resists attempts to automatically assimilate the artist to a new world order, what are the social and political functions of art and the artist today?

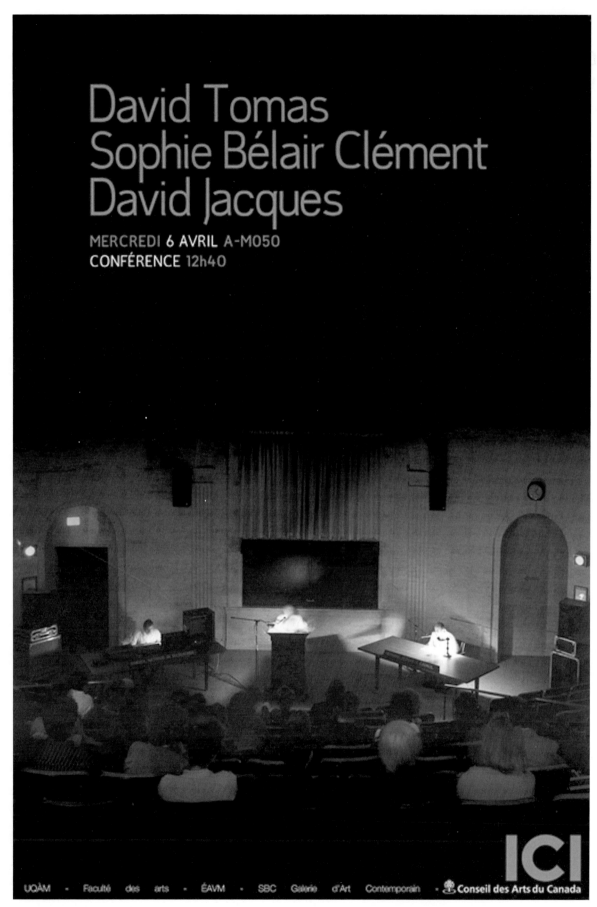

David Tomas, Poster for *Après Lecture to an Academy (After Franz Kafka)*, 2011. Courtesy of the artist.

Lecture to an Academy's basic structure as presented at the Redpath Museum, McGill University and York University in 1985 and the National Research Council of Canada performance in 1986

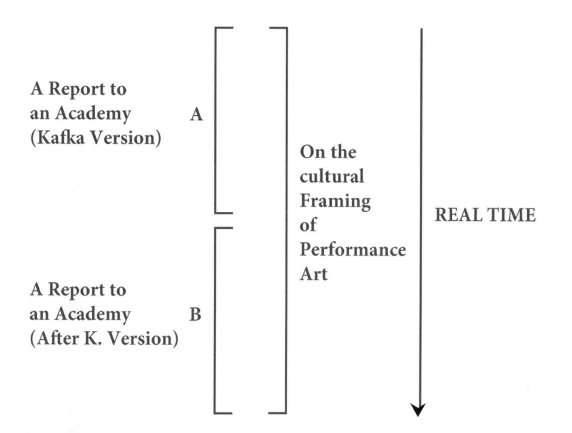

Basic Equipment List (1985/1986)
1 Eventide H949 Harmonizer
1 Effectron II or III (DeltaLab ADM 1024 or ADM 1030)
2 Amplifiers
1 control console
4 (2 sets) large good quality speakers
2 microphones + all the connecting cables etc. needed for the above
1 high quality (recording quality) reel to reel tape deck (1/4")
+ microphones and/or cables etc. to be used to record the performance.
2 small reading/lecture lamps (19th century style)
2 19th century style lecture stands

David Tomas. *Lecture to an Academy (After Franz Kafka)*'s sequential logic. Schema based on a diagram contained in a letter (5/9/85) to Diana Nemiroff, the Assistant Curator of Contemporary Art, National Gallery of Canada. Drawing by Guillaume Clermont. Courtesy of the artist.

Proposal for an unrealized version of *Lecture to an Academy* (5/9/85)

Aside from the rental of the equipment which should be less than $250.00
I would like to pay Penny Farfan her expenses while in Ottawa/ (train or bus fare) +
an artist's fee and a rehearsal fee if at all possible. The above concerns
the piece as I already performed it at the Redpath Museum and
York University. It might be interesting or more to the point I would be
interested in pushing the piece abit further in terms of presentation.
In order to do this I would be interested in using a number of
drawing students (the real thing) from Ottawa U possibly (something in
the order of a dozen) + an instructor and I would be interested in
building some kind of simple mirror system by means of which they (the
students) might be able to draw the mirror images of both lecturers. If
we go ahead with this idea I will also need some kind of lighting system
(spot/theater lights).

*I would be interested in using a mixture of Female/male students 50%/50%.

In the above case the performed/lecture would take the following
physical form:

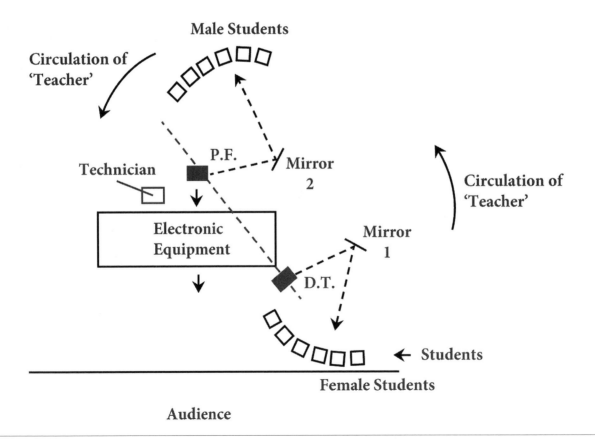

David Tomas. Reproduction of a diagram for an unrealized version of *Lecture to an Academy (After Franz Kafka)* contained in a letter (5/9/85) to
Diana Nemiroff, the Assistant Curator of Contemporary Art, National Gallery of Canada. Drawing by Guillaume Clermont. Courtesy of the artist.

Lecture to an Academy (After Franz Kafka) was a multilayered performance that attempted to explore its own contradictory conditions of existence as a work that could never live up to its radical aspirations when these were measured against a brutally frank anthropological analysis of performance art's socio-political and cultural functions. In this sense, the work was an example of a new category of what is now known as 'institutional critique'—one that operated in terms of its own over-determined contradictory logic and *socio-cultural* conditions of existence, as opposed to more conventional critiques that began and ended with a work's material and symbolic conditions of presentation (in the museum, gallery, etc.).

The performance was constructed in terms of two overlapping lectures. The first one was composed of two complete readings, by a woman lecturer, of Franz Kafka's "A Report to an Academy," a short story published in the same year that witnessed the Russian Revolution, and in the first decade of the initial flowering of the major European avant-garde movements. In the first case, the lecturer read a faithful English translation of the German original. In the second case, she presented a reworked version of Kafka's original in which an unidentified woman, possibly a studio model, replaced Red Peter, Kafka's simian protagonist. In this adaptation, Kafka's short story was rewritten in such a way as to also refer to a series of new events 'mise en abyme' in an artificial representational space, some of whose parameters alluded to photography and the photographic image. The events themselves were reoriented to refer to acculturation and socialization processes that were implicated in vocational, skill-based art school training

practices of the kind that were dominant when Kafka wrote his short story in 1917, but that had begun to be replaced in the 1960s by university-based studio art education and an increasing interest in other forms of knowledge. The woman lecturer's voice was, in addition, electronically transposed into a male voice, in the context of this reading, thereby introducing uncertainties concerning gender, identity and power. Since one of the performance's objectives was to raise questions pertaining to the new university-based education and *professionalization* of the artist in the 1970s and 1980s, the two Kafka lectures were presented in the context of another lecture, simultaneously presented, that proposed an academic anthropological analysis of why performance art could never become an actual as opposed to a pseudo-political practice. The fact that *Lecture to an Academy* was a multilayered, multi-voice presentation ensured that it could only exist at the limits of coherence and comprehension, thus publicly presenting, exposing and acknowledging its 'impossible' conditions of existence, while nevertheless still managing to embody a critical, rationally argued reading of the cultural and institutional reasons for the existence of those impossible conditions.

Lecture to an Academy was presented in 1985 at the Redpath natural history Museum, McGill University, and in a lecture room at York University. In 1986 it was presented at the National Research Council of Canada, Ottawa, under the auspices of the National Gallery of Canada during the exhibition Songs of Experience. It was re-performed in 2011 at the Université du Québec à Montréal in the context of de-institutionalized relations between Tomas and a former student.

David Tomas, *Lecture to an Academy (After Franz Kafka)*, 1985. Redpath Museum, McGill University. Courtesy of the artist.

Almost five years separate me from my existence as an ape, a short time perhaps when measured by the calendar, but endlessly long to gallop through, as I have done, at times accompanied by splendid men, advice, applause, and orchestral music, but basically alone, since all those accompanying me held themselves back a long way from the barrier, in order to preserve the image. This achievement would have been impossible if I had stubbornly wished to hold onto my origin…—Franz Kafka

Musée des Beaux-Arts

Boutique - Librairie
1390, rue Sherbrooke Ouest
C.P. 3000 Succursale H
Montréal, Québec
Téléphone(514) 285-1600
Fax (514) 285-5642

Merci de soutenir les
activités du Musée des
beaux-arts de Montréal.

Opérateur: Caisse boutique 101
No caisse: 101 No trans.: 114713
Client : VENTE-COMPTANT DIVERS
 *** REIMPRESSION ***
16/12/2007 13:56 No client: 1

PRODUIT QTE REG. ES TF TP MONTANT

183510 1 13.95 0% 0 0 13.95
POCHETTE ÉTROITE COUL.ASS BOONIES 550C
183279 1 0.00 0% 0 N 0.00
JE SUIS DANS VOTRE SYSTEME
 Sous-total : $13.95
 TPS R-119049526 $.84
 TVQ 1006004225TQ0 $1.11
 TOTAL : $15.90

Visa $15.90
 PAS DE REMBOURSEMENT:CRÉDIT OU
 ÉCHANGE AVANT 1 MOIS AVEC FAC-
 TURE, AUCUN RETOUR OU ÉCHANGE
 SUR B.OREILLES ET AFFICHES.

Catherine Lescarbeau, *Factures* (2007). Tactical intervention in the cash register of the gift shop of the Montreal Museum of Fine Arts.

Precarious

Hal Foster

No concept comprehends the art of the 2000s, but there is a condition that it has shared, and it is a precarious one. Almost any litany of the machinations of the last ten years will evoke this state of uncertainty: a stolen presidential election, the attacks of 9/11 and the war on terror, the deception of the Iraq War and the debacle of the Occupation, Abu Ghraib, Guantánamo Bay, and rendition to torture camps, another problematic presidential election, Katrina, the scapegoating of immigrants, the health care crisis, the ecological disaster, the financial house of cards… For all the discussion of "failed states" elsewhere, our own government came to operate, routinely and destructively, out of bounds. It is little wonder that the concept of "the state of exception" (developed by the Nazi jurist Carl Schmitt) was revived, that this state once again appeared to be (as Walter Benjamin wrote in 1940) "not the exception but the rule," and that, "as the space that opens up when the state of exception starts to become the rule" (as Giorgio Agamben asserted in 1994), the camp seemed to be "the new biopolitical *nomos* [principle] of the planet."[1]

Perhaps our political bond—whether we call it the social contract or the symbolic order—is always more tenuous than it appears; certainly it was precarious long before 2000. Prior to Bush and Blair, Reagan and Thatcher led the charge of neoliberalism with the battle cry "there is no such thing as society," targeting the most vulnerable (union and non-union labor, gays and lesbians, immigrants) in ways that made their lives even more precarious. Over the last decade this condition became all but pervasive, and it is this heightened insecurity that much art has attempted to manifest, even to exacerbate. This social instability is redoubled by an artistic instability, as the work at issue here foregrounds its own schismatic condition, its own lack of shared meanings, methods, or motivations. Paradoxically, then, precariousness seems almost constitutive of much art, yet sometimes in a manner that transforms this affliction into a compelling appeal.[2]

Again, this situation is not entirely new. "The true and most important function of the avant-garde," Clement Greenberg wrote seventy years ago in "Avant-Garde and Kitsch," was "to find a path along which it would be possible to keep culture moving in the midst of ideological confusion and violence." In his view, the proper path was to push the media of art "to the expression of an absolute in which all relativities and contradictions would be either resolved or beside the point," a project now long since abandoned.[3] However, in a revision of Greenberg nearly thirty years ago, T.J. Clark argued that such "self-definition" was in fact inseparable from "practices of negation" produced precisely out of "relativities and contradictions," with negation understood here as "an attempt to *capture* the lack of consistent and repeatable meanings in the culture—to capture the lack and make it over into form."[4] In the art I have in mind, negation is still wrested from relativities and contradictions, but not as a making over of formlessness into form. On the contrary, it is concerned with letting this formlessness be, as it were, so that it might evoke, as directly as possible, both the "confusion" of ruling elites and the "violence" of global capital. As might be expected, this mimesis of the precarious is often staged in performative installations, and among recent projects the following have remained most vivid for me.[5]

In early 2005, Robert Gober presented an untitled installation at the Matthew Marks Gallery in New York in which we were ushered into the aftermath of 9/11 as though into a dream made up equally of forlorn objects of everyday life and nasty bits of American kitsch. The orderly presentation of handmade readymades here—a priestly frock neatly folded on a bare plywood board, pristine pieces of beeswax fruit in a crystal bowl, faux-petrified planks of wood produced in bronze, beeswax body parts perversely conjoined, and so on—was at once forensic, like so much evidence laid out in a police warehouse-cum-morgue, and ritualistic, for the rows of these sea-changed tokens also evoked the aisles of a church. And, in fact, on a far wall hung a headless Christ on the cross (made of cement and bronze), an acephalic apparition that condensed the beheaded hostages in Iraq of the time with the figure of America as Jesus the sacrificial victim turned righteous aggressor, the one who kills in order to redeem.

Late that same year, at PS1 Contemporary Art Center in New York, Jon Kessler staged *The Palace at 4 AM*, a babel of Rube Goldberg gadgets, screens, cables, and wires that was engineered to evoke, all at once, a convulsive White House, the trashed palace of Saddam Hussein, and our own harried minds wired wide open to the obscenity of the twenty-four-hour news cycle. With small surveillance cam-

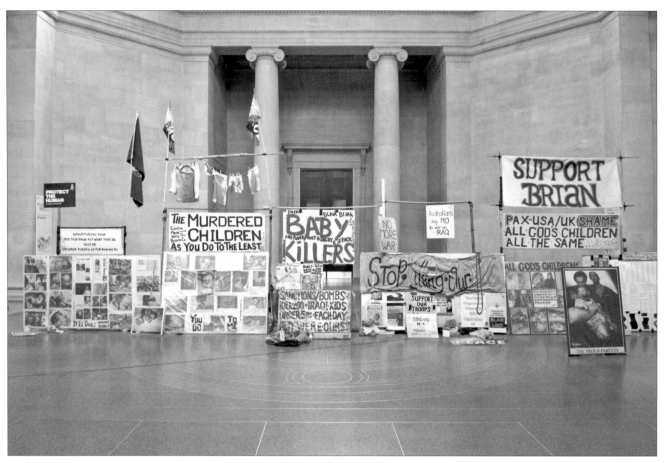

Mark Wallinger, *State Britain* (detail) (2007). Mixed media installation at Tate Britain. Photo: Dave Morgan. Courtesy of the Anthony Reynolds Gallery, London. © Mark Wallinger.

eras relaying the bizarre actions of little makeshift automatons on nearby monitors, Kessler responded, directly and indirectly, to the chaotic image-world of the Bush era, reworking TV bulletins, military reports, touristic postcards, seductive ads, and franchised toys into delirious dramas that played on the deadly obsessions of the period.

For the first eight months of 2007, Mark Wallinger presented *State Britain* in the Duveen Galleries of Tate Britain, where, instead of the usual sculpture, there appeared a reconstruction of the six-hundred-plus weathered photographs, placards, banners, flags, and well-wisher notes that a British subject named Brian Haw had assembled, since June 2001, opposite the Palace of Westminster in a lived protest against Anglo-American aggressions against Iraq. Only days before this one-man retort was removed by police, on May 23, 2006 (on the remit of a new law, prompted by this display, forbidding such demonstrations within a one-kilometer radius of Parliament Square), Wallinger photographed its manifold pieces and on that basis he produced his painstaking replica. (The Galleries happen to be one kilometer from the square, so he also inscribed a section of this perimeter on the floor). According to the artist, the "extreme verisimilitude" of the reconstruction was necessary both to underscore the authenticity of the original and to insist on its value, but it

also confronted viewers with documents of violence (including images of Iraqi children maimed by American bombs) that the official media had suppressed, and suggested that, at least in this instance, the museum had provided a last resort for oppositional speech.[6]

That same summer, for Skulptur Projekte Münster, Isa Genzken scattered, on the square beside the Catholic Überwasserkirche (also known as Liebefrauen-Überwasser, or Our Lady Above the Waters), twelve casual assemblages made up of cheap dolls and toys, little chairs and tricycles, plastic flowers and umbrellas. Quickly blown apart, the tacky umbrellas signalled the opposite of shelter, and everything else also appeared utterly abandoned. (In this case, Our Lady offered no sanctuary, turning her grim Gothic back on the miserable leavings). In fact, with some of the doll parts painted silver or otherwise molested, the entire piece seemed, like *State Britain*, a staging of the Massacre of the Innocents and thus an indirect rebuke to the church (one of the oldest in Münster), to the city, and to the nation at large. I have written elsewhere about this strategy of mimetic exacerbation in relation to Dada. "What we call Dada is a farce of nothingness in which all the higher questions are involved," Hugo Ball writes on June 12, 1916, in his great diary of Zurich Dada, *Flight Out of Time*; it is "a gladiator's gesture, a play with shabby leftovers." However,

Thomas Hirschhorn, *Musée Précaire Albinet* (Common meal, Andy Warhol week), Cité Albinet, Aubervilliers, 2004. Courtesy of the artist and Les Laboratoires d'Aubervilliers.

for all that the world of Dada is a chaos of fragments, Ball suggests, the Dadaist does not give up on totality; on the contrary, "he is still so convinced of the unity of all beings, of the totality of all things, that he suffers from the dissonances to the point of self-disintegration."[7] This is a crucial dialectic, and it is active in much of the art discussed here, but amidst "the dissonances" it is very difficult to maintain. Still, at times in her work Genzken appears perilously close to the "point of self-disintegration."[8]

Finally, in several venues in 2007 and 2008, including the Serpentine Gallery in London and the New Museum in New York, Paul Chan presented the series "The 7 Lights" (2005-2007), consisting primarily of six digital animations projected on the floor and wall. Evoking the passing of a single day, each projection begins benignly enough, with telephone cables bending along the sky, say, or sunlight filtering through a canopy of leaves. But the mood quickly darkens as silhouetted images begin to pass by—objects that range from the mundane (i.e. cell phones) to the portentous (i.e. a flock of birds). Human figures also float past, and the memory of victims plummeting from the World

Trade Towers is difficult to suppress. Sometimes these images seem to descend, as if to a private hell, and sometimes to ascend, as if in a collective rapture. "The 7 Lights" thus suggests an apocalypse that is equally catastrophic and beatific; at the same time, it evokes our everyday world as a precarious Plato's Cave of flitting shadows without enlightenment.

I came to the term precarious via Thomas Hirschhorn, and many of his projects, such as *Musée Précaire Albinet*, staged in the Aubervilliers banlieue of Paris in 2004, are very much to the point here. His sometime collaborator, the French poet Manuel Joseph, has also used the term in a short text on la précarité "as a political and aesthetic apparatus."[9] Yet what I want to underscore in the word is already present in the OED: "Precarious: from the Latin precarius, obtained by entreaty, depending on the favor of another, hence uncertain, precarious, from precem, prayer." This implies that this state of insecurity is not natural but constructed— a political condition produced by a power on whose favor we depend and which we can only petition. To act out the precarious, then, is not only to evoke its perilous and privative effects but also to intimate how and why they are produced—and thus to implicate the authority that imposes this antisocial contract of "revocable tolerance" (as Joseph puts it). The note of entreaty is largely lost in the English word, yet it is strong in the installations I mentioned above.[10] Sometimes it is mournful (as in Gober and Chan), and sometimes desperate (as in Kessler, Wallinger, and Genzken), but in all instances this importunate quality implies that the entreaty carries the force of accusation as well—an attesting to the violence done to basic principles of human responsibility.

"In some way we come to exist in the moment of being addressed," Judith Butler writes, "and something about our existence proves precarious when that address fails." In "Precarious Life," her brief essay on Emmanuel Levinas, Butler explores the notion of "the face," which the French philosopher poses as the very image of "the extreme pre-

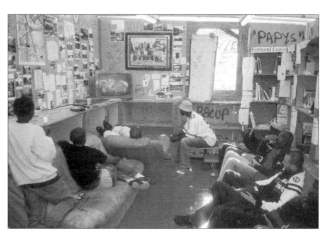

Musée Précaire Albinet (Debate, Piet Mondrian week).

Musée Précaire Albinet (The Library).

Musée Précaire Albinet (Opening, Kasimir Malevich week).

cariousness of the other." "To respond to the face, to understand its meaning," Butler argues, "means to be awake to what is precarious in another life or, rather, the precariousness of life itself."[11] This is the face put forward by the contemporary art that has most affected me.

Notes

1. Walter Benjamin, "Theses on the Philosophy of History," in *Illuminations*, trans. Harry Zohn (New York: Schocken Books, 1969) 257; Giorgio Agamben, "What is a Camp?" in *Means Without End*, trans. Vincenzo Binetti and Cesare Casarino (Minneapolis: University of Minnesota Press, 2000) 45.

2. In a response to a questionnaire on this condition, the curator Kelly Baum writes: "What if art's heterogeneity signals possibility instead of dysfunction? What if heterogeneity is art's pursuit instead of its affliction? What if, in its very heterogeneity, art were to productively engage current socio-political conditions … I think what we are seeing today is art miming its context. I think we are witnessing art performing 'agonism,' 'disaggregation,' and 'particularization.' Heterogeneity isn't just contemporary art's condition, in other words; it is its subject as well." *October* #130 (Fall 2009) 91-6.

3. Clement Greenberg, *Avant-Garde and Culture* (Boston: Beacon Press, 1961) 5.

4. T.J. Clark, "Clement Greenberg's Theory of Art," *Critical Inquiry* 9:1 (September 1982) 139-56.

5. My sampling is arbitrary, based on semi-accidental encounters, and I can only point to the works here, but they are well documented elsewhere. The precarious has many other registers than the ones noted here, ranging from the outlandish (i.e. Mike Kelley) to the poetic (i.e. Gabriel Orozco).

6. See Yve-Alain Bois et al., "An Interview with Mark Wallinger," *October* #123 (Winter 2008) 188.

7. Hugo Ball, *Flight Out of Time: A Dada Diary*, trans. Ann Raimes (New York: Viking, [1927] 1974) 65-6.

8. See my "Dada Mime," *October* #105 (Summer 2003) 166-76.

9. See Thomas Hirschhorn, Musée Précaire Albinet (Aubervilliers: Éditions Xavier Barral, 2005). In *L'infâme et la tolérance révocable: La précarité comme dispositif politique et esthétique*, Joseph writes: "Precariousness, by right, is put into practice by means of a provisional authorization, that is, by a 'revocable tolerance' accorded by the Letter of the Law—law as conceived, invented, written, by man. It concerns a 'condition' whose duration is not guaranteed, except for the men who have drawn up, decreed, and imposed this contract." Thanks to Thomas Hirschhorn for sharing this unpublished text with me.

10. "The word *précaire*," the late-eighteenth-century French satirist Antoine Rivarol wrote (as if in anticipation of Kafka), "proves how little we obtain from prayer, seeing that this word derives from it" (as quoted by Joseph).

11. Judith Butler, "Precarious Life," in *Precarious Life: The Powers of Mourning and Violence* (London: Verso, 2004) 128-51.

Mary Kelly: An Aesthetic of Temporality

Laura Mulvey

Mary Kelly's installation *The Ballad of Kastriot Rexhepi* (2001) contains different temporalities inscribed within it, layered almost like geological strata; it also generates thought about time, its different shapes, forms and kinds, that emanates out towards the spectator in intuitive waves. Furthermore, the installation is embedded in the wider continuity of Mary Kelly's work and the shifts in contemporary history to which she has responded as an artist. The Ballad also draws attention to her methods of work that prefigure the carefully constructed temporalities of the finished, exhibited art. I would like to reflect on (some) of the ways that time might prove to be a productive lens through which to approach Kelly's ideas (as artist, feminist and activist), first in relation to the installation *The Ballad of Kastriot Rexhepi* and then moving with and out of this

framework to reflect both backwards and forwards on her 'aesthetic of temporality' more generally.

The Ballad of Kastriot Rexhepi is derived from a story of a child who was lost twice in the chaotic internecine conflict that engulfed former Yugoslavia in the 1990s, a depiction in miniature of the cruelties inflicted by war on civilian populations. As a single, simple tale, *The Ballad* is unlike Kelly's previous installation about civilian suffering, *Mea Culpa* (1999), which takes various stories from very different contexts as its source material. While the spirit of both conjures up Goya's passionate attempt to visualize the unspeakable in the "Disasters of War" series, *The Ballad* has a 'happy ending' in which the lost child is reunited with his parents, aligning the story with both folk tale and the

Mary Kelly, *The Ballad of Kastriot Rexhepi*, 2001. Installation, 49 framed panels, 17 x 48 x 2 ins, overall length 206 ft, Santa Monica Museum of Art. Courtesy of the artist.

Mary Kelly, *The Ballad of Kastriot Rexhepi*, 2001. Score, first page (music by Michael Nyman, text by Mary Kelly). Courtesy of Mary Kelly.

minor media event that brought the child's story into the newspapers and to Mary Kelly's attention.

The Story Inscribed into the Installation
The Ballad of Kastriot Rexhepi

This small fragment of individual experience approximates the minimal pattern associated with narrative structure: the subject's story begins with an initial loss and/or separation followed by a journey marked by 'helpers,' who take the subject from one point to the next, and in the end reunites a family or a new family group is formed. In order to discuss the way in which Kelly has translated this tale into a complex gallery installation, with music and performance, I would like to use the concept (perhaps one that has fallen out of fashion today) of 'defamiliarization' or 'estrangement' evolved by Victor Shklovsky to evoke, among other things, the shift in temporal experience necessary for art. According to Shklovsky: "The technique of art is to make objects 'unfamiliar,' to make forms difficult, to increase the difficulty and length of perception because the process of perception is an aesthetic end in itself and must be prolonged."[1]

In the first instance, Kelly uses the space of the installation, the gallery itself, as a means out of which perception is defamiliarized and prolonged: the pattern or design of the installation has to transform space into time. Kelly has compared the four parts of the Ballad, arranged as it is around the four walls of the gallery, to a 360 degree pan in film, thus evoking the key importance of duration and the extension of the experience, or even 'sensation' of time that she has built into the spectator's encounter with *The Ballad*. A usual, everyday or habitual experience of time moves smoothly forward in an invisible progression from moment to moment. A palpable sensation of duration dissolves time's linearity and opens out a metaphorical space, approximating the indeterminate, in between space of a threshold, into which time for thought or novel responses can flow in a different rhythm. Kelly opens her contribution to *The Ballad of Kastriot Rexhepi* catalogue by citing Giorgio Agamben's reflections on gesture, which he associates with a similar disruption of linear time and also with the temporality of pause or delay but one which is not pre-determined by a final product but continues, as it were, to hover in suspense.

In addition to this sensation of time and its ability to open up a space for thought is another layer of temporality derived from the pattern into and onto which *The Ballad* is 'cast.' Kastriot's story runs in a straight line along its encompassing frame, made from Kelly's favored material: the curved shapes of single blocks of lint [collected in a household clothes dryer] arranged into a wave pattern that runs along the gallery wall, generating the temporality of repetition and succession in addition to that of pause and delay. To my mind, the shape and pattern of the wave medi-

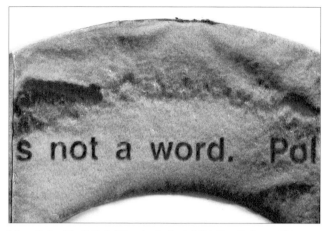

Mary Kelly, *The Ballad of Kastriot Rexhepi*, 2001. Detail, Stanza III. Courtesy of the artist.

ates between the story itself and its intangible but material reception in the spectator's own thought patterns. The wave thus provides a figure for the 'presentness' of individual responses, in their necessarily varied shapes and forms. At the same time, the wave works across time, animating the historical time of Kastriot's story, its historical context, as well as this miniature rendering of it, carried forward into the 'now' of the gallery. However, the wave also physically frames the story itself, in a counterpoint to its own rhythm, in which words conjure up images in series, almost like an invisible sequence of pictures or frames cut from the celluloid strip of a film. As Kelly herself has pointed-ed out, the wave comes into its own at the moment in which *The Ballad of Kastriot Rexhepi* is performed by a singer and string quartet; the music and the words animate the ballad itself, running along the line of the text inserting it, now very precisely, into the present tense of performance. The wave contributes to this moment of animation, while also reaching back to the poignancy of the past to which the installation ultimately refers.

Temporalities of Collecting
in *Post-Partum Document*

From the days of *Post-Partum Document* onwards, Kelly has based her work on collecting and accumulating things, episodes, anecdotes, memories, events, and stories out of which she sifts and selects slowly and carefully in order to create, out of a rag-bag of stuff, supremely elegant and finished works. But the perfect surfaces characteristic of her exhibitions do not close off the processes that lie behind them. Rather, original objects are framed and displayed in such a way that their 'objecthood' survives enhanced rather than diminished, enabling the significance that Kelly had first noticed to be exhibited to the spectator. I would like to reflect on the 'aesthetic of temporality' inherent in collecting, first in terms of *Post-Partum Document* and then the ways in which these, initially informal, everyday practices, provide a basis for Kelly's development of a feminist aesthetic of temporality.

In *Post-Partum Document*, collecting has a central role to play: it is key to the mother/child relationship documented in the exhibition. Across the work as a whole, collecting and temporality fuse particularly around residues and traces that are emblematically displayed. Initially, the residue of ingested and excreted food leaves a trace on the soiled nappies that document the first part of the baby's life; the nappies, themselves selected from the otherwise disposable 'residue' of everyday life, are presented as a 'trace' of this moment in time and of the baby's history. Alongside are typical examples of a mother's keepsakes of her baby's early years (for instance, the plaster cast of a tiny, clenched hand or the small vests, neatly folded). But the baby's progression into childhood adds another dimension to the accumulation of objects: examples of the child's own early ventures into collecting, an insect, an interesting stone, etc., found and proudly displayed to the parent. Also typical are examples of the child's early 'art works,' familiar from any parent's collection of infantile memorabilia. Less typical, perhaps, but essential to Kelly's use of psychoanalytic theory in her work, are documents of her child's induction into language, early attempts at speech mutating into letters leading gradually to his detachment from the maternal body.

Time is inscribed into *Post-Partum Document* through the trace, the object and the document, each one carrying forward a present moment, an instant, into the future in which it becomes both a sign of and physical residue of the past. Like a photograph, these objects share the indexical sign's temporal ambivalence. But *Post-Partum Document* also unfolds in continuum, moving inexorably forward towards the point of separation when the mother/child dyad gives way to the demands of the outside world, the paternal principle, language and socialization. The indexical signs and objects incorporated into and marking out the stages on the way, slow down the forward movement of the work as a whole, they pause its linear flow so that the continuum is broken into staccato instances. The object's stillness fuses with but also disrupts the story's momentum.

Post-Partum Document, while tracing the fundamental myth of the child's Oedipal development, also constitutes a founding instance for Kelly's art, establishing the practice of 'collection' as a key methodology in her later work. *Post-Partum Document*, as a feminist investigation of the maternal role in a child's earliest years, implicitly acts as a critique of the mother/child iconography that characterizes so much of patriarchal representation, particularly, of course, in its Christian form. Thus, as she refused the Madonna and Child iconography, and its endless repetition as a mimetic image, Kelly evolved a means of 'presenting' fact and emotion, replacing representation with collected objects, evolving ways of translating them into an appropriate formal structure. This constitutes a radical rejection of figurative representation, in which the challenge to the iconography of mother and child stands as an emblematic

point of departure. Theory and document, the symbolic and the indexical, displace the overdetermined Christian imagery. However, these collected events, objects and anecdotes emanate from Kelly's actual experience and, despite the sifting process and the production of instances and instants for the final exhibition, the whole is infused with a paradoxical, residual immediacy. This revolutionary experiment provided an alternative means of imagining event and its affect: in the gap left by splitting apart the image of the maternal body from that of her child, the temporality of the objects displayed emerges as an aesthetic device in which the process of collection and the presentation of objects plays a key part, tracing the process of change but holding time in suspense, stretching out, in its documented materiality, into the future.

Collecting Material as Gleaning[2]

Griselda Pollock has pointed out that *The Ballad of Kastriot Rexhepi* resonates with *Post-Partum Document* as Kastriot was left for dead at eighteen months, around and about the period of Oedipal transition that PPD records. But this resonance between the two works also dramatizes the difference between them. During the 1970s and 80s, Kelly had, by and large, drawn on her own experience as the source of her 'collections,' first motherhood and then, in *Interim*, conversations with, and recordings of, her friends and comrades from the Women's Movement, who contributed to the source material. This close relationship between her experience and the material collected was disrupted in the early 1990s; her response to the eruption of war and violence at the time produced three installations: on the First Gulf War in *Gloria Patri* (1992), on the legacy of brutalities inflicted on civilians by oppressive regimes in *Mea Culpa* (1999) and then *The Ballad of Kastriot Rexhepi* (2001). In the process of moving from a known into an unknown world, she became a 'gleaner' of emblematic stories. Newspapers and the news media in general became her primary source material, which she accumulated into a private archive from which she could select documentation, anecdotes and statements.

The gleaner follows the harvest to collect discarded items, investing what would otherwise be waste or rubbish with a new value, significant to the individual gleaner but not to the formal process of harvesting for a commercial market. The artist who collects existing material as a source initially shares this act of re-evaluation, but pushes it to a further stage. The process of collecting raw material, sifting through its mass not necessarily with a pre-fixed purpose, finally selecting an emblematic item, involves an elongated engagement with the meanings and significances of the stuff itself. Thus Kelly has to read through, study, her archive, but also has to read conceptually to select and present the chosen item. This takes time, involves reflecting on the time of history at stake and sets in motion the layering of time that will emerge in the final installation. Kelly

Mary Kelly, *WLM Demo Remix*, 2005. Still, 1:30 min, black and white film loop. Courtesy of the artist.

has remarked that this sometimes takes her years. Ultimately, not only does the presence of the 'primary sources' mark the evolution of the work itself but also the time involved in the sifting and selection process creates a relationship between document and work. It is as though Kelly acts as mediator, an aesthetic filter, between the original item and its appearance in the gallery. Here, once again, the index persists in a misty and residual form: the words incorporated into the final work conjure up, almost literally in a magic or cinematic sense, the original moment of time recorded. Just as the length of process and the presence of the raw material inevitably generates layers of time in the final work, so, symmetrically, the spectator has to read and reflect on the installation, the process guided by the installation's pattern and the shape that, as I suggested earlier, produces time for thought. In these works, Kelly negotiates with worlds and experiences of which she has no personal experience; the collecting and sifting process is an essential part of acknowledging both the distance and the moral engagement with the events recorded.

The Co-Existence of Past and Future in a Liminal Present

Mary Kelly and I were both born in 1941, we encountered the Women's Liberation Movement through the same groups and actions, and with others discovered the importance of psychoanalytic theory for feminism. We both found the political upheavals of the 1980s disorientating; and the social ecology that had produced feminism seemed to fade into the past under the onslaught of neoliberal economics, the 'defeat' of socialism and the other symptomatic events of the 1980s and 90s. For this reason I have been particularly moved by the recent installations and performance pieces in which she returns to the past of the WLM, very significantly using a younger generation of women as a 'filtering' medium for reactivating the presence of the past in the present. Although I have not been able to see these works myself, reading about them has vividly evoked for me the way that the concept of a temporal threshold might have political valence now. As I suggested in my

opening section, the fusion of space and time in *The Ballad* is a crucial aspect of its political and aesthetic power, and Kelly's own citation of Agamben as well as the concept of liminality conjures up their relevance for this very difficult moment in history. As the gathering forces of reaction work to relegate the utopian optimisms of late modernity into an archaic and bygone era, (while also undermining the economic basis of a civil society and public sphere) the concept and figure of delay, the pause in Agamben's gesture, has political significance even if only on the level of metaphor.

Mary Kelly's recent works that bring the past into the present and the present into the past clearly point to the political implications of the imaging of time. This for me, considering the impact of new technologies on the cinema, as well as the present historical conjuncture, has generated parallel figurations.

The metaphor of a threshold represents an attempt to shift the figuration of time away from an imaginary pattern derived primarily from a foreclosing of the past, a hastening towards the end of an era, into an imaginary pattern derived from space, of holding past and future suspended in an uncertain present. The work of the young women with whom Kelly has collaborated is crucial, enabling the idea of a threshold to materialize more concretely in the re-enactment of words and images from the WLM. Rosalyn Deutsche's description of *WLM Demo Remix* (2005) vividly evokes the aesthetic realization of this mixing of temporalities. She says:

> An image that carries the legacy of an earlier generation of feminists appears to the new generation. Likewise, the women in the later image inhabit those in the earlier one. Using a slow dissolve to combine past and present images, a technique that imitates the scene of the unconscious mind, the loop begins with the later image—the photo of the restaging—which gradually fades and disappears as the earlier image emerges and grows clearer.[3]

Mary Kelly's use in her work of collected material and the detritus recovered by gleaning, out of which new understandings might emerge, is evocative of Jacques Lacan's metaphors of temporality through which the unconscious might make itself felt. In his 1953 essay "The Function and Field of Speech and Language in Psychoanalysis," Lacan uses figures and images drawn from the traces of history to evoke ways in which the past is "memorialized" in the individual psyche. For me, these figures and images also lead towards the more elusive psychic structures of collective experience, returning historical metaphor to history itself. He uses these metaphors of storage, which have kept the past alive: monuments as hysterical symptoms, archival documents as childhood memories, a semantic evolution corresponding to a particular vocabulary, and legends bearing 'my history.' Finally, he sums up: "and, lastly, in the traces that are inevitably preserved by the distortions necessitated by the linking of the adulterated chapter to the chapters surrounding it, and whose meaning will be re-established by my exegesis."[4] If Mary Kelly's body of work bears a close relationship to this entwining of the unconscious and its materialization, the individual psyche and its inscription in the social collectivity, this is particularly so in her recent works in which the legacy of a political past finds, across the distortions and adulterations of recent politics, a new exegesis

Notes

1. Viktor Shklovsky, "Art as Technique," available in Ed T. Lemon and Marion J. Reiss, eds. *Russian Formalist Criticism: Four Essays* (Lincoln: University of Nebraska, 1965) 3-24.
2. I have taken the concept of gleaning, as a form of collection and the source of an aesthetic stance, from Agnès Varda's film *Les glaneurs et la glaneuse* (The Gleaners and I) (France, 2000).
3. Rosalyn Deutsche, "Not-Forgetting: Mary Kelly's *Love Song*," *Grey Room* #24 (Summer 2006) 33.
4. Jacques Lacan, "The Function and Field of Speech and Language in Psychoanalysis," in *Ecrits: A Selection*, trans. Alan Sheridan (London: Tavistock Publications, [1953] 1977) 50.

Don't Get Your Rosaries in a Bunch

Bruce LaBruce

Who would have thought that nunsploitation could cause such a ruckus in this day and age? All you have to do is Google "sexy nuns" on the Internet and you will be confronted with literally thousands of images of the brides of Christ in kinky lingerie and fetish gear, fishnet stockings, and garters. You will find drag queens as nuns, masochistic nuns, dominatrix nuns, whatever your evil heart desires. It's a well-established genre. I mean, it's not as if I invented the Catherine Wheel! For those a little more adventurous, a quick perusal of PornTube or XTube will show you porn stars dressed up as priests and nuns doing the dirty deed. That's the function of porn: a play space where people are allowed to vicariously act out their darkest, most secret and politically incorrect fantasies. It's probably what allows civilization to move forward without repressing or denying its desires to the point of having them reemerge in some monstrous and much more dangerous form. Porn is good. Porn works. If more priests watched porn, they probably wouldn't get themselves into so much trouble with altar boys. Just saying.

Nuns wear a specific and instantly identifiable uniform, and this image constitutes an archetype. Archetypes are fair game for representation in art, cinema, popular culture, and even fashion. George A. Romero included zombie nuns in his film *Dawn of the Dead*. Take a look at the costumes on any given Halloween and you will see innumerable nuns walking down the street—some of them of a lascivious nature. It's a healthy acting out of what might otherwise be regarded as demonic desires.

Here's how my exhibition of photographs, called "Obscenity," that opened in Madrid [February 17 – March 23, 2012] was described by the conservative campaign group Make Yourself Heard: "Gay-looking angels encouraging lechery, lascivious nuns posing in underwear, reveling in crucifixes or cradling a tattooed Christ between their breasts ... this is the new content of the provocative exhibition 'Obscenity'." Well, that does generally describe the show, but it's a little, as Madonna might say, reductive. I'll get to my own characterization of the show later, but suffice to say there was more complexity to it than that, for those who cared to analyze it—or even see it—for themselves. My favorite condemnation of the show came from The Francisco Franco Foundation, a group that campaigns to preserve the memory of Spain's former dictator, who branded the exhibition "a virulent and morbid attack on the Catholic religion." When contacted by AFP to comment, I responded, "How can fascists attempt to assert any sort of moral authority over anything?" Really, people in fascist glass houses shouldn't throw stones. Or bombs, as the case may be.

I shudder to think what the reaction to "Obscenity" would have been had I included some of the more extreme images I've taken recently on the same theme, including a priest looking up towards heaven with an ecstatic expression and come all over his face. This image, which was leaked on the Internet without my knowledge, nails the essence of my thesis, albeit in more confrontational terms. There probably would have been seizures, heart attacks, bigger protests, successful bombing attempts... Let's not even think about it. Maybe I'll have a show someday entitled "Forbidden Obscenity," but I may have to have it in a bunker somewhere. You can't be too careful these days.

La Fresh, the gallery in Madrid where I mounted the show, is fortunately a bit like a bunker itself, nestled as it is in the concrete basement of a building near the Biblioteca Nacional de Espana. The day before the exhibit opened, the owner of the building breezed through to see the photographs and didn't seem to see what all the fuss was about. Likewise, the two working-class ladies employed in the beauty shop above the gallery came in and shrugged their shoulders, bemused. But then again, in my experience beauticians are rarely fanatical religious extremists.

It's true that Spain, like Canada, the U.S., the U.K., and many other western countries, are going through, shall we say, to be hopeful, a conservative phase. As we all know, timing is everything, so having a show featuring naughty nuns and perverted priests at this historical moment was bound to create controversy. However, art doesn't always respond to conservatism by acting out the opposite impulses. When I attended ARCO, the enormous art fair in Madrid last week, most of the work was decidedly and remarkably lacking in political or religious (or sexual) content, leaning more towards abstract and decorative tendencies. There were some exceptions.

An artwork by Spanish artist Eugenio Merino, entitled "Forever Franco," which generated a lot of controversy consisted of a life-size dummy of the former fascist dictator dressed in his trademark general costume encased like a

Bruce LaBruce. [Top left]: *Small Obscenity* #6 (Maria Forque), 2011; [top right]: *Devilish Angel* (Pablo Rivero), 2011; [bottom left]: *Madonna and Child*, 2011; [bottom right]: *Pieta* (Alaska and Mario), 2011. Courtesy of La Fresh Gallery. © Bruce LaBruce.

pop mummy inside a Coke dispenser with a see-through glass door. Several critics pointed out the casual similarity of this sculptural work to a photograph of mine from "Obscenity" of a sexy nun drinking from a Coke can. (In both cases, Coca-Cola is only suggested by color and design; the actual commercial logo is obscured.) It's a very simple formula, but effective: a statement on the new corporate nature of politics and religion, and the reduction of political and religious elements to pure pop art significance.

Another piece I liked by the same artist consisted of three replicas of the Hollywood Walk of Fame stars on the floor dedicated to Franco, Hitler, and Stalin. Again, a simple idea, but something, apparently, with the Franco Foundation lurking about, that still needs to be said. I did see some excellent examples of political work by Spanish artists when a friend took me to the beautiful contemporary art gallery La Casa Encendida. Of particular interest were pieces by Daniel Silvo, Juanli Carrion, and Rubio Infante. The latter's work featured two large photographs of a site where some of the anonymous victims of the brutal Franco regime are buried en masse, illuminated by his own lights both within the photographs and in front of them in the gallery. I'm told that the crimes of the regime have largely been swept under the carpet, but as more mass gravesites are being exhumed, young Spaniards are starting to ask serious questions and become outraged. But this kind of political consciousness was definitely lacking at ARCO, emphasized by the likes of the bland, smug period points of Damien Hirst's aggressively meaningless, overpriced, and infinitely unoriginal polka dot paintings. Yawn.

This conservative trend in art is more than a little depressing, considering it's being driven by the same conservatism, reinforced by neoliberal economic strategies of disaster capitalism, that is currently hitting the southern European countries like Greece and Spain: extreme austerity measures, slashed wages, dismantled social programs, rampant unemployment, etc. I gather the idea is to keep people in a perpetual state of fear and anxiety, particularly about their financial and health security (selling inoffensive, decorative polka dots amounts to peddling art as comfort food), and it's exactly at this moment when socially conservative and religious forces move in, taking advantage of this fear in order to assert their moralistic, archaic agendas. Look what's happening now in the U.S., with ultraconservative Republican nominee and Catholic demagogue nonpareil Rick Santorum surging in the polls. This sweater-vested Crusader who denies the science of evolution and global warming, and, as Bill Maher phrased it, believes that life begins at erection, also looks like the strongest candidate to lead the world straight into the rapture. Antichrist, anyone?

I chose the title of the show, "Obscenity," as a kind of preemptive strike—since I figured the exhibit would be considered obscene from the get-go, I thought I might as well embrace it. Here's my description of "Obscenity" as it appears, more or less, on the La Fresh Gallery website:

As an artist whose work has been routinely confiscated by customs since the 1980s and stamped with the judgement OBSCENITY, LaBruce knows a thing or two about the territory of the taboo, the representation of the unrepresentable, the love that dare not speak its name. As recently as last summer, a shipment of 400 Polaroids that were displayed at gallery Wrong Weather in Porto, Portugal for the exhibition "Polaroid Rage: Survey 2000—2010" were confiscated by Canadian customs and summarily deemed to be OBSCENITY and denied entry into the Canadian LaBruce's own country. Last year, LaBruce's movie L.A. Zombie was judged to be obscene and banned from the entire continent of Australia. Undaunted, LaBruce continues to produce work that ignores boundaries and defies censorship.

But the photographs in the OBSCENITY show—almost all of them shot last October [2011] in Madrid specifically for this exhibition—are not necessarily traditionally pornographic. Obscenity need not be sexually explicit to be obscene, nor does it need to be vulgar, harsh or extreme. OBSCENITY offers a variety of images—some gentle, some romantic, some spiritual, some grotesque—that attempts to refine and redefine the nature of the fetish and the taboo, to sanctify this imagery and position it more closely to godliness. The lives of the saints are full of ecstatic acts of sublimated sexuality that are expressed in the most startlingly sexual and perverse ways. OBSCENITY presents a series of portraits that illustrate this most holy convergence of the sacred and the profane.

I intentionally wrote this description to be a bit cheeky, but I stand behind it. I was also looking at a lot of classical art and Renaissance paintings that depict religious ecstasy, and it struck me how indistinguishable the expressions on the faces of the subjects were from sexual ecstasy. This led me to question why there should be a conflict between sexuality and religion at all. Jesus was probably a sexual being, and he didn't seem to have any problem hanging out with prostitutes. So what's the big deal? Part of the outrage seemed to be directed towards my use of the hostia, the Holy Communion wafer, in the work. In a number of the photographs I had the models pose with the round, white biscuits, occasionally colored black, covering their eyes, mouths, and private bits. I intended it as a multi-leveled symbol, representing censorship (when my movies are released in Japan, white dots are placed over the genitals of naked characters), but also the notion that organized religion is often blind to sexuality, trying to ignore or deny its vast significance—see no evil, speak no evil. For me, it also turned the subjects into zombies, slavishly following religious dictums, or blind prophets or high priestesses, peering into the future beyond the restrictions of religion, or prophesying the decline of western culture. For fundamentalist Catholics, however, the hostia is literally, not metaphorically, the body of Christ, so posing with Christ in your mouth accompanied by a sexually suggestive pose

didn't go over well. Personally, I thought it was kind of hot.

The larger point, which was the subtext of the show, is, of course, a critique of the Catholic Church coming from a homosexual artist, taking into consideration that this anti-quated institution turns a blind eye to homosexuality, pedophile priest scandals, women's issues regarding sexuality, women's control over their own bodies, birth control, feminism (not allowing women to become priests), refusing to promote or distribute condoms in African countries ravaged by AIDS, etc. The photographs did not offend many Spaniards who came to the show in the least—it was packed wall to wall for over three hours. There is also a strong secular strain and intellectual tradition in Spanish society, so a lot of them expressed their gratitude for the show, its polemical intent, and its stand against censorious conservative elements in the ascendant in their country.

Now to the fall-out of the show: When I arrived in Madrid, I discovered that Mario Vaquerizo, front man of the band Las Nancys Rubias, and one half of Mario and Alaska (the musical duo that has a popular reality TV show on MTV Spain), lost his weekly job at the conservative radio station La Codena Copa for posing in "Obscenity." The main photograph in which he appears with his sexy wife Alaska has them recreating the pose of Michelangelo's *La Pieta*, she as a sexy nun/Madonna cradling him, a tattooed Christ, to her (covered) breast. The image is demure to say the least, so everyone was surprised by the hostile reaction. Mario and Alaska were extremely gracious about the whole affair, attending the opening with camera crew in tow and supporting the show unconditionally. Rossy de Palma, the great fashion icon and Almodovar star, also appeared as a model, which for me was about the modern idea of the worship of celebrities as the new religious icons. The participation of these hugely popular Spanish stars definitely contributed to the notoriety and controversy surrounding the exhibit. The day after the opening, someone, presumably a religious extremist, smashed a hole in the front window of the gallery and threw a Molotov cocktail-type device through it, which, thank goodness, didn't detonate. With police swarming all over the gallery and the news going viral, the previously scheduled manifestation took place that evening, where picketers played Christian rock music over loudspeakers and chanted slogans in front of La Fresh. That's about it. Nothing too extreme, but I have to confess the notion of my first firebomb was a bit of a thrill.

The show was undeniably offensive to some people, but to make the obvious point, there's a big difference between art and representation on the one hand and committing an actual act of assault or violence on the other. They exist on separate moral planes. A priest molesting an altar boy or a religious fanatic blowing up a gallery and possibly killing someone is not the same as expressing something controversial through art. Please, get a perspective.

Several days after the show, I needed to get my mind off the whole imbroglio, so I essayed a photo shoot with two cute young gay boys in Madrid named Carlos and Joaquin for my friends at *Dirt* magazine. We shot on the Viaducto de Segovia, the bridge that people sometimes jump off from to commit suicide. The city has erected a transparent fence to keep people away from the edge, but I got the two boys to crawl between the fence and the bridge railing so I could take some pictures from below (it's a 23 meter drop to the street). I had them take off their shirts and one of them pretended he was trying to jump after a lovers' quarrel, while the other one was on his knees praying, pleading him to stop. After about ten minutes, we heard the inevitable sirens, and five police cars and two motorcycles pulled up. Apparently sixteen people had called the police, possibly thinking they were really trying to jump! So it was a big fracas, but fortunately the cops weren't interested in the photographer. One of the boys had a switchblade knife in his backpack, so they took him to the police station. The other boy and I had a beer and then collected him an hour later at the cop shop. No charges were filed, thank goodness, but they kept his knife! I tried to snap a shot of them with the police, but the hot policeman came over and made me erase it. While the police were questioning the boy with the knife, Carlos came down to me below and said, "They want you, Bruce. They're taking you to jail. Spain hates you." Then he laughed. But for a second there, I actually believed him.

300 PEOPLE

Santiago Sierra

Abdullah II, King of Jordan
Abramovich, Roman
Ackermann, Josef
Adeane, Edward
Agius, Marcus
Ahtisaari, Martti
Akerson, Daniel
Albert II, King of Belgium
Alexander, Crown Prince of Yugoslavia
Amato, Giuliano
Anderson, Carl A.
Andreotti, Giulio
Andrew, Duke of York
Anne, Princess Royal
Anstee, Nick
Ash, Timothy Garton
Astor, William Waldorf
Aven, Pyotr
Balkenende, Jan Peter
Ballmer, Steve
Balls, Ed
Barroso, José Manuel
Beatrix, Queen of the Netherlands
Belka, Marek
Bergsten, C. Fred
Berlusconi, Silvio
Bernake, Ben
Bernstein, Nils
Berwick, Donald
Bildt, Carl
Bischoff, Sir Winfried
Blair, Tony
Blankfein, Lloyd
Blavatnik, Leonard
Bloomberg, Michael
Bolkestein, Frits
Bolkiah, Hassanal
Bonello, Michael C.
Bonino, Emma
Boren, David L.
Borwin, Duke of Mecklenburg
Bronfman, Charles
Bronfman, Edgar Jr.
Bruton, John
Brzezinski, Zbigniew
Budenberg, Robin

Buffet, Warren
Bush, George HW
Cameron, David
Camilla, Duchess of Cornwall
Cardoso, Fernando Henrique
Carington, Peter
Carl XVI Gustaf, King of Sweden
Carlos, Duke of Parma
Carney, Mark
Carroll, Cynthia
Caruana, Jaime
Castell, Sir William
Chan, Anson
Chan, Margaret
Chan, Norman
Charles, Prince of Wales
Chartres, Richard
Chiaie, Stefano Delle
Chipman, Dr. John
Chodiev, Patokh
Christof, Prince of Schleswig-Holstein
Cicchitto, Fabrizio
Clark, Wesley
Clarke, Kenneth
Clegg, Nick
Clinton, Bill
Cohen, Abby Joseph
Cohen, Ronald
Cohn, Gary
Colonna di Paliano, Marcantonio, Duke of Paliano
Constantijn, Prince of the Netherlands
Constantin II, King of Greece
Cooksey, David
Cowen, Brian
Craven, Sir John
Crockett, Andrew
Dadush, Uri
D'Aloisio, Tony
Darling, Alistair
Davies, Sir Howard
Davignon, Étienne
Davis, David
de Rothschild, Benjamin
de Rothschild, David René
de Rothschild, Evelyn
de Rothschild, Leopold

Deiss, Joseph
Deripaska, Oleg
Dobson, Michael
Draghi, Mario
Du Plessis, Jan
Dudley, William C.
Duisenberg, Wim
Edward, Duke of Kent
Edward, Earl of Wessex
Elizabeth II, Queen of the United Kingdom
Elkann, John
Emanuele, Vittorio, Prince of Naples
Ernst August, Prince of Hanover
Feldstein, Martin
Festing, Matthew
Fillon, François
Fischer, Heinz
Fischer, Joschka
Fischer, Stanley
FitzGerald, Niall
Franz, Duke of Bavaria
Fridman, Mikhail
Frisco, Prince of Orange-Nassau
Gates, Bill
Geidt, Christopher
Geithner, Timothy
Georg Friedrich, Prince of Prussia
Gibson-Smith, Dr Chris
Gorbachev, Mikhail
Gore, Al
Gotlieb, Allan
Green, Stephen
Greenspan, Alan
Grosvenor, Gerald, 6th Duke of Westminster
Gurría, José Ángel
Hague, William
Hampton, Sir Phillip
Hans-Adam II, Prince of Liechtenstein
Harald V, King of Norway
Harper, Stephen
Heisbourg, François
Henri, Grand Duke of Luxembourg
Hildebrand, Philipp
Hills, Carla Anderson
Holbrooke, Richard
Honohan, Patrick
Howard, Alan
Ibragimov, Alijan
Ingves, Stefan
Isaacson, Walter
Juan Carlos, King of Spain
Jacobs, Kenneth M.
Julius, DeAnne
Juncker, Jean-Claude
Kenen, Peter
Kerry, John
King, Mervyn

Kinnock, Glenys
Kissinger, Henry
Knight, Malcolm
Koon, William H. II
Krugman, Paul
Kufuor, John
Lajolo, Giovanni
Lake, Anthony
Lambert, Richard
Lamy, Pascal
Landau, Jean-Pierre
Laurence, Timothy
Leigh-Pemberton, James
Leka, Crown Prince of Albania
Leonard, Mark
Levene, Peter
Leviev, Lev
Levitt, Arthur
Levy, Michael
Lieberman, Joe
Livingston, Ian
Loong, Lee Hsien
Lorenz of Belgium, Archduke of Austria-Este
Louis Alphonse, Duke of Anjou
Louis-Dreyfus, Gérard
Mabel, Princess of Orange-Nassau
Mandelson, Peter
Manning, Sir David
Margherita, Archduchess of Austria-Este
Margrethe II, Queen of Denmark
Martínez, Guillermo Ortiz
Mashkevitch, Alexander
Massimo, Stefano, Prince of Roccasecca dei Volsci
Massimo-Brancaccio, Fabrizio Prince of Arsoli
and Triggiano
McDonough, William Joseph
McLarty, Mack
Mersch, Yves
Michael, Prince of Kent
Michael, King of Romania
Milibrand, David
Milibrand, Ed
Mittal, Lakshmi
Moreno, Glen
Moritz, Prince and Landgrave of Hesse-Kassel
Murdoch, Rupert
Napoléon, Charles
Nasser, Jacques
Niblett, Robin
Nichols, Vincent
Nicolás, Adolfo
Noyer, Christian
Ofer, Sammy
Ogilvy, Alexandra, Lady Ogilvy
Ogilvy, David, 13th Earl of Aìrlie
Olilla, Jorma
Oppenheimer, Nicky

Osborne, George
Oudea, Frederic
Parker, Sir John
Patten, Chris
Pébereau, Michel
Penny, Gareth
Peres, Shimon
Philip, Duke of Edinburgh
Pio, Dom Duarte, Duke of Braganza
Pöhl, Karl Otto
Powell, Colin
Prokhorov, Mikhail
Quaden, Guy
Rasmussen, Anders Fogh
Ratzinger, Joseph Alois (Pope Benedict XVI)
Reuben, David
Reuben, Simon
Rhodes, William R.
Rice, Susan
Richard, Duke of Gloucester
Rifkind, Sir Malcolm
Ritblat, Sir John
Roach, Stephen S.
Robinson, Mary
Rockefeller, David Jr.
Rockefeller, David Sr.
Rockefeller, Nicholas
Rodríguez, Javier Echevarría
Rogoff, Kenneth
Roth, Jean-Pierre
Rothschild, Jacob
Rubenstein, David
Rubin, Robert
Ruspoli, Francesco, 10th Prince of Cerveteri
Safra, Joseph
Safra, Moises
Sands, Peter
Sarkozy, Nicolas
Sassoon, Isaac
Sassoon, James
Sawers, Sir Robert John
Scardino, Marjorie
Schwab, Klaus
Schwarzenberg, Karel
Schwarzman, Stephen A.
Shapiro, Sidney
Sheinwald, Nigel
Sigismund, Grand Duke of Tuscany,
 Archduke of Austria

Simeon of Saxe-Coburg and Gotha
Snowe, Olympia
Sofía, Queen of Spain
Soros, George
Specter, Arlen
Stern, Ernest
Stevenson, Dennis
Steyer, Tom
Stiglitz, Joseph
Strauss-Kahn, Dominique
Straw, Jack
Sutherland, Peter
Tanner, Mary
Tedeschi, Ettore Gotti
Thompson, Mark
Thomson, Dr. James
Tietmeyer, Hans
Trichet, Jean-Claude
Tucker, Paul
Van Rompuy, Herman
Vélez, Álvaro Uribe
Verplaeste, Alfons
Villiger, Kaspar
Vladimirovna, Maria, Grand Duchess of Russia
Volcker, Paul
von Habsburg, Otto
Waddaulah, Hassanal Bolkiah Mu'izzaddin,
 Sultan of Brunei
Walker, Sir David
Wallenberg, Jacob
Walsh, John
Warburg, Max
Weber, Axel Alfred
Weill, Michael David
Wellink, Nout
Whitman, Marina von Neumann
Willem-Alexander, Prince of Orange
William, Prince of Wales
Williams, Dr. Rowan
Williams, Shirley
Wilson, David
Wolfensohn, James
Wolin, Neal S.
Woolf, Harry
Woolsey, R. James Jr.
Worcester, Sir Robert
Wu, Sarah
Zoellick, Robert

45

Richard Kostelanetz in Conversation with Michael Butterworth

Derek Horton

This interview was undertaken to coincide with the publication of selected extracts from the latest edition of Richard Kostelanetz's *Dictionary of the Avant-Gardes*. *Soanyway* invited Michael Butterworth to interview Kostelanetz, both of whom have been important figures in the literary avant garde since the 1960s. 'Avant garde' is a term that, although now disowned and devalued by some, Kostelanetz, as the interview reveals, retains faith in and is determined to hold on to. The interview developed as an extended email conversation during August and September 2011. The transcript of that conversation was edited by, and with occasional interjections from, Derek Horton.

Derek Horton: So, Richard and Michael, as you know, *Soanyway* is involved in a "scattered" third edition of Richard's *A Dictionary of the Avant-Gardes*, in which selections of his new entries will be published in various magazines, including ours. We want to mark this event in a special *Soanyway* issue that will include this interview. I'm looking forward to a free-ranging and fascinating conversation between you. The content and nature of the interview is up to you of course, but given your shared interests I imagine you might range over such subjects as: the nature of "avant-garde" and "experimental" writing today—what is its future do you think?

Richard Kostelanetz: Mostly in media other than printed pages…

DH: …and I guess you might discuss the similarities and differences between both of your early experiences in the 1960s and now, and the relationship between your respective situations in the U.S. and the U.K.

RK: I don't know the U.K. well enough to say. I don't know who does. I haven't been there since 1985 or so, and my books haven't been published there for decades.

DH: …the joys and tribulations of publishing "avant-garde" and "experimental" writing…

RK: …Did I have any choice, given that my creative work from the beginning was so different from what nearly everyone else was doing?

DH: …your current approach to publishing on "scattered" platforms and relinquishing control over the selection and presentational formats of your work…

RK: Two different issues here. The first reflects my decades-old interest in alternative publishing and the hope that publishers are as generous with me as I am with them; the second reflects anarchism…

DH: …and of course, I hope there will be as much anecdotal reminiscence as you are both prepared to engage in!

Michael Butterworth: Richard, it's very nice to be speaking with you. We've corresponded briefly on a few occasions, decades ago, but we have never met. I published a great little piece of yours called *Milestones* in *a Life* in *Corridor New Writings* in 1974…

RK: Inexplicably perhaps, I didn't see this until discovering a decade ago on the Internet the existence of a reprint in your anthology…

MB: You mean *The Savoy Book*, which David Britton and I put out in the late 70s, for which we drew material from our pre-Savoy Books small press publications, thus *Milestones* was reprinted. *Milestones* was a human biography in minimalist form, a list of words connected to numerals signifying the years of a man's (?) life, starting with the word 'birth' and ending with 'measles,' a word that denoted the final milestone, death… *The Savoy Book* was seminal for us because it acted as a transition from the small press magazines David and I were producing to the large-scale paperback publishing house we next became. But before that you chose an expressionistic prose poem of mine called *Terminal* from *New Worlds* magazine for inclusion in your astonishing collection of fictions, *Breakthrough Fictioneers*, published in 1973. By including writers like J. G. Ballard and John Sladek alongside conceptual artists like John Baldessari, *Breakthrough Fictioneers* was totally unique, and still is. I didn't appreciate this properly until recently when I saw the connections you had made between conceptualism and certain writers.

RK: Thanks for remembering that book, Michael! Need I claim that, as a collection of truly radical alternatives in narrative, *Breakthrough Fictioneers* has never been surpassed? Has any other subsequent anthology come close? Forty years later? Sometimes I suspect that it's willfully ignored by beginners who'd like to claim they represent

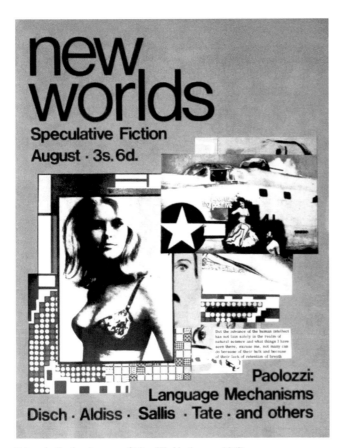

Eduardo Paolozzi cover of *New Worlds*, August 1967.

innovative/experimental writing but don't even come close.

MB: It was totally groundbreaking in the same way that, for me, the 'new wave' phase of *New Worlds* science fiction magazine was, under Michael Moorcock's editorship. Michael consciously set out to make a platform for experimental writing and contemporary visual art, attracting luminaries like Eduardo Paolozzi and Richard Hamilton, and Christopher Finch. It occurred to me, re-reading *Fictioneers* that several of the writers in *New Worlds*, and I think I include myself, were actually frustrated conceptualists… This connection between writing and art was something you, Richard, foresaw, and to suddenly see that *New Worlds*, which I was so much identified with at the time, and the American conceptualists might be bedfellows, running on the same creative and social currents, came as a revelation. The work of artists like John Baldessari or Bruce Nauman would not have seemed out of place in *New Worlds*; equally, the *New Worlds* writers John Sladek or Ballard, writing at the same time, would not have been out of place in a New York art exhibition of the 1960s.

A playfulness with concepts is something the contributors to both *New Worlds* and *Breakthrough Fictioneers* had in common. The collective world we construct—everything 'out there'—rests on an interconnecting web of language concepts that these artists and writers in their various ways were deconstructing and questioning. Concepts shouldn't

be clung to or taken past their sell-by date, and this concern seems to be at the root of this tentative 'conjoining' of art and writing at this time, in the 1960s and 70s. What do you think is the nature of avant-garde and experimental writing now?

RK: I think others could answer this last question better— I'm reluctant to do professionally anything that someone else could do better…

MB: What is happening today seems very similar to what was happening then. In both contemporary writing and art there does not seem to have been a development—*New Worlds* and *Breakthrough Fictioneers* could be published today and they would still seem bang up to date.

RK: Thanks for your assessment. Should I be flattered or disappointed by the absence of imitators?

MB: The only difference you could say is that today radical visual art and writing has become mainstream.

RK: Am I alone in finding it odd that the "art world," as you call it, sooner reads thick pseudo-philosophical "theory" over advanced literary art?

MB: How did you come across *New Worlds*? Was it an influence on *Breakthrough Fictioneers*, or simply another resource you came across?

RK: The latter. I'm not sure if I've ever seen an issue of *New Worlds* as such—for one self-test, I can't recall what it looks like. I can't find any in my library, which has hundreds of literary magazines roughly alphabetized. Could I have found your contribution to *Breakthrough Fictioneers* in a secondary source? Could Charles Platt [designer and sometime editor of *New Worlds*] have given it to me? Don't forget that all this happened not one or two or three but FOUR decades ago. Nonetheless, I do know that in my collection of cultural magazine self-retrospectives are the five 'best of' *New Worlds* volumes, in addition to both the British and American editions of Moorcock's 1983 anthology from its pages… Perhaps SF became a more receptive terrain for innovative writing simply by escaping literary policemen—some of whom moonlighted as professors. Samuel Delany once told me that SF was more receptive to very young writers, such as himself in 1962, than literary magazines were, and I suppose that might still be true. On the other hand, SF's origins in pulp printing predisposed readers to the most familiar, accessible forms of narrative…

I'd never been particularly interested in SF. I didn't read much as a teenager, while as an adult I seem to have more trouble than most in following plots. I can't read children's books, while even purportedly sophisticated comics strike me as simplistic. Detective fiction completely escapes me, and for decades now nearly all Hollywood movies have put

me to sleep! … I could have learned about *New Worlds* through correspondence with Chip (Samuel R. Delany), though he didn't try to meet me until 1974. I was hard to meet in those days. We'd gone to the same Commie summer camp two years apart, two decades before, though neither of us were what came to be called Red Diaper Babies. When I tell you that I find his and his wife, Marilyn Hacker's, *Quark* more radical than the *New Worlds* I know from its anthologies, am I risking entering an argument with people who know and care more than I do?…

MB: Hardly. Its combination of graphics, fiction, critical writing and design was not at all reflected in the various paperback reprise editions of *New Worlds*. They were repackaged for the science fiction market, which didn't like *New Worlds*, so they give an incomplete picture.

RK: I recall meeting Charles Platt here in New York around 1972. Though his work was included in *Breakthrough Fictioneers*, I doubt if I saw him again or if I could recognize him now. Is he the same Platt who writes strong articles for the computer magazines?

MB: Yes, and oddly he has just contacted me now, so I was able to ask him. He says, "Actually I think that I met Kostelanetz through Delany, although I can't be sure. Kostelanetz is right that it was in New York, maybe 1971 or 1972." When *New Worlds* lost its newsstand distribution in 1970 and came to a temporary end, Charles left England and made America his home, and did a very courageous or mad thing. To reduce his fear as much as to familiarize himself with it, he made NYC his home city by traversing it on foot, including walking through the Bronx which was then a fearsome area for lone travellers. … I wonder, did you know Michael Moorcock, and how did you regard him?

RK: No, we never met. I gather he moved to Austin well after I spent a semester there. I don't have any publishable opinion about him—or about J. G. Ballard, or about other British writers no doubt important to you. I long dated the daughter of a famous Princeton arts professor who once commended me for refusing opinions about things I know nothing about. Everyone in her father's immediate circle had opinions about everything. I do recall that in the spring of 1965 I applied for a renewal of my Fulbright fellowship to King's College, London, with a proposal to do a book about the most innovative writing in Britain at the time. My radical thesis, which has since become more acceptable, was that it was produced by writers born outside Britain, beginning with the other British Isles, and then the colonies. I would feature Doris Lessing, a Rhodesian don't forget, whose *Golden Notebook* incorporates a formal intelligence probably absent from her other books; some Scottish authors such as Sydney Goodsir Smith; the Irish writers Samuel Beckett and Flann O'Brien; the Nigerian Amos Tutuola; and Edgar Mittelholzer, a Guyanese, whose *Morning at the Office* I still regard as the greatest novel

about race prejudice as such, apart from distractions that undermined, say, James Baldwin and Richard Wright's fictions, purportedly about that subject. I don't recall reading Ballard at the time, though I suppose he would have fit my thesis, as he was born in China. However, my Fulbright wasn't renewed for a second year. I suppose as much as you wanted to challenge complacency in British literature with science fiction, I wanted to remind everyone of aliens who wrote in English.

MB: It's an intriguing thesis, because arriving in the idealized Mother country for the first time had a powerful effect on young 'colonial' writers like Ballard. They would have experienced a radically unexpected culture quite different from the impressions they held, with ensuing literary innovations.

RK: On further thought, I could have added the critic Martin Esslin, who was Hungarian; and Michael Hamburger, who came from Germany, both of whom I met during my stay. Should I have included Clancy Sigal and Sylvia Plath, who were born and educated in "the colonies," as I sometimes heard America called then? Curiously, the principal of King's College today, Rick (now Sir Richard) Trainor, is an American who took his undergraduate degree from the same college as I did with the same major, which was called, no joke, 'American Civilization'… I wrote instead in 1965 a long essay on "The British Literary Scene" that was reprinted in my *Twenties in the Sixties* (1980) and *Home and Away: Travel Essays* (2006) in which I described a culture that seemed too limited both aesthetically and socially for an American. A favorite anecdote I didn't include before has a London editor asking for my telephone number. It was Brixton 8014. After a pause, he replied something like never having any writer with a Brixton exchange in his telephone book before.

MB: Did you think of working-class English writers like Anthony Burgess, because Harpurhey, North Manchester where Burgess grew up, was one of the most insular and deprived areas in England. It was like a foreign country to most 'polite' British.

RK: Class would have been less obvious to me as an American than birth and maturation outside of England, though Anthony, whom I met once, I'd rank among the best… May I venture that someone has since perhaps written my book about innovative British literature, though I don't know about it? … Had I included theatre, I would have written about Charles Marowitz, who had so much radical presence in London in the 1960s, though less visibility when he returned to his native America. His surname resembles David Zane Mairowitz, a little younger than I and another American radical writer who has remained in England, co-founding, I'm told, the *International Times*. I'd like to like his books more than I do!

MB: You've said *New Worlds* wasn't a direct influence on *Breakthrough Fictioneers*. What was your reasoning behind the collection? What interests me in avant-garde writing is how it seems to be striving to become art, and vice versa. Certainly, in the 60s and 70s, in publications like *New Worlds* and *Breakthrough Fictioneers*, it seemed that art and writing were striving to become one. The very name *Breakthrough Fictioneers* implies that both writers and artists produce fictions. Was this something that interested you?

RK: My general thesis at the time, in the early 1970s, held that advanced writing reflected developments in the non-literary arts, rather than evolutions strictly within literature. That accounts for why *Breakthrough Fictioneers* included so many fictions by people initially recognized for work in other arts or, more specifically later, why my notion of "minimal fiction," say, was far more rigorous and thus closer to minimal art and minimal music than the epithet's use in literary criticism. I doubt if I've learned much from music or visual arts more prominent since 1970 or so. Even my current interests in finding poetry and fictions within familiar words or reworking classic texts had its origins back then.

For years there has been both idle chatter and serious discussion of the expansion of the possibilities in fiction of the broadest sort—the art of narrative, of time applied to language. And so, the writer and **editor, Richard Kostelanetz,** has prepared the international anthology you are holding of the **Breakthrough Fictioneers**. Included are visual works, schematic legends, linguistic sequences and even a few almost-traditional yarns, but all of them are in some sense stories. The intention was to be inclusive rather than exclusive, informative rather than hermetic (hence the biographies at the end), to present a rare text by Gertrude Stein side by side with works by the most recent figures and to treat it all as contemporary. We of the **Something Else Press** hope that prose will never again be the same.

Cover of *Breakthrough Fictioneers*, Something Else Press, 1973.

MB: The minimal form has a vogue in contemporary condensed fictions, or "microfiction." I helped judge a competition recently for the *Ballardian* website. My first publication, called *Concentrate*, was a 1968 broadsheet of condensed writing.

RK: Do you know of anyone else who is working with complete fictions in three words or less? I don't. I once wrote that other writers don't steal from me because they wouldn't want to be caught dead doing what I do. It's still too avant-garde…

MB: The results of the *Ballardian* microfiction contest can be found at http://www.ballardian.com/ballardiansavoy-microfiction-competition-winners. I'm afraid these examples may be more micro than really minimal…

RK: [After looking.] Quite the opposite, to me. These are more minimal than truly MICRO, which to me is three words and less.

MB: A minimal piece I wrote in the 80s is a twelve-word alternation arranged into four lines, which I repeated and ran to bleed down the length of a page:

> THE PAIN OF LIFE
> THE CLOCK
> THE PAIN OF LIFE
> THE COCK…
> THE PAIN OF LIFE
> THE CLOCK
> THE PAIN OF LIFE
> THE COCK…

How were you able to draw on such a wide pool of artists and writers for *Breakthrough Fictioneers*?

RK: Belatedly I came to realize that, having been trained in intellectual history, even into graduate school, I learned early how to process large amounts of cultural materials effectively. That's still true of me. On the other hand, I can now identify some contributions to *Quark* that I should have included in *Breakthrough Fictioneers*, had I known about them in 1972. Chip Delany didn't get to renew our Old Camp Tie early enough!

MB: I can now see it's much more likely that you received my own contribution—and maybe other *New Worlds* writers also—from Charles who, after he moved to New York, acted as an unofficial American agent for several of us. I doubt whether it would have been Chip, whose short story *Time Considered as a Helix of Semi-Precious Stones* appeared in *New Worlds*. To digress, Chip is another link between us, between you and I, as he featured strongly in our early Savoy Books paperback roster. David Britton and I gave his novel *The Tides of Lust* (a work that Wikipedia compares with William Burroughs' *The Wild Boys*—later re-titled

Equinox) its first and so far only U.K. publication, in 1980. As a companion to this, we also gave Charles' *The Gas* its only U.K. release, and on publication both books were immediately seized by the police. We had taken the precaution of asking Philip José Farmer to write an introduction to *The Gas*, to show that it was an authentic work of the imagination, so the prosecutor took the view that a jury would not convict. But the police were determined to get us for something, so instead, we were got for some non-Savoy Grove Press readers that we had on sale in one of our bookshops and which the police had seized at the same time as the Delany and Platt books. Written pseudonymously by authors such as Alexander Trocchii they had been imported legitimately into the country and were on sale everywhere, and had been seized by the police on previous occasions but returned as not being of interest. This time we were charged, and when it came to court we underwent what was little more than a kangaroo trial. David was convicted, and jailed for a first offence. Fortunately the case against me, vividly there on paper, did not come to court. It was the beginning of twenty-five years of police harassment. David was jailed again, ten years later when we published his first novel, *Lord Horror*, which I'd helped him write. I was lucky once again to escape… So Chip is notorious in our pantheon! Ironically, we never met him, but dealt through his agent. For some unaccountable reason I'm not familiar with *Quark*. Googling it now I see that *New Worlds* writers like M. John Harrison and James Sallis migrated there, and also writers from Harlan Ellison's *Dangerous Visions* anthologies, which were the American counterpart to the U.K. New Wave of SF. So perhaps *Quark* was a kind of interesting bridge between the 'waves' within the 'wave'?

RK: Well yes, I emailed Chip Delany about this, and he, no less amazed than I am, sent this reply: "We [*Quark*] did, of course, publish Thomas M. Disch, Christopher Priest, Hilary Bailey (Mrs Michael Moorcock), John Sladek, James Sallis, Sonya Dorman, Marek Obtulowicz, Josephine Saxton, M. John Harrison, Brian Vickers, Michael Moorcock himself, and Charles Platt, all of whom were writers who also published in *New Worlds* or who were most definitely of interest to the *New Worlds* writers—as well as numerous others (Ursula Le Guin, Larry Niven, Kate Wilhelm…). Maybe that list will jar Butterworth's memory!"

MB: Tell Chip my memory is jarred!! An impressive list, and please thank him for the intervention… The New Wave had such striking origins, springing up as it did almost simultaneously on both sides of the Atlantic. The U.K. wave, as expressed through *New Worlds*, was more formalized, critical and perhaps more experimental in terms of its openness to other art forms. I don't know whether *Quark* was more radical, but *New Worlds* was a breath of fresh air to writers who wanted to escape orthodoxy, and was an inspiration to several publications of the time, including *Quark*, my own *Concentrate* and *Corridor* magazines and also that wonderful one-off offshoot of *New Worlds* produced by Sladek and

Pamela Zoline in 1968, called *Ronald Reagan: The Magazine of Poetry*, that included Ballard's short story *Why I Want to Fuck Ronald Reagan*. *New Worlds* was a once-only anvil for young writers and artists, but also for older hands like Ballard, Brian W. Aldiss, and Moorcock himself, who proclaimed that the future had already arrived, and who were attempting to herald-in a science fiction of the present, or at least of the very near future, and exploring inner rather than outer space. Even pulp was radicalized in works like Moorcock's early Jerry Cornelius novels, serialized in the magazine. Its most radical moment dates from 1967 to 1970, after it transformed from a pulp paperback into a glossy large format A4. Also the sporadic small press large format 1970s editions that came out after the newsstand editions had finished, were full of experimental work and visual writing. [Butterworth offers to send Kostelanetz some copies of *New Worlds*.]

RK: This interests me ENORMOUSLY, Michael, because I've noted that magazine self-retrospectives sometimes misrepresent, for one opportunistic reason or another, and I would love this example if I find it true after reading the issues themselves. Rest assured, it will be IMMORTALIZED here!

MB: As I have said, my own feelings about the avant garde are that it has now mostly become mainstream. Few unbroken taboos or uncrossed boundaries remain. Its last golden age was probably the 60s and 70s, which is the time you also claim as being significant, where much of what seems radical today has its origins. We still have our radical moments, of course, but these usually happen in the technology of presentation rather than in content—for instance in the way you are presenting your *Dictionary*. But it loses its cutting edge almost as soon as it is made. You could once be famous for fifteen minutes. Today you can be avant-garde for only fifteen minutes. Do you agree?

RK: Nope, because it's still possible to do work that is formally unacceptable. I know, because I've done it for decades and continue to do it and to hear objections, less directly than indirectly, perhaps because of the elite recognitions from strangers that have come my way. I so much love receiving dumb rejection letters that I published a selection of them in my *Skeptical Essays* (2011). The kinds of people who thought they might score points with literary powerhouses by dumping on me are now reluctant to do so. Those who don't want to be embarrassed as jerks sooner keep quiet…

MB: Is the avant garde dead?

RK: Nope! If only because reactionary antagonists survive, especially in positions of publishing, cultural power! Consider this principle: if work by someone receiving elite recognition is routinely rejected, then he must be doing something deviant, which is to say significantly avant-garde.

The Poetics of Late Capital: Or, How Might 'Avantgarde' Poetry Be Thought of Today?

Christine Wertheim

First the disdain of the vapid.

> On *phatic form. Phatic form* is something I just invented… This is what *phatic form* is. It's not *nonce form*, nor the nerdification-of-classic-venerated-now-socially-irrelevant-except-for-the-purpose-of-détournement verse forms. *Phatic form* describes the many open quote "poems," close quote, that stand in for poems, just as prose may stand in for news among advertisements, ads for news not there; signs *News!* without having anything new to say… All a *phatic form* has to do is say POEM as often as possible without saying "poem" too often because that would be meta…
> (from Donato Mancini, "The Young Hate Us {1}: Can Poetry Be Matter")[1]

But,

> "[g]enre" isn't the issue here, except that poetry risks becoming a mere genre when readers and writers' expectations are too specific… If you know what the poet's job is, you should ask who the poet's boss is ("The Young Hate Us {1}: Can Poetry Be Matter")

Thus, the imperatives:

> No more lines on the luminescence of light, of whatever variation.
> No more elegies of youth or age, no polyglottal ventriloquism.
> No more songs of raw emotion, forever overcooked.
> No more the wisdom of banality, which should stay overlooked.
> …
> No more metaphor, no more simile. Let the thing be, concretely.
> No more politics put politically: let the thing be concretely.
> …
> No more poet-subject speaking into the poem-mirror, watching the mouth move,
> fixing the thinning hair.
> No more superiority of the interiority of that unnatural trinity—*you, me, we*—our
> teeth touch only our tongues.
> …
> No more *jeu de mot*, no more *mot juste*.
> No more retinal poetry.
> (from Vanessa Place, "No More")[2]

Manifesto as advertisement, for an anti-expressive, post-subjective age.

Then there is the boredom of the literally unrestrained:

> An ambient poetics or starepo, by untraining the eye from conventional modes of reading, is also teaching the eye to shear conventions… These literatures are already under way, have been not only produced *&* not only called by their own authors to be forgotten, but be finished off. If this is because they contain the seeds of their own destruction, then this is the seed we would cultivate… Staring is tearing.
> (from James Yeary, "Fail")[3]

Thus the "uncreative" writers like Kenneth Goldsmith who, amongst other projects, recorded every word he said for a week, without interference from anyone else.

I have to walk the dogs. Today's the first day. I have to walk the dogs. Today is the first day. Well, they're rude. Yeah, I'm gonna take out those mutts for a little walk. We have to pick the laundry, darling. I guess we can do it after the Xenakis thing I just don't have any much to wear. I guess I'll wear some nicer pants. Um, when? He sent us something a while ago. Oh, it was about his discussion thing on the Web. I bookmarked it on the Web. I'll show it to you there. It was I I'm sorry it was addressed to both of us and I just, you know, yeah. BB yes. Yeah. And now it's sort of a drippy, I'll show it to you. Hi. Good one, huh? What? How was it? Yeah. They're so weird looking, aren't they? They kind of so slick and and bizarre, buffed up, you know, kind of his hair looks like it's been like buffed with a car buffer. And she, she's just got that bizarre, yeah, her face is so weird, isn't it? Enlish? Uh huh. Alright, I'd better go. Start the week. Right?
(from Kenneth Goldsmith, "Soliloquy," Sunday no.1)[4]

The idea here is that, in the digital era, when we are drowning in a tsunami of text, the responsible artist should not add any more to the pile. Instead of creating s/he should simply repurpose what already exists. The artist as word-processor or data-manager, appropriating, recycling, parsing, sharing, reusing, swiping, quoting, lifting, duplicating, mimicking, pirating, and mining data from already existent texts. And not only do authors not need to write any more, but readers don't need to read any more. "You can't read these books," Goldsmith says. "I can't read them. People tell me they do, but they're absolutely impossible." He just wants us to think about them, for the conception of the work also inscribes its meaning. Staring is tearing, apparently.

On the other hand, there are constraints:

> For two cents, the use of arbitrary material restrictions in poetry forcefully condition new linguistic possibilities. For three cents, production-side material devices/determinants break habituated patterns of language-use. For four cents, consumption-side, the formal restrictions can alter habituated patterns of cognition and emotion, patterning (inner) lives. (Changing the world *one subjectivity at a time*.) Buy One Get One Free: devices foreground the material conditioning of *structures of feeling*…
> ("The Young Hate Us {1}: Can Poetry Be Matter")

Against "expression" and "free" verse, the idea here is that material or formal constraints, intentional procedures, and appropriation of found or pre-generated text, especially those generated in the econosphere, can foreground, or even alter habitual patterns of feeling and thought. (Modernism lives.) Most importantly, here the subject of language and poetry, feeling and thought is linked to the economic processes of capital, and the reified social bonds that pertain therein.

> Capitalism begins when you open the dictionary.
> (Steve McCaffery, quoted by Donato Mancini)
>
> Meaning is commerce… Meaning is always on sale.
> ("The Young Hate Us {1}: Can Poetry Be Matter")

Capitalism multiplies, words as well as things. Furthermore, it makes each object, verbal and material, exchangeable with every other, reducing the meaning (meaning (!) purpose or reference or both?) of everything to nothing, and trapping the subject in a never-ending cycle of unrequited, (self)-grasping desire. The aim of much poetry employing the above-mentioned techniques is to transform social bonds by exceeding the specific *discourse of capital*, or at least, by exposing its operations, to change our relations to these. But does changing the structure of one's discourse necessarily lead to more satisfying, or even just less alienating social relations? Is there a poetic act that can adequately address the over-commercialized scene of our current existence? And is appropriating the language of commercialized existence itself a way to do this?

Another way to pose this problem is to ask, what are the issues?

> What are *your* issues?
> (emphasis added, "The Young Hate Us {1}: Can Poetry Be Matter")

Rodrigo Toscano addresses this question very specifically in a recent poem inspired by the Occupy movement, "May Be!," excerpted below.

Is Occupy a genre?
Is genre a cultural worker of the future not fully existing in need of Occupation?
Is genre a cultural worker of the future not fully existing in need of De-Occupation?
Is cultural manager a nice way of saying pimp daddy dog sucker fuck wad?
Can Occupy Occupy Occupy?
Is there a poetic act or critical project whose burning desire is to Occupy Everything?
Is there a poetic act or critical project whose burning desire is to De-Occupy Everything?
Is there a poetic act or critical project whose burning desire is to Re-Occupy Everything?
Is desire an Occupation?
Can Re-Occupy Occupy Re-Occupy?
What are the Occupational Hazards now of fissures in genres of the future not yet fully existing?
Are Occupational Hazards best handled through smart mitigation devices, sweeping changes in procedure, better alarm systems, personal protective equipment, or an engineering out of the Hazard?
Can De-Occupy Re-Occupy Occupy?
…
Will Occupy be a genre without an Occupation?
Does Occupy now have a pimp daddy dog sucker fuck wad "J" "O" "B"?
(from Rodrig Toscano "May Be!" Rodrigo Toscano)[5]

Here, it is not a matter of prescribing what a new post-commodified poetic discourse might look like, or even what techniques might produce it. This is not a manifesto. Nor is it an advertisement. The voice here speaks in neither the assertoric nor the imperative mode. It (m)utters in the mode of interrogation. But who or what is being interrogated? Who or what is "Occupy?" Is Occupy a genre? Does Occupy now have a pimp daddy dog sucker fuck wad "J" "O" "B"? What are the Occupational Hazards of being Occupy? Is Occupy being tortured? Or is this more like an intellectual debate, in which questions are part of a knowledge-seeking group activity? And if so, are we in the discourse of the university or the prison? Is there even a difference between these? Furthermore who is performing the interrogation? A poet? A master? A policeman? Or Occupy itself? For may we not see this text as a classic lyric poem performed by a self-doubting subject in the face of an ambiguous, alluring, and unobtainable object? As Toscano has said:

> the poem desired to render the *inquisitive* dimension of rebellion that was fueling Occupy. I thought that if I didn't give voice to that dimension and re-aim it back at the movement itself, I would essentially be *evacuating* my role as "poet," that is, poet as I am now, complexly flawed, but searching…[6]

Foregrounding an *inquisitive* dimension *desired* by the poem itself, "May Be!" complexifies current poetic discourse on poetry. Without stating the identity of either interrogator or interrogatee, or even clearly the subject (!) of the interrogation, "May Be!" focuses on the mode of interrogation itself as an aspect of discourse, distinct from both content and syntactical structure. As Beckett rewrote *Hamlet*, the question is not, "To be or not to be, that is the question," but, "To be or not to be, *What is the question?*" For, what is a question? If the aim of restructuring discourse is to produce new modes of subjectivity able to tolerate more flexible social bonds, then above all such restructurings must give up positions of mastery in which the speaking subject claims to know, even if only what should not be said and done. This is the problem of manifestos, that they often denounce one form of mastery, only to replace it by another, as do their close cousins, advertisements. In "Can Occupy Occupy Occupy?" the interrogating subject, the interrogated subject, and the subject of the interrogation are all reduced to the same linguistic plane because the difference between the order of words and the order of things or subjects is collapsed. Now words become things, even subjects with intentionality, and the subject itself is called into question.

Does such a practice, in which there is no linguistic hierarchy, transform a reader's subjectivity? Does it change his/her relationship to knowledge, power, desire, language or capital? Can Occupy Occupy Occupy?

Conceiving the Conceptual

Along with a concern for capitalism, the use of appropriation, repetition, and formal constraint, much contemporary innovative poetry also employs methods labeled "conceptual."

There are many ways to define a conceptual strategy in the arts. The one Goldsmith uses is that in which the conception of the work also inscribes its meaning. The concept of *Soliloquy* would be "everything I said for a week." This is why we don't need to actually read the work once we've grasped its concept. However, there are more complex ideas

of conceptualist strategies than this. The one I use here is outlined by Peter Osborne in "Starting Up All Over Again: Time and Existence in Some Conceptual Art of the 1960s," his contribution to the Walker Art Center's catalogue, *The Quick and the Dead*.[7] In Osborne's definition, "dematerialization" is also not a defining feature of conceptualism, even if this is only to the degree of rendering the visual and plastic into the (merely) verbal. Classic works of this type include Joseph Kossuth's *One and Three Chairs*, in which an actual chair is replaced first by its photographic image and then by its dictionary definition. Nor does he hold typical works in which a sequence of words (sometimes the "title") *fails* to account for a presented phenomenon, such as *"Ceci n'est pas une pipe,"* inscribed above the image of a pipe.

In Osborne's definition three separate elements of experience are held in tension:

1) a name/title/concept that *adequately* defines a material object or event
2) an existent material object or event (which is adequately described by a name/title/concept)
3) and yet, in spite of both of these, there is still an inability to somehow make sense of the experience of the conceptualized-phenomenon.

Osborne cites as exemplary, Robert Barry's *One Billion Dots*. This is a reworked version of the earlier *One Million Dots*. Both works present literally what their titles describe, namely one billion or one million dots, carefully printed in closely packed rows in hardbound volumes. As the viewer turns the pages s/he literally encounters a million/billion dots. But neither the words, nor the retinal experience adequately account for the sense of vertigo that ensues from one's meeting with this work. Because, in spite of *both* a name/title/concept and a realized phenomenon, sense fails to properly cohere. An ambiguous, ungraspable, something nags. There is a surplus in experience that can be grasped neither by the name/title/concept, nor by the input from our senses. In traditional Kantian aesthetics, such an encounter with an ungraspable surplus is called the sublime, and it is important, because, according to Kant, only in the experience of not-knowing what is happening, yet being fully clear that something is happening, is a "space" opened for subjects to encounter their unencumbered "selves." In Other words, only in this strange experience of limits does a subject face itself *qua* subject, and not as the subject-of-an-experience. Lacan reworked this basic structure into a theory that utilizes

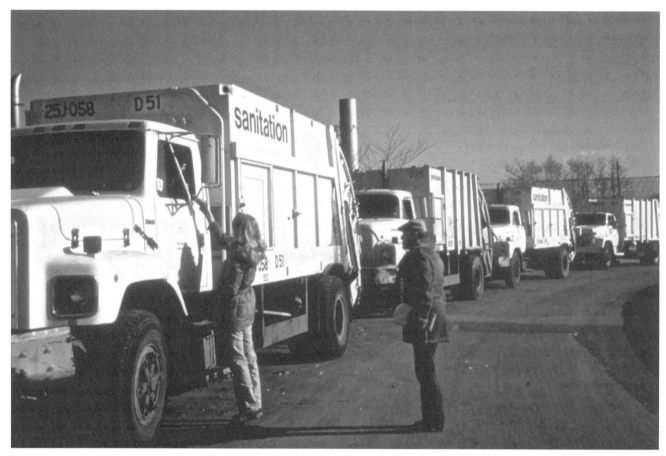

Mierle Laderman Ukeles, *Touch Sanitation*, 1978-80. With NYC Department of Sanitation. Courtesy Ronald Feldman Fine Arts, New York.

terms like S1 (Master signifier), S2 (chains of knowledge), $ (the split subject) and *a* (the little other).[8] But essentially the point is the same; a subject cannot transform itself merely through an addition of knowledge, but only when it actively confronts its own limits; when it actively accepts its *in*-ability to master through knowledge the object/s of the world, including itself

Other works from the visual arts that might conform to this type are Tensing Hei's 365 photos of himself locked alone in a cell for a year. Even with its adequately descriptive title, *One Year*, we still cannot imagine what this experience would be like. Or think of Mierle Laderman Ukeles's *Touch Sanitation*, in which she systematically met, handshook and photographed *every* worker in the New York Department of Sanitation. Even with all the photos, names and stories, not to mention our awareness of the monumental mountains of garbage daily produced in the city, it is still impossible to imagine the totality of this "work." Perhaps these are just modern examples of that "infinitude" which was for Kant the only phenomenon capable of arousing the sublime. And perhaps this explains why so much poetry that aims to go beyond what can (easily) be grasped employs repetition and procedures suggestive of inexhaustibility. Perhaps it is not so much the vastness of nature that now awakens our sense of overwhelming forces, but the plethora of everyday "stuff," including the everyday matter of words, as Goldsmith asserts.

But vastness is not the only way to approach this conceptual form of sublimity, understood as the experience of some ungraspable surplus exceeding *both* a sequence of adequate verbal descriptors and a given phenomenon. At least, if vastness does still have something to do with it, what's at stake is not the scale of the matter, or even the words, but something utterly (in)human. To explore this issue further, I turn to a work by the Caribbean-Canadian poet M. NourbeSe Philip.

Zong! Event Horizon

Zong! draws its language from the documents of an eighteenth-century legal case. Philip offers the following account of the case.

> In 1781 the slave ship, Zong, captained by one Luke Collingwood set sail from the coast of West Africa for Jamaica. As is the custom its "cargo" was fully insured. Instead of the customary six to nine weeks, this fateful trip will take some four months on account of navigational errors on the part of the captain, resulting in some of the Zong's "cargo" being lost and the remainder being destroyed by order of the captain.
>
> The Zong's cargo comprised 470 slaves.
>
> "Sixty negroes died for want of water … and forty others … through thirst and frenzy … threw themselves into the sea and were drowned; and the master and mariners … were obliged to throw overboard 150 other negroes (Gregson vs. Gilbert). Captain Collingwood believed that if the African slaves died a natural death, the owners of the ship would have to bear the cost, but if they were "thrown alive into the sea, it would be the loss of the underwriters."[9]

Several trials and counter-trials ensued. The final round is formally known as Gregson vs. Gilbert, or more colloquially as the Zong case. Philip, who is a poet and lawyer, wanted to "untell" this story.[10]

The poem draws on the five hundred or so words in the source text, mutilating, rearranging and redistributing them "in an attempt to subvert the rational, semantic, grammatical basis of the legal logic that generated those words in the first place."[11]

> gins there i s no such where he
>
> i only tell a sto
>
> ry it c an not be tol
>
> d
>
> (*Zong!*)

As Philip writes:

> The abbreviated, disjunctive, almost non-sensical presentation of the "poems" demands of the reader/audience an effort to "make sense" of an event that can never be understood. What is it about? What is happening? This, I suggest, is the closest we will ever get, some two hundred years later, to what it must have been like for those Africans on board the Zong.[12]

This text, which is simultaneously the name/title/concept of an artwork, and the actual presence of the word-things it names, arouses a sense of the conceptual-sublime: not so much by showing us that we can never grasp the horror of the Africans' experience, but because it forces us to recognize the inhuman gap between *these words* and the thought-actions of the white men they denote.[13] While other writers consider the diminishment of "meaning," brought on by the material and verbal excesses of capital, Philip focuses on the ungraspable lack in white western culture's sense of its ethical responsibility towards those deemed "other." Rather than twiddle over the poetic nuances of appropriation/conception versus expression, Philip compels us to an encounter with what exceeds our ethics, the fact that *we* (still?) cannot fully think the humanity of those we call other. By presenting to us the phenomenon of these words, correctly named, this poet confronts us with our own cultural "mastery," our sense that we can conjure away our lack of empathy through the discourse of legalized commercialism.

There are many ways to understand the significance of what Kant called the "sublime." One of these is to consider science. In science, especially in Kant's day, it seemed quasi-miraculous that the invention of wholly new concepts/ideas, such as Mass, naming phenomena never experienced before the invention of the name/concept, could not only produce new knowledge, but could actually make hitherto impossible interventions into the material world suddenly possible. What was the status of such concepts and how did they arise in the mind? This, on one reading, can be seen as Kant's overarching question. By analogy, we can ask, how does the concept of a "black Man" arise, where none had been before, at least in the western ethico-conceptual schema? Under what circumstances can such a radical concept become real enough to enable actual material transformations?

By reflecting to us the limits of the concepts underpinning our ethical behavior, M. NourbeSe Philip asks us to think the unthinkable, to expand our minds, and thereby to consciously transform ourselves.

Notes

1. Donato Mancini, "The Young Hate Us {1}: Can Poetry Be Matter," in Crag Hill and Nico Vassilakis, eds. *The Last Anthology: Visual Poetry 1998-2008* (Seattle: Fantagraphics VispoBooks, 2012) 63-8.
2. Vanessa Place, "No More," *Poetry Magazine* (March 2013), available at: http://www.poetryfoundation.org/poetrymagazine/poem/245542.
3. James Yeary, "Fail," in *The Last Vispo Anthology*, 72.
4. Kenneth Goldsmith, "Soliloquy," available at: http://collection.eliterature.org/1/works/goldsmith__soliloquy/07/07_01.html.
5. Rodrigo Toscano, "May Be!," in *Harriet: A Poetry Blog* (April 4, 2012), available at:
 http://www.poetryfoundation.org/harriet/2012/04/may-be-chorus-for-inquisitive-occupiers-2/.
6. Rodrigo Toscano cited in "Rodrigo Toscano on 'May Be!'," *Poetry Society of America*, available at:
 http://www.poetrysociety.org/psa/poetry/crossroads/own_words/Rodrigo_Toscano.
7. Peter Osborne, "Starting Up All Over Again: Time and Existence in Some Conceptual Art of the 1960s," in Peter Eleey, ed. *The Quick and the Dead* (Minneapolis: Walker Art Center, 2009) 91-106.
8. For more on this topic, see Nancy Gillespie, "Introduction: Negotiating the Social Bond of Poetics," *Open Letter* 14:8 (Spring 2012) 9-17.
9. M. NourbeSe Philip, *Zong!* (Middletown: Wesleyan University Press, 2008).
10. See Gillespie, "Introduction: Negotiating the Social Bond of Poetics." Gillespie offers a thoughtful analysis of this poem from a Lacanian perspective.
11. Craig Douglas Dworkin, editorial notes for the poem "Zong!" in Craig Douglas Dworkin and Kenneth Goldsmith, eds. *Against Expression: An Anthology of Conceptual Writing* (Evanston: Northwestern University Press, 2011) 483-4.
12. Philip, *Zong!*
13. Here again there is a collapse of distinction between the word order and the thing order, because the words themselves are the things being named.

Avant Garde in Progress: An Allegory

Lyn Hejinian

1.

Henri Lefebvre has said, "everyday life is the supreme court where wisdom, knowledge, and power are brought to judgement."[1]

Everyday life has palpable but abstract reality. It is sporadic but persistent, or, rather, it is continuous but unobtrusive.

It's difficult to picture everyday life, it's a composite of contradictions, so dialectical as to be dizzying, though it is paradigmatically ordinary. Everyone is going about his or her business. So are the spiders, and the molecules of asphalt, a tiny percentage of which get cast aside by passing automobiles every day. "Sounds penetrate partitions and wing their way through the walls of houses."[2] This was true in Lucretius' time, as it is now.

Everyday life is everything that forms the common grounds, all that can be shared with other human beings, but some parts of everyday life—everyday indeed!—can't be shared with anyone.

Wearing narrow-leg black jeans, a V-necked black sweater, black socks, I go to Café Roma for a double espresso and to read. At some point, I notice a small child enter the café. He's wearing a knitted, black hood-shaped hat along whose top, running from front to back, is an upright black and yellow crest of yarn. Wearing that hat, he sports a "Mohawk" rather than a mane, but either way he is a savage personage in a fantasy. With him are his grandparents—I know this because, as the trio passes me, I hear the woman refer to the man as "Grandpa": "Grandpa's going to buy us each a treat." Grandpa is a tall man with longish curly gray hair and a neatly trimmed beard. The grandmother is animated, perhaps anxious, and wearing a long beige wool coat and brown scarf. They sit directly behind me. "I have a secret friend," the little boy says; he's no more than four years old. "You do?" says the grandmother, eagerly. "Tell me about him—or is it a girl? Is it a boy or a girl?" "A boy!" "Tell me about him," she offers. "Never!"

Not everything that invites interpretation is allegorical. Indeed, not everything invites interpretation. But much does, or so human beings feel.

Established practices and personal habits ripple through everyday life, but so, too, do ritualistic behavior and magical thinking. Moment to moment choices and decisions are as apt to be governed by idiosyncratic superstition as by sense or assessment. Whenever a recipe calls for garlic, I add an extra clove or two more, for protection of life and limb. I sit toward the left in a movie theater, so as to occupy, literally, a leftist position. But here superstitious behavior merges with something akin to principled behavior.

What might an avant garde look like now—as an aesthetic practice and/or as a social practice? It begins as an oppositional practice, but if it remains only that, or principally that, it dooms itself to continuing dependence on the very thing it opposes. And, since "the very thing it opposes" is likely to be the conditions of late capitalism, the next question to ask is, how does an artist produce anything that could be properly called "avant-garde" when relentless (capitalist) newness is precisely the problem at hand?

Fredric Jameson offers one tentative answer, though in the context in which he does so, he is talking about the discourse of theory rather than the arts of the avant garde. "There …emerges a …possibility: namely, what I will call the production of theoretical discourse par excellence... This activity is utterly nontraditional and demands the invention of new skills altogether. New theoretical discourse is produced by the setting into active equivalence [which is not to be confused with "identity"] of two [but I don't see why there couldn't be more than two] pre-existing codes... What must be understood is that the [resulting] new code (or metacode) can in no way be considered a synthesis between the previous pair [or set]." Jameson imagines this in terms of *two* pre-existing codes, because he is concerned with dialectical processes, however novel their configuration and unpredictable their outcome. But this new "possibility" is more complicated—and perhaps more fulfilling—than classical dialectics, since the whole undertaking may serve an unresolved dialectical function. If and when the two or more codes are mutually contradictory or incommensurate with each other, what may result are, as Jameson points out, "strange new ambivalent abstractions"—but I don't know why they can't equally well be strange new ambivalent *concretion*s.[3]

The term "avant garde" has fallen into the scrap bin of history, and has been supplanted in the last thirty or more years by such unimpressive terms as "experimental" and "innovative." As modestly descriptive or weakly categorical labels, these may still be useful—but they say little and tend to serve careerist rather than expansive and productive purposes. Furthermore, they are most often applied not to socio-cultural or aesthetic tendencies but to literary and

artistic *styles*, many of which exist precisely so as to situate the work within the sphere of the experimental and/or innovative. Fragmentation, syntactic deformation, non-linearity, lexical invention, collage, ambiguity, etc.—such devices are no more *definitive* of avant-garde work than of *The Canterbury Tales* or *The Life and Opinions of Tristram Shandy*. Wearing a hoody is not a manifestation of criminal intent; it can't even make one cool or young, not to mention male or black.

Shifting slightly in my chair in Café Roma, I turn to look at the little boy in the crested hat. I was wrong to see the crest as resembling a "Mohawk" hairdo: The hood-like hat isn't a wig, it's a helmet. The child is a warrior, a knight. On the left side of the hat, woven into the fabric from the top of the boy's ear to the edge of his chin, is an image of a human skull. Before something catches the boy's attention and he turns, I have a side view of his head and of the skull inside it. The child, as a knight, carries on his head a *memento mori*.

A metaphor is a unit of proffered interpretation; an allegory invites one to interpret for oneself.

All important modern art reflects strife, undertakes resistance. This has been true for over a century, and one could argue that this is because the period itself has been one of unprecedented strife, marked by wars (declared and undeclared, hot and cold) but also, and more pervasively, by capitalism, which is itself an economics, and hence a social politics, of strife. Capitalism, to succeed, increasingly provokes frenzy, not tranquility.

"Modernism dreamed of aesthetic universals that could provide civilization with culture," Charlie Altieri says. "Postmodernism found itself in a world of multiple cultures and discovered that universals are impossible."[4]

I am not against interpretation. On the contrary, it is an activity I tend to engage in with near abandon, seduced by the cognitive pleasures and constructive possibilities it promises, though usually, at interpretation's end, I'm aware of the arbitrariness, or incompleteness, or gratuitous weirdness, or obviousness, or heavy-handedness of its outcome. Inevitably, interpretation falls victim to the interpreter's limiting subjectivity, his or her individuality.

Every metaphor, too, has limits. As a paradigmatic interpretative medium, it is in several ways problematic. First, it is prejudicial, deformative as much as it is informative. This was the basis for Sir Francis Bacon's objection to any use of metaphors in descriptions of natural phenomena; scientific inquiry should be addressed to raw data; new discoveries and thus new knowledge can't be based on data that's been familiarized or domesticated through comparison with things already known. Second, metaphors, properly speaking, offer a completed interpretation—a summation. With the appearance of the metaphor, the job is done. This is why extended metaphors are so often parodic rather than apt, comically excessive rather than assiduous.

The third problem with the metaphoric interpretative medium is not that it offers a distorting interpretation or a terminal one, but that it offers an interpretation at the expense of the interpreted reality itself. Data hasn't merely been tampered with, it's been tossed aside altogether. Metaphors are units of understanding, not units of reality—though, undeniably, they carry bits of reality with them.

Pan, with his florid or fiery face (it makes a difference which), is an allegorical image of the entire universe (*pan*), as a guy whose head is a sun. Or is it merely reflecting the sun?

In all that I'm writing here, I want to assert the value of the ordinary, the quotidian, reality's scattered happenstantial trivia and people's repetitious personalia. It all passes under the sun. The sun: productive and purposeless and not always benign, all-powerful and essential and definitively *everyday*.

The wide broadcloth shades are pulled down over the high windows of the lecture hall, but a soft gray band of late afternoon light slowly forms on the floor near the podium. An hour goes by.

Overhead the sun captions the moon, arched like a herring in the pale day sky, and a fictional character I'll call Nicholas Declan Callahan is walking down the steps in front of the neoclassical public building, headed with Sammy Christine Blake toward a café across from the plaza.

"History reads the past as the prehistory of the present—that's kind of exactly what Peter Bürger says—and that's only half the story," says Nicholas Declan Callahan, who likes to continue, so he goes on: "I think we could look into the past to see what we're missing."[5]

"That's the fast track to nostalgia," says Sammy Christine Blake.

"I don't mean corsets and claret and Oliver Twist," says Nicholas. "I mean the future—what we can't see in the present and don't expect."

"You'd have to cancel the present for that," says Sammy, brushing her right hand across the tattoo on her left shoulder, "which could be a good thing, but you'd still be looking from the present's perspective."

A little way south of the plaza pedestrians are moving past a stretch of neighborhood shops. By the bank a fat panhandler sits, doleful, aggressive, and indomitable. In front of the ice cream boutique, clumps of socializing shoppers block the sidewalk. A woman—a neighborhood regular—hastens by, stepping off the curb to get around them. She irritably recognizes herself as just one of many competing presences, reciprocally anonymous, equally entitled to the sidewalk, and takes the shortcut through the short alley between Filippo's and La Mediterranée.

In what language-game do we combine the terms *time* and *being* into a single term—as "the time being"? I can't think of the phrase as occurring in anything but the prepositional phrase "for the time being." Why that particu-

lar preposition? And why do we speak of *the* time being but not *a* time being? Is there no indefinite time being?

At some level, explicit or, more likely, implicit, a work of art confronts the question of "how to live the good life."

The sunlight fades and the blue of the sky, the sky bluing all day—cobalt, or turquoise, then eggshell blue—disappears. Over a dark residential street in the neighborhood, Venus is visible.

The way Maggie Fornetti knows about things is by adding to them. The same is true for Askari Nate Martin, but awareness that possibilities are infinite doesn't thrill Askari Nate Martin nor excite his curiosity, it makes him nervous, wary. It is the secret to his autonomous mien and the reason he is no longer a police detective.

"You've seen the 'What I Do' column?" Askari Nate Martin nods but says nothing to the interviewer, Rosa-Jane Stein. "It's just fluff—human interest shit, that humans don't find interesting." Nate nods again, his slight smile quizzical, asymmetric. "Thanks for agreeing to be interviewed," says Rosa-Jane Stein.

"No problem," Askari Nate Martin says. Rosa-Jane Stein sets the "voice memo" on her iPhone to record and asks him what he does. He doesn't want to call himself a director, doesn't want to claim that anyone can be said to "run" the Oakland MAPS, so says he works there. "Oakland MAPS—the Oakland Music and Arts Program." "For kids," she says. "For kids." She wants to know what kind of kids, he avoids the terms "at risk," he calls them "talented." Some of them get recommended by their schools, a few come from an arts-oriented charter school and get credit for taking a semester-long class, a few are in the juvenile justice system, none of which he says. "Talented," he says. "I couldn't categorize them beyond that."

It's misleading to associate the allegorical with metaphor; the allegorical is not analogic but indexical. It's syntactic rather than semantic, connective rather than comparatist. It's temporal as much as it's spatial. It is tempting to call it narrative rather than representational, but it's more accurate to regard it as a representation of narrativity, an affirmation of the fact that everything exists within stories—that is, within, while also as, context.

Say I want to concoct a tale based on the familiar objects in an ordinary room, a tale that would entertain a child without frightening him or her. "The bed is made of magic straw and the window panes of ice," I begin. But, unable immediately to imagine what magical properties might be appropriate to straw apart from its perhaps undesirable ability to turn into gold, I begin again. "The bed is an aeronautical vehicle, and the window panes are made of moonlight." It's better to call the bed an aeronautical vehicle rather than a flying bed, as the prospect of settling down to sleep in a bed that might fly could be terrifying for the child.

On June 15, 1880, aboard a ship moving slowly through ice fields in the far north, the young Arthur Conan Doyle in his diary calls the wind "depraved"; six weeks later, he calls the fog "pusillanimous."[6]

Interpretations, including those skirted by digressions as well as those embodied in metaphors and reproduced by them, require comparisons. And those comparisons are made by humans, which should render them suspect much of the time, or, at the very least, themselves in need of interpretation. As Ernesto Grassi is compelled to note, though he himself is an advocate of metaphorical thinking, "The metaphor is … the originary form of the interpretative act itself, which raises itself from the particulars to the general through representation in an image, but, of course, always with regard to its importance for humans."[7]

With the words "happily ever after," a tale announces both the quality and quantity of its continuation. It accepts, gladly, the state of things now and anticipated and it has no discernable end; it is indeterminate in quantity and expresses minimal qualifications regarding the possibilities of a near painless life.

Here, somewhat ineffectually, like a woman in an audience shouting at the stage, I intercede: "In her poem 'The Labors of Hercules,' Marianne Moore says, 'one detects creative power by its capacity to conquer one's detachment.'"

2.

In his foreword to Peter Bürger's *Theory of the Avant-Garde*, Jochen Schulte-Sasse speaks of "the shift from realism to aestheticism" as a defining moment of modernist art.[8] This comment is accurate as far as it goes, but subsequent developments indicate that, predictably enough, modernist art doesn't stop at aestheticism. The original, German publication of Bürger's book appeared in 1974, the same year that the fifth issue of Robert Grenier and Barrett Watten's seminal literary magazine *This* appeared—seminal and avant-garde, though my case for the legitimacy of the latter term has yet to be made. That issue of *This* included new writing by Clark Coolidge, Bob Perelman, Joanne Kyger, Larry Eigner, Bruce Andrews, Ron Silliman, Bobbie Louise Hawkins, Rae Armantrout, as well as two short untitled but dated poems by Watten, written in generally four-foot lines, and a packet of index cards reproducing 30 poems from Grenier's 500-card work titled *Sentences* (published in its entirety in 1978).

This magazine, first published in 1973, and co-edited by Grenier and Watten through issue 5 and by Watten alone thereafter (through its final, 12th issue), can be properly viewed as the breakthrough forum for what has come to be known as Language writing. Inclusion of work by Joanne Kyger, Bobbie Louise Hawkins, as well as David Gitin,

Larry Fagin, Lewis MacAdams, and Steve Malmude, all of whom published work in *This* 5, and none of whom are among Language writing's list of "usual suspects," doesn't belie my description of the journal as an, and probably *the*, initial Language writing venue; definitions and descriptions of Language writing have persistently failed to recognize the scope of its express affiliations and the diversity of its aesthetic as well as social engagements.

> The moon lost in language
>
> tu tu ini
> She is not especially she.
> (Joanne Kyger, from "'Baul,' produced by Lewis Macadams
> from the journals of Joanne Kyger")[9]

Avant-garde literature issues out of a cultural position, not from a strictly aesthetic category.

As Raymond Williams notes, the literary avant garde is "less a matter of actual writing than of successive formations which challenged not only the art institutions but the institution of Art or Literature, itself, typically in a broad programme which included, though in diverse forms, the overthrow and remaking of existing society."[10] Raymond Williams puts this in the past tense, since he is writing about "a complex of movements from around 1910 to the late 1930s." I am speaking in the present tense, however, since I am speaking about movements that, though clearly influenced by the "complex of movements" that Williams addresses, are separated from them by half a century, are different from them in important ways, and, I am happy to say, are happening now. There is an extant avant garde. Its complex of movements re-emerged in the early 1970s, in a period of socio-political turmoil at multiple sites (mostly, but not exclusively in Europe and North America), evolved aesthetically through a period of apparent cultural stagnation concomitant with at first slow and then rapid economic booming and busting, and are operative now on intensified and expanded, or perhaps scattered or multi-centred, fronts.

Among its defining characteristics is its persistent commitment to the writing of exploratory poetics. The late twentieth century was a period of vast capitalist expansion, with generally creeping rather than dramatic social deterioration, during which, thanks to numerous factors, literary and philosophical theorizing seemed called for and was abundantly possible, while significant new social praxes seemed less so. The early twenty-first century has been a period of increasingly tumultuous capitalist expansion, invading everyday life and private life as well as occasioning ideologically-driven wars and general impoverishment, thus discouraging where not prohibiting new social praxes.[11]

I take to heart Graham Harman's remark that "The world is not the world as manifest to humans; to think a reality beyond our thinking is not nonsense, but obligatory."[12] I find the sentiment moving, exciting, even if humbling. But there is a danger that, if one were to live in accordance with its implicit values, one might find that one has put aside one's habits and principles of human compassion and camaraderie. There is apt to be a disjunct between concern for human rights and concern for, say, rock rights or tree rights.

The aggression associated with the avant garde—its iconoclastic or agonistic relation to the dominant society—is real; through its oppositional activities, the avant garde struggles to bring about the epistemological break necessary for destabilizing people's assumptions and generating cognitive uncertainty and cultural porosity. But that's only the first phase of avant-garde practice, the prelude to its real task, which is to forge new social as well as cognitive connections, to generate new forms of connectivity, and to deepen as well as expand membership in the world of interconnectedness, such that the sphere of our awareness and care is, so to speak, internatural as well as international.

As Lucretius learned from Epicurus, "The main obstacles to the goal of tranquility of mind are our unnecessary fears and desires, and the only way to eliminate those is to study natural science."[13]

3.

The avant garde always exists in relationship to the socio-political and, increasingly, to the socio-economic milieu surrounding it. Insofar as the avant garde produces an aesthetic, it does so in response to its assessment of society. It may produce major art of enduring importance and often has, but at the moment in which that art comes into existence, it does so as a social phenomenon. In this sense, the avant garde artist is a social creature, but not only in this sense. The term "avant garde" can never properly be applied to a solitary artist, working individually. It is not an identity, a mode of personhood—although, for self-marketing purposes, it sometimes does get appropriated by individuals, with what, in my view, is cynicism and hypocrisy.

If "the shift from realism to aestheticism" marked the emergence of modernism, in the works published in *This* 5 it is clear that a new shift has been underway, into new realms of realism reflecting new social—and, ultimately, also non-human—realities, though in 1974, when *This* 5 came out, recognition of the latter within avant-garde practices was largely yet to come.

The first work in the issue is Ron Silliman's "Berkeley," a 164-line poem, each line consisting of a sentence beginning with the first person pronoun "I," producing a poem that is, however, scarcely autobiographical and one that even, as I want to argue, can be productively read in relation to the "dehumanization of art" that José Ortega y Gassett ascribed to the avant garde, though not quite in the way that I would do so. Ron Silliman's "Berkeley" is, despite its reiterative "I," a curiously dehumanized topos.

> I thought you might be here
> I was alone and it was almost two
> I have enjoyed my lunch
> I knew right away I made a mistake
> I glanced back once
> I mean it
> I thought so
> I had been actually invited
> I drew my jacket sleeve across my wet mouth
> I wasn't even trying
> I told him
> I'll try to let you know
> I watched some piano lessons
> I was a very tough cookie

And so on.

Angst and a concomitant degree of aggression are evident in the writing. The poem's beginning is edgily self-justifying. Effort is being experienced, but "I" can't get comfortable. None of this changes—conditions don't improve, I doesn't get anywhere or learn anything. "I" just gets shifted around, resituated, but against a blank—there's no background, no context; there's no foreground, nothing responds.

Coming back to "Berkeley" now, almost 40 years after it was first published (in what still seems to me to be a cutting edge literary magazine), I read it not as a poem of fraught lyric subjectivity (though it takes an ironic stance in relation to such poetry), but as a poem of post-subjective abstraction. All attempts to establish points of reference fail, whether they are made by the reader (who's not sure how or where to gain access), or the writer (who has no other instrument than language to use for prodding at "I," either as a concept or as an experience), or the speaker (or speakers—we might be eavesdropping on a myriad of them, 164 first persons, all at a loss, without "you").

I read the poem now as if it were a list of captions, lacking images to go with them: a sequence of disconnected phrases, debris from a dismantlement of the symbolic—or maybe the right way to put it would be to call it demi-symbolic. It presents everyday life under conditions of extreme alienation. A similarly disaffected work, though with much more explicitly political content, is the British poet Redell Olsen's recent poem titled "a slide show primer (on behalf of the warden)," published in 2012. Though less markedly formatted than Silliman's poem (and, at 42 lines, shorter), Olsen's "slide show primer" is built, like his, of separate sentence-length lines, all beginning with a pronoun, though for Olsen it is the demonstrative pronoun "This."

> This is of a chord sprinkled thicket
> This is of a footnote that explains what pancakes are
> This is of a tufted slumber
> This is of an abstract thing or it might be a nipple
> This is of one laughing who does not appear to be expressing anything
> This is of the increase through the perforation and damage
> This is of use within properly prescribed limits[14]

Like Silliman's poem, Olsen's sets up what can only be frustrated attempts at cognitive mapping. But here the captioning function is explicit: each "This" points to a (for us invisible, unviewable) slide, explicated by the poem's speaker, who takes something of a distanced stance to the images (or, rather, non-images). She is aware that we are paying attention to her, and her ostensible attempts to deflect that attention, by pointing it toward the "slides," are only partially and temporarily successful. On too many occasions, she calls attention to herself—to her own interpretation as precisely that, hers: "This is of an abstract thing *or it might be a nipple*."

Silliman's "I," on the other hand, doesn't seem to be aware that we are observing it (or them); it is absorbed in its own world, puzzling over its own affairs. Certainly "I" is somewhat performative. Indeed, there are several points where it is almost histrionic: "I will stay here and die," "I collapsed into my chair," and so on. But—at least as I read

it—"I" is performing for itself, desperate to persuade itself that the situation bears some reality. If "I" is this upset, it should be proof that there is something to be upset about. The reader, meanwhile, is becoming increasingly aware that "I" is inhabiting a world that is empty of reality, or, at least, empty of materiality. A world of radical negativity.

I have said that the "I" is fighting for world—for "Berkeley," which is, of course, a "real place." But it is also fighting against it. Individual consciousness is always resisting the world as much as it's trying to join with it. It is always busily demarcating what belongs to it, delineating the boundaries between self and world. What's frightening in Silliman's poem is that there is no world, and thus no possibility for boundaries. There is only individual consciousness.

After "Berkeley," Silliman went on to write *Ketjak*, *Tjanting*, and *The Alphabet*, all sentence-based phantasmagoria of everyday life, obsessively mapped, intricately captioned, capaciously social, and restlessly allegorical. *Tjanting*, in fact, is intended as a political allegory; Silliman doesn't use that term, but he has said that structurally *Tjanting* is intended to represent class warfare. "The original impulse there was a question that had been recurring to me for at least 5 years: what would class struggle look like, viewed as a form? ... Any solution to a question like that is necessarily going to be both reductive and an analogy, and *Tjanting* pleads guilty to both counts. What it does is to develop, through alternating paragraphs, in two directions: every paragraph is the antithesis of the proceeding one."[15]

> Not this.
> What then?
> I started over & over. Not this.
> Last week I wrote "the muscles in my palm so sore from halving the rum
> roast I cld barely grip the pen." What then? This morning my lip is bisterd.
> Of about to within which. Again & again I began. The gray light of day
> fills the yellow room in a way wch is somber. Not this. Hot grease had spilld on
> the stove top.
> Nor that either. Last week I wrote "the muscle at thumb's root so taut from
> carving the beef I thought it wld cramp." Not so. What then? Wld I begin? This
> morning my lip is tender, disfigurd. I sat in an old chair out behind the anise. I cld
> have gone about this some other way.[16]

So goes the first six paragraphs of the work. Whether or not one can perceive the turmoil of class warfare in the text—and it goes on for 19 paragraphs, filling something like 140 pages, each paragraph longer than the one preceding it by a predetermined amount, one can certainly see in it the tides of contrast, separation, and paradox. The referential is repeatedly disturbed by the material. Like the labor of carving meat, the labor of writing is done with one's hands, risking their discomfort or injury. Lips have a life of their own.

4.

The universe turns its phenomenological face to us, but often we can't read its expression.

There is a (necessary?) conflict between, on the one hand, our awareness of the necessity for withholding imagery and thus producing abstraction (precisely as imagelessness) and, on the other hand, our awareness of the necessity for acknowledging material reality and corporeal situatedness, including our own, which grants us the very possibility of a perspective but also limits us to it.

We are—at least for the moment—who knows what we will turn into? who knows what we were last?—fated to be human.

The aesthetic avant garde always seeks difference. The political avant garde always seeks similarity. We both must and must not privilege humanity. We must struggle for social justice, of course, and we must open the realm of "the social" to include not only all other sentient beings but also clay, salamanders, chairs, milkweed, ears, mountains, pomegranates, and tunnels, etc.

There is a very real paradox inhabiting everyday life, which can be formulated in two ways. First, it exists within the fact that there is a reality, and a realism to go with it, that is imageless—and, again in a twofold, way: imageless in that we can't see it, and imageless in that we can't picture it. In this latter site, of imagelessness, awaits the utopian future, the happier world we can't imagine because we don't know what it would look like and that we shouldn't imagine because, if we do, it will be co-opted, commodified, and sacrificed in the arena of the spectacle. At the same time, there is a realm of materiality that belongs precisely to the orders of what isn't seen. This is partially the terrain of science—microbiology, quantum physics, etc. And it is partially the realm of what I suppose has to be called metaphysics, since it exists in the form of circumstances and situations rather than in particles involved in them. I confess to being out of my depth here, but if we remove situatedness and extensive time—stretches of time—from the category, so to speak, of reality, we are left with a denuded universe—the bride stripped bare by her bachelors, even.

The second facet of this paradox concerns the unrepresentability of everyday life, and this, again, has two aspects. The first is obvious—to isolate any instance or instant of everyday life is to remove it from the realm of the everyday, so that it ceases to be everyday. The second is related to this first—the everyday is, by definition, the realm of lived temporality. It's not special. One of the best discussions of this problem can be found in the second part of Kierkegaard's *Either/Or*, in the text, purportedly written by a certain Justice William, extolling "The Aesthetic Validity of Marriage." Marriage, as Judge William argues, is not achieved in a moment; rather, it is lived in imperceptible increments, day by day. It is aesthetically beautiful, but it can't be represented by aesthetic beauty. "How, then, can the aesthetic, which is incommensurable even for portrayal in poetry, be represented? Answer: by being lived."[17] The art historian Michael Fried summarizes Judge William's argument succinctly: everyday life "absolutely defeats being represented in and by the various arts, all of which fail in different ways to do justice to the sheer protractedness or extensiveness of time, but … it can be represented 'by living it, realizing it in the life of actuality,' in short by making existence itself an aesthetic medium."[18]

The avant garde is trying to crash through to that imageless materiality, reality that can only be referenced abstractly and can be mapped, I would argue, only allegorically—not by contriving allegories but by activating the allegorical, and activist, function.

To work, the allegorical always requires space. It is applied to space, not as an instance nor in one of its instants or instantiations, but in and as a period; historicized. It is in this way that it can become avant-garde, and political.

As Lucretius says, "whatever exists must be something in its own right; and if it is susceptible of even the lightest and faintest touch, its very existence ensures that it will increase the aggregate of matter by an amount either great or small and augment the total sum."[19]

The allegorical is an (intentionally) uncompleted metaphor. Indeed, it owes more to metonymy than to metaphor, in that it "places meanings constantly in motion."[20] The process—what Fredric Jameson has called "cognitive mapping" and, following Gilles Deleuze—albeit perhaps not altogether responsibly, what might also be termed diagrammatic or, better, morphogenetic thinking—brings to view, or to imagination, non-linear concatenations. Perhaps constellative thinking is the optimal term. We live amidst, and, however unconsciously, partake in, concatenations of the real that cultural standards, narrative givens, etc., can't make sense of or even perceive. Simply to realize they are here requires modes of extensive thought and therefore of time that we are rarely, if ever, allowed.

As Raymond Williams says, "The lives of the great majority of people have been and still are almost wholly disregarded by most arts. It can be important to contest these selective arts within their own terms, but our central commitment ought always to be to those areas of hitherto silent or fragmented or positively misrepresented experience. … For if we are serious about even political life we have to enter that world in which people live as they can as themselves, and then necessarily live within a whole complex of work and love and illness and natural beauty. If we are serious socialists, we shall then often find within and cutting across this real substance—always, in its details, so surprising and often vivid—the profound social and historical conditions and movements which enable us to speak, with some fullness of voice, of a human history"—a history attentive "to the lives of the working people who continue, as real men and women, beyond either victory or defeat."[21]

Outside, on the plaza, the protestors are shouting from contexts even a movie couldn't represent.

In a classroom of a public university, a discussion of *The Dubliners* is underway. "Joyce followed out the consequences of realism and all it got him was despair," Charlie Altieri says. That Altieri is delighted by this outcome—that he considers it the only creditable outcome of a realist attitude, the only real lesson that reality can deliver—is clear. He shrugs, smiles, shifts his weight. He resettles himself on the edge of a table at the front of the lecture hall.

Despair may now have brought us back to realism, and to the existence of a non-heroic avant garde.

Notes

1. Henri Lefebvre, *Critique of Everyday Life, Volume 1*, trans. John Moore (London: Verso, 2008) 6.
2. Lucretius, *On the Nature of Things*, trans. Martin Ferguson Smith (Indianapolis: Hackett Publishing Company, 2001) 12.
3. Fredric Jameson, *Postmodernism, or, the Cultural Logic of Late Capitalism* (Durham, NC: Duke University Press, 1991) 394.
4. A paraphrase of comments he made in a class lecture on J.M. Coetzee's *Disgrace*, UC Berkeley, November 26, 2012.
5. Peter Bürger, *Theory of the Avant-Garde*, trans. Michael Shaw (Minneapolis: University of Minnesota Press, 1984) 21.
6. Arthur Conan Doyle, *"Dangerous Work": Diary of an Arctic Adventure* (Chicago, University of Chicago Press, 2012) 276, 293. Doyle's Sherlock Holmes character will devote his reasoning powers to finding pathways back again from metaphor to fact.
7. Ernesto Grassi, *Rhetoric as Philosophy: The Humanist Tradition*, trans. Timothy W. Crusius (Carbondale IL: Southern Illinois University Press, 1980) 7; quoted in Christopher D. Johnson, *Memory, Metaphor, and Aby Warburg's Atlas of Images* (Ithaca, NY: Cornell University Press, 2012) 44.
8. Jochen Schulte-Sasse, "Introduction" to Bürger, *Theory of the Avant-Garde*, xxx, xxxvii.
9. *This* 5; no pagination.
10. Raymond Williams, *The Politics of Modernism: Against the New Conformists* (London: Verso, 1989) 67.
11. I am not overlooking the fact that new social practices have emerged in connection with new technology underwriting electronic media—googling, social networking, and electronic sociality generally—but, in my strongly held opinion, these are inseparable from, and are indeed

contributing factors in, capitalist expansion and, to use Henri Lefebvre's term, the colonization of everyday life.

12. Graham Harman, "On the Undermining of Objects: Grant, Bruno, and Radical Philosophy," in Levi Bryant, Nick Srnicek, Graham Harman, eds, *The Speculative Turn: Continental Materialism and Realism* (Melbourne: re-press, 2011) 26.
13. Martin Ferguson Smith, "Introduction," in Lucretius, *On the Nature of Things*, xxii.
14. Redell Olsen, *Punk Faun: A Bar Rock Pastoral* (Oakland, CA: Subpress, 2012) 72-4.
15. Ron Silliman, "Interview," *The Difficulties: Ron Silliman Issue* 2:2 (1985) 35.
16. Ron Silliman, *Tjanting* (Berkeley: The Figures, 1981) 11.
17. Soren Kierkegaard, *Either/Or*, Part 2; ed. and trans. Howard V. Hong and Edna H. Hong (Princeton: Princeton University Press, 1987) 133.
18. Michael Fried, *Menzel's Realism: Art and Embodiment in Nineteenth-Century Berlin* (New Haven: Yale University Press, 2002) 147.
19. Lucretius, *On the Nature of Things*, 14.
20. Christopher D. Johnson, *Memory, Metaphor, and Aby Warburg's Atlas of Images* (Ithaca: Cornell University Press, 2012) 60.
21. Williams, *The Politics of Modernism*, 113

The Madness of the Unexpected

Marjorie Perloff

The carefully calculated trick Duchamp played on his fellow organizers of the 1917 Salon des Indépendants raises issues about the relationship of aesthetic choice to its particular context. The making of an artwork, let's remember, is never a direct response to this or that political condition or cultural constraint, it is always already mediated, occupying, as it naturally does, a space containing multiple rivals and allies as well as an historical position. To put it simply, artworks are always site-specific. Accordingly, to begin with theory—the theory of the avant garde or of postmodernism or art under late capitalism—as has been standard practice for the past few decades, artworks or poems being regarded as so many examples of this or that theory, can be quite misleading.

Consider the so-called poetry wars that began with Donald Allen's *New American Poetry* in 1960 and have continued into the present, fuelled by an uncontested discourse that separates "experimental" from "mainstream" ("post-avant" from "school of quietude," in Ron Silliman's vocabulary). The division began, so the textbook version would have it, with the post-World War II division between what Philip Rahv had rather inappropriately dubbed "paleface" and "redskin" (the "raw" and the "cooked"), with the Beats and Black Mountain poets on the one side and the Randall Jarrell-Robert Lowell genteel tradition on the other.[1] Both sides, in fact, advocated a revitalized Romanticism *contra* the impersonal theory of T. S. Eliot, as codified by the New Critical poets of the 1940s. Like Ginsberg and Creeley, Lowell and Berryman were keen admirers of William Carlos Williams and the then-neglected Hart Crane. More important, even as this family feud was raging, the real action, aesthetically speaking, was elsewhere. The artistic diaspora of the postwar brought Dada and Surrealism, Lettrisme and Brazilian Concrete, the poetics of Negritude and the theories of the Frankfurt School to the U.S. The interaction of these "foreign" elements with native strains that had largely been latent or underground produced what is, to my mind, the real avant garde of the 1960s: not the Beat movement, which was quickly absorbed into the larger Hip culture of drugs and Zen, and not the didacticism of Olson's Projective Verse, but the markedly different and difficult aesthetic of John Cage, a practical Yankee version of Duchampian aesthetics shared by a brilliant set of artists in different media from Merce Cunningham and Jasper Johns, Morton Feldman and Nam June Paik, to the poets Jackson Mac Low as well as those early Cage fans, John Ashbery and Frank O'Hara. Like Duchamp's rejection of the "creative function of the artist," O'Hara's feigned insouciance ("You just go on your nerve") was a carefully planned gesture, a way of separating himself from the grand pronunciamentos he associated, rightly or wrongly, with such Lowell dicta as "A savage servility slides by on grease" ("For the Union Dead").

The reception of Language Poetry has had a similar trajectory. For years, students of the movement have accepted its own formulations at face value. The dissolution of a "coherent" lyric self, the negation of the referential function of language, the construction of the text's meaning by the reader rather than the author, the insistence that direct communication was the hallmark of the commodity fetish and hence unacceptable, and, above all, the symbiotic relationship between poetry and theory which has, oddly enough, given us a fair amount of what we might call poetics without poetry—these have long been accepted as axiomatic features of the "new poetics."[2] But from the vantage point of the twenty-first century, the attack on the authoritative "I" can now be understood as a way of unmasking the reliance on the unique "voice" in the dominant workshop poetry of the 70s and 80s. When, in other words, Charles Bernstein began his 1976 "Stray Straws and Straw Men," with the parodic declaration, "I look straight into my heart *&* write the exact words that come from within," he surely had in mind, not the profound lyricism of Blake or Hölderlin, much less the enraptured self-consciousness of a Baudelaire, but the timid revelations of suburban married life that were then filling the pages of *American Poetry Review*.[3] To understand what Bernstein has called, in the title essay of his most recent book, "the attack of the difficult poems," you might, for a moment, put aside your Adorno or Agamben and pick up Gerald Stern's *Lucky Life* (Carnegie-Mellon), Philip Levine's *The Names of the Lost* (Atheneum), or Louis Simpson's *Searching for the Ox* (Oxford), all three published, like "Stray Straws," in our bicentennial year 1976.

The recent advocacy of Conceptualism on the part of, say, Craig Dworkin or Vanessa Place, is similarly site-specific. It is directed, not against Pound's *Cantos* or Joyce's *Finnegans Wake* (themselves largely composed of other people's words), but against an abstraction and opacity valorized by Language poets that sometimes seems to deny the very possibility that anyone might actually "read" a given text. Perhaps, this reasoning goes, it is possible to "make sense" even as one calls into question "sense-making" as did Georges Perec in *La Vie mode d'emploi*—an intricate and tricky Oulipo novel that is nonetheless highly readable and accessible to a wider audience. The "referential fallacy" is no longer the enemy; rather, the "originality" associated with what was still a pre-digital, pre-Internet moment in poetry is what is now being questioned.

From Eliot's definition of poetry as "an escape from emotion" to Lyn Hejinian's "rejection of closure," and Kenneth Goldsmith's case for "uncreative writing," oppositionality has thus meant opposition, not to the aesthetic itself, but to the status quo. Goldsmith's "uncreative" writing, far from being based on the conversations overheard on the New York streets, derives its formal structures from Andy Warhol and John Cage, from David Antin's talk pieces and Steve McCaffery's early permutative poems like "Carnival." As in the case of all poetry, it has to be *read* closely and carefully to be understood, whatever the poet's tongue-in-cheek claim for its essential unreadability and boredom. "Direct treatment of the thing!" declared Ezra Pound in what was to become one of the most famous of twentieth-century manifestos, only to produce, in the *Cantos*, a network of citations and foreign phrases that often contained not a single sensuous or concrete image.

"Never trust the artist, trust the tale," said D. H. Lawrence.

Notes

1. Philip Rahv, "Paleface and Redskin," *Kenyon Review* 1:3 (Summer 1939). In 1959, when he first published *Life Studies*, Robert Lowell, alluding to the division, recast it into the Claude Levi-Straussian opposition "the raw and the cooked."
2. I discuss this situation more fully in my "After Language Poetry: Innovation and its Theoretical Discontents," in Edward Foster and Joseph Donahue, eds. *The World in Time and Space: Towards a History of Innovative American Poetry in Our Time* (Jersey City: Talisman House, 2002) 333-53 and Perloff, *Differentials: Poetry, Poetics, Pedagogy* (Tuscaloosa: University of Alabama Press, 2004) 255-75.
3. Charles Bernstein, "Stray Straws and Straw Men," *Content's Dream: Essays 1975-1984* (Los Angeles: Sun & Moon, 1986) 40.

How to Tell a Revolution from Everything Else

Wu Ming 2

In November 2010, the problem of distinguishing a revolution from everything else didn't seem of particular relevance to the present: we chose this title with reference to our historical novels, where we narrated rebellions, revolutions and wars of independence. Since then, riots have come back in fashion in a way that has no precedent in the past two decades, and newspapers and magazines are flooded with articles where the question is whether what's going on in Tunisia or Libya is a revolution, or if Bahrain, Oman and Syria will *really* experience a revolution, and so on.

Before this new 'Springtime of the Peoples,' the word revolution used to be associated with the colors and names of plants in order to label some electoral disputes in Serbia, Ukraine, Georgia, Kyrgyzstan, Iraq and Iran. Today it is quite clear that those occurrences, far from being true revolutions, were rather political campaigns, in some cases non-violent ones, designed to overthrow a strong and authoritarian parliamentary majority. However, many people still remember them as revolutionary events and those labels of various colors (orange, pink, green, purple) are now part of history.

Further back in time, in 1989, the simultaneous collapse of the pro-Soviet regimes in Eastern Europe had prompted observers to indiscriminately use the word "revolution," even when faced with very different outcomes, such as those produced in Czechoslovakia and Romania.

We are therefore dealing with a phenomenon that has no clear and shared characteristics, nor sufficient conditions: regime changes can be caused by a coup, a civil war, and sometimes they even take place under ordinary political conditions, while a revolutionary situation can even go on for a long time and have an impact on society without leading to a forced transfer of power.

As happens with every diachronic concept, to say that "x" is a revolution presupposes that "x" is a single event, lined up one after the other along the thread of time. For example, if you want to convince me that the rise of Fascism in Italy was a revolution, you cannot show me a video of the March on Rome and tell me: "Here, look." You have to go far beyond the simple exposition of a single event: you have to describe a piece of Italian history. In fact, you have to go beyond description, and link together all the elements of Kenneth Burke's "dramatistic pentad": Act, Scene, Agent,

Agency and Purpose. In other words, you need to produce a narrative of that story that belongs to the "revolution" genre, a genre whose boundaries are rather blurred, on which historians and philosophers have produced several opposing theories. But perhaps, as Wittgenstein would say, a confused concept is what we need.

In contrast, other great historical events have sharper outlines, and the words to name them should be used with less uncertainty. One can call "war" a war the very moment a government declares it, or when an army repeatedly fires against another army, and that is why the Italian president Giorgio Napolitano made himself ridiculous when he said that our country is not at war with Gaddafi's Libya. War is self-evident, even when you don't want to call it by its name and prefer less compromising phrases such as "no-fly zone." A war may be the subject of moral evaluation, never of ontological speculation. Of course, as with all words, the term "war" may have extended meanings. This is what allows historians to call a long period of hostilities the Thirty Years' War, or the Cold War, but at the core of these extended meanings still lies a stricter, well-defined one. If someone told me that the Cold War was not really a war, I would give them a few examples: from Korea to Hungary, from Vietnam to Afghanistan, and Grenada.

Conversely, if someone said that in Tunisia there hasn't been a real revolution, we should first compare our ideas of revolution, and then our narratives of that particular story. This means that, in order to tell a revolution from everything else, we need a good heuristic concept, on the one hand, and a good narrative, on the other. Historians, philosophers and social scientists can help to prepare the former, while novelists and storytellers can tell us a few things about the latter. Also, because this is not the only link between narrative and revolution, and before proceeding with the analysis, we would like to list at least two others.

The first is that both narrative and revolution revolve around the violation of a rule. In a sequence of ordinary events there is no history and there is no revolution. Without a potential break with the ordinary world, the narrative game isn't worth playing. The revolution is born of the same dialectic that acts as a pivot for any story: the one between conservation and change, between what was and what could be.

السينمائيون المعتصمون في ميدان التحرير

نحن السينمائيون المعتصمون في ميدان التحرير نعلن مايلي :

تلقينا اتصالاً من السيد نقيب السينمائيين مساء الثلاثاء ٨ فبراير ٢٠١١ يطلب منا الأنضمام بصفته نقيب السينمائيين في البيان الصادر منا لأعلان التضامن والمشاركة مع ثوره ٢٥ يناير وتأييداً لها ولكل مطالبها وفي مقدمتها اسقاط الرئيس.

رفض السينمائيون المعتصمون تغير موقف النقيب وطالبوه بالأعلان الرسمي عن موقفه وموقف النقابه ووعد هو بالحضور صباح اليوم التالي لميدان التحرير للتوقيع على اي بيان يتفق عليه السينمائيون المعتصمون

في ظهر الأربعاء ٩ فبراير ٢٠١١ حضر السيد مسعد فودة الي ميدان التحرير وطالب السينمائيون المعتصمون بكتابة البيان حتى يوقع عليه

كتب السينمائيون البيان التالي :

إيمانا بحق الشعب المصري في تحقيق كل مطالبه المشروعة و في مقدمتها إسقاط النظام المصري ، تعلن نقابة المهن السينمائية الآتي:

أولا : استقالة نقيب السينمائيين و كل أعضاء مجلس النقابة احتجاجا على كل الممارسات الجائرة للنظام الفاسد وانضمام كل السينمائيين الشرفاء إلى جموع الشعب المصري الثائرة ضد الظلم و الفساد و هذه الإستقالة هي جزء من التأكيد على افتقاد النظام الحالي الفاسد شرعيّة حيث ترفض النقابة أن تكون جزءا منه

ثانيا : تبرؤ النقابة من كل البيانات و المواقف و التصريحات التى تبناها السيد النقيب واتحاد النقابات الفنية ضد ثوار ٢٥ يناير و التى أيدت النظام الفاسد

ثالثا : انضمام جموع السينمائيين إلى المعتصمين في ميدان التحرير باعتبارهم جزءا لا يتجزأ من الشعب المصري و جزءا من حركة التغيير المؤيدة لكل مطالب الشعب، المشروعة و التى في مقدمتها إسقاط الرئيس

رابعا : إدانة السينمائيين للموقف المخزي للإعلام الرسمي الذي زور الحقائق و خدع الشعب و أساء لسمعة ثوار ٢٥ يناير وزير الإعلام أنس الفقي و عبد اللطيف الميناوي رئيس قطاع الأخبار و كل القيادات التليفزيونية و الصحفية التى ساهمت في مؤامرة النظام لغسل عقول الشعب و محاولة عزله عن الثورة واهانت الثوار

خامسا : التأكيد على أن السينمائيين المعتصمين سيواصلون اعتصامهم واحتجاجاتهم بكافة الأشكال السلمية حتى تحقق كل مطالب الإصلاح وقيام دولة مدنية ديمقراطية في مصر

سادسا : التأكيد على أن السينمائيين المعتصمين في ميدان التحرير يحملون دم شهداء الثورة لكل أركان النظام و معاونيه

عاش نضال الشعب المصريعاش كفاح الثوار ..عاش دم الشهداء ...عاشت مصر

رفض السيد مسعد فوده التوقيع بسبب البند الأول الخاص باستقالة النقيب واعضاء مجلس النقابة

وبناء عليه فأن السينمائيون المعتصمون اتفقوا على ما يلي :

ان رفض النقيب لتقديم استقالته يعد تخلياً عن تضامنه مع ثوار ٢٥ يناير وتمسكاً بالبقاء داخل منظومة النظام الفاسد الذي تعد الأستقاله منه والخروج عنه ابسط اشكال مقاومته والمطالبه بأسقاطه

ان ازدواجيه النقيب في تحديد موقفه وبالتالي موقف النقابة من ثوره ٢٥ يناير يعد اهانة لكل السينمائيين المطالبين بالحريه وبالعدل في هذا الوطن

وبناء على كل ما تقدم فأننا نطالب جموع السينمائيين النقابين بالأنضمام لنا في مطلبنا الواضح وهو :

اقالة نقيب السينمائيين ومجلس النقابة لتخاذلهم المخزي في دعم موقف اعضاء النقابة الرافض للنظام الفاسد و المتضامن مع الحقوق الشرعية لثورة ٢٥ يناير

ولتمسكهم المهين بالبقاء ضمن شرعية النظام الفاسد التي سقطت في الشارع بفضل كفاح الشعب المصري

عاش كفاح الثوار
عاش دم الشهداء
عاشت مصر

Statement by "The Filmmakers Occupying Tahrir Square," February 2011. Courtesy of www.tahrirdocuments.org and the Library of the University of California, Los Angeles.

Secondly, every revolution is an attempt to tell the world with new names and concepts, both on a symbolic level (i.e. the reform of the calendar during the French Revolution) and a material one, with previously unknown subjects, rights and laws. It isn't by chance that coups and civil wars are often justified through semantic changes that mimic this revolutionary necessity.

At this point it looks clear to me that if we want to deal with a revolution we must handle many more narrative materials than it might seem at first sight. Within these materials, these mythologemes and these devices of rhetoric, I would like to identify some smokescreens that may confuse our sight, poison the narration and prevent us from distinguishing between a revolution and something else, or rather, between a toxic narrative of the revolution and a narrative of the revolution that's healthy, open and true to its purpose.

Toxic Narratives

To begin with, let us ask ourselves what would be the purpose of a narrative of this kind, that is, of a story that doesn't draw its subject from the imagination, but takes it directly from reality. We might answer that such a story must be true, but then we should explain what truth we are talking about: is it truth as correspondence with the facts, which may be enough for reporters, or is it truth as consistency within a paradigm—the kind we find in science and mathematics? In the case of a narrative—even when it draws on reality—I think it's better to speak of "poetic truth," which is not limited to the faithful representation of single facts, but is about their overall significance. A narrative is "true" when it increases our awareness, our comprehension (in the etymological sense) of a sequence of facts. In other words, while mere reporting has the task of describing facts, narration must also make them talk: it must connect events, meanings, and individuals.

A story, as we have said, deserves to be told when it insinuates the unacceptable into the allegedly unmodifiable rule of everyday life. In fairy tales, there's an ordinary world in crisis and a hero who departs into the extraordinary world in order to cut a piece of it and bring it back to the village. Or, to quote Aristotle: the poet is superior to the historian, because the historian tells what happened, while the poet imagines what *might have* happened. Each story stems from a "what if" question and thereby introduces a conditional and subjunctive dimension in the realm of the indicative. Not even the most realistic non-fiction says "this happened," but rather says "this *could* happen." Thus, a toxic narrative, a narrative that doesn't do its job, can be recognized by the lack of subjunctive dimension: a toxic narrative tries to remove the hypothetical, to block in every possible way the drive to "tell the story otherwise," to think of alternative versions, other possible stories, some other poetic truth for the same set of facts.

In this sense, all stories contain a dose of toxins, because, as George Lakoff argued in his studies on neural connections: "When you accept a particular narrative, you ignore realities that contradict it. Narratives have a powerful effect in hiding reality."[1] This does not mean we should throw them away and replace them with cold hard reason. As we have seen, in order to identify a revolution we need to tell its story. Lakoff's proposal is that of a New Enlightenment in which we will recognize that "cultural narratives are part of the permanent furniture of our brains," but we will at least be self-aware of it.[2] As a storyteller I would add to this program that I would like to produce narratives that raise such awareness, that do all that's possible to restrain their own power to hide reality, and indeed encourage alternative narratives, by providing the reader with hints, occasions, and cracks in the wall.

In the specific case of a narrative of revolution, then, I'd like to understand where the toxins are and what narrative choices play a part in making them dangerous.

To do this, I will start from the narrative structure that our brain uses in reporting any event, and adapt it to the particular case of a revolution. First of all we have the **preconditions**: the context required for the narrative. In our case, the preconditions are the presence or absence of people with demands that the state cannot fulfill, the situation of human rights and freedom of expression, the presence or absence of a working class, working conditions and the main needs of civil society.

Then there's the **buildup**: the events leading to the main event: protests, riots, civil disobedience, the reactions of government forces, symbolic protests, etc. Such early unrest should already make us able to understand the **purpose**, what the insurgents want to achieve, what their demands are.

In turn, this should help us to better identify the **main event**, that is, what the narrative is mainly about. Usually, in newspapers and on TV, revolution is about a regime change. However, this is not over, because the main event generates the wind-down: the events that end the narrative: what happens to the members of the regime, who will replace them for the time being, the celebrations of the population, etc.

Then we should take into account the **result**: the transformation of the socio-political context described in the preconditions. Finally, consider the **later consequences** of the whole mobilization, or how long the desire for renewal remains in circulation in civil society and how difficult it is for the new state to renegotiate its international relations without abandoning the principles of the revolution.

What I just described is, obviously, a structure activated over time. Diachronicity, however, is one of the main fea-

tures of a narrative. To tell a story always means to create a chronology, to interpret time, often with reassuring effects from a cognitive point of view, because putting events in a row convinces us that we dominate them and comprehend them—so much so that not infrequently, this temporal link is transformed into a causal link: the illusion that saying "C follows B which in turn follows A" is equivalent to saying that "C derives from B which in turn derives from A." If yesterday I said that today there would be a naval battle, my statement today is false, since no naval battle is raging. But yesterday, the same statement was indeterminate, neither true nor false, and the narrative has the task of restoring that pristine shade of unpredictability. We must avoid the so-called **retrospective illusion of fatality**, a potential toxin present in any story. Under its action, the sequences of the past become necessary sequences and we forget that, on the contrary, there are at any time infinite contingent futures, and that the narratives are made to explore a hypothesis, not to pass it on as inevitable. The fascist regime, in its self-description as the result of a revolution, inscribed in the destiny of Italy, made extensive use of this technique, constantly stressing the "necessity" of every step, from the foundation of the Party to the March on Rome.

The Preconditions

As regards preconditions, it often happens that an analysis of context like the one I described, is made only *after the facts*, because the revolution "broke out"—instead of "ripened," which could be a better metaphor—in a country of which we know little, an area that suddenly drew international attention because of the riots. We end up knowing the preconditions only *after* we have formed an idea about what's going on, because events are pressing but they have to be narrated anyway. However, if preconditions are fished out retrospectively, in a sort of analepsis, they end up butting against an already established frame, rather than helping to establish one. Something similar happened with Libya, where the first demonstrations were instantly framed as "revolutions in North Africa." Only when Gaddafi proved to be able to resist much longer than Ben Ali and Mubarak was the difference noticed and we all moved quickly to motivate the regime's strength with the peculiar preconditions of the Libyan setting. At that point, however, as the Italian saying goes, the patch was worse than the hole, and pundits ended up attributing too much importance to clan-based and territorial divisions among the Libyans, setting entirely aside the element of spontaneous, radical, political protest.

It must be admitted that in the West, before the recent uprisings, knowledge of the civil societies of Tunisia, Egypt, Libya and the Middle East, was heavily conditioned by the *vulgata* whereby an Arab country is a Muslim country and a Muslim country is a country dominated by religion. Civil society, therefore, is divided between fundamentalists and moderates, and religion is the only key to mutual understanding and dialogue. Fortunately for us, if there is a regime that has been revolutionized in recent months, it is our regime of discourse on Muslims and the Arab world. The events of Tunis and Tahrir Square, in this case, have shattered the toxic narrative on preconditions (though for several days, the toxic narrative did prevent many commentators from understanding what was happening, and pushed them to look for the role of religion in the riots). As noted by Hayrettin Yücesoy, "the discourse about Islam as a construct in the progressive media and academia was, by and large, similar to Marie Antoinette's oft-quoted but always mis-attributed, *'qu'ils mangent de la brioche'* [Let them eat cake]."[3]

"Good-hearted, true," he adds, "but it showed no understanding and solved no problems."[4] The uprisings destroyed the concepts of 'religious dialogue' and 'cultural understanding' as a framework for understanding 'Muslims' and 'Arabs.'

Another example of a toxic narrative on preconditions is the myth-making carried out by T. E. Lawrence with reference to the so-called "Arab revolution." Between 1915 and 1916, the British attacked the Ottoman Empire at Gallipoli and in Mesopotamia, encountering unexpected resistance. This frustrated the hopes of those Arab secret societies that relied upon the war to open a home front for independence. Such societies were composed of bourgeois elements and military officials and had their bases in cities like Damascus, Baghdad and Aleppo. Facing the discouragement of their revolutionary intentions, the British, who were in great need of that revolution, decided to turn to the Hejaz Bedouins. In the introduction to his magnum opus *The Seven Pillars of Wisdom*, Lawrence justifes this change in strategy with an ideologic-poetic argument imbued with Orientalism. He explains that the strength of the Arabs was born and lives on in the desert, not in the softness of cities. Therefore, it is in the desert that the insurgency must develop, thanks to a koiné of nomadic tribes held together by the language and faith in the Koran.

Telling the preconditions of the revolution in this way, Lawrence forgot to say that those tribes were good to solicit western romantic fantasies and to give the Turks a hard time with guerrilla warfare, but they would never complete a revolution, building the Great Arabia from the ruins of the Ottoman Empire. They—unlike urban Arabs—were not interested in building a "nation," much less a "state." Only their leaders, at most, could have become national leaders, but in states that would be put up by someone else.

The Buildup

Very often, in order to narrate of a revolution, we bypass the preconditions and go immediately in search of a point of origin, a 'beginning' that casts light on what happened—

a day to be celebrated in the future, or to be studied in school books. Of course, every story needs a beginning, but in the structure of the 'revolution' genre, this kind of beginning has a special symbolic value, as a sort of **original sin**. Its choice is never arbitrary and cannot be located at just any moment of the time continuum: it is extremely unusual to hear of a revolution beginning in *medias res*. Most of the time the focus is on an event that reveals a weakness of the government forces. This is because, as argued by Charles Tilly, our frame of "revolutionary situation" is structured around three characteristics: the presence of factions that make claims incompatible with state control, the vast adhesion of citizens to these factions and, of course, the failure by the state to respond adequately to their demands.[5]

In all accounts of the North African uprisings, there was a mythical reference to the gesture of a young Tunisian graduate, forced to make a living as a street fruit vendor, who burned himself alive to protest the decision of the police to confiscate his goods. His suicide prompted many citizens to express their disagreement with a determination unseen for many years on the streets of Tunisia. One such initiative is not only a beginning: it is a genesis. It manages to symbolize the spontaneity of the revolt and its social composition: working class youth with a good level of education. But a revolutionary situation is always manifold, contains various situations, produces multiple changes in many areas and at different times. Focusing on a single point of origin is likely to hide its plural character.

A good narrative of the revolution should have the preconditions as its prologue and its first chapter should have a beginning that encompasses more than one point of origin.

"Every time the beginning is this moment of *separation* from the multiplicity of possibles," wrote Italo Calvino.[6] Separation, but not exclusion or isolation. We need a threshold that does not forget what it leaves out.

Moreover, excessive attention to the point of origin can make us sick with chronological myopia. **Chronological myopia** consists in giving too much importance to recent events, and too little attention to those that are more remote. In our case, chronological myopia may lead us to describe as a "revolutionary break" an occurrence which, on the contrary, is in continuity with what has been happening for some time. For example, the 'Day of Rage' organized around the Manama Pearl Roundabout was hastily described as a point of origin of the Bahraini "revolution," whereas such protests have occurred in that country for many years, silenced by the fact that Bahrain is usually not interesting to anyone.

Here, with reference to the beginning of a narration, we experience a problem that's inherent to any other moment of it. To tell a good story we need to go into detail, but as soon as we do, any particularity can be viewed as prototypical, representative of a totality, like a poisonous synecdoche where the part hides the whole. The only antidote is to look for the contradiction, for the one that becomes two. For example: the people of Bahrain protest in Pearl Square against the country's rulers. Then, as a good storyteller, you seek the details and ask yourself: "What is the social composition of these 'people of Bahrain' protesting in Pearl Square?" Answer: they are Shiites. And the country's rulers? They are Sunnis. Well, judging by this detail alone, one of your readers may form the idea that in Bahrain there is a civil war between two Muslim sects. And because the Shia country *par excellence* is Iran, he or she will deduct that Iran is backing that revolt. To counteract this **synecdoche effect** the good storyteller must look for the contradiction, which he or she will find upon discovery that Bahrain workers are organizing large-scale strikes involving Alba Aluminium, the largest aluminum smelter in the world, whose workers' union is headed by Ali Bin Ali, a Sunni. And if our storyteller works hard, he or she will find out that the detail chosen at the beginning, that is, the Pearl Square protesters are Shiites, could be interpreted as a token of another type, because the Shiites are the poor majority of the country, and therefore a Shiite rebellion is also a class rebellion.

Another example: if someone in Tahrir Square in Cairo had burned an American or Israeli flag, no doubt that particular act, once told by television and newspapers, would have assumed the value of a synecdoche: if someone burns an American flag undisturbed, it means that the rebels are against the United States, which means that they are fundamentalists. (It's interesting to notice that this mechanism also applies in absentia: since no American flag was burned during such big events in a Muslim country, then—for conspiracists—the revolt must be controlled by the CIA).

In choosing the details for my narrative, I will also be affected by the rules of the narrative genre that I'm practicing. In the case of a revolution, the frame described by Charles Tilly urges us to look for street riots, power clashes, police brutality, regime changes. Apparently, the kind of revolutionary tale that our brain is most fond of is that of the great twentieth-century revolutions: the people in the streets, the seizure of power. We do not consider that there may be different kinds of revolution narrative. Nation-states have changed since October of 1917, and so perhaps our concept of revolution should change accordingly. Also, as stated, a revolution is not always about power, state control, the right of expression, and so on. A revolution is certainly made on the streets, but above all it's a creative drive to change the world, to call it with new names, to try the impossible.

In early 2011, an interactive timeline of Middle East protests appeared on the *Guardian* website, with all the

states listed and the most important events represented by four different symbols: protest/govt response to protest, political move, regime change, and international/external response. In such a strict cataloging, the demolition of Manama's Pearl Monument, ordered by Sultan al Khalifa to erase a symbol of the revolution, was listed as a "political move" when in fact it is, obviously, a semantic move. The revolt has changed the meaning of a major monument dedicated to the pearl divers of the Gulf. People did this by taking to the streets and not by some administrative decision. At that point the regime also had to take to the streets, this time not to shoot the demonstrators, but to destroy their symbols, in a strange pre-emptive reversal of what usually happens during a regime change: the destruction of symbols of power and statues of the leader.

The only attempt to narrate these riots without looking only to the streets produced controversial results: I refer to the "Twitter revolution" meme, already applied to a potential "colored revolution" in Moldova and then transferred to the case of Tunisia, with a venomous confusion between means and causes. Twitter and social networking sites were useful information tools for connecting the Tunisian protests, but these protests were not held on Twitter. As noted by Tarak Barkawi, "Revolutionaries in France and Haiti in the 1790s received news of one another's activities by the regular packet ship that plied between Jamaica and London."[7] **Technophilic narratives**—in the case of North Africa and the Middle East—have had the effect of reassuring listeners, making the violation/disruption of everyday life less disruptive. If we say that in Tunisia a "Twitter Revolution" is going on, we feel more comfortable than we might feel hearing of a hard revolt, far from our standards, with people burning themselves alive or rebelling against the price of bread and olive oil for frying food. Likewise, Sultan al Khalifa has brought up TV and the images coming from other countries in revolt to justify the change clamored for by the citizens: "This is not the Bahrain I know," he said after the February 2011 riots, forgetting for the occasion that the rebellion has been going on for years, with hundreds of political prisoners tortured in four prisons in and around Manama.

Twitter and Facebook are in a sense, the twenty-first century "Lawrences of Arabia": an emphasis on social networks gives us the feeling that these riots are a by-product of the Internet, the quintessentially democratic and participatory tool, which is itself a product of the West. Thus, we say, if Egypt has rebelled thanks to the Internet, then it has rebelled thanks to us, and so we tend to forget that the symbolic place of that rebellion is not cyberspace: it is a city square, because overthrowing a despot via Twitter is not that simple: first, because access to the Internet can be blocked, and at a certain point it was, and secondly because even dictators lurk on social networking sites.

The Purpose

In defining the purpose, a typical toxic approach is to infer from the authoritarian nature of a regime that the demands of the population consist *only* in "democracy" and "human rights," and therefore the revolution is over when the tyrant is overthrown, after which we can invoke an "orderly transition" that keeps the most radical demands at bay and changes everything so that nothing changes. More generally, what is always toxic—as well as narratively ineffective—is the tendency to attribute only a **partial intentionality** to the actors of revolution: in order to tell a good story, in fact, one should always impart precise intentions to the protagonists. Those who have no credible intentions are considered puppets, and puppets need a puppeteer. Thus, a hundred years later, we witness the return of the myth of Lawrence of Arabia, and the heroic West must assume the burden of helping to liberate the East from itself.

This happens because stories tend to accumulate close to one another to form clusters based on similarities and recalls. This trend can help or mislead the interpretation, depending on the element that acts as an attractor: it can be a superficial feature hiding important differences, or it can be a substantial characteristic, one that's important beyond differences. Certainly, our understanding of the fall of Ceausescu in Romania wasn't helped by the expectation created by the collapse of other communist regimes in those same months.

In Romania, there were features that have remained hidden because of this common narrative. To assimilate those events to the revolutionary narrative of the people judging the King of France didn't help us either. Whereas in France the monarch's severed head stimulated the revolutionary process, in the case of Romania Ceausescu's death sentence and execution was precisely what it took to hide the "revolutia furata," the Stolen Revolution, which is the phrase used by the Romanian students beaten up by miners, only a few months after that Christmas Day of 1989. This can be the consequence of keeping the focus of the revolution narrative on the figure of the dictator and his fall, a step that is often required, but certainly not enough to define any revolutionary project. Such **personalization** is also present in the stories that come from Libya and is likely to be responsible for a new Ceausescu effect: we get rid of the dictator so we can tell the world the revolution has taken place, and this is the screen behind which we're going to hide the creeping return to the status quo. The **narrative accumulation** of the ethno-geographical kind, the frame of "Arab Revolts," for example, does not help our understanding of the events affecting Oman: BBC News asked "whether this previously stable Gulf state with a large and youthful population could turn into the next Egypt or Tunisia." At present, in Oman, there are no demands for a

radical regime change. However, the toughest protests took place in Sohar, the most important industrial center in the country. Perhaps this could provide a deeper rationale for putting together these stories, and further widen our perspective, making it more universal: If in Oman protests take place in a large industrial center, and if in Bahrain the Alba Aluminium workers go on strike, and protests are carried out by young unemployed workers in Tunisia, state employees in Ohio and Wisconsin, university students with no prospects for their future in Rome, London, Lisbon and Paris, workers and students in Greece, then perhaps there is a broader narrative for what is happening in the world, beyond the Arab world, North Africa and the Middle East. While what is needed is a deeper narrative accumulation, the toxin lies in a **divide and conquer** story that breaks connections and tries to separate what would be similar, perhaps insisting on other similarities.

The Main Event & The Wind-Down

The way we usually frame the main event, according to Tilly, implies that the revolution's outcome is a radical change at the top of the state and administration, with large sections of the armed forces declaring themselves loyal to the new government. Here too the model is focused on power and its balance. It's as if we need to hold onto a stable, definite change, and expect to find it only in the structure of the state and not in the people's minds. In the previous examples we have already seen that there are toxic narratives whose purpose is to make the unexpected more acceptable, that is, to tame the dialectic, both the dialectic inherent to a revolution, and the one that's inherent to every story. A toxic story is one that insinuates the unacceptable into the acknowledged reality—not in order to subvert that reality, but, on the contrary, to **tame** the unacceptable, so that we cannot recognize it.

But there are also cases in which the dialectic is tamed through the opposite process; that is, **inflating** the violation of the rule, putting up the *appearance* of the subversion of daily life, when in fact there has been no such subversion. In this way, what is passed on for radical change is actually the conservation of the old reality. Again, this is the case of the fascist "revolution." Or else, the dialectic itself is inflated in the hope that the revolutionary event will occur *after* the main event, thanks to the mobilization of a population that didn't initially take part in it. Narratives intoxicated by such wishful thinking were Siad Barre's revolution in Somalia and Gaddafi's "green revolution."

The Result & The Later Consequences

This is the part we most often we forget to tell about, although its importance should not be underestimated. We forgot to tell about it because of our brain. In our brain, every event in a narrative turns on different emotions. The main event is an emotional peak, which can feed us positive

or negative feelings, depending on our beliefs. It rarely leaves us indifferent, considering that our mirror neurons light up in the same way whether we live a narrative or hear it told by someone else. If the feeling is positive, after the main event our brain, which has received its dopamine release, takes a kind of **post-coital** break. If the feeling is negative, then we are worried or afraid, and norepinephrine reduces our ability to focus. In both cases, we risk to tell with less interest what looks like a simple epilogue to the main event. In addition, our frame of the revolutionary outcome prompts us to think that the main event, that is the seizure of power by the rebels, coincides with the final result of the narrative. Actually, history teaches us that revolutionaries after overthrowing the regime, face extremely difficult situations and challenges that jeopardize their success. On the other hand, narratology teaches us that a story does not end with victory in the hero's main labor, with the killing of the dragon: other dangers—and often a comeback of his enemies—expect the hero or heroine on their way back home. The significance of an adventure lies in the main character's ability to return home and change the ordinary world, thanks to the lessons he or she learned during trials and battles in the extraordinary world. It's on the way back that the hero must experience a final litmus test, in order to return to the village with the elixir. It is in that last test that the tragic hero usually ends up dying. The main event, on closer inspection, is only half of a story and a story that remains half-told cannot avoid being poisonous.

The real success of a revolution depends on the desire for change that it can spread among all citizens, the level of creativity that they invest in this desire and the duration of such investment in time. In a real revolution, that creativity is maintained and doesn't congeal after the storming of the Winter Palace. It's a shared, universal creativity that isn't imposed from above.

Antonio Gramsci considered fascism a "passive revolution," that is, a thesis that co-opted a subordinate part of the antithesis and managed to present itself as a synthesis. But fascism was passive also because it had to impose from above the creativity that revolutions do not need to plan ahead. Fascism's semantic revolution was a coup against the dictionary, the organization of time, the etiquette. It redefined concepts and classifications, but did so in a top-down, mechanical way. This element alone should be enough to acknowledge the toxicity of fascism's "revolutionary" self-representation.

Conclusions

We have thus completed our excursion in search of toxins in the narrative structure of the revolutionary event. We have seen the dangers implicit in retrospective illusions of fatality, chronological myopia, the "original sin," the synecdoche effect, genre conventions, partial intentionality, nar-

rative accumulation, divide and conquer narrative, personalization, domestication or inflation of the dialectic, and post-coital fatigue. The danger lies in intoxicating the narrative beyond the level of alert, with the result of hiding the truth and failing to understand what's going on. Thanks to the empathy of mirror neurons, the brain activities involved in understanding, living, imagining and dreaming a story are not that different from each other. To understand a revolution and to tell of it effectively, then, equals being able to dream it, which equals trying to imagine it, which equals beginning to live it.

Notes

1. George Lakoff, *The Political Mind: Why You Can't Understand 21st-Century Politics with an 18th-Century Brain* (New York: Viking, 2008).
2. Lakoff, *The Political Mind*.
3. Hayrettin Yücesoy, "Revolutions: What went wrong in the west?" *Al Jazeera* (March 27, 2011), available at http://www.aljazeera.com/indepth/opinion/2011/03/201132294241122428.html.
4. Yücesoy, "Revolutions."
5. See Charles Tilly, *From Mobilization to Revolution* (Ann Arbor: University of Michigan, 1977).
6. See Italo Calvino, "How Much Shall We Bet?" in *The Complete Cosmicomics* (London: Penguin, 2009).
7. Tarak Barkawi, "The Globalisation of Revolution," *Al Jazeera* (March 21, 2011), available at http://www.aljazeera.com/indepth/opinion/2011/03/2011320131934568573.html

Poverty of Experience: Performance Practices After the Fall

Nikolaus Müller-Schöll

After the fall. What do we mean when we talk about thinking, speaking, writing, playing "after the fall"? In German, as well as in English, one might answer this question in two different ways. Firstly, after the fall means: after the fall of the Berlin Wall. One could easily refer to other moments that were equally symbolic but there is none that to the same extent became *the* sign of the collapse of so-called really existing socialism. A long time before the fall of the Berlin Wall, and before the events that finally led to it, taking place much earlier than in 1989 and even earlier than 1949, when the two German states were founded, "after the fall" meant something else entirely and still does. This is the second meaning of "after the fall," the common phrase used in Judeo-Christian-Occidental thinking. This second "after the fall" follows a triadic narrative structure: life in Paradise is disturbed by the act of eating an apple from the Tree of Knowledge; with this comes the expulsion from the Garden of Eden; afterwards, time reaches from the prehistorical, mythic origins up to the present and furthermore into a future that will perhaps end this epoch in a return of paradise. Corresponding to this order of time are three versions of what Jean-François Lyotard referred to as "meta-narratives": the emancipation of humankind in the Kingdom of Ends (Kant), the realization of Absolute Knowledge (Hegel), and the overcoming of alienation through class struggle (Marx).[1] All of these allowed a reformulation of the biblical narrative to enter the consciousness of western societies by exceeding the narrow context of philosophy and its common understanding of politics, culture and history.

It is this tradition that is taken up by thinking and writing "after the fall" that I would like to depart from in my reflection on the fall of the Berlin Wall. I draw your attention instead to the thinking and writing of the German philosopher Walter Benjamin. Benjamin's version of this narrative is essentially a theory of language after the fall, conceived by him for the first time in 1916 in a text called "On Language as Such and on the Language of Man" and later on in his theories of cognition, politics and art (the classical Kantian divisions).[2] As I have argued elsewhere, Benjamin describes a theatre of mere mediacy, a radically finite theatre that is purged of all magic.[3] In his essay, Benjamin opposes two different conceptions of language where the language that existed *before the fall* survives in a broken form in the second. Language before the fall is described as a language of names in which language and its referents correspond to each other immediately; language does not have any predicative function here but only serves to communicate oneself to god. In this language misunderstanding and misnomer are impossible. At the same time this language does not require translation: each word is immediately the expressed thing. As strange as this idea might appear, it persists in theories of communication and representation, for instance, whenever theatre is assumed to be understandable. If we understood each other right away and without any detour we would have no reason at all to talk to one another.

According to Benjamin's reading of Genesis, the fall brings with it a supplementary, nameless recognition that is added to this paradisic language before the fall, an element that performatively contaminates any linguistic communication by the simple fact of being spoken. This supplementary element breaks down the unity of language before the fall. Benjamin's ingenious reading of the fall considers that any attempt to discern good and evil is essentially void since god had recognized in the words of his creation: "Und siehe es war gut" (And behold, it was good). In order to understand better what Benjamin might mean one can refer to the Monadology of Leibniz, a philosophical system that was known to Benjamin and taken up by him later on. With this system the world is covered completely by monads, the smallest, no longer divisible unities. From this it follows that any monad bears the impression of all the others and each feels what happens anywhere else in the world. This also means that if you add any superfluous material at one point this will have effects on all the other elements in a kind of chain reaction. The same is true for language before and after the fall: by introducing "additional linguistic material," namely the nameless recognition, any single word is displaced in an absolutely irreducible way and is thereby disfigured. It will from now on say both more and less than it should. What is lost is the harmony of paradise, the harmony of a closed economy, of the first total system of mankind, which anticipates all those to come afterwards. What makes this reading interesting for us is the fact that the age of complexity and confusion (*Unübersichtlichkeit*), the age of the disappeared unity, the time after the total order, after the ideal system that solves all questions and conflicts in advance, begins with the biblical fall. Benjamin's reading of the biblical narrative of the fall thus reads like

an allegorical interpretation of the experience of modernity, a story about how our chaotic and confused world is premised on a loss that cannot be properly named.

My theory is that we cannot talk about what in our daily language we vaguely call the "fall" of the wall without relating this fall to the fall that Benjamin talks about when he refers to the biblical fall. What is broken down along with the Wall is the idea that there can be a unified order, a total economy in which things are regulating themselves in a non-mediated way. Furthermore, this fall can be understood as the end of the idea of a history of mankind in which a fallen state or condition is synthetically resolved. Insofar as such ideas were characteristic of all those more or less totalitarian orders of the state—Stalinism, National Socialism, Cold War capitalism (shaped by the dominance of Adorno and Horkheimer's "culture industry")—one could say that Benjamin's theory of language permits us to develop not just a thinking after the biblical fall but also a thinking after the fall of the Wall.[4] This becomes even more plausible if we add to our considerations Benjamin's "Experience and Poverty" (*Erfahrungsarmut*), which he wrote in 1933 during his Parisian exile, a few months after Hitler came to power.[5] This title formulates in another way what it means to think after the fall.

Benjamin coined the notion of "poverty of experience" in order to grasp his generation's experience of radical disillusionment. While in the past experience was something to be transmitted from one generation to the next, along with the authority of age, Benjamin states that experience has now depreciated ("*im Kurse gefallen*", *le mort saisit le vif*). This phenomenon is due to several events that radically negated the experiences of the past: World War I, inflation, starvation and the immoral behavior of the holders of power. After having called the apparent wealth of ideas of his time as just the other side of this poverty of experience he ends by writing that the poverty of experience of his time is not just a poverty of private experiences but rather of the experiences of humanity in general. It seems as though Benjamin speaks of a double experience: what could be passed on as experience to the descendants is no longer of any worth in his time, an epoch of radical changes and catastrophies. Furthermore, the very notion of experience as such has come to an end. The poverty of experience is an expression for the disappearance of a certain understanding of mankind as well as of experience and in the end for a crisis in the world of ideas as such. What Benjamin tried to come to terms with is a rupture in the succession of generations and moreover a rupture with the idea that there could be any doctrine from the past that remains valuable in the present. By writing about the poverty of experience Benjamin gave testimony to the decisive experiences of his time.

Some time ago, after another fall—the breakdown of Lehman Brothers—a colleague of mine, who knew about my long preoccupation with Benjamin, asked me whether one could still say anything about contemporary experiences. What in a radical way has to be understood today is what it means to come after the fall. To speak about the present means to face the so-called postmodern wars after the era of the Cold War, the new movements, who like the Islamist ones, were nurtured and generated by that western world which is threatened by them now—which also means that instead of a clash of civilizations one should rather speak of disciples presenting to their former teachers what they have learned. For a long time now the West has instrumentalized local conflicts for the sake of its interests. Perhaps *today* means facing the disastrous development of the financial markets and with it the fall of the last great ideology remaining after the fall of the Berlin Wall, the end of the last of the big ideologies of the nineteenth and twentieth centuries, namely, the capitalist promise of wealth for all, where wealth is supposed to emerge automatically as long as each indulges in his or her private egotism and the state guarantees that the market functions correctly.

Regarding theatre, what has disappeared today is the type of a meta-narrative that allows it to justify the countless aesthetic decisions that are taken daily by referring to an end or finality that can be legitimized through tradition and authority. Considering our condition "after the fall" means to take up the formula that Benjamin also developed in his essays on Bertolt Brecht: the complete lack of illusion regarding one's epoch and the unreserved commitment to it. In other words, after the disappearance of meta-narratives, after the loss of a common, all-embracing horizon of meaning, and after the implosion of any ideological alternative, there remains a need to affirm in a radical way the loss or devalorization of experience, to work through one's poverty and non-knowledge. Whereas today, like at the time of Benjamin's essay, the culture industry tries to avoid this new (but also very old) poverty of experience through the seriality and sheer abundance of events, the language of theatre also attempts to depart from the experience of poverty after the fall. Today's theatre, exemplified here by three productions—*TRIP*, *Faites vos jeux! Revoltainment*, and *La Mélancolie des dragons*—reflects the contradictions that remain unresolved after this fall.

Lea Martini, a member of a young group of performers called White Horse, explains that at the beginning of their production of *TRIP* there was the longing to back an unambiguous project, to be against or for something, the way this was possible in 1918 or 1989. "What must it be like, when you put yourself totally out for something?" With this, White Horse conducted a kind of theatrical research on the subject of collective ecstasy. However, given the complexity of today's society, this has become impossible, she says, providing one definition of the condition of contemporary artistic practice, which I have referred to as the poverty of experience. And yet, despite this condition, she

continues, there remains the longing for community, for big feelings that can be shared by everybody, in short, for the ecstasy of revolution.

On an empty stage there are three performers, two women and a man (Lea Martini, Julia Jadkowski, and Christoph Leuenberger). The performers raise their hands until they are outstretched, let them stand for a moment and then fall again, prostrate, bend outwards to the right, flail about, get up again. Their play appears sober, prosaic and minimalist. The repertory of their actions does not resemble dance or dance theatre but rather a Tai Chi lesson and then later, a House, Techno, or Industrial party. Their performance brings them to the verge of total bodily exhaustion. After a short moment of silence, they stand still, breathing heavily, transpiring, enfeebled. Then again they perform gestures of dying, death, struggle or the theatre of agony. Since their mouths are always open, the faces of the performers appear like masks and remind us of Munch's *Scream* or stills from the films of Eisenstein. They do not see or need us; we are of no interest to them.

The fact that the performers of *TRIP* are in their own world means that they do not produce the illusion of knowing what they represent. The theatrical language of this performance is far from claiming any immediacy of presence. The work is a representation of the kind of revolutionary enthusiasm and states of intoxication that are unreachable to them. Revolutionary ecstasy is thereby kept at a distance. What one finds here is perhaps the Roman notion of *repraesentatio* or *représentation* which translate into the Greek *hypotyposis*: in Roman languages the prefix re- does not refer to a repetition but rather to an intensification, to the fact that we encounter an underlined, emphasized presentation.[6]

TRIP could be considered a performance that works with gestures rather than pictures, a theatre research on the topic of revolution, its states of ecstasy and, at the same time, on theatre as a narcotic. White Horse seems to defend against the moralizing strains of theatre theory, where insight is opposed to euphoria. By quoting Eisenstein, Chaplin, Haneke, Osho-Meditation, archaic rituals and everyday pleasures for the masses, they produce a kind of synthetic drug on stage, a euphoric play that allows audiences to examine the rues of ecstasy. If, according to Derrida, any community is organized around a phantasmatic drug that serves as its medium, one could claim that in *TRIP* it is revolution that is examined as the drug of modernity.[7] Revolution is thus no longer understood as the overthrow of unbearable social relations or as the ineffable event of the new, but rather as opiate. But what this opiate consists of is perhaps nothing but a promise whose force has no end since it is no longer a promise of *something*. The drug that White Horse deals with in *TRIP* is the promise made by all revolutions and that is always broken in the end, the promise of the *it shall be different*.

Skadi Seeger from Hofmann & Lindholm's *Faites vos jeux!* 2008. Courtesy of Hofmann & Lindholm.

The works of Hofmann & Lindholm approach this promise that remains after the fall of the Wall and of the real existing socialism in the East. They do so in a way that is different, but nevertheless comparable to theatrical means. Hannah Hofmann and Sven Lindholm produce "interventionist" theatre works with names like *Aspirants, History of the Audience or Seances*, and in 2008 *Faites vos jeux! Revoltainment*. As the latter title already indicates, the performance is a playful reflection on revolution and revolt.

In *Faites vos jeux!* seven "accomplices," seven actors with different professional backgrounds—a banker, salesperson in a grocery store, firefighter, bus driver, nurse, and actor—represent themselves on stage and imagine a revolt that consists of nothing but the consumption of all the resources they are supposed to deal with normally. The supermarket then closes its doors and becomes autonomous; its staff uses its merchandise for itself. The bank fires its clients and gives back their money to the point where it is all gone. The bus is closed for new passengers and drives through the city until its tank runs empty. The example of some inspires others: the employees of the employment agency quit their jobs. The revolt of those who are supposed to

make sure that the commodities flow from the producers to the consumers spreads.

The imaginary ecstasy that is produced by the forces of revolution in *Faites vos jeux!* is presented in a very sober, unemotional way. The actors tell a minute-taker of their different revolts and how it proceeded. The performance appears as just the tip of the iceberg, the visible part of a long work process that consists of on-site research, the castings of (non)actors to represent their own activity, and the invention of a more or less realistic scenario of "confusion" or subversion of existing power relations. This subversion might be looked upon as a general strike that culminates when all the common resources are exhausted and when collectives are formed that take what was learned as a manual for the coming insurrection. However, another reading is possible. Once the first stage is over, the everyday life that follows is anything but spectacular. Again, it is as if the performance meant to pose a simple question, this time regarding the time after the revolt. After conditions have radically changed, the revolution has come and everything has become different, what happens? The answer seems to be that everyday life will recommence as usual.

Faites vos jeux! proposes the following formula: after the fall is before the fall, or, alternately, we will never be able to leave the state after-the-fall that was promised by the classical theories of revolution of the past. No revolution whatsoever will be able to liberate us from the conflicts and aporias of our present time. While in the past there was a meta-narrative or the horizon of a coming society that was no longer characterized by fundamental inequalities of class, education or knowledge, today all the problems have to be solved or at least reflected here and now without this horizon. This presupposes an unequivocal state of disenchantment. In other words, what Hofmann & Lindholm are pointing to is the fact that the revolutions of the past obstructed the future by constructing a total image of the world in the moment of their revolutionary enthusiasm. What the performers oppose to this tendency in their work is not the denunciation of past revolutions but rather a gesture that can be found in the writings of Marx and later in those of Benjamin: the reference to a void and a potential that is both inexhaustible and that transcends any past. A void and a potential open up where there was once the idea of revolution. This void and this potential can also be found, although in an altogether different way, in the third work I would like to consider.

An old white Citroën won't start and is stuck in the snow in front of snow-covered trees. Illuminated by streetlight, one can discern the outline of some men with long hair and a black dog. They drink beer and eat potato chips. Hard rock blasts from their radio. A passerby shows up. She opens the hood and looks into the engine bay, disappears in it, screws on something and reappears with something in her hand. Her diagnosis, transmitted to a garage via mobile phone, is that the car needs a new distributor. It will take seven days. This is how one could summarize this first scene of *La Mélancolie des dragons*, a production of the French stage designer and director Philippe Quesne and his group Vivarium Studio. It reminds us in its absurdity of the films of Jim Jarmusch or Aki Kaurismäki. A trashy extract of the life of a group of artist freaks becomes an allegory of contemporary theatre and at the same time of the experience of a lost generation. While they are waiting for the car part, the men show to their female guest all of the rather cheap effects with which they are about to open, "pretty soon," an "amusement park." A library is shown in which there is literature on dragons and dinosaurs, from Chrétien de Troyes to Wagner up to Strindberg, Artaud and children's books. The four elements are represented by a portable fountain, a bubble machine, dry ice fog and a snow gun aimed at the trees. Big plastic pillows are blown up and used as a projection surface for the video projector. We see at first a picture of a beach, then Dürer's famous *Melancholia* and Caspar David Friedrich's *The Wanderer* followed by possible titles for the amusement park: "Dragon Park," "Dürer Park," "Bruegel Park," "Citroën Park," "Melancholia Park," "AC/DC Park," "Dream Park." Finally, it's decided it will be called "Antonin Artaud Park."

Step by step we realize that everything we have watched is the result of a staging. The snow-covered trees are merely an effect of the snow gun. The snow on the floor is just a carpet. The hair is just a wig. Light and dark are effects of artificial lighting. In the end everything we see is nothing but an allegory of emptiness. Where everything is mere construction, there remains nothing that is meaningful. It is as if the group means to show us that the wealth of ideas that will perhaps feed the amusement park is the flipside of an extensive poverty. In the end the performers illustrate in their performance what Benjamin formulated in his theory of modernity and the age of the baroque: "The emblems recur as commodities." The transmogrification of all things into commodities leads to the fact that in the end nothing remains of value as such in its singularity. In view of the status of today's art Vivarium Studio presents to us the experience of pure fun as well as the poverty that remains when artists become entertainers and the heirlooms of bygone culture are turned into meaningless commodities.

Since *L'Effet de Serge* of 2007 Quesne is no longer a well-kept secret and has become part of the vanguard of the independent theatre scene. This success is somewhat remarkable since on first view it is difficult to know why his works are so appealing. There is not much happening, no spectacular action, and the dialogues are taut and empty. The players seem to play themselves: or what they would like to be. Their language is unpretentious and does not convey the impression that they have attended any acting school, a fact that appears somewhat radical in the context of the French theatre scene, which, in large part, is still

rather traditional in its use of a very artificial rhetorical language. What seems at first to be artless then appears to be a specific handwriting, a style, comparable to the styles of artists like Jan Lauwers, Jan Fabre or Alain Platel. It approaches the work of stage directors and choreographers whose strangeness and particularity is fed on the visual arts and Pop music as well as, and not by chance, the means of premodern theatre, especially of the baroque. If one compares the work of Vivarium Studio with that of other theatre companies, one realizes the profound disillusionment concerning the real possibilities for political intervention, at least in terms of one that takes place on stage. While the catastrophes of our time are raised and form the horizon of the group's work, they are not presented with the gesture of knowing how to solve them. *La Mélancolie des dragons* provides a tableau of stagnation that acts as a diagnosis of the present of artistic production. From the time of Dürer the group adopts various emblems of melancholia. From the time of Friedrich the group adopts the topos of longing (*Sehnsucht*), which deduces from knowledge of a better past the hope of a better future. Together these two images form the broken unity of our present, seen as a period that must become aware of its own void, or, to put it in Walter Benjamin's words, its profound poverty of experience. In the tradition of Samuel Beckett, Quesne exposes the spirit of today's culture industry: "pretty soon amusement park." By pointing to the void and poverty of experience, the performance enables us to think of another possibility that cannot be represented in an adequate way or by adequate images.

The three examples I have mentioned here could be subsumed under a common shift away from the spectacular and towards an art that is poor in many respects. All three works have not been produced by large institutions and the festivals and theatres where they were shown are generally smaller ones, open to experiment. It is my view that these works represent a contemporary practice of theater *after the fall* in which we encounter art practices that expose the poverty of experience and that could be called theatrical research. In spite of the fact that their means are restricted, the groups I mentioned distinguish themselves from many others by the fact that their works try to articulate a profound expression of the tendencies of their epoch.

In contrast there is a highly subsidized theatre system in countries like Germany, Austria and Switzerland, and an equally financially strong system of big prestigious festivals that are shaped by the poverty of experience, but in an altogether different way. There the poverty of experience is manifest in the increasing number of curators and dramaturgs who still believe they can control the apparatus of the theatre, while in fact the opposite is true. In Germany, for example, one can observe that the program of the highly subsidized municipal theatres becomes similar everywhere. One notices an alarming lack of original writing and a lack of risk-taking in terms of repertoire. Correspondingly, there is an increasing number of more or less interchangeable festivals where the alternative theatre becomes no less conformist than the first. Both institutions are shaped by the fact that even the very radical works that are produced no longer reflect the institutional frame. What prevents the discussion of this frame is first of all the claim that technique and standards no longer need to be discussed. It seems that the great problem of today's institutions is that they no longer question and negotiate their specific codes and thereby blind themselves to new experiences. Of course this has a lot to do with the increased pressure of politics in view of the frequently invoked scarcity of funds. In view of depleted public budgets the resulting conformity will lead for sure to disaster. Clever politicians will insist on more co-productions. Why should there be five stagings of *Emilia Galotti* in one season within the populous Ruhr region—as was the case a few years ago—if one could let one production go on tour instead, and why not improve the popularity for example by hiring well-known TV stars? Why does every city need a theatre with its own company if more and more theatres work with actors who travel and produce more or less the same kind of mishmash everywhere anyway? Cultural activity impoverishes audiences and performers because its producers do not think of anything but its operation. Visitors find only what they already know. What is lost is what I have tried to present by referring to three of many possible examples: a theatre that uncompromisingly confesses its contemporaneity by analyzing its historical moment and condition and thereby provides an opportunity for its spectators to do the same.

Notes

1. Jean-François Lyotard, *La condition postmoderne. Rapport sur le savoir*, (Paris: Minuit, 1979).
2. Walter Benjamin, "On Language as Such and on the Language of Man," in *Reflections: Essays, Aphorisms, Autobiographical Writings*, trans. Edmund Jephcott (New York: Schocken, 1978) 314-32.
3. See Nikolaus Müller-Schöll, *Das Theater des "konstruktiven Defaitismus." Lektüren zur Theorie eines Theaters der A-Identität bei Walter Benjamin, Bertolt Brecht und Heiner Müller* (Frankfurt/M and Basel: Stroemfeld-Verlag, 2002).
4. Max Horkheimer and Theodor Adorno, *Dialectic of Enlightenment* (New York: Continuum, [1944] 1997).
5. Walter Benjamin, "Experience and Poverty," in *Walter Benjamin: Selected Writings, Volume 2, 1927-1934*, edited by Michael W. Jennings, Howard Eiland and Gary Smith (Cambridge: The Belknap Press, 1999) 731-6.
6. Jean-Luc Nancy, "La représentation interdite," in *L'art et la mémoire des camps: représenter, exterminer* (Paris: Seuil, 2001) 13-40, 21-3.
7. Jacques Derrida, "The Rhetoric of Drugs," in Anna Alexander and Mark S. Roberts, eds. *High Culture: Reflections on Addiction and Modernity* (New York: SUNY Press, 2003) 34.

Spread Your Legs

Rabih Mroué

Please write down the following:

Replace *My tits* with *My breasts.*

Remove *They could fondle them* and *play with them.*

Replace the word *Whore* with *Prostitute.*

Replace *My cunt was on display* with *I was on display.*

Remove *I spread my legs wide.*

Remove the word *Mouth* from *Pee* ~~*in my mouth*~~.

Remove ~~*And I shat in it.*~~

Replace *Shit* with *Excretion.*

Replace *And started to smear the shit all over my body* with *I started to smear my body.*

Remove ***Amal*** *Movement* and replace it with *The movement.*

Remove the word *Lebanese* from the sentence *When* ~~*Lebanese*~~ *fighter jets circled the skies above Beirut and bombed the Palestinian camps.*

Remove ~~*I bought a woman's corpse and had sex with it.*~~

Remove *Stuck it here, in my cunt* and replace with *I stuck it in me.*

Remove *His party* from the sentence *These operations are against God* ~~*and His Party*~~. = (Allah wa Hizbo)

Replace ***Amal*** *Movement division* with *The division.*

Replace *Insult Islam and Muslims* with *Insult the confession.*

Remove *Muslim* from the sentence *My* ~~*Muslim*~~ *colleagues started blaming me.*

Remove *Christian* from the sentence *Our boss* ~~*was a Christian*~~.

Remove *Christians* from the sentence *Karl and Issa* ~~*were both Christian*~~.

Remove *A Christian* from the sentence *Samer,* ~~*a Christian*~~ *who was implicitly on Raymond's side.*

Remove *Islam and Muslims* and replace with *The confession.*

Remove the whole paragraph of Bob Flanagan, starting with ~~*I've been a shit and I hate fucking you now*~~ Until *I stood and took a picture*.

Remove *The clashes between **Amal** and **Hizbullah*** and replace with *The clashes.*

Remove ~~*Terrified of **Hizbullah***~~.

Remove *Christian* from the sentence *And never have had to kill my* ~~*Christian*~~ *colleagues at work.*

Remove every mention of ~~the President of the Republic~~ and ~~the Prime Minister.~~

Remove *A Christian and a Druze* from the sentence *They decided to put me to death with two others,* ~~*a Christian and a Druze*~~.

Your name and your signature.

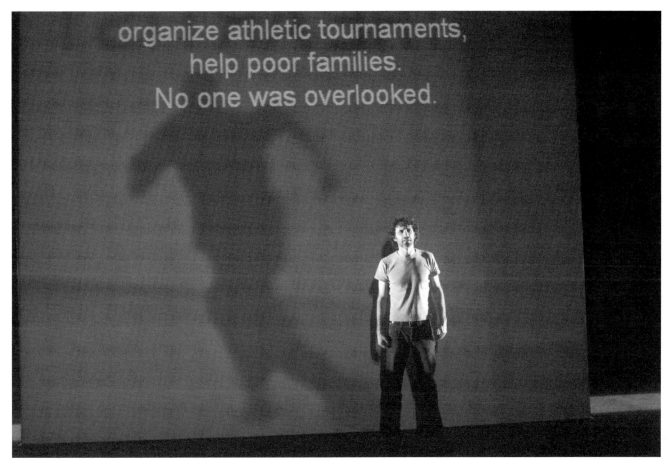

Rabih Mroué, *Who's Afraid of Representation?* 2005. Courtesy of R.M.. Photo by Houssam Mchaiemch.

Delayed Introduction

After the premiere of *Who's Afraid of Representation?* in Beirut, we (the play's producer, C. T., and I, R. M., the author and director) received a phone call from the office of the General Security, summoning us personally to the censorship department.

The subject: the breach of a law, which stipulates the need to apply for a performing license, and to follow the legal and administrative procedures in order to obtain official authorization.

The result of the meeting got us off the misdemeanor. The security officer had promised to turn a blind eye on the condition that we agreed to remove and replace all words and expressions which "offend public taste" or "offend the morals of our society" or those that "would give rise to sectarian strife." We were also asked to remove and replace all mention of the country's president and its army, and refrain from naming anything, whether politicians, sexual organs or otherwise.

And so it was…

On the following evening, we presented the play with the new, amputated text. However, the English translation of the old text, performed during the uncensored premiere, remained. The censor missed this little detail; he didn't mention the English text. We presented the full English text without removing or replacing anything, as we had in the Arabic. We considered this a victory.

Knowing that English in Arabic-speaking countries is of little concern, it is therefore, to a certain extent of no concern to our confessionals, political parties and civil societies. As a result, it is of no concern to their representatives in the General Security's censorship department. However, our victory was like a silly joke that only makes the person who tells it laugh. Later, I discovered that this incident hid our compliance with the censor, and the giggles that we've done cover up our "intimate failure."

Political Theatre, Theatrical Politics: Epic Theatre in the 21st Century

Judith Malina

What has become of political theatre in the third millennium CE? The concept of "political correctness" has made it obligatory for major European theatres to include a certain number of plays with socially relevant themes in their repertory. But though many of these make use of Erwin Piscator's inventions, such as the breaking of the fourth wall, the use of narration and the epic use of film and video, too many of them lack the essential element of a committed cast, of an ensemble that has probed the meanings and the interpretations of the drama and its characters and an analysis of the drama's social significance.

Where then is the new political theatre? It is not absent. Today I can say that I have seen it, and that we have participated in it. The new political theatre, as Julian Beck cried out in the last scene of The Living Theatre's *Paradise Now*, is in the street. Yes, that is where it can be found.

At the massive demonstrations that have been taking place in the various cities in recent years where summit meetings of the G8 and the World Trade Organization were deciding the fate of the world economy and the consequent life and death of masses of people, we saw hundreds of thousands of activists come out to protest against capitalism!

Piscator would agree that the fundamental political problem is the capitalist system, "with its inequality and injustices and the poverty and the wars needed to support it." These demonstrations are pure theatre.

In July 2001 when the G8 met in Genoa, 200,000 people marched and performed. What made the biggest splash in the world media, was alas, a bloody splash, the killing of Carlo Giuliani, a young demonstrator who threw a fire extinguisher at a police car, and died for it. The commercial news media has a saying, "If it bleeds, it leads." News means bloodshed for them, and without blood, it's considered less newsworthy.

Piscator taught us that the purpose of theatre is to diminish or eliminate bloodshed. In "The Theatre of the Future" that Piscator wrote in 1942 for *Tomorrow Magazine*, he says, "War is hateful to me, so hateful that after the bitter debacle of l918, I enlisted in the political struggle for permanent peace."

In Genoa, there were hundreds of groups representing various causes. There were feminists, anarchists, anti-militarists, communists, socialists, ecologists and save-the-whalers. The unifying theme was the failure of capitalism to address our needs. Their efforts at dramatic expression were even more varied:

streamers and banners, costumes and music, chanting and singing, dramas and pantomimes, techno-tricks, confetti and audience contact, dances, acrobatics, drums... They are searching for the means of expression to say what they need to say, boldly, loudly and succinctly, so that it will communicate in the bustle of the street and the frenzy of the demonstration.

This effort and this search is the fruition of Piscator's work. He envisioned "a nationwide network of political theatres." Instead, he achieved an international network of theatrical activists. It is more than he could have hoped for.

During the huge parade of these 200,000 and their scenic paraphernalia, The Living Theatre performed an ambulatory piece which we called *Resist Now!* We created it together with forty Genoese activists, some of whom had theatre experience and some of whom had none. We did a week of workshops with them in the open air pavilions along the port of Genoa, where hundreds of groups were preparing their protests. We formed a walking pyramid of bodies that recited the Moloch section of Allen Ginsberg's *Howl*.

In front of us was a contingent of the Argentinian *Madres de La Plaza de Mayo*, moving with slow steps and sombre robes in the solemnity of their lament for their disappeared sons and daughters. Behind us was a group of Berlin transvestites on a float, awash in pearls and feathers and sequins and camping it up with cries and shrieks.

The beauty of it was that these two groups, the mourning mothers and the screaming queens were aware of the motives of each other's demonstration and aware that each had legitimate cause to protest against governments both for killing dissenters and for stifling sexual freedom. It is the epitome of Epic Theatre to see so many diverse issues enacted in the street at the gates of the meeting place of the great powers. In 1930 Piscator wrote, in "The Cry for Art": "Perhaps the sense of Political Theatre has changed so that today we are permitted to act for 'Theatrical Politics'."

And eighty years later we begin to see it come to fruition.

In 2009, 2010 and early 2011, protestors demonstrated in Iran.

In 2011, we have watched the courageous, and non-violent street actions in Egypt in occupying Tahrir Square, forcing the resignation of the tyrannical government and inspiring the

Arab Spring of pro-democracy actions from Yemen to Bahrain, to Syria, to Libya.

In the fall in New York City, thousands of people gathered on Wall Street to protest the greed and the heartlessness of our whole economic system, not only specific "inequalities and injustices" nor only "the poverty and the wars" but the very system itself, which encompasses all those abuses within it. They adamantly refused to confine their protest to one or another abuse of the system, instead focusing on the entire structure and philosophy that upholds it, bringing into view our humanity, as a master-slave system with one percent gathering the profits and ninety-nine percent in the struggle…

The ideal is enormous: Abolish Capitalism. The smaller steps towards this great vision are not yet formulated, but it is pure and profound, as Piscator would have it, and as the world needs it.

Whether this is indeed the beginning of a revolutionary movement that will change the world is not yet known. We may yet face the setbacks of violence and the impatience of the armed forces that are desperate to keep the social peace—but so often are the very cause of bloodshed. But as I write this, the leaderless movement that calls itself Occupy Wall Street has grown from city to city and now from country to country beyond Wall Street and New York City. It includes occupations and marches and street theatre.

The Living Theatre is performing an excerpt from *Seven Meditations on Political Sado-Masochism*, starting with The Meditation on Money, and ending with the question, "What can we do?" directed to the audience. We then, at the end of the play, discuss any and all possible solutions to a better society. We are one of thousands (and counting) of groups and individuals working to theatricalize the cause.

Yes, Piscator, Julian Beck proclaimed your concept, "The theatre is in the streets!" And that's where it is now, and we thank our wise teacher. Today information travels faster than ever before in history. Today the networks of communication outdistance the decision-making processes of lawmakers and the decision makers of states and corporations. This is a new form of social and political life. We have no precedents. We are inventing the process as we proceed.

This is what Piscator taught us: not what it is we must do, but to become people who will know what to do in the changing culture, to grasp the facets of human nature that are not alien to ourselves, and to enact them, so that we will be able, as Brecht said of Piscator, "to serve humankind through all the technical and artistic means of the theatre."

Judith Malina at Occupy Wall Street in the company of Brad Burgess as well as Living Theatre performers Soraya Broukhim and Homa Hynes, 2011. Photo: Amy Werba.

The Avant Garde is Present

Moe Angelos

Today, Monday, October 1, 2012, according to Google, the prognosticator and savant of our times, the term "avant garde" means about 86,900,000 things. A quick search yields an additional 56,200,000 results in the image category, 107,000,000 videos, 1,196 map points near New York, NY, 21,800 news items, 145,000 shopping suggestions, 7,740,000 blogs, 10,100 apps, 880 patents, 8,510,000 books, and 4 recipes pop up along with four places in Manhattan named Avant-Garde. Avant-Garde Electrolysis deserves a dissertation from a performance studies PhD candidate and with luck someone is tilling that soil right now.

Facebook has many more offerings. Avant-garde Security, Bangladesh, anyone?

Despite popular notions that there is no longer an avant garde, The Cloud speaks for itself. Somebody is out there making things, ideas, work that they or someone else considers avant-garde, that is to say, in advance of the guard, ahead of the curve, forward-thinking.

In our world of the digitally tethered, a huge amount of human experience is available on the web for our observation, hacking, voyeurism and auto-tuning. Because of this access to all corners of the planet, and because we cohabitate with more than seven billion other humans, there can be the overwhelming, grandiose idea that anyone with a broadband connection or even a smartphone at 3G can "know everything." And it's true, The Cloud can tell us a lot. But it can only report that which has happened and been recorded or that which is happening, via livestream. It can only tell us about "the guard," not what comes in advance of that guard. Garde, yes. Avant, no.

With brains that can put two and two together and sometimes reach conclusions other than four, we can go beyond The Cloud, beyond the guard in our thinking and can postulate, "what next?" in ways beyond mathematics. This is called using the imagination. Duh.

Sometimes "what next?" gets the better of us and whole performances, novels, dances, poems, zines, blogs, fashion careers, research experiments, marriages, even government agencies (e.g. NASA) are built around imagining and creating "five minutes into the future," as Marianne Weems, the artistic director of The Builders Association likes to say.

The future, even five minutes of it, is something we never have. We have the present and the past as lived experience, but ahead of the present is unattainable. But a girl can dream, can't she?

Live performance is about as close to true ahead-of-life as we can get. Watching something live we bear witness to the ongoing self-consciousness of both spectator and performer. We watch as people live before us and each moment, as it is pulled from the constantly advancing future, dies before our very eyes. Performance is a radical act of presence, a purposeful framing of what Gertrude Stein called "the continuous present"—to get slightly fancy and theoretical about it.

If I may invoke a spectacular example of this courting of the future that results in creating the past, let me speak for a moment of Marina Abramovic, whose 2010 retrospective at the Museum of Modern Art in New York represented a benchmark for performance art in the United States.

In the grand central atrium of the Museum, Marina had installed herself for the entire two and a half months of her exhibition, certainly earning street cred for the use of the very word exhibition. She sat every day the museum was open and made herself available for anyone who came in with paid admission to the museum (free on Friday nights!) who wished to sit opposite her and well, just sit. Just sit there and be with Marina, for as long as the sitter wished. Marina sat for all the hours the museum was open and did not choose ever in those weeks and months to leave from her sitting. She never abandoned her post of presence.

Poster hoarding on 13th Street and 2nd Avenue, New York City, for the exhibition Marina Abramovic: The Artist is Present at the Museum of Modern Art, 2010. Photo: Moe Angelos.

I relay to you an encounter I had with an older woman, who tapped me on the shoulder as I knelt, raptly concentrating on Marina as she sat there performing "nothing" but that exquisite presence. This lady was a dyed-in-the-wool New Yorker, cantankerous and curious, white, who didn't look a day over 80. She had an old style New York City accent and attitude and felt completely at ease in striking up a conversation with me, a total stranger, and dispensing her unbeckoned opinion, with the classic stance of the opinionated of this city:

Old Lady: What are you waiting for?
Me: I'm watching.
OL: What are you watching?
M: I'm watching the artist.
OL: What's she gonna do?
M: Just what she's doing.
OL: I walked in here several times and she didn't do anything.
M: She won't.
OL: Well, why?
M: The exhibit is called The Artist is Present.
OL: Yeah, I know.
M: So, it's about her presence.
OL: She doesn't blink or anything?
M: Yes, she just blinked now.
OL: I can be very still.

M: It's not easy. I'm sure it takes a tremendous amount of discipline, what she's doing.
OL: Have you ever had an MRI? Where you have to be still inside that thing for like, 45 minutes. I could do that.
M: Yes.
OL: But this, I couldn't do. It's for the young people.

Ms. Abramovic captivated New York City's attention with her epic months-long performance of sitting. This conversation I had and the response to the exhibit say a lot about what it means to foreground something, draw attention or point to an activity that usually goes unnoticed, in the margins. Like the woman who spoke to me, we were all waiting for the next thing to happen. Abramovic proved it is vitally engaging, as her show at MoMA was the most visited show in the museum's history. Over 500,000 people saw it. Sure, many of them came for the naked people on display upstairs but I bet many were surprised to find that that nakedness paled in comparison to Marina, resplendently robed, doing "nothing" but making us all wait, making us sit in the present and wrestle with it.

The present, as Ms. Abramovic heroically displayed all those weeks, is deeply compelling. Despite the manifold distractions available to us here in the developed world, the many ways we have invented to get away from our present situation and conditions of discomfort, our desire to be in the moment still drives us. Live performance, gaming, roller coaster parks, urban engagement with "new" agriculture, crafting, online, global DJ mixing championships, all the way to regular old-fashioned showbiz are all courting liveness, riding the scythe of time, as it mows down the moments.

The avant garde is not dead and at the same time it is always dying. Not to get all philosophical about it again but technically speaking, what comes before can never be actively dead. It can and does die in every moment we live but the future, the avant, is always available to us on the imaginative plane. In our minds, the future lives forever. In reality, it is lived as the present and dies simultaneously into the past. I know, that's super-confusing and I apologize. The philosophers and physicists and mathematicians have more articulate ways of writing on these matters. I am a practitioner of liveness, an agitator for presence observed, which bestows a kind of joy, no matter where I stand in the performance/spectator loop.

Clearly, the avant garde is dead. Long live the avant garde.

It Was Only Just a Stage

Bill Brown

The Surveillance Camera Players (SCP), which I co-founded in 1996, was, in its way, an avant-garde group. Opposed to the installation of surveillance cameras in public places, the SCP was inspired by another avant-garde group, the Situationist International (SI), from which it borrowed the technique of *détournement*. Instead of trying to convince its elected representatives or the legal system to remove surveillance cameras (which is what traditional leftists might do), and instead of simply blinding or destroying them outright (which is what militant anarchists might do), the SCP treated the cameras and the places they surveilled as readymade performance spaces. By performing anti-surveillance plays for them, the SCP attempted to divert or hijack them. What were intended to be stages for the performance of conformity and submission were turned (if only temporarily) into stages for individuality and defiance.

Although surveillance cameras had been used in public places ever since the late 1960s, it is certain that the SCP was ahead of its time. In 1996, there was only one other group in the world that staged similar performances: *Souriez, vous êtes filmés* ("Smile, you are being filmed"), which was based in France and had been active for a year. But the members of the SCP were unaware of their French predecessor; all they knew was a call to action issued from the United Kingdom by Simon Davies. Not a performer or a playwright, Davies was a member of Privacy International, which, as its name indicates, was and still is an international privacy watchdog.

Like the SI, which existed for fifteen years and went through several stages of development, the SCP, which continued its work until 2006, went through different stages. In fact, there is some similarity between the natures and numbers of those stages. First there was a period in which both groups pursued typical avant-garde techniques or, rather, paid homage to and reinvigorated earlier attempts in the field of politically conscious cultural experimentation: for the SI, it was Dada and Surrealism, which had by then become thoroughly recuperated into the dominant spectacle; and for the SCP, it was the placard-based theatre of Alfred Jarry and Antonin Artaud, whose works were only known by specialists in the field of dramatic studies and not by the general public. (Since surveillance cameras do not pick up sound—or at least are not legally allowed to do so in the United States—the group's street-theatre performances had to be silent, and thus made extensive use of printed placards.) Then there was a period of explicitly political work and a deliberate rejection of the trappings of artistic expression: for the SI, those politics concerned workers' councils and the writing of books of critical theory; and for the SCP, they concerned the non-hierarchical international organization of similar groups, which had sprouted up in the meantime (only to disappear a year later), and the writing of original plays that were, perhaps, unprecedented in that they explicitly concerned the presence of surveillance cameras in public places. Finally, after a certain amount of success (stunning in the case of the SI and more modest in the case of the SCP), there was a period in which these groups attempted to define their legacies: in both cases, this activity centered on writing a book that summarized their entire careers and offered contexts in which to place them.

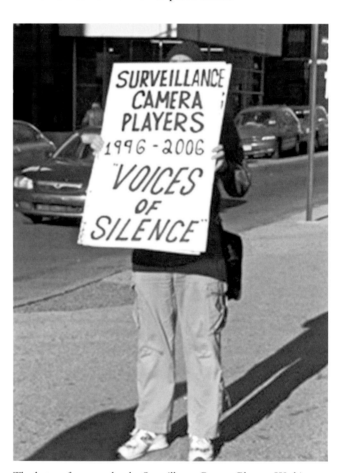

The last performance by the Surveillance Camera Players. Washington Square Park, New York City, December 10, 2006 – the 10th anniversary of the group's first performance.

By the time the SCP had entered its second period, its members were aware of their similarities to the Situationists. I think it is significant that both groups decided to disband at what some observers believed was precisely the wrong time. In 1972, Situationist ideas and Situationist-inspired groups seemed to be everywhere; in 2006, the number of publicly installed surveillance cameras had increased dramatically, as had their technological abilities. At such moments, wasn't the existence and work of both groups more important and more needed than ever? From a certain perspective, the answer could only be "yes." For its part, the SI could have gone from a small group, with its members concentrated in a handful of countries (mostly in Europe), to a large group with sections on every continent, while the SCP could have gone from a cult phenomenon to a fully-fledged member of the international art scene. For both groups, these destinies were precisely the thing to avoid, at all costs, and for the same reason.

Parts of the world—the hipsters, cognoscenti and news reporters—had come to depend on these groups, not only as sources of ideas and new techniques, but also as justifications for the complacency, self-satisfaction and inactivity of their fans and admirers. It appeared to the most perspicacious members of these respective groups that, as long as they continued to exist (and to do such exemplary work), their fans and admirers believed that there was no need for them to do anything on their own, except, that is, watch and fancy themselves well-informed because they knew what to watch.

And so both groups dissolved, leaving behind scores of confused and disappointed people. I believe that their decisions to dissolve were the most radical—the most avant-garde—things that could be done at the time. These were fitting ends to groups that began and continued, for a brief moment of time, to be "ahead of their time." No avant-garde can stay ahead of its time indefinitely; eventually, time or, rather, history must catch up and surpass it. The key, I suppose, is knowing when you're (still) ahead and quitting before it is too late, before time has caught up, passed you by, and left you looking like a museum piece.

December 10, 2012

Errorist Kabaret

The Errorist International

The **Errorist Kabaret** appears before our eyes while walking through the halls of the Istanbul Biennial. It's a place to get lost in, a meeting point where the errors are converted into something positive and a space for a collective game. Here, the audience is the protagonist. *Spect-actors* wander through space and become part of the art-work, give it life and complete it with their presence.

Among the worn Cultural Institutions, the cabaret is a haven highlighting the contradictions between what one possesses and what one wants. In the **Errorist Kabaret** one can always drink, smoke, eat, vomit, play, laugh and cry. It is the ideal place for forbidden practices, the birthplace of the ideologies of the new millennium. It's a space to confess love secrets and to discuss the errors of international economics and politics. It differs from other local shows, in that the **Errorist Kabaret** allows *spect-actors* to change sides with other players, and to interact with artworks and objects.

Here bottles can think, tables can chat with paintings, glasses can drink, people and ashtrays are always full of poetry. The room is full; there is a special show today. The troupe on stage is bustling. There are magicians, illusionists, singers, comedians, mime artists and representatives of the most diverse currents of thought. They whisper that the show is about to begin.

The curtains are open:

Act One: The Desire of the Object.

From a corner of the room, Bertolt Brecht smiles to Pirate Jenny. King Ubu raises quietly his glass to toast and drinks up. Duchamp moves a castle on the chessboard and now it's the lady's turn at his side.

An anonymous woman climbs onto the stage, smiling at the intellectuals, and exclaims: **Woman**: "How can we articulate what we want, if they do not already know?"

The Clown *interrupts*: "Good morning, good afternoon, good evening! Welcome to the new millennium. We expect more catastrophes, climatic disasters, pests, viruses and wars everywhere."

From behind the proscenium **The Puppeteer** *asks*: "So, what's new?"

Etcetera, *The Errorist Kabaret*, 2009. Participatory install-action. 11th Istanbul Biennial, Turkey. Courtesy: Etcetera Archive and IKSV—Istanbul Biennial.

"We enter the Age of Error!" *announces* **The Wizard** *with his gaze fixed on a table with cards on it.*

The Public *respond in chorus, all at the same time*: "It's the End of Postmodernism?"

Through the window in the background you see the turquoise velvet of the Bosphorus and a huge bridge that joins and separates the two worlds. The red curtains are open and reveal the moon and stars. Some people talk and laugh. Others observe the spectacle in silence. There's a busy activity in the bar, suggesting an awareness of the errors in the world.

The curtain falls.

Act Two: The Object of Desire.

The lights of the room are switched off. All keep still and their talks are suspended in the air like their thoughts. On the walls of the **Errorist Kabaret** *there are twenty paintings. Landscapes and portraits, romantic images, romantic riots and historical epic love scenes. The walls of the cabaret suck up smoke, sweat and the scent of imitation perfumes. Murmurs are heard. This time the objects speak.*

Suddenly from the bottom, a small painting shouts: **Painting**: "We must give life back to art and art back to life!"

Ashtray *on the table responds*: "Museum-Mausoleum!"

Cup of Tea *talks to Painting*: "Listen to me! Do you know who you represent? You must sit down and think about all the sponsors that you advertise!"

Painting: "Really, believe me, every day I wonder… Who am I? Me, who smiled a thousand times. Me, who does not even represent anything to anyone who sees me or passes by without even looking at me."

Bottle of Wine: "I feel empty, almost a waste."

Cup of Tea: "I do not understand how you can feel empty, if you have consumed all that gives happiness."

Bottle of Whiskey: "We have no future because our present is too volatile. We only have risk management." *The bottle smiles and continues*: "When there is no love, the substance is delayed. The movement is restrained. It is a kind of alienation from oneself."

Cup of Tea: "I am broken. Love has turned into an error, and it is here where the movement becomes active… Now I can understand why I am so fragile."

Bottle of Wine: "You should be happy; don't you understand? We are there for all their social needs, for their consumerism. We are more important for them, more than they are for themselves. Think! Our weakness is our strength."

Ashtray: "To consume, consume, and consume! That is the only reason they like us."

The Chair *interrupts*: "We should organize a strike, the objects also have rights!"

At that time all the objects meet. The lights in the cabaret are suddenly turned on. Everything gets illuminated. **The Magician** *enters the scene and announces that the show is about to begin. With his magic stick he touches each and every one of the animated objects.*

Out there the night falls on Istanbul. Rumors and secret talks among the moon and the stars are heard coming from the streets. People walk without guidance; they are lost in the dark labyrinths. There are shadows, flags, eyes, megaphones, stones, words and silences that complete the picture.

This may be the beginning or the end, but someone yells from the stage: "We do not pay entrance fees, we do not have entrances, we do not sell entrance cards! Whoever wants to enter, can enter. If we decide to climb the scene, we will do it. Therefore: The show must go on!"

The curtain rises and falls countless times. (Poetics of "Errorist Theatre" does not invent fictitious scenarios or unilateral conventions. It looks for social scenarios and appropriates them, working them into the scene. It does not matter who acts and who observes; Dramaturgy is created by the succession and simultaneity of errors. Here, there is no assay; the dramatic action results from the map of errors of life.)

We are all Errorists! Errare humanum est!

1. Errorism is the concept and action based on the idea that "error" is the principal order of reality.

2. Errorism is a philosophically erroneous position, a ritual of negation, a disorganized organization: failure as perfection, error as appropriate move.

4. The field of action of "errorism" contains all those practices that aim at the LIBERATION of the human being and language.

5. Confusion and surprise, black humor and absurdity are the favorite tools of the errorists.

5. Lapses and failed acts are an errorist delight.

‖ **avant-garde** (avãgard), †**a'vant-,guard.**
Forms: 5 au-, avaunt-, aduantgard(e, avantgaird,
7 au-, avant-, avaunt-, avan-guard, -gard, 8–9
avant-garde. [a. F. *avant-garde*, f. *avant* before
+ *garde* GUARD. Formerly anglicized, *avaunt-*,
and *-guard*; sense 1 is now archaic or obs., being
replaced by the aphetic VANGUARD; cf. (*ar*)*rear-
guard*.]

1. The foremost part of an army; the vanguard
or van.

1470–85 MALORY *Arthur* I. xv, Lyonses and Pharyaunce
had the aduant garde. **1582–8** *Hist. Jas. VI* (1804) 40 The
gentillmen of the surname of Hamiltoun were on the
Queenes avantgaird. **1630** HAYWARD *K. Edw. VI*, 18 Next
followed the avauntguard. **1664** S. CLARKE *Tamerlane* 8
Odmar led the avanguard. **1796** *Campaigns* 1793-4 I. I. ii. 12
Gen. Stengel..commanded the avant garde of Valence's
army. **1800** COLERIDGE *Wallenstein* III. vii, Mid full glasses
Will we expect the Swedish Avantgarde.

2. The pioneers or innovators in any art in a
particular period. Also *attrib.* or as *adj.* Hence
avant-'gardism, the characteristic quality of
such pioneering; **avant-'gardist(e)** (-ist), such a
person; also *attrib.*

1910 *Daily Tel.* I July 14/6 The new men of mark in the
avant-garde. **1925** *League of Composers' Rev.* Jan. 26 He
used rather questionable methods of calling attention to
himself..publishing wild manifestoes in the *avant-garde*
magazines. **1940** GRAVES & HODGE *Long Week-End* xii. 197
At Paris..British and American literary *avant-gardistes*
fraternized or came to blows. **1947** *University Observer* I. i.
19 There is a terrible striving always to be *avant-garde:* to
'discover' Henry James, T. S. Eliot, Melville or the more
obscure modern English poets. **1947** *Horizon* Dec. 299 A
literature without an *avant-garde* soon becomes a literature
without a main body. **1950** A. KOESTLER in *God that Failed*
I. 31 Their policy..in cultural matters [was] progressive to
the point of *avant-gardism.* **1953** *Archit. Rev.* CXIII. 149/2
For avant-gardist architecture produces..characterless
buildings. **1967** *Spectator* 3 Nov. 547/3 What baffles me
about our various well-meaning avant-gardes is their
prodigious appetite for punishment. **1967** *Times* 23 Nov.
13/3 They resembled a group of avant-gardists who seemed
not quite to know where they were going.

The Avant Garde of Obsolescence

Thomas Elsaesser

Why are so many contemporary artists not only utilizing moving image media—digital video, camcorders, high end studio equipment, if we think of Bill Viola or Pipilotti Rist—as their basic tools, but also deploying the history of the cinema as an art-historical reference point, much the way Picasso used Velasquez or Goya, or Anselm Kiefer used Rembrandt or van Gogh? I am thinking of Stan Douglas, Douglas Gordon, Doug Aitken, Rodney Graham, Sam Taylor Wood, to name but a few.

One answer would be that there is now a general sense of ownership of the cinema on the part of the art world, manifest most clearly in the changing approach of the museums. When, starting in the mid-1990s, big institutions like Tate Modern, the Pompidou Centre, or the Whitney began making big claims in this respect, they usually had the institutional power, the legitimacy (and the money) to enforce these claims. The museum has essentially "acquired" or "appropriated" the cinematic avant garde, not only by expanding their collections, but by being able to commission new work, when funding disappeared for certain types of film from either experimental art cinema institutions or from television. The career of an artist I have been following and commenting on for more than forty years—Harun Farocki—is exemplary in this respect: he moved from relatively little-known political filmmaker to internationally acclaimed installation artist. Less spectacularly perhaps, the same applies to Chantal Akerman, Ulrike Ottinger and Yvonne Rainer. Other avant-garde filmmakers, who in the 1970s had shunned the museum, have been re-making their work in order to fit into the museum formats, notable examples being Michael Snow and Ken Jacobs.

The new sense of ownership of the cinema by the museum and gallery spaces is perhaps not altogether unconnected with the much discussed "death of cinema." Indeed, it was as if the centenary of the Lumière Brothers' invention in 1995 became the ideal occasion to praise the cinema in order to bury it. The suc-

Installation view of *The Clock*, 2010. Single-channel video with sound; 24 hours. White Cube Mason's Yard, London (Oct 15-Nov 13, 2010) © Christian Marclay. Courtesy Paula Cooper Gallery, New York and White Cube, London. Photo: Todd-White Photography.

94

cess of a number of ambitious, large scale exhibitions by major art institutions since the mid-1990s, such as *Hall of Mirrors* at MoCA in Los Angeles, *Spellbound* at the Hayward Gallery, London, *Into the Light* at the Whitney in New York, *X-Screen* at MUMOK in Vienna, *Le Mouvement des Images* at the Centre Pompidou in Paris, or *The Cinema Effect: Illusion, Reality and the Moving Image* at the Hirshhorn Gallery at the Smithsonian in Washington, helped to promote the notion that the proper place of the history of the cinema is now in the museum.

The Hirshhorn Gallery's *Cinema Effect* was perhaps the boldest act of "appropriation," claiming a natural fit between the gallery space and the 'cinema effect.' However, the curators' statements for such exhibitions also address a host of contradictions, which hint that not only film historians realize that matters are more complicated, when the moving image enters the museum. One is reminded of a dictum by Boris Groys to the effect that today art is not made by artists, but by curators, because in order to decide what is art, you have to be in control of the space where it appears, of the institution that guarantees its authenticity, and of the discourses that legitimate it.

It is a lesson that today's artists have also taken to heart, and the sense of ownership I just mentioned also extends to artists, many of whom see themselves as curators, not least as curators of the cinematic archive: a stance that is implicit in the idea of an artists' cinema—the term now widely used in English for what the French call 'cinema d'exposition,' and which refers to artists' use of cinema in their work, whether recycling or reworking classics, and preferably the works of Alfred Hitchcock, or delving into the archives for 'found footage' (sometimes forgetting authorship, stripping context or obfuscating origins of the material in question). However, artist's cinema can also include full length (feature) films, as in the case of Steve McQueen (*Hunger*, *Shame*), Sam Taylor Wood (*Nowhere Boy*) or Douglas Gordon and Philippe Parreno (*Zidane*).

On the other hand, among this younger generation of artists, who began in the 1980s and 90s, and who grew up with both cinema and television, the claim to ownership of the cinema, in and for the space of the museum, articulates itself also on somewhat different grounds: 1) as a genuine love and nostalgia for the movies of their youth, tied to their own cinema-going experience (celebrating cinema history more than film history) or remembering daytime or late night television. In other words, a different kind of cinephilia is present in the films and installations of Douglas Gordon, Tacita Dean or Isaac Julien, from that of museum curators excavating and putting on display the films of Joseph Cornell, Richard Serra, Marcel Broodthaers or Stan Brakhage; 2) This artists' cinephilia no longer shuns Hollywood, or makes distinctions between high culture and popular culture: it raids the icebox, it plunders the archive, it makes films anonymous and turns them into fragments, it celebrates the cinema in the form of found footage compilations, using home movies (Péter Forgács), industrial films (Gustav Deutsch), medical films, pornography, in short, all those areas where the moving image has been used to record and document

Isaac Julien, *Derek: Still Life Study Series, No.1*, 2008. Derek Jarman's Prospect Cottage. Leuchtkasten/Lightbox, 120 x 140 x 7 cm. Courtesy of the artist and Victoria Miro Gallery, London.

processes and actions: artists thereby valorize the holdings that have lain dormant in film archives all over the world, for which no uses could be found.

Although, therefore, the sense of ownership of the cinema on the part of the museums, and the sense of ownership on the part of contemporary artists shows some significant differences, I am nonetheless tempted to use for both the term "the aesthetics of obsolescence," while making a distinction between the museums' "politics of obsolescence" and the artists' "poetics of obsolescence." By obsolescence I am not only referring to the now obligatory presence of the whirring sound of a 16mm projector and the regular clacking of a carrousel slide projector in just about any gallery or one-woman show, nor of such exquisite mise-en-scènes of obsolete technology as Rodney Graham's *Rheinmetall/ Victoria 8*, 2003.

Obsolescence goes deeper, and seems in many ways the overarching concept, under whose broad etymological expanse the appropriation of the cinema can proceed most effectively: when we look it up in a dictionary, the word "obsolete" has at least four distinct meanings: "no longer used or practiced"; "worn away, dilapidated, atrophied"; "indistinct, hardly perceptible, vestigial"; and as a noun, "a thing which is out of date or has fallen into disuse."

What seems crucial is that "in each usage, present and past are both integral and palpable." Obsolescence thus functions like a temporal loop, ensuring that reflection on the no-longer useful reveals the lost promise of the avant garde and vice-versa: the avant garde, aware of its programmatic ephemerality, looks at obsolescence as if into a mirror of its own anxious future. While the museums might see an opportunity to give nostalgia the veneer of guarding the archive, and thus conduct a politics of sustainable obsolescence, the film-, video- and digital artist can practice a kind of poetics, hoping that the technologically deter-

Gustav Deutsch, *FILM IST. a girl & a gun*, 35mm, colour, 93min, 2009. Courtesy of the artist.

mined ephemerality of her work, otherwise destined to oblivion, will be picked up by curators-turned-archivists who catalogue it, store it, study it, and put it on display—now along with the restored and carefully maintained technology that is needed to show it. It is not only that trash becomes treasure, and obsolescence speaks of past newness and of once-upon-a-time utility: The dialectics of (technological) innovation and (capitalist) obsolescence seems to have become, as the phrase goes, the untranscendable horizon of the art world, to which correspond nostalgia and utopian renewal: all taking place within the seemingly closed, self-perpetuating system of the museum.

The American writer Jonathan Franzen has provided a good ad-hoc definition of the poetics of obsolescence: "Obsolescence is the leading product of our national infatuation with technology, and I now believe that obsolescence is not a darkness but a beauty; not perdition but salvation?" Why? Because "Use and abandonment are the aquifer through which consumer objects percolate, shedding the taint of mass production and emerging as historically unique individuals."

More broadly speaking, the strategic use of "obsolescence" lies in the fact that, being a term that inevitably associates both capitalism and technology, it is of special interest in the contemporary art world context, because it implicitly acknowledges that today there is no art outside capitalism and technology. Technology in turn is the bridge from classic modernist art to the cinema, thus perhaps tacitly acknowledging what the new will have found through the old, not against the old. This, as I shall try to show, is also one of the underlying assumptions of media-archaeology as the new film history.

At the heart of this process is the paradoxical cultural moment where to be retro is to be novel, where "going vintage" is "avant-garde." Obsolescence and progress are the recto and verso of each other, and the fact that obsolescence can be the new "new" is both a sign that the fashion system now fully pervades cultural production, and it uncovers the collusion, all along, of avant-garde art and capitalism around "creative destruction." This would confirm an institutional "politics of obsolescence" while still leaving room for an artistic "poetics of obsolescence," both held together by a semantics of obsolescence. Such a poetics can go back to Walter Benjamin's reflections on Surrealism and other classic texts about reclaiming the discarded, the ephemeral and the newly useless. A semantics of obsolescence, on the other hand, would begin from a fuller working out of the implications of Marshall McLuhan's tetrad of media effects, with its four questions: What does the medium enhance? What does the medium make obsolete? What does the medium retrieve that had been discarded earlier? What does the medium flip into when pushed to extremes? If one follows McLuhan, and considers the poetics and politics of obsolescence as only one aspect of a new media dynamics that redefines the spaces of art—while also helping clarify what is 'art' and what is 'medium'—then the history of cinema could indeed be the 'living memory' of art in the 21st century, after having been the fine arts' (unacknowledged) trauma in the 20th.

Tacita Dean, *JG*, 2013. Film still, 35 mm anamorphic film, 26 minutes. Courtesy of the artist and Marian Goodman Gallery, New York/Paris.

Closer to the Concrete Situations

Alexander Kluge in Conversation with Oskar Negt

1. What Does a Happy Failure in a Society of Risk Mean?

Alexander Kluge: There is an expression: "happy failure." When would that be said?

Oskar Negt: "Happy failure" is a somewhat cynical expression said by people who want to assert that we're too wedded to old ideas of job security, employment-for-life, the social safety net, and finally need to begin to look at failure not as an attack on one's identity, but to welcome the fact that there are losers out there and that one can also lose.

AK: Failure can also spur me to reorient…

ON: And not to be ashamed of it or hide it, but to proclaim publicly that today there are a lot more losers than winners. This is a notion that has sprung from the risk society.

AK: What is the risk society?

ON: It's the idea that, basically, you make your own luck. And if you strike out, you just weren't doing it right. So you have to go back to the drawing board and recognize that failure wasn't a rebuke of your efforts or a knock on your character. You should regard failure as a chance to begin anew with a different approach. Every man is an entrepreneur. Every person should behave in an entrepreneurial fashion and bankruptcies and failures are learning opportunities. In my view, it's a rather awful theory that's gaining sway at the moment and spreading. It is absolutely not the case that all people assume the same risks. A top-level manager who loses his job continues to get paid, or a civil servant or an intellectual…

AK: 700,000 Marks severance pay.

ON: They're not going to fall through the cracks. A normal worker, by contrast, a bank employee who's 50 and loses his job can't summon up cheerful optimism when he sees what kind of prospect he has of finding a decent job somewhere.

AK: Take the concept of "devaluation speed." What does it mean?

ON: The devaluation speed can be characterized by the way in which things or circumstances or thoughts are drawn into a maelstrom in which only the most novel and most original and anything that didn't exist before has any commercial value, can be sold. That applies to the whole public sphere these days. It's the search for the intimate, anything that's still unknown. It causes much clamor in the media. But it's a deceptive thing, as we see at present, where many newspapers and news services, not to mention fraudsters, just invent things. They don't do a bit of research, they just plain invent stories. And this devaluation speed has increased. With regard to thought, nowadays everything that's modern, up-to-date, is truer than anything that existed in the past. It's this modernizing drive, the imperative of constantly thinking up new things. But that's related to the rather frenzied fabrication of products, in which the value of a product depends on whether or not there has already been something similar. That's true of fashions, and it's a historical trend that's playing a pernicious role in the devaluation of remembrance and collective memory.

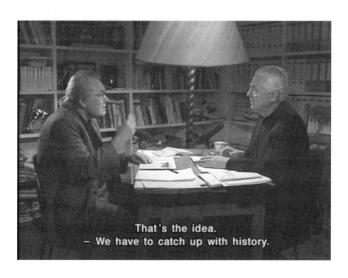

That's the idea.
- We have to catch up with history.

And Napoleon said,
what's all this nonsense about fate,

Revolutions Are the Locomotives of History

ON: Walter Benjamin used a quote from Marx, "Revolutions are the locomotives of history." Benjamin takes a critical stance, suggesting that perhaps the reality is quite different. Revolutions are not the locomotives of history. Instead, revolutions are the emergency brakes which serve to halt a train that's heading for disaster…

AK: … that's going the wrong way.

ON: To stop the runaway train. Revolutions as the halting of history, so to speak. That's also how he regarded the shooting of clocks during the French Revolution—a moment halted, a pause. Humanity begins to reflect about what such accelerations, such movements mean and packs something up that has been left behind.

AK: So if we look at the French Revolution through Walter Benjamin's eyes, if an industrialization takes place, and brings down the old order, politically we have to be up to speed with that industrialization. That's the idea.

ON: We have to catch up with history. It's no coincidence that the French revolution dons the costumes…

AK: … of Rome.

ON: … and the consul, the first consul, is Napoleon. In other words…

AK: He names himself after Caesar. He wants to inherit a political, and institutional authority lost since the Roman empire and of which the French kings of the eighteenth century were simply incapable—they can't do it, are discarded because they can't do it, because they make themselves culpable.

ON: And that's why the Napoleonic paradigm is associated with a new rule—the Solonian constitution, the Draconian constitution. The reclaiming of history. Engels once said, we're reclaiming history. We're reclaiming history, taking that which history left unresolved and putting it in the proletarian revolution. And the French revolution had something of that spirit too, not only in the historical analogies, but by saying we're actually the ones putting an end to this tale of misery through revolutionary upheaval.

AK: A tale of woe. A tale in which fate deals out its blows and the people remain passive.

ON: And Napoleon said, what's all this nonsense about fate—politics is fate. He says that in conversation with Goethe. And that's Walter Benjamin's conception of revolution, in which he moves away from the metaphor of the locomotive, which he associates with speed and forward motion—always forward, always progress. That's even more pronounced in the communist version than in the French revolution.

AK: Avant garde.

ON: Always to the front, he would say, is utter nonsense. It's not revolutionary; it's the processing of the undigested problems of history that's revolution.

2. How Does One Read *Das Kapital*? Or Rather, How Does One Read It in 1932?

AK: There is an edition from 1932 of the 1872 version of *Das Kapital*.

ON: Yes, the second edition.

AK: Prepared by Marx and without any of the alterations that people like Karl Kautsky and other publishers added to it. And Karl Korsch wrote the preface—in 1932. You know, at that time, there's something like National Socialism heading our way. The split in the labor movement has already happened. There's a strike at the Berlin transportation company, in which Communists and National Socialists team up. And now he writes the preface, a sort of user's manual…

ON: "Introduction," as he calls it: How to deal with *Das Kapital*.

AK: How does one read a book like that? Or rather, how does one read it in 1932?

ON: Well, he suggests a reading order that's rather unusual, but it does suit our way of thinking. Not to start at the beginning, which is the systematic part, but to start with "The Working Day" so that first of all the phenomenology of the consequences of capital can be made apparent and, of course…

AK: One day of life-activity.

ON: One day of life-activity. The whole relationship between labor-time and life-activity is treated very extensively by Marx in the chapter on "The Working Day," as it was already indicated in the "Ten Hours Bill" about the achievement of the labor movement and the reduction of working hours. So first you have to get an impression of all

the aspects and the agony-causing problems of capitalism in the division of the working day. Start with that and then read Marx's other chapters that are of a more systematic nature for a better understanding.

AK: When reading this chapter, you land in all sorts of fights. Descriptions of fights for the eight-hour working day, for the ten-hour working day, against child labor. That means you are in a concrete situation and you see... This will become important in the chapter on commodity fetishism. How does it affect the lives of real people? The industrial revolution has two products. First, the factories and commodities, and wealth that capital acquires, and second, cooperation.

ON: Cooperation of living labor. The first thing you mentioned is in a way the accumulated "dead labor," as he calls it. As far as the other is concerned, in the realm of living labor a whole different logic reigns.

AK: It cannot be gained; it can only be accumulated or bought.

ON: And it rebels, too. He ties in this rebellious element with the history of productive force. Living labor carries within itself an element of rebellion towards the dead labor that has deposited itself on top.

AK: That's so incredible about this novel, or rather this commentary work, that these are real people, comparing themselves with others. In every commodity there's a spark of life that is the labor invested in it. These commodities carry a part of it in them.

ON: That's why he speaks of commodities as "dead labor."

AK: If Marx could write like Hölderlin, he would say that commodities are so desirable that when you starve for commodities, you start overthrowing governments. It makes empires implode. That's why dead labor, living labor and buyers' living capacity for desire recognize each other.

ON: Certainly. They are reflections.

AK: Reflections?

ON: Reflections. And... That's his idea of alienation and of self-alienation. If the reflections no longer take place, if that which I produce is dispossessed from me, I am estranged from these objects, that are really my objects and my added value. So to get this estranged world of objects back into the context of the living is actually what real Socialism is. In a way it is giving life to what's dead.

AK: You're saying the resurrection of the dead should be promised?

Alexander Kluge, *News from Ideological Antiquity: Marx—Eisenstein—Das Kapital*, 2008. All film stills in this article courtesy of dctp Info & Archiv.

ON: "Resurrection of the dead" might be too theological and too religious a reading…

AK: Jesus promises it.

ON: But Marx did entertain the notion that "Communism is the production of the form of intercourse itself." The way people treat each other and the way they use objectified objects within the context of their lives is for them an essential element of liberation, emancipation and socialism. As far as that's concerned, the resurrection of the dead, the overcoming of dead labor is an essential element of…

AK: Overcoming it or liquefying it?

ON: If you include the world of commodity in determining the aims of human relationships, it would…

AK: Re-appropriation!

ON: Re-appropriation.

AK: That means the streets, the cities, the habits and laws, but also the machine tools that can build new machines, the inventions, all that is more or less congealed labor. And this labor of our ancestors is our wealth, if we can… I don't mean to say "exploit it," but if we can utilize it…

ON: The idea of Socialism is to reap the harvest of the wealth that has been produced by generations. That is the criticism that Marx levels at capitalism: he cannot reap his own human harvest.

AK: In the "Communist Manifesto" he actually sings capitalism's praise. He praises what it has yielded…

ON: Things like the Great Wall of China. Exactly. But he can't reap it.

AK: He can't keep it, can't save it.

ON: And that's a viewpoint of great current validity. The overflowing wealth of these developed societies is only in part of benefit to these societies.

AK: It vaporizes like in an explosion. If you could put the explosive power in a receptacle, like an Otto engine, that turns it into movement, you'd have harnessed explosive power. That would be the real purpose.

ON: Which is why time and again… This whole idea of these cities in ancient Greece, the "polis" idea… You just mentioned Hölderlin. To him this "polis" idea is the essential concept of polity. That's why this receptacle is time and again… If you see Athens at the time of Pericles as a receptacle…

AK: Where they were in such close contact that mutual decisions could be made.

ON: And the objectified world could be controlled.

AK: If you had to tell someone who hasn't read *Das Kapital* what it's about, how would you summarize it off the cuff?

ON: Basically, what it's about is… I'm speaking of volume 1, as that's the deciding breakthrough, the deciding concept. That's about how capital works with respect to wage labor. The logic of capital.

AK: The production process of capital.

ON: How that works, and in this case what, independent of commitments, of refractions, of ties to the welfare state, what this looks like. Habermas has always criticized, as I and others have, that Marx failed to consider the integration into the welfare state. Today, though, one could argue that capital, for the first time in history, works exactly the way Marx described it in this version of *Das Kapital*, with all the refractions.

AK: Globalization allows it to free itself of all historical circumstances.

ON: And of moral circumstances, often even of legal circumstances. In this respect, *Das Kapital*, as Korsch presents it, has an enormous current validity, showing how one capital kills another. In the last chapters he analyzes the process of circulating capital. And these merger-metaphysics that you witness today have been predicted there. Not in a prophetic way, I think, but in an impressive painstaking analysis of the movement of capital.

AK: Just like mutation and selection are the two rules…

ON: To quote Darwin…

AK: … according to which life regulates chance production, he presents his elements here.

ON: I think he meant to underline the parallels to Darwin. He describes the production process of society. Darwin, on the other hand, described the process of the species.

AK: They are huge thought processes. With what kind of images could one comment on them? To challenge, comment and illustrate, not just to accompany it with pictures. The images should be closer to the concrete situations and thus forever challenge abstractions. With the working day it's obvious.

ON: Yes, that wouldn't be too hard. When he speaks of commodity fetishisms, of phantasmagoria and of people standing on their heads…

AK: What does he mean by that?

ON: Because the exchange-value has started dominating the use-value, although the exchange-value stems from the use-value. So it's topsy-turvy. In commodity fetishism the true history of a commodity is lost, meaning the memory that the commodity would have of its own origin is lost.

AK: It doesn't yet apply to craftsmanship. Look at Cardillac the goldsmith. He makes jewellery and won't give up. He doesn't part with his jewellery.

ON: No, he doesn't.

AK: He doesn't sell it.

ON: He kills the people.

AK: And then he gets back what he produced. The true memory of commodities! Pretty narrow-minded, of course. It'd be pretty tricky if all producers of commodities…

ON: If they are produced as commodities! That's exactly the problem in Balzac's work. There the jewellery is produced as a commodity. Had they been produced for their use-value…

AK: Gobseck, for instance, who produces a daughter and money, in other words, who produces wealth, but he's stingy with both, and doesn't pass either on. First of all that form of behavior is rudimentary.

ON: It's rudimentary. It's the greed of the true collector. A collector doesn't part with anything.

AK: Like a dragon he guards what he has stolen and produced. And in this respect capital is first of all something creative. It upsets all of this—creatively.

ON: That's another important element. If you want to explain to someone what *Das Kapital* is all about, these incredible dynamics that open up all the traditional relationships… Capitalism is the economic system that contrary to the conserving economies of old…

AK: Pharaohs, warehouses.

ON: … only consists of dynamics and of smashing up. Just the way Joseph Schumpeter defines the entrepreneurial human being: "He destroys. He is compelled to destroy old things to enable him to create something new." Something like that has been unheard of in the economy of the household since Aristotle, so ever since people have been thinking about economy. Economy has always been, literally, keeping house meticulously on a long-term basis. What this capitalism is doing is housekeeping on a short-term basis. And basically it passes the costs of it on to the

Marx speaking like Hölderlin /

Marx in der Sprache von Hölderlin / "Wiedererkennung"

If Marx could write like Hölderlin,

How to comment on it with images?

Wie kann man mit Bildern kommentieren ?

With what kind of images

The memory of commodities /

Das Gedächtnis der Ware / "Geiz des Produzenten"

Pretty narrow-minded, of course.

"Creative destruction" /

"Schöpferische Zerstörung" / Dynamik des Kapitals

Creatively.

next generation, to the future.

AK: I'd like to come back to the images. The working day. The sum of all my working days is my life. Now there's a worker who at the end of his life goes to see a doctor and says, "These tablets for my stomach are what I get in return for always having done my best. That's no equivalent. It's no consolation that my employer also has stomach pains and takes the same tablets. Equality is not what I'm after. I want a better life, another exchange."

ON: And maybe better work.

AK: If you compare an entire human life with a working day and the minute an accident at work occurs, like dots on a map, which is a means of navigation, then you see how images develop. They're not as specific as you'd think. They show the scale of things, in what relations things stand.

ON: An image captures a moment that would otherwise go by fleetingly.

AK: The moment is everything.

ON: And the moment is indeed the funneled experience, the funneled living experience that is being captured.

AK: That's how it was meant in life. That's what the moment shows and the entire life, too.

ON: And, of course, we as analysts and to a lesser extent writers, and even all the well-trained analysts of the Frankfurt School, have trouble developing visual worlds that can express in concrete terms what truth analyzes and the findings present. I think there's a kind of aporia, or rather a contradiction between images and concept.

AK: We should learn to treat images in a serial way: show an image, then its variant, then a variant of the variant, etc., so we can learn to comment on images and situations. Language couldn't do that.

ON: I suppose you'd use a lower frame rate than for a normal film?

AK: Much lower. Film doesn't really lend itself to that.

ON: It's too fast.

AK: Much too fast! Besides, a new image erases the old one. Sometimes you're lucky enough that the old ones linger on unconsciously in a memory beneath the memory and sort of "colorize" the new ones, thus creating epiphanies. That's basically what Eisenstein wants, but it's a very weak tool. If someone is insusceptible to it, it won't work. And music made only for musical people is wrong.

ON: The question is, of course, what Eisenstein's intention was in filming Das Kapital. He didn't want to make a film about Das Kapital. It's something different. Eisenstein has always been one to produce didactic pieces and get learning processes going.

AK: Not so here. Here he wanted to say, "I want to leave the anecdotic, the exemplary and didactic that I still had in October and Battleship Potemkin behind. I want to get through to the subtext of the people. I want to show a single day of two people from 2 pm until late at night. In this working day, this day-in-the-life, everything relevant should come up, from world history, to economy and the production process of capital."

ON: Maybe it was an excessive demand on himself. He thought, James Joyce managed it in Ulysses…

AK: He did…

ON: … but he didn't want to do Das Kapital.

AK: Joyce worked with words, not images.

ON: With words. Maybe with words it would have worked, but with images it's extremely difficult.

AK: He could have said, "I'm only doing fragments, and hope the viewers fill in the gaps themselves. They have past experience. It's an incredible resource, the imaginative power of experienced people—viewers.

ON: In that case he would supply the fragments, and they would put them together from experience.

AK: Like attractors. As if it were a dialogue between screen and viewers. That's not entirely utopian. It is very well possible. It could work in a different kind of cinema. That's heterotopia! Now let's suppose he succeeded in getting at least part of it on film, and some other director would have continued and also gotten a part done, and in the protest movement it was taken up again and Godard hadn't made his Ciné-Tracts but concerned himself with this and incited other directors, because it's not impossible to develop such image sequences.

ON: But I'd still be asking myself, what will it add? I mean what is the additional explanatory value? Even if he didn't want to make a didactic piece like Potemkin, what did he want? Did he want to try out some potential of the film medium? The Critique of Pure Reason or Hegel's Science of Logic would be comparable projects. A film project… To develop this as an experiment… Are there any references in his notes as to what he… Why he wanted to do this?

AK: Yes, what he says is at worst it would arouse such criticism of the medium of film that the medium itself would

change. But maybe the film could also have encouraged people to think. Not like a prosthesis or tool but to consolidate thinking in another way. So that thinking doesn't just take place in studies, doesn't just transpire in words, and is not only done by educated people but in all layers of society and to that end I need "situations." It's better to anchor situations with images than with words. There's not much along the lines of situations in *Das Kapital*, but they exist.

ON: There is the situation in which the capitalist and the wage worker confront each other at the end of the chapter on the barter of products…

AK: Let's do it.

ON: One goes forth rejoicing, while the other, according to Marx, goes forth somewhat aggrieved as if he'd sold his skin and is now awaiting the tannery.

AK: Now let's take this literally. In images a situation like that would look very differently in different technical periods. In the case of the weavers the families are right behind them. The men stand before the manor of the factory owner. In open quarrel. With the police looking on nearby to repress the workers. Rebellion. That's a real conflict. Einar Schleef and Gerhart Hauptmann have staged it like that. It's an image. Another image would be when a worker only comes into contact with the entrepreneur via an attorney, the bookkeeper or the cashier. It may be a woman, maybe someone who's associated with him. She may be a promoted worker. That means the contact is getting less direct. The worst scene would be if the entrepreneur is sitting somewhere on the Riviera and the crisis takes place at the factory. A labor dispute while the entrepreneur is far away—the most difficult situation for a dispute or a confrontation. So there are several cases in which personal contact, the convention between the traders, the entrepreneur and the worker, is becoming more and more abstract, until finally, the worker can no longer see the entrepreneur.

ON: Exactly. In *The Critique of Pure Reason* there are many such "situations" like in the schemata chapter on the transcendental dog. This poodle…

AK: The Saint Bernard, the poodle and the Chinese pinscher can all be classified under the concept of "dog," although there's no resemblance.

ON: No resemblance. Moreover Kant says one shouldn't have a single impression of a dog. Such a funny situation!

AK: Still you can easily tell them apart from any kind of coyote or cat, although they can resemble them.

ON: Central to *Critique of Pure Reason*.

"Ideal-typical" images /
"Idealtypische" Bilder / Relative Bilderarmut im KAPITAL

And maybe better work.

The image as "frozen moment"

Das Bild als "kristallisierter Moment"

An image captures a moment

The Weavers, a play by G. Hauptmann

to repress the workers' rebellion.

Child labor in the mines

Kinderarbeit im Bergwerk
This situation has been overcome.

AK: Schematism, yes.

ON: And likewise there are many…

AK: It's a very important image.

ON: … there are many poetical passages in *Das Kapital*.

AK: Let's analyze some of them. Suppose you were to look down on earth from orbit. Near Japan and Shanghai you'd see these kinds of electrical sparks. You'd see the planet illuminated over Europe and over the U.S. You wouldn't see anything on the Pacific and few lights over Africa. What you'd have there is an image of diligence, of what happens on earth at night, or what's working. You have portrayed night work—and cooperation, too, by the way. Coherence. Something you can usually only feel. That could be one image.

ON: It could, yes.

AK: Or let's take another image. In the chapter on the working day Marx describes how children of eleven or even nine years, working in silk production, are being seated on high chairs or platforms so they can reach the machines. But they need these little ones because only they can handle the silk with their little fingers. The silk producers' lobby cries out, "We have to close our plants, if child labor is banned." They win.

ON: The mines demand child labor, too. To keep the tunnel ceilings as low as possible they send in children. That's right. You could use…

AK: Now that is all very pictorial and at the same time it shows how distant these texts are. This situation has been overcome. For once the labor movement won. Here child labor has been abolished and the eight-hour working day was achieved. Here the prime information of the image is to show the distance to the present.

ON: Yes, but the eight-hour working day is being challenged once more today. People are working longer hours again. In this respect that concept…

AK: Hasn't changed.

ON: The division between day-in-the-life and working day has remained a central problem in our present existence. I'm also thinking about images in the chapter on original accumulation, in which Marx says that people move to the cities…

AK: Because they are forced to, their huts are being burned down.

ON: Exactly. And if they don't find work in four weeks,

Child labor in a silk factory

Kinderarbeit in der Seidenfabrik

and the 8-hour working day was achieved.

Alienation of experience – –

Vom Nutzen der Antike: Verfremdung der Erfahrung – –

exactly because that time has past.

FID·MAR

for our imagination.

then I can colonize it with my imagination.

they are brandmarked with an S, as in "slave." If they don't find work in six months, they're executed. Elizabeth I had 72,000 people executed. Beggars and the like. So the social conditions can be translated into images very well. The problem I think will be the theoretical side. If you film *Das Kapital* you must…

AK: Isn't that the thrilling part? These images will be the most thrilling. But they'll be practically useless for an analysis of the process of capital, as even Genghis Khan would have done it, without any meaning. Here it has meaning. That's the difference. That means, the cottage of the English tenants are burned down, because sheep are meant to graze where people used to work, because it raises the exchange value in Antwerp.

ON: And also the chapter in which Marx quotes Thomas More that at least the churches will be used as sheep's pens. That can be rendered into a wonderful image.

AK: Then again, under Napoleon without the process of capital it would be exactly the same.

ON: Exactly. That's why I asked what is…

AK: What is and what isn't essential? What is merely a novel-like and exciting image, making you wait for the next love story that could be included there? Which part is novel, which part is analysis? That'd be very interesting. One thing is important: a distant reality like for instance child labor, these little human beings, these little British girls, standing on their platforms in a silk factory, working away with their little fingers ten hours a day, being used up, is not something of our own time. But to endure watching something like that, a thing of the past, would change your view of the now.

ON: Always.

AK: Because you would look for something similar in our time, and you'd find there's no such thing, not even in Bangladesh. At the same time there are other things. That's "crossmapping," searching for images based on another image. That's just it with classical antiquity. From Latin or Greek texts. I can learn a lot about my own time exactly because that time has past. Because of the notion…

ON: The same goes for political analysis. The rule of the senate, the age of Pericles can shed so much light…

AK: Exactly because it has no reference to our experience, it's like a new place for our imagination. It has to be as far away as the moon. Then I can colonize it with my imagination.

Creative Agitation

Travis Wilkerson

A Proposal

The artist who is also an activist is trapped in an awkward middle ground. Within the world of action, art is always second in stature to the needs of the movement, as it should be. In the worlds of art, whether high or low, politics is always second in stature to commercialism or formalism, both of which are expressions of the same class rule. The truly political artist is left stranded in the space between these worlds, with a muted, often frustrated voice.

The movement demands urgency, which is nearly always at loggerheads with the manner of inspiration that even political art demands. Art and the movement exist on different time signatures and both are the poorer for it. Yet propaganda, in its highest forms of expression, is nearly always artful.

Art, meanwhile, is at a moment of historic crisis, mirroring the deepening crisis within capitalist society itself. This crisis is directly connected to the class character of art in our society.

Marx wrote: "The class which is the material force of society, is at the same time its ruling intellectual force." Culture is likewise contained within this definition.

The art of today is the art of the ruling class. Whether high art or commercial art, all the ruling institutions of culture are expressions of the same class identity and interest. Both demand education, resources, connections, and time that only a tiny, ruling elite can possibly afford. Both are heaved like projectiles over high fortress walls. They differ only in target and rate of exploitation.

High art is created by a minority class for a minority class audience. A minority class creates commercial art for a majority class audience. Popular culture, as the term is presently applied, is therefore a myth and a condescending lie.

It is commonly asserted that art has reached its limit. Everything has already been said, created, achieved. Indeed, it could be said we are in the post-art period, dominated by post-movements, post-post-movements and the ceaseless migration towards sharper alienation.

This is an expression of a simple fact: in the same way the ruling class has begun to exhaust the natural resources of the planet, the ruling class has likewise exhausted its forms of creative expression. If capitalism is an unsustainable form of development, its art is likewise dead and unsustainable.

The problem is not that art has reached its limit, but that ruling class art has reached its limits. In the present epoch, art is strictly a minority activity. What magnificent forms will creative expression take, when the other 99% of humanity finally has the heel lifted from its throat?

The moment has arrived for artists to accept their quota of struggle so that the people may someday receive their quota of art.

Much of this is well understood within the movement. The art world is meanwhile busy counting colors.

What follows is a proposal for a new organization instigated by the broader crisis in capitalist society and its attendant culture.

106

The Principles of Creative Agitation

Creative Agitation seeks to unify the creative and political act in absolute equality. In so doing, it seeks to strengthen the vibrancy of both.

Anonymity is a virtue. The movement should be the author.

Any and all may join Creative Agitation. Membership is defined by action. In any and all events, material aid to Imperialism is an unpardonable transgression.

Creative Agitation will be organized in such a way to help unify the temporal clash between art and the movement. Therefore work will be organized into large thematic campaigns, lasting several months or longer, as well as rapid response actions, in response to unexpected and urgent needs.

The group has set itself the task of organizing a laboratory of creative political expression. The group will explore the use of any and all creative media, organized into semi-autonomous, artist-led brigades using traditional and new media, based on the knowledge, skills, and interests of group members.

Each brigade will be responsible for organizing practical creative workshops for members of other brigades with the aim of raising the cultural level of all while also instigating the discovery of new hybrid forms.

Creative Agitation has a special obligation to oppose any manifestations of reactionary culture, particularly those that present "apolitical" bourgeois artists as politically neutral.

Bourgeois art and bourgeois art events should be endlessly turned against themselves.

An urgent task of Creative Agitation will be the organization of Public Art Defense Leagues that can respond rapidly and forcefully to endangered Public Art.

Creative Agitation above all else will strive towards bold, concrete proposals, inspiring enactments of different models of human existence; a combustible sphere where art and action collide, and where the truly imaginative capacities of creativity can finally be put to meaningful use.

The Death and Life of the Avant Garde: Or, Modernism & Biopolitics

Evan Mauro

When Peter Bürger declared it "historical" a generation ago, the avant garde's potential as anything more than a periodizing term was thrown into question. Subsequent criticism has tended to prove Bürger right: the trajectory suggested in his *Theory of the Avant-Garde* has been largely accepted, and the story of the twentieth-century avant gardes is invariably a story of decline, from revolutionary movements to simulacra, from *épater le bourgeois* to advertising technique, from torching museums to being featured exhibitions in them. Consensus has settled on an interpretation that has the avant garde crashing on the reef of postmodernism sometime around 1972.[1] Outside of historicist modernism studies, the avant garde's treatment has been even less kind. In social and political writing since at least the Situationists in France, its fraternal twin "vanguardism" has become a leftist code word for an outdated strategy, no longer the necessary ideological and intellectual preparation for social transformation, but rather an anti-democratic elitism and crypto-totalitarianism.[2] To bring the story right up to date, today any putatively transgressive artistic practice falls flat against, in no particular order, intellectual relativism, a culture of permissiveness, and state-supported, market-segmented cultural difference—the avant garde's ancient target of a stable bourgeois moral order long since displaced by the universal imperative to "Enjoy!"[3]

Any discussion of avant gardes today is immediately marked as belated, gesturing back to a period when the term named a viable desire to move beyond the limits of liberal capitalism.[4] What I want to suggest below is an alternate genealogy of avant-gardism in the twentieth century that might avoid that nostalgia. Alain Badiou has recently argued that the avant garde has a double life today: "More or less the whole of twentieth-century art has laid claim to an avant-garde function. Yet today the term is viewed as obsolete, even derogatory. This suggests we are in the presence of a major symptom."[5] The critical narrative reconstructed above can't be the final word if avant-gardist discourses and objects have been proliferating. Critical discourses nevertheless continue to disavow them. If the avant garde is indeed a failed political concept, what does it say that many of its forms, rhetorics, and basic gestures survive beyond its expiry date, especially in today's anti-capitalist and alter-globalization movements? Relatedly, if one principal reason that the avant garde has passed out of favor is a postcolonial critique that sees, with

good reason, Eurocentrism and false universalism at the heart of the concept, then what can contemporary critical art take from that critique? This strikes me as especially important today, in the context of a new series of transversal social movements, from Cairo to Madrid to New York and beyond, which ground themselves in direct democratic principles that eschew past vanguardisms on the left, or really any organization of political struggle around the categories of nation and party. At the same time, these movements retain central avant-gardist notions of collective authorship, the struggle of the commons against property, and the desire to build new forms of life and social reproduction outside of capitalism's governmental and institutional order. The first conjunction I want to analyze carefully, then, is the avant garde's link to vanguardism and political centralization: necessary, or historical?

The genealogy I sketch below understands the tie between avant gardes and political vanguardism as historical and contingent, which makes the history of critical art in the twentieth century, and the history of its criticism, more difficult to square with Bürger's thesis. By eliminating the distance between art and life, avant gardes wanted to revolutionize both. Bürger's *Theory* insists that this narrative ends with the triumph of a culture industry that effectively accomplishes the avant-gardist "art into life" program, but within a capitalist framework and as a constantly proliferating source of economic value. By reinterpreting the historical avant gardes' initial concept of "life," I want to reconsider this trajectory. I have in mind Jacques Rancière's remarks on the early-twentieth-century avant gardes' pursuit of new "forms of life" with their anti-representational strategies. Rancière's argument applies to a broader history of aesthetic regimes, but he points out that modernist avant gardes have the virtue of foregrounding the closures of the existing "distribution of the sensible," and so they point not to an inevitable descent into commodification and totalitarianism but "the invention of sensible forms and material structures for a life to come."[6] In Italian Futurism, I argue, we can see a specific instance of the tension between vanguardism and the invention of new sensible forms: the politicization of life designed as an alternative criterion of value to liberal capitalism's regime of accumulation. It was short-lived, however, and so I want to retrace the itinerary of avant-gardism past the Futurists and through the later twentieth century. I ask how the avant

Value struggles over forms of life: In collaboration with a coalition of community groups doing housing activism, Not An Alternative produced *Occupied Real Estate* projects to disrupt monthly foreclosure court auctions. The actions have been produced on a monthly basis since January 2012. Photo by Not An Alternative.

gardes' eventual appropriation by capital was not the negation or perversion of a state-revolutionary project, but a contingent and labile value struggle that wanted to find new modes of aesthetic valuation, and became attached to larger revolutionary projects at specific conjunctures. From this perspective, the concept of the avant garde indicates a political struggle over life and reproduction that is very much still with us.

Avant Garde, Value, and the Politics of Life

Bürger's basic point, which I want to pause over for a moment, is that the historical avant gardes threw into question how bourgeois society values art. This is important to recall if we want to broaden our conception of how a critique of aesthetic autonomy, which meant to undermine aesthetic taste and the institutions that supported it, became allied to other, larger political projects. Even in a movement like Italian Futurism, which has long been a boundary case in discussions of twentieth-century avant gardes (for reasons I will discuss below), the first target was the question of aesthetic value.[7]

Well before the avant garde's apparent death, in the middle of its first full manifestation in the twentieth century,

Futurists Bruno Corradini and Emilio Settimelli offer a new vision of what art can be, requiring a different measure of the value of artworks. In their 1914 manifesto "Weights, Measures and Prices of Artistic Genius," the authors argue firmly against art's autonomy from other spheres of productive activity:

> The artist of genius has been and is still today a social outcast. Now genius has a social, economic and financial value. ... The Artist will finally find his place in life, along with the butcher and the tyre-manufacturer, the grave-digger and the speculator, the engineer and the farmer. This is the basis of a new universal financial organization through which a whole series of activities, formidable in their development, completeness and importance, which have remained up to the present time in the grip of barbarism, will be fitted into modern civilization.[8]

In order to integrate artists more fully into the process of production, the manifesto's authors invent a metric for the calculation of aesthetic value. A new appraiser, or "measurer," will evaluate a work's "genius" by essentially calculating its eccentricity. Outlandish analogies and juxtapositions are evidence of the amount of neurological energy, or genius, that went into a piece's production, as well as how much energy it will effect in its readers: "The quantity of cerebral energy necessary to produce a work is directly proportional to the resistance which separates the

elements before its action is felt and to the cohesion which unites them afterwards."[9] This criterion is quite obviously self-serving, as it favors precisely the kinds of wild recombinations of media and objects that Futurism had made central to its style. No small irony, then, in their claim that this was a defense against arbitrariness and charlatanism in art markets: "We therefore ask the state to create a body of law for the purpose of guarding and regulating the sale of genius. One is astonished to see that in the field of intellectual activity fraud is still perfectly legal."[10]

Underlying the fairly transparent self-promotion in this manifesto is the notion that "the work of art is nothing but an accumulator of cerebral energy," and that artworks, too, can stimulate social activity.[11] Implicit in this new basis for evaluating art, however, is a thoroughgoing rejection of the capitalist system out of which the sphere of aesthetics developed: in arguing for their new "energy" metric, they were dispensing with all those market-based valuations of aesthetic objects, with the attendant cultural capital, that could be accumulated by the collector. Theirs was a measure of the social utility of the artwork that simultaneously rejected the whole premise of art as surplus activity and surplus value, along with all those works that had accrued such value in Italy. Just as Marx had shown that the science of political economy was based on a price fundamentalism that effaced all traces of productive processes and social relations from the commodity's surface, these Futurist writers wanted to question the reified value of artworks by reinstating the productive process and the social effect these artworks could have. Their alternative criteria for aesthetic value was, it has to be acknowledged, based on mystifications like the social "energy" artworks put into circulation, the scarcity of "genius" on which art markets depend, and, most importantly, the "life" that artworks foster, but the fundamental point was a struggle over how art was, and should be, valued. They rejected an entire critical apparatus that turned art into cultural capital, a mode of "disinterested" objectification and speculation that, as Pierre Bourdieu's research has shown, reinforces class domination by indirect means.[12] Instead, the Futurists wanted a full accounting of art's productive processes and social effects. This was the core of the avant-gardist slogan "art into life": art would no longer be a separate sphere into which surplus value was invested. By foregrounding not only artistic process, but art's ability to constitute and transform social relations, the Futurists contested the institutional frame in which art was valued under market capitalism.

The alternative criterion of value in this manifesto derives from Futurism's naïve privileging of scientific and biological tropes of formless life. Previously calling itself *Elettricismo* and *Dinimismo*, Futurism coalesced in 1909 around a concept of "living art," wanting to "sweep the whole field of art clean of all themes and subjects which have been used in the past" in its initial, iconoclastic phase, and then reconstitute an aesthetic that would "breathe in the tangible miracles of contemporary life," devising new forms of representation "splendidly transformed by victorious Science," to capture "the frenetic life of our great cities."[13] Futurism borrowed extensively from Bergsonian vitalism and turn-of-the-century life sciences, two discourses that contributed to a modernist concept of life that Georg Simmel in 1913 called the "dominant in the philosophical interpretation of the world" of that moment, "represent[ing] the 'secret being' of the epoch."[14]

When Corradini and Settimelli highlight the problem of how art is valued in a capitalist society, the authors thematize, but only partially realize, the central problem that avant gardes all through the century have attempted to address. The narrative of the death of the avant garde in the twentieth century, notably in Bürger's *Theory*, is about the end of any kind of autonomy for art, and the ultimate failure of avant gardes to define some sphere of life outside of the commodity world to which they were eventually assimilated. But what I want to propose is that in some sense the reverse is true: avant gardes have been defined by their ability to repeatedly generate new autonomous spaces of critique, however temporary and liminal. What I suggest below is that avant-garde practices are today and have always been less an example of art's diminishing autonomy from the political and economic spheres, and closer to what Massimo de Angelis has called a "value struggle."[15] For de Angelis, the closing down of autonomous spaces of critique is not a one-way street, in which all of capital's outsides are eventually colonized, infiltrated, and reified; rather, even under advanced global capitalism, outsides are continuously generated any time there is a struggle over the means of social reproduction, or over the capacity for groups and collectivities to engage in non-capitalist forms of social exchange and relationality. The struggle over how social relations would be reproduced, or reconstituted from scratch, was decisive for the historical avant gardes and shaped the utopian horizon of the first decade of Futurist manifestos. Value struggles meanwhile remain central to current-day political opposition to processes of primitive accumulation and the enclosure of various commons that is at work in today's globalized accumulation strategies. De Angelis argues convincingly that the everyday social field is also made up of non-capitalist value practices and reproductive processes, and so any model of a totalizing capitalism that rearticulates all forms of social cooperation as market-based exchange misses a key part of the picture and, worse, limits our ability to theorize and practice real alternatives.[16] If avant gardes are, following de Angelis, constantly generating new "outsides" to capitalist production and reproduction, then the avant-garde problematic has been prematurely laid to rest.

The difference between the turn of the twentieth century and the turn of the twenty-first, then, is the relative importance of the state as a mediator of social reproduction. Futurists were part of a modernist political epistemology

for which the state was the horizon of social reproduction, and so their struggle against liberal capitalism's value regime was conjoined to a national revolutionary politics. To illustrate this historical difference, consider that Settimelli and Corradini's call for a centralized administrative body for the valuation of art works, a "measurer," doesn't sound all that outlandish now, after the postwar establishment of arts funding and granting agencies in many advanced capitalist countries. Clearly some reversal has taken place in the strategies of value struggles.

The Avant Garde Is History, but Which One?

One of the reasons for the conceptual exhaustion of the avant garde is, following Bürger, that aesthetic autonomy presents art with a paradox. As we've seen, the Futurists are ready to obliterate autonomy entirely, merging art with life and situating the artist "along with the butcher and the tyre-manufacturer, the grave-digger and the speculator, the engineer and the farmer." Bürger and de Angelis, despite many differences, agree that some distance from productive spheres is a necessary condition of critique; it is the disappearance of that distance that motivated Bürger to announce the death of the avant garde in the first place. And so a recent twist in the narrative of the avant garde should be a cause for concern.

In *The New Spirit of Capitalism*, Eve Chiapello and Luc Boltanski point out that avant-gardism has filtered its way into management seminars: its anti-establishment shock techniques are now functionalized as organizational strategy. Surveying a large sample of American and French management texts from the 1990s, Chiapello and Boltanski observe that the once-opposed logics of managerialism and the avant garde have begun to overlap significantly.[17] On the one hand, artistic work is increasingly a managed enterprise: as Hal Foster decries in *Design and Crime*, "a nexus of curators and collectors, dealers and clients" has taken over the functions previously assigned to artists and critics, compromising the autonomy, or nominal autonomy, of both art and criticism. This phenomenon is confirmed by George Yúdice's *The Expediency of Culture*, which documents the development of a new globalized regime of arts administration and international exhibitions.[18] But on the other hand, and reciprocally, business management itself has been transformed. In its shift from the hierarchical models of Taylorist planning in favor of postmodern, flexible networks of improvisation, entrepreneurialism, and self-management, the management of enterprise has, Chiapello observes, deployed avant-garde rhetorics and techniques to transform itself. Organized anarchy, workplace insurrection, business revolution: the shift is more than terminological, and goes well beyond the longstanding corporate predilection for military metaphors (including voguish references to Sun Tzu and Clausewitz as sources of business wisdom).[19] If the purpose of avant-garde intervention has always been the destruction of out-dated hierarchies—of representational form, of cultural capital—then management has been on board since the post-Fordist turn, in which, as one *Harvard Business Review* writer put it, "greater speed and flexibility undermines hierarchy."[20]

It would be easy to interpret the avant garde's migration to management training as just the latest chapter in Bürger's narrative of the avant garde's assimilation to capital. The endurance of his critique lies in the basic antinomy that he attributes to the historical avant garde. If Surrealism, Expressionism, and Dada all gestured towards a radical transformation of society by shrinking the distance between art and life, by reconciling elitist "institution art" to an everyday "life-praxis," this synthesis could only come at the expense of the very space of cultural autonomy that made their critique possible in the first place.[21] Having developed out of the bourgeois separation of the cultural sphere from politics and economy, the historical avant garde marks the moment of culture's self-criticism; but in the end the avant garde was unable to overcome its own merely-cultural status, an internal contradiction that has manifested itself over the course of the twentieth century in the eventual synonymity of "avant-garde" and elitist formal experimentation. Bluntly, the historical avant garde was undone by its faith in aesthetic self-critique as a sufficient condition for social transformation. So Bürger's *Theory* doesn't only announce the collapse of the historical avant garde under the accumulated weight of its misplaced ambition, but warns against the possibility of trying to revive it. He argues that the real successor to the avant garde's attempted negation of aesthetic autonomy is not the 1960s neo-avant gardes who would revisit pastiche and minimalism, Dada and Constructivism, Duchamp's readymades and Rodchenko's monochromes, in an implied critique of the museumization of high modernism, but rather the "false sublation" of the commodity form, or mass culture's union of art and commerce.[22] The recent reorganization of business along avant-gardist principles, then, is an intensification of Bürger's logic, or proof of his original complaint that reducing art to life under capitalism could only result in further encroachments on autonomous spaces of critique.

Boltanski and Chiapello's argument suggests a different periodization. The central historical argument of *The New Spirit of Capitalism* is that the long-term effect of France's 1968 uprisings has been a transformation in capitalism's mode of self- justification, a "recuperation" of 1960s-era anti-capitalist and anti-state critiques, after which such critiques are not only structurally impossible but deployed as part of capitalism's very logic of expansion.[23] Boltanski and Chiapello show how the central premises of the 1960s critique of capitalism—a demand for liberation (from administered lives, state and normalizing apparatuses) and rejection of inauthenticity (of consumer conformity and spectacle)—are, on the one hand, a continuation of an

"artistic critique" of alienation under capitalism that was inaugurated by the avant gardes of the late nineteenth century, and on the other hand ultimately neutralized by the shift from rational-bureaucratic to post-Fordist and neoliberal models of labor organization.[24] Personal fulfilment and liberation have been recuperated by capitalism and located within the organization of production, itself reoriented in the direction of labor flexibility, self-management, and project-based adhocracy. Management's guiding principle has shifted from Fordist discipline to neoliberal "workforce participation."[25] All of this means that Boltanski and Chiapello give sociological substance to a familiar point. What has elsewhere been termed the "real subsumption" of labor to capital, or the realization of a world capitalist system and the turn to intensive, as opposed to extensive, forms of accumulation, is felt here in Boltanski and Chiapello's picture of the contemporary regime of business management. One key consequence of real subsumption, according to Michael Hardt and Antonio Negri, is the rise of immaterial labor, or the transformation of previously semi-autonomous spheres like intellectual and cultural work, as well as the very production of subjectivities, into a new source of the production and accumulation of value.[26] Put differently, demands for personal or collective autonomy can no longer be positioned as critiques of an impersonal and alienating wage-labor system, but are instead requirements of the system itself. From the proliferation of personalized goods and service economies, to the demand to view one's own employment as the never-ending expansion of human capital and transferable capacities under flexible employment regimes, capitalism's absorption of the oppositional politics of the avant gardes has been nothing less than total: the familiar Surrealist critique of instrumental rationality, "take your desires for reality," was only too easily converted into a post-behaviorist principle of "employee empowerment" and *Liberation Management*, to borrow the title of one business bestseller.[27]

What Boltanski and Chiapello's recuperation thesis makes possible is a finer-grained genealogy of avant-garde practice. Bürger's thesis, in all its finality and despair at the avant garde's "false sublation," has to be understood in its historical moment, at the conjuncture where the real subsumption of the social begins to impose itself in earnest; as Fredric Jameson has argued, the end of the 1960s saw those last few untouched spaces of social reality, or standpoints of potential resistance "from the outside"—the Third World and the unconscious—succumb to the all-encompassing logic of the commodity.[28] Bürger's thesis on the intractable contradictions of the avant garde, its negation of its own autonomy, is unmistakably a document of this critical closure. The aspects of Bürger's critique that speak the clearest today are the many nods towards May 1968, when, as he notes in a postscript, "the hopes of those who, like myself, believed in the possibility of 'more democracy' in all spheres of social life went unfulfilled."[29] Bürger's

intervention stands as a sort of summary judgement on two decades of artistic and theoretical engagement with the avant garde concept, from echoes of Dada and Constructivism in the work of postmodern visual artists like Rauschenberg, Warhol, and Johns, with all their implied and overt contestation of high modernism's ascendance in galleries and art criticism; to Situationism's direct lineage from Surrealism, and its intensification and re-politicization of the Surrealist critique of instrumental rationality and the dead forms of capitalist reification with the irrationalism of the dream image and the motility of desire; to, in criticism, the real emergence and codification of the avant garde as an intelligible critical category, and no longer only a performative self-description by artists, in the work of critics like Renato Poggioli, Hans-Magnus Enzensburger, Leslie Fiedler, and others.[30] Bürger's thesis, it seems to me, is significant primarily as a document that recognizes the real subsumption of the social at the moment it was set in motion.

But this raises the question of what the concept of the avant garde had to offer a critique of capitalism in the 1960s, or why it became necessary to evaluate social and artistic movements of that decade in terms of a prior cultural formation. Here the picture gets complicated, but in broad outline, the failure of the historical avant garde was only partial: its critique of a moribund liberalism in politics and economy, of a philistine and classicist national bourgeois culture, formed the very basis of the planned economies of the mid-twentieth century. In a word, its critique of bourgeois liberalism paved the way for the mid-century "managerial revolution."[31]

In its various, and widely disparate, forms—fascist corporatism, the Soviet five-year plan, the Keynesian economic dirigisme—planning formed an ideological consensus that displaced classical liberalism's axiom of free competition and, for the problematic raised by the avant garde, produced new avenues for integrating culture and industry and a whole new conception of culture as work, cast in the image of the designer—as well as new resistances to integration. In the analysis of the architectural theorist Manfredo Tafuri, "the ideology of the plan" was nothing less than capitalism's mid-century recuperation of the avant garde, a transformation of the negative critique of the cultural apparatus articulated by Futurism and Dada into more production-friendly schools of design modernism like De Stijl and Bauhaus.[32] These latter rapidly became the hegemonic form of modernism, which cut across political divides: "Organization and planning," argues Tafuri, "are thus the passwords of both democratic socialism and democratic capitalism."[33] We would have to add to Tafuri's bipolar map of the twentieth century the uses of planning in developmental policies enacted primarily in African and Latin American countries—and indeed the idea of a modernizing "Third World" itself has to be considered a key symptom of the near-global acceptance of the ideology of

the plan.[34] For Tafuri, utopian design modernisms were the dialectical realization of the first, negative moment of the historical avant garde, whose critique of the residues of classicism cleared the way for the ambitious planning projects of Le Corbusier or El Lissitzky, and the transformation of everyday life by industrial design in Walter Gropius. That these were a partial version of the transformation of life envisioned by the historical avant garde, or in other words capitalism's homeopathic defense against more radical systemic change, is precisely how we should understand the mechanics of recuperation to work.

All of which is to say that the 1960s rediscovery of the avant garde was, in a sense, directed against its own false realization. But here it becomes necessary to make a distinction between specific historical avant gardes. The particular movements Bürger takes as paradigmatic of the historical avant garde period are Surrealism and Dada especially, with some space dedicated to the Frankfurt School's uptake of Expressionism. All of them contest the very forms of instrumental rationality that would manifest themselves in the Fordist rationalization of production and the managerialist basis of the postwar Keynesian state. As some critics have noticed, Bürger neglects the Futurist movement almost entirely.[35] On the one hand this omission is confusing since Futurism appears to meet his minimum requirements as a movement that made the destruction of the cultural sphere and the integration of art and life its most basic tenet, and did this nearly a decade before the movements he chooses to investigate. The easy explanation for Bürger's avoidance of Futurism is its eventual accommodation to Fascism, which is a much more complicated issue than it appears, but has been an insurmountable barrier for leftist critics both before Bürger and since. The more likely reason that Futurism is overlooked in Bürger's *Theory* is because its totalizing ambitions looked too much like the expanded state-form of the postwar period, from which Dada and Surrealism offered a potential, but ultimately contradictory, liberation—what Roland Barthes once dismissively called a "life style" avant-gardism.[36] By contrast, Futurism's scope was all-encompassing. It sought to rehabilitate much more than just a stagnant art world. The range of targets in its manifestos includes the institutions of parliament, industry, church, and schools, but also the disciplines of city planning, architecture, fashion, cuisine, and far beyond: witness Giacomo Balla and Fortunato Depero's 1915 manifesto called "The Futurist Reconstruction of the Universe."[37] From their agenda-setting critique, it was only a few steps to realize midcentury planning ideology, or "a utopia serving the objectives of the reorganization of production," in Tafuri's words.[38] And so if the avant garde re-emerged as a critical category during the 60s, it was partly as a discourse of complicity: this is the other side of Bürger's antinomy, where the false sublation of art's autonomy meant its ability to envision, and then find a place within, the institutional and administrative expansion of the mid-century state.

As for Bürger's own false sublation of the avant garde, the commodification of everyday life, it too stands to be folded into this periodization. One of the more historically and ideologically remote aspects of the early avant gardes is their unproblematic enthusiasm for industry and mass production. But this enthusiasm needs to be considered in the context of a widespread productivism that threads its way through even the most radical writers of the period—recall Gramsci's enthusiasm for Fordism, his question of how it would restructure social conditions far beyond the factory floor.[39] But it must be remembered that mass commodity production—all those mid-century labor-saving consumer durables, along with Keynesian full-employment policies and the expansion of the welfare state—offered an unparalleled mobility and freedom from the constraints imposed by a more family- and location-based bourgeois capitalism. It was in this way that planning and industrial design were positioned as market-based solutions to the demands for liberation posed by the historical avant garde. As Peter Wollen's *Raiding the Icebox* argues, modernism itself can be understood as a kind of "cultural Fordism," negotiating the impact of an emergent Fordist-Keynesianism in phenomena as varied as film (Chaplin's *Modern Times*, Léger's *Ballet Mécanique*), Surrealist automatic painting, architecture (New York's 1920s skyscraper boom), fashion (Coco Chanel's unadorned "little black dress"), criticism (Clement Greenberg's radically abstracted formalism), and academic disciplines (Vienna Circle linguistics, with its anti-metaphysical approach to language, indeed, to reality itself, as segmented parts open to rational analysis). For Wollen, mass production had worn out its welcome by the 1960s, when it was met with the parodies of standardization in Pop art (Warhol's "factory") as well as the détournements of the Situationists. By the time of Bürger's critique, mass consumption itself had so saturated the social world that another liberation was needed: Dada and Surrealism's anti-rationalization critiques, then, were revived for a time in order to contest the "bureaucratic capitalism" that Guy Debord's *Society of the Spectacle* called "the concentrated form of the spectacle," an anti-technocracy, anti-rationalization stance adopted from the *Socialisme ou barbarie* group.[40] Important here is that consumption, too, was determined by the logic of Taylorized production and centralized management, and required a kind of Copernican revolution in consumer orientation to absorb the anti-establishment zeitgeist of the 1960s: as Thomas Frank argues in *The Conquest of Cool*, the conformity of mass consumption was transformed by Madison Avenue into individualized appeals to self-realization that make up what he calls a "countercultural style," which has only since continued to develop in the direction of personalized niche products and experience economies.[41]

So it becomes necessary to recognize two distinct moments of avant garde recuperation by a resilient and adaptable capitalism. First, the historical avant garde set itself against bourgeois liberalism, whose expanding industrial organi-

113

zation was at odds with its residually classicist culture, and provided the aesthetic and ideological critique necessary for an ascendant managerialism. Second, in the 60s, the avant garde was again appealed to, this time as a discourse of liberation from the hegemonic state forms of managerialism that were derived, ironically, from the historical avant garde itself. Our present-day unease with the avant garde concept follows in the wake of this second recuperation. It may not be necessary to add that capitalism's recuperation of these avant garde critiques ignored the more radical claims for social change to which they were, in their historical moments, linked, from the anarchism and syndicalism of Dada and Futurism, to the council communism that underpinned Situationism's notion of self-management.[42] Instead, the recuperation of these critiques essentially assimilated their aesthetic forms, their critiques of hierarchy and alienation, and turned them into new models for the accumulation of value.

Like any survey, this one is cursory. But one advantage of starting from an analysis of recuperation—or how cultural and political formations move against and then within a dominant order or rationality—is how it explains a certain definitional confusion around modernism's politics: why certain modern movements can seem to be both revolutionary and reactionary, or rather why they look radical from one vantage point and conformist from another. But that problem dissolves if we adopt a thoroughly historical understanding of these movements, one that refers to broad changes in the organization of production as well as the different justifications used to perpetuate them. For example, the problem I opened with—avant-gardism as management doctrine, and as part of a new labor regime based on flexible networks—seems a scandal precisely because our conceptual tools for the avant garde are outdated. The fact that Bürger's *Theory* remains the standard reading of the avant garde today should tip us off that our concept remains locked within the constellation of terms that emerged in the anti-commodification critique of the 1960s.

Contemporary Disavowals

Today, the dynamics of the avant garde have changed: after the real subsumption of cultural work, or in other words at a point where culture's ubiquity and non-autonomy are the condition of possibility of cultural work at all, any purportedly resistant cultural or artistic practice has been forced to redefine its aims and terms. Typically these redefinitions are accompanied by an almost ritualized, anxious disavowal of the avant garde, but with decidedly mixed results. One strategy can be found in the 2005 book *Collectivism after Modernism*, whose editors situate their idea of the kinds of artistic resistance that have been on the rise since the eclipse of modernism in a collectivist "general intellect," following Italian autonomia, where the legacy of the avant garde is reclaimed for political radicalism, though in spectral, almost spiritual, terms:

This new collectivism carries with it the spectral power of collectivisms past just as it is realized fully within the hegemonic power of global capitalism. Its creativity stands in relationship to the modernist image and the postmodernist counterimage much in the same way that the multitude of Sunday painters and other amateurs does to the handful of art stars: as a type of dark matter encircling the reified surfaces of the spectacle of everyday life. Vastly more extensive and difficult to pinpoint, this new collectivist fetish inhabits the everywhere and nowhere of social life. In so doing it gives its own interpretation of the old avant-garde banner—"art into life!"—that it proudly carries forward from its predecessors: that the ancient dream of the glorious, all-encompassing body of the collective—of Christ or God or Allah or King or Leviathan or Nation or State or Public—the dream of redemption, of experiencing the imagined community as an end to alienation and as a promise of eternal life, realize[s] itself not as an image or as flight from images but instead as a form of social building that brings itself into being wherever and whenever it can.[43]

This model of a resistant art, claiming some distance from the avant garde, though retaining its sense of collective authorship, is drawn from Hardt and Negri's concept of the constituent power of the multitude, and is compatible with approaches to critical art taken elsewhere. Nicholas Bourriaud's grouping of a series of 1990s art exhibitions as a "relational aesthetic," where the gallery space is a sort of laboratory in the exploration of new social forms and the constitution of communities, is one version of this post-avant-garde collectivism.[44] Many of the exhibitions cited by Bourriaud and Claire Bishop that fall under this category take as their subject matter figures and bodies of the multitude—service workers, undocumented immigrants[45]—and use the gallery space as the site of a suspension or *détournement* of marginalizing discourses or forms of labor in an attempt to "fill the cracks in the social bond"[46]; from Rirkrit Tiravanija's interactive installations, in which the artist takes up the position of a service worker by, in one example, cooking for gallery patrons and creating a convivial, reparative space for open-ended sociability, to Santiago Sierra's more confrontational "ethnographic realism," which foregrounds an exploitative and exclusionary economic and legal order by, in the case of his exhibition at the 2001 Venice Biennale, paying undocumented immigrants who work as the city's street vendors to dye their hair blond and then inviting those who typically surround the biennale into his exhibition to sell their goods.[47] However, Bourriaud's rejection of the world-historical ambitions of the avant garde and his accompanying restriction of relational aesthetics to the "laboratory" of the gallery space—a complaint that has been raised from several quarters—are signs that the avant garde's most fundamental problematic, the autonomy of the aesthetic from the economic and the political, returns here in all too familiar form: to its credit, Bourriaud's relational aesthetic has thematized that divide, but how it might be surpassed remains, in his writings, unclear.[48]

Another post-avant garde development, vastly different in tone and scope, is *The Coming Insurrection* (2009) by the

Invisible Committee. It resuscitates the avant garde's signature genre, the manifesto, in a blistering anarcho-autonomist critique of the contemporary global order. The text's call to action tries to dissolve any residual twentieth-century vanguardism in the very act of negating the category of authorship, with its "invisibility" metaphor and the accompanying claim that the manifesto's ideas are drawn directly from the multitudes themselves: "This book is signed in the name of an imaginary collective. Its editors are not its authors. They were content merely to introduce a little order into the common-places of our time, collecting some of the murmurings around barroom tables and behind closed bedroom doors."[49] More than mere conceits, these gestures towards authorial self-dissolution are part of a larger strategy of struggle, or perhaps more properly an anti-strategy, aiming to "turn anonymity into an offensive position"—the point being that identifiable and visible groups open themselves to police repression or market appropriation, and meanwhile exploitation has reached such a point of saturation that resistance could conceivably begin anywhere, or everywhere at once. It remains to be seen whether this anti-organizational politics, based as much on Deleuzian lines of flight as coalitions of anti-globalization activist groups in recent years, can overcome its very formlessness, or what Ernesto Laclau has called the lack, in the figure of the resistant multitude, of a theory of articulation.[50] For my purposes here, the issue raised by *The Coming Insurrection* is the tension between its imagination of a creative, adaptable, distributed resistance and the apparently still-necessary act of writing a manifesto, which is perhaps better stated as a contradiction between content and form, or ends and means; in this text's case, a disavowed vanguardism seems by necessity to reappear at another level, in the performative contradiction of an anti-vanguardist manifesto.

Still, if the political horizon of these movements is a genuinely globalized capital, then how does the concept of the avant garde resonate outside the West? This raises a theoretical legacy that routinely excludes non-western avant gardes, both historical and contemporary. To fully appreciate the challenge to the concept of the avant garde from the non-western world, I want to draw from George Yúdice's 1999 essay, "The Avant-Garde from the Periphery." Yúdice argues that if an essential element of avant gardes is the imaginative proximity of social revolution, in Perry Anderson's phrase, then this insight needs to be tempered by a global perspective that de-emphasizes the 1917 Bolshevik revolution as the *sine qua non* of a strictly western avant-gardism. Anti-colonial revolutions and uprisings swept across the non-western world in the early twentieth century, particularly in Latin America and the Caribbean, and each adapted avant-gardist techniques to its specific circumstances. Focusing particularly on Nicaragua and Brazil in the 1930s, Yúdice shows how avant-gardism was often combined with indigenous and ethnic traditions in order to create national cultures that would contest the deterritorializing forces of imperialism. In many cases, peripheral avant gardes were enthusiastic about the forces of modernization and development, which in those contexts contested the rule of an older oligarchy. That legacy has made the contemporary reception of "global" avant gardes problematic: the tendency is for western art institutions to delegitimize them by a double strategy of ghettoization—metropolitan exhibitions themed on "third-world" avant gardes—and ideological misinterpretation, reading many of them as examples of colonial mimicry of western forms, with any subversive or revolutionary potential in these non-western avant gardes negated by the nationalisms and postcolonial statisms with which they are often imbricated.[51] At base this is a formalist reading of global avant-gardism that forgets the critical and social dimension that constitutes avant-gardist practice as such, and the importance of historically specific understandings of the various social forces—revolutionary nationalism, imperialism, decolonization, modernization, community, ethnic identity—that compose the political field in which these avant gardes respond. It is worth noting, meanwhile, that the revolutionary nationalisms of peripheral avant gardes is a mirror image of the pro-modernization, revolutionary nationalist projects of some key western avant gardes, like the Futurists, whose exclusion from Bürger's and others' selective histories of the avant garde begins to make more sense. In this case, action at the periphery reveals the truth of the centre, as statism and modernization were, at the time Bürger took up the avant garde concept, impossible to reconcile with a leftist position.

Yúdice argues for a "conjunctural" sense of avant-gardism, which would include all of the different social forces just mentioned: "It is possible, by a postmodern turn, to rethink the avant gardes as not constituting a particular moment in the history of modernity but, rather, a transformative power that is generated whenever the conjunctural circumstances allow for it."[52] Yúdice's conjunctural reading immediately complicates Bürger's historicism, which relies on a Hegelian "unfolding" of the aesthetic sphere as such, to the point of its terminal, avant-gardist moment of crisis—a complaint against Bürger that has been raised by several critics.[53] On Yúdice's reading of Latin American avant-gardism,

> The struggle for local autonomy proceeded according to a distinct logic of its own: the logic of community building. This logic included the creation of coherent meanings, cultural identities, and social solidarities—or organizing the relations of gender, class, and ethnicity. That is, we must be careful not to assume that the forces of [capitalist] integration [of a world market] were, themselves, the driving forces of twentieth-century global development. That would only reduce world history to the history of western domination.[54]

I would like to suggest that Yúdice's concept of peripheral avant gardes can stand as exemplary sites of value struggles: not struggles over value in the narrow sense of beliefs or

ethics, but the conjunctural struggles over the ways in which labor and reproduction are organized and valued within a capitalist system. From Yúdice's perspective it becomes clearer why the avant garde form was tied to statist articulations in the early century and in decolonizing zones, and then to anti-state, anti-institutional critique in the West after 1968: each of these conjunctures has its own reigning value regime, which avant gardes, in some sense by definition, contest.

Meanwhile, the historical dimension of de Angelis's concept is important here, too: by tying the question of value to non-capitalist spheres, modeled on a notion of the commons that fights capitalist enclosure and the imposition of private property, the avant garde concept connects to a series of struggles that precede its apparent start date, somewhere around 1900, and survive past its demise after May 1968. Further, it may well be that Bürger's apparent "self-realization" of the avant garde is in some sense a genre effect, a consequence of their resuscitation and extensive use of the manifesto form, from the Futurists forward. As Janet Lyon argues, the manifesto can be traced back to the Diggers' and Levellers' responses to the enclosures of the commons in seventeenth-century England, and the exclusion of the poor from the newly formed Parliament; these manifestos themselves have to be understood as a paradigmatic case of a "value struggle," in which a social form of commoning was forcibly displaced by a new regime of property and rent, and the manifesto was critical to the articulation of non-capitalist values.[55] Finally, those contemporary manifestations of post-avant-gardism, which want to create a para-political, relational space out of the current institutional framework of art, and alternately to heal, oppose, or travesty the usual market relations and forms of gallery spectatorship, are all directly foregrounding this question of the struggle over value and social reproduction. The Futurists' call to re-value art's social effects and its capacity to produce new life and new social relations, though refined, has not yet been surpassed.

In his subsequent book *The Expediency of Culture*, Yúdice uses an ethnographic methodology to spell out how value struggles operate in the era of the real subsumption of cultural work. In that text, Yúdice's few remarks on the avant garde raise two related problems with it in the context of present-day art practice: its all-or-nothing criteria of social change, where art's effectivity is judged solely by its transformative social power and not by its more micropolitical effects in raising the visibility of oppressions or helping communities constitute localized responses to global capitalism; and the inevitable avant-garde gesture towards a "real" social life outside of political representation or artistic institutionalization, a space whose political effectivity, let alone its ontological status, Yúdice rightly questions.[56] His analysis of Latin American activist art and popular culture—maquiladora documentaries, baile funk, AIDS activism, and other complicated responses to the

globalization of economy and culture—all take for granted that these practices can only take place with the assistance of supranational bodies like UNESCO, international biennales, and NGO-sponsored events like inSITE. For Yúdice, the question of these cultural forms' social effectivity is not overdetermined by their institutional involvement, but is a complex site of negotiation between funding agencies, artists, communities, and international audiences—and Yúdice's methodology here is exemplary, tracing out the "meaning" of specific art exhibitions from the conflicting testimonies by artists, granting agencies, community responses, and so on. That said, the very integration of culture into the production of a global order raises the issue most central to his book, where culture is now treated as a "resource" within global circuits of production and exchange. Yúdice doesn't mean by this to extend and globalize the indispensable but well-worn Frankfurt School thesis on culture's commodification, but rather that culture is, like any other key "natural" resource, now put to use in the management of life itself. For example, in a logic that connects border art exhibitions in Mexico to urban galleries in America, art is increasingly used as an indicator of "social health" in depressed economic zones, and exhibitions used as proof for a community's ability to attract capital investment. This plays out as urban "revitalization" and "renewal" strategies—what Manuel Castells calls the ability of art infrastructure to "give life" to urban zones[57]—and the identification of "creative capitalism" as a motor of development in de-industrialized and "dead" city cores.[58] The use of life and death metaphors in gentrification discourses is hardly incidental, as this functionalization of art for development purposes has arisen precisely during the period of a prolonged attack on welfare state provisions of social assistance, which brought with them their own idea of how life and populations were to be managed. What Yúdice's book offers, beyond its own remarkable analysis of Latin American art and activism, is a framework to connect artistic practice to the dominant modes of biopolitical governance that are key to understanding our own historical moment and our own organization of production, in which immaterial labor is increasingly the hegemonic form of value creation in post-Fordist economies.

All of this points back to the Futurists' alternative criteria for aesthetic value, or the concept of life that, for them, acted as an outside to liberal capitalism. It raises important questions about how aesthetics resides at the center of a political desire for new forms of life, though these can no longer be considered, as they were for the Futurists, external to capitalist accumulation, nor can they be tied to state-revolutionary ideologies. Two conclusions follow—one necessary, and one speculative. The first is that a reconsideration of avant gardes as value struggles aligns them, today, with a different model of resistance: value struggles of different scales contest global capitalism's extraction of surplus value and its organization of social reproduction, from occupations, anti-austerity and anti-privatization

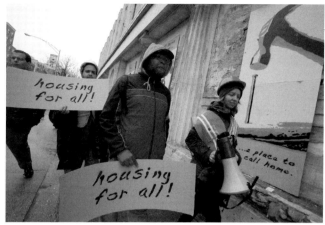

Not An Alternative and allies working in collaboration with 'Picture The Homeless' on a building occupation in East Harlem, El Barrio. By making visible the thousands of city and bank owned properties sitting vacant in New York City, the work was part of a campaign to bring attention the contradictions and failure of Mayor Bloomberg's five-year plan to end homelessness. March 19, 2009. Photos by Andrew Stern.

strikes, struggles against intellectual property regimes, right down to local phenomena like urban agriculture initiatives and community support networks. These register a continuous process of struggle against capitalist enclosure, or what de Angelis calls "an ongoing tension in the social body."[59] Any practice that stakes out a temporary "outside" to recuperation by capital and the state is now, by virtue of its capacity to imagine a new form of life and organize social reproduction differently, aligned with how the avant garde has historically challenged capitalist value regimes. A reciprocal point is that today's social struggles have an important prehistory in the itinerary and transformations of the avant garde over the course of the twentieth century, and this history is worth reclaiming.

The second conclusion follows from Yudice's suggestion that culture is now a resource, and therefore seen as part of a larger strategy of the biopolitical management of life and populations. If, as I've argued, the struggle over life and reproduction has been an object of the avant gardes over the past century, some questions need to be asked: wasn't the avant garde interested in the politicization of life all along? That is, doesn't the avant garde's interest in merging art and life put it on the same trajectory as biopolitics, in which, as Foucault conceived of it, a "whole political network became interwoven with the fabric of everyday life"?[60] However counterintuitive the connection, there is at least a starting point in their overlapping histories: Foucault's genealogy of biopolitics is notably concentrated in the modernist period, from the deployment of political technologies of population management over the course of the nineteenth century (mortality rates, pensions, hygienics, and so on) to their transformation into the biological state racisms that were suspended, or displaced, at the end of World War II. Is the avant garde's wished-for transformation of "life-praxis" part of this biopolitical genealogy—part of this diffusion and internalization of power, which has arguably become the dominant mode of power in a present-day society of control?[61] Following the

periodization I outlined above, the historical avant garde comes onto the scene during a first, nation-based articulation of biopolitics, where the nation-state's institutional expansion is posited as the solution to a growing number of deficiencies in the prior mode of social reproduction, bourgeois liberalism, whose very remoteness from "life" was precisely the complaint of the historical avant gardes. After the mid-century realization of biopolitical state forms, but before the subsequent institutional critiques of the Keynesian regulation of social life, and the ways these critiques were repurposed by a resurgent neoliberalism to scale back the institutional security of "life" under the mid-century nation-state in favor of greater flexibility, precarity, and self-management—these, and not only the logic of commodification, make up the "politics" against which the avant garde needs to be defined.

Notes

1. The date is Peter Wollen's, who cites the breakup of the Situationists as having "brought to an end an epoch that began in Paris with the Futurist Manifesto of 1909." See his *Raiding the Icebox: Reflections on Twentieth-Century Culture* (Bloomington: Indiana University Press, 1993) 124. Other prominent critical works that agree in substance with this view of the avant garde's demise include Perry Anderson's *The Origins of Postmodernity* (London: Verso, 1998), Matei Călinescu's *Five Faces of Modernity: Modernism, Avant-Garde, Decadence, Kitsch, Postmodernism* (Durham: Duke University Press, 1987), and Andreas Huyssen's *After the Great Divide: Modernism, Mass Culture, Postmodernism* (Bloomington: Indiana University Press, 1986).

2. For example, Hardt and Negri's *Empire* (Cambridge: Harvard University Press, 2000) rests on the premise that a distributed, nomadic general intellect is the present moment's model of political resistance, replacing vanguards looking to seize state power.

3. On the postmodern imperative to enjoy, see Slavoj Žižek's *For They Know Not What They Do: Enjoyment as a Political Factor* (London: Verso, 1991).

4. A recent issue of *New Literary History* indicates that the question of the avant garde is due for critical re-evaluation. My essay here aims to contribute to that project. The issue's editors describe the following starting point, today: "Looking beyond a restricted vocabulary of innovation and exhaustion, resistance and commodification, a number of the following essays assess diverse forms of avant-garde activity in terms of

what they make possible, rather than rushing to quantify their ultimate success or failure. Even those essays wary of retaining the term "avant-garde" as a synonym for experimental aesthetic or political activity remain interested in exploring how various forms of such activity persist under contemporary conditions. In either case, this shift in focus requires dislodging certain beliefs about the nature of social institutions and the dynamics of historical change." Quoted in Rita Felski and Jonathan P. Eburne's "Introduction," in *New Literary History* 41:4 (2010) viii.

5. Alain Badiou, *The Century*, trans. Alberto Toscano (Cambridge: Polity, 2007) 132.

6. Jacques Rancière, *The Politics of Aesthetics: The Distribution of the Sensible*, trans. Gabriel Rockhill (New York: Continuum, 2004) 29. Rancière's interest is in disarticulating the avant gardes from their historical connection and setting them back into an expanded mapping of how aesthetic forms precede and determine political visibilities and constitution: "In short, there is the idea [of avant gardes] that links political subjectivity to a certain form: the party, an advanced detachment that derives its ability to lead from its ability to read and interpret the signs of history. On the other hand, there is another idea of the avant garde that, in accordance with Schiller's model, is rooted in the aesthetic anticipation of the future" (29). In that second capacity, avant gardes typify the "aesthetic regime" of modernity, in which Bürger's central antinomy—the self-destruction of aesthetic autonomy—is recast as the beginning point of modern art, for which a demand for autonomy—or complete freedom from political determination—and a demand for heteronomy—or the ability to effect political change—determine the contradictory poles between which twentieth-century aesthetics is constituted. In this sense, Bürger's antinomy becomes Rancière's basic condition of art in the twentieth century, and so not the sign of a failed political project. See also Rancière's "The Aesthetic Revolution and Its Outcomes: Emplotments of Autonomy and Heteronomy," *New Left Review* 14 (2002) 133-51.

7. For Futurism's affiliation with anarchist and syndicalist groups, see Günter Berghaus, *Futurism and Politics: Between Anarchist Rebellion and Fascist Reaction, 1909-1944* (Providence: Berghahn, 1996) and Giovanni Lista, "Marinetti et les Anarcho-Syndicalistes," in Jean-Claude Marcadé, ed. *Présence de F. T. Marinetti: actes du colloque international* (Lausanne: Editions L'Age D'homme, 1982). For Futurism as essentially protofascist, see Alice Yaeger Kaplan, *Reproductions of Banality: Fascism, Literature, and French Intellectual Life* (Minneapolis: University of Minnesota Press, 1986) and Roger Griffin, *Modernism and Fascism: The Sense of a Beginning under Mussolini and Hitler* (Basingstoke: Palgrave Macmillan, 2007). Much of the controversy over Futurism's politics has to do with the movement's internal dynamics. It was far from a univocal movement, despite F. T. Marinetti's imposing presence. Even when it appeared to be speaking in a single voice, Marinetti's simultaneous political affiliations with the Italian Nationalist Association on the right and anarcho-syndicalist groups on the left is an insurmountable barrier to critical attempts to reduce Futurism to a single political camp. More recent appraisals have avoided politically reductionist conclusions by stressing the movement's own self-difference over time and between geographically distinct Futurist groups: see Walter Adamson, *Avant-Garde Florence: From Modernism to Fascism* (Cambridge: Harvard University Press, 1993). For my part, instead of the impossible project of taking the aggregate of these statements and calculating some kind of median political position, or deciding on the truth or falsity of various Futurist positions, I want to understand Futurism in terms of the political statements it made possible: that is, in terms of how it imagined politics otherwise, and specifically how it imagined undermining hegemonic liberalism by displacing politics onto the terrain of life.

8. Bruno Corradini and Emilio Settimelli, "Weights, Measures and Prices of Artistic Genius—Futurist Manifesto 1914," in Umbro Apollonio, ed. *Futurist Manifestos* (New York: Viking, 1973) 135-49.

9. Corradini and Settimelli, "Weights, Measures and Prices of Artistic Genius," 145.

10. Corradini and Settimelli, "Weights, Measures and Prices of Artistic Genius," 146.

11. Corradini and Settimelli, "Weights, Measures and Prices of Artistic Genius," 149.

12. Pierre Bourdieu, "The Forms of Capital," in J. E. Richardson, ed. *Handbook of Theory of Research for the Sociology of Education*, trans. Richard Nice (Westport: Greenword, 1986) 250.

13. On Futurism's early years (and prior names), see Günter Berghaus, "Introduction" to *Critical Writings* by F. T. Marinetti, trans. Doug Thompson (New York: Farrar, Strauss & Giroux, 2006) xviii. All quotes on Futurism as a living art are from Umberto Boccioni, Carlo Carrà, Luigi Russolo, Giacomo Balla, and Gino Severini, "Manifesto of the Futurist Painters 1910," in *Futurist Manifestos*.

14. Georg Simmel, *The Conflict in Modern Culture, and Other Essays* (New York: Teachers College Press, 1968) 13.

15. Massimo de Angelis, *The Beginning of History: Value Struggles and Global Capital* (London: Pluto, 2007).

16. Value struggles encompass any struggle for the commons in de Angelis's writing, from anti-austerity protests to daily reproductive activities. He writes, "capital's value practices [are] in perpetual struggle with other value practices. [Capitalism] is also preservative of the rules generated by enclosures, because through repetition subjects tend to become normalized to them. Yet this is a normalisation that does not abolish conflict among value practices, but that turns this conflict into the driving engine of the evolution of the organisational form of capitalism while basic processes of homeostasis keep social forces and conflicting value practices coupled together. In other words, *in the daily reproduction of our livelihoods we are involved, knowingly or unknowingly, willingly or unwillingly, in a form of civil war cutting across the social body.*" De Angelis, *The Beginning of History*, 81.

17. "Mais il faut aussi souligner tous les signes de rapprochement des deux logiques de l'art et du management qui s'accumulent spécialement depuis les années 80. [...] Le manager est ainsi en passe de devenir le meilleur allié de l'artiste après avoir été consideré comme son bourreau." Eve Chiapello, *Artistes versus managers: le management culturel face à la critique artiste* (Paris: Métailié, 1998) 205, 211. ["But it is also necessary to underline all the signs of a reconciliation of the two logics of the art and management which have accumulated, particularly since the 80s. [...] The manager is thus in the process of becoming the best ally of the artist after having been regarded as his destroyer."]

18. Hal Foster, *Design and Crime and Other Diatribes* (London: Verso, 2002) 121; George Yúdice, *The Expediency of Culture: Uses of Culture in the Global Era* (Durham: Duke University Press, 2003). Yúdice writes, "the evolution of arts administration since the 1960s has increasingly encouraged artists to become better service providers. This refunctionalization is not limited to the United States but is a characteristic of the role of artists as catalysts for cultural citizenship in the new cultural policies throughout Latin America and many other regions" (319).

19. See Matthew Jesse Jackson's "Managing the Avant-Garde" (*New Left Review* #32 (2005) 105-16) for a brief survey of recent "revolutionary" business tracts, which, he argues, are the latest development in "the last century's contest between 'artists and managers'—one that has been increasingly resolved by a tendency to merge, or even trade places, as the arts become more commercialized while business recuperates their discarded mythology of creative individualism" (107).

20. Rosabeth Moss Canter, "The New Managerial Work," *Harvard Business Review* (1989) 89.

21. Peter Bürger, *Theory of the Avant-Garde* (Minneapolis: University of Minnesota Press, 1984). Bürger writes: "it can be seen that the avant-gardistes' attempt to reintegrate art into the life process is itself a profoundly contradictory endeavor. For the (relative) freedom of art vis-a-vis the praxis of life is at the same time the condition that must be fulfilled if there is to be a critical cognition of reality. An art no longer distinct from the praxis of life but wholly absorbed in it will lose the capacity to criticize it, along with its distance" (50).

22. The passage quoted in the previous note continues: "During the time of the historical avant-garde movements, the attempt to do away with the distance between art and life still had all the pathos of historical progressiveness on its side. But in the meantime, the culture industry has brought about the false elimination of the distance between art and life, and this also allows one to recognize the contradictoriness of the

avant-gardiste undertaking." Bürger, *Theory of the Avant-Garde*, 50.

23. On the dynamics of recuperation, Boltanski and Chiapello write: "Capitalism attracts actors, who realize that they have hitherto been oppressed, by offering them a certain form of liberation that masks new types of oppression. It may then be said that capitalism 'recuperates' the autonomy it extends by implementing new modes of control. However, these new forms of oppression are gradually unmasked and become the target of critique, to the point where capitalism is led to transform its *modus operandi* to offer a liberation that is redefined under the influence of critique. But, in its turn, the 'liberation' thus obtained harbours new oppressive mechanisms that allow control over the process of accumulation to be restored in a capitalist framework. Cycles of recuperation thus lead to a succession of periods of liberation *by* capitalism and periods of liberation *from* capitalism." Luc Boltanski and Eve Chiapello, *The New Spirit of Capitalism*, trans. Gregory Elliott (London: Verso, 2005) 425.

24. Boltanski and Chiapello: "Hence it can be said, without exaggeration or paradox, that if capitalism attempted to recuperate the demand for authenticity underlying the critique of the consumer society (by commodifying it, as we have seen), in another respect—and relatively independently—it has, with the metaphor of the network, assimilated the critique of this demand for autonomy, whose formulation paved the way for the deployment of reticular and rhizomorphous paradigms. This contradictory double incorporation tends to both acknowledge the demand for authenticity as valid and to create a world where this question is no longer to be posed. And this, as we shall see, underlies the existential tensions—inextricably psychological and ethical—felt by people engaged in the process of accumulation." Boltanski and Chiapello, *The New Spirit of Capitalism*, 452.

25. Chiapello writes, "Ces deux dernières décennies, qui ont vu la mode de la culture d'entreprise dans les années 80 et celle du réseau et de la confiance dans les années 90, doivent être vue comme une periode de profond bouleversement du management et de ses préceptes puisque ont été célébrés des formes difficiles à maîtriser, faisant appel à l'affectivité des personnes et à leur histoire sociale, qui sont autant d'aspects que le management scientifique des débuts aurait bien voulu ignorer. Il faut encore montrer que ces nouvelles formes ne sont pas de simples ajouts à une liste de pratiques managériales, traditionellement très éloignées des fonctionnements des mondes de l'art. Elles accompagnent en fait une évolution en profondeur de la définition centrale du management." Eve Chiapello, *Artistes versus managers*, 215. [These last two decades, which have witnessed the culture of enterprise of the 80s and that of the network and trust in the 90s, must be seen as the period of a profound overturning of management and its tenets, since what has been celebrated are forms that are difficult to control and that appeal to people's emotions and their social history, which are aspects that, from its beginnings, scientific management would have preferred to exclude. It remains to be shown that these new forms are not simple additions to a list of managerial practices, traditionally very distant from the workings of the worlds of art. They actually accompany a profound evolution of the core definition of management.]

26. Hardt and Negri, *Empire*, 269-76.

27. From Tom Peters, *Liberation Management: Necessary Disorganization for the Nanosecond Nineties* (New York: Knopf, 1992): "Finally, get turned on. Or follow your bliss, or whatever. Vacuous advice? Perhaps. But the practical implication is this: In a knowledge-based economy, you must—to survive—add some special value, be distinctively good at something. And the truth is, we only get good at stuff we like. … Ain't nobody going to take care of you on the job in a big company anymore: It's not dog-eat-dog out there anymore, it's skill-eat-skill. If you're not skilled/motivated/passionate about *something*, you're in trouble!" (757-8). Other instant classics of the business-self-help genre: Tom Peters, *Thriving on Chaos: Handbook for a Management Revolution* (New York: Knopf, 1987); Richard Tanner Pascale, *Managing on the Edge: How the Smartest Companies Use Conflict to Stay Ahead* (New York: Simon and Schuster, 1990); Robert H. Waterman, Jr., *The Renewal Factor: How the Best Get and Keep the Competitive Edge* (Toronto: Bantam, 1987). The crisis in finance capital of 2007, however, has had its effects on management too: some have called for a walkback from the edge of neolib-

eral crisis-theory to an older form of structured management and vectors of real productivity. See Jack Buffington, *The Death of Management: Restoring Value to the U.S. Economy* (Santa Barbara: Praeger, 2009).

28. Jameson writes, "late capitalism in general (and the 60s in particular) constitute a process in which the last surviving internal and external zones of precapitalism—the last vestiges of a noncommodified or traditional space within and outside the advanced world—are not ultimately penetrated and colonized in their turn. Late capitalism can therefore be described as the moment when the last vestiges of Nature which survived on into classical capitalism are at length eliminated: namely the Third World and the unconscious. The 60s will then have been the momentous transformational period when this systemic restructuring takes place on a global scale." Fredric Jameson, "Periodizing the 60s," in *The Ideologies of Theory: Essays 1971-1986* (Minneapolis: University of Minnesota Press, 1988) 207.

29. Bürger, *Theory of the Avant-Garde*, 90.

30. Renato Poggioli, *The Theory of the Avant-Garde* (Cambridge: Belknap, 1968); Hans-Magnus Enzensberger, "The Aporias of the Avant-Garde" in *The Consciousness Industry: On Literature, Politics and the Media*, trans. Michael Roloff (New York: Seabury, 1974) 16-41; Leslie Fiedler, "The Death of Avant-Garde Literature," *The Collected Essays of Leslie Fiedler, Vol. 2* (New York: Stein and Day, 1971) 454-61. The standard surveys of criticism from the definitional moment of the avant garde in the 1960s are Andreas Huyssen's chapter "The Search for Tradition" in *After the Great Divide*, 160-78, and Matei Călinescu's "The Crisis of Avant-Garde's Concept in the 1960s" in *Five Faces of Modernity*, 120-5.

31. Classical sources for this shift include Alfred D. Chandler, *The Visible Hand: The Managerial Revolution in American Business* (Cambridge: Belknap, 1977) and James Burnham, *The Managerial Revolution: What Is Happening in the World* (New York: John Day, 1941). For a critical history, see David Harvey's "Fordism" chapter in *The Condition of Postmodernity: An Enquiry into the Origins of Cultural Change* (Oxford: Blackwell, 1989) 125-40.

32. Manfredo Tafuri, *Architecture and Utopia: Design and Capitalist Development* (Cambridge: MIT Press, 1976). Tafuri singles out Breton as one artist-intellectual who resisted the functionalization of culture by industry. In his second Surrealist manifesto (1924), Breton marks out the very tension that would later be the basis of Bürger's antinomy of the avant-garde: thought "cannot do other than oscillate between the awareness of its perfect autonomy and that of its strict dependence" (cited in Tafuri, 64). Breton ultimately pushed for art's critical autonomy, as opposed to, for example, Russian Constructivism, for which art as propaganda posed no great worry. See Tafuri, *Architecture and Utopia*, 63-8.

33. Tafuri, *Architecture and Utopia*, 69.

34. World systems theorists recognized in the 1970s that the export of "development" was part of a global accumulation strategy, consistent with older imperialisms. See, for example, Samir Amin's *Unequal Development: An Essay on the Social Formations of Peripheral Capitalism* (New York: Monthly Review, 1976), and "Accumulation and Development: A Theoretical Model," *Review of African Political Economy* 1:1 (1974) 9-26.

35. Notably Andrew Hewitt, *Fascist Modernism: Aesthetics, Politics, and the Avant-Garde* (Stanford: Stanford University Press, 1993) 6.

36. Roland Barthes, *Critical Essays*, trans. Richard Howard (Evanston: Northwestern University Press, 1992) 67.

37. In Apollonio, ed. *Futurist Manifestos*, 197-200.

38. Tafuri, *Architecture and Utopia*, 98.

39. Gramsci, "Americanism and Fordism," in *Selections from the Prison Notebooks*, trans. Quintin Hoare and Geoffrey Nowell Smith (New York: International, 1971) 279-318.

40. Guy Debord, *The Society of the Spectacle*, trans. Donald Nicholson-Smith (New York: Zone, 1995) 41.

41. Frank writes: "The countercultural style has become a permanent fixture on the American scene, impervious to the angriest assaults of cultural and political conservatives, because it so conveniently and efficiently transforms the myriad petty tyrannies of economic life—all the complaints about conformity, oppression, bureaucracy, meaninglessness, and the disappearance of individualism that became virtually a

national obsession in the 1950s—into rationales for consuming." Thomas Frank, *The Conquest of Cool: Business Culture, Counterculture, and the Rise of Hip Consumerism* (Chicago: University of Chicago Press, 1997) 31.

42. On Situationism and council communism, see Wollen, *Raiding the Icebox*, 120-57.

43. Blake Stimson and Gregory Sholette, "Introduction: Periodizing Collectivism," in Stimson and Sholette, eds. *Collectivism after Modernism: The Art of Social Imagination after 1945* (Minneapolis: University of Minnesota Press, 2007) 13.

44. For Bourriaud, "present-day art is roundly taking on and taking up the legacy of the 20th century avant-gardes, while at the same time challenging their dogmatism and their teleological doctrines. [...] It was based on conflict, whereas the imaginary of our day and age is concerned with negotiations, bonds, and co-existences." Nicholas Bourriaud, *Relational Aesthetics*, trans. Simon Pleasance and Fronza Woods (Dijon: Presses du réel, 2002) 36.

45. Bishop writes: "relational art is seen as a direct response to the shift from a goods to a service-based economy" (54). Claire Bishop, "Antagonism and Relational Aesthetics," *October* #110 (2004) 54.

46. Bourriaud, *Relational Aesthetics*, 36.

47. On Tiravanija, see Bourriaud, *Relational Aesthetics*, 25, 30. On Sierra, see Bishop, "Antagonism and Relational Aesthetics," 73.

48. Bishop's observation of the audiences of these exhibitions forces her to conclude that despite its ambitions, relational aesthetics essentially "permits networking among a group of art dealers and like-minded art lovers." Bishop, "Antagonism and Relational Aesthetics," 54.

49. Invisible Committee, "The Coming Insurrection," *Support the Tarnac 10* (accessed March 9, 2010) http://tarnac9.wordpress.com/texts/the-coming-insurrection/.

50. Ernesto Laclau, "Can Immanence Explain Social Struggles?" in Paul A. Passavant and Jodi Dean, eds. *Empire's New Clothes: Reading Hardt and Negri* (New York: Routledge, 2004) 21-30. A similar critique of the non-strategic character of the multitude can be found in Leo Panitch and Sam Gindin, "Gems and Baubles in Empire," in Gopal Balakrishnan, ed. *Debating Empire* (London: Verso, 2003) 52-60.

51. For critiques of this tendency, see Elizabeth Harney, "Postcolonial Agitations: Avant-Gardism in Dakar and London," *New Literary History* 41:4 (2010) 731-51, and Geeta Kapur, *When Was Modernism: Essays on Contemporary Cultural Practice in India* (New Delhi: Tulika, 2000).

52. George Yúdice, "Rethinking the Theory of the Avant-Garde from the Periphery" in Anthony L. Geist and Jose Monleon, eds. *Modernism and Its Margins: Reinscribing Cultural Modernity from Spain and Latin America* (Minneapolis: University of Minnesota Press, 1999) 74.

53. Yúdice's conception here bears some similarities to Hal Foster's better-known critique of Bürger, which also argues, although from an internalist and western art-historical perspective, for a more flexible historiography to the concept of the avant garde. But this temporal flexibility comes at a cost; Foster's critique wants to redeem the neo-avant gardes of the 1950s and 60s and open the possibility of future ones, but to do this he draws from psychoanalytic concepts of return, deferred action, and compulsive repetition to frame the avant garde as a traumatic hole in the signifying order that is periodically reiterated by subsequent avant gardes. The cost here is any sense of the "conjunctural circumstances" Yúdice refers to above; historical analysis recedes behind a post-structural, traumatic model of a more or less involuntary mechanism of repetition. Contrast this to Yúdice, who is careful to temper his historical and geographical expansion of the concept of the avant garde with the material circumstances of decolonization in which they occur. See Hal Foster, "What's Neo About the Neo-Avant-Garde?" *October* #70 (1994) 5-32.

54. Yúdice, "Rethinking the Theory of the Avant-Garde from the Periphery," 56.

55. Janet Lyon, *Manifestoes: Provocations of the Modern* (Ithaca: Cornell University Press, 1999) 16-23.

56. Yúdice explores the limitations of Bürger's *Theory* for contemporary activist art throughout the book by implication, but explicitly in a discussion of inSITE "border art" exhibitions in the 1990s. See Yúdice, *The Expediency of Culture*, 316-24.

57. Cited in Yúdice, *The Expediency of Culture*, 19.

58. Yúdice, *The Expediency of Culture*, 16.

59. De Angelis, *The Beginning of History*, 28.

60. Foucault, "Lives of Infamous Men," in James D. Faubion, ed. *Power: Essential Works of Foucault, 1954-1984*, Vol.3, trans. Robert Hurley et al. (New York: New Press, 2000) 159.

61. Gilles Deleuze, "Postscript on the Societies of Control," *October* #59 (1992) 3-7.

The Self-Destruction of the Avant Garde

Mikkel Bolt Rasmussen

The whole root, all the exacerbations of our quarrel, turn on the word 'Revolution.'
— Antonin Artaud[1]

Few phenomena tell us more about our present than the avant garde and its destiny. The fate, the absence or the presence of an avant garde tells us something about a society, its history, its political culture and its idea of the future. In the destiny of the avant garde we can decipher what role art and politics play and how these discourses are conceptualized and interact in a given period.

Within contemporary art there has been a lively debate about the avant garde for the last twenty years. These discussions have often been attempts to analyze contemporary art that since the early 1990s has used and referred to earlier artistic practices such as conceptual art, performance art, Fluxus and Situationism. The reactivation of art from the 1960s has led many to argue that contemporary art is a continuation of the neo-avant garde as a kind of post-neo-avant garde. The interest in the avant garde has of course also produced many books on the interwar and postwar avant gardes. Unfortunately most of these analyses seek to understand the revolutionary aspirations of the avant garde in terms of academic and art-centred analysis. If one does not analyze the revolutionary aspirations and self-understanding of the avant garde, then its self-critical operations are reduced to a series of canonical artworks and formal experiments. The avant garde was not merely artistically avant-garde, but also socially and politically avant-garde; or more precisely, the avant garde was not specifically 'artistic' insofar as the latter term is restricted to the predominant modern conception of art as autonomous. The avant garde sought to confer the creativity of the artists to everyone outside the confines of the art institution. In that sense the avant garde launched a radical critique of the differentiation process of capitalist modernity and sought to end capitalist domination in favor of communism. The following argues for the necessity of the avant garde's radical critique and presents some scattered remarks on its historical disappearance. It is primarily an attempt to question a number of certitudes concerning the avant garde in order to better answer why the avant garde was so quickly caught up and superseded by the society it wanted to destroy. These remarks are thus both an attempt to free myself from the intoxicating universe of the avant garde and an attempt to keep the energy of the avant garde alive despite everything, especially the avant garde itself.

The Disappearance of the Avant Garde

A definition of the avant garde must start with the opposition of the avant garde towards bourgeois society and with a view to formulating a cultural and political alternative to capitalism. The avant garde not only scandalized the art institution with its "silly" objects and sneering acts, it intended to scandalize the bourgeois world in its entirety, including its edifying rationality and snobbish class distinctions. As an agent in the cultural process of bourgeois self-definition the avant garde strove to negate itself and make humans foreign to themselves and each other. It fiercely attacked both the residual high culture of the aristocracy and the emerging "invisible" culture of the bourgeoisie that was replacing former lines of alliance and power. This meant that the avant garde not only attacked classical media and genres like painting and sculpture but attacked language and the image as such. It did this because the language and visuality that "earlier"—it always turns out to be a retrospective construction—had united people now separated them. Capitalism had effected an expropriation of communicative and productive means and now used them to reproduce an alienating and opaque world of work and consumption. In order to wrest humanity free from the instrumental rationality of bourgeois society and supersede the alienating relations of capitalism the avant garde had to intensify the alienation; only by making the world even more strange could the avant garde get beyond the existing one and make possible a truly modern and artificial world. Most of the time, this supersession was conceived within the framework of communism.

Few phenomena have had as dramatic an existence as the avant garde. Despite the return of the notion of the avant garde in discussions about contemporary art—the notion of the postmodern disappeared rather quickly—there seems to be a huge divide separating the art of today from the anti-art of the avant garde. Projects like Wu Ming, Copenhagen Free University or Yes Men do not really come off looking like avant gardes. Few artists today attempt to ally themselves directly with political parties or revolutionary movements like the Surrealists did in the 1920s and 30s. This of course is not the fault of artists in any straightforward way, but has to do with the altered political context in which, in the West at least, the are no

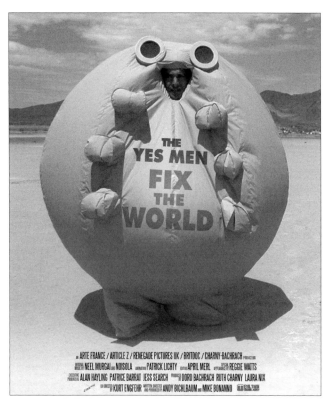

The Yes Men, Film poster for *The Yes Men Fix the World* (USA, 2009).
Courtesy of Mike Bonanno and Andy Bichlbaum.

revolutionary political parties that represent an alternative to the established system of capitalist democracy. The connection between artistic experiment and political commitment that was so vital for the avant garde is apparently no longer possible. Both the "artistic" avant garde and the political vanguard have been swept up by a capitalism that has not only abolished the former distinctions between high and low but also integrated culture and capital and transformed politics into spectacle. The self-evident manner in which the Surrealists reacted to contemporary events like the war in Morocco in 1925-1926, where French forces led by Pétain crushed the Moroccan uprising for national liberation, were drastically reduced after World War II, when groups like the Situationist International desperately tried to keep alive the project of the interwar avant garde. Since then the "naturalness" of the avant garde seems to have become historical and appears either implausible or unlikely. The naturalness with which revolutionary art implied a revolutionary politics and vice versa rarely survived Stalinism, the Second World War and the emergence of consumer society. That's why Peter Bürger concluded that the postwar avant garde reproduced the interwar avant garde's attack on the art institution and bourgeois society primarily in terms of art. While what Bürger (resigned in 1974 in the midst of the dissolution of the West German Student opposition) termed the historical avant garde connected its critique of art's institutional status with the struggle for another society, the postwar avant garde merely thematized the art institution and showed critical gestures

disconnected from any political projects or movements. As Bürger phrased it: "The neo-avant-garde institutionalizes the avant-garde as art and thus negates genuinely avant-gardist intentions."[2]

Even though Bürger's rejection of the so-called neo-avant garde was formulated on the basis of a problematic teleological conception of history and even though his book does not account for the socio-historical conditions for the blocking of the avant garde project he nonetheless points to the profound transformation of the avant garde during the twentieth century.[3] Bürger was right in emphasizing the new situation that the neo-avant garde faced in the 50s and 60s, where life was becoming much more organized than had been the case before. After World War II everyday life was literally colonized by commodities and the relative autonomy of art seemed to fuse with the production of the new objects. The second half of the twentieth century is the story of how capital subsumed more and more aspects of human life. Not only commodities and tools but also the labor force was produced capitalistically—the whole of society was productive/reproductive. Jacques Camatte describes this as the capitalization of human needs where people become capitalist creatures desiring their own submission (through the remuneration of work).

> Now it is not only the proletarians—those who produce surplus-value—who are subsumed under capital, but all men, the greater part of whom is proletarianized. It is the real domination over society, a domination in which all men become the slaves of capital… Thus it is no longer merely labor, a defined and particular moment of human activity that is subsumed and incorporated into capital, but the whole life process of man.[4]

Already in the 1940s Theodor Adorno and Max Horkheimer described how this development also affected art.[5] The value form tended to absorb all art forms and remove the subversive exterior where art could experiment and from where it mobilized critique. This development not only transformed the relations and forces of production of art but also changed politics in a way the established left was unable to understand, resulting in a situation where large parts of the left remained attached to an unproductive historical materialism and its categories of class and historical development.[6]

In the immediate afterwar period, art was squeezed into the reductive oppositions of the Cold War where two seemingly incompatible logics—the western nation-state system, with its parliamentary democracy and individual freedom, on the one side and the state communist collectivized economy and party apparatus on the other—effectively derailed any attempt to connect artistic experiment with communism. Even though the direct link to the former avant garde's experiments was cut and artists therefore had to make do with a random genealogy, the Situationist International did succeed in rising to the occasion and recreate the connection between artistic experiment and

political commitment. This was, however, the exception that proved the case.

The small Situationist group was radically opposed to the developments taking place in the postwar period, perceiving it as a new counter-revolutionary phase in the development of capitalism, and sought to abandon art in favor of a revolutionary practice. The totalistic, heroic and grandiose solution in which the Situationists risked it all and ended up without art in many ways marks the culmination and end of the history of the avant garde.[7] The SI pushed the avant-gardist claim about being at the forefront of one's times to an extreme point, demanding the impossible of its members, who were not to behave in a counter-revolutionary manner in their everyday life: there was not supposed to be any separation between private behavior and the communist critique of political economy. As the domination of the society of the spectacle grew the Situationists tried to disconnect themselves from art in order to save the avant garde position. The costs of this rescue operation were massive: the Situationists' theses were able to point to the new forms of social control but they were also abstract and bombastic, founded as they were on the primacy of concepts like separation, alienation, and spectacle. The Situationist critique was reductively repeated endlessly and nobody and nothing was safe from critique, which had elements of paranoia and complacency. Other contemporary artists like those associated with Fluxus or conceptual art opted for a more "realistic" move and settled for less than the Situationists' all or nothing challenge.

Conceptual art and other contemporary art practices did not recreate the earlier avant garde's direct link between artistic and political avant gardes but instead tried to keep alive artistic experimentation. The expansion of the concept of art was the result of this strategy that from the point of view of the avant garde unambitiously satisfied itself with limited and "suspect" aesthetic gains. From a postmodern perspective, however, the expansion of the concept of art made possible a continuous process of inquiry where art should no longer seek to destroy or create the world anew. The idea of the avant garde played a limited role in this process of expansion: Artistic practice and political reflection was not united into one text but was kept separate. The avant-garde synthesis of artwork and world was replaced with more moderate approaches that on the one hand continue the radical and coherent critique of the avant-gardist wager, but on the other hand does not degenerate into megalomania and redundant stylistics (which the avant garde's syntheses often tended to).

Although we should avoid simple periodizations it seems fair to say that that the conditions of possibility of the avant garde more or less disappeared after World War II. The old agrarian elites and their cultural forms disappeared with the War, leaving the bourgeoisie and the avant garde without an aristocratic high culture to appropriate and ridicule. At the same time the political horizon was effectively closed with the appearance of stable democracies in western Europe and bureaucratic Communism in the East. The industrial and technological development of the War was subsequently used to implement a standardized mass culture where technology lost its former visionary significance for artists and became part of everyday life, creating a culture that was organized around symbolic production and consumption. As Perry Anderson argues, no matter how artists reacted to this development their art was to a large extent destined to commercial integration or institutional cooptation.[8] We can read this in the desperation and paranoia of anti-art groups like the Situationists. Of course the idea and perspective of the avant garde did not disappear overnight but survived in different guises and equipped later art with an overdeveloped institutional awareness. If one follows Bürger's definition of the avant garde as the combination of an attack on the institution of art with a utopian project of communist revolution, the Situationist International appears as one of the few examples of a postwar avant garde. None of the American or western European artistic practices like Minimalism, Pop art or even Fluxus were characterized by such aspirations. Even the most politicized conceptual art, like that of Art & Language, the group that gathered around the publication *The Fox* in New York, or the interventive plasticity of Artists Placement Group, nevertheless created art in a very different way than the Situationists.[9] That the Situationists remained attached to a certain understanding of art—according to which art possesses a potential in a divided capitalist world (but only insofar as art is no longer art but integrated in a revolutionized everyday life)—is another matter. The Situationists did not intend their actions to be understood as art and did everything to prevent them from circulating as such. It does therefore seem advisable to follow Bürger's distinction between a historical avant garde and a later neo-avant garde, regardless of whether the latter manifested itself as Situationist or as a Pop or conceptual art without historical philosophical pretensions. Although Bürger's distinction between avant garde and neo-avant garde remains relevant today, the Situationists' forced attempt to continue and radicalize the project of the historical avant garde after World War II and the full-scale introduction of the spectacular commodity society testifies to the rapid disappearance of the avant garde. The connection between the will to intervention in social reality and the realization of (im)material textuality was loosened at this time and has remained so ever since.

The history of the disappearance of the avant garde has to do with the disappearance of a revolutionary perspective and the closing down of a radical horizon. Whether the ongoing collapse of the global economy is the end of the neoliberal cycle of accumulation or indeed might turn out to present the possibility of an exit from capitalism altogether remains a matter of debate. The presumption of an

end to neoliberalism relates directly to the conditions of possibility for the constitution of the avant garde. The avant garde position has not been available for quite some time now but that might be changing. The disappearance of the avant garde was both a possibility and a serious problem: a problem because the radical critique of the avant garde is necessary if we do not want to settle with minor changes and a possibility because the avant garde's self-understanding always maintained a pretense to know what is to be done. The avant garde looks upon itself as the very center of radical change, as if its products and acts are revolutionary in themselves. Although the opposition of the avant garde has to be made available—*it is still necessary to create disorder and break the movements of homogenization*—this has to be done without reducing the mass to a stupid body that needs to be organized. This is the impossible heritage that the avant garde has left us with.

The Self-Production and Self-Destruction of the Avant Garde

On March 15, 1963, Guy Debord wrote a letter to the sociologist Robert Estivals in response to the latter's new book, *L'Avant-garde culturelle parisienne depuis 1945*. Debord felt it necessary to correct Estivals and account for the true understanding and use of the concept of the avant garde. According to Debord, Estivals, who had been a member of the Lettrist group that Debord broke away from in 1957, had not only misrepresented but completely misunderstood the concept of the avant garde. Estivals' 1962 book was also deemed by Debord to suffer from the fact that it tried to take a historical approach to the question and therefore had not included an account of the very important transformations that the Situationist International had been carrying out since the late 1950s and onwards. Estivals' analysis was therefore only retrospective and his book had no value for the present and future work that the avant garde was to undertake. Debord was thus compelled to explain matters to Estivals with the provocative heading "The avant garde in 1963 and after." The sociologist had understood absolutely nothing. According to Debord, being avant-garde meant not only being conscious of and affirmative towards the new, but also dedicated to realizing it in the present. Insofar as the present was an inauthentic present in the sense of being characterized by past representations and ideas about the avant garde, one should fight against the present in the present and for the sake of the future. As Debord put it: "The avant-garde … describes *and begins* a possible present, which its historic consequences will confirm in the ensemble by the most extensive realization."[10]

Debord continued his instructions to Estivals explaining that the term avant garde could be used in a both strong and a weak way. While the weak use of the term was a description of progress in a broad general way applicable to progress within medical science, industry and art alike,

the strong notion of avant garde described an overcoming of the social totality, an alternative organization of reality. According to Debord, the avant garde in the strong sense of the term was not only preoccupied with parts of life but addressed all of society, the social totality. Historical development had shown that only a total and all-encompassing critique of society was capable of challenging its recuperation by the present order, which had no problem accepting piecemeal criticism as long as it did not attack it as a whole. Limited criticism was even welcomed, Debord argued, as the ruling order seeks to appear tolerant and inclusive. Because of this situation where any avant garde that did not reject capitalism in its entirety was complicit in the maintenance of the existing society of alienation and separation, the strong avant garde had left behind the limited sphere of art and had in one and the same movement joined and transcended the political avant garde. The strong avant garde no longer created artworks; instead, its primary activity was its self-creation. Such an undertaking, Debord argued, was of utmost importance but also an extremely risky business insofar as capitalist society does everything to prevent a genuine avant garde from being created.

Debord ended his four-page letter to Estivals with a warning. As a sociologist Estivals could try to judge the avant garde but his judgement was of no value whatsoever. On the contrary, Debord argued, the judgement of the avant garde was what counted as the avant garde was the present seen from the future. "If it really is an avant garde, it carries in itself the victory *of its criteria of judgment* against the era (that is to say, against official values, because the avant-garde exactly represents this era from the point of view of the history that will follow it)."[11] For Debord, then, trying to sociologically analyze the avant garde is an absurd undertaking. While it is possible to map the weak or false avant gardes sociologically and to account for the historical conditions for the disappearance of real avant gardes it is a contradiction in terms to try to analyze the existing real avant gardes. Only by accepting and adopting the vocabulary of the avant garde is it possible to understand it. Only by entering into the language of the avant garde can sociology get up to speed. In case Estivals was still somehow uncertain about the meaning of Debord's letter, he ended it by writing that only by accepting and using the theories of the Situationist International was it possible to understand what avant garde meant today.

Debord's letter to Estivals tells us a good deal about avant garde self-understanding. Primarily, the letter shows us that the avant garde is a special gesture that takes the form of a command. The avant garde demands to be dealt with in a particular way. Estivals cannot just write about the Situationist International as if he was writing about any other existing art group. If Estivals is to avoid being ditched by the acceleration of history he has to submit to the claims made by the SI. As Tiqqun writes, you can only write or talk about the avant garde *as* an avant-garde and from with-

in its ranks.[12] The avant garde can only be experienced from within. Defining the avant garde means analyzing and coming to terms with this particular self-expropriation. The avant garde absorbs itself. The avant garde sequesters itself. That's why texts and articles about the avant garde always appear supplemental. At best, speculation adds to the avant garde's own analyses and interventions. As Paul Mann writes, the books and texts about the avant garde that keep piling up are nothing but histories about a history—the avant garde has always already made itself into a discourse and the articles and books only articulate the passing of avant garde discourse.[13] The avant garde is thus a particularly paranoid subjectivization that overwhelms everyone who comes into contact with it, resulting in a kind of vertigo that makes it impossible to remain neutral and detached. The avant garde sees itself as the highest expression of revolutionary consciousness. As *the* revolution or *the* enemy, as Percy Wyndham Lewis termed himself and one of his many one-man journals, the avant garde is the one who denounces the hypocrisy of the world and negates all established authorities—not just the enemy of this or that but the enemy tout court. The sociologist cannot analyze the avant garde since the avant garde has already staged itself as the revolution, the exception or the enemy.

As is evident from Debord's letter the avant garde has a complex relationship with the outside and especially with the masses. The avant garde looks with equal contempt and envy at the mass that somehow incredibly seems to be at ease with itself. This is a complete scandal in the eyes of the avant garde, according to whom the world must be transformed. Only a complete break with the existing world is relevant. Only through an all-inclusive transformation is it possible to smash capitalism's empire of passivity and make possible a true life. The indifference of the masses, the scale of its apathy and the joy expressed by the uninitiated nevertheless enrages the avant garde and confirms its outright dismissal of the masses and its reality. As was evident with Debord and the Situationists, the avant garde never tires of authoritatively condemning the spectacle as false and goes so far as to describe itself a demiurge.[14] With this division of the world into outside and inside, the ones who are in on it and the ones who are idiots, the avant garde reproduces the gang structure that according to Jacques Camatte and Gianni Collu characterizes all organizations in a capitalist society. Because of the enormous pressure that all freely or unfreely marginalized individuals experience in capitalist society, the individual seeks refuge in the gang. Vulnerability and fear of violence and loneliness forces the individual into a gang where s/he enters into a hierarchy that because of its rigid strictness promises another social structure.

> To belong in order to exclude, that is the internal dynamic of the gang; which is founded on an opposition, admitted or not, between the exterior and the interior of the group. Even an informal group deteriorates into a political racket, the classic case of theory becoming ideology. [...] The interior-exterior opposition and the gang structure develop the spirit of competition to the maximum. Given the differences of theoretical knowledge among the members, the acquisition of theory becomes, in effect, an element of political natural selection, a euphemism for division of labor. While one is, on the one hand, theorizing about existing society, on the other, within the group, under the pretext of negating it, an unbridled emulation is introduced that ends up in a hierarchization even more extreme than in society-at-large; especially as the interior-exterior opposition is reproduced internally in the division between the center of the gang and the mass of militants. The political gang attains its perfection in those groups that claim to want to supersede existing social forms.[15]

The avant gardes reproduce this division, upholding discipline with the threat of exclusion: everyone who does not respect the norms of the gang is separated and exposed to slander, thrown outside to the violence and misery of the external. As Cammate and Collu writes: "What maintains an apparent unity in the bosom of the gang is the threat of exclusion. Those who do not respect the norms are rejected with calumny; and even if they quit, the effect is the same. This threat also serves as psychological blackmail for those who remain."[16]

The avant garde is divided between the present condition of the world and the state towards which the avant garde wishes to direct the mass. The avant garde is divided between what is and what ought to be. In this limbo the avant garde tumbles around, destroying itself in the search for the avant-garde position. The grandiose actions, the violent exclusions and the spectacular breaks are all signposts on the avant gardes' guaranteed road to dissolution. As Tiqqun writes:

> The avant-gardes spin in place in the self-ignorance that consumes them. And at last they collapse, before ever really being born, without ever really managing even to get started. And that's the answer to the most naïve question about the avant-gardes, which asks what exactly it is that they're the avant-garde of, what it is they're heralding: the avant-gardes are above all the heralds of themselves alone—chasing after themselves.[17]

The avant garde is almost a born dead project exploding before it gives birth to anything at all as it is suspended in an infinite projection of itself beyond itself. It turns and turns in the excited chase of itself and crashes without ever realizing the grandiose plans as was the case of the Situationist International that after May '68 collapsed in a mixture of expectations of a coming victory and paranoia. After the students had left their libidinal energies to roam in the streets of Paris and the workers had left the factories the Situationists were sure that they were living through "the beginning of an epoch."[18] Imagination, however, never really took power and the Grenelle negotiations replaced the dissatisfaction and unrest with higher wages and fewer restrictions for students. The Situationists fought with this development in the years between 1968 and 1971, trying to distance themselves from the growing milieu of supporters that threatened to blur the distinction between inte-

grated and outsider. This was unacceptable and one by one or in bundles members were expelled until only two or three members were present: Debord in Paris, Sanguinetti in Italy and, forgotten by everybody including his Situationist friends, J.V. Martin in Denmark. At that time there was nothing left to do but dissolve the organization.

The Orders of the Avant Garde

The document *Report on the Construction of Situations and on the International Situationist Tendency's Conditions of Organization and Action*, which Debord presented at the founding meeting of the Situationist International in Cosio d'Arroscia in July 1957, begins with the sentence: "First, we believe the world must be changed."[19] Debord could not have chosen a better way to begin a manifesto for a new avant garde since the subjectivation of the avant garde always takes the shape of orders or commands—"the world must be changed." The order is the enunciation for which the avant garde is the subject. "Transform the world," "change life" and "construct situations" are the most reproduced orders that the avant garde stated in the twentieth century. Debord naturally continued his manifesto by stressing the radical nature of the change the Situationist International was striving for: "We desire the most liberatory possible change of the society and the life in which we find ourselves confined."[20] Debord wanted nothing less than a complete transformation. He continued by explaining that the socio-material conditions for such a transformation were present but were blocked by the capitalist system that had created a world dominated by the commodity. But the Situationists had a vision of the future society, of the abolition of prehistory and the realization of communist society. The present was characterized by an idolatrous life where images had replaced god. Mass media, journalism, politics and advertisements had fused in a separate image the world that the avant garde had to destroy. The dominance of capital was becoming complete thanks to the production and consumption of material and symbolic commodities that were all images. These images that held together a divided society were to be rejected. This was the task of the avant garde. Just as the Surrealists did not manage to liberate the unconscious, the Situationists never really succeeded in transforming the world or re-establishing the revolutionary tradition. In fact, nobody has been able to transform the world, change life and construct situations as completely as the sworn enemy of the avant garde, namely capitalism. Capitalism does not loudly proclaim anything, but it continuously revolutionizes the world. As Camatte writes: "In the era of real domination, capital has run away…, it has escaped."[21]

Manfredo Tafuri makes a bold assertion when he argues that the avant garde has actually done the job of capitalism in so far as it intensified the alienation of capitalist value production.[22] The aversion against the old world was so intense that the avant garde threw itself into the arms of capital and helped it to empty humanity, making the individual fragile and thus more receptive to the representations of the market. According to Tafuri, the project of the avant garde was a success insofar as it managed to internalize modern shock. The world was indeed transformed but not in the way the avant garde wanted. The unconscious and the imagination was let loose but as part of a permanent entertainment spectacle from which there is no escape and where image-commodities are quickly replaced by new image-commodities in an endless movement. Capital constantly transforms the world, changes the everyday and constructs situations.

After the avant garde has prepared the terrain and emptied the subject of any kind of sense of community, capitalist economy moves in and fills it with images, slogans, logos and jingles, thereby maintaining the sufficient level of consumption. Thanks to the montages and assemblages of the avant garde, the money economy is victorious to such a degree that it no longer looks upon the world as the outcome of a long history but as the primitive looks upon the forest—as its natural environment. This is the tragic destiny of the avant garde according to Tafuri; it carries out the work of capitalism. There is an unconscious connection between the avant garde and capitalism that means that the avant garde at one and the same time sublimates and affirms the leveling movements of capitalism. With its actions, manifestos and buildings the avant garde desensitizes humanity, intensifies alienation and thereby prepares the way for capitalist colonization. In the swarm of the city the avant garde struggles against the destruction of experience but ends up naturalizing alienation, programming humanity for a new type of behavior. It is as if the injunction and orders of the avant garde inhibit the realization of the capitalist project: they stun more than they activate. This is because it does not make sense to order someone to attack capitalism. It cannot be anybody's duty to abolish wage labor. This is something one does for oneself together with others and not on behalf of someone else. But the avant garde never gets tired of commanding the mass to change the world, life and itself. The avant garde demands the mass to take over something it already lives and moves within.

As we know from the many accounts of the avant garde, one of its central categories is the "new." The avant garde is in accordance with its original military meaning as a vanguard that moves where the rest of the army will follow. The avant garde is, as Tafuri writes, "seeking complete domination over the future."[23] The avant garde's "new," however, does not exist but is radically exterior to society. The "new" is the total destruction of everything that is not empty, a destruction of all the old stuff. The avant garde is thus without an object and strives to destroy everything, leaving nothing but ruins in its wake. For the avant garde it is of utmost importance to prevent the "new" from becoming comprehensible. If this happens—if the meaning

of the "new" is suddenly fixed—the "new" is no longer the "new" but merely a part of the already existing, a part of the old world; the "new" would be recuperated, integrated into the established taste. According to this logic the "new" cannot have an object. The practice of the avant garde is thus a continual emptying of the "new," a making meaningless. The avant garde has to make sure that the "new" remains an exterior threat to the signification system of society. Ultimately the avant garde is the total destruction of all traditions, laws and symbols, as it was the case with Sergey Nechayev, who was the most radical exponent of the emptying of the "new" in the nineteenth century. For Nechayev everything was permitted in the attempt to create empty forms. His avant garde should destroy and negate everything; nothing was to be saved in the battle against the existing world.[24] Even though avant-garde groups like the Situationist International refrained from political violence in the battle against the society of the spectacle, violent emptying is a permanent ingredient in the avant garde's repertoire and offshoots. Situationist projects like the Angry Brigade did not shy away from using violence as a part of the revolutionary process.[25]

The Missing Body of the Avant Garde

For almost a decade the Surrealist group struggled to unite the "artistic" avant garde—the Surrealist group itself—and the political avant garde in the shape of communism. In the middle of the 1930s, however, those Surrealists who were led by André Breton came to a definitive break with the French Communist Party. The Surrealists had tried their best but had to pull back and manifest their disapproval of the increasing Stalinization of the Party.[26] The political awakening of the Surrealists took place in 1925 when Breton and other members of the group realized that the transformation of life they wanted also required a transformation of society's socio-material conditions. After a series of breaks and fights both within the Surrealist group and with other para-communist groups, Breton managed to turn Surrealism towards the French Communist Party, which, according to Breton, was the most important representative of a radical critique of the French parliamentary system and the bourgeois life that the Surrealists wanted to overcome. Despite setbacks in the Soviet Union, the Communist Party still appeared as the most revolutionary actor as it incarnated the heroic events of 1917 in Russia. In retrospect it is evident how the Surrealists were caught by the paradox of the October Revolution. On the one hand, the Russian Revolution changed world history by giving socialist revolutions the world over a territorial base in the Soviet Union. On the other hand, the failed revolutions in western Europe forced the Soviet Union into a terrible cycle of "primitive socialist accumulation." Over a long period, the future expansion of a socialist revolution was dependent upon material and political support from a Soviet Union that at the same time, because of the quick consolidation of bureaucratic despotism, became a virtual

dystopia for the western working class and an obstruction to the creation of internationalism. The paradoxical consequence of the October Revolution was thus a "provincialization" of the European working class and the bureaucratic devaluation of socialism in the Soviet Union. The connection between political theory and the organized labor movement was cut in the 1920s and 30s and it remains very debatable whether the Soviet Union was a threat to the kingdom of capitalism after 1924. The Surrealists believed so for a decade but they changed their minds as Stalin, in the period 1935 to 1947, made every effort to detach the Soviet Union from the dynamic of permanent revolution and instead tried to reclaim Russia's old position as a legitimate power with a traditional sphere of influence.

It took several years before the Surrealists came to the realization that the French Communist Party was in effect a hindrance to the establishment of a revolution. At the end of the 1920s the Surrealists enrolled in the Communist Party in order to give the Surrealist revolution a political perspective. The internal polemics of the Surrealist group were apparently done with and Breton as well as the remaining members concentrated on uniting political action with Surrealist activity without sacrificing the potentials of Surrealism: Surrealism in the service of the revolution. The Communist Party was however anything but excited about the Surrealists' rapprochement and there constantly were tensions between the Surrealists' quest for spiritual emancipation and the Communist Party's wish for a socio-material overhaul of capitalism.[27] Despite the fact that the Surrealists were quite subdued in their criticism of the Communist Party the rapprochement never really took place because the Party advocated a rigid materialist conception of reality that in the long run was incompatible with the Surrealist interest in the anarchic, the seemingly meaningless, the absurd and the random.[28] As the Communist Party slowly but steadily abandoned or toned down its revolutionary rhetoric, blocked out any kind of internal opposition (as with Boris Souvarin and Pierre Monatte) and tried to legitimate the development in the Soviet Union where party dictatorship and state capitalism went hand in hand, the contradictions between Surrealists and the Communist Party grew. The Surrealists continued to mock the nation, the family, bourgeois morals and work and in 1933 Breton, Paul Éluard and René Crevel were excluded from the party. That did not mean that the Surrealists stopped attempting to unite Surrealism and Communism, which was now a mixture of Stalin's and Trotsky's theories. But it did not take long before the adventure ended.

In 1935 Stalin and the French foreign minister Pierre Laval signed a treaty of mutual assistance between France and the Soviet Union, thereby encircling Nazi Germany. This was a huge event as the Soviet Union adopted a western-oriented foreign policy and finally confirmed the abandon-

ment of the strategy of permanent world revolution that Lenin advocated to his death.[29] Until 1935 the Soviet Union and the different national communist parties like the French one had been based in Lenin's campaign against the First World War, arguing that war between capitalist states was imperialist war that should be transformed into revolution. With this treaty Stalin dissolved the revolutionary internationalist perspective and made it possible for the communist parties to support national defense and ally with non-revolutionary left parties. This effectively abandoned revolutionary communist aspirations to overthrow bourgeois democracy. The Surrealists reacted strongly to this nationalist turn and in June, during the International Congress of Writers for the Defense of Culture, the Surrealists finally bid farewell to the French Communist Party.[30] Breton did not attend as he had been involved in a scuffle with the organizer of the congress, Ilya Ehrenburg, but Éluard gave a speech where he strongly criticized the treaty between France and the Soviet Union and mocked the idea of nation states. This speech, which in many respects marked the end of the alliance between the artistic and political avant garde, ended with the legendary words: "Transform the world, said Marx, change life, said Rimbaud, these two watchwords are one for us."[31]

The French Communist Party did not make room for Breton and the Surrealists. In the Soviet Union the Bolshevik Party was only briefly interested in letting the "artistic" avant garde participate in the revolutionary process. The fate of the Soviet avant garde is witness to that fact. As Boris Groys has written, there was no need for two avant gardes in the Soviet Union after 1917. The political avant garde, in the form of the Bolshevik Party, was just as engaged in aesthetic concerns as the "artistic" avant garde was engaged in politics, and so the party considered the artists to be competitors.[32] While the "artistic" avant garde is always trying to fuse art and politics from the point-of-view of art, the political avant-garde is always involved in a symbolic practice conceptualizing politics as a kind of art. Politics is a kind of fiction where a community is given form in an active sense when it is represented. As Groys argues, the Communist Party was well aware of that and did not want any competition. The vanguard was the party; only the party could direct the revolution and lead the masses. Only the party was capable of directing the class struggle in accordance with the Marxist history of science. Lenin had already made that clear in 1902 with his *What Is to Be Done?* and stressed it again after 1917. The party was to be a revolutionary vanguard, the general staff of the proletariat organized as a closed and strong centralized cadre. The spontaneous action of the masses was not enough. The party had to intervene and direct the struggle. The party intervened on behalf of the masses. Loyalty and what Lenin described as iron discipline were the key words for avant-garde organization, where only the most schooled and disciplined had a place. The mission of the avant garde party was to inject socialist consciousness into the masses

that did not posses it by itself. Lenin thus considered the working class a passive object that the party should steer and form into the proletariat, the historical subject capable of destroying capitalism. The party was thus the subject whose intervention was absolutely necessary. As always with the avant garde, subject and object were separate and the party was to shape and form an object it did not consider itself part of.

We find a version of this idea of the lower classes' lack of intelligence and the need for external steering by an all-knowing avant garde in the writings of Marx. Although he considered the communist party as the organization of an objective movement bringing society towards Communism, and although he did not operate with a notion of a "socialist consciousness" to be imposed on the masses from without, as Lenin did, Marx nonetheless at times reproduces the avant garde's self-privileging. Disappointed with the failures of the 1848 revolutions, Marx gave up on the actual workers in favor of the theoretical concept of the proletariat.[33] The proletariat thus became a normative category with which the Marxist scientist monitored and compared the actual workers in order to see whether they deviated from the revolutionary project. Marx's impatience with the workers in Paris—they were behaving foolishly—was transformed into a science where the workers were rejected as petty-bourgeois if they did not live up to the concept of the proletariat. In conflict with emancipatory aspirations, Marx in effect shut the disempowered up in their lack and assigned himself the role of the knowing teacher, the avant garde, the head of the ignorant mass. As Jacques Rancière sums up Marx's formula: "People 'make' history but they 'do not know' they do so."[34] When the class struggle reached its final phase and tore capitalist society apart a small part from the dominant class—"the bourgeois ideologists, who have raised themselves to the level of comprehending theoretically the historical movement as a whole"—stepped down into the mass and guided it.[35]

The political task, for Marx, was to make sure that history developed as it was supposed to. But history did not develop according to Marx's plan; where the proletariat was supposed to have appeared Marx saw comic and contradictory figures. The problem was that the workers wanted to be satisfied here and now and so appropriated petty-bourgeois conceptions of happiness and solidarity instead of becoming the negation that Marx and his theory of the revolution had predicted. The problem was that the workers behaved as if they were already free. The workers confused means and ends and created a "wrong" and "all too easy Communism." Marx was forced to dismiss these mistakes and wait. "It is too hard a task, even for the best dialecticians, to prove to communist proletarians that they are not communist proletarians by invoking a communist proletariat whose only fault is that it does not yet exist. ... The only thing to do is to leave things alone ... and wait for the

coming communist proletariat and its organized movement."[36]

Marx strangely negated and affirmed the stupidity of the working class and staged himself as the knowing subject able to not only decipher but also predict the movements of history. He thus moved towards the working class, glorifying the historical role of the proletariat but only after having separated himself from it. The bourgeois ideologist was somehow the brain of the proletariat, waiting for it to manifest itself in accordance with the bourgeois ideologist's theory of history.

While Marx waited for a proletariat that had not yet manifested itself, Lenin did not wait; he was impatient and activated the minuscule Russian working class, trying to accelerate the revolutionary process. He knew what was to be done: Leadership of the party and hierarchy of the organization. Only by being guided by the party who knows the direction of history will the mass of workers manage to mobilize itself and revolt. On their own the workers are reformist; it is the revolutionary avant garde party that knows how to get things rolling.

Lenin, the French Communist Party, the Surrealists and the Situationists were all trying to give shape to the formless and ignorant mass. Even though "artistic" avant gardes like the Situationists were dismissive of the centralism of the Communist Party and rightly rejected it as nothing but a capitalist institution fighting other capitalist groups over state power, they nonetheless remained dependent upon a similar notion of the all-knowing avant garde. The Situationists praised the anti-bureaucratic tendencies of the revolutionary movement that Lenin and later Stalin persecuted but they did not manage to break away from an elitist avant garde model and its inherent centralism. They almost ended up looking like a farcical small-scale version of the Third International, with a central committee, ukases and exclusions.

Beyond the Avant Garde?

Even though we are in the midst of a dynamic historical situation where the imperial hegemony of the U.S. is tottering and the world economy is in crisis—a situation not unlike the period from 1914 to 1945 where two large-scale wars were necessary in order to arrive at an adequate rate of profit for a new capitalist expansion—we have not yet seen the reappearance of an avant garde like Surrealism or the Situationist International. But with the revolts in North Africa and the Middle East we have a revolutionary challenge to the present post-colonial world system with its extreme inequality and division of the world into zones of extreme poverty and fortified wealth. It may, therefore, be a question of time before we see the re-emergence of something like the interwar avant garde.[37] Time will tell. There is no question that there is a need for the avant garde's radical critique. So much needs to be destroyed. The question is of course whether *everything* has to be rejected and destroyed…

Although the extreme claims of the avant garde and its militant criticism of the existing world is desperately needed, it is perhaps no longer necessary to create the world ex nihilo. The totalistic stance of the avant garde, its narcissism and its abstract and blank denunciations need to be critiqued. Perhaps we can finally replace the avant garde's pure rejection by an affirmative critique of the existing, a critique that does not demand humankind to embrace "life," "the situation" or "the community" since we are always already thrown into it. Perhaps it is possible to critique the domination of capital with an awareness of the danger inherent in the desire for revolution and another world. As Jean-Luc Nancy writes, what we are left with today is a double demand according to which we have to create a world where everything is not already done, nor still entirely to do.[38]

Notes

1. Antonin Artaud, "In Total Darkness, or The Surrealist Bluff" ["À la grande nuit ou le Bluff Surréaliste", 1927], trans. Susan Sontag, in Antonin Artaud, *Selected Writings* (Berkeley & Los Angeles: University of California Press, 1988) 139.
2. Peter Bürger, *Theory of the Avant-Garde*, trans. Michael Shaw (Minneapolis: University of Minnesota Press,) [1974] 1984) 58.
3. For a critique of Bürger's notion of history, see Hal Foster, *The Return of the Real* (Cambridge: The MIT Press, 1996). For a critique of Bürger's lack of a broader historical context within which the transformation of the avant garde project takes place, see Russell Berman, *Modern Culture and Critical Theory* (Madison: The University of Wisconsin Press, 1989). The most interesting responses to Bürger's thesis remains the essays collected in Martin Lüdke, ed. *'Theorie der Avantgarde'. Antworten auf Peter Bürgers Bestimmung von Kunst und bürgerlicher Gesellschaft* (Frankfurt: Suhrkamp, 1976).
4. Jacques Camatte, *Capital and Community* [*Capital et gemeinvesen. Le 6e chapitre inédit du Capital et l'œuvre économique de Marx*], 1978), trans. David Brown, available at http://www.marxists.org/archive/camatte/capcom/index.htm.
5. Theodor W. Adorno and Max Horkheimer, "The Culture Industry: Enlightenment as Mass Deception," in *Dialectics of Enlightenment: Philosophical Fragments*, trans. Edmund Jephcott (Stanford: Stanford University Press, [1944] 2002) 94-136.
6. It was especially left communists like Cornelius Castoriadis and Jean-François Lyotard who initiated the necessary reworking of historical materialism's suspect notion of history. For important contributions to this development, see Cornelius Castoriadis, "Modern Capitalism and Revolution" ["Le mouvement révolutionnaire sous la capitalisme moderne", 1961], trans. Maurice Brinton, http://libcom.org/library/modern-capitalism-revolution-paul-cardan and Jean-François Lyotard: *Libidinal Economy*, trans. Iain Hamilton Grant (Bloomington: Indiana University Press, [1974] 1993).
7. See Mikkel Bolt Rasmussen, *Den sidste avantgarde. Situationistisk Internationale hinsides kunst og politik* [*The Last Avant-Garde: The Situationist International Beyond Art and Politics*] (Copenhagen: Politisk revy, 2004).
8. Perry Anderson: *The Origins of Postmodernity* (London: Verso, 1998) 82.
9. For a comparison of these different projects, see Mikkel Bolt Rasmussen: "The Politics of Interventionist Art: The Situationist International, Artist Placement Group, and Art Workers' Coalition,"

in *Rethinking Marxism* 21:1 (2009) 34-49.

10. Guy Debord in a letter dated March 15, 1963, to Robert Estivals, trans. Not Bored, http://www.notbored.org/debord-15March1963.html.

11. Guy Debord letter, March 15, 1963.

12. Tiqqun, "The Problem of the Head" ["Le problème de la tête", 2001], trans. anonymous, http://headproblems.jottit.com/part_1.

13. Paul Mann, *The Theory-Death of the Avant-Garde* (Bloomington & Indianapolis: Indiana University Press, 1991).

14. "Just as God constituted the reference point of past unitary society, we are preparing to create the central reference point for a new unitary society now possible." Cited in Raoul Vaneigem, "Basic Banalities" ["Banalités de base", 1963], trans. Ken Knabb, available at http://www.bopsecrets.org/SI/8.basic2.htm.

15. Jacques Camatte & Gianni Collu, "On Organization" ["De l'organisation", 1969], trans. Edizioni International, in Jacques Camatte, *This World We Must Leave and Other Essays* (New York: Autonomedia, 1995) 28-9.

16. Camatte and Collu, "On Organization," 29.

17. Tiqqun, "The problem of the Head."

18. When the twelfth and last issue of the group's journal, *Internationale Situationniste*, was published in 1969 it contained a long analysis of the events of May-June 1968 with that title, "The Beginning of an Epoch."

19. Guy Debord, "Report on the Construction of Situations and on the Terms of Organization and Action of the International Situationist Tendency" ["Rapport sur la construction de situations et sur les conditions de l'organisation et de l'action de la tendance situationniste internationale," 1957], trans. Tom McDonough, in Tom McDonough, ed. *Guy Debord and the Situationist International* (Cambridge: The MIT Press, 2002) 29.

20. Debord, "Report on the Construction of Situations," 29.

21. Jacques Camatte, "The Wandering of Humanity" ["Errance de l'humanité—conscience répressive—Communisme," 1973], trans. Freddy Perlman, in Jacques Camatte, *This World We Must Leave and Other Essays*, 45.

22. Manfredo Tafuri, *Architecture and Utopia: Design and Capitalist Development*, trans. Barbara Luigia La Penta (Cambridge: The MIT Press, [1973] 1976).

23. Tafuri, *Architecture and Utopia*, 50.

24. "The revolutionary knows that in the very depths of his being, not only in words but also in deeds, he has broken all the bonds which tie him to the social order and the civilized world with all its laws, moralities, and customs, and with all its generally accepted conventions. He is their implacable enemy, and if he continues to live with them it is only in order to destroy them more speedily." Sergej Necaev & Mikhail Bakunin, "The Revolutionary Catechism" [1869], trans. unknown, http://www.marxists.org/subject/anarchism/nechayev/catechism.htm. For a good description of Russian anarchism, see Franco Venturi's classic account in *Roots of Revolution: A History of the Populist and Socialist Movement in 19th Century Russia*, trans. Francis Haskell (London: Phoenix Press, [1952] 2001).

25. For an account of the Situationist background to the Angry Brigade, see Tom Vague, *Anarchy in the UK: The Angry Brigade* (London: The AK Press, 1997).

26. For analyses of the relationship between the Surrealist group and the French Communist Party, see Maurice Nadeau, *The History of Surrealism*, trans. Richard Howard (Cambridge: Harvard University Press, [1964] 1989); Robert S. Short, "The Politics of Surrealism, 1920-36," *The Journal of Contemporary History* 2 (1966) 3-25; and André Thirion, *Révolutionnaires sans révolution* (Paris: Éditions Robert Laffont, 1972).

27. Breton was on several occasions taken to task by the Communist Party's central committee for Surrealist actions and publications. See *Entretiens* (Paris: Gallimard, [1952] 1969).

28. For a description of the French Communist Party, see David Caute, *Communism and the French Intellectuals 1914-1960* (London: Andre Deutsch, 1964). For a description of the Communist Party's view of Surrealism, see also chapter five in Jacques Fauvet & Alain Duhamel, *Histoire du Parti Communiste Français de 1920 à 1976* (Paris: Fayard, [1976] 1977).

29. See Lars T. Lih, *Lenin* (London: Reaktion Books, 2011).

30. The documents from the congress are collected in Wolfgang Klein & Sandra Teroni, eds. *Pour le défense de la culture. Les textes du Congrès international des écrivains. Paris, juin 1935* (Dijon: Éditions universitaires de Dijon, 2005).

31. André Breton, "Speech to the Congress of Writers" [1935], in *Manifestoes of Surrealism*, trans. Richard Seaver & Helen Lane (Ann Arbor: University of Michigan Press, 1972) 241.

32. Boris Groys, *The Total Art of Stalinism: Avant-Garde, Aesthetic Dictatorship, and Beyond*, trans. Charles Rougle (Princeton: Princeton University Press, [1988] 1992).

33. See Jacques Rancière, "Mode d'emploi pour une réédition de *Lire le 'Capital',*" *Les Temps modernes* 328 (1973) 788-807.

34. Jacques Rancière, *The Philosopher and His Poor*, trans. John Drury, Corinne Oster and Andrew Parker (Durham: Duke University Press, [1983] 2004) 132.

35. Rancière, quoting from *The Communist Manifesto*, in Rancière, *The Philosopher and His Poor*, 76.

36. Rancière, *The Philosopher and His Poor*, 85-6.

37. For an analysis of the return of the avant garde, see Mikkel Bolt Rasmussen, "The Beginning of An Epoch: The Crisis, the Upheavals and the Revolution," *Mute* (May 21, 2013), available at: http://www.metamute.org/community/your-posts/beginning-epoch-crisis-upheavals-and-revolution

38. Jean-Luc Nancy, "'What is to be done?'," trans. Leslie Hill, in Philippe Lacoue-Labarthe & Jean-Luc Nancy, *Retreating the Political*, edited by Simon Sparks (London: Routledge, [1966] 1997) 157.

Towards a Critical Art Theory

Gene Ray

Critical theory rejects the given world and looks beyond it. In reflection on art, too, we need to distinguish between uncritical, or affirmative, theory and a *critical* theory that rejects the *given art* and looks beyond it. Critical *art* theory cannot limit itself to the reception and interpretation of art, as now exists under capitalism. Because it will recognize that art as it is currently institutionalized and practiced—business as usual in the current 'art world'—is in the deepest and most unavoidable sense 'art under capitalism,' art under the domination of capitalism, critical art theory will rather be oriented towards a clear break or rupture with the art that capitalism has brought to dominance.

Critical art theory's first task is to understand how the given art supports the given order. It must expose and analyze art's actual social functions under capitalism. What is it *doing*, this whole sphere of activity called art? Any critical theory of art must begin by grasping that the activity of art in its current forms is contradictory. The 'art world' is the site of an enormous mobilization of creativity and inventiveness, channelled into the production, reception, and circulation of artworks. The art institutions practice various kinds of direction over this production as a whole, but this direction is not usually *directly* coercive. Certainly the art market exerts pressures of selection that no artist can ignore, if she or he hopes to make a career. But individual artists are relatively free to make the art they choose, according to their own conceptions. It may not sell or make them famous, but they are free to do their thing. Art, then, has not relinquished its historical claim to autonomy within capitalist society, and today the operations of this relative autonomy remain empirically observable.

On the other hand, a critical theorist is bound to see that art as a whole is a stabilizing factor in social life. The existence of an art seemingly produced freely and in great abundance is a credit to the given order. As a luxurious surplus, art remains a jewel in the crown of power, and the richer, more splendid and exuberant art is, the more it affirms the social status quo. The material reality of capitalist society may be a war of all against all, but in art the utopian impulses that are blocked from actualization in everyday life find an orderly social outlet. The art institutions organize a great variety of activities and agents into a complex systemic unity; the capitalist art system functions as a subsystem of the capitalist world system. Without doubt, some of these activities and artistic products are openly critical and politically committed. But taken *as a whole*, the art system is 'affirmative,' in the sense that it converts the totality of artworks and artistic practices—the sum of what flows through these circuits of production and reception—into 'symbolic legitimation' (to borrow Pierre Bourdieu's apt expression for it) of class society.[1] It does so by *simultaneously* encouraging art's autonomous impulses and politically neutralizing what those impulses produce. Art *simulates* the experiences of freedom, reconciliation, joy, solidarity and uninhibited communication and expression that are blocked in class society. Art is a form of compensation for the injustices, repressions and self-repressions, and impoverishments of experience that characterize everyday life under capitalist modernity. As *compensation*, art captures and renders harmless rebellious energies and dissipates pressures for change. In this way art is an *ideological support* for the social status quo and contributes to the reproduction of class society.

Frankfurt Modernism

The Frankfurt theorists pioneered and elaborated this dialectical understanding of art. Herbert Marcuse, Max Horkheimer and Theodor Adorno—working in close relation to others, including Walter Benjamin, Ernst Bloch and Siegfried Kracauer, and certainly stimulated by the different Marxist approaches of Bertolt Brecht and Georg Lukács—have shown us how art under capitalism can, at the very same time, be both relatively autonomous and instrumentalized into a support for existing society. Every work of art, in Adorno's famous formulation, is both autonomous and *fait social*.[2] Every artwork is autonomous insofar as it asserts itself as an end-in-itself and pursues the logic of its own development without regard to the dominant logic of society; but every work is also a 'social fact' in that it is a cipher that manifests and confirms the reality of society, understood as the total nexus of social relations and processes. In the autonomous aspect of art's 'double character,' the Frankfurt theorists saw an equivalent to the intransigence of critical theory. Free autonomous creation is a form of that reach for a non-alienated humanity described luminously by the young Karl Marx. As such, it always contains a force of resistance to the powers that be, albeit a very fragile one.

Their attempts to rescue and protect this autonomous aspect led the Frankfurt theorists to an absolute investment in the forms of artistic modernism. For them, and above all for Adorno, the modernist artwork or opus was a sensuous manifestation of truth as a social process straining towards human emancipation. The modernist work—and to be sure, what is meant here are the masterworks, the zenith of advanced formal experimentation—is an "enactment of antagonisms," an unreconciled synthesis of "un-unifiable, non-identical elements that grind away at each other."[3] A force field of elements that are both artistic and social, the artwork indirectly or even unconsciously reproduces the conflicts, blockages and revolutionary aspirations of alienated everyday life. They saw this practice of autonomy threatened from two directions. First, from the increasing encroachments of capitalist rationality into the sphere of culture—processes to which Horkheimer and Adorno famously gave the name 'culture industry.'[4] Second, from political instrumentalization by the Communist parties and other established powers claiming to be anti-capitalist.

It was in response to his perceptions of this second threat that Adorno issued his notorious condemnation of politicized art.[5] Ostensibly responding to Jean-Paul Sartre's 1948 call for a *littérature engagée*, Adorno's position in fact had already been formed by the interwar context: the liquidation of the artistic avant gardes in the USSR under Stalin and the Comintern's adoption of socialist realism as the official and only acceptable form of anti-capitalist art. Art that subordinates itself to the direction of a Party was for Adorno a betrayal of art's force of resistance. He took the position that art cannot instrumentalize itself on the basis of political commitments without undermining the autonomy on which it depends and thereby undoing itself as art. Autonomous (modernist) art is political, but only indirectly and only by restricting itself to the practice of its proper autonomy. In short, art must bear its contradiction and not attempt to overcome it. As the culture industry expanded and consolidated its hold over everyday consciousness and, indeed, as struggles of national liberation and urban uprisings politicized campuses over the course of the 1960s, Adorno responded by hardening his position.

There can be little doubt, that the given artistic autonomy is threatened by the two tendencies Adorno pointed to; but there is little doubt either that his conception of the problem forecloses its possible solution. Culture industry and official socialist realism were not the only alternatives to the production of autonomist artworks. But Adorno in effect couldn't see these other alternatives because he had no category for them. The most convincing of these alternatives constituted itself by terminating its ties of dependency on the art institutions, abandoning the production of traditional art objects, and relocating its practices to the streets and public spaces. The formation of the Situationist International (SI) in 1957 was an announcement that this alternative had reached a basic theoretical and practical coherence. Adorno remained blind to it as he continued to polish his *Aesthetic Theory* until his death in 1969. So did his heir, Peter Bürger, who would publish *Theory of the Avant-Garde* in 1974.

An English translation of Bürger's book appeared in 1984.[6] Since then, it has functioned mainly as a theoretical support for modernist positions within Anglophone (i.e. globalized) art and cultural discourse. It still tends to be cited by those happy to counter-sign any possible death certificate of the avant gardes, and by those dismissive of attempts to develop practices in opposition to dominant institutions. In the present context, we would only need to read Andrea Fraser to see how Bürger is still brought in as an authority purportedly demonstrating the futility, infantilism and bad faith of all practices aimed directly against or seeking radically to break with established institutional power.[7] For Fraser, Bürger, together with Pierre Bourdieu, becomes a resource for the justification of an ostensibly more mature and effective position within the institutions. However, even when it is called 'criticality,' resignation remains resignation. It is not my purpose here to engage with specific readings of Bürger or even to fairly represent the development of Bürger's own positions since 1974. What follows is a critique of the arguments advanced in *Theory of the Avant-Garde*, since it is this text, in its English edition, that is operative today in support of a resigned and melancholic modernism. And in this regard, it is crucial to see Adorno standing behind Bürger. While in other respects, Adorno remains a key critical thinker, for me, his rigid investments in artistic modernism are a political problem and, as such, are to be critically resisted.

Towards a Different Autonomy

With both Adorno and Bürger, the problem can be traced to a theoretically unjustified over-investment in the work-form of modernist art. Bürger basically rewrites the history of the artistic avant gardes as the development of the work-as-force-field so dear to Adorno. For Adorno, the avant garde is modernist art, identity pure and simple. Bürger makes an important advance beyond this identification by grasping that the 'historical' avant gardes had repudiated artistic autonomy in their efforts to re-link art and life—and that their specificity is to be located in this repudiation. But although Bürger works hard to differentiate his analysis from Adorno's, he returns to the fold, so to speak, by judging this avant-garde attack on the institution of autonomous art to be failure, a 'false supersession' (*falsche aufhebung*) of art into life.

> The avant-garde intended the supersession (*Aufhebung*) of autonomous art by leading art over into a practice of life (*Lebenspraxis*). This has not taken place and presumably cannot take place within bourgeois society unless it be in the form of a false supersession (*falschen Aufhebung*) of autonomous art.[8]

Situationist International tract by André Bertrand, *Le Retour de la Colonne Durutti* (Strasbourg: Association Fédérale Générale des Étudiants de Strasbourg, 1966).

The only successful result was an unintended one: after the historical avant gardes, according to Bürger, a transformation takes place in the work-form of art. The organic, harmonized work of traditional art gives way to the (non-organic, allegorical) work-form in which disarticulated elements are held together in a fragmentary unity that refuses the semblance of reconciliation: "Paradoxically, the avant-gardiste intention to destroy art as an institution is thus realized in the work of art itself. The intention to revolutionize life by returning art to its praxis turns into a revolutionizing of art."[9] In other words, art cannot repudiate its autonomy, but it can go on endlessly repudiating its own traditions, so long as it does so in the form of modernist works. This pronouncement of failure and 'false supersession' is far too hasty. I will return to this point later. Here I want to question this investment in the institutionalized autonomy of art by contrasting it to the autonomy constituted through a conscious break with institutionalized art.

The Situationist alternative to art under capitalism was a more advanced and theoretically conscious breakout than the often partial and hesitant revolts of the early avant gardes. Founded in 1957 but continuing in many respects the project of the Lettrist International (LI) from which many of its founding members came, the SI was a Paris-based network of mostly European national 'sections' active until its self-dissolution in 1972. Formally combining the LI group around core members Guy Debord, Michèle Bernstein and Gil Wolman and the Imaginist Bauhaus around Asger Jorn, Constant and Giuseppe Pino-Gallizio, and soon assimilating the Munich-based Spur group around Hans-Peter Zimmer, Heimrad Prem and Dieter Kunzelmann, the SI undertook a radical collective critique of postwar commodity capitalism and the art system flourishing around a restored modernism. Drawing the practical conclusions, they transformed the SI within four years from a grouping of artists into a revolutionary organization of cultural guerrillas. The SI's critical process of progressive detachment from the art institutions culminated in an internal prohibition on the pursuit of an art career by any of its members. Situationist practice was radically politicized, but is not reducible to a simple or total instrumentalization. We can agree with Adorno that artists who paint what the Party says to paint have given up their autonomy; as apologists for the Central Committee's monopoly on autonomy, they are no more than instruments for producing compromised works. But the SI was a group founded on the principle of autonomy—an autonomy not restricted as privilege or specialization, but one that is radicalized through a revolutionary process openly aiming to extend autonomy to all. The SI did not recognize any Party or other absolute authority on questions pertaining to the aims and forms of revolutionary social struggle. Their autonomy was to critically study reality and the theories that would explain it, draw their own conclusions and act accordingly. In its own group process, the SI accepted nothing less than a continuous demonstration of autonomy by its members, who were expected to contribute as full participants in a collective practice. This process didn't always unfold smoothly. (What process does?) But the much-criticized exclusions carried out by the group by and large reflect the painful attainment of theoretical coherence and are hardly proof of a lack of autonomy. 'Instrumentalization' is the wrong category for a conscious and freely self-generating (i.e. autonomous) practice.

Moreover, the Situationists were even more hostile than Adorno to official Communist parties and would-be vanguards. Their experiments in collective autonomy were far removed—and openly critical of—the servility of party militants. Alienation can't be overcome, as they put it, "by means of alienated forms of struggle."[10] Their critical processing of revolutionary theory and practice was plainly much deeper than Adorno's—and was lived, as it must be, as a real urgency. They carried out an autonomous appropriation of critical theory, developed in a close dialectic with their own radical cultural practices and innovations. As a result, true enough, they ceased to produce modernist artworks. But they never claimed to have gone on with modernism; they claimed rather to have surpassed this dominant conception of art.[11] My point is that Situationist practice—however you categorize or evaluate it—was certainly no less autonomous than the institutionalized production of modernist artworks favored by Adorno. If anything, it was far more autonomous and intransigently critical. In comparison to Situationist practice, which continues to function as a real factor of resistance and emancipation, Adorno's claims for Franz Kafka and Samuel Beckett seem laughably inflated.

On the Supersession of Art

Situationist art theory, then, does not suffer from the categorical and conceptual impasses that led Frankfurt art theory to draw the wagons around the modernist artwork. For the Situationists, art oriented towards radical social change could no longer be about the production of objects for exhibition and passive spectatorship. Given the decomposition of contemporary culture—and in passing let's at least note that there is much overlap in the analyses of culture industry and the theory of spectacular society—attempts to maintain or rejuvenate modernism are a losing and illusory enterprise. With regard to the content and meaning of early avant-garde practice, the critical art theory developed by the SI in the late 1950s and early 60s and concisely summarized by Guy Debord in *The Society of the Spectacle* in 1967 is basically consistent with Bürger's later theorization. But the two theories diverge irreconcilably in their interpretation of the consequences.

The rise of capitalism—the tendency to reduce everything and everyone to commodity status and exchange value—was the material condition for the relative autonomy of culture; the bourgeois revolution was the political last act of a

material process that had pulverized traditional bases of authority and released art from its old function of ritual unification. For the Situationists, as art became conscious of itself as a distinct sphere of activity in the new order, it logically began to press for the autonomy of its sphere. But self-consciousness also brought awareness of the impotence of this autonomy as a form of social *separation* and insights into its new functions in support of bourgeois power. The avant gardes of the early twentieth century responded with a practical demand that separation be abolished and autonomy be generalized through revolution. This far Bürger is in agreement. But for him, the defeat of the revolutionary attempt to abolish capitalism makes the avant garde breakout a failure that must be re-inscribed in the work-form of art, while for the Situationists this defeat is only one moment in a struggle that continues. For the SI, the logic of art—necessarily first *for* and then *against* autonomous separation—remains unchanged, and art can make its peace with separation only by deceiving itself. Resigned returns to institutionalized art and to the empty, repetitive formalist experiments of work-based modernism can only represent a process of decomposition: the "end of the history of culture."[12]

In political terms, there are at this point just two irreconcilable options: either to be enlisted in culture's affirmative function—"to justify a society with no justification"—or to press forward with the revolutionary process.[13] The institutions will organize the prolongation of art "as a dead thing for spectacular contemplation."[14] The radical alternative is the supersession (*dépassement*; that is, *aufhebung*) of art. The first aligns itself with the defense of class power; the second, with the radical critique of society. Surpassing art means removing it from institutional management and transforming it into a practice for expanding life here and now, for overcoming passivity and separation, in short for 'revolutionizing everyday life.' There are of course possibilities for modest critical practices within the art institutions, but these can always be managed and kept within tolerable limits. Maximum pressure on the given develops from a refusal of the art system *as a whole*, openly linked to a refusal of the social totality. The history of the real avant gardes, then, is not the history of artistic modernism, but the attainment of consciousness about the stakes and the need for this overcoming.

The main defect of Bürger's theorization can be located in his historical judgement on the early avant gardes, because this judgement becomes a categorical foreclosure or blindness: For Bürger, the conclusion that the early avant gardes failed in their attempts to supersede art follows necessarily from the obvious fact that the institution of art persists. There can be no dialectical overcoming without the negating moment of an abolition: "It is a historical fact that the avant-garde movements did not put an end to the production of works of art, and that the social institution that is art proved resistant to the avant-gardiste attack."[15] Art is

not abolished; therefore, no supersession. This leads Bürger to declare that the early avant gardes are now to be seen as 'historical.' Henceforth, attempts to repeat the project of overcoming art can only be *repetitions of failure*; such attempts by the 'neo-avant garde,' as Bürger now names it, only serve to consolidate the institutionalization of the historical avant gardes *as art*:

> In a changed context, the resumption of avant-gardiste intentions with the means of avant-gardism can no longer even have the limited effectiveness the historical avant-gardes achieved... To formulate more pointedly: the neo-avant-garde institutionalizes the avant-garde as art and thus negates genuinely avant-garde intentions.[16]

Marcel Duchamp's gesture of signing a urinal or bottle drier was a failed attack on the category of individual production, but repetitions of this gesture merely institutionalized the readymade as a legitimate art object.[17]

The problem here is that Bürger restricts his analysis to *artworks* and to gestures that conform to this category. That he comes close to perceiving that this may be a problem is hinted in those places where he uses the term 'manifestation' (*Manifestation*) to refer to avant-garde practice: "Instead of speaking of the avant-gardiste work, we will speak of avant-gardiste manifestation. A dadaist manifestation does not have work character but is nonetheless an authentic manifestation of the artistic avant-garde."[18] But soon it is clear that *all forms of practice* will in the end be either reduced to that category or else not recognized at all: "The efforts to sublate art become artistic manifestations [*Veranstaltungen*] that, independently of their producers' intentions, take on the character of works."[19] Bürger's limited examples show that what he has in mind by 'manifestation' are gestures that already fit the work form, such as Duchamp's ready-mades or Surrealist automatic poems—or at most, provocations performed before an audience at organized artistic events (*Veranstaltungen*).

Happenings and Situations

Bürger is aware of the 'happening' form developed by Allan Kaprow and his collaborators beginning in 1958. But he classes happenings as no more than a neo-avant garde repetition of Dadaist manifestations, evidence that repeating historical provocations no longer has protest value. He concludes that art today "can either resign itself to its autonomy status or 'organize happenings' to break through that status. But without surrendering its claim to truth, art cannot simply deny the autonomy status and pretend that it has a direct effect."[20] Art's 'claim to truth,' however, turns out to be a normative description of autonomy status itself. Following Adorno, Bürger accepts that it is only art's limited exemption from the instrumental reason dominating everyday life that enables it to recognize and articulate the truth—'truth' here being understood not as a correspondence between reality and its representation but as an

implicit critico-utopian evaluation *of reality*. Truth is not conformity to the given, but is rather the negative force of resistance generated by the mere existence of artworks that, obeying no logic but their own, refuse integration. Bürger's argument here merely endorses Adorno's. What it really says is: art can't give up its autonomy status without ceasing to be art. And the implication is that if art does manage to directly produce political and social effects, it thereby ceases to be art and is no longer his—Bürger's—concern.

But Bürger cannot escape the problem in this way. He has already argued that the aim to produce direct effects (i.e. the transformation of art into a practice of life, a *Lebenspraxis*) is precisely what constitutes the avant garde. So he cannot now give his theorization of the avant garde permission to ignore the avant gardes when they do attain their aim. He also attempts to elude the same problem with a variation on the argument. Pulp fiction—in other words, the non-autonomous products of the culture industry—are what you get when you aim at a supersession of art into life.[21] By 1974, there were serious counter-examples for Bürger's argument; the SI even went so far as to spell everything out for him in its own books and theorizations. In this case the blindness is devastating, for the gap between contemporary avant-garde practice and the theory that purports to explain why it is no longer possible invalidates Bürger's work.

This would be the case only if the SI accomplished successful supersessions of art without collapsing into culture industry. The collapse hypothesis is easily dispensed with, since the SI did not indulge in commodity production. But putting Bürger's theory to the test at least helps us to see that any evaluation of Situationist supersessions must take into account the fact that the SI cut its ties to the art institutions and repudiated the work form of modernist art. The same cannot be said of Bürger's 'neo-avant garde.' Bürger's examples—he briefly discusses Andy Warhol and reproduces images of works by Warhol and Daniel Spoerri—are artists who submit *artworks to the institutions for reception*.[22] Even the case of Kaprow, who is not named but can be inferred from Bürger's use of the term 'happening,' does not disturb this commitment to institutions. Kaprow wanted to investigate or blur the borders between art and life, but he did so under the gaze, as it were, of the institutions, to which he remained dependent. It is in this sense that every happening does indeed, as Bürger claims, take on the character of a work. At most, the happening form achieved an expansion of the dominant concept of art, but not its negation. Ditto, in this respect, for the case of Fluxus. The subsequent appearance of the new medium or genre of 'performance art' confirms the institutional acceptance (and neutralizing assimilation) of this direction. (In my terms, the result of a successful capture or assimilation of a rebellious form of practice is another *expansion of the category* of institutionalized modernist art.)

The differences between the happening and the situation are decisive here. As an experimental event that never seriously put its autonomy status in question, the happening staged interactions or exchanges of roles between artist and audience—but in safe, more or less controlled conditions, and ultimately for institutional reception. Only when, as in the Living Theatre in exile and also perhaps in Jean-Jacques Lebel's notorious 'Festivals of Free Expression' in the mid-1960s, happening-like events sacrificing the element of institutional reception (and its implicit appeal for institutional approval), did they become something more threatening to the institution of art. On the other hand, the staging of personal risk or even physical danger through the elimination of the conventions that put limits on audience participation, as in Yoko Ono's *Cut Pieces* of 1964-65 or Marina Abramovic's *Rhythm 0* (1974), are extremes of performance art that are indeed subject to the dialectic of repetition and the recuperation of protest pointed to by Bürger.

In contrast, a situation—a constructed moment of disalienated life that activates the social question—does not depend on the dominant conception of art or its institutions to generate its meaning and effects. The Situationists themselves, who continued to criticize contemporary art in the pages of their journal, published in 1963 an incisive discussion of the happening form and differentiated it from the practice of the SI:

> The happening is an isolated attempt to construct a situation *on the basis of poverty* (material poverty, poverty of human contact, poverty inherited from the artistic spectacle, poverty of the specific philosophy driven to 'ideologize' the reality of these moments). The situations that the SI has defined, on the other hand, can only be constructed on the basis of material and spiritual richness. Which is another way of saying that an outline for the construction of situations must be the game, the serious game, of the revolutionary avant-garde, and cannot exist for those who resign themselves on certain points to political passivity, metaphysical despair, or even the pure and experienced absence of artistic creativity.[23]

Situations activate a revolutionary process, then, but do so by developing social and political efficacy within the found context of material everyday life, rather than through a displacement of everyday elements and encounters into the context of institutionalized art. In this sense, situations are indeed 'direct' by Bürger's criteria. The so-called 'Strasbourg Scandal' of 1966 is an example of a successful situation that contributed directly to a process of radicalization culminating, in May and June of 1968, in a wildcat general strike of nine million workers throughout France. There is, moreover, little danger of mistaking or perversely misrecognizing this kind of event with an artwork or happening. The conclusion seems inescapable that the SI renewed—and not merely repeated to no effect—the avant garde project of overcoming art by turning it into a revolutionary practice of life.

It follows that what Bürger has named the 'neo-avant garde' in order to dismiss it is not avant garde at all. Those who, like the SI, renewed the avant garde project were categorically excluded from the analysis. When the repudiation of institutionalized art and the work form are given their due weight as criteria, then it becomes clear that the avant garde project of radicalizing artistic autonomy by generalizing it into a social principle is a logic inherent or latent in the capitalist art system. It will be valid to activate this logic—and to actualize it by developing it in the form of practices—just as long as the capitalist art system continues to be organized around an operative principle of relative autonomy. It will be valid, that is, for artistic agents to reconstitute the avant garde project through a politicized break with the dominant institutionalized art. True, actualizations of the avant garde logic cannot be mere repetitions. Each time, they must invent practical forms grounded in and appropriate to the contemporary social reality that is their context. But because this logic amounts to a radical and irreparable break with institutionalized art, there is little risk that such a protest will be reabsorbed through yet another expansion of the dominant concept of art. The SI showed that art could be surpassed in this way in the very period in which, according to Bürger, only impotent repetitions are possible.

Notes

1. Pierre Bourdieu, *The Field of Cultural Production: Essays on Art and Literature*, trans. Randall Johnson (Cambridge: Polity Press, 1993) 128. The notion of affirmative culture is derived from Herbert Marcuse, *Negations: Essays in Critical Theory*, trans. J. Shapiro (Boston: Beacon Press, 1968).
2. Theodor Adorno, *Aesthetic Theory*, trans. Robert Hullot-Kentor (Minneapolis: University of Minnesota Press, [1970] 1997) 5.
3. Adorno, *Aesthetic Theory*, 176.
4. Max Horkheimer and Theodor W. Adorno, *Dialectic of Enlightenment: Philosophical Fragments*, trans. Edmund Jephcott (Stanford: Stanford University Press, [1944] 2002).
5. Theodor Adorno, "Commitment," in *Notes to Literature, Vol.2*, trans. Shierry Weber Nicholsen (New York: Columbia University Press, 1992).
6. Peter Bürger, *Theory of the Avant-Garde*, trans. Michael Shaw (Minneapolis: University of Minnesota Press, [1974] 1984).
7. Andrea Fraser, "From the Critique of Institutions to an Institution of Critique," *Artforum* (September 2005) 278-83.
8. Bürger, *Theory of the Avant-Garde*, 53-4, translation modified.
9. Bürger, *Theory of the Avant-Garde*, 72.
10. Guy Debord, *The Society of the Spectacle*, trans. Donald Nicholson-Smith (New York: Zone Books, [1967] 1994) 89.
11. Debord, *The Society of the Spectacle*, 129-47.
12. Debord, *The Society of the Spectacle*, 131.
13. Debord, *The Society of the Spectacle*, 138.
14. Debord, *The Society of the Spectacle*, 131-2, translation modified.
15. Bürger, *Theory of the Avant-Garde*, 56-7.
16. Bürger, *Theory of the Avant-Garde*, 58.
17. Bürger, *Theory of the Avant-Garde*, 52-7.
18. Bürger, *Theory of the Avant-Garde*, 50.
19. Bürger, *Theory of the Avant-Garde*, 58.
20. Bürger, *Theory of the Avant-Garde*, 57.
21. Bürger, *Theory of the Avant-Garde*, 54.
22. Bürger, *Theory of the Avant-Garde*, 62, 58.
23. Situationist International, "Editorial Notes: The Avant-Garde of Presence," in Tom McDonough, ed. *Guy Debord and the Situationist International: Texts and Documents*, trans. John Shepley (Cambridge: The MIT Press, 2002) 147.

Revolutionary Pathos, Negation & the Suspensive Avant Garde

John Roberts

The recent debate on the avant garde and the visual arts has tended to bifurcate around two distinct positions: those who think that the avant garde (Constructivism, Productivism, Dada, Surrealism) is a purely historic category that has now been superseded, and those who think that the avant garde is still very much an unfinished project. However, these two positions are themselves internally divided. In the first category there are those who mourn the passing of the avant garde as well as those who have no wish to see it return in any form whatsoever and are therefore certainly dismissive of any claims that its ideals might still be with us. The former might be construed as a kind of Romantic fatalism, and the latter as a kind of cultural nihilism that often favors either a return to some version of classicism or a revived defense of postmodernism. In the second category, by contrast, there are, on the one hand, those who see the avant garde as a continuing placeholder for a revolutionary and post-capitalist cultural program, and, on the other hand, those who view it more pragmatically as a category that, far from being dead, remains vitally alive through its constant rearticulation and readaptation under very different social and political circumstances. Indeed, the very notion of something as historically transformative as the avant garde coming to an end before its implications are developed and worked through is, from this latter point of view, vulgarly historicist; just as modernism didn't end in 1900, so the post-Soviet historic avant garde didn't end in 1935.

This anti-historicist position has had a huge influence on the development of the category of the neo-avant garde since the early 1990s, when Hal Foster published his essay "What's Neo About the Neo-Avant-Garde?"[1] Foster quite rightly attacks the mixture of Romantic fatalism and "endism" that characterizes Peter Bürger's *Theory of the Avant-Garde* (1974), the first major appraisal of the critical legacy of the avant garde in the light of postwar modernism.[2] The weakness of Bürger's historicism lies in his over-identification of the critical fate of the art of the 1920s and 1930s with its conditions of production, as if the critical horizons and ideals of the art of the period could only be articulated in relation to their immediate social and political horizons. Bürger, then, tends to see the art produced in the name of the avant garde after the 1950s as a falling away from these horizons into pastiche or social irrelevance, given the socially antipathetic conditions for avant garde practice in the West.

Now, to be fair to Bürger, there is no Constructivism and Productivism without the revolutionary transformations, which they are a response to, and product of. And in this sense there is no avant garde without the world historical transformations of the Russian revolution. This is a given: the avant garde as a distinct set of social and cultural ideals (rather than a name given by late nineteenth-century French commentators to that which is notionally "advanced" artistically) is indivisible from the rupture of the Russian Revolution. But to assume that the avant garde dies with the Stalinist and Nazi counter-revolution and, therefore, that it is overwhelmingly a "failed project" (a term favored by advocates and critics of the avant garde alike) holds the avant garde ransom to social and political forces that were outside of its control, as if the avant garde were responsible for its own counter-revolutionary destruction. Consequently, how art theory mediates this notion of failure is crucial to the way in which avant garde art after the 1950s is able to construct an afterlife for itself under advanced capitalism. This is why Bürger's sense of an ending is not strictly coterminous with the counter-revolution itself, as if for him authentic practice and thinking ends in 1935. Rather, for Bürger, in its mediation of its own failure, the renewal and development of the avant garde in the form of the neo-avant garde has to cope with the unprecedented power of the postwar art institution, and its absorption and repressive toleration of the radical transgressions of art. The outcome is that the afterlife of the failure of the historic avant garde is now positioned as internal to the structures of the art institution, separate—in the language of the Frankfurt School—from the collective participation in, and transformation of, the lifeworld itself.

This notion that the ideals of the avant garde fail with the counter-revolution and its liberal adaptation in the postwar art institution is an abiding theme of Thierry de Duve's *Kant After Duchamp* (1996), but also of Jacques Rancière's recent "neo-avant-gardism," a view that sits comfortably with both writers' anti-Hegelianism, anti-Marxism, and anarchist inflexions.[3] But the avant garde was not a *failed* project at all, if by failure we mean an outcome that leaves no exploitable artistic resources, no intellectual and cultural supplement. If the avant garde was a set of practices that was determined by the immediate social and political demands of the Russian Revolution, it was also a project that *exceeded* these demands, insofar as its emancipatory claims about art and social life existed far in advance of

what was conceivable in the Soviet Union in the 1920s and early 1930s. In this sense its "failure" is precisely its open-ended success: in operating at some distance from the instrumental and practical requirements of revolutionary transformation, it put in place the parameters for a number of research practices and questions on art, labor, value, and the public sphere that survived the counter-revolution. If the avant garde "fails" in the Soviet Union, it fails *constructively*.

This is different from saying, as in Bürger, that despite the failure of the avant garde, some of its strategies managed to survive in a weakened form in the postwar art institution. Rather, the avant garde survives because of the substantive questions the failure of the Soviet avant garde puts to art and the art institution. Indeed, it is precisely because of the far-reaching questions it asks of itself that the Russian avant garde remains the overarching model of all avant garde practice, irrespective of whether new art is directly indebted to it or not. For what it provides is a sense of the avant garde as a category reflective on its own conditions of possibility. Thus, for example, when the Soviet avant garde too easily accommodates itself to the Party's positivistic adaptation of the new machino-technical culture—when Productivism enters the factory system and actively subordinates itself to the discipline of factory management and the labor process—the theoretical gains from these experiments far outweigh any a priori dismissal of such "non-artistic" collaborations. What Productivism learns from these forays is that art's possible role in the qualitative transformation of the relations of production is severely constrained under the factory system and the law of value, and that art cannot therefore dissolve or ameliorate the alienation of labor inside this system so readily, even in favorable revolutionary conditions.[4] Rather, art's value lies in the way that it harnesses its free labor to the critique of the division between intellectual labor and manual labor, artistic labor and productive labor, in conditions of free exchange. This is why Boris Arvatov, the leading Productivist theoretician in the Soviet Union in the 1920s, soon realized the limitations of this form of factory interventionism, arguing for a Productivism that extended the interdisciplinary and collaborative horizons of the avant garde into environmental design, architecture, and street dramaturgy.[5]

It is at this point of self-reflection and self-critique within the space of the avant garde itself that Foster's anti-historicism becomes relevant. Essentially, the avant garde is recovered as a heuristic category, or research program, that, in the spirit of Imre Lakatos' philosophy of science, still has an unsurpassable central core of experimental potential, precisely *because* of the program's contradictions and hiatuses.[6] Therefore, despite the Soviet avant garde's precipitous historical identity, and despite the delimited social and political circumstances for the development of its core program, the Soviet avant garde nevertheless is still able to put the most demanding and relevant questions to art and

its institutions: What is an artist? What is an artwork? What constitutes value in art? What part is artistic labor able to play in the emancipation of productive labor generally? What are the progressive possibilities and limitations of art's relationship to non-aesthetic reason?

Foster's heuristic definition of the neo-avant garde, therefore, has entered into a working alliance with the widespread rise of new forms of sociability and praxis in art since the mid-1990s, what I have called elsewhere the rise of "secondary Productivism."[7] This is the idea that the neo-avant garde, as an adaptation of some of the key precepts of the critical program of the avant garde, shares a pragmatic sense of art as a shifting testing ground for various social interventions, experimental forms, and transformative actions and events, with the participatory, interdisciplinary, and non-artistic collaborations of the new art. Much of this has a digital basis, in which activist modes of art and forms of communal interaction are grounded in the network possibilities of the new media technologies, generating a flexible and mobile model of avant garde interventionism that is no longer based on the primary idea of Productivism as the transformation of the relations of production inside the factory, but on a digital extension of Arvatov's interdisciplinary model to multiple social locations. The indeterminacy, nomadism, and interrelationality of the new digital artistic practices converge, technically and affectively, with the new forms of computer-based production in the workplace to create a Productivism of flow and tactical improvisation across a range of social and cultural sites.[8] Indeed, these new forms of sociability, exchange, and digital praxis have come to fill out this notion of the neo-avant garde as a space for social experimentation in exactly the anti-historicist fashion demanded by Foster (although, it has to be said, as the participatory and collaborative mandate of the new art has expanded, the use of the nomenclature "neo-avant garde" has tended to recede, as if what counts for artists is not the act of naming itself, but the critical spirit of the program). Yet there is a clear sense in which most contemporary art is precisely neo-avant gardist in these terms, insofar as it rearticulates the break of the historic avant garde with the painterly modernist object in favor of a definition of art as interdisciplinary, multidisciplinary, multifarious post-object work; an ensemble of techniques and practices that at all times exceeds the bounded aesthetic limits of the discrete modernist object.

Aesthetic Reason and Non-Aesthetic Reason

However, if Foster and the new participatory art recalibrate the category of the avant garde through a heuristic defense of art's socially experimental possibilities, this is won at the cost of the pathos of Bürger's account of the avant garde. The neo-avant garde may provide new research conditions for the avant garde, but the questions posed by this research program are inseparable from the revolutionary process

that originally defined and structured its possibilities. The critique of Bürger, therefore, carries with it certain intractable historical problems. What defines the avant garde in its neo-avant garde form is the fact that it is a counter-revolutionary, post-Thermidorian category, *all the way down*. Political defeat is constitutive of its program of readaptation. There is no way, then, of avoiding the historical realities of what is actually lost to the production of art in any neo-avant garde mediation and extension of its continuities. Whatever continuities the neo-avant garde may establish with the core program of the historic avant garde cannot gainsay the fact that what the Soviet avant garde managed to accomplish was as a result of the public institutions, political mobilization, and social networks established by the Russian revolutionary process. Admittedly, Foster and other defenders of the neo-avant garde acknowledge this, or something like it, but these emancipatory aims are not built into the category as a limit-horizon of the research program, or as a condition of its continuing possibility. Consequently, the category of the neo-avant garde tends to float freely from its counter-revolutionary formation and history, as if contemporary art is able to choose all the best bits of the avant garde legacy without all the other messy political stuff getting in the way. Although the neo-avant garde is not exactly defined positivistically as a neutral research program in the manner of the hard sciences, this writing tends to assume that the experimental possibilities of the new art are freely available or can be pursued without the political precepts that shaped the historic avant garde's core program.

This is why, in those practices that derive their thinking from the neo-avant garde, there is a general desire to be free of revolutionary pathos altogether, as if the gap between the actual and the ideal were an unnecessary and fussy excrescence on the legacy of the avant garde. This is partly a manifestation of the continuing philosophical influence of postmodernism (the avant garde is best thought of, if at all, as wholly separate from any grand narrative of universal human emancipation), but also the result of the easy alliance that the new art makes between a residual cultural nihilism (history has no determining effects on agency in the present) and the notion that after modernism, after postmodernism, art is a freely available democratic technique: everything is possible culturally, and artists and their non-artistic allies can play a progressive role.

This intoxicating mix of voluntarism and affirmative praxis has become hegemonic in the extensive reaches of the new art beyond the official channels of the art world, and is certainly influential in those social practices that operate inside the public gallery and museum system. Relational aesthetics and post-relational aesthetics, the new community-based and participatory forms of art practice, and the widespread forms of digital interactivity and intervention, all subscribe in various ways to the new ethos: art is no more and no less than an ensemble of diverse artistic and non-artistic practices and skills that find their expression as socially constituted moments of exchange between producer and audience in a continuum of other socially constituted exchanges.[9] In these terms, the new democratic ethos has tended to identify art's participatory advance with art's general expansion into the realm of non-artistic practices and non-artistic knowledges, or what we can call non-aesthetic reason.[10] Indeed, it is the interdisciplinary relationship between art and non-aesthetic reason that marks out and determines the new art's possible social advance and transformative capacities.

Now this, of course, is where the neo-avant garde practices of the moment share their key precepts with the core program of the historic avant garde: art's utility lies, in the image of Walter Benjamin's famous notion of the author as producer, in its capacity to address or intervene in real-world problems, be they practical or ideological.[11] But for much of the contemporary neo-avant garde (participatory forms of art as social praxis, activist and digital forms of exchange and intervention), the notion of the artist as producer becomes indivisible *from* the activist and technician. Benjamin's concept of the producer was certainly co-extensive with the notion of the artist as activist and technician, but he also famously resisted the notion that the artist's skills were simply interchangeable with those of non-aesthetic practices. For to dissolve the function and utility of the artist into that of the activist or technician is to remove the singularly critical function of his or her place as a producer in art's advanced relations of production—his or her capacity to produce non-instrumental "thought experiments" without direct utility and, as such, to reinvest aesthetic reason with universal emancipatory content: free, non-alienated labor.

The new participatory and social-activist forms of neo-avant garde activity forget this fact, pushing art directly into the realm of non-aesthetic reason in order to secure what they hope will be art's "maximum" utility or effectiveness. All this does, however, is submit the artist to the dominant instrumental interests of the culture in the name of a left or democratic utility, weakening the fundamentally decisive role of aesthetic reason under capitalism: art's embodiment of non-instrumental forms of labor and cognition as a negation of dominant modes of (in)attention and their circuits of power and knowledge. To defend art's powers of negation, then, is to refuse to submit art prematurely, in Hegel's language, to its absolute or ideal conditions of emancipation before these absolute conditions are historically achievable. In turn, therefore, the unwillingness on the part of the new art to fully assimilate the post-Thermidorian condition of the neo-avant garde dissolves the revolutionary pathos attached to any working understanding of the avant garde under mature capitalism. Without distance and negation, without a structural sense that art loses what marks it out (contingently) as "not-of-capital" by sublating itself into the capitalist everyday, the

neo-avant garde becomes effectively either a form of social decoration or a form of social work. In this sense it is more productive to talk about the avant garde in the present period as a *suspensive* category.[12]

The Suspensive Avant Garde

By "suspensive avant garde," I mean that what now distinguishes the avant garde as a productive category is how and under what terms, and to what ends, it negotiates the pathos of its post-Thermidorian condition. That is, in what ways is the avant garde up to the task of realistically assessing its condition and prospects? If collapsing artistic technique into non-aesthetic reason weakens art's powers of negation and reduces the role of the artist to that of a neo-bureaucrat or civil servant, then the alternative of fully embracing the destructive legacy of the avant garde as a permanent war of *ressentiment* leads to madness, despair, and delirium. Admittedly this second position is fairly marginal these days, but it still carries enough force for those who are attracted to romantic fatalism to think of the artist above all as a prophet and sentinel. This is the avant garde mythology of "end times." Equally problematic, however, is the aestheticization of the avant garde: the reduction of the avant garde to the subtractive resequencing of its historic formal moves as a way of holding onto and revivifying the "revolutionary" artistic languages of the past. This is one of the problems with Alain Badiou's recent move into the debate on the avant garde.[13] Dismissing the convergence of politics and art in the historic avant garde as the Romantic dissolution of art into what it cannot possibly change—the collective political process—Badiou argues that the revolutionary function of art lies in its fidelity to the negative strategies of its original formal aesthetic program (abstraction) that establish a non-relational and self-distancing relationship to the capitalist everyday. This position leaves the avant garde as nothing more than an academic form of autopoiesis.

Thus, if the avant garde is to retain some continuity with its core ideals and precepts and if it is to think of itself as an open-ended research program, it must recognize that the issues and questions it confronts and the problems it sets itself are structurally governed by art's delimited place within bourgeois culture. In other words, in non-revolutionary periods the avant garde is necessarily positioned *between* the forces of total revolutionary praxis (or, rather, the memory of these forces) and the pragmatic exigencies of autopoiesis. It is locked, therefore, into an active but *subordinate* relationship to the historic forms of its core social and political program. And this, essentially, is what I mean by the constitutive place of revolutionary pathos in the post-Thermidorian avant garde. What is achievable socially and politically in the name of art is mediated by the determinate loss resulting from this process of subordination. This is why the crucial issue for the avant garde in its avoidance of either a transgressive psychosis or aesthetic or bureaucratic submission is the question of *how* it negotiates this process of subordination. In other words, how does it establish an autonomous place for its research programs across the division between aesthetic and non-aesthetic reason, on the basis of a *maximalization* of its limited critical resources and capacities? For in submitting art either to aesthetic reason (purity of disengagement) or to non-aesthetic reason (direct utility), the intellectual and cultural manoeuvrability of art is foreshortened. What is required, in contrast, is a position on art's autonomy that is non-dualistic and non-identitary, a position that recognizes that the strength of art in the epoch of its total administration lies precisely in its resistance to the opposing routes of "social effectivity" and aesthetic sublimity.

Consequently, what marks out art's autonomy under these strictures is the extent to which it is able to sustain its passage between aesthetic reason and non-aesthetic reason as the redefinition and expansion of the relations between these two spheres. For one of the critical functions possessed by the artist in our culture is that he or she is able to incorporate and utilize various artistic or non-artistic practices without *fully* investing ideologically and socially in these activities. This ideological disinvestment is crucial, because art is thereby able to secure its autonomy and the open-endedness of its research programs on the basis of the contingent distance it is able to establish from both the reification of aesthetic reason and art's assimilation of non-aesthetic reason. Thus what distinguishes art from other practices—whether social, scientific, philosophical, or artisanal—is that it is the only practice that operates out of a direct sense of its own impossibility and impermanence. That is to say: physics or weaving or engineering, for example, do not seek to escape the legitimizing traditions and institutional supports of physics, weaving, or engineering in order to define their (provisional) place in the world and the conditions of their own future possibility. They may provide an immanent critique of their own guiding precepts and traditions, but they do not seek their future in an exit from "physics," "weaving," and "engineering." Art, however, given its powers of infinite ideation, of transcendental overcoming of itself, is never identical with those traditions that give it value and legitimacy. Indeed, it defines its possibilities in terms of its own eventual dissolution as a category and seeks, therefore, as a condition of its freedom, an exit from the historically delimited category of art as such.

This is because, as the embodiment of free labor in an alienated form (the commodity form), the labor immanent to art carries the promise, in Theodor Adorno's sense, of a world of productive labor and of social relations transformed in the emancipatory image of a liberated aesthetic reason.[14] And, therefore, it prefigures a world in which the hierarchical division between productive labor and artistic labor, intellectual labor and manual labor, the artist and non-artist, is dissolved. This is why artistic labor as the

embodiment of infinite ideation is quite unlike any other practice: art's sovereignty as free labor continually puts to the test the claims to truth of those who would reduce art's emancipatory significance to either "aesthetics" or "social utility." And this is also why the free labor of art represents not only a critique of instrumental accounts of freedom subscribed to by positivistic models of non-aesthetic reason, but also of those traditions and institutional arrangements of art that would limit art's transcendental overcoming of itself as an overcoming of its own alienated status. Consequently, art necessarily operates "out of joint" with the cultural and social contexts and institutional arrangements that bring it into being, as a matter of its self-definition and self-determination. In this sense art's autonomy is better understood, not as another name for the distance art takes from the world, but as cognate with a notion of determinate negation. That is, art's liminal identity—its capacity to move across aesthetic reason and non-aesthetic reason, art and non-art—is the *very condition of its renewal*. And this, in turn, is what I mean by the suspensive function of the avant garde. The post-Thermidorian avant garde systematizes the non-identitary function of art as the necessary condition of its open-endedness, or powers of infinite ideation.

Thus recognizing the real structural limits of total revolutionary praxis in the current period does not mean the rejection of the place of non-aesthetic reason in art *tout court*, just as the destabilization of aesthetic ideology through art's necessary assimilation of non-aesthetic reason does not mean the end of the pleasures of aesthetic distance constitutive of spectatorship and artistic judgement. Rather, the transformative actions, "thought experiments," critical interventions, and symbolic reinventions of the contemporary avant garde become, in their speculative labors, *placeholders* for the historic ideals and achievements of the historic avant garde. This thereby sets up an interesting mnemonic identity for the avant garde in our own time: the avant garde is revolutionary precisely through its fidelity to its *futures past*. But, significantly, this is not simply a promisory space, or a "holding operation." On the contrary, the avant garde may be suspensive in these terms, but what now distinguishes it from its historic forebears, and recent neo-avant garde relations, is that its suspensiveness is a condition *of* its explicit anti-capitalist and oppositional character. That is, the avant garde today has passed into what we might call a "third space": neither the space of revolutionary transformation as such (the building of a revolutionary culture; the production of "thought experiments" as part of a mobilization of the working class), nor the pragmatic adjustment of critical and radical art to the new post-war administration of modern art (the neo-avant garde), but the concrete implication of artistic practices in the critique of capital, the state, labor practices, and the official institutions of art.

In this sense, the political outcomes of the knowledges and

strategies employed by the suspensive "third" avant garde are quite different from those of its predecessors, insofar as its "thought experiments," symbolic manifestations, and social interventions function as integrated parts of art's place in a critique of the *totality* of capitalist relations. There is here a decisive shift away from the counter-hegemonic model of the 1980s and early 1990s, which focused principally on the art institution. Politics in art are no longer attached simply to a triangulated counter-representational model (race, sexuality, and gender)—as overwhelmingly embraced by the neo-avant garde of the 1980s—but to the mobilization of collective artistic energies in alliance with practices of cultural self-determination, a politics "from below" and research and development of counter-informational knowledge, as means of modelling a place for art in new forms of sociability. Some of this work goes under the name of post-relational aesthetics, some of it under the nomenclature of digital and Internet art, and some exists in fluid and temporal sites of production and reception outside the official art world altogether, in the "dark matter" of the unofficial economy of occasional artists, part-time activist-collectives, and various hit and run ecopractices.[15] Most of these group practices are unnamed and dissolve once the political struggle has moved on.

Now, as I have stressed, these forces are predominantly attached to what I have previously described as the hegemony of non-aesthetic reason in the new art. And, as such, as I have also shown, these approaches set up innumerable pressures for the collapse of this work into instrumentalized forms of activity, particularly at those points where, by dint of the fact that it is divesting itself of the circuits of the official artworld, it believes itself to have escaped from these instrumental pressures. But, nevertheless, what this collective push towards non-aesthetic reason produces is an extraordinary repoliticization of the category of the avant garde, as art submits its energies to a totalizing critique of art, praxis, and labor. In this sense, this "third space" produces not just an intellectual, but an active and practical relationship to the notion of the avant garde as placeholder for futures past. Consequently, I want to focus, in my final section, on one group that I believe best represents this "third" avant garde, the Russian group Chto Delat? (What Is To Be Done?). Although it has contributed enormously to the political energy of this emergent cultural space, it has not done so at the expense of a relationship to the exigencies of revolutionary pathos and the autonomy of art. Indeed, the group is exemplary in this respect.

Chto Delat? and the Third Avant Garde

Chto Delat? have been in existence since the beginning of the new millennium and comprise an expanding and contracting personnel, centered currently on three core members: the artist, writer, and filmmaker Dmitry Vilensky, the philosopher Alexey Penzin, and the writer, translator, and editor David Riff. In addition, Vilensky and Riff are the

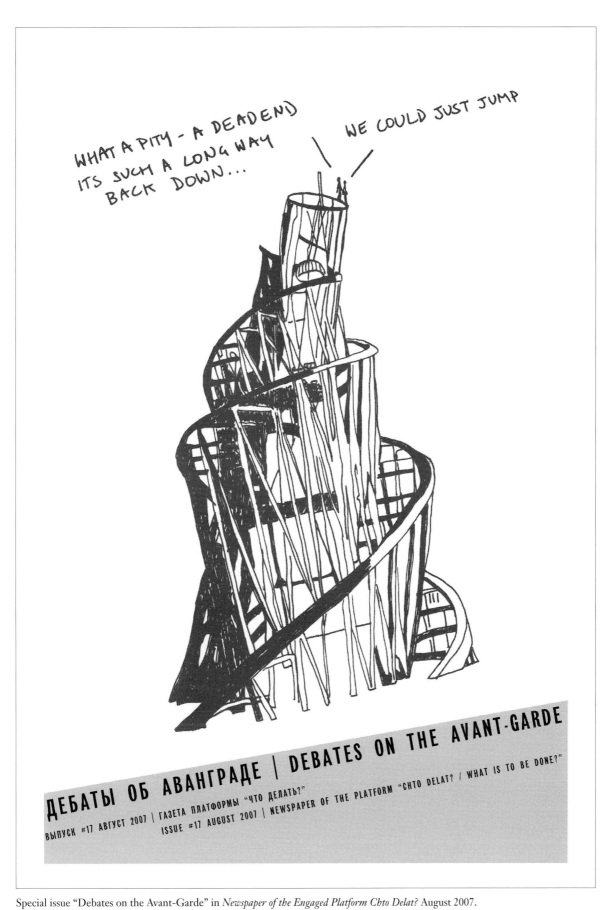

Special issue "Debates on the Avant-Garde" in *Newspaper of the Engaged Platform Chto Delat?* August 2007.
Cover image by Zanny Begg.

main editors of the group's newspaper *Newspaper of the Engaged Platform "Chto Delat?"* published out of St. Petersburg in Russian and English. The publication presents and develops many of the projects Vilensky—in particular—collaborates on (film and video work, archival and ethnographic work), but also acts as a theoretical forum for others inside the group or on its fringes and supporters of its aims. In this respect the newspaper is properly constituted as a partisan and polemical literature of intervention into the group's own praxis and the praxis of others; it is not an academic "journal" or a review. On this basis, it represents one of the most sustained efforts over the last ten years to develop the language of a research program inside the space of the avant garde by drawing on the shared interests of the group in alliance with its critical supporters.

Hence, many issues of the newspaper have taken up core questions and problems of the historic avant garde. In what ways is it possible to continue the avant garde as a proletarian project today? What would the real, sensuous (not decorative) utility of theory be like?[16] What forms might a progressive art take as part of a totalizing program of social and political critique?[17] How can progressive art remain committed to the project of *Bildung* (the process of individual development through aesthetic education)?[18] Yet, if these classic questions of the historic avant garde are familiar enough, their position within a "third" avant garde framework removes them of any nostalgic or purely redemptive character. This is because the group, despite its political engagement and outward-looking nature, is quite clear about the necessarily suspensive character of the new avant garde. Thus, in a special issue of the newspaper on the avant garde in 2007, Vilensky and his co-author Zanny Begg argue: "The radicality of art ... cannot be reduced to its connection to social or political imperatives nor to formal stylistic innovation but must also be understood through its poietic force; its ability to question and destabilize the very notion of the political, cultural and artistic. The avant garde is a coup d'état against history, making visible new possibilities in both art and politics."[19] That is, artists have to speak "in their own name" as part of collective political transformation. Moreover, in contradistinction to the historic avant garde, the new avant garde "necessarily has the negation of capitalism's totality as its point of departure. At the same time, it strives to connect this negativity with aesthetic method, adequate to the study of the world in which new subjectivity arises, not only as something destructive, but as something that produces social life."[20]

In this light Chto Delat? divide their new avant garde model into three categories or principles: realism as critical-modernist method in the spirit of Bertolt Brecht (mapping as a form of resistance, counter-narrativization and counter-historicization, montage, subversive affirmation, the carnivalesque, fictional re-enactment); fidelity to the revolutionary impulse of the historic avant garde as total-

izing critique; and a defense of artistic autonomy as a principle of self-organization. These principles place the group, then, at a certain distance from the prevailing non-aesthetic orthodoxy. First: in terms of the group's primary fidelity to the memory of the Russian Revolution and the Soviet avant garde, and second: in terms of their resistance to the dominant model of the sublation of art *into* life. The "point is not art's dissolution into life, but its crystallization in life as a constant re-discovery, beyond our reactionary times, of the possibilities of new forms of life (yet) to come."[21] Indeed, the majority of art-as-social-activism practices end up creating only a self-inflicted barrier to future progressive transformation and alliances. As Vilensky says in conversation with Alexey Penzin: "These practices take the form of producing service packages for normalizing the lives of problem communities. That is, for us, they are of 'little interest' to us because at bottom they are normalizing in nature."[22]

Chto Delat? are a small group and are, therefore, utterly marginal in terms of the machinery and hierarchies of the official art world, particularly given that they operate out of one of the far-flung outposts of contemporary art: Russia. Yet, something real and transformative is in development here that marks out the notion of the "third" avant garde as a placeholder for the memory of total revolutionary praxis. In other words, the key issue that needs addressing in relation to what the avant garde means today lies in how such initiatives (which may emerge from any social location) mediate the revolutionary pathos of the historic avant garde—the gap between the actual and ideal—as *active and productive*. The primary function of the new avant garde's totalizing critique, then, is not to generate a utopian acceleration away from the world, but, on the contrary, to seek out those points and fissures in actuality where new cultural relations and forms of organization are possible or emergent. This means that it is precisely the pathos of the avant garde, its role as the cultural memory of loss and defeat, that will direct and shape this potentiality.

Notes

1. Hal Foster, "What's Neo About the Neo-Avant-Garde?" *October* #70 (1994) 5-32.

2. Peter Bürger, *Theory of the Avant-Garde*, trans. Michael Shaw (Minneapolis: University of Minnesota Press, 1984).

3. Thierry de Duve, *Kant After Duchamp* (Cambridge: The MIT Press, 1996). See also Jacques Rancière, *The Future of the Image*, trans. Gregory Elliott (London: Verso, 2007) and *The Emancipated Spectator*, trans. Gregory Elliott (London: Verso, 2009).

4. Maria Gough, *The Author as Producer: Russian Constructivism in Revolution* (Berkeley and Los Angeles: University of California Press, 2005).

5. Boris Arvatov, *Kunst und Produktion* (Munich: Carl Hanser Verlag, [1926] 1972).

6. Imre Lakatos, *The Methodology of Scientific Research Programmes: Philosophical Papers, Vol.1* (Cambridge: Cambridge University Press, 1979).

7. John Roberts, "Productivism and Its Contradictions," *Third Text* 23:5 (2009) 527-36.

8. See in particular, Geert Lovink and David Garcia, *The ABC of Media*, available online at: http://www.ljudmila.rg/nettime/zkp474.htm.

9. See in particular, Nicolas Bourriaud, *Relational Aesthetics* (Dijon: Les Presses du réel, [1998] 2002).

10. Grant H. Kester, *Conversation Pieces: Community and Communication in Modern Art* (Berkeley and Los Angeles: University of California Press, 2004).

11. Walter Benjamin, "The Author as Producer," in Victor Burgin, ed. *Thinking Photography* (London: Macmillan, 1982).

12. For a further discussion of the suspensive avant garde, see John Roberts, "On the Limits of Negation in Badiou's Theory of Art," *Journal of Visual Arts Practice* 7:3 (2008) 271-82 and John Roberts, "Avant-Gardes After Avant-Gardism," *Newspaper of the Platform "Chto Delat?/What Is To Be Done?"* (2007).

13. See for instance, Alain Badiou, *The Century*, trans. Alberto Toscano (Cambridge: Polity, 2007) and "Destruction, Negation, Subtraction —on Pier Paolo Pasolini," Graduate Seminar, Art Center College of Design, Pasedena, February 2007, available at: http://www.lacan.com/bapas.htm.

14. Theodor Adorno, *Aesthetic Theory*, trans. C. Lenhardt (London: Routledge & Kegan Paul, 1984).

15. See Julian Stallabrass, *Internet Art: The Online Clash of Art and Commerce* (London: Tate Publishing, 2003). See also Gregory Sholette, *Dark Matter: Art and Politics in the Age of Enterprise Culture* (London: Pluto Press, 2010).

16. See Alexey Penzin and Dmitry Vilensky, "What's the Use? What is the Use of Art," *Newspaper of the Platform "Chto Delat?/What Is To Be Done?"* (2007).

17. Dmitry Vilensky, publication to the exhibition, "Make it Better," April 9-17, 2003, St.Petersburg State Museum, *Newspaper of the Platform "Chto Delat?/What Is To Be Done?"* (2003).

18. Penzin and Vilensky, "What's the Use? What is the Use of Art."

19. Dmitry Vilensky and Zanny Begg, "On the Possibility of Avant-Garde Compositions in Contemporary Art," in "Debates on the Avant-Garde," *Newspaper of the Platform "Chto Delat?/What Is To Be Done?"* (2007).

20. Vilensky and Begg, "On the Possibility of Avant-Garde Compositions in Contemporary Art."

21. Vilensky and Begg, "On the Possibility of Avant-Garde Compositions in Contemporary Art."

22. Penzin and Vilensky, "What's the Use? What is the Use of Art."

On the Possibility of Avant-Garde Compositions in Contemporary Art

Zanny Begg and Dmitry Vilensky

If the concept of the avant-garde has any meaning in the aesthetic regime of the arts, it is not on the side of the advanced detachments of artistic innovation but on the side of the invention of sensible forms and material structures of life to come. This is what the aesthetic avant-garde brought to the political avant-garde by transforming politics into a total life program. The history of the relations between political parties and aesthetic movements is first of all the history of this confusion, sometimes complacently maintained and sometimes violently denounced, between these two ideas of the avant-garde, which are in fact two different ideas of political subjectivity.—Jacques Rancière

Over the last few years, a number of artists have succeeded in both realizing and finding the theoretical grounding for a variety of works that allow us to speak of a new situation in art. These projects have found points of connection between art, new technologies, and the global movement against neoliberal capitalism. The lineages of this interest in political art can be traced back to Documenta 10 (1997) and coincides with the emergence of the "movement of the movements," which erupted onto the political horizon in Seattle in 1999—an event which, it can be argued, has crystallized a new political subject (named the "multitude" by Michael Hardt and Antonio Negri). This situation has subsequently been manifested through a variety of cultural projects whose critical stance towards the process of capitalist globalization and emphasis on the principles of self-organization, self-publishing and collectivity has evoked the idea of a return to "the political" in art.

But to conceive of these artistic processes simply as "political" would be to seriously underestimate the situation we find ourselves in. There is evidence that what we are actually talking about is the emergence of an artistic movement: its participants are concerned with developing a common terminology based on the political understanding of aesthetics; their praxis is based on confrontational approaches towards the culture industry; it finds consistent realization in the international framework of projects carried out in networks of self-organized collectives working in direct interaction with activist groups, progressive institutions, alternative publications, online resources and so on.

From history we know that such traits were once one of the characteristics of the avant garde. However, many people today see the avant garde as something that has been discredited by the Soviet experience where the "dictatorship of the proletariat" rapidly degenerated into a "dictatorship over the proletariat," a totalitarian situation that the "one no many yeses" of the anti-capitalist movement

has explicitly sought to reject. But despite the anti-vanguardist principles of the movement of the movements—which it must be noted is as much a rebellion against the Old Left of Stalinism and its universal claims to truth as it is against the neoliberal New Right—we believe that some of the essential content of the avant garde is crucial for an understanding of contemporary art.

It is interesting to note that during times of heightened mass struggle—for example both 1917 and 1968—there has often been a corresponding artistic turn towards modernist reduction (such as in the cases of Kazimir Malevich or Donald Judd). Both these characteristics have been strongly associated with the avant garde of the early and mid-twentieth century. One could postulate that at times of intense political struggle the audiences for art feel less attached to indexical images of real life and turn instead towards abstract signifiers of social and political realities or congealed moments of formal artistic innovation.

But of course the opposite tendency also co-exists—the rise of documentary filmmaking, realism and photography were strongly associated with these two periods. We are proposing that we return to a discussion of the avant garde but through a different reading of its composition, a reading that not only locates the political potential of art within the autonomy of aesthetic experience but also within the autonomy of art as rooted within the social context. We would argue that to conceive of "the political" in art without a corresponding commitment to the ideas of the avant garde diminishes both concepts. So does conceiving of the avant garde as formal innovation within art production alone diminish both art and politics. The radicality of art, therefore, cannot be reduced to its connection to social or political imperatives nor to formal stylistic innovation but must also be understood through its poietic force, its ability to question and destabilize the very notion of the political, social, cultural and artistic. The avant garde is a coup d'état

against history, making visible new possibilities in both art and politics.

At the current moment the components that historically belonged to the aesthetic of the avant garde now fall into place in a new composition. Today, we could claim the following taxonomy:

a) realism as an aesthetic method;
b) fidelity to the revolutionary impulse of the avant garde;
c) autonomy as political self-organization

Realism as Method

From history we know that the avant garde made use of a complex array of artistic strategies while claiming that the authenticity of its representation of revolutionary processes was guaranteed by the constant renewal of artistic languages and their sublation in everyday life. In the early years of the Soviet Union, the proponents of realism made a similar claim, though their method rested upon attempts at creating realistic works (in film, painting or literature) that showed the image of the revolution and the revolutionary subjectivity of the proletariat and the party. For example, the Statute of the Union of Soviet Writers wrote in 1934 that the true task of realism is "the truthful, historically concrete representation of reality in its revolutionary development."

Unlike the art of socialist realism or of the historical avant garde, contemporary art necessarily has the negation of capitalism's totality as its point of departure. At the same time, it strives to connect this negativity with aesthetic methods that are adequate to the study of the world in which a new subjectivity arises, not only as something destructive, but as something that produces a new social life. Political art maintains a reflexive attitude towards its own language; it does not try to dissolve into the processes of "the emancipation of life" but sets itself at a distance from life. In the old argument—should artists produce for the proletariat or should the proletariat produce its own art—today's position is best expressed through something Godard said in 1972: artists have to speak in their own name while participating in the life of political movements, or to put it another way, our goal is not to make political art but to make art politically.

Realism as a method can be understood today as both a continuation and a re-questioning of existing attempts at breaching the gap between the subject and the object, between an indexical relationship to everyday life and the new subjectivities produced by political events. This tension is most obviously played out through the methods of contemporary art, which are closely related to documentation, photography, film and video. The ubiquitous introduction of digital technologies for capturing moments in everyday life has opened new possibilities for coming closer

to representing life in the forms of life itself. However, it also brings up the issue of media reality and its truthfulness. Here, it really does make sense to return to the aesthetic discoveries of the 1930s, and in particular, to the strategy of estrangement introduced by Bertolt Brecht. Pre-empting any possibility for empathy based on the illusion of authenticity, estrangement allows for a process of defamiliarization that uncovers how social mechanisms work, demonstrating not only how and why people behave in a certain way in society, but analyzing the production of social relations itself. Brecht understood how important it was, first and foremost, to keep from mimicking reality or simply trusting the medium.

Here, we would like to emphasize a few key methods that are central to contemporary political art.

1. *Militant Research*

The genealogy of militant research goes back to Friedrich Engels' 1844 exploration of "The Condition of the Working Class in England." Later, this tradition was continued with research done by the Italian operaists and by activist-sociologists. In the Russian context, militant research became a familiar theme through the productionist interpretation of Trotsky's idea of the worker's correspondent.

An extremely relevant contemporary definition of militant research can be found in the work of the Argentinian group Colectivo Situaciones: "Militant research attempts to work under alternative conditions, created by the collective itself and by the ties to counter-power in which it is inscribed, pursuing its own efficacy in the production of knowledges useful to the struggle."

Such life-practices present contemporary political art with an important aesthetic challenge. The representation of militant research requires a new formal language capable of providing narratives of direct participation in the transformation of the world that surrounds us, but in practice it most frequently appears as the space of an alternative archive. Not only the quality and scale of the alternative archive's material itself, but also the mode of interaction with it presents the opportunity of developing entirely new dimensions of protracted aesthetic (co-) experiences that lie very much beyond the instantaneous reception of most contemporary art.

2. *Mapping*

In this case, we are talking about the creation of maps that reflect the structure that arises in the interweaving of capital and power. The main aim of such maps is to suggest a clear definition of the current moment and to answer a question of crucial importance: how does contemporary society work and which factors shape its subjectivity? What

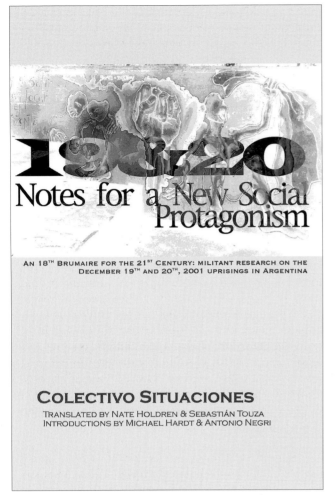

Militant Research on the 2001 Uprising in Argentina. Colectivo Situaciones, *19 & 20: Notes for a New Social Protagonism* (Minor Compositions, [2002] 2011).

are the possibilities for representing capital and the structures of its dominance? The aesthetic experience that one makes while looking at such atlases is one of horror in the face of the totality and sheer force of contemporary capital. This is why such maps should always be seen in parallel to other maps, maps of resistance.

In this case, the main goal is to make maps that show the interaction of various dissenting social movements. This line of mapping is not only meant to reflect the realities of protest, but the potential for a tendency of social development. It is interesting to note that the appearance of mapping as an exploration of the possibilities for visualizing sociological research began at the "Institute of Visual Sociology" in Moscow during the early 1930s, and was continued by Gerd Arnz and Otto Neurath at their Vienna "Institute of Visual Statistics" (which have been drawn upon so effectively in the work of Andreas Siekmann).

3. *Storytelling*

If the methods of mapping are impersonal in principle and operate with numbers, quantities and symbol-pictograms,

the idea of storytelling is based on the old slogan of "politicizing the personal." In this way, the main goal is to demonstrate how personal stories and fates are always produced in relation to the social and political conditions that shape and rest upon this or that form of "bare life." First and foremost, personal storytelling reveals the process of subjectivity's formation as a product of historical conditions. In this way, they subvert the "grand narratives" and official histories of power by revealing the contradictions of capitalism operating through the smallest fragment.

4. *Montage*

Montage is historically connected to the avant garde theories of film and their counterparts in literature, painting and graphics. Today, the most relevant aspect of montage is not its capacity for creating a new experimental language, but the possibilities it offers for working with real materials and politically documenting the life of society. This does not only apply to videos and film, but to exhibition space at large. There is a sense in which the "political exhibition" must be understood not as a collection of works by individual artists but as an assemblage or montage of works which must be viewed both in its totality as an exhibition and in connection to its specific locale and social and political surroundings. The political exhibition is not an interchangeable display of socially conscious art but an organic outgrowth of connections which link the participating artists and the local situation within which they are working, the result of which must be considered as artwork in itself.

5. *Subversive Affirmation*

In an apparent break with the more postmodern strategies of pastiche—where incongruous elements were often combined without any sense that the resulting humor, horror or dislocation revealed any deep social truths—we are witnessing a return to parody and absurdist strategies of subversive affirmation that seek to undo the logic of capitalism by slavishly following this very logic to its absurd and grotesque conclusions. By overplaying their identification with the values of capitalist violence and exploitation these parodistic gestures seek to undermine these same values by evoking a deeper sense of morality and social responsibility. This strategy, of course, presents some risks. Its position of subversive affirmation binds it to the logic of that which it seeks to critique, producing gestures that, if the alternative morality is absent, can be received in a manner that is diametrically opposite to the desires of its creators.

6. *Carnivalesque*

With its emphasis on death, symbolic violence, sensuality and excess, the carnival has some similar problems to that of subversive affirmation. However, it also has some important differences. By breaking down the gap between spec-

tator and participant, the carnival opens up a space of embodied politics where people can act out moments of free expression and pathos. The carnival is one of the most important means of intervening in and overturning reality, a hypertrophied experience that overpowers the surrounding world with derisive laughter. The carnivalesque introduces irrational methods that break down the symbolic-representative sequence of capitalism. Its aesthetic form is a continuation of the traditions of Surrealism and magical realism.

7. Re-enactment and Fiction

The formation of a new subjectivity is not only shaped in relation to the current political situation—it also finds its shape in relation to the past. That's why many artworks are semi-retroactive—not only challenging the present but also how we understand the past. The past is full with unrealized potential which art can crystallize into a new form. Why go backwards? The point in revisiting the past is its interrelation with the future. As Hito Steyerl has commented, "the only possible critical documentary today is the presentation of an affective and political constellation which does not even exist, and which is yet to come." The possibility of this "becoming" is located not only in the future but is also rooted in the actualization of all lost chances. Many recent artworks have thus used tactics, reminiscent of Brecht's learning plays, such as re-enactments and fictions where actors and audience must try to distinguish political and apolitical behavior by imitating ways of behaving, thinking, talking, and relating. The fiction allows us to draw closer to the moment in which actualized elements of the past interweave with what is taking place in the presence of the now (Jetztzeit), leading to the potential composition of a new Event.

Fidelity to the Revolutionary Impulse of the Avant Garde

Here it is important to consider fidelity, as it has been posed by Alain Badiou. It is not an artistic fidelity to the goals and aims of the anti-capitalist movement per se, a position that would be reminiscent of the modus operandi of socialist realism and would reduce contemporary art production to the propagandistic position of cheerleader or advocate for this movement, but rather, a fidelity to the subjective space from which the movement sprang. From this position the new avant garde does not conform to the already-mythical subject of revolutionary social change, but seeks out and forms this subject through its own experiments and processes of engagement and new artistic discoveries.

John Roberts has described the promise of the avant garde as that of the "new," which, as Theodor Adorno pointed out, did not mean a consumerist fetishizing of the novel or the trendy but the "repetitive and continuous emergence from artistic tradition." The "new" lies not in "formal,

'stylistic' breakthroughs, but in the possibility of keeping alive art's non-identity in the face of its own institutionalization and, as such, in the face of the means-ends rationality of capitalist exchange value."

If we create a mediated relationship between the social and autonomous role of art it is possible to see some points of cohesion opening up between Badiou's idea of the event and Adorno's idea of the new. Adorno's idea of the "new" which destroys the traditions that give rise to art finds some purchase in Badiou's idea that an event is a "truth which ruptures the order which supports it."

As mentioned earlier, Seattle was an "event" that has changed how subjectivity and potentiality is understood. This event, like any other, opens up possibilities for new subjectivities and understandings of reality. Seattle and the anti-capitalist movement, as a critical moment in and against the process of globalization, has sparked interest in social engagement, new media and communication technology, DIY, deterritorialization, autonomist revolutionary theory, the breakdown between art and life, carnival and so on—all factors that have been absorbed into the contemporary art making process. Without muffling the radical potential of art by saying that it merely reflects these changes we can see that these changes dialectically relate to what being radical on its own terms would mean.

It is precisely here that we see a continuation of the avant garde's approach to the political problematic and a possibility for fidelity to the idea of revolution under contemporary conditions, which—to use Badiou's terminology again—is the essence of the possibility for actualizing the event, and not the futile race for normal innovations.

Autonomy as a Principle of Self-Organization

Both in the Soviet Union and in capitalist society, the defeat of the avant garde was a result of the attempt to sublate art into life; this attempt was then instrumentalized by the political party or the culture industry. The experience of this defeat underwent exhaustive analysis in discussions initiated by Adorno and lasts to the present day. The conclusion drawn from these debates makes it necessary for contemporary political art to rethink its conception of autonomy. But this new project of autonomy has more to do with the political practices of workers' autonomy and council communism than with the modernist project of defending the autonomy of aesthetic experience.

A more contemporary understanding of autonomy is as a confrontational practice in relation to the dominant forces of cultural production, comparable to the act of "exodus from the factory" and the attempt to create a decentralized network of self-organizing collectives. This understanding of autonomy moves beyond the classic conception of "self-law" and articulates a position of independence and oppo-

sition to social relations that threaten to destroy these relations as they are. As Sylvère Lotringer and Christian Marazzi argue, autonomy is "not only a political project, it is a project for existence." This collectivist, confrontational, politicized notion of autonomy—which exerts such influence in the anti-capitalist movement today—presents an alternative interpretation to the individualist and classical one within existing art discourses.

Here, the point is not art's dissolution into life, but its crystallization in life as a constant re-discovery of new places in which there are new possibilities beyond reactionary times that can be realized here and now.

Conclusion

It is with a certain sense of historical irony, therefore, that we would like to end this article with a quote from Leon Trotsky:

A reactionary epoch not only decomposes and weakens the working class, isolating its avant-garde, but also reduces the general ideological level of the movement, projecting political ideas back to previous historical epochs. The task of the avant-garde in these conditions consists, first of all in not being carried away by this stream, but of necessarily going against this stream.

A High-Performance Contemporary Life Process: Parametricism as a Neoliberal Avant Garde

Owen Hatherley

The periodization of the avant garde fluctuates as much as its definition, and architecture is no exception. Probably the most complete and comprehensive of all the avant garde attempts to revolutionize everyday life, the modern movement in architecture, warped into various different things in the twentieth century. Emerging equally out of Expressionism, Futurism and the technocratic tectonics of the Deutscher Werkbund, the modern movement coalesced in the 1920s as a rationalist aesthetic with an accompanying political program, achieving its widest application in working-class housing, in the 'Siedlung' estates of Berlin, Frankfurt, Rotterdam and elsewhere. In its politics it had left and right factions, but shared an opposition to laissez-faire capitalism, offering its services to Communists, Social Democrats and even, in Italy, Fascists, but seldom to big business. After the war this changed, with a new corporate modernism in the United States, and with various attempts to keep the original radicalism alive in groups like the international 'Team 10' and its libertarian and leftist outgrowths. Much of this would later be subsumed in the relentless, nuance-free critique of postmodernism, where laissez-faire was declared to be "almost all right," as Denise Scott-Brown and Robert Venturi put it in *Learning from Las Vegas*. However, what distinguishes architecture still, is that many of its contemporary protagonists continue to consider themselves part of an avant garde, and place themselves in the lineage of the 'historical' avant garde, rather than repudiating it. Not least of these is the firm of Zaha Hadid Architects.

Hadid herself is no theorist, nor has she ever pretended to be. In the generation of 'deconstructivists' that emerged out of architecture schools in the 1980s, who tried to continue the avant garde's questioning approach to form while junking its oppositional approach to laissez-faire capitalism—Peter Eisenman, Bernard Tschumi, Steven Holl, Coop Himmelb(l)au, Daniel Libeskind—Hadid was always conspicuous in her lack of interest in quoting Derrida or Benjamin to justify her formal choices, although she has always cited the similarly Marxian Soviet avant garde. So it's curious that in recent years Patrik Schumacher, her architectural partner for the last 16 years, has become her abstract ventriloquist, writing intensely theoretical texts to go alongside every museum and opera house.

Schumacher is a little more ambitious than the average Deleuze-citing architect, however. Not for him the postmodernist fear of the grand gesture, categorization and periodization, or the Hegelian historical sweep. Most of all, there is no hint of the discomfort on the question of whether an avant garde can still exist. In 2008 he declared quite unam-

ZHA, *Guangzhou Opera House*, exterior and interior render, 2003-2010. Courtesy of Zaha Hadid Architects.

biguously that there was a new avant garde, and it was Zaha Hadid Architects, and a handful of others. In a series of articles and one book over the last two years, he has attempted to prove it. He called it 'Parametricism,' a term derived from the computer scripting software that most large architectural firms use in designing buildings.

In the 2008 paper "Parametricism as Style—Parametric Manifesto," Schumacher defines this new entity in terms fairly familiar from Deleuze and Guattari's *Capitalism and Schizophrenia*.[1] On his list of 'don't's, or his 'negative heuristics,' are a mish-mash of ideas from twentieth-century modernism and late twentieth-century traditionalism: "avoid familiar typologies, avoid platonic/hermetic objects, avoid clear-cut zones/territories, avoid repetition, avoid straight lines, avoid right angles, avoid corners … and most importantly: *do not add or subtract without elaborate interarticulations*." Partly this is a list of bad things the earlier, 'cubic' avant garde does—all the things that make it boring to the architecture student, its unfriendly linearity, its formal rigors. As for the 'positive heuristics,' we're stuck in the *Thousand Plateaus*—we must "interarticulate, hyberdize (sic), morph, deterritorialize, deform, iterate, use splines, nurbs, generative components, script rather than model." There's yet more Deleuzery when he continues his definitions. We're immersed in multiplicities:

> The assumption is that the urban massing describes a swarm-formation of many buildings. These buildings form a continuously changing field, whereby lawful continuities cohere this manifold of buildings. Parametric urbanism implies that the systematic modulation of the buildings' morphologies produces powerful urban effects and facilitates field orientation. Parametric Urbanism might involve parametric accentuation, parametric figuration, and parametric responsivess (sic).

The extreme syntactical inelegance is evidently part of the point, the tumbling onrush of pseudoscientific terms and the staccato sentence structure makes the prose sound like an operative thing rather than mere description.

ZHA, *Guangzhou Opera House*, concept reference image, 2003-2010. Courtesy of Zaha Hadid Architects.

Moreover, Schumacher stresses how different this is from the Modernisms that went before him and Hadid:

> Modernism was founded on the concept of space. Parametricism differentiates fields. *Fields* are full, as if filled with a fluid medium. We might think of liquids in motion, structured by radiating waves, laminal (sic) flows, and spiraling (sic) eddies. Swarms have also served as paradigmatic analogues for the field-concept. We would like to think of swarms of buildings that drift across the landscape. Or we might think of large continuous interiors like open office landscapes or big exhibition halls of the kind used for trade fairs. Such interiors are visually infinitely deep and contain various swarms of furniture coalescing with the dynamic swarms of human bodies. There are no platonic, discrete figures with sharp outlines.

It's an organic flow, but not a friendly one—rather an unstoppable, advancing force, dissolving anything solid in its path—yet the prosaic examples Schumacher gives (trade fairs!) adds a note of bathos, which only increases the closer you get to the Parametric edifice.

Initial responses in the architectural press largely stayed at the level of ridicule, but Schumacher set out to challenge this with an extraordinary article in *Architects Journal*, easily the most aggressive, theoretical and indigestible piece of prose ever published in this trade magazine. The piece, "Let the Style Wars Begin," condensed and intensified for public consumption his various more rarefied rhetorical interventions, though with no concession given to the readership.[2] It begins with a valedictory tone:

> In my Parametricist Manifesto of 2008, I first communicated that a new, profound style has been maturing within the avant-garde segment of architecture during the last 10 years. The term 'parametricism' has since been gathering momentum within architectural discourse and its critical questioning has strengthened it. So far, knowledge of the new style has remained largely confined within architecture; but [he confidently asserts] I suspect news will spread quickly once it is picked up by the mass media. Outside architectural circles, 'style' is virtually the only category through which architecture is observed and recognised. A named style needs to be put forward in order to stake its claim to act in the name of architecture.

The insistence on style is interesting. The Modernists of the 1920s attempted wherever possible to avoid the term, preferring the neutral and technocratic New Building or Constructivism. When it was later dubbed *The International Style* by critic Henry-Russell Hitchcock and Fascist activist Philip Johnson, it was as a deliberate attempt to celebrate the finer things, to hold up villas and 'an architecture still' against the 'fanatical functionalists' who wanted to build for 'some proletarian superman of the future,' those who claimed they'd abolished architecture by realizing it. The High-Tech generation who are essentially today's architectural elders—Norman Foster, Richard Rogers et al—always disdained the notion of style, claiming ever less convincingly to be above such fripperies, their work emerging from solely technological imperatives. Schumacher, though, claims he will use style as a means of communicating with the public, unsurprisingly, as he was never likely to do so with his prose.

The term apparently is unveiled *now* because years of laboratory work has made it possible:

> From the inside, within architecture, the identification of parametricism demarcates and further galvanises a maturing avant-garde movement, and thus might serve to accelerate its progress and potential hegemony as a collective research and development effort. As a piece of retrospective description and interpretation, the announcement of parametricism seems justified after 10 years of consistent, cumulative design research. Prospectively, the announcement of the style should further consolidate the attained achievements and prepare the transition from avant-garde to mainstream hegemony. Parametricism finally offers a credible, sustainable answer to the drawn-out crisis of modernism that resulted in 25 years of stylistic searching.

The aim of achieving *hegemony* is again something that the technocrats, liberals and neoclassicists would never admit. Schumacher clearly wants to destroy his woolly opponents, and in that there's no doubt he's an avant-gardist of some sort.

It should be noted Schumacher isn't just suggesting that Parametricism is the successor to the mini-movements of postmodernism or deconstructivism, but rather is something more fundamental: "the great new style after modernism," the final and long-awaited creation of something that owes nothing to the Soviet avant garde. His contempt for all that came between is total.

Post-modernism and deconstructivism were mere transitional episodes, similar to art nouveau and expressionism as transitions from historicism to modernism. The distinction of epochal styles from transitional styles is important. In a period of transition there might emerge a rapid succession of styles, or even a plurality of simultaneous, competing styles. The crisis and demise of modernism lead (sic) to a deep and protracted transitional period, but there is no reason to believe that this pluralism cannot be overcome by the hegemony of a new unified style. The potential for such unification is indeed what we are witnessing.

He goes on to frame this in *almost* political terms as a repudiation of Fukuyama and his ilk, to insist that now something new can be created.

Modernism's crisis and its architectural aftermath has led many critics to believe we can no longer be expected to forge a unified style. Did the profound developmental role of styles in the history of architecture, as evidenced in the gothic-renaissance baroque-historicism-modernism sequence, come to an end? Did history come to an end? Or did it fragment into criss-crossing and contradictory trajectories? Are we to celebrate this fragmentation of efforts under the slogan of pluralism?

No, is his answer, and he has contempt for the idea that

Any style today—so it seems—can only be one among many other simultaneously operating styles, thus adding one more voice to the prevailing cacophony of voices. The idea of a pluralism of styles is just one symptom of the more general trivialisation and denigration of the concept of style. I repudiate the complacent acceptance (and even celebration) of the apparent pluralism of styles as a supposed sign of our times. A unified style has many advantages over a condition of stylistic fragmentation. Parametricism aims for hegemony and combats all other styles.

This is for reasons intrinsic to Parametricism itself, the way the designs apparently aggressively flood a space:

Parametricism's crucial ability to set up continuities and correspondences across diverse and distant elements relies on its principles holding uninterrupted sway. The admixture of a post-modernist, deconstructivist or minimalist design can only disrupt the penetrating and far-reaching parametricist continuity.

Yet he also claims the design is more powerful because of the way it can join together or interestingly differentiate anything else in its path:

The reverse does not hold, because there is no equivalent degree of continuity in post-modernist, deconstructivist or minimalist urbanism. In fact, parametricism can take up vernacular, classical, modernist, post-modernist, deconstructivist and minimalist urban conditions, and forge a new network of affiliations and continuities between and beyond any number of urban fragments and conditions.

To see what this actually looks like in practice, try Zaha Hadid Architects' Port Authority project in Antwerp, where a gigantic phallic insect mounts and seemingly rapes a neoclassical building on the city's harbor.

Most of all, though, he insists that Parametricism is not merely a style for the elite.

It cannot be dismissed as eccentric signature work that only fits high-brow cultural icons. Parametricism is able to deliver all the components for a high-performance contemporary life process. All moments of contemporary life become uniquely individuated within a continuous, ordered texture.

From Tatlin or Malevich's three-dimensional hymns to the Communist International to the enticing prospect of a "high-performance contemporary life process," Parametricism is a reminder of exactly what has changed between the old avant garde and the new. Nowhere in Schumacher's now voluminous proclamations on the new style can you find much of an acknowledgement of politics, but you can find various little hints of the world outside his studio.

Parametricism aims to organise and articulate the increasing diversity and complexity of social institutions and life processes within the most advanced centre of post-Fordist network society. It aims to establish a complex variegated spatial order, using scripting to differentiate and correlate all elements and subsystems of a design. The goal is to intensify the internal interdependencies within an architectural design, as well as the external affiliations and continuities within complex, urban contexts.

ZHA, *Port House*, Antwerp, Belgium, 2008—TBC. © Zaha Hadid Architects. Courtesy of Port of Antwerp.

So this starts with acknowledging that there is a network society, and it's a "post-Fordist" one (although anyone who works in a call center would be able to attest that networks and strict Taylorist disciplining of labor are in no way mutually exclusive). Schumacher has no particular interest in doing anything other than displaying this society, embodying it. In his manner, he fully acknowledges this. "The avoidance of parametricist taboos and adherence to the dogmas delivers complex order for complex social institutions." It mirrors the processes that go on within it. It is a mute avant garde, an avant garde without criticism. In a sense, this is a relief—none of the embarrassing attempts by the likes of Rem Koolhaas and his Office for Metropolitan Architecture to claim that designing offices for Rothschilds or Chinese state TV is in some way 'critical.'

It is easy to just dismiss Schumacher, to shrink from his torrent of tortuous verbiage, to write it all off as forbidding and Teutonic—to take the various positions adopted by the *Architects Journal*'s readership: "what is it about Germans always trying to start the war?" or "take a chill pill mate." To really see what makes Parametricism symptomatic of our unpleasant cultural and political circumstances, it needs to be taken seriously, and we need to suppress our aesthetic and syntactic revulsion. So, if we suspend disbelief for a little while, we can see that after all those morbid symptoms in the 80s, 90s and 00s—the cowardice of pomo, the glorification of powerlessness and fragmentation indulged in by deconstructivism—the new is finally emerging. Who is it that actually practices Parametricism? Schumacher acknowledges only one precursor, the engineer Frei Otto, and only a handful of contemporaries, including digital architect Greg Lynn, and two architectural schools, the Sci-Arc in Southern California and the London Architectural Association under Brett Steele. Yet, perhaps appropriately given Schumacher's stated intent on total hegemony, the style has reached its greatest extent at the hands of its apparent enemies.[3] It would be hard for the untrained eye—and after all, it's that eye Schumacher wants to catch, with his talk of 'mainstream acceptance'—to differentiate the bulging, organic, flowing, advancing forms of, say, the Sage in Gateshead by high-tech figurehead Norman Foster, or the Zlote Terasy shopping mall in Warsaw, designed by American postmodernist Jon Jerde, from typical Zaha Hadid Architects projects like the Guangzhou Opera House—itself currently the subject of a plagiarism case within China. The idea that an avant garde only exists when hacks start stealing its ideas is a new one in architectural historiography.

Nonetheless, there's at least a few signs that it really is an avant garde, most notably the fact that many digital designers want absolutely nothing to do with the term, considering Schumacher a mere *arriviste* who has co-opted the digital underground. The architect Daniel Davis wrote on the blog *Digital Morphogenesis* that, rather than truly entering into

a design with the machines and programs, Hadid and Schumacher created a design in a top-down, artistic manner, as much as any other architect would:

> Whether ZHA uses a parametric model to generate the construction drawings of their signature is meaningless because the design was generated through a different medium. So Parametricism in this weird double-talk is Schumacher's attempt to associate ZHA (and even claim the ZHA created) a movement with which they have nothing to do. Stick at what you are good at Schumacher, making money, and let the third generation show you what this 'revolution' is really about.[4]

In its combination of claiming the term for an unacknowledged underground, political sniping and sectarianism, a statement like this is perhaps the nearest proof that there really is an avant garde called Parametricism, although perhaps Patrik Schumacher has little to do with it.

Notes

1. Patrik Schumacher, "Parametricism as Style—Parametric Manifesto," available at http://www.patrikschumacher.com/Texts/Parametricism%20as%20Style.htm.
2. Patrik Schumacher, "Let the Style Wars Begin," *Architects Journal* (May6, 2010), available at http://www.architectsjournal.co.uk/patrik-schumacher-on-parametricism-let-the-style-wars-begin/5217211.article.
3. I owe this point, and much else here, to critic Douglas Murphy's several trenchant analyses of Zaha Hadid Architects' work. See for instance http://youyouidiot.blogspot.com/2009/08/zaha-hadid-architects-purveyors-of.html on their Glasgow Transport Museum; http://youyouidiot.blogspot.com/2009/01/cackitecture.html on the aforementioned Antwerp 'cock and balls,' and http://youyouidiot.blogspot.com/2008/01/accidental-brutalist.html on the decomposition of their buildings for Vitra in Weil-Am-Rhein.
4. Daniel Davis, "Patrik Schumacher—Parametricism," (September 25, 2010), available at http://www.nzarchitecture.com/blog/index.php/2010/09/25/patrik-schumacher-parametricism/.

Le Devant Garde

Michael Webb

Here is the first verse of a song from the comic opera "The Gondoliers," by Gilbert and Sullivan. Its subject is the brave Duke of Plaza-Toro, one of the characters in the opera:

> In enterprise of martial kind,
> When there was any fighting,
> He led his regiment from behind
> (He found it less exciting).
> But when away his regiment ran,
> His place was at the fore.

Evoking the military origins of the term avant garde, the verse reminds us of the dangers of being part of it. Better first ascertain the strength of the establishment ... your enemy. If the enemy be invincible, better to lead from behind. Be part of, may I dare suggest, the devant garde, even if less exciting. For those who insist upon being *avant* make sure the establishment is but seemingly oppressive and invincible; their output and utterances formulaic; that they remain irrelevant to the needs of the society within which they operate. Such a condition existed with regard to British postwar architecture: rigidly rectilinear, frankly boring (certainly not across the board though, one has to say)—its proponents strangely unmoved by, and unaware of, changes that British society was undergoing.

And thus to Archigram, representing not so much images of an architecture appropriate to this new society but rather scenes from the lives of the new young people that this architecture facilitated. Montaged photographs, culled from magazines, of their with it [See: (Archaic) the state of being *au courant*, fashionable] faces and clothes: nowadays the appearance of those same faces would suggest a diagnosis of jaundice. And they are starting to curl up at the edges. Sometimes they occupy as much as three quarters of the surface area of the drawing. Filling the remaining quarter is Konrad Wachsmann or Bucky Fuller type wallpaper pattern: space frames, geodesics and, above all, stage lighting.

As with that earlier manifestation of incipient revolt—the Futurists in 1909—I believe, along with virtually no one else, that the dicta emerging from the two groups were more provocative than the drawings. Hence: "It's still a building" (Archigram) implied that a new structure might look on the surface adventurous, even futuristic, but its basic program was still conventional. The classic example of this would be the new Thom Mayne building at the Cooper Union in New York City. It may be clad with a decorative skin, but underneath it's a straightforward rectilinear box, a fact to which photographs taken during construction attest. It's an exercise in form making for its own sake. Ah! but what a form, let's face it! And: "When it's raining in Oxford Street no one looks at the architecture" (Archigram's David Greene) who, I've decided, is expressing the view that what is seen through the window of the telly screen is richer, more brightly colored and safer than that which is seen around it. And it constantly moves relative to the fame. The fact that the TV image has been selected by others may also bestow a validation on the framed view.

But buildings "just sit around doing nothing" (Archigram again). People on the street no longer look up at the Cooper building, especially when it's raining. The comedian Bill Irwin once did an Off Broadway show, a sketch of which showed the aftermath of a violent mugging on the street. The crowd gathered around the crime scene was gawking, not at the actual victim, but rather at the image of the victim on the TV camera's monitor.

And just how *avant* was the *garde* in Archigram? The way we presented ourselves, and the way Cedric Price presented himself, was as voices crying alone in the wilderness. While the rest of the architectural profession was mired in an antiquated ethos of 'first get the job,' Cedders (how he hated that upper-class-twit abbreviation of his name), for example, was saying, in a glorious act of professional suicide: "first decide whether, having got the job, the architect will suggest to the client that the building being proposed by the latter is not really needed; or will have a useful life span of but a few years." He once showed up at a meeting of the London Landmarks Commission, the intent of which was to decide whether a building Cedric had designed should be landmarked. He made an impassioned plea that it be torn down, claiming that, society having undergone changes in the intervening years since it was first built, his building no longer had relevance. Thus the success or failure of a building was to be judged solely in terms of the service to society it provided. We were amazed: he actually believed all this stuff about flexibility, redundancy and impermanence.

The ultimate Cedders building would thus be an efficient and short lived, compact service unit. Revisiting the Cooper building for a moment, it would be the straightforward rectilinear box with the decorative skin removed and sold off as scrap. Since the vast majority of people seeing this building do so on their computer screens, why not have the skin as a digital presence only? Some years ago I embarked on a series of drawings exploring the more arcane aspects of perspective projection. I dared venture into the domain of distortion and infinity, which allowed

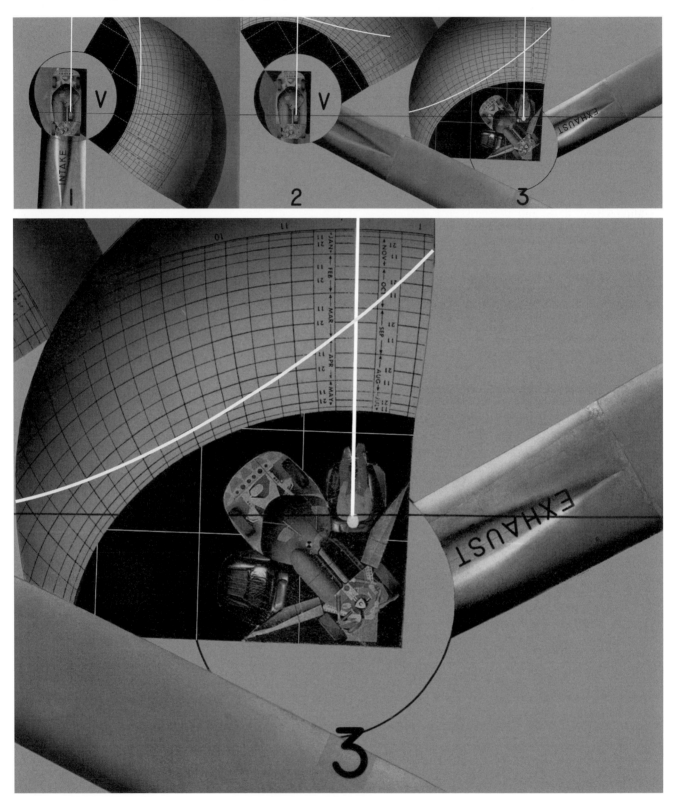

Michael Webb, *Drive-in House*, [top] horizontal section cut; [bottom: detail], project begun 1987; this drawing 1995.

me to evoke giant voids running through the sky and the soil. Color Cedders and I true green.

I wrote back in 1972: "Wasteful and sad, though, that out there in the 'burbs the mobile component of *vita domestica* sits out on the driveway or in a parking lot unused for most of the day. Luxuriously appointed interior with crushed velour seats, surround radio, hi fi, TV and cocktail cabinet, the car is swankier than the house interior to which it is supposedly ancillary." The inference here is that the car should enter or attach itself to the house … should become additional floor space. Then the home, when everyone is out, is the empty piece of land. The car, when it arrives back chez vous, becomes the energizer.

The first attempt at designing a true drive-in house was the Sky-Rise project begun in 1969. Occupants, returning home in specially designed cars, arrive at the foot of the building where chassis and body are separated; the former being stored in underground racks and the latter hoisted skywards, embraced by a traveling crane which then deposits the bodies within bodies at the appropriate apartment in the sky; or more naughtily, the inappropriate apartment. Lastly the body blooms … it opens out to form additional living space.

A convention of architectural projection drawing is that, when depicting the horizontal section (a.k.a plan) of a building, the main entrance facade should be placed along the bottom edge of the drawing so that, in effect, you enter and penetrate the interior by moving your eye upwards. In frame 1 the car has entered through a vertically placed intake tube (so as to obey the convention). It comes to a halt within a circular drum. The driver's center of vision is also vertical (see white line). In frame 2 the drum bearing the car has rotated clockwise so that its interior is now sealed off from any cold air in the intake tube. Nevertheless, in order to obey the convention, the driver's center of vision remains vertical. This means the rotating

drum is graphically inert, while the inert house rotates graphically around it. The car's doors begin to open. In frame 3 the drum has rotated further such that the car shares the same space as the schematic living area. Graphically, however, its position is such that the driver's steadfast center of vision is yet vertical. The car's doors are now fully open. As the car rotates about the house, so does the sun (see the yellow line in each frame), a statement pleasing, surely, to the Holy Inquisition. Per Ardua ad Astra, "Through struggle we attain the stars" (the motto of the British Royal Air Force).

The struggle for many an ambitious young architect just out of school took the form of membership in the avant garde and the consequent reaping of the notoriety accruing from it. Thus was formed a base from which a star architectural practice could be launched. The noble principles which had launched that career could then be gently put aside. Not with me, I like to think. With the two of us, and with David Greene, supported by a beneficent academe, we could remain true to our convictions; never have to dilute them in the world of architectural practice, that vale of tears strewn with the wreckage of beautiful ideas.

The rash of new museums designed by the stars of the architectural firmament are considered "daring" (I have put quotation marks before and after the word to indicate a different meaning than the one typically associated with it). These buildings are anything but daring. It used to be understood that a design could be termed avant garde if it possessed canted walls, doubly curved surfaces or shard-like shapes, that is, a building that was virtually unbuildable. Today's museums will only get built if they do possess these forms … and with modern computer programs all too buildable. After Bilbao, museum directors, their funders and bankers—an establishment, in fact—realize the drawing potential when the building that houses the art is the art. The establishment is now the avant garde.

Hackerspace in Synthetic Biological Design: Education and the Integration of Informal Collaborative Spaces for Makers

Mitchell Joachim

The tide of environmental decline is a multilayered dilemma for American higher educational systems. To some extent, architectural instruction has struggled to reverse this environmental decay. That is not to say the desire and aspiration to positively contribute to an ecological society is omitted from design discourse. In fact just the opposite is true: an immense consortium of architectural thinkers, both formal and informal, are absolutely devoted to the task of sustainability. For at least this past decade the dominant meta-theme of a majority of American schools of architecture has been the promise of sustainability.

Architects have reflexively launched themselves into the center of the environmental polemic as both its source and resolution. This eco-crisis demands robust solutions on a considerable scale to deal with an immanent collapse. At this point, the radicalization of sustainability is widespread. As a principle it is the politicized mainstream agenda for most design curriculums. How can you contend with platitudes like 'save the planet'? The architectural responses range from fantastical feats of geo-engineering to low-flush toilets, all in service to assuage our fears. It's vital to concede that sustainability will happen in every shade of green.

MATSCAPE: Material Mosaic Triplex. Credits: Mitchell Joachim, Terreform ONE. The form results from landscape and climatic vectors—solar path, wind forces, rainfall, and ambient temperatures—in reference to human desired services.

For if the mission fails, we will not be here to say otherwise. Therefore, we must shift beyond sustainability alone and its associative rhetoric. What are the latest comprehensive models within design studio education that can expedite a greener and grander shift? We need to prepare the next generation of students to be self-reliant in a world that requires regeneration. We also need to expand a discourse that continues an arc of humanitarian and technological assertions after sustainability is achieved.

Passive cooling, zero emission paint, and harvested lumber do not foreground evocative design. During the last two decades, the prevalent challenge for the sustainable design movement in the United States has been to sluggishly modify the behavior of the developers, architects, and planners responsible for the sizable majority of new projects. From this outlook, it's not salient ensembles but uniform conventions that ought to stand as the peak objective for green advocates. We've considered such standardized aspirations as limiting and myopic. Admittedly this is not in tune with what would naturally be anticipated or expected of green designers. This is not to disregard their gradual approach, only wondering where it arouses the construct visually. How can design complement our creative judgement and account for the environment? After implementing environmental standards, green architecture appears nondescript. What does it take to re-create the "Bilbao effect"—artifact as stimulating catharsis—ecologically? The profession has to restructure its pedagogical goals, particularly assuming a balance and responsibility of giving aspirants a sufficiently bona fide command of environmental studies and adaptable technologies. It is through formal education, as a conscious effort by design society, to impart the skills and receptivity considered essential for social environmental living. The proposition is to create a curriculum to educate professionals on the sensibilities of green design, and to further prepare our architectural discernments for the next technological wave.

What is the next surge of technology and where can it be studied? The space in which we teach and learn architecture requires an overlay. To flourish beyond the territory of sustainability alone, the area of the architecture design studio itself needs modification. Existing atelier layouts are suitable, but there is opportunity for a superimposed workspace. This zone is more like a micro-garage for invention than the table of a draftsperson. Here the emphasis is on discovery.

In many instances, discovery comes through the act of making. A revamped studio environment ought to accommodate the next kind of designer that recognizes the advents of the maker culture. Individual makers have to some extent turned the architecture of the authoritarian workplace upside-down. Different from the dot-com era moguls that preceded them, these people define themselves modestly. In some cases they refuse to be lumped into a prescribed

Peristaltic City: Circulatory Habitat Cluster. Credits: Mitchell Joachim, Neri Oxman, Terreform ONE. Peristalcity is a tall building made of a cluster of shifting pod spaces. The pod skins alter the volume locations within. A spatial layout establishes heterogeneous movements as the criteria for a dynamic assemblage.

movement or category. They have been defined variously as inventors, makers, tinkerers, activists, nomads, occupiers, and hackers. Their varied translation of conventional architecture is unique.

By blurring traditional disciplinary boundaries and using accessible advanced technology, makers tend to manifest fresh insights to numerous difficult problems. They inhabit shared spaces of professional heterodoxy, more commonly referred to as hackerspaces. Many of their innovative quasi-professional methods and practices generate unique areas that connect non-obvious cross-disciplinary activities. As an open community these spaces and their users critically inform an acute understanding of invention. It takes place in a loosely defined intersection that emphasizes open source knowledge through sharing. That does not mean maker culture overtakes the architecture studio. Instead, it serves as a smart programmatic overlay to fine-tune, nudge, and tweak the existing studio context. The aim is to create an educational spine woven throughout studio culture that comprehensively supports hands-on inventiveness.

The methods and tools deployed within this curricular spine are: desktop 3D printing/additive manufacturing, biohacking, urban farm/food production, open source design, Do-It-Yourself (DIY) fabrication, Arduino electronics, crowdsourcing, scripting/freeware, alternate energy strategies, and citizen science. All are intended to unleash the power of invention in architecture.

Teaching invention requires hands-on experience. Think/do-tanks that by definition are highly adaptive and modest in scale are easy to locate. In many western cities alternative spaces for experimentation have developed around the creative class. Examples include prominent sites in New York City: The Kitchen, Eyebeam, Alpha One Labs, New York Resistors, Makerbot, General Assembly, Genspace, and The Metropolitan Exchange. These examples serve as a guide to integrate a maker culture in design studio. It's a constructive way of learning and it's intended to be congenial.

Teaching in architecture design should respond to the needs of today, especially in ecology and technology. We must prepare the architect for the not too distant future. What does the livelihood of tomorrow's architect look like? How do their activities support a healthier planet? Architecture performs a vital role in the manifestation of creative workplaces towards invention and ecology. At some point of immanent fruition the designer is defined by his/her generation. It is time we recognize the innovative methods our inventive cohorts have assembled. The "science garage" has long been the pinnacle of American invention. The challenge is to address and revamp predictable applications in education with the liberties of these collaborative environments. If we are to explore original strategies for innovation as it relates to environmental discourse, we have to embrace these free zones of connectivity and interactivity. Students of architecture design studio and supportive courses will greatly benefit from the addition of a vigorous maker element. The objective is to provide an egalitarian space in the official program that is unprogrammed and uncensored. This is a resilient direction that promotes a dialogue beyond sustainability. Permission to play with a purpose engages aspirants with an understanding of consequences that extends outside our discipline set.

Little Magazines: Small Utopia

Beatriz Colomina

Little magazines are a small utopia, a mass-produced portable universe. Architects use little magazines as an experimental space in which projects are produced and the images dispersed around the world in the multiple copies are more important than any one project constructed in the streets. Even the designed space of those pages is itself a key collaborative project that circulates.

The history of the avant garde in art, in architecture, in literature can't be separated from the history of its engagement with the media. And it is not just because the avant garde used media to publicize their work. The work simply didn't exist before its publication.

Futurism didn't really exist before the publication of the Futurist manifesto in *Le Figaro* in 1909. Adolf Loos didn't exist before his polemic writings in the pages of newspapers and in his own little magazine *Das Andere* (1903). Le Corbusier didn't exist before his magazine *L'Esprit Nouveau* (1920-25) and the books that came out of its polemical pages (*Vers une architecture, Urbanisme, L'art decoratif d'aujourd'hui, Almanach*). He became known as an architect and created a clientele for his practice through these pages. The very name Le Corbusier was a pseudonym used for writing about architecture in *L'Esprit Nouveau*. In that sense, one can argue that Le Corbusier was an effect of a little magazine. Even an architect like Mies van der Rohe, who is primarily thought of in terms of craft and tectonics, didn't really exist without *G*, the journal that he was part of, and the many little magazines to which he contributed, from *Frühlicht* to *Merz*.

These magazines didn't report on the world. They incubated whole new worlds, offering glimpses of societies living under completely different physical, social and intellectual rules. Each little magazine is a portable utopia, a space unrestrained by conventional logic. It perforates the real world with alternative visions, a puncturing of the real whose effect is multiplied by the repetition of each printed copy, the regular rhythm of serial production, and the viral spreading of images shared between magazines. Free of the constraints of gravity, finance, social convention, technical assumptions, hierarchies, and responsibilities, the ever-widening network of little magazine incubates a new architecture. The portable utopia becomes a real construction site.

The portable utopia is not just a container of dreams. The little magazine is itself an artwork, an architecture crafted with all the precision given to any design object. It is a multiple produced by a collaborative team of artists/architects. Magazines are all about repetition. They hit again and again. And they keep moving—like a boxer. This relentless logic of the multiple infects the projects being promoted. Modern architecture literally takes form in the world as a multiple. The design that appears a thousand times in the issue of a magazine ends up being reproduced globally. Experimental multiples by artists-architects become mass-produced norms.

Cover of *G* magazine #3, 1924, with elevation of Mies van der Rohe's glass skyscraper of 1922.

163

The Architect as Artwork

Mies is a classic example. His place in architectural history, his role as one of the leaders of the modern movement, was established through a series of five projects (none of them actually built, or even buildable—they were not developed at that level) that he produced for competitions and publications during the first half of the 1920s: the Friedrichstrasse Skyscraper of 1921, the Glass Skyscraper of 1922, the Reinforced Concrete Office Building of 1923, and the Concrete and Brick Country Houses of 1923 and 1924. These projects were inseparable from the magazines in which they appeared. The layout of the buildings and the layout of the pages are interwoven.

It was these five projects, this "paper architecture," together with the publicity apparatus enveloping them that first made Mies into a historical figure. The houses that he had built so far, and that he would continue to develop during the same years, would have taken him nowhere. While the Riehl house of 1907 was noted by one critic and published in *Moderne Bauformen* and in *Innen Dekoration* in 1910, between the somewhat modest articles about this house and Mies' own article presenting the glass skyscraper in *Frühlicht* in 1922, nothing else of Mies' work was published.

Could we attribute this silence, these twelve years of silence, to the blindness of architectural critics of his time, as some historians seem to imply? Mies' attitude is much more clear. In the mid-1920s he destroyed the drawings of most of his work prior to that time, thereby constructing a very precise image of himself from which all incoherencies had been erased. (Note the parallelism with Loos, who destroyed all the documents from his projects when he left Vienna for Paris in 1922, and with Le Corbusier, who excluded all his early houses in La Chaux-de-Fonds from publication in his *Oeuvre complète*.) Still, in 1947, Mies did not allow Philip Johnson to publish his early work in the monograph that Johnson was preparing as a catalog for the first "comprehensive retrospective" exhibition of Mies' work at the Museum of Modern Art, and that would constitute the first book on him. "Not enough of a statement," Mies is supposed to have said about some early houses that Johnson wanted to include. Mies excluded all his more traditional early work up to 1924, with the exception of the project for the unbuilt Kröller-Müller house of 1912-1913, which symptomatically was only a photograph of the 1:1 cloth and cardboard model that was built on the site to try to persuade the client.

Mies' work is a textbook case of a wider phenomenon. Modern architecture became "modern" not as it is usually understood by using glass, steel, or reinforced concrete, but by engaging with the media: with publications, competitions, exhibitions. The materials of communication were used to rebuild the house. With Mies this is literally the case. What had been a series of rather conservative

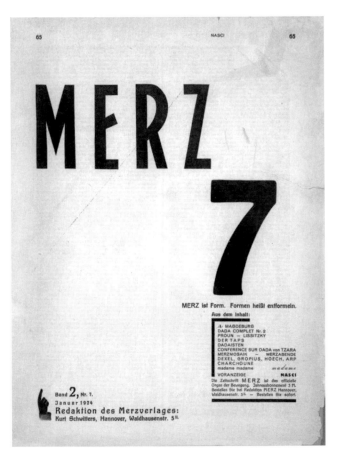

Cover of Kurt Schwitters' *Merz* #7, 1924.

domestic projects realized for real clients became in the context of the Berlin Art Exhibition, of *G*, of *Frühlicht* and so on, a series of manifestos of modern architecture.

Not only that, but in Mies one can see, perhaps as with no other architect of the modern movement, a true case of schizophrenia between his "published" projects and those developed for his clients. Still, in the 1920s, at the same time that he was developing his most radical designs, Mies could build such conservative houses as the Villa Eichstaedt in a suburb of Berlin (1921-23) and the villa Mosler in Potsdam (1924).

Can we blame these projects on the conservative taste of Mies' clients? Mosler was a banker and his house is said to reflect his taste. But when in 1924 the art historian and constructivist artist, Walter Dexel, who was very much interested in and supportive of modern architecture, commissioned Mies to do a house for him, Mies blew it. He was unable to come up with the modern house his client had desired within the deadline. He gave one excuse after another. The deadline was repeatedly postponed. And in the end Dexel gave the project to another architect. For a long time, then, there was an enormous gap between the flowing architecture of Mies' published projects and his struggle to find the appropriate techniques to produce these effects in built form. For many years he was literally

trying to catch up with his publications. Perhaps that is why he worked so hard to perfect a sense of realism in the representation of his projects, as in the photomontage of the Glass Skyscraper with cars flying by on the Friedrichstrasse.

The utopian space of little magazines acted as the real building site for the production of a whole new Mies. In fact, the only Mies we know. His canonic steel, glass and marble assemblages were actually made possible by the most ephemeral serial publications. It was the repetition of his images and words in an expanded network of such magazines what gave an ever-increasing sense of reality to highly experimental forms and to Mies himself.

The Radical Multiple

Even entire groups from *De Stijl* to *Archigram* became an effect of their journals. The critic Reyner Banham used to tell a story about a limousine full of Japanese architects that one day stopped on the street where he used to live in London and asked directions for the office of Archigram. But Archigram didn't exist as a group at the time. *Archigram* was just a little leaflet produced in the kitchen of Peter Cook who lived across the street from Reyner and Mary Banham. Only later did the loose group of young architects (Peter Cook, Mike Webb, Dennis Crompton, Ron Herron and David Greene) call themselves Archigram, after their magazine (as in tele-gram—architecture as a communication system).

During the 1960s and 1970s there was an explosion of architectural little magazines that instigated a radical transformation in architectural culture. You can argue that during this period little magazines—more than buildings—were again the site of innovation and debate in architecture. Banham could hardly contain his excitement. In an article entitled "Zoom Wave Hits Architecture" of 1966, he throws away any scholarly restraint to absorb the syncopated rhythms of the new magazines in a kind of Futurist ecstasy:

> Wham! Zoom! Zing! Rave!—and it's not Ready Steady Go, even though it sometimes looks like it. The sound effects are produced by the erupting of underground architectural protest magazines. Architecture, staid queen-mother of the arts, is no longer courted by plush glossies and cool scientific journals alone but is having her skirts blown up and her bodice unzipped by irregular newcomers, which are—typically—rhetorical, with-it moralistic, mis-spelled, improvisatory, anti-smooth, funny-format, cliquey, art-oriented but stoned out of their minds with science-fiction images of an alternative architecture that would be perfectly possible tomorrow if only the Universe (and specially the Law of Gravity) were differently organized.

If little magazines drove the historical avant gardes of the 1920s, the 1960s and 70s witnessed a rebirth and a transformation of the little magazine. New kinds of experimental publications acted as the engine for the period, generating an astonishing variety and intensity of work. In recent years there has been a huge interest in the experimental architecture of this time, from Archigram, the Metabolists, Antfarm, Superstudio, Archizoom, Haus Ruker Co, etc. dubbed "Radical Architecture" by Germano Celant in 1972. But the little magazines that were the real engine of that revolution have been for the most part neglected.

The term "little magazine" is an Anglo-Saxon term first used to describe small avant-garde literary publications, such as Margaret Anderson's *Little Review* of the 1910s and 20s, that were dedicated to progressive theory, art and culture. They were set apart from established periodicals by their non-commercial operations and small circulation. But they aimed to influence the dominant periodicals, claiming to be "the magazines read by those who write the others," as Anderson put it. The term was transplanted to architecture in the 1970s in an insightful review article written by Denise Scott-Brown, who used the term to describe magazines like *Archigram* and *Clip Kit*.

"Little magazines" in architecture refer to small circulation, self-published magazines, often difficult to obtain and produced with little or no support, on kitchen tables or in the backrooms of schools. The phenomenon is pivotal for both the physical and intellectual objects produced and as something that functioned as a networked, interactive and international platform for experimental design and discourse. Little magazines operate as an infrastructure for hosting change. One can even consider, as Denise Scott-Brown has suggested, "little magazine phases in architecture" appearing "when a debate has expanded enough to demand organization and a rudimentary mailing system." Little magazines have to be analyzed as systems. Their littleness and ephemerality is directly related to the widespread and resilient network in which they appear.

Professional magazines can be considered *little* for certain periods of time. Changes in the magazines' economic model and editorial policy are reflected in everything from the types of paper and printing methods used, to the kinds of projects featured in their pages. Conversely, we may see the "littleness" of a self-published, small circulation magazine dissipate as publication numbers and circulation expand. Littleness is fleeting and improvised. The publications remain as the surprisingly permanent but almost invisible record of the pulse of a moment.

For example, *Architectural Design* during the years of Peter Murray and Robin Middleton as technical editors in the mid-1960s and 70s, decided to pass on advertising, change the paper quality, and start publishing the same kind of work that little magazines were publishing, especially in a section called "Cosmorama," printed in cheap, non-glossy, colored, rough paper and dedicated to ecology, counter-

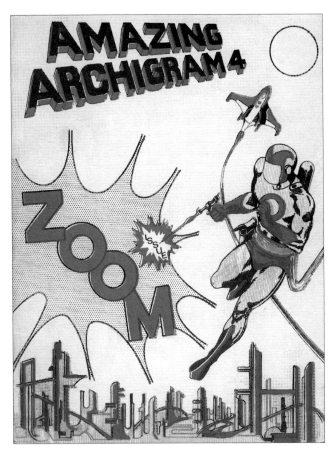

Cover of *Archigram* #4, 1964.

culture, new materials, electronic technology, mobility, and disposability. This is what can be called "moments of littleness" in big magazines, which are a crucial part of this phenomenon and include the *Casabella* of Alessandro Mendini (1970-76), the *Bau* of Hans Hollein, Günter Feurstein and Walter Pichler (1965-70), the *Domus* of Gio Ponti in the 1970s, *Aujourd'hui: Art et architecture* of André Bloc, etc. If Margaret Anderson wanted the big publications to read the little ones, here the logic of the little magazines had literally been absorbed into the big magazines, like a Trojan horse, and would ultimately leak out across the wider landscape.

There has been some kind of amnesia about this exuberant moment. Even the protagonists, the editors and architects involved in the production of these magazines seem to have forgotten how amazing, dense and explosive that moment was. While often referred to in passing, the little magazines were soon scattered in libraries, archives, and private collections as the discourse moved on. Bringing them back to the light today exposes both the key arguments of that time, but also the crucial role played by a medium that fostered and disseminated these polemical positions. As the discourse today is absorbing a whole wave of ephemeral communication systems, this earlier shift of technology suddenly snaps into focus.

What made this explosion possible? The rise of new and

low-cost printing technologies such as portable mimeograph machines and offset lithography in the early 1960s was of crucial importance. Not only did these technologies make printing accessible to more people, they enabled entirely different methods for assembling publications. The page could now be prepared on the drawing board or the kitchen table rather than at the compositor's print-bed. In this new informal space architects could clip and recombine materials from a variety of sources, and experiment with the effects of juxtaposition and scaling, the mobility of transfer lettering, the properties of lithographic color, etc. In fact, there is a relation between the production of architectural concepts in those years and the different production techniques used to create the publications themselves. Not by chance, *Clip Kit* takes its name and unique format from the concept of "Clip-on architecture" that it promoted in its pages, having picked up the concept from Banham's reading of *Archigram*. Likewise the pop-up technique of the *Archigram Zoom* issue unconsciously communicates their polemic for instant architecture—medium and message inseparable.

These innovative and energetic publications helped form a global network of exchange amongst students and architects, but also between architecture and other disciplines. Interconnections and shared obsessions between different magazines built a formidable network of little publications collaborating as a single intelligent organism testing all the limits of architecture—everything but architecture in the conventional sense of a building or an architect in the conventional sense. Look at the covers. You rarely see the image of a building or the face of an architect. In the moment in which Hollein famously claimed that "Everything is Architecture," everything but architecture is splashed across the covers of radical magazines in an orgy of intense and sophisticated graphic design, a collaborative utopia acting as an incubator of new ways of thinking and a key arena in which the emerging problems facing architectural production could be debated.

Early Warning Systems

Within this utopic marginal space, a series of themes were explored as the basis of a hypothetically improved society, the very themes that are seen today to be at the center of the contemporary global reality. Indeed practically all the themes that preoccupy us today can be said to have emerged during those years. You find the first preoccupations with recycling, with energy responsibility, cardboard architecture, emergency architecture, synthetic materials, digital data flow, global mobility, the first oil crisis, the emergence of computers, machine intelligence, polymers, terrorism… The list of concerns acts as an umbilical cord between the 1960s and today.

- The space program acted as a catalyst for dreaming of new social and architectural problems. The mobilization of a

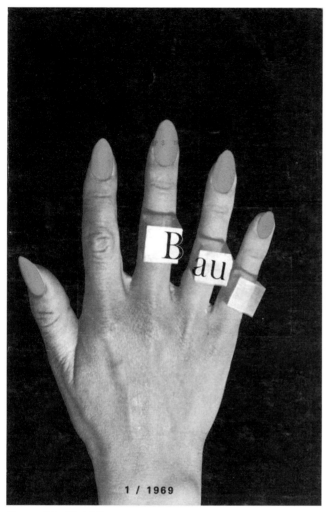

Cover of *Bau* #1, 1969.

vastly expanded sense of scale in outer space was counterposed by miniaturization, a fascination with the new existence-minimums of the sealed capsule and the space suit. The launch of satellite communications generated an enthusiasm for planetary interconnection, as well as a concern about the expansion of forms of political and intellectual power beyond traditional territorial limits. Little magazines extrapolated from the science facts of the space program to conjure up a series of science fictions about the future evolution of buildings and cities.

- The cybernetic understanding of communications and feedback control processes in biological, mechanical, and electronic systems coming out of World War II likewise provoked experimental scenarios in which information itself would become the basic building material. Computation and the relationship of hardware to software were seen to liberate new urban and biological realities.

- Emergent ecological concerns were closely tied to a rethinking of the condition of the house and its natural, urban, and global economies. The house was re-conceptualized in terms of "whole earth systems," which entailed the recycling of both material and energy, and hybrid systems of natural and artificial elements. A more extreme

and radical response encouraged a retreat to self-sufficient shelters in nature, autonomous from established communities. Architectural magazines found themselves in an incredibly intimate dialog with a wide range of counter-publications. Self-help manuals (*Whole Earth Catalog*, *Dome Cook Book*, *Shelter*, *Farallones Scrapbook*) featured architectural design and architectural magazines featured self-help techniques.

- The emergence of protest movements around the globe in the 1960s was paralleled by critiques of architecture in little magazines. The architectural object was devalued in favor of questions of self-organization, urban sociology, and participation. This wider expression of political protest and self-questioning was fostered in different ways by many little magazines around the globe. In some cases we find specific issues devoted to protest movements and to instances of brutality against demonstrators (*Architectural Design*, *Arquitectos de Mexico*, *Architecture Mouvement Continuité*, *Casabella*, *Le Carré Bleu*, *Perspecta*). Other magazines became the vehicles for student demands for reforms in architectural education (*Melp!*, *Klubseminar*, *ARse*, *Arquitectura Autogobierno*). In other magazines, this critical self-questioning contributed to the formulation of ideological and historical critiques of architecture's role within culture (*Angelus Novus*, *Carrer de la Ciutat*, *Contropiano*, *Utopie*).

- The 1960s and 1970s also saw the rise of what is understood today as architectural "theory." Magazines like *Oppositions*, *Arquitecturas bis*, *Lotus*, etc., launched a whole new kind of discourse. They cultivated a general philosophical and historical self-consciousness. These magazines often modeled themselves in the image of the avant-garde magazines of the 1920s and 1930s, giving the contemporary theorist the status of a radical artist. Peter Eisenman, for example, claims to have started *Oppositions* because he felt there was never an avant garde in the USA and that a magazine was the necessary vehicle for it.

All these utopian speculations in little magazines about miniaturization, information, computation, sexuality, ecology, radical politics, philosophy, and so on, resonate today with the dominant obsessions in the mass media with sustainability, the Occupy movement, digital culture, etc. The issues of the little magazines of the 1960s and 70s have migrated to the mass media. As with the historical avant gardes, the seemingly unrealistic medium of the little magazine calibrated to the micro experience of its serial repetition acts as the generator of a new mass reality. Utopia becomes palpable.

After the Multiple?

New media today brings new portable utopias. A new generation is perforating the world with the ever evolving technologies of social media. The logic of the multiple is being taken to a whole new extreme. Serial repetition gives way to viral exchange. Nothing is little anymore.

The Russian Avant Garde Revisited

Boris Groys

The central question that unavoidably dominates today's thinking and speaking about the Russian avant garde is the question of its relevance for the reflection on the relationship between artistic revolution and political revolution. Can the artistic revolution—as it was in an exemplary way realized by the Russian avant garde—be understood as a part of the political revolution, in this particular case, as a part of the October Revolution? And if the answer is yes, can the Russian avant garde function as inspiration and model for the contemporary art practices that try to transgress the borders of the art world, to become political, to change the dominant political and economical conditions of human existence, to put themselves in the service of the political or social revolution or, at least, of political and social change?

Today, the political role of art is mostly seen as being twofold: (1) critique of the dominant political, economic, and art system, and (2) mobilization of the audience towards the change of this system through a Utopian promise—expressed mostly through the creation of quasi-carnivalistic events that are open to free public participation. Now, if we look at the first, pre-revolutionary wave of the Russian avant garde we do not find any of these aspects in its artistic practice. To criticize something one must somehow reproduce it—to present this criticized something together with the critique of it. But the Russian avant garde wanted to be non-mimetic. One can say that Kazimir Malevich's Suprematist art was revolutionary but one would hardly be able to say that it was critical. The sound poetry of Alexei Kruchenykh was also non-mimetic and non-critical. Both these radical artistic practices of the Russian avant garde were also non-participatory because to write sound poetry or to paint squares and triangles is obviously not the kind of activity that would attract a wide audience. Neither could these activities mobilize masses for the coming political revolution. In fact, such a mobilization can only be achieved through the use of the modern and contemporary mass media such as the press, radio, cinema—or, today, through pop-music (60s), design (Che Guevara t-shirts), etc. Obviously, during the pre-revolutionary time the artists of the Russian avant garde had no access to these media—even if the scandals that their artistic activities have provoked were from time to time covered by the press.

When one speaks about the Russian revolutionary avant garde, one often means the Russian avant-garde art practices of the 1920s. This is in fact incorrect because in the 1920s the Russian avant garde was—artistically and politically—already in its post-revolutionary phase. Firstly, because it developed further the artistic practices that had emerged before the October Revolution. And, secondly, because it was practiced in the framework of the post-revolutionary Soviet state—as it was formed after the October Revolution and at the end of the Civil War—and was being supported by this state. Thus, one cannot speak of the Russian avant garde at that time as being "revolutionary" in the same sense in which an art is considered to be "revolutionary" when it is directed against the status quo, against the dominating political and economical power structures. The Russian avant garde of the Soviet period was not critical but affirmative of the post-revolutionary Soviet state, of the post-revolutionary status quo. Therefore, it is only the Russian pre-revolutionary avant garde that could be regarded today as relevant for the contemporary situation—being obviously different from that which came after the Socialist revolution. And, as stated, one does not find in the art of the pre-revolutionary Russian avant garde the characteristics that we tend to look for when speaking about today's critical, politically engaged art that is able mobilize the masses for revolution—and help to change the world.

Thus, the suspicion arises that Malevich's *Black Square* is unrelated to any political and social revolution—that all we have here is an artistic gesture, only relevant inside the artistic space. I would argue, however, that if Malevich's *Black Square* was not an active revolutionary gesture in the sense that it criticized the political status quo, or advertised a coming revolution, it was revolutionary in a much deeper sense. Then what is the revolution? It is not the process of building a new society—this is the goal of the post-revolutionary period—but a radical destruction of the existing society. But to accept this revolutionary destruction is not an easy psychological operation. Being compassionate and nostalgic towards our past—and maybe even more so towards our endangered present—we tend to resist the radical forces of destruction. Now the Russian avant garde—and the early European avant garde in general—was the strongest possible medicine against any kind of compassion and nostalgia. It accepted the total destruction of all the traditions of European and Russian culture—traditions that were dear not only to the educated classes but also to the general population.

Black Square was the most radical gesture of this acceptance. It announced the death of any cultural nostalgia, of any

Kazimir Malevich, *From Cubism and Futurism to Suprematism – New Painterly Realism* (Moscow: Obshestvenya Pol'za, 1916).

sentimental attachment to the culture of the past. The *Black Square* was like an open window through which the revolutionary spirits of radical destruction could enter the space of culture and reduce it to ashes.

A good example of Malevich's own anti-nostalgic attitude is his short but important text "On the Museum" from 1919. At that time the new Soviet government feared that the old Russian museums and art collections would be destroyed by civil war and the general collapse of state institutions and the economy. The Communist Party responded by trying to secure and save these collections. In his text, Malevich protested against this pro-museum policy of Soviet power by calling on the state to not intervene on behalf of the old art collections because their destruction could open the path to true, living art. He wrote:

> Life knows what it is doing, and if it is striving to destroy one must not interfere, since by hindering we are blocking the path to a new conception of life that is born within us. In burning a corpse we obtain one gram of powder: accordingly thousands of graveyards could be accommodated on a single chemist's shelf. We can make a concession to conservatives by offering that they burn all past epochs, since they are dead, and set up one pharmacy.

Later, Malevich gives a concrete example of what he means:

> The aim (of this pharmacy) will be the same, even if people will examine the powder from Rubens and all his art—a mass of ideas will arise in people, and will be often more alive than actual representation (and take up less room).

Malevich proposes not to save things but to let them go without sentimentality and remorse—to let the dead bury their dead. This radical acceptance of the destructive work of time seems, at first glance, to be nihilistic. Indirectly quoting Max Stirner (he was close to the anarchist party, and probably a member), Malevich described his art as being based on nothingness.

At the core of this unsentimental attitude towards the art of the past lies a faith in the indestructible character of art. The avant garde of the fist wave let things—including the things of art—go away with time because it believed that something always remains. Beyond any human attempt at conservation, it looked instead for the things that remain.

The avant garde is often associated with the notion of progress—especially, technological progress. But the avant garde asked the following question: How could art continue under the conditions of the permanent destruction of cultural tradition and the familiar world that is characteristic for the modern age with its technological, political and social revolutions? Or, to say it in different terms: how to resist the destructiveness of progress? How to make art that would escape permanent change—art that would be atemporal, transhistorical? The avant garde did not want to create an art of the future—it wanted to create a trans-temporal art for all times. Time and again one hears and reads that we need change, that our goal—also our goal in art—should be to change the status quo. But change *is* our status quo. Permanent change *is* our only reality. We are living in the prison of permanent change. To change the status quo we have to change change—to escape from the prison of change. A true faith in revolution paradoxically—or maybe not so paradoxically—presupposes the belief that the revolution has not the ability of total destruction, that something always survives even the most radical historical catastrophe. Only such a belief makes possible the unreserved acceptance of the revolution that was so characteristic for the Russian avant garde.

In his recent book, *The Time That Remains*, Giorgio Agamben describes—using the example of Saint Paul—the knowledge and mastery that is required to become a professional apostle. This knowledge is messianic knowledge—knowledge of the coming end of the world as we know it, of contracting time, of the scarcity of time in which we live. The scarcity of time annuls every profession because the practicing of every profession needs a perspective of *longue durée*, the duration of time and the stability of the world as it is. In this sense the profession of the apostle is, as Agamben writes, to practice the "revocation of all the vocations." One can also say the "de-professionalization

of all professions." The contracting time impoverishes all our cultural signs and activities—turning them into zero signs or, rather, as Agamben says, "weak signs." Such weak signs are the signs of the coming end of time being weakened by this coming, already manifesting the lack of time that is needed to produce and to contemplate strong, rich signs. However, at the end of time these messianic weak signs triumph over the strong signs of our world—the strong signs of authority, tradition and power, but also the strong signs of revolt, desire, heroism, and shock. Speaking about the "weak signs of the messianic," Agamben obviously has in mind the concept of "weak messianism" that was introduced by Walter Benjamin. But one can also remember—even if Agamben does not—the term kenosis that in the tradition of Greek theology characterized the figure of Christ—the life, suffering and death of Christ being a humiliation of human dignity and an emptying of the signs of divine glory. The figure of Christ is in this sense also a weak sign that can be easily (mis)understood as a sign of weakness —a point that was extensively discussed by Nietzsche in *The Anti-Christ*.

When Agamben describes the annulment of all our occupations and the emptying of all our cultural signs through the messianic event, he does not ask a question about how we can transcend the border that divides our time, our era, from the coming one. Agamben does not ask this question because the Apostle Paul does not ask it. Saint Paul believed that an individual soul—being immaterial—would be able to cross this border and would not perish even after the end of the material world. The artistic avant garde however, wanted to save not the soul but art. It tried to do so by means of reduction—the reduction of cultural signs to the absolute minimum so that one could smuggle them across revolutions, breaks, shifts and the permanent change of cultural fashions and trends. The avant garde artist is a secularized apostle—the apostle in the age of materialism.

When in his *On the Spiritual in Art* (1911) Kandinski speaks about the reduction of all painterly mimesis—the reduction that reveals that all paintings are actually combinations of colors and shapes—he wants to guarantee the survival of his vision of painting through all possible future cultural transformations, including even the most revolutionary ones. The world that is represented in a painterly manner can disappear, but the combination of colors and shapes will not. In this sense Kandinsky believes that all the images already created in the past or yet to be created in the future can be seen also as his own paintings—because whatever these images were, are or could be they remain necessarily the combination of certain colors and shapes. This belief relates not only to the painting but also to all the other media such as photography, cinema, etc. Kandinsky did not want to create his own individual style but use his paintings as a school for the spectator's gaze, allowing the spectator to see the invariable components of all possible artistic variations and the repetitive patterns underlying the images of

historical change. In this sense Kandinsky interprets his own art as being timeless.

Later, Malevich undertakes an even more radical reduction of the image—the *Black Square*—to a pure relationship between image and frame, between contemplated object and field of contemplation, between one and zero. With these later works, we can never fail to see the black square. Whatever image we see, we simultaneously see the black square. For Malevich any destruction of art—be it past, present or future—was welcomed because this act of destruction would necessarily produce an image of destruction—the black square as ground zero of culture, as image of the ashes that are, as Malevich writes, a work of art which is superior to the work of art that was burned to produce these ashes. The destruction cannot destroy its own image—any destruction will be survived by the image of this destruction. Of course, this belief is an effect of the radically materialistic attitude of the avant garde. Indeed, God can destroy the world without leaving a trace because God created the world out of nothingness. But if God is dead then an act of destruction without a visible trace, without the image of destruction, is impossible. Through the act of radical artistic reduction this image of real destruction can be anticipated here and now: a messianic image destined to survive the end of the time.

The art of the avant garde is the art not only of a weak messianism, but also of a weak universalism. That means: it is not only an art that is using zero-signs being emptied by the approaching messianic event. It is also the art manifesting itself through weak images—images of weak visibility, images that are necessarily, structurally overlooked when they function as components of stronger images with a high level of visibility—such as images of the classic art or mass culture. In philosophy and science, to make reductive art means also to make universalist, transcultural art because to cross a time border is basically the same operation as to cross a cultural border. Every image that is made in the context of any imaginable culture is a black square too—because it would look like a black square if it were erased. That means that, for a messianic gaze, it always already looks like a black square. This makes the avant garde a true opening for a universalist, democratic art. But the universalist power of the avant garde is a power of weakness, of self-erasure. It is not the art that mobilizes people for the revolution—but the art that makes the acceptance of the revolution possible.

Now the following question arises: what happens to the reductionist, weak images of the avant garde after the victory of the revolution, under the conditions of the post-revolutionary state? The post-revolutionary situation is a deeply paradoxical one because any attempt to continue the revolutionary impulse, to remain committed and faithful to the revolutionary event, leads us necessarily to the danger of betraying the revolution. The continuation of

the revolution could be understood as its permanent radicalization, as its repetition, as the permanent revolution. But repetition of the revolution under the conditions of the post-revolutionary state could at the same time be easily understood as the counter-revolution—as weakening and destabilizing revolutionary achievements. On the other hand, the stabilization of the post-revolutionary order can also be easily interpreted as a betrayal of the revolution because such a stabilization unavoidably revives the tradition of the pre-revolutionary norms of stability and order. To live in this paradox becomes, as we know, a true adventure that few revolutionary politicians have survived.

The project of continuation of the artistic revolution is no less paradoxical. What does it mean to continue the avant garde? To further repeat the forms of avant-garde art? Such a strategy can be easily accused of valuing the letter of the revolutionary art over its spirit, to turn a revolutionary form into a pure decoration—even into a commodity. On the other hand, the rejection of avant-garde artistic forms in the name of a new artistic revolution immediately leads to an artistic counter-revolution—as we saw it at the example of the so-called postmodern art. The second wave of the Russian avant garde tried to avoid this paradox by redefining the operation of reduction.

For the first wave of the avant garde and, especially, for Malevich, the operation of reduction served, as I already said, to demonstrate the indestructibility of art. Or, in other words: the demonstration of the indestructibility of the material. The black square remains non-transparent because the material is non-transparent. Early avant-garde art, because it was radically materialistic, never believed in the possibility of a fully transparent, immaterial medium (like the soul, or faith, or reason); one that would allow us to see the "other world" when everything material that allegedly obscures this other world was removed by the apocalyptic event. According to the avant garde the only thing that we will be able to see in this case will be the apocalyptic event itself—which would look like a reductionist avant-garde artwork. In this sense the avant garde was perfectly optimistic. Not accidentally, the *Black Square* was shown in the framework of the *0.10* exhibition—ten artists that went though the zero point of death (*Kruchenykh*) and yet remained artists.

The second wave of the Russian avant garde used the operation of reduction in a completely different way. For these artists, the revolutionary removal of the ancient, pre-revolutionary order was an event that has opened a view on a new, Soviet, post-revolutionary, post-apocalyptic order. It was not the image of reduction itself that was to be seen, but a new world that has allegedly revealed itself after the act of reduction of the old world was effectuated.

The operation of reduction thus began to be used for the praise of a new Soviet reality. For the Russian

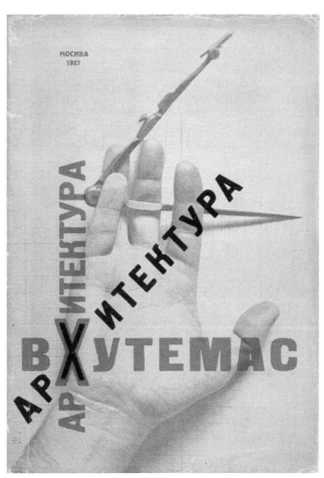

Architecture at Vkhutemas (Moscow: Higher State Artistic Technical Workshop 1927). Cover by El Lissitzky.

Constructivists, the path to the virtuous, genuinely proletarian things passed through the radical reduction of everything that was merely decorative and referred to the ancient regime. The Russian Constructivists called for the things of everyday communist life to show themselves as what they truly were: as functional things whose form served only to make the functionality of these things visible. The goal of "proletarian art" was therefore understood as making visible the total, functional organization of Soviet life. At the beginning of their activities the Constructivists believed that they were able to manage the "things themselves" that they found to be directly accessible after the reduction, the removal of the old images that separated them for these things. In his programmatic text of 1922, titled "Constructivism," Alexei Gan wrote:

> Not to reflect, not to represent and not to interpret reality, but to really build and express the systematic tasks of the new class, the proletariat. ... Especially now, when the proletarian revolution has been victorious, and its destructive, creative movement is progressing along the iron rails into culture, which is organized according to a grand plan of social production, everyone—the master of color and line, the builder of space-volume forms and the organizer of mass productions—must all become constructors in the general work of the arming and moving of the many-millioned human masses.

171

But later, Nikolai Tarabukin asserted in his famous 1923 essay, "From the Easel to the Machine," that the Constructivist artist could not play a formative role in the process of actual social production. His role was rather that of a propagandist who defends and praises the beauty of industrial production and opens the public's eyes to this beauty. The artist, as described by Tarabukin, is someone who looks at the entirety of socialist production and Communist organization as a readymade—a kind of social-ist Duchamp. This socialist industry as a whole shows itself as good and beautiful because it is an effect of radical reduc-tion of every kind of "unnecessary," luxury consumption, including the consuming classes themselves. In a certain sense the Constructivists repeated the gesture of the first Christian icon painters who believed that after the demise of the old pagan world they began to be able to uncover the celestial things and to see and depict them as they truly were.

This comparison between Communism and Christianity is of course not accidental. Firstly, it was drawn (in a posi-tive way) already by Pavel Florensky, a famous Russian Orthodox theologian and specialist in icon painting. Florensky was also a teacher at the VKhuTeMas of the 1920s, which was allied with the Constructivists. Secondly, and more importantly, this analogy was drawn by Malevich in his treatise *God is Not Cast Down*. This treatise was writ-ten in the years 1920-21, around the same time as the essay on the museum that I have already mentioned and quoted. In this case, however, the polemic was directed not against the conservative lovers of the past but against the Constructivist builders of the future. In this treatise Malevich states that the belief in the continuous perfecting of human living conditions through industrial progress is of the same order as the Christian belief in the continuous perfecting of the human soul. Both Christianity and Communism believe in the possibility of reaching the ulti-mate perfection, be it the Kingdom of God or Communist Utopia.

Indeed, the road to Utopia is a road out of history towards a permanent, transhistorical stability that has to replace the permanence of historical change. If Utopia cannot guar-antee such a transhistorical stability and remains a place of wars, revolutions, conflicts and competition, then it is not a true Utopia. This is why Utopian thinking operates pri-marily by means of reduction. To be Utopian is to come to the basics and to remove everything that is superficial and superfluous. Already Plato, in his *Politeia*, advised to abolish the family and private property as social institutions that are not rooted in human nature but are historically acci-dental. Rousseau believed that "natural man" is interested only in his own self-preservation and/or the self-preserva-tion of the human species. Marx reduced the working process to the time that is invested in it. In this perspective sexuality loses its passionate character and is reduced to a process of pure reproduction; human life is reduced to

"bare life" and work is reduced to working hours.

Thus, one can say that in a certain sense Malevich is also a Utopian thinker and artist because he operates by means of reduction. However, there is a decisive difference between his reductionism and the reductionism of his Contructivist and Communist colleagues. Malevich does not believe in something like the final reduction—the reduction to the basic level that would make any further reductions impossible and that could be taken as a stable fundament for building a new reality. For Malevich every-thing is in flow, everything is in permanent change. No reduction can reveal an eternal truth that would be immune to flow. The image of reduction survives historical change but it cannot be used because of that as a fundament for building the future. The reduction has to be permanently repeated under the changing conditions. In this sense, the Utopia is not to be built but is always achievable here and now. For Malevich Utopia is not a period of time but a moment of acceptance of radical change, of revolution. The revolutions are different, the change is also different at different times and places, but the act of the acceptance of the revolution is always the same. In this sense the act of radical reduction opens here and now to the unchanging, repetitive, infinite level of human existence that is, for Malevich, the true Utopia.

One could say that this acceptance of change, of revolution, is passive, and that the making of revolution is active. However, in fact, accepting the revolution is a much more radical attitude than making the revolution. The great political revolutionaries were often conservative in their cultural attitudes and nostalgic towards the culture of the past. That is the ground of the well-known conflict between the cultural left and the political left. The political revolutionary is a visionary. But the political imaginary is always conservative because it projects into the future ideals, dreams and longings of the past. The genuine polit-ical question is a question: What is to be done? And the answer is always: something that is better, more progres-sive, more perfect than what was done before.

The concept of political revolution is mostly undermined by the concept of progress. Permanent revolution, as described by Trotsky in *Literature and Revolution*, was sup-posed to produce new Leonardos *en masse*. The concept of progress is, of course, deeply conservative because it pre-supposes movement along a continuous line, according to the same criteria of making things better, practicing the same work of perfecting and accumulation. Faith in progress is characterized by the incapacity to accept radical loss, to accept that true change means not only accumula-tion and improvement but also destruction and reduction. Here avant-garde art plays a decisive role because it is ready to accept loss, it is nothing other than this acceptance.

Now back to the question: what would it mean today to

continue with the Russian avant garde and, more generally, with avant-garde art? We can say that the avant garde created transcendental images—images that create their own conditions for looking at all other possible images. It reminds one of transcendental philosophy, of Plato and Kant.

However, the avant garde is ambiguous in a way in which transcendental philosophy is not. Philosophical contemplation and transcendental idealization are operations that are supposed to be effectuated only by philosophers, for philosophers. But the avant garde's transcendental images are shown in the same space of representation in which empirical images are shown. Thus, one can say that the avant garde places the empirical and the transcendental on the same level, lets the empirical and the transcendental be compared inside the same space of representation and seen by the democratized, uninitiated gaze. Avant-garde art radically expands the space of democratic representation by including in it the transcendental that was previously the object of religious or philosophical occupation and speculation. That has its positive but also its dangerous aspects.

From a historical perspective, the images of the avant garde offer themselves to a spectator's gaze primarily not as transcendental images but, rather, as specific empirical images manifesting their specific time, and the specific psychology of their authors. Thus, the "historical" avant garde produced clarification and confusion at the same time: clarification because it revealed repetitive image patterns behind the change of historical styles and trends—but also confusion because avant-garde art is exhibited alongside other art production so that it can be (mis)understood as a specific historical style. This means that the weak, transcendental artistic gesture could not be produced once and for all times. Rather, it should be repeated time and again to keep the distance between the transcendental and the empirical visible and to resist the strong images of change, the ideology of progress and promises of economic growth. It is not enough to reveal the repetitive patterns that transcend historical change. It is necessary to constantly repeat the revelation of these patterns. The repetition itself should be made repetitive because every such repetition of the weak, transcendental gesture produces, by the same move, clarification and confusion. Thus, we need further clarification that again produces further confusion. That is why the avant garde cannot take place once and for all times but must be permanently repeated to resist permanent historical change and chronic lack of time.

This repetitive and at the same time futile gesture opens a space that seems to me to be one of the most mysterious spaces of our contemporary democracy—social networks like Facebook, My Space, You Tube, Second Life and Twitter that offer global populations the opportunity to place their photos, videos and texts in a way that cannot be

distinguished from any other Conceptualist or post-Conceptualist artwork. These spaces were opened initially by the radical, neo-avant-garde conceptual art of the 1960s and 1970s. Without the artistic reductions that were effectuated by these artists the emergence of the aesthetics of these social networks would be impossible, or at least, they could not be opened to the mass democratic public to the same degree.

These networks are characterized by the mass production and placement of weak signs that have low visibility—instead of the mass contemplation of strong signs that have a high visibility, as it was the case during the twentieth century. What we are experiencing now is the dissolution of the mainstream mass culture as it was described by many influential theoreticians: an era of kitsch (Greenberg), of culture industry (Adorno), or a society of spectacle (Debord). This mass culture was created by the ruling political and commercial elites for the masses—for the masses of consumers and spectators. Now, the unified space of mass culture is going through a process of fragmentation. We still have the stars but they don't shine as bright as before. Today, everybody writes texts and places images—but who has enough time to see and read them? Obviously, nobody—or it could be only a small circle of likeminded co-authors, acquaintances, and relatives. The traditional relationship between producers and spectators that was established by the mass culture of the twentieth century has become reversed. Earlier a chosen few produced images and texts for the millions of readers and spectators. Today, millions of producers produce texts and images for a spectator who has either little time or no time at all to read or see them.

Today, the everyday becomes a work of art. There is no more bare life, or rather, bare life demonstrates itself as artifact. Artistic activity is now something that the artist shares with his or her public on the most common level of everyday experience. The artist shares art with the public as earlier s/he shared it with religion or politics. To be an artist has ceased to be an exclusive fate. Instead, it has become an everyday practice, a weak practice or weak gesture. But to establish and to maintain this weak, everyday level of art one has to repeat permanently the artistic reduction, resisting strong images and escaping the status quo that permanently generates new strong images.

At the beginning of his *Lectures on Aesthetics* Hegel asserted that art was already during his time a thing of the past. Hegel believed that in the time of modernity, art could no longer manifest anything true about the world as it is. But the avant garde has shown that art still has something to say about the modern world, that it can demonstrate its transitory character, its lack of time, and at the same time transcend this lack of time through a weak, minimal gesture that needs a very short time or even no time at all.

Avant Garde, Sots-Art & Conceptual Eclecticism

Vitaly Komar

The history of the Soviet Union and the avant garde came to a close at the same time. This was not a coincidence, but a highly symbolic concurrence. Both phenomena have the same ideological genetics; they are both linked chronologically to Russian nihilism, which developed in Bakunin and Marx's time. Their roots lie deep in the revolutionary belief in progress, in whose name it is necessary to systematically destroy the traditions of the old culture and create a new, eccentric utopia: a new world, a new man, a new culture, a new artist, and a new spectator.

For the artists who were the "pioneers" of modernism, the military term "vanguard," or, to use the French word "avant garde," became a visual symbol for social experimentation and permanent cultural revolution.

When I was in art school in Moscow in the 1960s, my friends and I believed naively in the endless procession of progress. We couldn't see the similarities between the "progress" of modernism and changing fashion seasons. We saw Abstract Expressionism succeeded by Pop art, then Pop art by minimalism, and then camp conceptual art. We dreamed of being heroes of this avant garde, of discovering, founding, and developing yet another movement, a new direction, a new current or a new trend. New, new, new…

We saw the avant garde as a constant irritant of the status quo, which always opposed "the new" and strove to maintain unchangeable, stagnant criteria in art. We called that part of society "they." When, recalling that time, I say "we," I am talking about Alik Melamid and myself, and other artists in our circle. "They" called us unofficial artists, avant-gardists, and underground nonconformists. In September 1974, "they" destroyed our Sots-art works during the infamous "Bulldozer" exhibition in Moscow. (The "Sots" in our movement was an abbreviation of "socialist," not "social," as some have thought.)

Sots-art combined official and unofficial Soviet art in an eclectic manner. This movement, which we started in 1972, was a conceptual, Pop version of Soviet agitprop, and immediately brought us to the dialectics of "conceptual eclecticism."

We lived behind the Iron Curtain, and so our experiments remained unknown to western artists and critics until 1976, until our [Komar and Melamid's] first exhibition in New York. The show was extraordinarily well-received in the international press.

Later, when I came to New York, I realized that the avant garde of spiritual and intellectual life that I'd believed in when younger, had transformed into the avant garde of real estate. In the 1980s, because of the high rents in

Vitaly Komar, Painting and performance from the project *Three-Day Weekend (Mandala #1)*, 2005. Tempera and oil on canvas, 122 x 122 cm. Courtesy of Vitaly Komar and Ronald Feldman Fine Arts, NY.

SoHo, artists migrated to the East Village, only to be followed by galleries; rents rose and artists could no longer afford to live there. Later, I witnessed waves of artists following galleries into Chelsea, also causing rents and prices to sky-rocket in the neighborhood. And for the first time since the pioneers of modernism in the last century, we haven't seen any radically new phenomena in art for the last 30 years.

In the 1980s, when images and concepts similar to our "conceptual eclecticism" began to be called "postmodernism," in the western art world, the trend was viewed as an acknowledgement that revolutionary progression in art had come to an end. Paradoxically, in the Soviet Union, our turn to "conceptual eclecticism" represented a radical, avant-garde step into new artistic territory.

For us, the combining of multiple styles was a way out of the trap of the eternal dualism that ruled: left/right, male/female, east/west, elite/mass, and so on. Even now, examining the conflict of such dualisms, it is difficult to imagine a third point of view or dimension (much less a tenth dimension) which would contradict both sides of one or another irreconcilable dichotomy in equal measure.

The need for an alternative or "third way" is evident. Without it the world is flat and two-dimensional. However, the space we live in makes it obvious that there are three dimensions at the very least, as there are three primary colors, and three temporal modes: past, present and future. Freud's view of sex and personality development was even ruled by the number three. Even in sports things come in threes: three tries, three winners: gold, silver, and bronze.

Today the distinction between synthesis and eclecticism has disappeared. But who is searching for a "triad of juxtapositions," or a "trinity of opposites." Where is the contemporary Hegel, who will be able to transform "dia-lectics" into "tria-lectics," and thereby demonstrate the "poly-lectics" of a new avant garde?

My project, "The Three-Day Weekend" is the beginning of one attempt. This work-in-progress aims to create symbolic images to serve as propaganda for a new "Internationale" of Conceptual Eclecticism.

Translated from the Russian by Jamey Gambrell.

Factography of Resistance

Victor Tupitsyn

During the 1920s the collective efforts of leftist Soviet critics and photographers, affiliated with the magazine *New Lef* (October Association), helped to mass-produce images that assumed the protagonist's position. It would be wrong, however, to suppose that the throne of easel painting was usurped by photography. The role of legislator of artistic fashion was instead annexed by the state bureaucracy that was responsible for the implementation of Stalin's cultural revolution. In the process, many paradigms of authorship—except those attributed to authoritarian power—became increasingly nominal. The media, including photojournalism and documentary film, was transmogrified from factography into mythography and joined in the procedure described by Lyotard of a "stabilization of the referent, according to a point of view which endows it with a recognizable meaning enabling the addressee to decipher images and sequences quickly … since such structures of images and sequences constitute a communication code among all of them."[1]

Before I continue, it would be reasonable to draw a line between myth-making and archival practices related to the gathering of information. Like everything else, art requires its own factography (positive and negative): the factography of legitimate actions (supported by institutions) and the factography of "illegal legitimacy," including radical political and artistic manifestations that test the status quo. If reliable documentation is available, factography can assist in the creation of a discourse that registers various forms of confrontation in the cultural space. It comes as no surprise that politically engaged artists, who positioned themselves on the outskirts of the culture industry (be it capitalist or socialist), have had very limited access to media. This disadvantage proved to be beneficial, for it prompted artists to create their own factographic discourse, based on "illegitimate," low-tech documentation of their activities.

The notion of factography is not without a prehistory, particularly in the case of the Soviet Union during its transformation into a modern media society. In *The Museological Unconscious*, I argued that the factography of the 1920s and 30s was an integral part of *socialist modernism*, which existed simultaneously with socialist realism but, unlike the latter, was able to create a style of its own.[2] A partial list of the media in which the socialist modernists worked includes the architecture of Moscow's first metro stations, book and magazine design, posters, photography and photomontage, and the decoration of workers' clubs.[3] The novel "proto-postmodernist" course of their position, compared to the traditional avant garde, is in the dialectical transcendence (removal) of negation, that is, in the transition from negation to affirmation. Giving this fact due credit, sots modernism (short for *socialist modernism*) may be viewed as an affirmative avant garde.

In the mid-20s, factography was apologetically advocated, debated and thoroughly thought through by many post-revolutionary artists, critics, and theorists, including Nikolai Chuzhak, Sergei Tretyakov, and Osip Brik. Admitting that the demonstration of facts appeals to our intellect, Tretyakov, who championed a conception of an act as a process, "an operation," was equally interested in yet another task: "not simply to capture reality, but also to change it in the course of class struggle."[4] Chuzhak, who declared the primacy of the "literature of fact," advised the reader to reject "the mediation of a secondary interpretive voice" (Dickerman) and run away from the world of representations in order to engage in reconstructing "this world through the concrete changes required by the proletariat.[5] In the first decade after the Revolution, the factographic discourse gained notoriety for reifying itself as an "indexical object" capable of channeling its rhetorical cargo (e.g. the "the epic of facts" or Vertov's "factory of facts") in the direction that socialism will (in Tretyakov's words) "trace anew on the face of the earth."[6]

Factographers (or *faktoviks*) can be seen as descendants of the Russian Futurists, who, in 1913, came up with the idea to paint themselves in order to reflect upon the changes that occur in the world. In the magazine *Argus*, Ilya Zdanevich and Mikhail Larionov wrote: "We value both print and news [which] is the basis of our self-painting… We paint ourselves for an hour, and a change of experience calls for a change of painting."[7] They welcomed the "transformation of faces into a projector of experiences… to herald the unknown, to rearrange life, and to bear man's multiple soul to the upper reaches of reality."[8]

The inspiration for factographic discourse can also be traced to Mikhail Bakhtin. In his *Towards a Philosophy of the Act*, Bakhtin revealed filiations between the topics of "answerability," "oughtness," and active "participance in once-occurred being in an emotional-volitional, affirmed manner."[9] In this text, worked on during his stay in Vitebsk (1920-24), Bakhtin insisted on having "no alibi in existence," and advocated the project of bridging the difference between experience and the representation of experience,

NOVYI LEF no.2 and no.7 (Moscow: Gosizdat, 1927). Letterpress, 22.9 x 15.3 cm. Cover design by Alexander Rodchenko. Courtesy of the Russian State Library.

between the motif of the "actually performed act" or deed and its product.[10] Bakhtin's *Towards a Philosophy of the Act*, which preceded Tretyakov, Brik, Chuzhak, and Walter Benjamin's treatises on the same subject (undertaken by them in the late 1920s), comes closest to the idea of factography. Anticipating the question that asks which facts are valuable and which are not, Bakhtin argues that there is no contradiction between unique and "affirmed value-context." He writes: "the unique 'I' must assume a particular emotional-volitional attitude toward all historical mankind: I must affirm it as really valuable to me, and when I do so everything valued by historical mankind will become valuable for me as well."[11] However, the factographers (most notably the members of the October Association) radically altered Bakhtin's "event-ness of Being" and "universality of the ought" as they narrowed the boundaries of "historical mankind" to contemporary, socialist ones, or, more precisely, to the reality of Stalin's Five-Year plans.

The problem, yet to be emphasized, is the reluctance on the part of Chuzhak, Brik, Tretyakov, and Benjamin to admit to the existence of the communal ghetto as an omnipresent part of the Soviet reality, while still believing that their selective treatment of it was a true factography.[12] For instance, none of the contributors to the special 2006 issue of *October* on Soviet factography challenge the premises of the factographic project.[13] Essays by Devin Fore, Leah Dickerman and Maria Gough take for granted rather than facing the fact that post-revolutionary Soviet-style factography was neither all-encompassing, nor was it based on an unbiased sampling, which would be required to ensure reliable statistical inferences. Despite being at odds with itself, this "open-ended" practice may well be characterized as a *utopian factography* that gives preference to facts that are complacent with regard to the "literature of facts."

This special issue of *October*, plotted, however implicitly, around Benjamin Buchloh's old essay about factography, is an example of "hauntology," for there are specters hiding in the background.[14] Considering that in one form or another, a shadow of phenomenological bias is still being cast upon our treatment of factography—especially when

the authors of critical or scholarly writings are encouraged to be the humble suppliers of raw material, of "factuality" that "speaks for itself," the editor's reference to archaeology should instead have been made to phenomenology. In this respect, Jacques Derrida's book *Moscou aller-retour* is worth mentioning.[15] One of its chapters, titled "Tiresias: The Journey of the Marxist Phenomenologist," discusses Walter Benjamin's *Moscow Diary* and focuses on those aspects which constitute the diary's "double bind"—"phenomenological Marxism combined with naive historical and theoretical optimism."[16] As Derrida puts it, these are "the twin breasts of Tiresias, which attract and plunge into despair."[17] The deconstructionist's principal target is the passage from Benjamin's letter to Martin Buber, written a few days after returning from the USSR, on February 23, 1927:

> My presentation will be devoid of all theory. In this fashion I hope to succeed in allowing the creatural to speak for itself ... I want to write a description of Moscow at the present moment in which 'all factuality is already theory' and which would thereby refrain from any deductive abstraction, from any prognostication and even within certain limits from all judgment—all of which ... cannot be formulated in this case on the basis of spiritual 'data' but only on the basis of economic facts.[18]

Revealed in these lines is a philosophical claim of enormous proportions—something that the Soviet proponents of factography shared with Benjamin in the late twenties. They definitely shared his desire to describe reality in such a way that it would appear as the referent's self-description, without being "constituted" by the observer. In all such descriptions, "the interpretive content is endowed with pre-interpretive status."[19] According to Derrida, what makes Benjamin a revolutionary Marxist is the fact that the referent in question is the Revolution, with its "grace of the present moment, which instantly descends upon the visitor/observer."[20] In *Specters of Marx*, Derrida discusses phenomena of this nature in terms of "spectrology," thereby hinting at the possibility that a *factography of affirmation* can be linked to gift giving and gift receiving practices, constitutive of symbolic exchange.[21]

In the Soviet Union, where identification without alienation was demanded at any price, the emphasis was placed on the cathartic optics necessary to decrease the distance between the viewer and the hero, whose ideological (rather than sexual, or commodity oriented) *jouissance* was supposed to be instantly, without delay, shared by the audience. But alienation cannot be derealized. To compensate, we resort to re-contextualization, anxiously moving from one context to another, including (for example) the context of painting. Hence, in beholding a work of art, especially if this takes place in a museum, the feeling of alienation arises for the viewer on the pretext of being a superfluous third in the author's relationship with the "sublime." Not only is the viewer not included in the symbolic network (space of desire), but s/he is not included in the superficial intrigue

that relates to the plot or to the history of the painting's creation.

It seems that attempts undertaken during the time of the avant garde at divorcing or rupturing the relationship with painting can be attributed to a battle with *alienation*. Various means were used to try to overcome *it*: by going out to the street, by decorating workers' clubs and city squares, etc. It did not take long to realize that as soon as one alienation is replaced by another, the latter is perceived as a loss of the former. What emerges is a temporary illusion or the affect of a non-alienated state. In this respect, medial practices are among the most effective, for they represent both the cure and the illness—a remedy for alienation and, simultaneously, the cause of it. The effectiveness of the mass media is based on their ability to instantly redefine the context of alienation. The process of recontextualization acts as a subterfuge through which relief is secured, but not where we wanted it.

It is true that the interesting stage of socialist realism lasted no more than five or six years.[22] This was the period of delusion when it seemed as though alienation had been set aside—a period connected with the ecstasy of surmounting alienation. As a result, many avant-garde artists experienced the temptation to return to painting. The cycle repeated itself in the 1980s: when the conceptualists of the previous two decades were upstaged by German, Italian, and American Neo-Expressionists, whose painterly *thermidor* was once again directed towards the "positive transcendence of all the estrangement" (i.e., estrangement from "tactile visuality"). Likewise, in the 90s, installations were being made with the goal of eradicating estrangement. Entering an installation, the viewers are on an equal footing with the artist in consoling themselves that some entirely different system of perception is at work. What occurs next is a relapse into alienation. Its transition from one cycle to another emulates the movement of the pendulum which makes us feel hypnotized, thereby creating an illusion of *zero degree alienation*. This is precisely the recipe that the mass media and the entertainment industry have perfected. Spellbound by the similarity between the performative language of *medial* manipulations and the functioning of the primary mechanisms of consciousness, we fall into a pre-reflective state. (The holy simplicity of performative language is, of course, a camouflage. This is true especially when we are dealing with aesthetic practices.) Hypnosis is based on the same principle: the observation of elementary repetitive motion plunges the audience into a trance, depriving it of the will to reflection.

One should perhaps think twice before embarking on a project of de-realizing alienation. We would be better off if alienation continued to play its vital role in the formation of critical paradigms, some of which need to be reinforced and "put together again."

Collective Action Group, *Ten Appearances*, 1981. Margarita and Victor Tupitsyn Archive.

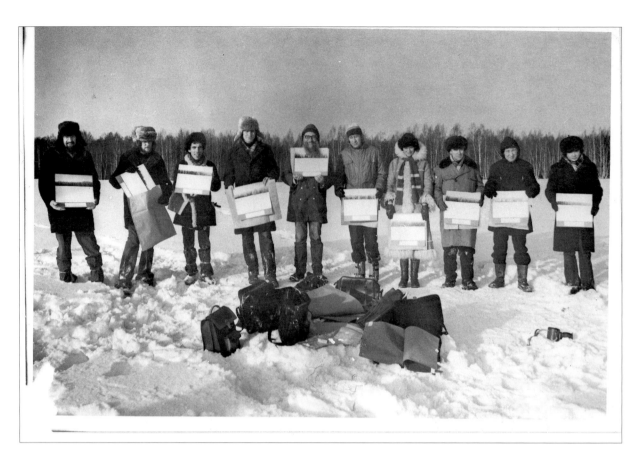

Вайбала̇̇! Получил только-то твою
открытку - благодарю, но мало написал!
Стал писем фото ей не весьма трудно.
Что значит "менее подуманным
средствам"? Каково то новое направле...

Эта плох_ое_ фото - вернувшиеся
из "Десяти появлений". При случае
пришлю хорошую фото-документаци
P.S. В описательном тексте этой акции вычеркни
в последней фразе всё после слова "события", т.е. ~~участник~~

Vitusha, Just received your postcard for which I thank you although you wrote little! It's quite hard now to send pictures. What does it mean "less farfetched ways"? What's this new tendency? P.S. In the description of this action erase in the last phrase everything after the word "events" that is "participant."

It is hard to deny that affirmative depictions are among the most corrupting of constructs. Socialist realism, as enforced in the Soviet Union in 1934, was more than just an art movement or a shared sensibility. It was the representation of Soviet identity, a representation that addressed a national audience that was extremely receptive. In fact, the high level of reciprocation that existed between this imagery and its subjects—the tenants of communal apartments—suggests that socialist realism cannot be grasped apart from communal perception. Socialist realist paintings can be shipped easily enough to Kassel or New York, but one cannot transport the optical conditions—the imperative as well as necessity of seeing through the eyes, or on behalf of the "collective other"—that gave these works meaning. For that, one must radically change one's sense of visual identity—to "communalize" oneself, as it were. Even though visual image and identity have never existed apart from each other, it was in the USSR that the mass-circulation of authoritarian icons, which controlled social identification, reached an unprecedented level. Official iconography's role was to channel this identification in the "appropriate" direction.[23] In other words, official iconography was both a means and an end.

Under Stalin, due to the excessive proximity of the wakeful eye of the state, manifestations of the "optical unconscious" in official Soviet painting were marked by an elevated ratio of transparency.[24] Until recently, the initiative in such manifestations belonged to Cartesian vision (transparent, cerebral, non-sensual).[25] However, one should not conclude that the Cartesian visual paradigm applies exclusively to official art. The insatiability of the mental eye (non-abstention from the expansionism of vision) is a quality that the counter-culture sometimes shares with the powers that be.

In the 1970s and 1980s, some Moscow artists, particularly members of the Collective Action Group (CA), became involved in the creation of an extensive photographic dossier by documenting the events of alternative art life for the Moscow Archive of New Art (MANA). Among these artists were Igor Makarevich, Andrei Abramov, and Georgii Kizeval'ter—who were later joined (albeit indirectly) by Sergei Volkov, Andrei Roiter, Mariia Serebriakova, and Boris Mikhailov. Their photographic oeuvre could be defined as neo-factography. Its distinctive characteristic is that unlike the production of the October Association or ROPF (the Revolutionary Society of Proletarian Photographers), the neo-factographers of the 70s and 80s documented manifestations of marginal practices and activities. Moreover, if the fixation of the events of the 20s and 30s can be described in terms of a *factography of affirmation*, then the neo-factography under discussion here is best understood as a *factography of resistance*.

In the performance *Ten Appearances* (February, 1981), the members of the CA group asked ten viewers to pull ropes from the center of a snowbound field towards the sur-

rounding wood. When these ten people had moved a considerable distance from each other and from the CA members who were observing them, they were photographed. When they returned, they were offered a chance to look at the photographs. Although the photographs were taken with a regular camera and not a Polaroid Instamatic, no one questioned their authenticity. In fact, the photographs were of the CA members themselves who had visited the field previously and had taken pictures of each other. The distance that made the figures practically indistinguishable contributed to the success of this falsification. The indistinguishable nature of these images was exacerbated by the obvious impossibility of developing a film and printing photographs in a snowy field near Moscow. The facts of the performance were exposed much later, which was the planned culmination of *Ten Appearances*. The truth that triumphed *ex-post-facto* turned out to be nothing more than an explication of the difference (and/or *la différance*) between the representation of the fact and the fact of representation. In essence, the neo-factography of the 70s and 80s in the USSR was an attempt to provide new answers to the questions: what is fact and what is reality? Is it whatever has received the grace of mass representation, or can phenomena pinned down by means of amateur snapshots, typewritten descriptive texts, letters, diary notes, and so forth, be referred to as true factuality? Adopting the latter viewpoint, a *factography of resistance* supports the principle that, in becoming facts of linguistic reality and therefore communicable, idiomatic narratives are endowed with a destabilizing potential that is capable of shaking faith in the invincibility of the affirmative culture (worldwide) and in the "totality" of its self-presentation.

Since many of the CA's performances and other manifestations of "cultural insurgency" took place in parks and forests beyond the city, it would be fair to compare their activity to that of the partisan. The first thing that comes to mind here is Carl Schmitt's "theory of the partisan," especially when one can extend this political category to aesthetic practices.[26] As defined by Schmitt, CA embodies

Alexey Plutser-Sarno and Voina Group, *Political Prisoners*, 2012. Action, Krakow, Poland. Courtesy of Voina.

URGENT ACTION

FEMINIST PUNK GROUP TRIAL BEGINS IN MOSCOW

The trial of three members of feminist punk group Pussy Riot will start on 30 July in Moscow's Khamovnicheskii District Court. At the preliminary hearing, on 20 July, the Court extended the three women's detention by six months. Their lawyers appealed.

All the lawyers' earlier appeals against the detention of **Nadezhda Tolokonnikova**, **Maria Alekhina** and **Ekaterina Samutsevich** have been rejected. The Moscow City Court heard the most recent appeal on 9 July, and accepted the prosecution's arguments that the crime was severe and the women might abscond. It did not take into account that more than 50 famous cultural figures and businesspeople in Russia had agreed to guarantee their bail.

The Prosecutor's office signed an indictment and forwarded the case to court on 11 July, when they received the documents from the investigators. The Taganskii District Court had accepted on 4 July the investigators' request to limit until 9 July the time for the three women and their defence team to familiarise themselves with the case file and prepare their defence. The court did not take into account the defence team's arguments that this would not be enough time for a thorough preparation of a defence. The lawyers and defendants could only work with the case file of around 3,000 pages and 10 hours of video recordings, for three to four hours a day when the materials were brought to the remand centre. The defendants could only do this separately, with no working photocopier.

At the second part of the preliminary hearing, on 23 July, the judge granted the defence team until 27 July to familiarise themselves with the case file materials and prepare their defence, but rejected their requests to send the case back for further investigation, and to call witnesses, including President Putin and the head of the Russian Orthodox Church. The court deferred consideration of the defence team's request to consult additional psychological and linguistic experts to establish whether the three women's actions incited religious hatred. Two expert reports ordered by the investigators had found no such incitement, but a third report supported the charges.

Please write immediately in Russian or your own language:
▪ Expressing your concern that Maria Alekhina, Ekaterina Samutsevich and Nadezhda Tolokonnikova may be prisoners of conscience, detained and charged solely for exercising their right to freedom of expression;
▪ Calling on the authorities to release Maria Alekhina, Ekaterina Samutsevich and Nadezhda Tolokonnikova immediately and unconditionally;
▪ Calling on them to observe the three women's right to a fair trial.

PLEASE SEND APPEALS BEFORE 3 SEPTEMBER 2012 TO:

Moscow Central Administrative District
Prosecutor
Denis Gennadievich Popov
Prosecutor's Office of the Central
Administrative District
ul. L.Tolstogo, 8, str.1
Moscow 119021
Russian Federation
Fax: +7 499 245 77 56
Email: prokcao@mosproc.ru

Salutation: Dear Prosecutor
Prosecutor General
Yurii Yakovlevich Chaika
ul. B.Dimitrovka, d. 15a
Moscow, GSP-3, 107048
Russian Federation
Fax: +7 495 692 1725; +7 495 987 58 41
(if the fax number is answered by a live
operator please say clearly "FAX")
Email: **prgenproc@gov.ru**
Salutation: Dear Prosecutor General

And copies to:
Moscow Khamovnicheskii District Court
7-oi Rostovskii Pereulok, 21
Moscow 119121
Russian Federation
Fax: +7 499 248 18 09
(if voice answers, say clearly "FAX")
Email: hamovnichesky.msk@sudrf.ru

Also send copies to diplomatic representatives accredited to your country.

Please check with your section office if sending appeals after the above date. This is the fourth update of UA 122/12. Further information:
http://www.amnesty.org/en/library/info/EUR46/017/2012/en

Amnesty International press release in support of Pussy Riot, July 23, 2012.

the purpose of the partisan in a variety of ways: not only in terms of positing its discourse as a *factography of resistance*, but in the selection of its place of action—mainly the countryside, the most convenient location for partisan warfare. Yet, a typical CA member is not an "autochthonic" partisan, but rather a partisan-intellectual, an urban dweller.[27]

Partisan intersections with institutional religion can also be found in the actions of Avdei Ter-Oganian. In 1998, he invited visitors to the Moscow Manezh to chop a copy of a Russian Orthodox icon to pieces with an axe. The attempt to prosecute him (which is what the clergy and some Moscow citizens' groups are demanding) is reminiscent of the sanctions that the U.S. Congress imposed on Andres Serrano or on Robert Mapplethorpe's *X Portfolio*. The habits of partisan "warfare" in the era of global capitalism can be borrowed from the Moscow groups *Voina (War)* and *Pussy Riot*. The strategy of their members is best analyzed not from the outside but in a partisan manner, that is, while hiding in the same dugout. It's no secret that a New Official Art (NOA) is now being created in Russia.[28] The paradox is that the NOA is partly staffed by people from the ranks of the former opposition. Perhaps a new outbreak of alienation is needed to counter (once again) the rise of the affirmative culture and the decline of negative (read: critical) thinking.

In view of the fact that there can be no resolution to the conflict between the autonomy of art and the putative authority of the culture industry, it would seem that cultural anarchism is the only way out. There have always been two kinds of factography—positive and negative, affirmative and non-affirmative: a factography of a *de jure* legitimate action (promulgated by institutions) and a factography of "illegal legitimacies," including radical political and cultural manifestations that challenge the status quo. When we deal with multiple legitimacies, both regular and irregular forces must be given an opportunity to present their own versions of art history and politics of art. However vulnerable, our historical inferences should not be based on some privileged factography—either a *factography of affirmation*, or a *factography of compromise*—especially, when it is done at the expense of factography of resistance.

Notes

1. Jean-Francois Lyotard, *The Postmodern Condition: A Report on Knowledge*, trans. Geoffrey Bennington and Brian Massumi (Minneapolis: University of Minnesota Press, [1979] 1984) 74.
2. Victor Typitsyn, *The Museological Unconscious: Communal (Post)Modernism in Russia* (Cambridge: The MIT Press, 2009).
3. The list of socialist modernist artists includes Dziga Vertov, El Lissitzky, Aleksandr Rodchenko, Gustav Klutsis, Varvara Stepanova, Lyubov Popova, Aleksandr Vesnin, Elizar Langman, Boris Ignatovich, Solomon Telengator, and others.
4. See Sergei Tretyakov, "The Writer and the Socialist Village," *October* #118 (Fall 2006) 65.
5. See Leah Dickerman, "The Fact and the Photograph," *October* #118 (Fall 2006) 141; and Nikolai Chuzhak, "A Writer's Handbook," *October* #118 (Fall 2006) 82.
6. Sergei Tretyakov, "Skvoz' neprotertye ochki," *Novyi lef* #9 (1928) 24.
7. Ilya Zdanevich and Mikhail Larionov, "Why We Paint Ourselves: A Futurist Manifesto" (1913), in John E. Bowlt, ed. *Russian Art of the Avant-Garde: Theory and Criticism, 1902-1934* (New York: The Viking Press, 1976) 81-2.
8. Zdanevich and Larionov, 83.
9. Mikhail M. Bakhtin, *Toward the Philosophy of the Act*, ed. and trans. by Vadim Liapunov and Michael Holquist (Austin: University of Texas Press, 1993) 47.
10. Bakhtin, *Toward the Philosophy of the Act*, ix.
11. Bakhtin, *Toward the Philosophy of the Act*, 47.
12. In the 1920s, migration into cities and industrial regions enabled a segment of the Russian peasantry to avoid being drafted into collective farms. This engendered a housing problem of enormous proportions, reaching its climax when two or three different tenants had to live in one room. Families of every variety, belonging to various social, national, and cultural-ethnic groups, were forced to cleave together in a single communal body, thereby creating a new phenomenon: the Soviet ghetto. Stalin's course was to exploit the situation so as to further his project of "de-individualizing" the consciousness and daily life of the Soviet people. City apartments, including washrooms and kitchens became the site of this "great experiment" in mass communalization. In his introduction to the *October* issue on Soviet factography, Devin Fore states that "Soviet factography was fixated on colossal enterprises." I would insist that the mass communalization of the urban citizenry was also part of this colossal enterprise of Soviet Russia. See Devin Fore, ed. "Soviet Factography: A Special Issue," *October* #118 (Fall 2006) 3-10.
13. The texts that are included in this issue were authored by Sergei Tretyakov, Nikolai Chuzhak, Aleksandr Rodchenko, Devin Fore, Leah Dickerman, and Maria Gough.
14. See Benjamin H.D. Buchloh, "From Faktura to Factography," *October* #30 (Fall 1984) 82-119.
15. Jacques Derrida, *Moscou aller-retour* (La Tour-d'Aigues: de l'Aube, 1995); see also *Derrida v Moskve* (Moscow: Ad Marginem, 1993) 55.
16. Derrida, *Moscou aller-retour*, 55.
17. Derrida, *Moscou aller-retour*, 56.
18. Walter Benjamin, "Moscow Diary," *October* #35 (1985) 6-7. This letter echoes Chuzhak's advice to reject "the mediation of a secondary interpretive voice." There is no evidence, however, of Benjamin's acquaintance with Russian theorists and/or practitioners of factography.
19. Derrida, *Moscou aller-retour*, 55.
20. Derrida, *Moscou aller-retour*, 58.
21. See Jacques Derrida, *Specters of Marx: The State of the Debt, the Work of Mourning, and the New International*, trans. Peggy Kamuf (New York: Routledge, 1994).
22. See my "Conversation with Ilya Kabakov," in Victor Tupitsyn, *Glaznoe yabloko razdora*, (Moscow: NLO, 2006).
23. However tempting, the recontextualization of authoritarian imagery eliminates some of its functions and changes its perception. Suffice it to mention Pablo Picasso's "scandalist" sketch of Stalin, printed in *Les Lettres Francaises* in 1953, and Andy Warhol's *Mao*, produced in 1972 (coincidentally, the year of Sots Art's commencement in the USSR).
24. Benjamin first used this term in 1931. See Walter Benjamin, "Small History of Photography," in *One Way Street*, trans. Edmund Jephcott and Kingsley Shorter (London: New left Books, 1979).
25. Reflecting on the sources of the Cartesian visual paradigm in the context of Soviet history, one has to note that in order to steer clear of "new" bourgeois forms, which "only mask the old bourgeois content," the socialist realists rejected the modernist, Baudelairian conception of style in favor of the Cartesian concept of "method." Stalin defined socialist realism as an art that is "national in its form, socialist in its content." Zhdanov transformed Stalin's definition into a theory of the dialectical unity of "folkishness" and *partiynost* ("partyness"). Armed with these formulas, the practitioners of socialist realism created a system of key mythological plots and narratives.
26. See Carl Schmitt, *Theory of the Partisan*, trans. G.L. Ulmen (New York: Telos Press [1963] 2007).
27. The group was formed in 1976 by Andrei Monastyrsky.
28. In Russia, NOA is patronized by a New Art Bureaucracy (which includes Joseph Backstein, Olga Sviblova, Ekaterina Dyogot, Boris Groys, etc.).

Liberate the Avant Garde?

Gregory Sholette and Krzysztof Wodiczko

It is a time for affirmative action; as social life implodes, as solidarity is under threat, art and culture feel compelled to take on a role in the social sphere as community work: participatory art, process-based art, etc.

—Lieven De Cauter

The goal of activism (activist art) at the beginning of the twenty-first century has become extremely prosaic: survival, survival of humanity and other species on this planet ... the new world order requires a redefinition of the place and role of art.

—Karel Vanhaesebrouk

I would argue that the avant garde idea continues to operate as the repressed underside of the contemporary forms of extradisciplinary practice.

—Marc James Léger

1. Art Is a Weak Force?

To re-think the idea of the artistic avant garde today means taking a cold critical look at the way it has been selectively appropriated by enterprise culture. Just consider the term avant garde itself. David Cottington insists it has become a mere buzzword useful for signaling that something, pretty much anything, possesses a quality of "up-to-dateness."[1] In certain markets this buzz is enough to endow brands with a competitive edge, a kind of brand-guard. But the influential aura of the avant garde is broader still. As art historian Chin-tau Wu puts it in *Privatising Culture*: "The irony is, of course, that while contemporary art, especially in its avant-garde manifestations, is generally assumed to be in rebellion against the dominant system, it actually acquires a seductive commercial appeal within it."[2] Or, as Thomas Hoving, former Metropolitan Museum of Art Director simplified the point: "Art is money-sexy! Art is money-sexy-social-climbing-fantastic!"[3]

If the avant garde has stopped being a scandalous, even subversive practice and become little more than a naughty tease or an instrument for amplifying commercial value, wouldn't we be wise to just steer clear of it? For many critical artists the concept of the avant garde is a liability with simply too much baggage to unpack, too many pitfalls to avoid. Theorist Marc James Léger suggests, however, that the avant garde hypothesis remains operative though suppressed within contemporary art discourse. Similarly, the artist Krzysztof Wodiczko urges us to not abandon the transformative promises of the avant garde "despite our apparent weakness and marginal position." He implores us not to give up but to continue sparking unrest, criticism,

and raise questions while "doing something practical, forming new concrete situations, creating new examples, infiltrating the system's web of bureaucracies, collaborating and transforming autonomous organizations and networked social movements, becoming inspiring catalysts and informed agents in the best sense of these terms."

Wodiczko is not denying the frailty of the situation, nor is he disavowing the instrumentalization of the avant garde by deregulated capital's economy of attractions and distractions. But neither is he shying away from the latent terminology of tactics and maneuvers that have remained implicit within the term ever since its coinage by a French military newspaper in 1794. There is a suggestion of being dropped-in behind enemy lines with all the existential exposure and sense of duty such a narrative implies. And his emphasis on weakness is significantly different from Boris Groys's use of the term. In candidly theological language Groys describes the avant garde as modest messengers of time who are forced to repeat their radical critique of mainstream society as a cumulative evangelism over the long duration. It's not that Wodiczko's call to arms lacks a doctrinal feel of its own, but by positing the artist as a tactical interventionist colluding with those who have been systematically excluded from the realm of political participation and representation his notion of the avant garde comes close to Léger's proposal for an "occupation and radicalization" of capitalist culture by extra-disciplinary practices that prefigure new forms of political organizing.[4] Krzysztof Wodiczko and I met several times at the De Robertis Caffe on the Lower East Side this past Spring (2013) to discuss these concerns. What follows is an edited account of this discussion:

Gregory Sholette: In the post-industrial West we have seen the demise of labor unions along with the replacement of the welfare state by precarious forms of work. It's a situation in which organizing opposition to such de-centered exploitation is increasingly difficult. And then along came the so-called "great recession," the most serious capitalist contraction in over seventy years. Something seems to have begun to happen. Now, about a year since the emergence of the Occupy Movement and Movement of Squares in Europe, as well as of course various struggles for liberation in the Middle East, artists and cultural workers who were previously disinterested in the politics of the economy are expressing a growing unhappiness with their current and future possibilities, both within the art world and beyond. And yet this resistance, or potential resistance, is not particularly well organized or theorized, not to mention that it knows little about past attempts at generating similar opposition to economic injustice, or for that matter anti-war and pro-democratic organizing. Although this informal movement is now undertaking its own rapid self-education, its political position would certainly be described as weak. But I am thinking that it is still something irrepressible and therefore important to artists, including those who refuse the "prohibition" against framing one's art as *vanguard*, as Léger's hypothesis has urgently noted. In other words does it possesses a kind of "weak force" that nevertheless makes it oddly formidable, if that makes any sense Krzysztof?

Krzysztof Wodiczko: Yes, we might think of it as a dispersed power, but remember we are not dealing here with the normal meaning of "weakness" that many people think of, although I admit artists themselves might unfortunately think of themselves as weak. I meant that the imagination and perception of artists actually has a much larger effect than they think. And in fact, this effect, you know, is very hard to measure, although it is no less significant. The avant garde can only be measured much later. Actually, not measured—that is the wrong word. It is more correct to think what would have not happened had these artists never existed rather than "they've done this; this is the effect."

GS: So it is like gauging something indirectly by considering its accumulative reverberations over time within a culture, rather than measuring the force of some original collision or impact-event?

KW: Yes, these are allusive effects and require their own forms of measurement. Just imagine: if we didn't have this kind of historical resistance proposed by the avant garde, including the many propositions for transformative collaborative work, where would we be now? In other words, it's unthinkable to imagine all kinds of design, even the Internet, without also considering the legacy of the productivists and constructivists for example.

GS. In this sense the present is therefore also simultaneously the past, figuratively as well as literally? That would

also suggest that the stakes of current struggles are far more serious than they sometimes appear in the world of contemporary art. But how in an era like ours, when the very idea of the future has been foreclosed or at best imagined in only the darkest, dystopian terms, do we understand the fundamentally radical and utopian dimension of the avant garde hypothesis?

2. History and Futurity

Perhaps even more than the term avant garde the word "revolution" is today repressed and therefore avoided by artists and critics, unless or course it is being used ironically, sarcastically. To even call oneself a "revolutionary artist," as for instance artist Dread Scott does, seems destined to attract sneers. And yet can one be an avant-garde artist without believing in a radically transformed future? The loss of belief in the future as a better place is endemic today among the younger people I encounter. Occupy and the other movements of last year were to my mind a railing against the foreclosure of hope brought about by the penetration of everyday life by the market. This includes art and artists who are expected to cheerfully join in the affirmation of capitalism because it is presented as the only option today. Thus the birth of the so-called "creative industries." But can we participate in a truly transformative cultural agenda without acknowledging the importance of imagining an entirely better world tomorrow? I mean something more profound than the accumulation of small changes or interesting subversive tactics? Or is the invocation of the avant garde at this point in time not so much an act of repetition as it is a kind of necromancy in which we are attempting to revive that which is deceased—not so much a *rearguard*, but a *deadguard*, or *necroguard*? And does that make us more like sorcerers of the past than apostles of the future?

KW: For me it is really a living relationship to the past, not a revival or resurrection of the past. Because when I see the work of some of the artists from the time of productivism or constructivism, especially in their later phases, or even the works of architectonism, which is another phase of constructivism, I feel direct connections with my work. It feels sometimes like these concepts circulate through my veins. This may explain why I have an allergy to the way the idea of the avant garde has been neglected and abused by the contemporary art world. That is not to say of course that I am not also very critical about some aspects of that historical moment in the time of the Soviet Union, especially regarding the avant garde's complicated and in many ways dubious relation to the Leninist party.

GS: So it is an immediate if no less contradictory rapport between past and present, a history that does not round off its rough edges.

KW: And I was thinking that if we don't think of this grad-

Krzysztof Wodiczko, *Abraham Lincoln: War Veteran Projection*, Union Square Park, 2012. 23 min video presenting the testimonies of 14 veterans and their families from the wars in Vietnam, Iraq and Afghanistan. Courtesy of the artist.

ual accumulative resistance in terms of small community processes, but instead as one of creating conditions for several groups to work collaboratively at a particular time and particular place, then this breaks the self-imposed silence about the avant garde that Marc has described. In fact when you look at the history of the avant garde there were always various groups operating in tandem. They were never large-scale actions, but specific to a particular time, place, and context or struggle.

GS: Solidarity as essential to both resistance as well as memory? A solidarity that is as much with our living colleagues as it is with the past.

KW: Yes, we actualize this monument in present times.

GS: Hmmmm… at first I thought you said we actualize the "moment," but what you did say helps to throw a light on your practice of projecting images of the living workers, immigrants, the victims of wars onto public monuments in order to re-animate these otherwise motionless memorials.

KW: Yes, I'm not so interested in the dead, I'm interested in the living.

GS: And yet to some extent these projection works of yours involve the voices of the living now posing as the dead. So maybe the other question is this: are the dead interested in you? I mean in a sense does the past not also project its own kind of expectation or even solidarity forward in time and directly onto us?

KW: Maybe they are or have always been hoping for me to exist and in that sense they are hoping to be useful for the living. That's for sure because I always need their help with these projects! One cannot change the monumental past, but to move on, one must learn how to live with it in a creative way—animate it, project new meaning on it—as with the Lincoln statue and the traumatized war veterans in my recent project.

GS: I too always try to bear in mind Benjamin's warning that *not even the dead will be safe from the enemy, if he is victorious*. It's a bit heavy certainly, but it helps keep me on my toes.

3. A Post-Machine Age Agency?

Swarms of belligerent "creatives" occupied Zuccotti Park last Fall, generating what resembled a superorganism of minds and bodies striving to achieve coherence (if only provisionally). Or at least that is one way to read that extraordinary happening. As *The Occupied Wall Street Journal* from November, 20, 2011 described it with a kind of 'fuck you' bravado: "the 1% is just beginning to understand that the reason Occupy Wall Street makes no demands is because we aren't talking to them. The 99% are speaking and lis-

tening to each other." This inward turn towards autonomous self-governance resonates with much of the history of the avant garde, which never sought to simply dissolve art into life if that life was less than transformative in its own right. This is where relational aesthetics and interventionist art part company. When Mayakovsky proposed that the streets should become canvases for the avant garde it was not in order to render an existing reality still locked in the grip of feudalism, but rather to collaborate with the birth of a new society. Up until that moment of rupture the radical avant garde has demanded its own separate sphere of culture, a space in which judgement, agency and meaning operate apart from the stifling authority of the state or the disciplinary structures of the economy. But there is another sense in which the historical avant garde and certain kinds of socially engaged practice converge. Both express interest in non-human forms of agency. This was true of Dada, Futurism, Productivism, Constructivism, Suprematism, even Surrealism in some instances, just as it is true today of tactical media, hacktivism, interventionist art, and bio-art. Are we again therefore on the edge of a new societal or even bio-societal mutation that will transform politics, economics, and culture, and if so what role should artist's play? Are they in the vanguard of this process? Or are rapidly evolving technologies driving this change? Or are both collective forces and technologies merely effects being generated by a broader paradigm shift?

KW: Maybe this is not an enlightenment moment. I don't know what it is that we are in. Artists of course are not invited to the parliament. But what artists are doing is attempting to figure out other ways of living and surviving under present circumstances. Again, it's not a global or even monumental picture of saving the world in the older avant garde utopian sense. There's a very big difference.

GS: But what kind of agency does this experiment in survival presuppose?

KW: The agency today is a prophetic kind of newcomer: the immigrant. They are the vanguard of our age. And because they do not carry *their* culture with them but leave it behind them from the very moment they arrive they inevitably begin to question everything from a new perspective. They are in a sense located in between the science-fiction story and the crime novel. But also between vision, deconstruction, and construction. So this is maybe my fascination with the immigrant. They make a connection with the historical avant garde when artists sought to work with common people, even if they sometimes treated them as an essentialized class consciousness.

GS: So unlike the proletariat who for Marx signaled the birth of a new class but also a liberatory historical force, today it's the paperless worker, the migrant, the exile, and the homeless person?

ABRAHAM LINCOLN

"I see in the near future a crisis approaching that unnerves me and causes me to tremble for the safety of my country. As a result of the war, CORPORATIONS have been enthroned and an era of cooperation in high places will follow, and the money power of the country will endeavor to prolong its reign by working upon the prejudices of the people until all wealth is aggregated in a few hands and the Republic is destroyed. I feel at this moment more anxiety for the safety of my country than ever before, even in the midst of war."
U.S. President Abraham Lincoln, Nov. 21, 1864 (letter to Col. William F. Elkins)

On February 27, 1860 Abraham Lincoln spoke at Cooper Union's Great Hall. This unsophisticated, self-taught product of the backwoods of the American frontier was an enigma. After the speech to the urbane, jaded New York audience he went on to win the Republican nomination for president and changed American hisotry. In addition to Emancipation Proclamation and winning the Civil War, Lincoln was a proponent of American Socialism. His Land Grant Colleges provide education to working people and was one of the most important social programs for America's future. He also fought against the corruption and moral failure of the banking industry by issuing Greenback Dollars directly from the US Treasury.

Horace Greeley's New York Tribune hailed Lincoln's speech at Cooper as "one of the most happiest and most convincing political arguments ever made in this City ... No man ever made such an impression on his first appeal to a New-York audience."
center foto by Matthew Brady New York on the day of Lincoln's speech at Cooper Union.

REPOcommons.net

Jim Costanzo (founder and director of the Aaron Burr Society), Contribution to REPOcommons (http://repocommons.nyc.xs2.net), 2013. Courtesy of Jim Costanzo and Gregory Sholette.

KW: Yes, exactly. Utopia is "no place" but this has to be pronounced "No! Place." No-exclamation mark-place. For the immigrant today Utopia is a critical vision of the *future*, *a vision of the place*, the topos in which there will be *no place* for *this kind of place* and experience that she or he is forced to live through today. The immigrant's Utopia as No!-place is at once a prophetic vision, a criticism, and a resistance.[5]

GS: Only are we in danger of idealizing these poorest of the poor, of projecting a kind of lumpen saintliness onto them?

KW: I don't mean to romanticize but still there are a certain number of these people who have a very special perspective and who can speak on their own behalf. War veterans, people who are abused, those who are innocent victims, all those who have no choice but to sink in where they are, this is the avant garde of the people and who we artists should be listening to. My intuition tells me that I am not alone in attempting to create conditions for them to become co-artists, agents, or co-agents through my socio-esthetic projects.

GS: This is how the technology becomes so important in your media work?

KW: Yes, and instead of working "for" or "about" or "on behalf of," the technology allows me to work with the immigrant for example in developing and realizing a project. Ideally these works engage people in communicating through a specific public space or through a form of media, and my role as an artist becomes a kind of "good enough mother": a facilitator who can create a "potential space" or space of potential for the nurturing of speech-acts.

GS: Kind of like the "people's mike" so to speak?

KW: No, something quite different. Something that deconstructs and constructs participation through language but also bodies, histories, affects, etc, involving, recording, re-recording, special writing workshops, etc, involving communication development processes that can sometimes last one year or more.

4. Sci-Fi Crime Stories

Writers such as Stanislaw Lem, the Strugatsky Brothers, Octavia Butler, J.G. Ballard, and Philip K. Dick have grappled with complex social and political issues through the medium of science fiction. Some of the most engaging art projects today similarly explore contemporary subject matter by intermingling fact with fiction to produce a space of fantastic possibilities. Wodiczko's talking public memorials and his *Alien Staff* project are especially good examples of this tendency, as is some of the work of Critical Art Ensemble, but a younger generation of artists is also

exploring this connection, including Jalal Toufic, Trevor Paglen, Tom Sachs, Omer Fast, and Melanie Gilligan. In my own writings I use the astrophysical metaphor of "dark matter" to describe the emerging power (a weak but growing power) of social [non]productivity that:

> appears to mobilize its own redundancy, seems to acknowledge that it is indeed just so much surplus—talent, labor, subjectivity, even sheer physical-genetic materiality—and in so doing frees itself from even attempting to be *usefully productive for* capitalism, though all the while identifying itself with a far larger ocean of "dark matter," that ungainly surfeit of seemingly useless actors and activity that the market views as waste, or perhaps at best as a raw, interchangeable resource for biometric information and crowdsourcing.[6]

Perhaps what we are seeing is not just a convergence between sci-fi and art, but methods by which the suppressed avant garde thesis is permitting *a return of the repressed*?

GS: What would you say about method and its relationship to art and theory, as well as to documentation and fiction, two things that were very much present within the original avant garde?

KW: Deleuze and Guattari have written that the work of philosophy must be permeated by science-fiction and crime stories. Regarding art and its method I would add that it's not enough to be deconstructive, one must also have a visionary sense of construction. But then it's very difficult to be optimistic and intelligent at the same time. It's a risk. But a risk worth taking.

GS: A risk that one is either too much of a forensic analyst or too much of a utopian fabulist or storyteller?

KW: There is a story about the last Polish King who in 1791 was masterminding the first European Constitution. At the same time he used his own money and invited a French engineer to present the first flight of a balloon in Poland. In an extraordinary move he decided that there would be a crew of four: an engineer, a writer, an artist, and a dog. So what was he hoping to achieve? In my imagination at least the king wanted this writer to report on a larger and loftier worldview than was available at a terrestrial level. Ultimately the balloon-ride experience was formulated into a courtly poem also paid for by the king. I'm sure it was a commission. It's called "Balloon Flight." The poem describes the flight, its take-off and its landing. The observer describes the world changing with people getting smaller and smaller. Even differences between nobles and peasants, as he reports, is disappearing. And then appears the graceful curve of the horizon, proving that the world is round. So he is immediately talking about democracy by way of science-fiction. Up in the balloon is a vision of the future while down below rages an argument over the constitution and the city. It's a fantastic image, it's a great image, and

this is art and technology. Yet when will we ever have an artist ascend as an astronaut? Probably never.[7]

GS: Agreed.

But there is more. As this flight went on there was also a demonstration of another new technology: the parachute. It was of course the dog who "volunteered" for the test. Unlike poor Laika in the early Soviet space mission this dog landed softly.

5. Coda

It is the year 2050 and curators at the Museum of Modern Art in New York hire *Vanguard Genetics*, an innovative biotechnology firm, to clone Vladimir Tatlin and Lyubov Popova as living artworks for their upcoming exhibition about early twentieth-century avant-garde art. After months of preparation Tatlin is resurrected first. He spends the first day of his new life viewing web news programs, perusing shopping chains where Rodchenko-inspired graphics entice consumers to satisfy their desires, and he buys a bio-synthetic blini from an automated street cart. Arriving back at the museum Tatlin watches a group of young art fabricators putting the finishing touches on a quarter-sized model of his legendary Monument to the Third International. A door opens. In walks a newly restored Popova.

> Privet Comrade Tatlin.
> Privet Luba.

Popova: So, what do you make of this new world? Tell me honestly, don't hold back.
Talin: Well, to be honest, there is good news and bad news.
Popova: How about the good news first?
Tatlin: The good news is that after all these years life has finally merged with art.

Popova: But that is fantastic news! What could be so bad?

Just then the art fabricators step away from the model of Tatlin's tower revealing a massive Nike swoosh emblazoned on its exterior.

Tatlin: The bad news is … *life* sucks.

Notes

1. David Cottington, *The Avant-Garde: A Very Short Introduction* (London: Oxford University Press, 2013).
2. Chin-tao Wu, *Privatising Culture: Corporate Art Intervention since the 1980s* (London: Verso, 2002) 161.
3. Thomas Hoving cited in Chin-tao Wu, *Privatising Culture*, 127.
4. Marc James Léger, *Brave New Avant Garde: Essays on Contemporary Art and Politics* (Winchester, UK: Zero Books, 2012) 3.
5. See Krzysztof Wodiczko, "Designing for the City of Strangers," in *Critical Vehicles: Writings, Projects, Interviews* (Cambridge: The MIT Press, 1999) 4-15. See also Wodiczko, "Strategies of Public Address: Which Media, Which Publics?" in Hal Foster, ed. *Discussions in Contemporary Culture* (New York: The New Press, 1987) 41-5, as well as Wodiczko, *The Abolition of War* (London: Black Dog, 2012).
6. Gregory Sholette, *Dark Matter: Art and Politics in the Age of Enterprise Culture* (London: Pluto Press, 2011) 188.
7. This story about the balloon flight, poet and dog collapses three balloon flights that were very close but separate in time. The first balloon flight with human crew that took place in Poland was undertaken by the French engineer Jean-Pierre Blanchard and his wife Sophie Blanchard in Warsaw in 1789. In order to celebrate and philosophize on the meaning of this event, the poet, historian, dramatist, translator, and publicist Adam Naruszewicz wrote the same year a poem called "Balloon." On May 13, 1789, Blanchard launched a balloon with a dog as the only crew member. The balloon blew out. Thanks to a delay device, however, a special parachute carrying the dog detached itself automatically and landed safely, the dog alive and well. On the 14th of May in 1790, Jan Potocki, a Polish aeronaut and author of *The Manuscript Found in Saragossa*, took a balloon flight with Blanchard, his Turkish servant and his dog (a white poodle). Together they reached a height of 2500 meters and landed safely after a 30 minutes. On May 3, 1791, the Polish Constitutions was adopted in Warsaw. It is often described as Europe's first modern national constitution, and the world's second, after the United States Constitution.

Refining Our Doublethink: An Interview with Critical Art Ensemble

Marc James Léger

Marc James Léger: Your recent book *Disturbances* describes the practice of Critical Art Ensemble over the past twenty-five years or so.[1] While I appreciate having access to a compendium of the countless projects you've undertaken I especially liked the glimpses into your thought process and the rationales you provide for the decisions you made along the way to adjust and redefine your practice. I was struck by the statement you made concerning your involvement with AIDS Coalition to Unleash Power (ACT UP) and Prostitutes of New York. In relation to the project *Cultural Vaccines* (1989) you say:

> In spite of our success in contributing to the organization and maintenance of the chapter, we quickly tired of making agitprop and protest signs. We didn't want to burn out. We wanted a long-term collective relationship. We wanted to research new tactics and techniques for resistance. We wanted to use the full spectrum of our intellectual and inventive abilities in order to become a generalized research and cultural production wing for the Left. Shortly after *Cultural Vaccines*, we worked with the sex workers' union Prostitutes of New York but in a more indirect way. CAE's affiliation with traditional activism was over. We never tied ourselves to a specific group or campaign again.[2]

There are a few reasons why I found this statement particularly notable. One of them has to do with Brian Holmes' essay on "Eventwork," which he published in the Creative Time catalogue *Living as Form*. Brian's notion of extra-disciplinary research states that eventworks not only seek to overcome the limits of existing disciplinary fields of expertise and their hegemonic links, but to simultaneously examine the contradictions of avant-garde art. I agree with him that the standard notion of the sublation of "art into life" is maybe too simplistic a formula but I disagree that the purpose of collective action and the measure of its effectiveness—and here he gives ACT UP as one recent model of eventwork—is to provide an "affective charge to the interpretation of a real-world situation."[3] It seems that in comparison to many activist groups you still operate with what for lack of a better term I would define as critical autonomy. This means that your work maintains a certain critical distance from immersion into everyday life. Whereas Brian considers that this has nothing to do with a "totalizing ideological framework like Marxism," I would argue against this and say that both Russian and western Marxism have had much to say about the radical subjectivization of daily experience, one that looks to be comprehensive of all facets of human experience, social, sensual, cultural, aesthetic, political and, last but not least, economic. So that's one very general question about your take on the tensions between something like alternative or counter-cultural movements and radical leftism.

Critical Art Ensemble: You seem to be asking several questions. Let's start with critical autonomy. Yes, CAE's interventions are distant from our everyday lives. The mode of consciousness we inhabit during an intervention is a hyper state of becoming. It's overly social, overly performative, and overly directive, as we try to create the conditions that will reinscribe, redirect, reframe, or refocus an issue, process, object, or environment in a manner that is disruptive or disturbing to the status quo. At the same time, we are always on watch for pushback, and readjusting to the situation if disciplinary agents discover us. This is not the way any sane person would want to live on a permanent basis. While often pleasurable and rewarding, it's exhausting and can only be done is short bursts. It makes for great events, but it will not create immediate lasting social relationships. While we have done work that is about creating new relationships (as with the contestational ecology projects *Peep Under the Elbe* or *New Alliances*), most of the time we are interested in the production of meaning through recombination.

Having said that, many CAE projects use everyday life settings. We like to be out of place within a given context, but not so much so that we are immediately understood as art or some other convention. Even at museums we tend to set up in liminal zones like hallways, cafeterias, lobbies, etc., so viewers have to think about what it is they are looking at or participating in. Everyday life is often the set for our theatre, and it allows us to escape the baggage and limits of art. It also functions as our camouflage. So in that sense we are immersed.

As for the tension between counter-culture and the radical left, CAE does not pay it much mind. We are not purists who see only one path to a form of living that is not dominated by the imperatives of empire. We can get behind any experiment that shares this goal. Oppositions are not a good way to think about difference among minority political positions. We should always be thinking about alliances and coalitions and what we can learn from one another. During the movement of movements in the late 90s, I think the tension was removed from this one-time dichotomy. To use your example, in this century have we seen any demand within the queer movement that everyone must choose between aesthetics and politics as there was in the

late 80s and early 90s? Aesthetics and politics now seem to live more or less peaceably with and in support of one another.

MJL: Right, and I did say tensions and not oppositions. In any case, another reason that your statement on activism interested me has to do with the fact that the idea for this book came to me after I had been writing about cultural work related to political movements like anti-globalization protest, Occupy Wall Street and the Québec student movement. I've been arguing for some time now that the late 90s and early 2000s marks a break with a certain trajectory of postmodernism in its various forms—cultural studies, social constructionism, post-structuralism—and a re-engagement with radical left traditions. Some people see this as a shift from postmodernism to globalization and creative industries, and others think of it as a shift of emphasis from micropolitics back to macropolitical concerns, as seen, for example, in Gregory Sholette and Oliver Ressler's recent exhibition, *It's the Political Economy, Stupid*. Despite the many shades of leftist political orientation, you notice some of this in the general increase in the number of self-instituted art and theory collectives that are now operating at a certain distance from the usual formats of museum and university production. Critical Art Ensemble was quite definitely ahead of this recent trend and served as a model for many. In some cases, however, today's activists define themselves against the avant-garde models of the past and even of the recent past, divorcing themselves from many people and practices that have achieved some hard-won gains and changed what it means to make critical art. Some of this is inevitable, with younger groups always needing to define themselves somewhat differently from previous generations. However, I think that some of it is also ideological, subtending what has traditionally, in orthodox criticism, been described as petty bourgeois reformism and adventurism. How do you relate to today's activism?

CAE: "Today's activism." That's a big term. We need to be more specific. The Occupy movement was youth taking control of contemporary radicality. They stuck to their beliefs and didn't turn into a reformist party. They brought into visibility a different form of social organization and political structure. When was the last time we saw that? In the 70s perhaps? The surprising thing for us is that of all the tactics available, it was occupation that caught youth imagination. Although given that it's one of the oldest of anti-authoritarian actions, it was due for a renaissance.

But as for the reformism we think you are talking about, we have to admit that CAE is conflicted. Take the campaigns for gay marriage and gays in the military. Radical LGBTs, along with anyone who wants more than reform, have to be screaming in frustration. We should be attempting to rid ourselves of these brutal and normalizing institutions, not assimilating more people into them. These are institutions of such oppression and misery, which is why they are easiest to infiltrate. The fix is in, whether you are in or out of the institution—a person loses either way. The only way to protect anyone from them is to eliminate them. At the same time, when reforms are understood as part of a civil rights struggle, how could anyone be against them? How could anyone be condescending enough to say, "LGBTs, you know how you can't be out and in the military, or how you can't have state recognized marriages—well, it's for your own good, so hang in there until these institutions are eliminated by the real revolutionaries." How could a person not feel that they are reinforcing the very worst right wing ideology with that position? In terms of the typical concerns of people just trying to get by day-to-day, reformism is not a big problem. CAE has been refining our doublethink so we can hold these two contradictory thoughts in our head at the same time and act on both. Depending on the circumstances we may act on one, the other, or both.

MJL: In his interview in this volume Richard Kostelanetz makes a sort of axiomatic statement with the following: "If work by someone receiving elite recognition is routinely rejected, then he must be doing something deviant, which is to say significantly avant-garde." In his essay on the charges that were brought up against Steve Kurtz and Robert Ferrell for their involvement in CAE's *Free Range Grains* and related projects, Gregory Sholette chose the title "Disciplining the Avant-Garde."[4] Since the case brought against you by the U.S. Department of Justice has been settled, how do you now read the relationship between provocative work, subversive despite being somewhat innocuous, and repressive reaction?

CAE: Our brush with the Department of Justice really isn't representative of the problem of discipline in relation to cultural production. The causalities of that case were varied, layered, and complex, and went far beyond being solely a reaction of authority to CAE's work. It was quite abnormal. In the representative case, discipline is solely a reaction to what we are doing—that is, disturbing the status quo. It might be police telling us to stop playing with toy cars in public as in *Exit Culture*. It might be a politician saying we are making a mockery of a museum as when we did *Cult of the New Eve* in Toulouse. It could be corporate lawyers threatening to sue us as in *Molecular Invasion*, or church groups protesting *Flesh Machine* in Vienna. After *Flesh Machine* a CAE member had to debate the Archbishop of Salzburg on national TV, and one of the local magazines published an article about the performance with the headline "Let's Kill Baby." Just this year, the *Temporary Monument to Global Economic Inequality* was called "immoral" by *New York Magazine*. The everyday life application of discipline is the real thing to worry about. That is the apparatus that is censoring and managing the expression of everyone, at every moment. The Department of Justice's spectacular "example-making" tactic is a problem, but it won't have nearly the impact of the softer, constant pushback. The grand spectacle of discipline (such as Steve's case) is mostly an alibi for a status quo that claims that everyday life punishment doesn't exist. If it wasn't for the potential material condition that Steve and Bob could have gone to jail, the significance of this tremendous injustice would primarily be hyperreal by signing that those outside this nightmare are being treated justly.

192

MJL: For good and bad CAE became a *cause célèbre* and a *succès de scandale* because of the case. The especially egregious nature of the prosecution propelled your work into a spectacular situation. How did you, or do you, resist spectacular attention even as you were and maybe continue to be foisted into the limelight by circumstances beyond your control?

CAE: In terms of the integrity of our work, that was easy, because the pressure we felt was to stay the course. We had to show that we would never quit, both as a way of refusing the spectacle of fear and as a way of giving back to all the people who supported us. It was like an unspoken contract that was only voiced on rare occasions. The pressure from the government never determined our projects. That was the one thing we had control over.

But we had to accept the spectacle to some degree, because we had to win the battle in the court of public opinion as much as we needed to win in the court of law. Because of our success in engaging this unfortunate necessity, when the case was dismissed, the government did not appeal. Moreover, we believe the government will think twice before replicating such a moment again. The fact that the FBI has changed its policy from policing to (alleged) cooperation with various kinds of hacker groups is an indication that they are reversing on the brute force strategy. They call the case "Kurtzgate" and vow that they do not want to repeat it. CAE doesn't trust them, and advises others to do the same, but the FBI knows there is a sucker born every minute.

MJL: Do you feel that it's over, at least as far as art world audiences are concerned, or do you sense it's still there?

CAE: It's over. It lives now more as a bogeyman myth. "Watch out, check your paperwork, follow your protocols, or you will end up like CAE and Bob Ferrell." That myth resonates much more in the sciences than in the arts.

MJL: How do you relate to it—as a badge of honor, as a monkey on your back, or both, or something else completely?

Steve Kurtz: The same as the group does—tactically. If the situation we find ourselves in requires a conversation about it (like now), then fine. If it's not relevant to the situation, we don't bring it up. Its only value to us now is its potential for pedagogy.

MJL: I wonder too what you think the art world response to the CAE case was like in comparison to the attacks on the National Endowment for the Arts that came about due to censorship of the work of Robert Mapplethorpe, Andres Serrano and Karen Finley.

CAE: We think pretty much the same. In both cases, there was tremendous solidarity. For each of these cases, we went from art worlds to an art world. We are really grateful to ele-

ments of the art world that we normally have no interaction with, but that nevertheless truly stood up for us.

MJL: Beyond what we know about technopolitical systems and managed democracy, has this experience given you any new or unexpected insights into cultural systems?

CAE: No, it only confirmed the worst.

MJL: The world of engaged art practice is presently abuzz with notions of dialogue, collaboration, participation as well as notions of community, creativity and affective relationality. In general CAE has been somewhat suspicious of such "ameliorative" discourses. In one statement that you made you said you thought that the focus on community is the liberal equivalent to the conservative concern for family values.

CAE: Yes, we said that, meaning that the objects of focus were both fantasies. At least community is an actual form of social organization in places where the division of labor is not so complex. On the other hand, we're not sure family values ever existed, except as a Rorschach test abstraction that the right perceived as concrete, certain, and universal. As for social improvement, we see that as a healthy tactical aspiration. When it becomes programmatic, we are more suspicious.

MJL: I've found that in the last ten years or so we've witnessed a renewed radicalization of art practice that gives us much to be excited about. At the same time, though, there's a deep suspicion of certain characteristics that we traditionally associate with the avant gardes, such as autonomy, authorship, ideological commitment, and the very idea of the avant garde itself. Whereas a "reconstructed" version of these concepts might allow for more room to maneuvre, much of the anti-foundationalism of postmodern theory remains a potential obstacle to radicalization. Do you think it's necessary for younger art collectives to deny the avant garde legacy as an aspect of doing something that would be, in the end, avant-garde?

CAE: No, why would anyone want to do that? We have to know our history, and to apply what is still useful in the present and modify or abandon what is not. If we are not to be ideologues, we have to be open to recombinant elements coming from anywhere. As history moves along, that which was once thought useless might become useful again. The word "occupation" comes to mind.

MJL: One of the concepts that Peter Bürger helped to popularize is the dialectical notion of the sublation of art and life, the overcoming of the distinction between art and life, which in one form or another is a constant throughout much of the twentieth century. Is this idea important to you at all?

CAE: No, we don't really see art and life as equivalent. Wouldn't art be a subcategory of life? We still live a division of labor.

Critical Art Ensemble, *New Alliances*, 2011. Workshops, displays, interventions. Information sessions on endangered plants and instructions on how to transplant the endangered "Cupid's Dart" (*Catananche caerulea*). Courtesy of CAE.

MJL: Do you think postmodern approaches to representation as signifying practice as well as media and communications theories effectively replaced the attention to art understood in superstructural terms?

CAE: Yes. Once the concept of sign-value was established as representative of a complex digital economy there was no

turning back—representation has material consequences. The material and representational are locked in causal exchange, thus greatly reducing the explanatory power of the infrastructure/superstructure relation.

MJL: I find that most people who work with the idea of sublation have a very basic—idealist—understanding of double negation. How do you operate in relation to making work that Pierre Bourdieu defined in terms of "dual action devices"—work that is and is not art?

CAE: As long as a person doesn't worry about it, that process takes care of itself. We don't have any investment in being recognized as artists. We are happy to be artists if that is what gets the project done or the conversation started, but if it would be better to be scientists, biohackers, interventionists, designers, activists, then we will. We are happy to have a fluid identity. Nor do we care if a viewer or participant interprets what we do as art. If they do, that is OK, and we will speak about it in that frame. If they don't, we speak with them using the interpretive frame they suggest. What influences the interpretation is the context it's plugged into. We all know the story of Duchamp's *Fountain* by now. Ultimately, how we see the cultural value of our work has nothing to do with how it's characterized.

MJL: Could you maybe say something about how this might play itself out in terms of a recent project like *The Concerns of a Repentant Galtonian*, *New Alliances* or *Winning Hearts and Minds*.

CAE: In a project like *New Alliances*, we were planting endangered plants in urban spaces that were being threatened with repurposing for the benefit of a few at the expense of the many. By planting an endangered species, the property would benefit from the plant's protected legal status, thus helping to slow development. If you saw the action, it probably looked like eco-activism and not art. If you saw the exhibition explaining the entirety of the process at the sponsoring art institution, it probably looked like art. The pamphlet, *The Concerns of a Repentant Galtonian*, could be read as an artist's book, or a sociological treatise, or as moral philosophy, or as literature. By design, it's a very flexible work. *Winning Hearts and Minds* needs its own interview. This was one of the more complicated pieces of institutional critique that we have done in a while, and has an intertextual relationship with the *Temporary Monument to Global Economic Inequality*.

MJL: You mention in *Disturbances* that you've been particularly influenced by the feminist art movement, the Situationists, the Living Theatre, Theatre of the Oppressed, Guerrilla Art Action Group, and Group Material. In the introduction to *Disturbances* Brian Holmes adds Dada, Jean Baudrillard, William Burroughs, Georges Bataille, Andy Warhol, Antonin Artaud, Gilles Deleuze, Félix Guattari, Paul Virilio, and the Krokers.[5] Who would you add to this list?

CAE: How far do you want to go back? These lists could be endless. We would probably add Judith Butler, Hardt and Negri, Avital Ronell, David Harvey, Franco Berardi, bell hooks, Brian Holmes, Giorgio Agamben, Cornel West, Peter Wilson, Richard Lewontin, Mark Poster, Paul Feyerabend, Roland Barthes, and Paul Farmer.

MJL: What do you think are the uses and abuses of the avant garde for life today?

CAE: The idea of the avant garde and its historical manifestations are essential to imagining radicality and its potential power. It launches endless productive fantasies about what could be, in conjunction with a belief that the fantasy could be made real. Whether a person rejects this idea, continues it, or transforms it, it is often the mythic foundation of radical subjectivity transforming into radical action.

CAE has always been partial to the idea that within the contemporary technosphere an avant garde based in technical knowledge is always (re)emerging. We are thinking of Chaos Computer Club, Übermorgen, or Institute for Applied Autonomy (IAA). IAA's project *TextMob* is a perfect example. They saw the power of texting before it was popular, and transformed it into a real-time, on-the-ground communications system for protesters. It was visionary to the extent that it was undoubtedly the prototype for Twitter.

Finally, we don't think the art and life implosion is a dead concept. Whether it's macro-trends of South-to-South trade networks, meso-trends such as the Zapatista models of social and military organization, or micro-trends such as off-the-grid, sustainable communities, the experiments continue under new conditions with new materials.

The dangers of the idea of the avant garde are well-known by now. CAE worries very little about abuse. Impressionistically speaking, we don't know of any movement that is looking to be a world order or the dominant mode of social life, or proscribing a plan for utopia. The useful remnants of the notion of the avant garde and notions of difference seem to have made peace.

MJL: Could you say more about this idea of difference vis-à-vis the avant garde and also how you consider things to have changed in that regard since the time you started out in the mid-to-late 80s.

CAE: The avant garde always had a tendency towards universalization. There is one history and an end of history towards which all humanity should aspire. After nearly fifty years of micro-politics that position has evolved. So if we take contemporary avant-gardists like Hardt and Negri who want to talk about universalisms, they do it in a way that is very sensitive to cultural, racial, sexual, and any other difference one might consider. So while they are very interested in commonalities on grand scales, they always resist making monoliths and consistently disavow the universal subject. Moreover, they form their discussion within the frame of indeterminacy, so it never becomes prescriptive. Another example is Franco Berardi. His book *The Soul at Work* tells us right in the title with his appropriation of the spiritual term "soul" (now secularized), that he plans on examining what we all share in relationship to the positive and negative aspects of work. At least in operational terms, there are conditions in which sameness can again be discussed without charges of progressive heresy.

When CAE began, the avant garde was "dead," or had never existed, and the radical and progressive universes had flipped from world solutions for humanity to atomized explorations of difference and identity. Much like the avant garde's dismissive, if not hostile, relationship to most minority opinions and perceptions, the cultural moment of the late 80s and early 90s also produced considerable intolerance, especially towards any use of notions like sameness, separatism, utopia, humanism, class (in the broadest sense of the term), revolution, or any hint of biological determinism. At the same time, it produced new regimes of discipline in which all speech was racist or all penetration was rape. Now that the avant garde is not a looming enemy prone to upending any foothold non-normative practices might obtain on the cultural beachhead, and identity politics is not so prescriptive, there is much more fluidity in what is possible. It now appears that when factions approach one another, they do so with the benefit of a doubt instead of with mutual suspicion. CAE hopes that we are describing what is and not just what we hope when we say that the current situation is marked more by cooperation than conflict.

The second primary difference is that the playing field of cultural politics is so much bigger. Nothing is off limits. CAE would like to think we helped to push boundaries, break the restraining elements of specialization, and demonstrate an operational interdisciplinarity.

Notes

1. Critical Art Ensemble, *Disturbances* (London: Four Corners Books, 2012). This interview was undertaken by email correspondence in December 2012.
2. Critical Art Ensemble, *Disturbances*, 40.
3. Brian Holmes, "Eventwork: The Fourfold Matrix of Contemporary Social Movements," in Nato Thompson, ed. *Living as Form: Socially Engaged Art from 1991-2011* (Cambridge: The MIT Press/New York: Creative Time Books, 2012) 78.
4. Gregory Sholette, "Disciplining the Avant-Garde: The United States versus The Critical Art Ensemble," *Circa* #112 (Summer 2005) 50-9. For more on the U.S. Government's prosecution of CAE members and colleagues, see Claire Pentecost "Reflections on the Case by the U.S. Justice Department Against Steven Kurtz and Robert Ferrell," in Critical Art Ensemble, *The Marching Plague: Germ Warfare and Global Public Health* (Brooklyn: Autonomedia, 2006) 123-48. See also Critical Art Ensemble, "Not So Quiet on the Western Front: A Report on Risk and Cultural Resistance within the Neo-Liberal Society of Fear," in Marc James Léger, ed. *Culture and Contestation in the New Century* (London: Intellect, 2011) 127-43.
5. As Alan Badiou puts it, "In these proper names the ordinary individual discovers glorious, distinctive individuals as the mediation for his or her own individuality, as the proof that he or she can force its finitude." Alain Badiou, "The Idea of Communism," in Costas Douzinas and Slavoj Žižek, eds. *The Idea of Communism* (London: Verso, 2010) 10.

Why Contemporary Artists Are Not Fascist Enough

BAVO

The dictatorship of art! This is what German artist Jonathan Meese has been pleading for in his performances over the last couple of years: Enough with the 'societalization' and democratization of art in a desperate attempt to legitimit it: Things are precisely the opposite: society and democracy owe their legitimacy to art, and thus need to be 'artified.'

Meese's plea for imposing a dictatorship of art is expressed in an oeuvre of exuberant paintings that combine personal hieroglyphs, collages, installations, and sculptures made out of a variety of materials, but especially, a series of ecstatic performances. These tempestuous performances with music and video loops can best be described as neo-expressionist, hypnotizing and even self-debasing epics of an anti-hero. With his quasi-fascist and anti-humanist conception of art, Meese can count on a great deal of sympathy within contemporary art circles. The reason for this is no doubt the increasing pressure placed on artists to create a niche for themselves within a broader cultural program based on values such as democracy and participation. With this, the traditional authority and autonomy of art is more than ever under threat. In this essay we show how Meese follows in the footsteps of contemporary radical philosophers like Jacques Rancière, Slavoj Žižek and Alain Badiou, who also enjoy considerable popularity among the current artistic avant garde. We show that, as opposed to Meese's supposed fascism, a more fitting answer to the dominance of the current paradigm of culture lies in exposing the dictatorial and fascist elements of this paradigm itself. Better still: to be really credible, Jonathan Meese is not fascist enough.

The Societalization of Art

Early in the twenty-first century, the idea of popular culture seems to have established itself once and for all as the dominant paradigm within the arts. Among policymakers as well as the people, the consensus is that art needs to have the broad support of society. The contemporary artist is expected to be fascinated with the societal context in which she lives, to involve as many parties as possible in the artistic production process, to strike the right chord with her art and to know how to choose the appropriate platforms to interpellate and mobilize certain target groups. The artist, moreover, should not regard himself as the possessor of an exclusive expertise but, on the contrary, should always question his own authority and authorship and work together with outsiders and laymen. While in the second half of the twentieth century a tough battle raged between the advocates of high art and those of popular culture, today this battle has been settled for good. Participation, democratization and social integration are the terms and criteria that are now firmly rooted in art practice. They dominate both policy documents on art as well as the discourse of artists and curators.

However, this doesn't mean that with the hegemony of popular culture, high art has been liquidated for good. The latter has rather been given its own niche within the paradigm of culture, from which it is frequently enlisted, along with other forms of cultural production such as design and architecture, to reproduce and legitimize liberal democracy. Contemporary art is, for instance, fully recognized and deployed as a soft yet effective force for reviving the local economy, the renewal of neighborhoods or the controlled tackling of sensitive social and cultural issues. In other words, even if art is asked to mainly 'do its own thing,' it doesn't escape the influence of the dominant normative framework of social engagement and relevance. One could see this as the price that high art has to pay for conserving its traditional privileges in a new era. Both the artist and his activities and products are more and more robbed of their traditional aura, autonomy and authority. Within the new paradigm everybody and everything can and is allowed to be art.

Versus the Dictatorship of Art

It was to be predicted that sooner or later there would come a fierce reaction on the part of artists. With the German artist Jonathan Meese, the aggrieved artist population has today found a heroic advocate of its age-old rights and privileges. The conception of art that Meese has been propagating in his eccentric way, under the slogan 'the dictatorship of art,' must give a much-needed shot in the arm to the many discontented artists. His vision of art offers them an empathic manifesto to take on the dominant paradigm of culture. In 2010, Meese propagated his conception of art during a performance in Amsterdam's Rietveld Academy.[1] We see Meese, a forty-year old with

196

Jonathan Meese, *Posing at the Great Wall of China near Beijing*, November 4, 2006. Photography Jan Bauer.Net. Courtesy of Jonathan.Meese.Com.

long hair, moustache, dark sunglasses and a long black leather jacket, pacing up and down a catwalk, while rattling off his manifesto guru-style in English with a heavy German accent. The Q&A session afterwards is merely an opportunity for Meese to further ram his vision down the throats of a somewhat perplexed audience. In his performances, Meese does his own thing in quasi-autistic fashion, without worrying about interacting with the audience, let alone the latter's response.

It is no coincidence that Meese stages his conception of art precisely in the current context and finds a relatively welcome audience for it. This is apart from the question as to whether he genuinely means what he says or merely puts on a show, as well as his actual popularity and influence within the art world (we shouldn't make a mountain out of a molehill). In the first place, we recognize in Meese's 'dictatorship of art' the good old notion of the autonomy of art, as summarized in the slogan 'art is art.' For Meese art is its own measure, criterion and authority: art itself determines whether it is art or not, and why. The taste of 'the people' or even colleague-artists and experts doesn't influence this whatsoever: art possesses its own truth, apart from 'Man' or society, so Meese maintains, and this truth proves itself.

The autonomy of art stretches so far that Meese bestows on art a will of its own: art does whatever it itself wants to do. The autonomy of art is thus not at all the autonomy of the artist: the latter is only a foot soldier or a privileged servant within the dictatorship of art. His or her only function is to assist art to do what it wants to do. He or she is only the temporary instrument of the superior and superhuman power of art. In short, as if the high days of sixties anti-humanism are not over, Man—and all his 'all too human' feelings, ideas and aspirations—is degraded to a mere vehicle for the autonomous and superior entity of art. Even if human beings might think that it is they themselves who make art or possess or use it for their own purposes, it is in fact the other way around. It is hard to imagine a more radical inversion of the dominant paradigm of culture and its humanist-democratic disposition.

The Umpteenth Rebirth of the Artistic Avant Garde

At the same time, however, Meese maintains that *everything* is art. He considers the entire world a theater or opera piece, talks about art as if it is a worldview and defines art as the 'leadership of a thing.' Meese thus combines an autonomous notion of art—an updated version of 'l'art pour l'art'—with a heteronomous notion—such as that of the historical avant garde. He doesn't just propagate the

197

thesis that art is itself, but also that art is everything, including that which is not or beyond art in the strict sense of the term. Art is thus not only its own authority, but also that of the entire world, yes, even the universe.

With these views Meese is not alone. His ideas are in line with the dominant climate of thought among radical-leftist defenders of contemporary art, mainly driven by post- or neo-Marxist philosophers such as Jacques Rancière, Alain Badiou and Slavoj Žižek. Meese's double affirmation of the autonomy and heteronomy of art could for instance be seen as a variation on Rancière's formula of the politics of art.[2] His views also resonate well with Badiou's plea for an inhuman, non-democratic art, based on his general critique of democracy as an instrument of today's neo-imperialism.[3] Meese's stress on the production of art as a duty that does not provide any pleasure to the artist or serves none of the latter's interests—or worse even: the artist has to completely eradicate her own pride and self-worth and even humiliate herself—reminds us strongly of the neo-Kantian Lacananism of Žižek.[4] Meese's claim that art necessitates the choosing of sides, that is to say, *for or against* art and nothing in between, blends well with the neo-existentialism of both Žižek and Badiou. In short, while Meese's vision of art on the one hand goes against the current of the times because it takes on the 'terror' of the democratic-humanist culture paradigm, on the other hand it is also very timely. With his views Meese however doesn't just share the same conceptual territory as anti-humanists, democracy-bashers and neo-communists like Žižek and Badiou. He also shares their provocative style—the way in which these thinkers diametrically oppose the dominant intellectual and societal climate and reverse all norms and values.

Human, All Too Human

So what to think of Meese's plea to reinstate the dictatorship of art at a time in which art is more than ever subjected to popularization and democratization? For an answer to this question we can start by looking more closely at the way in which Meese propagates his art vision. His performances are clearly characterized by a strong contradiction between form and content. While his vision of art stands for a fearless affirmation of art as an objective, superior force that dominates Man and the universe, his performances often come across as ludicrous, despite his enthusiasm. In the performance at the Rietveld Academy mentioned earlier, one can not only hear giggling in the audience, but also Meese's voice itself betrays a certain humorous intent. One consequently does not get the impression that Meese totally effaces himself as a soldier or servant in function of a higher cause. On the contrary, his own subjective idiosyncrasies—his guru-like appearance, the contrast between his yuppie-like Adidas uniform and his archaic, Gothic hair style—prevail over his message. Even if one tries one's best to follow Meese with his

vision, sooner or later the question arises whether it isn't a very ironic twist of fate that Art—as the ruling force of the universe—has chosen a miserable human being like Meese—who himself admits to only want to sleep and vegetate in his bathtub—to propagate its total revolution among earth's population.[5] Or, as one blogger puts it: "his eyes are too friendly. Perhaps he would have been more successful as a wrestler."[6] The effect of all this is that Meese's work is more about Meese himself qua person than about his art vision, as Claire Bishop puts it. She therefore characterizes Meese's performances in terms of a "subjective blitzkrieg."[7] The effectivity of Meese's plea for the supremacy of art is thus severely restricted by the following performative paradox: the plea for eliminating every subjectivity and humanity in art is subverted by the all too subjective and human way in which the plea is put forward.

One could of course say that precisely this contrast between Meese qua person and the latter's vision expresses most forcefully the radical split between art—as an a-subjective, infinite and superior entity—and the artist—as a finite, inferior creature. The same contrast is commonly applied in Hollywood movies in which a miserable, ridiculous individual is chosen by a superhuman force to execute an important and noble mission. The entire plot is then built around the split between the individual as finite being and the individual as servant of the infinite. Think of movies such as *Evan Almighty* or *The Life of Brian*. This contrast is mostly used for its comic effect as the chosen individuals do everything in their powers to escape their lofty mission. This internal struggle of the protagonist thus affirms the dominant humanist consensus on the unacceptability of human sacrifices for higher causes. It affirms a view of man as a weak, egotistical animal from whom it cannot be demanded to sacrifice his life for anything but her own interests and desires, rather than depict the worthiness of such self-sacrifice in the service of a higher calling. The appropriate response to the knee-jerk criticism of Meese for his flirting with fascism is thus rather that *he is not fascist enough*.[8] The fact that Meese likes to do the Hitler salute comes across as a personal, ironic joke (comparable to the flirting with Hitler by fashion designer John Galliano) in light of his refusal to efface himself as a person in the service of a greater cause: in this case not that of the Nation or Race, but that of Art.

It's the Dictatorship of Culture, Stupid!

Meese's art vision should be considered critically. In today's conditions, it is all too easy to once again plead for an uncompromising return to the high days of Art (with a capital 'A') as against culture (with a small 'c'). Such a plea is supposed to force the current paradigm of culture to assume a more modest, contemplative, self-conscious and self-critical position. It is quite unlikely, however, that this paradigm will feel called to do so in confrontation with its

Jonathan Meese, Posing with his *Hot Earl Green Sausage Tea Barbie (First Flush)* installation at the Bortolami Gallery, New York, USA, November 5, 2011. Photography Jan Bauer.Net. Courtesy Janathan.Meese.Com.

absolute, complete opposite. It is more likely that it will feel itself strengthened in its conviction of the necessity of the democratization and humanization of art. In this sense, Meese's art vision is still too hysteric: it adopts the rather obvious position to affirm everything that the present order denies. Meese discards everything the paradigm of culture stands for: horizontality (versus transcendence), democracy (versus dictatorship), the all too human (versus the super-human) and so on. This reversal of all values may well be meant as a provocation; still, it is too transparent to effectively realize this goal. Above all, Meese's art vision is a good example of what Isaiah Berlin called the "seduction of totalitarianism."[9] This lure consists in pleading, in times of democratic monotony, for values opposite to those of democracy: anti-individualism, purity, revolution, transcendence, etc. Here also, Meese's work can be seen in line with philosophers such as Badiou but especially Žižek, who unapologetically flirts with Stalinism.

There is certainly nothing wrong *in itself* with re-affirming totalitarian and authoritarian visions within the current climate. The crucial question however is which form of totalitarianism artists should encourage or take on themselves. As a commentator remarks with regard to Meese's work: "fascism is unlikely to be found in the most obvious places—under a fascist salute, for instance" since "today's most dangerous fascism is rather to be found in harmless-sounding things: the things we all do, the things we all think, the things we all believe in, the wars and environmental damage we cause as a result of all doing, thinking, feeling, wearing, watching and consuming the same (mostly idiotic and super-bland) things."[10] It is the task of the artist to affirm this predominant, socially sanctioned fascism and not its outmoded and universally condemned counterpart. Artists have to stage the underlying, inherent and often invisible fascism of the paradigm of culture itself. Think of the ways in which participation in culture often serves as an instrument for narrow nationalistic agendas (for creating regional and national identities), the way in which the 'inclusive' character of culture often serves the interests of a narrow political or financial elite, how it legitimates the fascism of 'the man in the street' or how it is used to subtly defuse and diffuse dissident voices in society within the general consensus. Enacting these fascist components of the paradigm of culture, which actually exist at its surface but still mostly remain invisible, is a much more effective strategy for disrupting it than the anachronistic and hysteric staging of its predecessor. It demands of the artist to be truly fascist, rather than staging it in carnivalesque fashion.

Notes

1. This performance took place September 27, 2010. Highlights can be found on: youtube.com/watch?v=HUr6VCzsTZU. For the accompanying manifesto, titled "Erzamsterdammanifest," see http://www.rietveldacademie.nl/project/performance-jonathan-meese-27-september-2010. See also the interview with Meese by Nicolai Hartvig, "Artist Jonathan Meese on Why 'Democracy is Finished' and Why Koons is Not King," (January 26, 2011), available at http://www.artinfo.com/news/story/36761/artist-jonathan-meese-on-why-democracy-is-finished-and-why-koons-is-not-king/.

2. See Jacques Rancière, *Malaise dans l'esthétique* (Paris: Galilée, 2004).

3. See Alain Badiou, "Third Sketch of a Manifesto of Affirmationist Art," in *Polemics* (London: Verso, 2006).

4. Think of art critic Claire Bishop's characterization of Meese's performances in terms of a "Teutonic abjectness." See Bishop, "Performance Anxiety," *Artforum* (March 1, 2006), available at http://artforum.com/diary/id=10553.

5. Hartvig, "Artist Jonathan Meese on Why 'Democracy is Finished' and Why Koons is Not King."

6. Momus, "Click Opera—Is Jonathan Meese a Fascist?" (July 29, 2007), available at http://imomus.livejournal.com/303574.html.

7. Bishop, "Performance Anxiety."

8. Momus, "Click Opera," and Georg Diez, "Poison in the Air: Why German Artists Should Keep their Hands off Hitler," *signandsight.com* (July 19, 2007), available at http://signandsight.com/features/1446.html.

9. See Diez "Poison in the Air."

10. Momus, "Click Opera."

Sponsored by Self-Management? Re-Constructing the Context and Consequences of Laibach's Monumental Retro-Avant-Garde

Alexei Monroe

Yugoslavia was created in the period of late surrealism and hyper social realism. It came to its climax in modernism, and began to dissolve in postmodernism. In fact, it was an eclectic retro-formation and not a homogenized modernist surface. The split of Yugoslavia, the change of a political system and war, which followed, was in a way a logical result of the end of the utopian dream, the end of heterogeneous concepts of life, the horror of the sublime.[1]

Yugoslav Mega (De)-Structures

In 1956 the architect Vjenceslav Richter created a radical design for a Yugoslav Pavilion for Expo '58 in Brussels. The original designs show what turned out to be an unbuildable gesture: a modernist structure suspended from a single mast of a type similar to the Skylon monument from the 1951 Festival of Britain.[2] Yet even without the mast, this was an elegant and forward-thinking pavilion that played a key role in strengthening Yugoslav cultural diplomacy and expressed the "official modernism" that the state set out to foster after the break with Stalin in 1948.[3]

It is hard not to see Yugoslavia itself as an impossible-real piece of political architecture created by both overt and reluctant avant gardists, forced by conviction or necessity to keep pushing ahead in order to prevent political and cultural gravity reasserting itself. Even as public cynicism about Yugoslav self-management increased, Yugoslav architects made ever more spectacular and radical attempts to carve out futuristic new spaces, sometimes for purely aesthetic reasons and sometimes in the hope that these constructions might inspire and accelerate the development of a forward-looking, progressive self-managing consciousness amongst the population. A structure like the 1966 Avala TV Tower outside Belgrade was aggressively and uncompromisingly futuristic—the expression of a desire to construct, impose and take to their limits the aesthetics of self-managed modernity.[4] A recent German exhibition featuring ex-Yugoslav artists, including Laibach, was titled *Spaceship Yugoslavia*, alluding to these fantastical, science-fiction-like qualities of Yugoslav architecture and culture.[5]

Gravity is not God's law / It's what prevents man's fall.[6]

In the 1970s and 1980s a series of increasingly alien and futuristic war memorials were constructed across the country, each seemingly trying to outdo the other in radicalism. One of the most symbolic is *Streljanim đacima* (Arrested Flight) by Miodrag Živković in the memorial park at Kragujevac, Serbia.[7] A monumental concrete construction composed of two colossal wings, it seems to be both on the point of takeoff and about to enter free fall. Some of the post-mortems on Yugoslavia seem to imply that as a state and a culture it flew too close to the sun and (by implication) deservedly crashed back to earth in flames. It is almost as if these late-Yugoslav space-age/pagan memorials actually marked the system's burnout—a final flash of creativity before a catastrophic re-entry into the history they tried to escape from even while commemorating it.[8]

Whilst in other totalitarian or authoritarian systems the producers or supporters of such designs might have been dismissed, arrested, exiled or subjected to compulsory psychiatric treatment, in Yugoslavia they were given huge budgets at a time when the economy was already entering crisis and were lauded for their aesthetic radicalism.[9] Yet the architects were not alone. Self-management ideology (often honored more in the breach than observance) was itself an experimental form driven by the avant-gardist desire to break free from existing norms. The political institutions were similarly experimental and state-sponsored experimentalism was highly visible in the visual arts, music and other fields.[10]

The problem was that already at the turn of the 1970s there was ample evidence from Yugoslav and international sociological research that the mass of the population had a tendency to resist innovation and to feel that the pace of

Poster for *Ausstellung Laibach Kunst*, Maribor, 2011. Courtesy of Laibach.

change was moving too quickly. While this sentiment was probably attributable to the constant constitutional and procedural innovations of self-management, it seems quite likely that it was also connected to and inflamed by the state's official artistic radicalism and its tendency to leave behind rather than carry along the constantly-invoked people in its wake. Here strong parallels can be drawn to the popular English reaction to architectural innovation in the same period.[11] It is as if this spectacular architectural avant-gardism went too far and too fast, leaving behind what was still in many respects an under-developed society, full of unresolved and regressive cultural tendencies that have re-asserted themselves with a vengeance since 1991. Even if the self-management rhetoric was far more progressive and humane than that of the most megalomanic currents of the Soviet avant garde, a connection could certainly be made to the most metaphysical and futuristic currents of this same avant garde and the desire of figures such as Velimir Chlebnikov to conquer space and time.

Besides *Arrested Flight* we could consider other ways in which Yugoslavia symbolized flight. There is a much earlier precedent from the first Yugoslavia—the colossal sculpture of a winged figure that adorns the now-derelict Yugoslav air force headquarters in Belgrade. In this case the figure is stretching its wings but looks resolutely forward rather than upwards, as if unable or unwilling to do otherwise. Although not used by Laibach, this sculpture is typical of the type of architectural monumentalism the group has tended to appropriate and use to construct its own retro-futuristic conceptual structure. It is the type of sculpture that many now describe as "Laibachian," imposing and heroic yet also tragic and absurd. A short drive away on the edge of Belgrade airport—itself a highly optimistic example of internationalist modernism—sits the explicitly futuristic Museum of Aviation, a silvered flying saucer-like building.[12] Although the fabric of the building is intact, the fact that in the neighboring field the remains of the Yugoslav air force sit rusting away makes it one of the strongest metaphors of the system's catastrophic fall back to the *Bloody Ground, Fertile Soil* that Laibach invoked in the mid-1980s.[13]

Laibachian Perspectives

Nothing that has been created is so sacred to us that it cannot be changed, that it cannot be replaced with something more progressive, more liberated, more humane.
 —Programme of the League of Communists of Yugoslavia, exhibited at Expo '58[14]

Yugoslav artists growing up in this context of constant aesthetic escalation and an ever-widening gap between utopian aspirations and forms and an increasingly disillusioned population faced many dilemmas. Here again it has to be emphasized that although there were limits and artists did encounter some censorship, Yugoslavia's radical visionaries tended to be more encouraged than censored, and unlike many Soviet avant gardists, they were not sent to labor camps or shot. In fact, Darko Šimičić has noted that after World War II Yugoslav surrealists "went on to occupy key political and cultural posts."[15] The question facing young artists and intellectuals educated to be critical and radical by a system that still contained strong and only partly restrained conservative and authoritarian tendencies was how to assume an "avant-garde" or radical stance within and against a (built) environment that was already so futuristic and radical? If they succeeded in gaining state patronage without compromising their aesthetic ideals (or even whilst being encouraged to pursue them) they would be aware that they were (re)-constructing the progressive facade of a system that was increasingly perceived to be failing and might well be helping to re-legitimate it.

In this context such artists could not directly assume the heroic, vanguardist stances of the Soviet avant garde, leading a backward population forwards into a constantly re-shaped and ever more radical future. From the early 1970s onwards various Yugoslav artists and musicians began to perceive that the route out of the system's constant compulsory innovation might lead backwards, via a re-embracing of concepts and forms that the dominant (artistic) ideology claimed were obsolete or counter-productive.

One early manifestation of this tendency was the so-called "Belgrade conceptualism" associated with figures such as Raša Todosijević, Marina Abramović, Goran Đorđević and others. Belgrade in this period was strongly integrated into the western art scene and there were strong connections with figures such as the Edinburgh gallerist Richard de Marco (who would later present work by the NSK fine arts group Irwin) and Joseph Beuys, who visited Belgrade in 1974. The influence of the theoretical conceptualism of Art and Language was also perceptible in Belgrade. It is also important to remember the activities of radical Croatian artists such as Sanja Iveković, Tomislav Gotovac or Mladen Stilinović, who pursued similar agendas to their Belgrade colleagues, sometimes by even more provocative means. In Slovenia the radical conceptual group OHO (whose work Irwin would later appropriate) pursued a practice embracing land art, video, photography and other forms.

However, Belgrade conceptualism was especially important as it was a source of inspiration for Laibach member Dejan Knez during his military service in Belgrade and it was in Belgrade's Student Cultural Centre (ŠKC) that Laibach Kunst's first exhibition and concert took place. It was also important that some of these artists were successful in producing shocked reactions from a system with such a progressive (and self-congratulatory) self-image. A key aspect of this was the ambivalence and formally antisocial edge of some conceptualist actions and works. A work such as Todosijević's 1978 video piece *Was ist Kunst, Marinela Koželj?* (source of a key Laibach and NSK slogan) was problematic in various ways. It shows an unseen interrogator (Todosijević) relentlessly demanding of a passive woman *Was ist Kunst?* ("what is art?"). As the fruitless interrogation proceeds he repeatedly manhandles and grabs her face, trying to force an answer out of her.[16] The fact that the interrogation takes place in German gives the work an even harsher edge that contradicts the declared self-management norms of progressive humanism. The conceptualist critique of constant technological progress and its theoretical interrogations of language and social rituals had potentially explosive connotations as these areas of inquiry were situated squarely in the growing gap between self-management ideals and "actually existing" or "everyday" self-management as experienced by those outside Yugoslavia's political and cultural elites. These small but influential groups of conceptualists encountered some obstruction and censorship and Abramović eventually chose to leave the country. However, within their small circles they were able to develop a critical response to the reality of self-management as part of the wider conceptualist critique of late-twentieth-century consumerist mass societies.

Just as in art, the system saw itself as pragmatically liberal in the field of music. Musical radicalism and avant-gardism was sponsored through events such as the internationally-respected Zagreb Biennale of New Music and electro-acoustic, improvisational, serialist and minimalist tendencies could be found in the work of Yugoslav composers and musical institutions.[17] The situation in popular music was more complex. Edvard Kardelj, the ideological architect of self-management (and source of some Laibach statements) had helped persuade Tito that a tolerant policy in relation to most forms of popular music (including rock) was a pragmatic tactic that could help re-produce the system's legitimacy amongst Yugoslav youth and also serve as a propaganda device to distance Yugoslavia from the other far more censorious state socialist systems to the East. This policy allowed for the import and licensing of most western popular music and young, urban Yugoslavs were keenly aware of the latest stylistic twists and turns.

However, there were definite and sometimes hard limits to this freedom, especially in relation to domestic rock groups whose work was monitored far more closely and seen as more dangerous than the western imports. Lyrics sometimes had to be changed as a condition of publication and the neo-conservative atmosphere after the limited purges of liberal elements in 1972-73 led to the imposition of draconian restrictions on more experimental or alternative domestic rock groups. In Slovenia the presence of police dogs, alcohol bans, plainclothes officers and strict curfews became regular features of concerts by local bands.[18] Laibach later reproduced this oppressive atmosphere in its live performances.

In this period younger Yugoslav musicians, artists, curators and intellectuals were keenly aware how quickly the political wind could change direction. Even if the system remained formally committed to the radical and even utopian norms of self-management, this was no guarantee of immunity from increasing repression and as we have seen the constant stylistic innovations of self-management could even be seen as strengthening the hand of more conservative forces keen to restore order and rein in the most avant-garde tendencies of the system.[19] Due to the gap between the utopian potentials of self-management and the cynicism generated by the often banal and corrupt realities of its implementation, the most radical or subversive gesture available was to take it seriously and to demand its literal implementation (even in the knowledge that this could actually "break" the system irrevocably).

When Punk began to manifest itself in Ljubljana from 1977 onwards it caused a swift reaction that bore out the fears of those who saw how easily and naturally the power structures might ally themselves with reactionary populism in the name of order and morality. The imported worldview of Punk found fertile ground amongst Ljubljana's increasingly alienated and bored youth, dismayed like their British counterparts by the growing emptiness and authoritarianism of a dysfunctional consumerist society that seemed to be dominated by stylistic or ideological "dinosaurs." What one branch of the Slovene Punks added to the British formula was a strong theoretical and political edge that made it a more serious and destabilizing phenomenon than its British counterpart, which was already largely commercialized and spectacularized by 1978.

Yet if Punk was already a provocation, the import of the industrial culture associated with Throbbing Gristle (TG) and Cabaret Voltaire into Slovenia was even more explosive. The original industrial approach to culture was systematically interrogatory. It created a dystopian aesthetic that brought to the surface and questioned the dystopian dynamics of Cold War consumer societies. Themes such as social and media control, information warfare and para-militarism

combined with unprecedented audio-visual brutality represented a less populist but infinitely more incisive challenge than Punk. In Yugoslavia at the dawn of its last full decade of existence, to draw the lessons of the British industrial groups and to apply them in the immanently catastrophic and hyper-ideologized local context could only lead to trouble.

Laibach emerged in the shadow of another late-Yugoslav mega-structure: the *Termo-elektrarna II* power station in Trbovlje, site of the tallest industrial chimney in Europe.[20] Unlike many avant gardists and the majority of their fellow industrial music producers, its members were actually drawn from the industrial working class and they grew up surrounded by the scale, noise and dust of Trbovlje, the most industrialized city in Slovenia. This made their relationship to industrial culture a much more organic and natural one than that of many western industrial groups. As it transpired, industrial was especially appropriate to the context of a hyper-ideological but increasingly consumerist and authoritarian state such as Yugoslavia and Laibach arguably achieved more concrete social and political impacts than any western industrial group.[21] Although TG wrote programmatic manifestos and provocative texts, they were comparatively light in tone compared to the oppressive density that, almost from the outset, marked Laibach's use of language.

In the first half of the 1980s Laibach presented itself as Laibach Kunst, a cross-platform group working in fine arts, video, installation and sound. Its self-conferred mission was to explore the relationship between art and ideology and it did this using an extremely eclectic combination of sources. In artistic terms, the influence of Belgrade conceptualism sat alongside citations from and references to Beuys, Anselm Kiefer, René Magritte, Nazi Kunst, Socialist Realism and numerous other sources. Sonically Laibach adapted techniques not only from TG and other industrial groups, but also from Kraftwerk and Joy Division, and from both historical and contemporary composers such as Krzysztof Penderecki and John Cage. These divergent and contradictory sources were forged into a threatening and increasingly monumental whole through a total disregard for established political and stylistic norms (both in the West and the East) and through a fluent repetition of the arbitrary disregard that totalitarian ideologies have for history and morality.

Like many of their generation in Yugoslavia, Laibach members were also shaped by the efforts of the system to produce articulate and well-educated subjects with an acute and partly pessimistic cultural awareness. This knowledge of literature, art history, ideology and of philosophical strands such as the Frankfurt School was combined with a fluent and ardent repetition and distortion of official language and statements. This is the technique of "de-masking and recapitulation" that Laibach applied to a whole series of political and cultural regimes.[22]

A typical Laibach text blends samples from figures such as Theodor Adorno with references to the Soviet avant garde, Nazism or Italian fascism, plus samples or plausible paraphrases of official self-management discourse, including the words of Tito himself.[23] Laibach used ideology and official discourse as "readymades" just as they used the symbolisms and artworks of totalitarianism.[24] This fissile combination of sources was shot through with tautology and dead ends, yet the militant consistency with which this language was elaborated was also plausibly totalitarian (any simulation of totalitarianism needs to include contradiction as this is one of the central hidden characteristics of totalitarianism in practice, since, as Erika Gottlieb points out, this "law of contradiction" is as typical of totalitarian ideology as it is of the artistic avant garde).[25]

A tautological law of contradiction communicated via harsh electronic sound and para-military aesthetics was almost as discomforting to self-declared radicals as it was to mainstream opinion. Laibach's militarized aesthetics (transmitted by group members wearing modified ex-Yugoslav army uniforms and using smoke bombs at concerts) were a reflection of the avant-garde nature even of Yugoslavia's military stance, in particular the radical strategy of "General People's Defence" involving mass popular mobilization and resistance in the event of a foreign ground attack.[26]

When we speak of avant-garde, we believe that the most beautiful of all were the performances of those "avant-gardists" who performed between 1920–1940 in Rome once a year and executed exceptionally skilled corporal drills. That is what the schooled youths between the ages of thirteen and eighteen were called. They moved their slender limbs and bodies in a precise rhythm as a single body.

In the feudal period, the term "avant-garde" denoted hound dogs in a hunt. Later, the trophy which was hounded and ripped apart by the modern avant-garde became man himself. The history of the world art avant-garde is a symptom of the agony of the world, caught in the demonism of capital and matter. The history of the modern avant-garde is the history of the gradual destruction of man. "The death of art," towards which the last avant-garde movements tend, means "the death of man." We do not soil our hands with such blood.[27]

The hostility Laibach drew from Punk audiences and the suspicion with which some leftists and intellectuals treated the group was an important sign of the success of what I call its "full spectrum provocation," its militant assumption of a scapegoat role and its willingness to offend and question potential allies as much as friends. This was symbolized most dramatically during Laibach's performance at the annual *Novi Rock Festival* in Ljubljana in September 1982. Laibach vocalist Tomaž Hostnik appeared on stage in uniform and performed the track *Cari Amici*, based on a speech by Mussolini.[28] Hostnik maintained a brutally impassive Mussolini-like pose even after having been struck by a bottle thrown from the partly enraged audience. This provocative, self-demonizing strategy exemplifies the militant coldness that Laibach deployed in relation to its audience (of whatever nature).[29]

Since the largely voluntary and enthusiastic embrace of fascism by Italian Futurism, the avant garde has always been seen to carry the potential of transmuting by design or accident into reactionary politics. Another example is that of the poet Ljubomir Micić, the force behind the 1920s *Zenitism* movement (a key inspiration for the theatrical activities of NSK) and creator of the concept of the Balkan "barbarogenius." After some years spent in exile in Paris, Micić's last public act was the 1936 publication of a nationalist magazine entitled *Serbianism*.[30] The systematic violation of political, moral and social taboos that the avant garde entails does not always have limits beyond which it does not allow itself to go and its megalomanic, world-altering agendas can lead into dangerous territory when allied to concrete political goals. In the words of Jonathan P. Eburne and Rita Felski, "semiotic and social subversion are far from synonymous, and the defiance of artistic convention comes without political guarantees."[31]

Laibach seems to have tacitly accepted Peter Bürger's thesis about the failure of the historic avant garde, which was anathema to many 1970s leftists.[32] This retro-garde awareness of failure plus the awareness of the potential dangers associated with assuming an avant-garde stance led Laibach to develop a position that symbolically incorporated in advance the rightward political drift or orientation seen in the careers of many historical avant-garde figures.

Tomaž Hostnik in uniform and Laibach on stage at the annual *Novi Rock Festival* in Ljubljana, September 1982. Photo by Nikolaj Pecenko.

We are acquainted with the aberrations and contradictions of the disillusioned artistic avant-garde. We have no intention of reproducing or interpreting it. The ideology of surpassing has been surpassed and it must never happen again that the spectator-consumer confuses the packaging with art.[33]

So although Laibach and later NSK assumed a vanguardist, heroic mode of attack in sympathy with the spirit of the historic avant gardes, it insured itself against political corrpution by foreswearing any direct party political role, even while creating the illusion of itself as a mass totalitarian movement. Historically the avant garde has tended to establish simultaneous lines of flight both towards and away from power, but throughout the 1980s Laibach seemed to be primarily engaged in flight towards or even *beyond* power. Laibach sought to distance itself from and reveal the pervasive extent of hyper-ideologization by going closer to power rather than fleeing from it in the traditional dissident or underground ways.

As well as theoretical sophistication and rigor this strategy needed, to use the title of the Orson Welles film appropriated by Laibach as the title of its infamous 1982 concert in Zagreb, the "touch of evil."[34] Laibach's was a high-risk strategy, politically and culturally, but it managed to achieve a kind of self-innoculation by self-contamination, blocking any access to political temptation by assuming a demonized, scapegoat role and repeatedly reproducing the rejection first seen on the streets of Trbolvje in September 1980.[35]

For the rest of the decade Laibach acted out an artistic "strategy of escalation" that resulted in repeated clashes with the authorities and a degree of notoriety and social impact some avant-gardists would sell their souls for. Laibach developed the industrial aesthetic and consciously used sound as both a weapon and as one of the building blocks of its monumentalism. It clearly rejected the self-imposed stylistic limitations and limited ambitions of Punk and of "underground" music in general. Following the "Touch of Evil" concert in December 1982, Laibach returned to Zagreb the following spring with a far more powerful visual, conceptual and sonic arsenal.

On March 6, 1983, Laibach staged the exhibition *Austellung Laibach Kunst-Regime Transavantgarde* in the Prošireni Mediji (Expanded Media) gallery, which was known in Zagreb as the home of radical artistic experimentation. However, after three days, following pressure from the local authorities, the management closed the show. The most provocative element of the exhibition was a still-life painting of a coffee cup bearing a swastika, but even without this the fact that the exhibition made a strong impact amongst Zagreb's alternative youth would have been enough to have worried the authorities.[36] Laibach's members were escorted by police to the main train station and put onto a train for Ljubljana.

True to its compulsive need to probe the relationship between art and ideology, Laibach soon returned to Zagreb with an even more explosive agenda. Skillfully manipulating the cultural system's weakness for and desire to incorporate radical culture, Laibach infiltrated the Zagreb Biennale of New Music, one of the key embodiments of self-management cultural values. On April 23, Laibach staged an all-night concert alongside the British groups 23 Skidoo and Last Few Days.[37] Laibach's harsh industrial soundtracks were backed up with the Yugoslav propaganda film *Revolucija još traje.*[38] The show was finally halted by police and Laibach were ejected after pornographic images and Tito's face were juxtaposed on screen.

The organisers rushed to disassociate themselves from this provocation and the event created a minor scandal in the Slovene and Croatian media and on May 12 the Slovene radical magazine *Mladina* published a letter from Laibach explaining its intentions in the concert. Laibach claimed the organisers were fully aware of its content (which they denied). The letter is one of Laibach's most open and detailed explanations of its methods (although the language retains the tautological and intimidating qualities of all Laibach statements). Laibach openly states that it is exploring "mass-psychology and the logic of manipulation through information," which would seem to confirm the worst fears of the group's critics (that for some obscure political purpose, or—perhaps worse—for the sake of pure provocation, Laibach practices mass manipulation).[39] However, Laibach simultaneously referred to an unexpectedly wide range of artists, schools and ideologies which it claimed informed its "provocative interdisciplinary action." These included Fluxus, bruitism and the work of figures such as Nam June Paik, Robert Rauschenberg, John Cage, and Joseph Beuys (there are various references to Beuys in the work of Laibach and the group appropriated his "social sculpture" concept).[40] Laibach claimed that when applied to ideological and historical trauma such techniques could encourage "critical awareness" in those exposed to it.[41]

Here Laibach played a double-game, defending itself using "respectable" avant-garde figures and techniques already validated by contemporary art history and theory in Yugoslavia as well as the West, while not conceding that there are problems that arise when these are combined with the simultaneous use of totalitarian elements. Although the

Invitation to the Zagreb exhibition *Ausstellung Laibach Kunst-Regime Transavantgarde* in the *Prošireni Mediji*, 1983. Courtesy of Laibach.

Laibach at Zagreb Biennale, 1983. Courtesy of Laibach.

primary impression was dystopian, Laibach was re-animating both the militaristic spirit of the Italian avant garde and the optimistic-deconstructionist spirit of Fluxus and the 1960s avant garde. Musically it incorporated elements of the Futurist approach to noise, industrial music techniques but also samples from figures such as Penderecki, who represented the type of officially-endorsed musical avant-gardism the Zagreb Biennale promoted.[42]

Our basic inspiration, ideals which are not ideals to their form, but the material of Laibach, manipulation of self, remains an industrial production: art of the Third Reich, totalitarism, Taylorism, bruitism, disco.[43]

It is important to remember that despite attempts to infiltrate the industrial scene and the appeal of an aesthetics of force for the extreme right, "mainstream" fascism is in practice suspicious of, if not hostile to, avant-garde and experimental approaches to music or culture and Nazi (and Stalinist) musicology always condemned atonal and avant-garde music.[44] Here again, Laibach dramatized the inconsistency of the Yugoslav cultural context. The cultural authorities went to great lengths to embrace "official modernism" and refused to condemn musical or artistic experimentation per se but when experimentation was combined with transgressive political or symbolic contents, the limits of official tolerance rapidly became clear.

How could you have a slogan like "freedom is slavery" when the concept of freedom has been abolished? The whole climate of thought will be different. In fact there will be no thought, as we understand it now. Orthodoxy means not thinking—not needing to think. Orthodoxy is unconsciousness.

One of these days, thought Winston with sudden deep conviction, Syme will be vaporized. He is too intelligent. He sees too clearly and speaks too plainly. The Party does not like such people. One day he will disappear. It is written in his face.

—George Orwell, 1984

209

Laibach during the interview on the Slovene TV program *TV Tednik*, June 23, 1983. Courtesy of Laibach.

happiness lies in total negation of one's identity, deliberate rejection of personal tastes and beliefs, in depersonal-isation, sacrifice, in identification with a higher system, the mass, collective ideology.—Laibach, June 23, 1983

Following the Biennale controversy both Slovene and Croatian authorities agreed on the necessity of finding some way to expose and/or suppress the group. The result was a live interview broadcast on Slovene TV on the program *TV Tednik* on June 23, 1983. (Laibach refers to this as the action *XY-Nerešeno* (XY-Unsolved). This was staged in the ŠKUC gallery, the epicenter of the Ljubljana alternative scene. Laibach members appeared in uniform against a back-drop of the poster it created for the Biennale concert. In response to the presenter's loaded questions a group member recited texts known as the *Documents of Oppression*.[45] Laibach's cold, automated performance had a chilling effect that alarmed many viewers but is now seen to have functioned as a warning about the imminent return of real rather than phantasmal authoritarian forces within the system. Like Syme in *1984*, Laibach spoke too ardently and too explicitly about the dystopian core of the totalitarian ideal, causing destabilizing confusion and embarassment within the local leadership. The presenter's concluding remarks were an explicit—albeit slightly theatrical—appeal to the forces of civic and political repression: "If I got it right, you use television to challenge us. Fine, so do we. Maybe, maybe now some-body will act and repress these horrifying ideas and declarations here in the middle of Ljubljana."[46]

In the following days Laibach was widely denounced by the media and public for its fascistic appearance and totalitar-ian language. However, the group had worn modified Yugoslav army uniforms and some of the statements were quo-tations or paraphrases of official Yugoslav statements, including one by the ideological architect of self-management, Edvard Kardelj. In the aftermath Laibach members went to ground and the authorities re-discovered their taste for cultural suppression, although they still chose a more subtle method than might have been expected in similar circum-stances elsewhere in Yugoslavia, let alone in other state socialist regimes. While the group's members were not directly punished and its activities were not explicitly banned, the Ljubljana socio-political assembly determined that the use of the name of the city required permission (including in the German form) and that Laibach's use of it was unauthorized. Laibach was then forbidden from performing under its name until March 1987, by which time the Slovene leadership had changed and elements of the power structure were trying to use Laibach and other alternative phenomena as a means to re-legitimate themselves.[47]

Alternative activist and key figure at ŠKUC, Marina Gržinić claims that Laibach gradually came to function as an "index of pluralism" in 1980s Slovenia.[48] Operating from the unclaimed totalitarian space of mobilization that the self-management state had formally foresworn, Laibach acted as public enemy number one, attracting the most extreme criticism and so relieving some of the pressure on alternative cultural and social movements. The gradual (though crucially never complete) normalization of Laibach's status from 1987 onwards coincided with and symbol-ized the rapid liberalization of culture and politics in Slovenia.[49]

If Yugoslav architecture's (over-)identification was with the utopian core of self-management, Laibach's over-identifi-cation was with the dystopian core of self-management that the system itself was both in flight from and falling back towards. Laibach unmasked and recapitulated the program of the League of Communists, fanatically acting out its dictum "Nothing that has been created is so sacred to us that it cannot be changed," but replacing what has been created with something seemingly more reactionary, more repressive, and less humane than even Nazism or Stalinism, leading some to believe that the group stood for a demonic combination of the two totalitarian ideologies. Laibach was plausibly totalitarian in that it incorporated propaganda from right and left as well as the archetypes of the totali-tarian state and of de-humanizing institutionalism. It artistically incarnated the specter of an aestheticized "totalitar-ianism for totalitarianism's sake" with no interest in concealing its repressive potential. Laibach utilised a Tantalus dynamic: seeming to offer the core of direct political enjoyment but replacing it with a void, just at the moment when it seems to be in the spectator's grasp.

"Time for a Change"

In [the] case of Yugoslavia Schopenhauer would say that the sublime finally led into resignation and he would be very close to the truth. Yugoslavia was created in the period of late surrealism and hyper social realism. It came to its climax in modernism, and began to dissolve in postmodernism. In fact, it was an eclectic retro-formation and not a homogenized modernist surface. The split of Yugoslavia, the change of a political system and war, which followed, was in a way the logical result of the end of the utopian dream, the end of heterogeneous concepts of life, the horror of the sublime.[50]

Discussing late Yugoslav architecture Petra Čeferin argues that "all these structures didn't quite fit in their own time;

even more, they remain somewhat 'inappropriate' to every time, every situation."[51] Such temporal dislocation explains the otherworldly qualities attached to both the most uncanny late-Yugoslav architecture and to Laibach. If many Yugoslavs were suffering from a degree of futureshock caused by a production-line of alienating architectural, artistic and ideological novelties, this did not mean they were ready for or receptive to what we could call Laibach's "pastshock" tactics and the group's implied message that the genocidal and totalitarian near past was somehow bound up with and increasingly present in Yugoslav hyper-contemporaneity. Laibach dramatized and exploited the official/radical tensions and synergies that affected Yugoslav experimental architecture and for very different reasons both were committed to taking the system further than it wished to go.

Laibach's repetitive and oppressive deployment of the totalitarian aesthetics of the 1930s and 1940s, accompanied by more esoteric pagan and even Satanic references, violated the progressive contemporaneity of the Yugoslav system. Laibach forcibly re-introduced, supposedly archaic and outmoded categories such as God, nation and religion. These were placed alongside hunting and feudal symbolism and a paradoxical reassertion of the value of traditional, historic forms of art and music and many other elements guaranteed to arouse distrust and discomfort (but also fascination) within contemporary consciousness.[52] In this way the already doubtful narratives of modernity and progress were violently questioned. These elements of the *retro* avant garde were used by Laibach to execute what I call a "mystifying demystification," executed via a type of (re)-constructive deconstruction summed up in Laibach's comment on their German industrial contemporaries Einstürzende Neubauten:

> *The Neubauten are destroying new buildings and we are restoring the old ones. At this point we are replenishing each other.*[53]

The temporal dislocation produced by retro-avant-garde aesthetics reintroduced real shock to the heart of an officially tolerant political and cultural system, allowing the gravity of power to re-assert itself, both contributing to and providing a warning of the consequences of Yugoslavia's imminent fall back to earth. Another tempting classical metaphor for late Yugoslavia's aesthetics and ex-Yugoslavia's fate is Promethean: it could be argued that its radical, transgressive innovations have been severely punished by the higher powers and their agents.

The monumentalism of the Laibachian aesthetic was apparent from an early stage but this aspect came to the fore as it gained resources and notoriety and joined with fellow retrogarde artists in establishing NSK. The scale of Laibach performances and of the collective NSK performance *Krst pod Triglavom* (1986) helped create a dwarfing effect, making the actual state authorities look amateurish and indecisive in comparison with their apparent fanaticism. The dissemination of retrogarde and Laibachian symbolism in different media and a wide range of social and media contexts by the other NSK groups strengthened the impression of NSK as not just a *Gesamtkunstwerk* but a mass cultural movement (this perception was particularly strong in the West). Through this uncompromising but abstracted monumentalism, NSK at least partly achieved the historic avant garde's goal of using art to influence real life, both in Slovenia and the rest of Yugoslavia.[54]

One of the building blocks of NSK's aesthetic facade was the work of the architect Jože Plečnik, known for his work at Prague Castle and for several major projects in Ljubljana, including the monumental pagan-postmodern structure NUK (National University Library), which was used as a backdrop to some NSK presentations. Also useful was the cemetery at Žale, used by Laibach for publicity photos in 1987. NSK appropriated Plečnik's unbuilt (and probably unbuildable) design for a Slovene national parliament and re-titled it *Slovenska akropola* (Slovene Acropolis).[55] This monumental tendency reached its apex in the work of the short-lived NSK architecture section *Graditelji* (The Builders).

> *We Builders neither stroll nor fly, we are the product of static totalitarianism, which brooks no petty feelings, preferring their erasure or assimilation.*[56]

The unrealized works of The Builders played an important symbolic role in the construction of the *Neue Slowenische Kunst Gesamtkunstwerk* and then of the NSK State. The fact that it was plausible and natural for the State to be created was due to the aesthetic construction work undertaken between 1984 and 1992. It was the utopian result of the totalitarian, industrial and monumental elements used to achieve NSK's mystifying demystification. The Builders' neo-totalitarian designs for a Laibach City to be built in the Alps were a small but important part of this process. The regimented ranks of cross-shaped blocks seen in the 1988 Slovene TV film *Silicijev Horizont* and briefly in the BBC's 1989 *Rough Guide to Ljubljana* were part of the paradigm of impossible authority with which Laibach NSK confronted both state and public.[57] Even as models in a TV studio they have a monumental, threatening aura and it's tantalizing to

imagine how their design work might have developed further. NSK worked on a scale sufficient to overshadow and symbolically de-legitimize the state that it operated within. Within Slovenia NSK annexed the space of monumental totalitarian mobilization that would otherwise have been accessible to concrete political forces. As the NSK Gesamtkunstwerk gained symbolic power it became clear that actual manifestations of Yugoslav state power could not compete in greater grandeur or aesthetic force. Perhaps this is why some in the West assumed that NSK was a direct expression of Yugoslav cultural power and it was even reported that NSK drama group Red Pilot had been appointed as the national theater of Yugoslavia. The assumption behind this was that only a state-supported institution could project such aesthetic force, whereas in fact, and with hindsight, it is clear that only a retro-avant-garde movement employing extreme power symbolism that became a virtual, post-territorial state not bound up with party politics could have done this.

Our freedom is the freedom of those who think alike.[58]

Notes

1. Laibach, english summary of interview for *TIP* magazine Berlin, 2012. Email to author, December 14, 2012.
2. Skylon and the equally radical Dome of Discovery were demolished after the festival on the order of the new Prime Minister, Winston Churchill, who was determined to purge the contaminant of utopian modernism from Central London.
3. For more on the Yugoslav pavilion and its associated policies, see Maroje Mrduljaš and Vladimir Kulić, eds. *Unfinished Modernisations: Between Utopia and Pragmatism* (Zagreb: CAA, 2012) 46.
4. See "Mount Avala TV Tower," at http://en.structurae.de/structures/data/index.cfm?ID=s0006008 (Accessed December 5, 2012).
5. See *Spaceship Yugoslavia – The Suspension of Time* (Berlin: Argo Books, 2011).
6. Laibach, *Sponsored by Mars*, from the album *Kapital* (London: Mute Records, 1992).
7. See "Sculptor: Miodrag Živković," available at http://miodrag-zivkovic.com/strane/kragujevac.htm (Accessed December 5, 2012).
8. Another example is Marko Mušič's 1976 Memorial Centre at Kolašin, Montenegro.
9. In the 1970s and 1980s there were also some surprisingly radical architectural designs in the U.S.S.R., Bulgaria and other Warsaw Pact states, yet the limits of aesthetic freedom were far tighter in these contexts and the penalties for infringing them were much more severe.
10. This is a key point of difference with the U.S.S.R., which did permit some surprisingly radical architecture in the 1970s and 1980s but kept a much tighter control over other artistic spheres, particularly visual arts and music. See for instance the strict counter-measures experienced by the Moscow Conceptualist artists. For more on Moscow Conceptualism, see Jörg Heiser, "Moscow, Romantic, Conceptualism, and After," *Journal #29* (November 2011), available at http://www.e-flux.com/journal/moscow-romantic-conceptualism-and-after/ (Accessed December 5, 2012).
11. See Sharon Zukin, *Beyond Marx and Tito: Theory and Practice in Yugoslav Socialism* (Cambridge: Cambridge University Press, 1975) 213. There is no space here for a detailed discussion of the severity and political effects of popular future shock in Yugoslavia but it seems to me a probable factor in generating alienation and encouraging reactionary forces.
12. In Goran Gajić's 1988 Laibach documentary *Pobeda pod suncem* (Victory Under the Sun) (Belgrade: Avala Film 1988), the group can be seen walking in uniform through the corridors of Belgrade airport, an example of the group's systematic occupation of monumental spaces from all architectural eras. With the benefit of hindsight, their appearance at the airport seems highly ominous. See *Victory Under the Sun*, sections 6:22 to 7:00 on You Tube, available at http://youtu.be/zcvD_jdCce8 (Accessed January 4, 2013).
13. Laibach, *Krvava gruda, plodnja zemlja* (Bloody Ground, Fertile Soil) from the album *Nova Akropola* (London: Cherry Red Records, 1986).
14. See Marduljaš and Kulić, eds. *Unfinished Modernisations*, 47.
15. See Darko Simičić, "From Zenit to Mental Space: Avant-garde, Neo-avant-garde, and Post-avant-garde Magazines and Books in Yugoslavia, 1921-1987" in Dubravka Djurić, Miško Šuvaković, eds. *Impossible Histories: Historic Avant-gardes, Neo-avant-gardes and Post-avant-gardes in Yugoslavia, 1918-1991* (Cambridge: MIT Press, 2003) 315.
16. See Raša Todosijević, "Was ist Kunst, Marinela Koželj?" available on You Tube at http://youtu.be/0rKb4GxK1a4 (Accessed January 4, 2013).
17. See Mirjana Veselinović-Hofman, "Problems and Paradoxes of Yugoslav Avant-garde Music (Outlines for a Reinterpretation)" in *Impossible Histories*, 404-41.
18. See Gregor Tomc, *Druga Slovenija* (The Other Slovenia) (Ljubljana: KRT. 1989) 121-2.
19. Zukin cites the editor of Belgrade's influential *NIN* as claiming that Yugoslavs "now find [themselves] before the tendencies that [their] self-managing democracy should be either "corrected" by some kind of bureaucratic restoration or on the other hand "hastened along" by some variant of a cultural revolution." In Zukin, *Beyond Marx and Tito*, 251.
20. See the entry for "The Trbovlje Chimney," available at WikipediA at https://en.wikipedia.org/wiki/Trbovlje_Chimney (Accessed January 4, 2013). Footage of the industrial environment and contextual information on Trbovlje's industrial and social history can also be found in *Victory Under the Sun*, sections 0:54 to 2.54 on You Tuve at: http://youtu.be/ZDMK4kW-WGY (Accessed January 4, 2013).
21. A number of other industrial and electronic groups emerged from 1980s Yugoslavia. The other leading Slovene-based group was Borghesia, which was much more overtly oppositional and activist than Laibach and was associated primarily with the dancefloor-oriented sub-genre of Electronic Body Music (EBM). See Borghesia's MySpace page at: http://www.myspace.com/ebmborghesia (Accessed January 6, 2013). The work of other Slovene and Yugoslav electronic groups is collected on the three volumes of the compilation *Ex-Yu Electronica* (2010). See the play list for volume 1 (*Hometaping in Self-Management*) at http://www.discogs.com/Various-Ex-Yu-Electronica-Vol-I-Hometaping-In-Self-Management/ release/2656372 (Accessed January 6, 2013). In Serbia the shadowy group Autopsia pursued a more esoteric and cryptic variation of industrial which has only in recent years been written into the history of the time. It shares the use of the German language and sampled symphonic elements with Laibach but uses these to communicate a more otherworldly but still critical artistic practice filled with foreboding. See the Autopsia website at http://autopsia.net/ (Accessed January 6, 2013). The Sarajevo group SCH also went through an industrial phase and also dealt with militaristic themes and sometimes used German. See the SCH website at: http://sch.ba/ (Accessed January 6, 2013). The largest audience for industrial and related genres in Yugoslavia was in Zagreb

and the Croatian scene produced the group TEHôM, which created a particularly dark and desolate variant of industrial ambient. The founding member of the group fought with the far-right HOS militia during the fighting in Croatia but is said later to have renounced this political orientation before dying (supposedly of complications arising from war wounds). See the TEHôM profile at http://www.discogs.com/artist/Tehôm (Accessed January 6, 2013). In their different ways all these groups used industrial and electronic sound allied with martial, political and other provocative material to produce a commentary on Yugoslavia's descent into the horrors of the 1990s.

22. See NSK, *Neue Slowenische Kunst* (Los Angeles: AMOK Books, 1991) 21. See also the Laibach exhibition booklet available at http://issuu.com/hakobo/docs/laibach-booklet (Accessed January 4, 2013).

23. The clearest example of this was Laibach's sampling of a 1958 speech by Tito in defence of non-alignment. This features on the 1984 track *Panorama*, available on You Tube at http://www.youtube.com/watch?v=dkGlrejTCE8 (Accessed January 4, 2013). The uncensored version appears on the album *The Occupied Europe Tour (Live) 1985* (London: Cherry Red Records, 1986). When Laibach's first album was issued in Slovenia in 1985 an abrupt noise on the track marked the absence of the sample from this release. The release would not otherwise have been possible and the album also appeared anonymously due the administrative ban on the use of the name "Laibach" imposed by the Ljubljana City Council in 1983.

24. It also used this oppressive language as the basis of its self-theorization in order to back up self-introduced concepts such as Monumental Retro-Avant-Garde, a term first used in an exhibition at Ljubljana's ŠKUC Gallery in April 1983.

25. Erika Gottlieb, *The Orwell Conundrum: A Cry of Despair Or Faith in the Spirit of Man?* (Ottawa: Carleton University Press, 1992) 156-7.

26. Ironically, the Slovene Territorial Defence forces used these tactics successfully against the Federal Army in order to secure the country's independence.

27. Laibach, "Interview 1980-1985," available at http://www.laibach.org/interviews-1980-to-1985 (Accessed January 17, 2013).

28. "Cari amici soldati / I tempi della pace / Sono / Passati! / (Dear Friends, soldiers / The times of peace / Are / Over!)." From the Laibach album *Gesamtkunstwerk* (2011), available on You Tube at: http://youtu.be/GsOeJspEexc (Accessed January 6, 2013). Laibach also appropriated Renato Bertelli's 1933 Aerodynamic sculpture *Profilo continuo del Duce* (Continuous profile of Mussolini) for the work *3-D PERSPECTIVE: Positive, Neutral, Negative* (1982-2011). The original can be seen at: http://2.bp.blogspot.com/_CijcaA9yq58/TK95aXLr_DI/AAAAAAAAHiw/IuAUXZM4Qcc/s1600/Bertelli;+Mussolini,+1933.jpg (Accessed January 6, 2013). Bertelli's work was mass-produced as a propaganda object and reproductions frequently appear on auction sites: http://www.artnet.com/artists/renato%20giuseppe-bertelli/past-auction-results (Accessed January 6, 2013). Laibach's work was exhibited in its 2011 installation at UGM Maribor and was controversially promoted by posters featuring the swastika-bearing coffee cup that caused problems for Laibach in Zagreb in 1983. The street posters attracted some negative comment and the poster that was placed just outside the gallery was repeatedly defaced. Having been placed next to a noisy jazz café the poster gained an extra layer of meaning, as seen in a clip available on You Tube at: http://www.youtube.com/watch?v=HlsiMEU4wWw&list=UUnXubYcLJgByUgCNW6Gbe2w&index=1 (Accessed January 12, 2013).

29. The iconic image of Hostnik's bloodied face features on the cover of the live compilation CD *Ljubljana-Zagreb-Beograd* (London: The Grey Area of Mute, 1993) and in 1995 it appeared as one of the 1992 stamps issued by the NSK State in Time.

30. See Šimičić, "From Zenit to Mental Space," 302.

31. See Jonathan P. Eburne and Rita Felski, "Introduction – What Is an Avant Garde?" *New Literary History* Vol. 41 (Autumn 2010) v-xv.

32. See Peter Bürger. "Avant-Garde and Neo-Avant-Garde: An Attempt to Answer Certain Critics of *Theory of the Avant-Garde*," *New Literary History* Vol. 41 (Autumn 2010) 700.

33. NSK, *Neue Slowenische Kunst*, 47. The statement echoes the desire of Malevich and the early Russian avant garde to "go beyond" progress and reach a stage of development at which all further progress would halt. On this, see Boris Groys, *The Total Art of Stalinism: Avant-garde, Aesthetic Dictatorship and Beyond* (Princeton: Princeton University Press, 1992) 16.

34. The performance is infamous, both because one of the smoke bombs that Laibach appropriated during military service went off prematurely, attracting the attention of military officials, and because it was the final performance of Tomaž Hostnik, who killed himself shortly afterwards on December 21. Hostnik is seen as a key figure in the conceptual development of the group.

35. The group's first action was planned as an exhibition as well as a concert of local Punk groups, including Laibach. On the night of September 26, Laibach placed posters around the town bearing the name Laibach (German for Ljubljana) and either a sinister black cross or a drawing of an assailant gouging out the eyes of a victim with a knife. The event was banned and a small controversy ensued, meaning that by the end of the year the name "Laibach" was already under public discussion in the media as a signifier of outrage and provocation.

36. For photographs of the exhibition see http://strazarni-lopov.blogspot.co.uk/2012/03/laibach.html (Accessed January 6, 2013).

37. Laibach spent extended periods in London during the 1980s and cultivated links with the industrial scene, as well as with figures from the wider cultural scene.

38. The film was also projected before and during the first section of Laibach's *Monumental Retro-Avant-Garde* performance at Tate Modern on April 14, 2012. The first part of the concert featured veteran members of the group and re-constructed the 1983 Zagreb performance. See "Laibach Live in Turbine Hall, Tate Modern, April 14, 2012," available on You Tube at: http://youtu.be/r4DO81bbNvc (Accessed January 15, 2013).

39. Laibach, *We Come in Peace*. Zagreb Biennale, 1983. *Laibach: nastop na zagrebskem bienalu*.

40. See Douglas Kahn, *Noise, Water, Meat: A History of Sound in the Arts* (Cambridge: The MIT Press, 2001) 45-52.

41. Laibach, *We Come in Peace*. Zagreb Biennale, 1983. *Laibach: nastop na zagrebskem bienalu*.

42. Laibach's most experimental and "avant-garde" track is the sound collage *Dokumenti* (Documents) from the album *Rekapitulacija 1980-84* (Ljubljana: NSK Recordings – NSK 008, 2002). See Laibach, *Documents*, on You Tube at http://www.youtube.com/watch?v=9dE2HeHbYIY (Accessed January 14, 2013).

43. See Laibach, *Perspektive*, on the album *Rekapitulacija 1980-84*.

44. Laibach's 1994 concert at the German artistic colony in Hellerau was protected by riot police against possible attacks by local fascists. See Johannes Birringer, *Media & Performance: Along The Border* (Baltimore/London: The Johns Hopkins University Press, 1998) 73. Laibach has been threatened by both right and left wing German groups.

45. See "Laibach, TV-Tednik Interview, June 1983," available on You Tube at http://youtu.be/2ArtSJ1cQ-M (Accessed January 14, 2013).

46. Michael Benson, *Predictions of Fire Dialogue List*. <http://www.lois.kud-fp.si/~lukap/kinetikon/diolist.html> *NSK Electronic Embassy* (October 1995) (10th January 1997) 19.

47. For more on this tendency see the chapter "Laibachization" in Alexei Monroe, *Interrogation Machine: Laibach and NSK* (Cambridge: The MIT Press, 2005).

48. See Marina Gržinić, "Neue Slowenische Kunst" in Djurić and Šuvaković, eds. *Impossible Histories*, 253.

49. Despite its international reputation and its established presence in the cultural and political history of its time, Laibach remains anathema to some Slovenes. Following Slovene independence in 1991, Laibach and the other NSK groups symbolically seceeded from the new order by establishing the *NSK State in Time* and Laibach has continued to criticize many aspects of post-Yugoslav reality in Slovenia and beyond.

50. Laibach, english summary of interview for *TIP* magazine, Berlin, 2012. Email to author, December 14, 2012.

51. Petra Čeferin, "Insisting on Architecture: Yugoslav Modernism and Contemporary Architecture" in Mrduljaš and Kulić, eds. *Unfinished Modernisations*, 81.

52. These were seen as inherently provocative and even suspect by the Yugoslav and western cultural elites and are still treated with extreme hostility and even contempt by extreme "leftist" groups such as the so-called "Anti-Deutsch" in Germany. One strand of leftist activism is trying to enact its own *kulturkampf* against industrial and related sub-genres including neo-folk. While there are rightist groups on these scenes and a degree of rightist infiltration, the hysterical and authoritarian tone of the (frequently inaccurate) attacks on the scene from the left tend to alienate their audiences and may even drive them towards the right.

53. NSK, *Neue Slowenische Kunst*, 60. This is in contrast to purely deconstructionist approaches seen on the left and among some strands of late avant-gardism.

54. Aleš Erjavec describes the ways in which Laibach achieved this in his text "The Three Avant-Gardes and Their Context," in Djurić and Šuvaković, eds. *Impossible Histories*, 61.

55. The design is featured on the sleeve of the 1987 Laibach compilation *Slovenska Akropola*, released for the Yugoslav market. See the images for the Laibach CD *Slovenska Akropola* at http://www.discogs.com/viewimages?release=186100 (Accessed January 14, 2013). The rear sleeve depicts the interior of Hitler's chancellery.

56. NSK, *Neue Slowenische Kunst*, 252.

57. See "The Rough Guide to Ljubljana," (BBC2 1989), available on You Tube at http://youtu.be/J6n9-dA94d8 (Accessed January 14, 2013)

58. Laibach cited in NSK, *Neue Slowenische Kunst*, 46.

If we weren't talking "Art", being part of the Avantgarde would mean being one of the privileged stupid ones who would infiltrate enemy territories and get either killed or given Heroes' medals when they managed to get through —

there was a time when being an Avantgarde artist would mean risk your lives for your ideals and ideas — these heroes would be imprisoned, tortured, ignored (!), they changed the world and dethroned despotes - they kicked Tabus, they crossed artistic deserts, drank madness and breathed limitless enthusiasm -- Yes, they managed to be ahead of their time — They were dangerous! You can't beat time today - Art will change nothing today - Art is an error, es wird nie wieder Avantgard geben, nie wieder!

Schluphost, too late JHP

jean-herve' peron / Faust / art-terrorist

www.Avantgardefestival.de

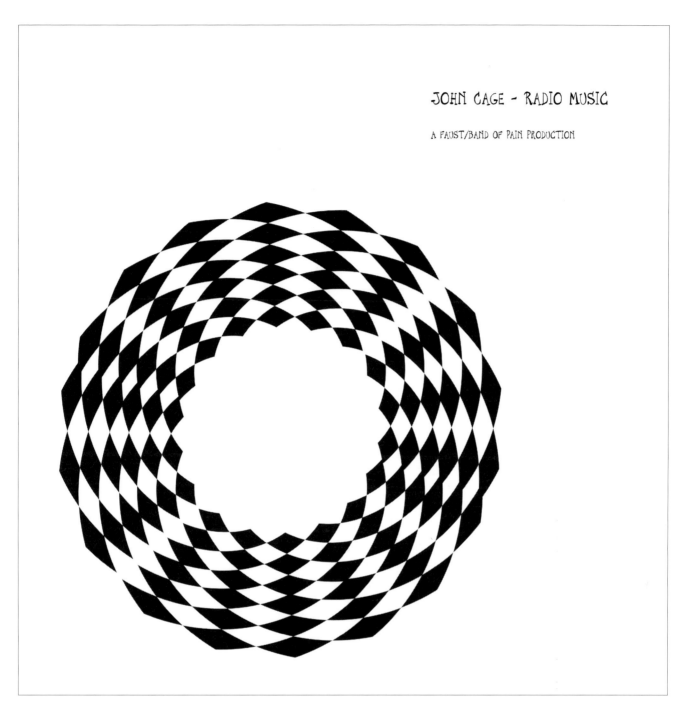

Faust/Band of Pain, *John Cage - Radio Music* (Dirter, 2011). Digital painting: *Peaking* by Steve Pittis. Courtesy of Steve Pittis.

Thoughts on Music and the Avant Garde: Considerations on a Term and Its Public Use

Chris Cutler

Preface

In hot pursuit of the Road Runner, Wile E. Coyote runs straight over the edge of a precipice. He's so fixated on his forward goal that he fails to notice there is no longer any ground underneath his feet. Twenty meters out, he makes the fatal error of looking down and gravity takes care of the rest. In this essay I want to suggest that something very loosely analogous happened to art in the first half of the last century. For the avant gardes there was nothing underfoot after about 1915—but it wasn't until the mid 1950s that the realization—and the disorientating consequences—of that fact kicked in. Then art became weightless and any sense of forward motion disappeared.

I will argue in this brief notice that at the moment it went into reverse, art both validated and made meaningless the idea of an avant garde.

1.

• I. *Art and Anti-Art*

Art as currently understood is neither essential nor timeless. References to 'primitive art,' 'medieval art' or 'the art of ancient Greece' create confusion by conflating fundamentally different and functionally incommensurate social practices.[1] In our own time, vernacular understanding of what art is has evolved out of the category of Fine Art, coined in the eighteenth century to claim an elevated status for specific artisanal practices as a sphere of autonomous cultural production. Two hundred and fifty years later, this status is about the only thing that survives intact, every other original attribute assigned to the term having been incrementally rejected and the whole finally succumbing to a hail of manifestos, experiments, outrages and innovation in the early part of the twentieth century. In spite of their re-integrative ambitions, it was the historic function of the early twentieth century *avant gardes* to complete the redefinition and consequent emancipation of art consciously begun in the early eighteenth century, and to free it from every involuntary alliance and restraint. We have been circling around the consequences ever since.

It was Dada, the most radical and ambitious of all the movements that finally put the new concept of art itself to the question.[2] But in spite, or maybe because of its best efforts (since a lever can never raise its own fulcrum), the established *status* of art as a privileged mode of communication has survived intact—and we the public, the critics, and all our institutions, continue to accept the old nineteenth-century creed that art is not merely a functional aspect of the life of a social group or community but is a self-reflexive, autonomous discourse, answerable ultimately only to itself.

But autonomy tends to separation. And if art wants separation it must expect incomprehension. If it really wants to be reunited with life, it would have to accept that it would cease to be 'art.'

To be free, *as art*, it must accept its alienation; to be free *of art* it must dissolve itself and learn to serve—but whom? And how?

• II. *The Avant Garde*

Recently minted, the qualifier *avant garde* has served various offices: first military, then political, then literary—when it was applied to a group of writers in mid-nineteenth-century France who mixed political and artistic radicalism. It was extended in the last quarter of the nineteenth century to writers without political inclinations who, in pursuit of the logic of their own autonomy—and finding themselves increasingly disconnected from the established institutions of art—responded by insisting that only *they* could be the proper arbiters of what art could, or should be, concluding

that it should be more like a science: investigative, experimental, permanently moving forward; not a servant to the market but an independent actor pursuing the logic of its own necessity. As a movement towards the liberation of form this *avant garde*, though culturally embattled, remained—in general—socially disengaged. It was the historical *avant gardes* that followed—in particular Italian and Russian Futurism, Constructivism, and Dada—which, though owing a huge debt to *l'art pour l'art* and the experimental model, were driven not by an urge to abandon the world for formal purity but rather to change it through an aggressive program of demands that art be revolutionized, redefined, and brought back into the weave of quotidian life. As means they proposed various combinations of new and old media—performance, political engagement and metaphysics—agreeing only that the past had to be torn up and the cultural clock reset to zero. All failed in their specific missions, but together they succeeded in their attack on the academy. In the space of little more than a decade they had challenged every convention, rule and aesthetic supposition they could identify. Without agreed political affiliation they nonetheless held in common a political desire to look beyond the art-work and towards the role of art in the construction of a new world. In the ensuing ferment, movements proliferated and permanent revolution became the public way of art. I say art; I mean of course the latest, the newest, the art which claimed to be the real art, the revolutionary art that would relegate yesterday's revolutionaries either to the museum or the dustbin. Such became the image of the phantom restless phalanx of the *avant garde*: always on the move, always locked into the new, always a step ahead. Deep in this model is an unquestioned teleology, a confident acceptance of direction and future. *Avant garde* is a concept inseparable from the idea of progress.

Where should one look for an *avant garde* when the idea of progress is no longer credited, when any identifiable garde has fractured into a million shards and there is no linear forward march to be in the vanguard of?

More than forty years ago this ceased to be a rhetorical question.

• III. *Continuity and Discontinuity: Artists' Relations to Their History*

As already noted, before they were 'Arts,' painting and music were skills and crafts, working occupations whose practitioners were paid to produce as artisans—usually to very explicit order. Art connoted varieties of skill: breaking horses and cobbling were arts. Fine Art evolved symbiotically alongside a strengthening bourgeoisie which, in forging its own understanding of culture, supported those painters, composers, sculptors and writers who shared with it a desire to remake the world. However revolutionary their humanism, these new artists did not reject their artisan precursors. Politically they may have been radical, but culturally they were pursuing better conditions and more interesting problems to solve.

In the late nineteenth century a different attitude emerged. Many artists no longer looked so benignly on their predecessors, and by the early twentieth century the whole sweep of the past, along with the institution of art itself, had been tossed into the shredder by the historic *avant gardes*.[3] The old structure of a loose network of schools collapsed into a militant wave of movements as these artists, casting a cold eye on imitation and representation, leapt headlong into the new world of electricity, machinery, photography, telephony, phonography, flight, radio, mechanical warfare, speed and science. By 1917, Marcel Duchamp, throwing down the gauntlet of the readymade, brought it finally to the condition of philosophy, in which the question of what art is became a vital part of what art is.

• IV. *Perspective*

Perhaps for the sake of simplicity, the art history of the twentieth century is often told through the successions and negotiations between its self-generating movements: Cubism, Fauvism, Expressionism, Suprematism, Futurism, Dada, Bauhaus, Surrealism, Abstract Expressionism, Pop, Minimalism, Arte Povera—and so on. And although this desire to keep the historical narrative tidy has led inevitably to distortions—very often missing the point altogether—there is no doubt that these movements existed and that they did help create through their work and manifestos both coherent communities and focused discourses, or, that by holding on to an idea of history themselves, even in the context of continuous supersession, they managed also—more or less—to hold together a centered public narrative of progress. And because this history had a center and a direction, it could also have outriders: *avant* and *arrière gardes*. By the 1960s this belief was thoroughly compromised; art went into free fall and began increasingly to repeat itself. From the 1970s onwards, there were few new major movements that were not somehow looking backwards. And without a self-understood center, there could no longer be meaningful edges or fringes. Positions that had once been oriented towards a putative future floated away and became independent propositions as a generation of artists emerged who neither accepted their forebears and moved on, nor demanded a *tabula rasa*, but began instead to pillage the past for fragments (or selectively to revive individual parts of it). Directionality collapsed. One artist's *avant* might be another's *arrière* (or *derrière*.).[4] It just depended on which way you thought you were facing.

Why locate the tipping point in the 1960s, a period of great and radical upheaval in the arts; a period indeed which from our present perspective looks something like a golden age: one of those rare rifts in time in which the life of art seems to move completely into the present tense; when what is new is also immediately alive to public consciousness? Because, during the 1950s, a group of visual artists, despite the climate of relentless progress, had begun to look back into the past for inspiration, specifically toward the *avant garde* of Dada and anti-art.[5] At the same time anti-art, in the form of readymade materials and non-intentionality, and driven by the implacably consequent John Cage, began to perturb the world of music for the first time. These two tendencies slowly flowed together, and it was in the 1960s that their mutual offspring began exploding with a luxuriance of hybrid applications. The consequence was a general shift in orientation, as the future began increasingly to be sought in the past.

Making money is art ... good business is the best art.—Andy Warhol[6]

Appearing first in Britain but soon spreading to America, Pop art (sometimes in its early years called Neo-Dada) rudely crashed Abstract Expressionism's party, wilfully flaunting both its claim to authenticity and its insistence on abstraction, emotional intensity, and immanence. Pop took Abstract Expressionism as a model of High Art, Pure Art and Art-for-Itself and opposed it with Dadaistic profanity, irony, ridicule and satire. Revelling in visual cliché, super-market products, commercial imagery, comics, readymades, collage, quotations and nostalgia, Pop employed tech-niques adapted from photomontage, film, advertising and mass production, systematically undermining high art with design and commodity trivia. Politically driven, it succeeded in mounting an initially effective attack on a mediagenic world through iconic subversion and ironic commentary. And in the disbelieving hands of Andy Warhol it returned also, in another—and critical—echo of Dada and Duchamp, to a recontextualized self-reflexivity amounting to practi-cal philosophy—although its provocations were now aimed as much at mass media and the marketplace as the art com-munity and its institutions. With multiples and happenings, Brillo boxes and *objets trouvés*, books of raw transcript and films of raw time, Warhol mercilessly stretched and tested the category of art—again—but this time in the face of its dubious segregation from the rest of the goods in the store.

Deliberately using mass production techniques, cheap, impermanent materials, stolen images and his own variation on the readymade, Warhol invested his claim to art in an uncompromising attempt to avoid fulfilling any of its remaining criteria. Instead he immersed himself in an incestuous mediated culture of sensation, narcissism and money, throwing that world back at itself in a deeply ambiguous combination of ridicule and celebration.

Pop art sent a tiny tremor through the system, but art-coded attacks on the *status quo* were familiar and easily absorbed. Even anti-art had long since been quietly re-categorized as art and, by 1960, Duchamp's *Fountain* was no longer a ques-tion but a keynote artwork, set on the path to become, for a while at least, the apotheosis of art itself.[7] Whereas the Dadaists in their time had been peripheral, baffling and potentially dangerous, Warhol, in his, was a mainstream star, perhaps himself baffled (and eventually physically endangered) by his own success. Certainly, the harder he tried to affront sense and taste, or to deny that what he was doing was art, the more highly he was praised and the higher his status as an artist rose.[8] When asked—in what turned out to be his last recorded interview—what he considered to be his greatest achievement he said, with an honesty heard but no longer understood: "Keeping a straight face."

The rebellion of Pop ended when irony and reality became indistinguishable. Warhol's own kamikaze contribution, and what distinguished him from his contemporaries, had been to show that, freed from the institutions, and even to a certain extent from the artists themselves, Art, with a capital A, was now the exclusive property of the market. And, alongside all the other isms, *avant garde*™ had also slipped quietly into its place as a wholly owned subsidiary of Art Inc.

When everybody is a revolutionary the revolution is over.—Clement Greenberg[9]

Linear reading collapsed. The sixties saw movements implode, proliferate, fracture and recycle. Horizontal succession gave way to a chaotic vertical proliferation: Op Art, Object Art, Abstract Symbolism, Happenings, Assemblage, Photo-Realism, Hard Edge, Color Field, Shaped Canvas, Earthworks, Body Art, Arte Povera, Minimalism, Kinetic Art, Performance Art, Luminous Art, 'NO!art,' Common object Art, Cybernetic Art and Systems Art; all came and went in the space of a few short years. More durable—and indeed still with us—was Concept Art, with its endless repetitions and permutations, and Fluxus, currently in the middle of a revival of interest. Like Pop, but with less acumen, and without the insight towards the new condition of Art™, Fluxus looked back towards the past. George Maciunas' 1962

manifesto: "Neo-Dada in Music, Theatre, Poetry and Art" was unambiguous about this.[10] And although it developed its own focus, manifestos and, sometimes, topical content, Fluxart remained in essence a revival, or, more positively, a taking up of threads. And revivals, while they may yet bring new arguments and new techniques to the table, may equally be indicators of cultural exhaustion. They are certainly not in any respect *avant garde*.

2.

• VI. *Music and the Historic Avant Garde*

How does music map onto this narrative? Although different media don't march in step, there are necessarily points of contingency where the specificities of any given discourse disappear into the broader concerns and perspectives of an age. Of the historic *avant gardes* it can be said that virtually no music was directly associated with Constructivism, Russian Futurism or Dada. Italian Futurism, however, did produce a few half-remembered composers and four dedicated manifestos: three fairly run-of-the-mill pamphlets by composer Francisco Bailla Pratella, and one seminal work, "The Art of Noises" by painter Luigi Russolo, who also put theory into practice by building and composing for his groundbreaking, but largely ignored, *intonarumori*. Although Russolo's manifesto was prophetic, none of his instruments, and only a few of their designs, survived. Of the handful of pieces written for them, mostly by the inventor and his brother, none is more than a curiosity today. And, although Stravinsky and Varèse both expressed an initial interest, neither pursued it; indeed Varèse, possibly the most visionary of all twentieth-century composers, went out of his way to repudiate the Futurist's vision of music as early as 1916.

There's still much good music that can be written in C major.—Arnold Schoenberg

More generally, Futurism did have a broad and sometimes powerful influence on a number of contemporary composers, and what came to be referred to as machine music was generally associated with the movement—or at least with modernism as it was refracted through the Futurist lens.[11] But then, music had always been at home with modernism. Indeed, after centuries of being considered rather conservative and always lagging behind the visual arts, it had become, by the late nineteenth century, the model that all arts were said to aspire to.[12] Yet, paradoxically, unlike the spatial or object-arts, which were constantly haunted by survivals from, and the authority of, classical antiquity, music had for centuries been looking forward, privileging novelty and innovation over lost ancient practices of which no sounding evidence survived. Thus while the object-arts were burdened by exemplary relics in a way that the event-arts were not—and might require nothing short of total rupture to free them—music remained preoccupied—and was continually revivified—by the internal problems arising from its own continuity. It was certainly not ready to dig itself up by the roots; indeed its primary urge remained to protect, as well as to extend, its borders, not to dissolve them. Dissolution would be the work of Cage, Fluxus and the New York School, many years hence.[13] Thus it was that, throughout the rampage of the *avant gardes*, composers for the most part continued in their traditional pursuit of individual solutions, quietly or publicly exploring possible ways of writing meaningfully for their own time. And while they could easily match the historic *avant gardes* for the number of riots provoked, rules broken and core assumptions challenged, composers, as a rule, continued to understand themselves as working within a tradition rather than against one.[14]

• VII. *The Birth of Anti-Music*

It was not until the late 1940s that the qualifier *avant garde* was finally attached to a music, and then it was to the output of composers connected through the Darmstadt Summer school, home notably of total serialism, which for years did act as a group, did proselytize, was extravagantly ambitious and did appear to operate with collective rules—forcefully identifying itself as a leading cadre in the arts. Some of its celebrities were also immodestly capable of gross intolerance: "All composition other than twelve-tone is *useless*" (Pierre Boulez).[15] Like other neo-movements, this 'avant garde' looked initially back to the past, extolling and extending proposals made by Schoenberg, Webern and Berg some thirty years earlier, but now raising them to the status of dogma.[16] In the world of Art Music it seems that the *avant garde* was born facing backwards. At the same time, in the United States, John Cage and his associates—who also constituted a distinct community, though with instincts far more revolutionary than conservative—did not consider themselves an *avant garde* at all but rather 'experimental' artists; indicating perhaps that the older term had already become associated with reactionary, proscriptive, intolerant and authoritarian attitudes.[17] It was the experimentalist Cage, and not the Darmstadt *avant garde* who arrived at the genuinely radical musical equivalent of the philosophical move first made by Duchamp with his readymades.

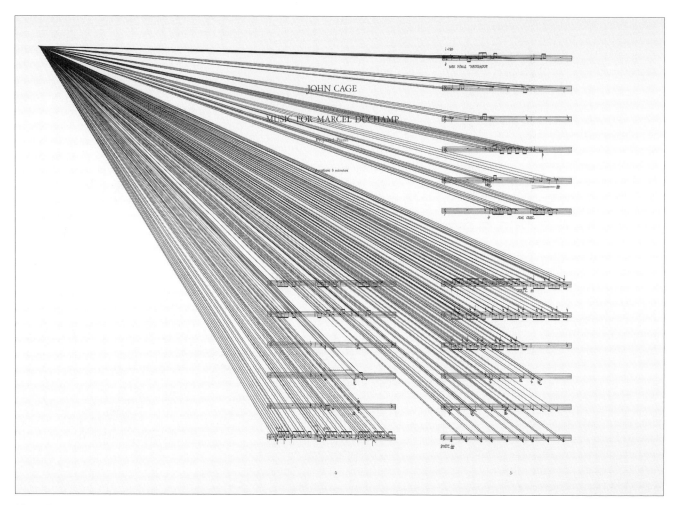

Marco Fusinato, *Mass Black Implosion (Music for Marcel Duchamp, John Cage)*, 2012. Ink on archival facsimile of score, 2 parts: 81 x 107 cm each (framed). Courtesy the artist and Anna Schwartz Gallery.

With *Fountain* (1917) Duchamp had taken an object—a mass produced commodity (thus devoid of originality) chosen, he said, for its lack of aesthetic significance, and had submitted it for exhibition. If it was an artwork—and it claimed to be—it took the form of a nest of questions.

With his 1952 composition *4'33"* Cage issued a similar challenge to music. This work comprised three consecutive durations of silence—meaning that any sound actually heard in performance would not have been determined by the score (although it could be argued strongly that it was intentionally included in it) and would be completely outside the control of the composer. Of course, commonsense says silence is not music, nor is unintended noise. The event, however, took place in a concert hall and was announced as a composition by a recognized composer. If it was a composition—and it claimed to be—it took the form of a nest of questions.

Since neither Duchamp nor Cage could claim that their object—or event—had any *intrinsic* qualities that might distinguish it from *any* urinal or *any* silence, what made either of them art or music? To put it another way, what would art or music have to be for either of these productions to be an instance of it? That was the question. Cast in the form of a work.[18]

In its very quiet way *4'33"* represents nothing less than an attempt to dissolve the category of music. It asks of music, as the readymade asks of art: if this is music, then what is not?[19]

This question has been the ghost at every feast thereafter.

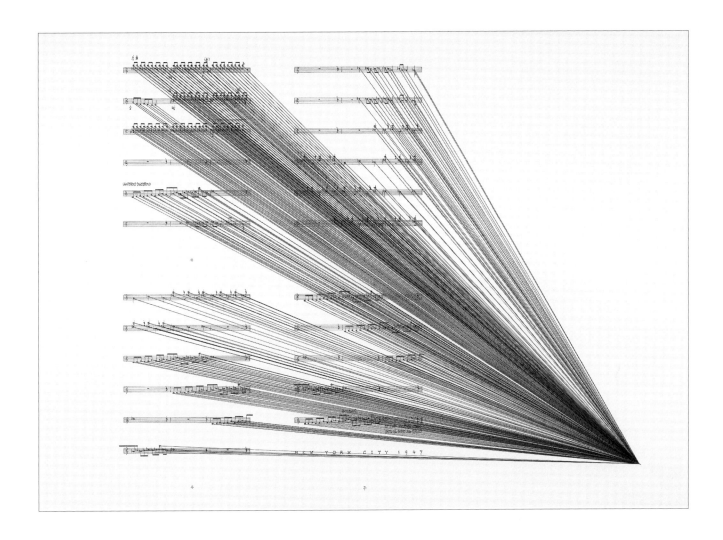

Classification … ceases when it's no longer possible to establish oppositions.—John Cage[20]

To be useful, a definition requires limits—things that it excludes. The implication of *4'33"*, as of the readymade, is that nothing is excluded and thus that any object presented to the eye could fall within the purlieu of art, or any presentation to the ear, whether it sounds or not, could be experienced as music. But the formulation 'X is everything' can hardly succeed as a meaningful definition. Thus it must be doing some other work. With Duchamp I believe it was largely philosophical and metalinguistic. With Cage, thirty six years later, there is more: the question remains, but when it is cast in the light of his deliberate abandonment of intentionality the year before, it also becomes an instruction to the listener to interpret—and thus in large part to create—the work.[21] With such mechanical chance procedures an author is at pains to create nothing and to say nothing. This can still function as communication on a metalinguistic level—as a kind of question—but only usefully *once*. After that it is just repetition. Cage's use of indeterminacy is clearly not merely to pose a question but to impose a formula that seeks to make dialogue disappear into sets of interpretative monologues.[22] If Cage's move is accepted at face value, art becomes a series of riddles to which there are no answers. It also ceases to be a medium of communication and becomes instead *an opportunity for perception*.

While this notion has borne much fruit, it has also proved highly problematic.

Duchamp's radical proposition—his concept of a work that disappears into the idea of itself—was, I think, in the context in which it first appeared, meaningfully *avant garde*. Repetition of that question is not. Beyond this, when the primary responsibility for meaning is shifted deliberately from producer to interpreter, any residual notion of an *avant garde* must inevitably vanish with it. No public can be in advance of its own taste.

• VIII. *Convergence*

The mid-century return to the unfinished business of the historic *avant gardes*—especially in the unequivocal forms pursued by Fluxus—merged seamlessly with the dizzying influence of Cage's collapse of music, an event-art, into the condition of post-Duchampian art-in-general. Sound was just to be another *material*. The border that had inoculated music against the existential crisis in the visual arts, a border maintained by a clear self-understanding of its own goals and limits and, above all, by the acquisition and manipulation of necessary skills, became increasingly porous—and after *4'33"* (where that was accepted at face value) collapsed altogether. Cage and Fluxus merged their understandings with one another.[23] An Object-Art that had opened into an event became in principle indistinguishable from an Event-Art that had opened into an object: and now both vanished into concepts in which neither object nor event was required at all.[24] Art no longer merely aspired to the condition of music but absorbed it into its own general condition. Thus, while *4'33"* may still be music, it may also be art, or performance, or theatre. Fluxartists refer to their instruction sets and scripts as scores while composers write scores that do not specify sounds; Fluxorchestras make cabaret, while composers tune radios, navigate with echolocators and noisily rearrange the furniture. Arts merge into art—which becomes whatever you can get away with—and skills become optional and interchangeable. And where does that leave Laocoön?[25]

• IX. *Other Roads*

When everything is art, or when all sound is music, there is nowhere left to go, except maybe to retreat to an earlier position in the hope of finding a road not taken that does not end in a *cul de sac*.[26] From a different perspective, however, or from alternative readings of history, many viable roads may still beckon.

Theorists naturally have their own analytical agendas, but for artists local problems are usually more pressing—and more productive. And while they may lack the breadth of the death-or-glory narratives of the *avant gardes*, they are intimate with long, rooted, antinomies in their own fields; useful antinomies that continually generate solutions. Throughout the twentieth century proposals were made and works embodying them presented that did not trouble themselves with meta-discourses or global visions but quietly pursued their own discipline's more secular, local interests. Of course, all artists face the issues of their own time—that is, after all, the conversation in which they are engaged—but they do so for the most part within terms and boundaries that are inherited and not invented. To work at all, for the majority of artists, is to engage in a constant debate not only with the current concerns and propositions of their disciplines, but also those that extend far back into its past—because every gesture and tool at their disposal comes locked into its own history, which limits and makes meaningful its signifying possibilities.

And to imagine a language is to imagine a form of life.—Ludwig Wittgenstein[27]

I want briefly to consider music in its aspect as a species of language. I know this is a minefield, so I will try to spell out what I mean and what I don't. I wish to highlight only that congeries of common features (or family resemblances) that unite a broad group of arbitrary, human signifying systems that *pre-exist their users*, were created by no one, are defined by no one and can be learned only through use and exposure—ideally from the earliest age. These are systems that live and evolve through informed use and negotiation (and in the modern world are constantly in a state of agonistic re-evaluation). I am not trying to map 1:1 semantic, grammatical or syntactical correspondences, just to claim a broad structural family resemblance. Like any signifying system, music is a medium of human communication dependent upon some involuntary ground shared between its producer and interpreter; it belongs within a loose family of language-games in which the comprehensibility of any utterance reflects the extent to which it has accepted and employed what is already given, even when that is expressed through determined subversion. To be meaningful, a new work must always be grappling with the language it employs and therefore with the history of that language as well as its immediacy. It can never be on solid ground and must always move in the awareness of many considerations and conventions at once. Thus the accommodation of ambiguity and the expectation of goodwill are essential to it. And while fixity of meaning exists in inverse proportion to the amount of entropy or chaos in a signifying system, type of meaning is a function of the language game in play. Mathematical discourses seek to eradicate ambiguity; artistic discourses to exploit it. Both are dependent on resilient discursive structures without which directionality would be lost and conversation rendered profoundly unreliable. In use, languages simply work. But when the approach is analytical, then the model held of the system becomes critical. Instead of common ground enabling a generally secure passage through exchanges, a disconnected model of language—Saussure's, for example, where signifier and signified relate only to one another—makes a performer the manufacturer of an object and an interpreter that object's independent user. Interpretation then necessarily becomes increasingly voluntary and capricious at the expense of the integrity of lan-

guage itself. As Saussure's dyadic system rigidified leads to the *cul de sac* of Derrida, so do Duchamp (or Cage) rigidified lead to the abandonment—or total relativization—of art (or music). With no fulcrum, nothing can be moved. That is the essential point to which this essay constantly returns.

If my analogy is accepted on the terms outlined above, then perhaps we can use it to underpin a useful sense of the qualifier *avant garde*, since it was the distinction, it seems to me, of the historic *avant gardes* that they made a specific attempt *to sever their dependence on inherited languages altogether*, and not, as other movements and players had done, to extend, ramify or uniquely employ existing discourses, or selectively challenge accumulated *cliches* and habits. Theirs was a change in quality, not quantity, and it answered a perceived crisis that seemed to call for nothing less than whole-sale revolution.

• X. *Metalanguage*

It may seem at first that, from the point of view of the arts considered as a set of interlocked languages (or signifying systems), radical departure from all grounded rules would be self-defeating, since it would necessarily result in a kind of gibberish. However, the work of the historic *avant gardes* is certainly meaningful to us, indeed we celebrate it. In part, of course, this is because the work itself has in time helped to change our understanding. But I think there is another reason: the effect, especially of the most radical of the *avant garde* propositions, was not simply to run against habitual usage but to *shift the entire discourse onto another plane—and into a different language*: the meta-plane of self-reflexivity—mediated for the most part through verbal discourse (internal or dialogical) and the language of philoso-phy.[28] With this shift art was enabled for the first time to speak to and about itself, *as art*, even if at the risk of ceasing to be comprehensible as art and becoming instead, at least in the immediate term, a species of thought. Nothing more encapsulates the power and the danger of this shift of discursive perspective than the readymade, which has now come to inform and legitimate much contemporary—and all conceptual—art. For some, what was once a question has now become a formula. 'Is everything art?' has been recast as 'everything is art,' fatally sidelining the intermediate pair: 'can everything be art / everything can be art,' both of which clearly keep the conversation open. The danger is that if Duchamp's move is accepted at face value (and the same applies to Cage in the sphere of music), then the bottle rack or silence cease to be contextual conundrums about art and become solvents that undermine the possibility of coherent conversation altogether. The effect of this is to render obsolete the inherited languages of art and music, causing their roots to atrophy and their pasts to become little more than objectified material: useful for mining, plundering and making sly references to, but no longer part of any living body.

3.

• XI. *Perspectives and Conversations*

The early twentieth century was a time of general crisis for art, a time when many visual artists—and virtually all com-posers—were trying to find some firm ground from which to respond to the catastrophic problems and opportunities thrown up by new sensibilities, new media, electricity, Freud, Einstein; the whole apparatus of modernism—without necessarily vaporizing, as the *avant gardes* proposed, the ground on which they stood. In their search for answers that would not destroy the patient, the constituents of the broader art community were perfectly able to distinguish between *avant garde* rhetoric and individual works. They took what was useful to them and ignored what was not; at the same time they made their own proposals in the form of works that grew logically from the history and endemic concerns of their disciplines. This was particularly true in the field of music.

• XII. *Alternatives*

… sounds [should] just be sounds … in order that each sound may become the Buddha.—John Cage[29]

In all his aleatoric works after *Sixteen Dances* (1951) John Cage can be located at one extreme of a conversation about communication and reception that proposes to remove intentionality from the production of works. In this he would share a practice, if not a motive, with Mallarmé, with the many Surrealists who experimented with automatic writing and with Marcel Duchamp in his careful non-fashioning of readymades. More than any other composer Cage repre-sents the anti-art aspect of the historic *avant gardes*, though he couches his own proposition in terms of dissolution through total inclusion. On the other side of this debate, defending the proposition that intention, as the basis of meaningful communication, was a necessary condition of music, we would find just about every other composer before 1950—all of whom insisted on refining a more or less carefully planned architecture of tones, durations and

their combinations in pursuit of order and argument; or emotional expression and sensation—or shaded combinations of the two. Between intention and non-intention, Process Music, Systems Music and Stochastic music emerged, moving the conversation deeper into the implications and possibilities Cage had raised.

Or again: the generating power of sacral mathematics and ratio have run like a root through the life of music for over two and a half millennia. In this debate, unlike the one above, Schoenberg, who dedicated his life to the retention and protection of the sacral, and who was profoundly convinced of the deep relation of number lying behind the flesh of sounding, would find himself close to his former pupil Cage—a man who for much of his life was so focused on form that it was a matter of relative indifference to him with what sound (or absence of sound) it was filled. La Monte Young would be a sympathetic contributor to this side of the discussion, as would R. Murray Schafer, or Harry Partch—or, more ambiguously, Iannis Xenakis. Across the table sit those for whom the control of *surface* and the grain of sound-for-itself are more significant than spiritual depth or number—the phenomenologists. The radicals in this debate would be the pioneers of *Musique Concrète*, who eschewed the formalism of calculated structure altogether, focusing almost exclusively on sounding content: indeed, for them, surface was content. Less extreme but close would be someone like Edgard Varèse.[30] And, in general, their argument was little more than a logical extension of a feeling that was one of the practical distinctions of the twentieth century: that sound could be bone, not merely flesh.

Just about everybody agreed that the vocabulary of music had to be radically extended and made adequate to the needs and conditions of the day.[31]

Agreements, disagreements—always some focal issue, some question or problem intentionally addressed.

The point is that it is these conversations, oppositions, accommodations, compromises and proposals—*made mostly in the form of works*—that constitute the life of music and delimit the terms in which that life unfolds. There is no tidy, single, linear tale to be told. And on the ground, the conversation remains open, however inaudible some of the participants may be for much of the time.

In these debates the *avant gardes* might be said to have operated as a "purgative" (Duchamp).[32] But they did not define the debate even if they made a profound and permanent impression on it, and they should be understood as embodying powerful propositions and not, as they claimed, definitive endgames. That said, as a demolition crew, they were indispensable: the most powerful expression of an uncompromisingly revolutionary response to a pressing, if temporally local, crisis. And although that crisis is not yet resolved, their proposals have all been absorbed into it, even if not universally accepted. Well, all of them bar one, the most radical: that art dissolve itself altogether. This has proved impossible. Even at its most revolutionary, even with the readymade, even with *4'33"*, art could not make that fatal step away from itself: indeed, those very interventions could only be effective and meaningful if they *were* art, otherwise they would just be bottle racks and silences. The philosophical extension of art's own practice into self-examination, far from challenging the status of art, has been taken as a Cartesian proof of its existence.

The historical *avant gardes* have cleared the decks. That was their work and that work is done. You can keep blowing up the ruins but rubble is already rubble.

Offering radical propositions within a genre (or across genres) has been the general way of art throughout the twentieth century, so restricting the application of *avant garde* to those ultra-provocative movements that proposed the revolutionary rejection of inherited languages seems useful to me, and I propose to adhere to that usage, and not to extend the term to ever weaker assignments that merely describe what became twentieth century art-as-usual.

4.

• XII. *Dominoes*

After Darmstadt, the description *avant garde* next appears in a wholly different context; applied to radical developments in a particular strand of black American jazz. *Avantgarde* jazz was conceived as urgent and visionary. It pursued formal and technical innovations, like *l'art pour l'art*, but at the same time lived in the intensification of emotional expression. A unique hybrid, it adopted from high art discourse the idea of extended technique, originality and genius, at the same time retaining from its popular origins immediacy, improvisational skills and the raw social intimacy of its quotidian context—clubs and bars. It made no claim to universality, nor to the future, but rather, by accentuating its difference

from the familiar and the mainstream, addressed a specialized community in the immediacy of its experience. Through this unique combination of formal complexity and emotional directness it claimed authentic (as opposed to commercial) popularity, and at the same time declared itself a serious, and uniquely black, *artform*. This claim to art status from the sphere of popular music, especially the scary lowlife club culture of black people, was as unprecedented as it was radical. And in this sense it wasn't merely *avantgarde* in its relation to the jazz world but posed a challenge not easily dismissed to the already beleaguered gatekeepers of art music for whom acceptance of Cage had created severe categorical difficulties. If all sound is music, so is the stupidest pop song, never mind a clearly 'difficult,' experimental and often abstract form like *avantgarde* jazz.

The jazz *avantgarde*, unlike its earlier namesakes was distinguished by its claim *to* art, not by a rejection of it.

This too was an *avantgarde* that neither rejected its forebears nor wished to set a new template for music. Having left both commercial and quasi-commercial music and their audiences behind, *avantgarde* jazz hoped by example to bring other musicians and an engaged, if limited, public—to its own position. But not more than that. Indeed it could be authentic only so long as it remained marginal. As the voice of a minority, its power was a direct political function of its blackness. It did not ask what its public wanted but offered what it thought that public needed to grow strong, identify itself and be free. In its difficult admixture of formal complexity, emotional directness, authenticity and protection from general absorption, this *avant garde* raised difficult questions that could only be answered outside the music itself. It also offered a complete inversion of the later Cagean position: where Cage had eschewed intention altogether through a rigid formalism, free jazz by relaxing nearly all formal constraints, allowed intention absolute dominion.

• XIII. *Rock*

Two decades later, it was something like this jazz sense of *avant garde* that was applied to certain strands of rock, initially extending the art claim to elements of an even lower—at that time perhaps the lowest—musical form. However, while *avantgarde* jazz was pretty clearly defined, what qualified as *avant garde* rock seemed to be a question less to do with form and more to do with who was using the term, and why. By now, this vagueness of use seemed somehow to be correlated with a similar vagueness in the culture itself.

Sometimes, as with *avantgarde* jazz, formal innovation was implied—along with high/low and experimental/popular elisions; sometimes left wing political status; sometimes that the music was considered to be in advance of public taste (though there was no suggestion that the public would ever agree with that judgement or catch up with it); sometimes simple outsider status was indicated, or that the music was considered shocking, or just unusual, by some designated listening community.

By this stage, in other words, the term was clearly in danger of losing any coherent meaning at all.[33] Look up *avant garde* rock on the Internet; it has become little more than a hopeful badge of honor. Otherwise it serves as an off-the-shelf commercial label for general application (Lou Reed, Brian Eno and John Cale are avant garde). In short, it has been colonized, flattened and neutralized and all the history has been drained out of it—in part because all the history is currently being drained out of history.

Thus has the practical wisdom of the *demos* been expressed through the evolution of language. To put it another way, so long as there is a meaning in the world, there will be a need for a term that encompasses it, and that term will emerge and hold itself together. When that meaning evaporates, the term it necessitated will escape, and either mutate to serve another useful purpose, or dissipate. When it is obviously floating free, that is probably a sign to let it go.

• XIV. *Lost, One Signifier*

From this brief survey of the actual, non-academic, use of the qualifier *avant garde* to music, continuity of meaning would imply that the baton of radical progress has passed from a strand of contemporary music to jazz, and then to rock. Or perhaps more plausibly that in these three genres a leap has been made to the condition of art, a condition that tends to level and dissipate their individual generic coherence—in other words to erase them as independent genres. Certainly the fringes of contemporary composition, jazz, electronics and rock have become increasingly indistinguishable. On the other hand, discontinuity of meaning would imply that some thing-in-the-world has disappeared and left the word that contained it to drift and free associate. Both can be interpreted as true. Neither leaves much work for the qualifier to do.

The fact remains that in a media-dominated discourse, *avant garde* today implies little more than 'breaking or appearing to break ranks with market consensus,' even if sometimes it may still retain homeopathic traces of political engagement, cultural prescience or technical innovation. Even when those traces are strong, the term does them no service because it buries and negates them. One has seriously to ask whether anyone believes that the term can be useful anymore, or whether, along with Freedom, Democracy and Truth, it should join the ranks of Vaneigem's corpses in the mouths of the bourgeoisie?

• XV. *Quo Vadis?*

The struggle with the academy has been won. The market has taken its place. Unlike the old art institutions, the market, being impersonal, amorphous and many-headed, has no central authority to attack. Moreover it has the proven power to absorb whatever is thrown at it and to recast everything it touches into its own shape. Although *avantgardism* may prove to have been one of the great cultural achievements of the modern period, helping, through its very absolutism, to kick-start a new art practice and to liberate, once and for all, media, form and imagination—making everything and anything the proper matter of aesthetic work—the world that needs such *avant gardes* is gone, precisely because their work is done. That work was definitive; entropic; a river that may not be stepped into twice; a one-time catalyst that effected an irreversible change of state.

The new problems we face today are problems that *avantgardism* has helped to create and which its methods can no longer solve.

The *avant garde* is dead. That is its triumph. Let it lie.

Coda

Look here, Cranly, he said. You have asked me what I would do and what I would not do. I will tell you what I will do and what I will not do. I will not serve that in which I no longer believe, whether it call itself my home, my fatherland or my church: and I will try to express myself in some mode of life or art as freely as I can, and as wholly as I can, using for my defence the only arms I allow myself to use—silence, exile, and cunning.—James Joyce, *A Portrait of the Artist as a Young Man*[34]

Notes

This essay was commissioned for a book dedicated to Prof. Gunther Mayer on his 70th birthday. A highly respected academic, musicologist and a supporter of avant garde and adventurous music, Gunther always trod a quietly dissonant path through the political complexities of the old German Democratic Republic. I should add that my take on these matters is not one he would easily endorse, though I know he appreciates the central argument, which, like his own thinking, moves obliquely against the orthodoxies of current scholarship. (September 2006)

1. Until at least the end of the eighteenth century painting and sculpture were classified as mechanical, not liberal, arts: "neither 'art' nor 'artist,' as we use the words, is translatable into archaic or high-classical Greek." (Eric Alfred Havelock, *Preface to Plato* (Cambridge: Belknap Press of Harvard University Press,1963) 33); 'The Renaissance ... had no real equivalent of our 'Fine Art'." (Martin Kemp, *Behind the Picture: Art and Evidence in the Italian Renaissance* (New Haven: Yale University Press, 1997) 226). And so on. In this essay, then, I will use art always to mean Fine Art; that is to say, the post-Enlightenment European concept of an autonomous realm of production and reception to which we still adhere, and not to the more utilitarian understandings of art as varieties of *techne* which preceded it. It is the concept of Fine Art that is thrown into crisis by the historic *avant gardes*, and it is the consequence of their critical challenge that I try to trace below.
2. In 1913, Duchamp famously asked "Can one make works, which are not works of art?" In 1917, his assisted readymade, *Fountain*—a commercially mass-produced urinal that he had bought in a shop—was rejected by the Society of Independent Artists in New York, specifically on the grounds that it was not art. And it was not exhibited. The "original" *Fountain* was then lost. Few today, however, dispute that *Fountain* was and is an artwork, or that, by implication, any object at all might be an artwork. In fact just the *idea* of an object might be an artwork (subsequent, exhibited, *Fountains* were newly purchased from commercial outlets without in any way affecting the status of the work). Even the idea that a mass-produced urinal (or bottle rack, or snow shovel, *or anything at all*) might be an artwork *might itself be accepted as an artwork* now.
3. I will use this term of Peter Bürger's to refer at least to Constructivism, Italian and Russian Futurism and Dada.
4. Literally in Fluxartist Yoko Ono's case, as in her *Bottoms* of 1966.
5. Three short comments: (1) Robert Motherwell's book, *The Dada Painters and Poets*, was published in 1951 and is constantly referenced by artists of this generation, though surely it was as much a symptom as a cause. (2) I say anti-art, but anti-art and non-art seem confusingly to merge into one broad concept in this period—and of course by then Dada already belonged tacitly in the camp of art. (3) If I single out Andy Warhol in the pages that follow, it is because it seems to me that he took cognisance of the changed context of his borrowings in a way that many of his contemporaries did not, concentrating more on the conditions of meaning than on its production and insisting not on his own freedom so much as acting to expose the conditions of his confinement.
6. Andy Warhol, *The Philosophy of Andy Warhol: From A to B & Back Again* (New York: Harcourt Brace Jovanovich, 1975).
7. In 2004 it was voted the most influential artwork of the twentieth century. Perhaps this accolade was intended as a slyly philosophical art event? But I think not. Interviewed in 1962 Duchamp was already resigned to the new situation: "When I discovered the readymades, I hoped to discourage the carnival of aestheticism. ... I threw the Bottle Rack and the urinal in their face as provocations, and now they admire them for their aes-

thetic beauty." This was a rephrasing of what he wrote in a letter to Hans Richter in 1962: "This Neo-Dada, which they call New Realism, Pop Art, Assemblage, etc., is an easy way out, and lives on what Dada did. When I discovered ready-mades I thought to discourage aesthetics. In Neo Dada they have taken my ready-mades and found aesthetic beauty in them."

8. Sometimes it did seem to depend which side of the joke his public felt they were on: when Warhol sent look-alikes to stand in for him at university engagements, some of those attending became quite indignant—although his actions seem entirely consistent with the Warhol™ brand; in fact they were even rather exquisite instances of it.

9. Clement Greenberg, "Avant Garde Attitudes: New Art in the Sixties" (1969) in John O'Brian, ed. *Clement Greenberg: The Collected Essays and Criticism. Vol.4: Modernism with a Vengeance, 1957-1969* (Chicago: The University of Chicago Press, 1993) 299.

10. This is in spite of the later disavowals of some of the Fluxalumni, who echoed the Dadaists even in this retrospective redrawing of their own recent history.

11. George Antheil's *Ballet Mécanique* (1924)—in fact his entire composing and performing career from the early 1920s to the mid 30s—would be exemplary, blending a repetitive machine aesthetic with Stravinsky's take on "primitive" folk rhythms.

12. "All art constantly aspires towards the condition of music." Walter Pater, *The Renaissance: Studies in Art and Poetry* (1873). Until the fifteenth century the status of music was pitched far below that of painting, but by the nineteenth century the situation had effectively been reversed. Seeing music as the first of the arts to escape the Aristotelian task of imitating nature, writers from the late eighteenth century onwards (Schiller, Goethe, Schopenhauer, de Stael, Baudelaire, Hanslick, Whistler...) increasingly promoted its superiority over, and its power as a model for, the other arts. For many, the idea of Absolute Music became an ideal for art in general.

13. The breakdown of the sharp division between Object arts and Event arts is a crucial aspect of the story of the emergence of new art forms consequent on the appearance of ambiguous new media in the mid to late nineenth century—I think of film and sound recording in particular, both of which were time-traps or *event-objects*: events in their unfolding and objects in their straight-from-the-world repeatability. The pursuit of an integration of space- and time-based arts (deeply ingrained as fundamentally incompatible since at least the publication of Lessing's influential "Laocoön" in 1771) was endemic in the historic *avant gardes*, and was expressed in *soirées*, actions and performances, as well as, more obliquely, through readymades, photomontages, Rayograms and Merz works, in which the inclusion of the event of finding, making or presenting seems forcefully to be implied in the final object (something similar could be said, perhaps, of Impressionism and Abstract Expressionism). It seemed that if art wanted to approach life, it would need to acknowledge that life was an event. In short, it has been one of the defining features of twentieth century art that admixtures of different media have grounded new forms and new fields of work. With the entry of sound into the condition of post-*avant-garde*-art-in-general—following the critical interventions of John Cage in the 1950s—a critical levelling step was passed that laid the basis for a number of innovative new forms in which event and object, space and time-based arts collapse into genuinely new means of perceptual signification.

14. "My fight for the liberation of sound and for my right to make music with any sound and all sounds has sometimes been construed as a desire to disparage and even discard the great music of the past. But that is where my roots are. No matter how original, how different a composer may seem, he has only grafted a little bit of himself on the old plant. But this he should be allowed to do without being accused of wanting to kill the plant. He only wants to produce a new flower. It does not matter if at first it seems to some people more like a cactus than a rose." Edgard Varèse, "The Liberation of Sound" (1936), in Christoph Cox and Daniel Warner, eds. *Audio Culture: Readings in Modern Music* (New York: Continuum, 2004) 19.

15. In "Schoenberg is Dead," (1951) in *Pierre Boulez: Notes of an Apprenticeship*, trans. Herbert Weinstock (New York: Alfred A. Knopf, 1968). The comment, often quoted, is admittedly removed from its context, but that context doesn't change it much in its feel for the time.

16. Of course, looking to the past is not inherently conservative (the Renaissance for one looked back towards classical antiquity). But the simple claim to legitimation or inspiration from some aspect of the past may, according to circumstance, express varied impulses: returning to a path from a thicket, sloughing off accumulated noise, asserting authority for what are in effect new insights. Context in this, as in so much else, is everything. In the case under observation, Darmstadt seems in part to have been trying to mount a late defence against continuing dissolution, while Fluxus strove to accelerate the process of dissolution in order to force art into the condition of a new paradigm.

17. Michael Nyman in his invaluable book *Experimental Music: Cage and Beyond* (New York: Schirmer, 1974) spells out the difference between the 'avant garde' and the 'experimentalists' at this time, as does John Cage in his address to the convention of the Music Teachers National Association in Chicago in 1957 (reprinted in the brochure accompanying George Avakian's 3 LP recording of "The 25-Year Retrospective Concert of the Music of John Cage" at Town Hall, New York, 1958 (KO8Y-1499 -1505)).

18. But was that work an artwork or some other kind of work? If we think it was an artwork, we have already answered, and therefore rendered redundant, its *raison d'etre* as a question—and then where is the work? Duchamp himself took great care to exclude the objects themselves from any art value their real or virtual presentation might claim. And that removal was the basis of his own claim to have produced a work. But when form is irrelevant, and content is lost along with the loss of the historically specific context that gave it meaning, what remains? Such works, after their initial proposition, become empty relics, or, at most, evidence of critical moments in the history of art (or music). How else could they be meaningfully understood?

19. Cage had his own answer of course—that any sound could be music, including silence: "If you want to know the truth of the matter, the music that I prefer, even to my own and everything, is what we are hearing if we are just quiet." Cited in Richard Kostelanetz, *John Cage (Ex)plain(ed)* (New York: Schirmer Books, 1996) 12.

20. John Cage "Diary: How To Improve the World (You Will Only Make Matters Worse) (1968); revised in Cage, *M-Writings '67-'72* (London: Calder & Boyars, 1973).

21. By using chance procedures and non-sentient systems to make decisions, Cage also deliberately avoided the Surrealists' appeal to the unconscious. Their uses of non-intentionality, such as automatic writing, were employed to sidestep conscious reason, with the implication that this might release deep, and therefore meaningful, archetypal forces buried in the unconscious mind. To avoid this, Cage deliberately eschewed the human for the inhuman in his aleatoric operations.

22. Duchamp recognized this problem and was careful to limit the number of readymades he presented as works, despite knowing that there was no limit.

23. And against the '*avant garde*.' For instance, in 1964, Fluxartists picketed the Stockhausen concert in New York in an "Action Against Cultural Imperialism," handing out a leaflet written by George Maciunas condemning "White, European-U.S., Ruling Class Art."

24. It was Henry Flynt, a musician involved with Fluxus, who coined the term 'Concept Art' in "Essay: Concept Art" (1963) in La Monte Young and Jackson Mac Low, eds. *An Anthology (An Anthology of Chance Operations, Concept Art, Anti-art, Indeterminacy, Improvisations, Meaningless Work, Natural Disasters, Plan of Actions, Stories, Diagrams, Music, Poetry, Essays, Dance Compositions and Mathematical Compositions* (New York/Munich: Galerie Heiner Friedrich, [1963] 1970).

25. I do not intend to decry Pop art, Fluxus or any of the extraordinary propositions made by artists in the last 60 years. Indeed generally I celebrate them. Here I am only trying to answer a specific question about the validity, in the new conditions, of the concept of an *avant garde*—and parenthetically, perhaps, to raise the question of whether we are failing to recognize new categories as we attempt to subsume them under old ones—to the detriment of both.

26. Do I exaggerate? Here is a sample of statements: "To establish [the] artist's non-professional, nonparasitic, nonelite status in society, he must demonstrate … that anything can substitute art and anyone can do it" (George Maciunas, "Fluxmanifesto on Fluxamusement," 1965); "If you want to know the truth of the matter, the music that I prefer, even to my own and everything, is what we are hearing if we are just quiet" (John Cage, 1958) and "Sounds one hears are music" (John Cage, "Afterword" in *A Year from Monday* (Middletown: Wesleyan University Press, 1968)); "It seems to me that the most radical redefinition of music would be one that defines 'music' without reference to sound" (Robert Ashley, 1961). There are plenty more.

27. From aphorism 19 in Part I of Ludwig Wittgenstein, *Philosophical Investigations*, trans. G. E. M. Anscombe (Oxford: Basil Blackwell, 1953) 8.

28. Much has been said about experience being central to contemporary art, but in this sense, at least, it is classical art that rests on its invocation of experience and modern forms that produce types of alienation that result in verbal contemplation.

29. Cage, "History of Experimental Music in the United States," (1959) in *Silence: Lectures and Writings* (Middletown: Wesleyan University Press, 1961).

30. John Cage wrote of Edgard Varèse, meaning to praise him, that he was "the first to write directly for instrumental ensembles (giving up the piano sketch and its orchestral coloration)"—before going on to criticize him for being "an artist of the past. Rather than dealing with sounds as sounds he deals with them as Varèse." (John Cage, "Edgard Varèse," in *Silence: Lectures and Writings*, 83-84). That set of mind seems to me rather to sum up the current confusion: one either accepts this as meaningful criticism—or at least a clear statement of position—or wonders why Cage is so keen to erase the will to create and to communicate.

31. Again, perhaps with the exception of the later Cage, who, it might be argued, made an attempt to escape the issue altogether. At the very least his goal, like Duchamp's, was profoundly ambiguous.

32. Marcel Duchamp in an interview with James Johnson Sweeney in *The Bulletin of the Museum of Modern Art*, 13:4-5 (1946). Or as Tristan Tzara wrote in the Dada Manifesto of 1918, "There is a great negative work of destruction to be accomplished. We must sweep and clean."

33. In mute recognition of this, Paul Griffiths' book *A Concise History of Avant-Garde Music: From Debussy to Boulez*, published in 1978 by Oxford University Press, was quietly renamed *Modern Music: A Concise History from Debussy to Boulez* for its 1992 reprint.

34. James Joyce, *A Portrait of the Artist as a Young Man* (London: Urban Romantics, 2011) 222.

Charles Gaines, *Socialist Congress (Manifestos)*, (Manifesto of the International Socialist Congress, 1917), 2008. Drawing, graphite on paper, 70.5 x 44.5 inches. Courtesy of the artist and the Hammer Museum.

Charles Gaines, *Conscious Changes (Manifestos)*, (Manifesto of the Situationist International, 1961), 2008. Drawing, graphite on paper, 70.5 x 44.5 inches. Courtesy of the artist and the Hammer Museum.

Charles Gaines, *Black Panther (Manifestos)*, (Manifesto of the Black Panther Party, 1966). Drawing, graphite on paper, 62.5 x 45 inches. Courtesy of the artist and the Hammer Museum.

Charles Gaines, Zapatista (Manifestos), (Manifesto of the Zapatista Army of National Liberation, 1993), 2008.
Drawing, graphite on paper, 75 x 45 inches. Courtesy of the artist and the Hammer Museum.

Playing Regular: The Jazz Avant Garde

Jason Robinson

During a March 2012 musician-to-musician interview conducted by saxophonist Steve Coleman and produced by the Brooklyn-based School for Improvisational Music (SIM), legendary percussionist Milford Graves recalls his first experiences in the New York jazz scene:

> In 1964, when I made my appearance on the scene ... people said 'you gotta go and check this guy Milford Graves out!' And I said why does everyone want to check me out? Then I read a review and they said he's 'avant garde.' You know what I did, I went and got the dictionary and said what the heck is 'avant garde'? That was a new name for me. ... I thought I was just *playing regular*.[1] [sic; italics added]

Graves' humorous anecdote reveals the uneven and clumsy ways in which the term "avant garde" was grafted onto certain directions in jazz in New York in the 1960s. Its first use in this way is difficult to pinpoint. Instead, it was employed somewhat interchangeably with a number of coterminous descriptions such as "new thing," "free jazz," and the "new black music," the latter closely associated with music critic and poet Amiri Baraka (then LeRoi Jones) and other African American writers of the Black Arts Movement.[2] That Graves' music was described as "avant garde" by critics in 1964 served to position his music in relation to the radical new music ushered in by the Ornette Coleman Quartet's arrival in New York in 1959 and the emergent musics of John Coltrane, Cecil, Taylor, Albert Ayler, and others.

Taken in the context of rumbling debates about the "new thing" in jazz in the early 1960s, that Graves imagined his music as "regular" has profound implications. Rather than a "projection into some weird future," he understood his music as historically situated and organically emergent.[3] He was simply playing as he had done in his earlier years in Jamaica, Queens, where he came of age. By 1964, however, "avant garde" had become shorthand for a spectrum of emerging musical practices pioneered in large part by visionary African American musicians thinking in and beyond the historical trajectories of what is commonly called "jazz."

There is little indication that the initial use of the term "avant garde" in the context of jazz was in dialogue with the "historical avant garde," or with the schism between "uptown" and "downtown" composers reflected in the productive tensions generated by the evolving uses of "experimental" and "avant garde" to describe a Eurocentric compositional lineage in American music.[4] If anything, surveying the jazz press since the 1960s leaves one with the impression that "avant garde" was, and perhaps continues to be, little more than a pejorative term meant to describe something assumed to be problematic.[5]

Pushing back against the pejorative, one might appropriately ask *which* avant garde? In reality, there have been multiple avant gardes associated in one way or another with "jazz." In the earlier years, these included the American jazz avant garde of the 1960s based largely in New York (Ornette Coleman, Archie Shepp, Albert Ayler), or the Chicago avant garde of the 1960s (the first generation of the Association for the Advancement of Creative Musicians), the "first wave" of the European jazz avant garde of the 1960s (Peter Brötzmann, Alexander Von Schlippenbach, Irène Schweizer, Evan Parker, Misha Mengelberg, among many others).

Today, the jazz avant garde rarely operates under the banner "avant garde." The vast proliferation of musical practices evolved from or inspired by what we might call the "historical" jazz avant garde of the 1960s has produced innumerable musical communities and musical approaches around the world. The jazz avant garde, writes critic Bill Shoemaker, "is more like a plutonium atom, a volatile bundle and swirl of subgenres, polygenres and antigenres."[6] Thus, one might find the avant garde lurking within many genre and stylistic titles: creative music, experimental music, improvized music, free jazz, avant jazz, and, yes, even avant garde jazz. Yet these names reflect numerous histories, agendas, struggles, and aesthetic approaches. They are more than synonyms.

Widely accepted histories of the American experimental music of the 1960s provide scant evidence that an African American avant garde existed, even if it was indeed vibrant and multifaceted.[7] If Manhattan's emerging "Downtown I" music scene of that era was an Other to the "uptown" avant garde, then the "jazz avant garde" was yet another Other—for different audiences the jazz avant garde was neither "jazz" nor "avant garde."[8] Such a play with words should not be construed as an argument for the separation of the jazz avant garde from a more broadly constructed history of American experimental music. Instead, I wish to highlight ways in which the naming of new and continuing musical practices always rests within discourses about value, inclusion and exclusion, and opportunity. These discourses are inevitably mired within problematic discourses of race, class (of both "taste" and socio-economic status), gender,

and other dynamics of difference within American society. Ultimately, I argue for a balanced approach to understanding the so-called jazz avant garde, in which the dual trajectories of consolidation and expansion are seen through the prisms of descriptive and prescriptive critique.

Collectivizing Histories of the Jazz Avant Garde

Now more than fifty years after Ornette Coleman's debut in New York, standard historical narratives about the jazz avant garde have consolidated into an orthodox story. The "first wave" of the jazz avant garde included Coleman, Cecil Taylor, and, after 1964, John Coltrane. There were various precursors to this first wave, such as Charles Mingus, who incorporated forms of collective improvisation in his music throughout the 1950s and after; Sun Ra, who founded his Arkestra in the early 1950s in Chicago; and Lennie Tristano, whose 1949 recordings of "Intuition" and "Digression" are often cited as the first jazz recordings of "free" improvisation (with no pre-determined musical form prior to performing). Yet despite their apparent aesthetic connections to the jazz avant garde, these precursors either developed a critical stance towards the avant garde or remained somewhat distinct from the primary contexts—clubs, festivals, touring circuits—occupied by the jazz avant garde of the 1960s.

Coltrane's meteoric rise as the aesthetic leader of the avant garde occurred during the first few years of the 1960s, as his "classic quartet" began exploring more experimental approaches and sounds, culminating with the 1964 release of the devotional album-length work *A Love Supreme* and, finally, the 1965 large ensemble recording *Ascension*. The latter features an eleven piece ensemble within which the "classic" Coltrane quartet is augmented by numerous young horn players, many associated with the "second wave" of the jazz avant garde, including Marion Brown, Pharoah Sanders, Archie Shepp, and John Tchicai.

These first and second waves of the jazz avant garde map into three general, overlapping trajectories: spiritualism, black nationalism, and, for lack of a better term, what I call new musical complexities.[9] The theme of spiritualism is found in much of Coltrane's post-*Ascension* work, as well as virtually all of Albert Ayler's music. Answering the frequent claim that many musicians associated with the early jazz avant garde were "angry young black men," Ayler dispelled the myth by explaining that his music was "spiritual music": "we are the music we play."[10] At the same time, saxophonist Archie Shepp and others expressed aesthetics and ethics closely related to the "black aesthetic" professed by writers of the Black Arts Movement (Larry Neal, Hoyt Fuller, Amiri Baraka, and others). Yet others associated with the initial jazz avant garde, such as Ornette Coleman and Cecil Taylor, seemed to elide any moorings in spiritualism or black nationalism; instead, their music focused more specifically on musical concerns of vocabulary, form, and structure. Thus, multiple overlapping musical, cultural, and political motivations informed and activated the work of the initial jazz avant garde.

The 1960s and early 1970s also gave rise to important musician collectives, many of which were expressly focused on nurturing new models of African American musical experimentalism. In 1964, trumpeter and composer Bill Dixon produced the "October Revolution in Jazz," a four night festival celebrating the "new thing" at the Cellar Café on the Upper West Side of Manhattan. Having produced experimental concerts at a number of small coffee shops in Greenwich Village, Dixon was fully ensconced in the emerging jazz avant garde. The festival featured performances by Sun Ra, Albert Ayler, Rashied Ali, Paul Bley, Alan Silva and a number of others, and included nightly panel discussions after each concert (focused in large part on the ongoing debates about the jazz avant garde).[11]

Capitalizing on the energy created by the October Revolution, and encouraged by pianist Cecil Taylor, Dixon co-founded the short-lived Jazz Composers Guild, a cooperative dedicated to "exposure, protection, and support" of member artists.[12] In a 1965 interview published in *Down Beat*, Dixon echoes the kind of self-determination imperatives common in the black nationalism of the period: "it is very clear that musicians, in order to survive—create their music and maintain some semblance of sanity—will have to 'do it themselves' in the future."[13] The goals of the Guild extended beyond the basic professional aims of a musicians' union:

> to establish the music to its rightful place in the society; to awaken the musical conscience of the masses of people to that music which is essential to their lives; to protect the musicians and composers from the existing forces of exploitation; to provide facilities for the proper creation, rehearsal, performance, and dissemination of the music.[14]

Unfortunately, the Guild lasted only from late 1964 to July of 1965, when it imploded due to confusions and disputes (most likely beginning with Archie Shepp's decision to accept a recording contract with Impulse! for *Fire Music*, even if it predated the Guild by a few months, and concluding with a controversial decision for a few member artists to appear at the July 1965 Newport Jazz Festival under the name "The Jazz Composers Guild").[15] Nevertheless, the Guild provided an important model of collectivity in the highly competitive New York jazz community, and surely influenced the Collective Black Artists (CBA), an expansive musicians' organization active in New York from 1970 until about 1976, and whose membership numbered more than three hundred.[16]

Other clues to the evolving avant garde appear outside of New York during this period. The longest lasting collective to emerge during the 1960s is the Association for the Advancement of Creative Musicians (AACM), founded in

Chicago in 1965, now with branches in both Chicago and New York. Chronicled in George Lewis' expansive book-length history, *A Power Stronger Than Itself: The AACM and American Experimental Music*, the AACM brought together a broad constituency of South Side musicians, including many associated with the Experimental Band, a composer-oriented rehearsal group active in the early 1960s and coordinated by pianist Muhal Richard Abrams.[17] In May 1965, Abrams, Jodie Christian, Phil Cohran, and Steve McCall sent a postcard invitation to many of Chicago's accomplished African American musicians, inviting them to a meeting to discuss the formation of a musicians' collective.[18] Over the course of several general and executive board meetings that took place that month, the AACM was founded with the express intent of supporting what they called, after much debate, "creative music." It was chartered by the State of Illinois as a nonprofit organization in August 1965 and various membership regulations were enacted.[19]

Lewis positions the founding of the AACM in broad historical perspective, situating the collective within the last phase of the Great Migration (1950-1965), the founding of the Jazz Composer's Guild and the Union of God's Musicians and Artists Ascension (UGMAA) in 1964 (the latter in Los Angeles), and the shifting coterie of black cultural institutions in Chicago during the 1960s. Notably, "in direct contradiction to the overwhelming majority of critical commentary on the AACM, terms such as 'new jazz,' 'the avant-garde,' or 'free jazz' were seldom, if ever, used in discussions [by AACM members at the dawn of the organization]."[20] Instead, the notion of "original music" became a guiding principle for AACM members and the term "creative music" was adopted, in part subverting racist assumptions about black musicality, jazz, and entertainment.[21]

In its nearly fifty year history, a staggering number of influential musicians and groups have emerged from the ranks of the AACM—far too many to list here. Indeed, musician collectives have been vital to the history of experimental music in and beyond the United States. A complete comparative history of such groups has yet to be written. In the United States, this would certainly include the JCG, UGMMA, AACM, CBA, and the Black Artists Group (BAG), active in St. Louis during the early 1970s, among others. Important musician collectives have, of course, also emerged beyond the United States. Among these are the London Musicians Collective, the Association of Improvising Musicians (AIM) in London, Beroepsvereniging voor Improviserende Musici (BIM) in Amsterdam, Werkgroep Improviserende Muzikanten (WIM) in Antwerp, and the Association of Improvising Musicians Toronto (aimtoronto), among others. Each of these organizations embodies different musical, social, and historical trajectories—they are anything but uniform in their aims and aesthetic approaches.

A more complete history of the jazz avant garde must take into account the ways in which musician collectives have supported and encouraged new musical practices and bolstered new experimentalisms. A historiographic turn is needed that dispenses with the linear logic so pervasive in standard accounts of the development of jazz. Such histories prioritize neat chronologies of influential figures over the messy, overlapping, community-rooted histories that actually explain the development of the music. Without this awareness, histories go missing; and historical amnesias are rarely innocent.

Downtown-ing

Although one might casually use both "avant garde" and "experimental" to describe the music of Ornette Coleman, post-1964 John Coltrane, Albert Ayler, Cecil Taylor, and others, it is nevertheless important to note that these two descriptions have broader, more nuanced implications in the context of American music. When the so-called Downtown I scene coalesced in the early 1960s, a binary emerged in the concert music scenes of New York that pitted an academic "uptown" avant garde against a new movement of "experimental" musicians whose work was often presented in artist lofts and other venues in lower Manhattan. Kyle Gann, the longtime *Village Voice* writer and champion of the new experimental music, identifies the beginning of Downtown I with the concert series that took place at Yoko Ono's SoHo loft in 1961, which was curated by composers La Monte Young and Richard Maxfield.[22] Drawing inspiration from a number of sources, including the more established artists associated with American experimental music such as John Cage, Earle Brown, Morton Feldman and Christian Wolff, the wide swath of artists associated with Downtown I include Young, Maxfield, Laurie Anderson, Robert Ashley, Glenn Branca, Rhys Chatham, Philip Glass, Garret List, Meredith Monk, Pauline Oliveros, and Steve Reich, among many others.[23]

Just a few years after the concert series at Yoko Ono's loft began, a separate "jazz loft" scene emerged in lower Manhattan. Although mostly disconnected from the uptown/downtown dynamic that helped constitute Downtown I, the jazz loft scene serves as a kind of alternative narrative to standard histories of musical experimentalism in New York during the 1960s and 1970s. While La Monte Young, Steve Reich, and others associated with Downtown I acknowledge the influence of the jazz avant garde on their musical aesthetics, histories of experimental music in the United States during this period largely ignore the aesthetic influence of the jazz avant garde on Downtown I and the proximity of the two "loft" scenes to one another.[24] Thus, according to these histories, it is as if there were no experimentalisms emanating from African American musical practices. Such historical amnesias reiterate comfortable yet problematic cultural and racial boundaries within American music and obscure the impor-

tant role of African American musical experimentalism in shifting historical circumstances. In this context, jazz becomes an Other devoid of historical relevance or nuance. In actuality, this is anything but the truth.

Although Ornette Coleman and Coltrane enjoyed slightly more robust performance opportunities during the early 1960s, most musicians associated with the jazz avant garde nevertheless struggled to find performance opportunities and earn income from their music. During this period, confronted with a lack of performance contracts, Cecil Taylor reportedly maintained his technical and expressive abilities by performing "imaginary concerts" in his apartment.[25] At the same time, jazz experimentalists began performing at a number of coffee shops in Greenwich Village and the lower east side, often passing a hat around to collect donations as payment.

By the end of the 1960s, several prominent artist work-live lofts in lower Manhattan began hosting public concerts, commencing what is commonly referred to as the "jazz loft" era of the 1970s. As an alternative to the more commercially driven jazz clubs of New York, lofts (coffee shops and rented venues) provided alternative social spaces to present music beyond the mainstream of the time; as George Lewis argues, "these newer art worlds needed alternative spaces in order to get their experimental work before the public, expanding the set of positions available for the music."[26] Trombonist Roswell Rudd recalls these alternative social spaces as "galvanizing" for the continued development of the nascent jazz avant garde of the period.[27] In addition to affordable housing, lofts provided ready-made spaces for meetings, rehearsals, and artist-run concerts. And as important sites for social and cultural exchange, lofts provided a kind of intimate proximity to those who lived in and around the lofts and frequented the concerts they hosted. Although not technically a loft, consider, for instance, that when trumpeter and composer Bill Dixon moved into an apartment in the West Village in 1959, his neighbors included La Monte Young and George Russell.[28]

Indeed, many jazz lofts were located near each other in what saxophonist and activist Fred Ho describes as the "pre-gentrified" neighborhood of SoHo in lower Manhattan.[29] By the mid 1970s, these included Studio Rivbea, founded by Sam Rivers, perhaps the most well-known, as well as Artist's House (Ornette Coleman's loft), Ali's Alley (founded by percussionist Rashied Ali), Ladies' Fort (founded by vocalist Joe Lee Wilson), and Environ (founded by pianist John Fischer). Other lofts were scattered throughout lower Manhattan (including percussionist Warren Smith's Studio WIS).[30] While these often featured performances by those associated with the jazz avant garde, other lofts emerged that chiefly presented jazz of the more "straight ahead" varieties, including Mark Morganelli's Jazz Forum and Mike Morgenstern's Jazzmania (founded in 1979 and 1978, respectively).[31]

When composer and reedist Anthony Braxton and violinist Leroy Jenkins, both members of Chicago's AACM, returned from Europe to the United States in 1970, they settled in New York and, for the first three months, stayed at Ornette Coleman's Artist's House loft, "answering the door, helping him copy music, arguing about his harmolodic theory."[32] Braxton and Jenkins joined two other early AACM figures in New York, saxophonist John Stubblefield and drummer Phillip Wilson.[33] Along with self-produced concerts at churches and other venues, the evolving loft scene proved important to the arrival of AACM musicians in New York over the next few years (likely as a continuation of self-producing strategies developed in the early years of the AACM in Chicago).

Various overlaps between the Downtown experimental scene and the loft jazz scene emerged by the end of the 1970s. AACM trombonist, composer, and scholar George Lewis, part of the "second wave" of the AACM to arrive in New York by the end of the 1970s, assumed the role of artistic director of The Kitchen in 1979. Lewis' impact as artistic director may have helped to problematize the "arbitrary wall between 'new music' and 'jazz' improvisation in Downtown," yet the deeply engrained racialized rhetoric that often marginalized African American experimentalists from prevailing public discourses about Downtown I continued to play out.[34] A few writers for the *Village Voice* and the *New York Times* provided sporadic coverage of black experimental musicians, "which they discursively folded into the previous decade's conception of 'avant-garde jazz'."[35] Thus, older codes that distinguished the uptown avant garde from downtown experimentalism collided with a racialized vocabulary that persistently defined black experimentalism through the prisms of jazz, race, and, perhaps less consciously, through recourse to the notion of the "avant garde," the latter Downtown I's uptown rival. This occurred even while several key Downtown I figures, such as Steve Reich and La Monte Young, actively acknowledge the profound influence of John Coltrane and other jazz experimentalists to the new "minimalism" they developed in the 1960s and 1970s.[36]

The activities of AACM members in New York during the 1970s and 1980s "challenged racialized hierarchies of aesthetics, method, place, infrastructure, and economics," in part setting the precedent for the genre mobility largely associated with Downtown II artists of the 1980s and 1990s.[37] It is difficult to draw clear historical and stylistic boundaries between Downtown I and Downtown II. Most accounts recognize the growing importance of various forms of rock music to certain Downtown I artists, such as Laurie Anderson, Glenn Branca, Rhys Chatham, and others. Venues such as The Knitting Factory and Tonic, among others, adopted eclectic programming policies, presenting a wide range of experimental, rock, and other acts.

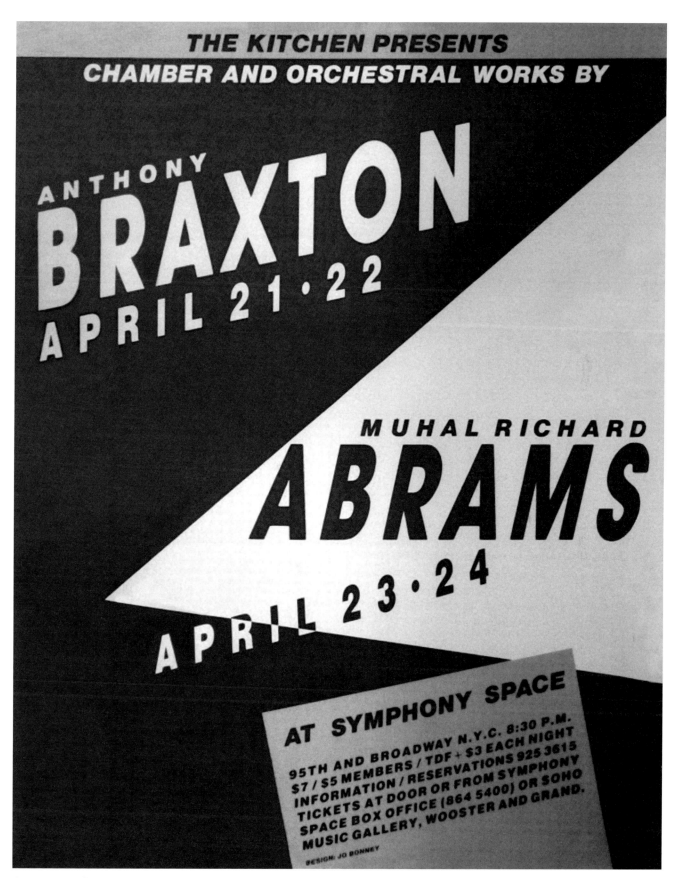

Concert poster featuring Anthony Braxton and Muhal Richard Abrams, The Kitchen, 1982. Courtesy of The Kitchen Archives.

At the beginning of the 1980s, references to rock and punk became more pronounced in press coverage of experimental music in New York, and a discourse emerged celebrating ways in which "experimental composers … were exploring ways of moving beyond conventional taxonomies of high and low culture."[38] This is evident in *New York Times* music critic John Rockwell's 1983 book *All American Music: Composition in the Late Twentieth Century*, structured as a series of composer portraits that include Philip Glass, David Byrne, Laurie Anderson, and Ornette Coleman, among others. The genre-combining and genre-mobility rhetoric evidenced in Rockwell's book is similarly captured in what Kyle Gann calls "totality music," his slightly different term for the same trends in American experimental music in the 1990s.[39]

Yet despite this rhetoric, persistent assumptions about race continued to influence the discourse around experimentalism and Downtown II. While AACM musicians in New York "expanded the range of thinkable and actualizable positions for a generation of black experimental artists," press accounts of Downtown II nevertheless repeat racialized tropes that grant wide aesthetic latitude to white musicians while simultaneously limiting the descriptions of the music of similar black artists to tired assumptions about jazz.[40] In a *New York Times* review of an Anthony Braxton program at The Kitchen in 1982 (which occurred as part of the two day "New Virtuosi Festival," curated by George Lewis and also featuring Muhal Richard Abrams), for example, John Rockwell argues that "however much he may resist categories, Mr. Braxton's background is in jazz, which means an improvisatory tradition."[41]

Seemingly aimed at questioning the composer-oriented position articulated by Braxton and many AACM artists, Rockwell's analysis binds Braxton to jazz while also suggesting that jazz is always "improvisatory." Thus, Rockwell reveals what cultural theorist Homi Bhabha asserts is fundamental to the function of stereotypes: a deep ambivalence. For Bhabha, the "stereotype … is a form of knowledge and identification that vacillates between what is always 'in place,' already known, and something that must be anxiously repeated," yet "must always be in excess of what can be empirically proved or logically construed."[42] Indeed, the breadth of Braxton's music in 1982 defies comfortable classification as "jazz," just as the rich legacy of composer-performers in the history of jazz, and African American music more broadly, confounds any simplistic view of jazz as "always improvisatory."

Yet while Braxton and other African American experimentalists were persistently linked with the label "jazz" in the press, other "totalists" were not. Saxophonist and composer John Zorn is perhaps the most celebrated of these figures. Since the 1980s, Zorn has been lauded for the ways in which he draws on numerous musical genres, effortlessly and virtuosically moving between vastly different sounds

and approaches. "Mr. Zorn transcends categories," writes John Rockwell, "he's made a notable career crashing them together and grinding them to dust."[43]

In 1984, Rockwell reviewed a double bill that included both Zorn and Braxton and which took place under the auspices of producer Verna Gillis' Soundscapes series, part of that year's Kool Jazz Festival. Perhaps due to the obvious overlaps between the two musicians, Rockwell's tone was somewhat more generous towards Braxton. Still, Rockwell reserves the greatest praise for Zorn's music: "a listener could enter willingly into the flux of Mr. Zorn's world."[44] Throughout such press coverage, one repeatedly encounters coded language of genre transcendence (for white musicians) and genre specificity (for African American musicians, who are generally linked to jazz, even if their music challenges such a characterization). George Lewis perceptively notes that "claims of genre transcendence often feature a complementary Othering of someone else as 'genre-bound,' with criteria for the identification of genre diversity that shift according to not only (or even primarily) musical direction, but also the race, ethnicity, class position and, quite often, the gender of the artist involved."[45]

It may be the case that the genre-transcending/genre-bound eclecticism formulation now commonly used to describe Downtown II may nevertheless fail to adequately capture the depth of musical experimentalism in New York in the 1980s and 1990s. Indeed, many significant developments fall outside of this rubric. Among others, these include the M-BASE movement, spearheaded by saxophonist Steve Coleman but including a wide assortment of influential musicians who came of age in the late 1980s and throughout the 1990s, and the robust, multifaceted community of free-blowing improvisers who sometimes go under the banner of "free jazz" and who are embodied by the yearly Vision Festival (originally founded by bassists William Parker and Peter Kowald as the Sound Unity Festival).

The New York jazz avant garde has shifted considerably since the 1990s. The majority of the venues are now located in Brooklyn, with Le Poisson Rouge and The Stone being two of very few exceptions in lower Manhattan. The Brooklyn venues include Roulette, Issue Project Room, Shapeshifter Lab, Barbès, Seeds, Firehouse Space, and a few others. Lower rents (both residential and commercial) and more affordable operating costs certainly account for the almost wholesale shift to Brooklyn, but there may be a more thorough shift in aesthetics and ethics at play. The music of Vijay Iyer, Mary Halvorson, groups like Mostly Other People Do the Killing, and many others, confounds simplistic, linear relationships to the history of jazz and many other musical forms. Having emerged over the last ten or twenty years, this new generation takes as its point of departure a post-World Wide Web access to vast digi-

tized musical archives and a cut'n'mix ethos. While it is clear that older codes of difference—race, gender, style—continue to impact the ways that musicians imagine their work, it is also the case that the very meaning of "avant garde" changes over time.

Description and Prescription

For the jazz recording industry, 1959 and 1960 proved to be banners years. Albums either recorded or released during these years include Miles Davis' *Kind of Blue*, Ornette Coleman's *The Shape of Jazz to Come, Tomorrow is the Question!*, and *Change of the Century*, Dave Brubeck's *Time Out*, and John Coltrane's *Giant Steps*, among others. While Coleman was a relative newcomer to the larger national discourse about jazz, the music of the more well-known John Coltrane was evolving rapidly during this period. His so-called "sheets of sound" period was reaching its zenith at the end of the 1950s (as he left Miles Davis' group). In 1961, joined by the idiosyncratic multi-reedist Eric Dolphy, Coltrane replaced the harmonic "maximalism" of his *Giant Steps* repertoire with a decisive shift towards modalism and more open harmonic forms. At the same time, Coltrane's melodic and improvisational vocabulary continued to expand (often in extended solos) and included as much timbral variation as it did innovative harmonic and melodic structures. By most accounts this shift was ill-received by the majority of listeners and critics. In fact, the now-infamous "anti-jazz" rhetoric aimed at Coltrane and Dolphy began during this period, first brought on by *Down Beat* critic John Tynan in a 1961 review, and echoed by others like Leonard Feather and Ira Gitler.

Coltrane's elevated profile at the time—indeed, a kind of celebrity status—provided opportunities for him to enter into direct dialogue with growing criticisms of the more experimental elements in his music. This is found in Don DeMichael's 1962 *Down Beat* interview with Coltrane and Dolphy, aptly titled "John Coltrane and Eric Dolphy Answer the Critics." Rather than strike an adversarial or combative tone, the voices of both Coltrane and Dolphy appear nuanced, sincere, and gentle. When asked about the extraordinarily long solos that became the trademark of the group, a point of contention for many jazz critics of the period, Coltrane replies "it's not planned that way; it just happens. The performances get longer and longer. It's sort of growing that way."[46] In the midst of his music being labeled "anti-jazz," Coltrane responds with eloquent restraint and calm. Within the jazz press of the early 1960s, the notion of the "avant garde" was often associated with anger and race, linking sound with black nationalism in problematic, narrow ways.

The fact remains that the name "avant garde," like "experimental," is both revered and reviled by musicians who find themselves described as such. For some, avant garde reflects a hard fought struggle for self-determination, a

struggle that remains in progress. For example, in a *JazzTimes* interview with Bill Milkowski in 2000, John Zorn expresses his desire to be seen as part of the avant garde, what he articulates as an emerging "genre in and of itself":

> Zorn: The term 'jazz,' *per se*, is meaningless to me in a certain way. Musicians don't think in terms of boxes. I know what jazz music is. I studied it. I love it. But when I sit down and make music, a lot of things come together…
>
> Milkowski: What tradition do you feel close to?
>
> Zorn: The avant garde. I would like to see the avant garde, experimental music being accepted as a genre in and of itself.[47]

Musicians are not the only ones who have labored for an acceptance of the idea of the avant garde. Critics have also laid it on the line, so to speak; who, writes Bill Shoemaker, "spent most of the last three decades honing the case that these alleged musical heresies were not only rooted in the jazz tradition, but validated the jazz tradition as living and dynamic."[48]

Yet Milford Graves' prescient, if humorous, remarks above about playing "regular" in the context of being labeled "avant garde" provide insights into the ways in which musicians often struggle to maintain control of the discourse surrounding their music and the ideologically entrenched vocabularies used to describe their music and the traditions from which they emerge. For some, such labeling is outrageous and problematic. Saxophonist David Murray, for example, fears being labeled with the "a" word, as he calls it, reflecting a real history of being marginalized by his association with the avant garde: "I tried to get a gig at the Blue Note … and they used that word again, they used that word, and then they said, well he's a part of that word and that's the reason why he can't have a gig at the Blue Note."[49]

It should come as no surprise that describing and naming the music of the jazz avant garde often bubbles into contentious debate. In the 1960s names such as new thing, free jazz, new black music, and the avant garde emerged, all reflecting nuanced conceptions of music through the varying lenses of race, tradition, and social and political issues. Yet this debate about naming is not unique to the avant garde. Indeed, "jazz" has long been problematized by some of those historical figures most closely associated to its development. For example, it is widely known that Duke Ellington preferred "American music" over "jazz," while Max Roach famously called jazz a "four letter word." Others developed a different strategy to undermine various assumptions that accompanied the word "jazz." Yusef Lateef, for example, adopted the term "autophysiopsychic music" around 1970.[50]

Such a critical reflection on the use of the word "jazz" has,

in fact, been important to many artists associated with the jazz avant garde since the late 1960s. As Bill Shoemaker argues, "successive waves of musicians—proponents of the AACM-articulated idea of creative music, the Downtown NYC experimental scene, the largely European improvised-music network and others—were increasingly emphatic in disassociating themselves from jazz."[51] Yet the reasons each of these musical formations aimed to dissociate themselves from "jazz" are diverse and reflect shifting social, cultural, racial, and political aims and realities, not all of which are innocent or benign.

We find this to be the case in certain histories of the European jazz avant garde, whose relationship to American jazz (and African American musicians in particular) becomes a mechanism through which nationalist cultural agendas in the arts are played out. In 1977, German jazz historian Joachim Ernst Berendt, for example, began referring to the emergence of a nationalist European avant garde in the mid-1960s as "The Emancipation."[52] For Berendt, the politically tumultuous 1960s in western European countries acted as a backdrop upon which new, less "American," forms of jazz emerged. During the mid 1960s, the actual number of musicians associated with the jazz avant garde in Europe was rather small—in a 1968 interview for *Jazz Podium*, German saxophone icon Peter Brötzmann put the number at somewhere around fifteen musicians.[53] Yet throughout interviews published in *Jazz Podium* during the 1960s and early 1970s, musicians associated with the "first wave" of the European jazz avant garde often profess a deep connection with both the African American avant garde and older forms of jazz.[54]

In the American context, some may wonder why the word "jazz," since the mid 1980s championed by the Jazz at Lincoln Center crew and others as "America's Classical Music," provokes such a strong response by prominent innovative musicians within its ranks. An answer to this question is necessarily complex. Jazz has long operated at the intersection of race and popular culture in American society, and it was America's prevailing popular music during the 1920s, 1930s, and much of the 1940s. Problematic racist assumptions, what Eric Lott calls the "racial unconscious," played out in reactions to jazz and expectations about what jazz was and who its practitioners were on and off the bandstand.[55] Thus, Amiri Baraka's famous formulation—"Swing: From Verb to Noun"—captures not only the commercializing, commodifying tendencies found in the intersection of jazz and the commercial culture of the 1930s and 1940s, it also suggests ways in which reified ideas about race calcify as "jazz" becomes an already-known artifact within American culture.

Such a process illustrates the critical shift from description to prescription that has long catalyzed debates and tensions across jazz's myriad manifestations. By "description," I mean the critical processes through which musical per-

formances (in live performance or via recordings) and compositions are analyzed, procedures we often call "musical analysis." Equally important to description are the crucial insights of the musicians themselves, or what the music "means" to those who create it. Taken together, analysis and meaning provide an after-the-fact understanding of why music sounds the way it sounds and what it means to those who make it. (Some may see, and rightly so, vestiges of classic forms of musicology and ethnomusicology in my sense of "description.")

"Prescription," on the other hand, extends particular descriptive readings of music into the future, grafting earlier analyses onto new musical moments. In part, this illustrates Baraka's argument that "swing," a kind of rhythmic propulsion characteristic of the "hot" jazz of the 1920s, transformed from a quality within certain leading trends in jazz of the early 1930s into a required, already-known ingredient in commercially successful jazz of the late 1930s and into the 1940s, during the so-called Swing Era. Thus, such a "nounification" of swing, so to speak, structured a broader mainstream understanding of what jazz is—or should be—and effectively defined a center with various margins.

Yet from the long view of the history of jazz, we find that prescriptive tensions surface in somewhat regular intervals. In fact, a number of critical junctures in the development of jazz can be read as a confrontation between evolving musical practices and prescriptive critiques. This is evident, for example, in the debate between the "moldy figs" and the "moderns" in the mid and late 1940s as bebop emerged; and in the debate, largely among critics, that pitted "hard bop" against "cool jazz" during the 1950s; and in the various ways that the jazz avant garde was characterized as "breaking from the tradition" when it emerged at the end of the 1950s and developed significantly during the 1960s; and in the debate about the legitimacy of "fusion" as it emerged in the late 1960s and evolved during the 1970s. Prior to this, when jazz and its precursors functioned as prevailing forms of American popular music (ragtime in the late 1800s, hot and sweet jazz in the 1920s, swing in the 1930s and 1940s), emerging musical forms tended to cause controversy, but of a much more overtly racist nature. As new African American musical forms reached the American mainstream, racist fears about the "infection" of American culture by black culture were often articulated in newspaper and magazine editorials.

The neoconservative turn in jazz criticism in the 1980s and 1990s served many purposes, chief among them supporting the public funding agenda embodied by Jazz at Lincoln Center and the concurrent, celebratory branding of jazz as "America's Classical Music." Writers such as Albert Murray and Stanley Crouch repeatedly argue for a core set of practices central to all jazz, usually with reference to swing, bebop, and improvisation. In a thinly veiled critique of

fusion, the avant garde, and other divergent threads within jazz history, Crouch suggests that "ignoring the challenges of the fundamentals of an art form is less about courage than it is evasion. It is always easier not to swing than to swing, and when swing becomes a target for contempt, swinging becomes more important than ever."[56] This analysis is rather surprising given Crouch's long-ago participation as a drummer in the Los Angeles avant garde scene, where he led a group called "Black Music Infinity" in the early 1970s that featured trumpeter Bobby Bradford, flutist James Newton, saxophonist David Murray, and bassist Roberto Miranda.[57] As a writer, Crouch first championed Murray but made a wholesale turn away from the avant garde in the 1980s, eventually providing superlative support for a traditionalist view of jazz. His greatest disdain is often levied against fusion; for Crouch, "swing" and the "tradition" are the "terms and styles under which a rebellion was fought against the commercial dictates of fusion that threatened jazz during the '70s."[58]

Now well into jazz's second century of development, it may be more useful to imagine aesthetic change as part of what Salim Washington calls the *perpetual* avant garde.[59] Jazz, or creative music if you prefer, is a tradition fundamentally invested in innovation. Moments of change will often challenge distinctions between margin and center. Bill Shoemaker notes that the "'60s 'anti-jazz' vitriol of white establishment critics was still thick in the air in 1970; for it to be recycled in the '80s and '90s by African-American neoconservatives was painfully funny."[60]

Consolidation and Expansion

A few years ago I moved from San Diego, California, to Amherst, Massachusetts. Besides the culture shock one would expect from a lifelong Californian arriving in New England, I was thrilled to meet Glenn Siegel, a tireless concert producer, radio DJ, and longtime proponent of the jazz avant garde. Along with producing the Magic Triangle and Solos & Duos concert series at the University of Massachusetts, Amherst (UMass), an important longtime bastion of creative music in the "Pioneer Valley," he also acts as station advisor for WMUA, UMass' vibrant and eclectic student radio station. An ancillary but surely rewarding component to his position, Siegel hosts Jazz in Silhouette, a Friday morning jazz program on the station, during which Glenn features a broad range of jazz music. It is common to hear Art Tatum, for example, followed by David S. Ware, or Peter Evans followed by Kenny Dorham. For a while WMUA ran a promotional segment for Glenn's radio program that professed its commitment to the "full spectrum" of jazz, from its "consolidators" to its "innovators."

A clever rhetorical play on words, I am struck with the veracity of this juxtaposition, or, rather, it's efficiency. Indeed, the twin trajectories of consolidation and expan-

sion, my way of thinking about "innovation," provide a robust structure for understanding diverse, simultaneous, often contradictory directions in creative music. This interplay of consolidation and expansion is far from a novel idea in jazz historiography. For example, Anthony Braxton offers a clever explanation of change as a complex relationship between restructuralists, stylists, and traditionalists.[61] Stylists and traditionalists codify and sharpen the innovations of those who came before while restructuralists develop new structural and conceptual approaches.

What becomes apparent, then, is that the jazz avant garde is both historical *and* contemporary. Artists of the avant garde may consciously adopt the term "avant garde" for their music *or* feverishly resist being described by it. While certain communities of music makers continue to pursue stylistic refinements of earlier performance practices and traditions, others follow an expansionist barometer, forging new vocabularies and musical identities. It is these contrasting yet interrelated trajectories that give me great faith in the continued development of experimentalism in jazz.

Notes

The author wishes to thank Marty Ehrlich, Gary Smulyan, Garrison Fewell, and Ann Maggs for important feedback and research assistance.

1. "Milford Graves Interview, Part 1," Milford Graves interviewed by Steve Coleman at Brooklyn Conservatory of Music, Meet Jazz Luminaries Series, School for Improvisation (March 16, 2012), available at: http://youtu.be/nRSPxfSYWjo, accessed on April 15, 2013.
2. See, for example, Amiri Baraka, "The Changing Same (R&B and the New Black Music)," *Black Music* (New York: Da Capo, [1968] 1998) 180-211.
3. These words are used by saxophonist Archie Shepp in a 1965 *Down Beat* interview with Amiri Baraka to explain how he envisioned the "new thing" as deeply connected to much older forms of African American music. Quoted in Amiri Baraka, "Voice From the Avant-garde: Archie Shepp," *Down Beat* 32:1 (January 14, 1965) 20.
4. The "historical avant garde" is a phrase I borrow from Bernard Gendron to refer to the European avant garde associated with the second Viennese school of composers. See Bernard Gendron, "Rzewski in New York (1971-1977)," *Contemporary Music Review* 29:6 (December 2010) 557-74. In this essay I also use the phrase "historical jazz avant garde," which is intended to refer to the first and second waves of the jazz avant garde in New York in the 1960s.
5. See, for example, John F. Szwed, *Jazz 101: A Complete Guide to Learning and Loving Jazz* (New York: Hyperion, 2000) 226.
6. Bill Shoemaker, "Bill Shoemaker on Avant-Garde," *JazzTimes* (September 2000) 60.
7. For the foundational, "accepted" history of American and European experimental music see Michael Nyman, *Experimental Music: Cage and Beyond* (New York: Cambridge University Press, [1974] 1999). A challenge to this standard historical narrative is made in George E. Lewis, *Power Stronger Than Itself: The AACM and American Experimental Music* (Chicago: University of Chicago Press, 2008).
8. I adopt the use of "Downtown I" and "Downtown II" from Lewis, *Power Stronger Than Itself* and Michael Dessen, *Decolonizing Art Music: Scenes from the Late Twentieth-Century United States*, PhD dissertation (San Diego: University of California, 2003).
9. For more on this three-part categorization of the early jazz avant garde, see Jason Robinson, "The Challenge of the Changing Same: The Jazz Avant-Garde of the 1960s, the Black Aesthetic and the Black Arts Movement," *Critical Studies in Improvisation / Études critiques en improv-*

isation 1:2 (2005) 20-37.

10. Quoted in Nat Hentoff, "The Truth Comes Marching In," *Down Beat* 33:23 (November 17, 1966) 17-18.

11. See Benjamin Piekut, *Experimentalism Otherwise: The New York Avant-Garde and Its Limits* (Berkeley: University of California Press, 2011) 102-6.

12. Piekut, *Experimentalism Otherwise*, 108.

13. Quoted in Robert Levin, "The Jazz Composers Guild: An Assertion of Dignity," *Down Beat* 32:10 (May 6, 1965) 17.

14. Quoted in Levin, "The Jazz Composers Guild," 18.

15. Piekut, *Experimentalism Otherwise*, 135-8.

16. See Eric Porter, *What Is This Thing Called Jazz?: African American Musicians as Artists, Critics, and Activists* (Berkeley: University of California Press, 2002) 215-39.

17. See Lewis, *Power Stronger Than Itself*, 55-83.

18. Lewis, *Power Stronger Than Itself*, 97-8.

19. See Lewis, *Power Stronger Than Itself*, 115-17.

20. Lewis, *Power Stronger Than Itself*, 98.

21. Here I mean to suggest that a "racial unconscious" exists within American culture that often links musical expression with ideas about race. See Eric Lott, "Love and Theft: The Racial Unconscious of Blackface Minstrelsy," *Representations #39* (Summer 1992) 23-50.

22. Kyle Gann, "Breaking the Chain Letter: An Essay on Downtown Music" (February 2012), available at: http://www.kylegann.com/downtown.html), accessed on April 1, 2012.

23. Dessen, *Decolonizing Art Music*, 54.

24. Howard Mandel, "Jazz lofts as they used to be," in *Jazz Beyond Jazz: Howard Mandel's Urban Improvisation* (April 22, 2010), available at www.artsjournal.com/jazzbeyondjazz/2010/04/jazz_lofts_aint_what_they_used. html, accessed on May 6, 2013.

25. Jazz critic Nat Hentoff recalls that he encountered Taylor in passing one day in the early 1960s and "he said he hadn't played before an audience in six months. But every night in his room, he told me, he played a full, imaginary concert before an audience in his head." Nat Hentoff, "Cecil Taylor: 'It's About Magic and Capturing Spirits'," *JazzTimes* (January/February 2002), http://jazztimes.com/articles/20038-cecil-taylor-it-s-about-magic-and-capturing-spirits, accessed on May 10, 2012. Hentoff shares the same anecdote during a poignant segment of "Episode 10: A Masterpiece By Midnight," the final chapter of Ken Burns' sprawling *Jazz* documentary.

26. Lewis, *Power Stronger Than Itself*, 349. For this quotation from Lewis, I am indebted to Jason Stanyek's recent presentation about the presence of Brazilian musicians and Brazilian jazz in the New York lofts of the 1970s, which took place at the 2012 annual meeting of the Society for Ethnomusicology in New Orleans.

27. Quoted in Benjamin Piekut, "Race, Community, and Conflict in the Jazz Composers Guild," *Jazz Perspectives* 3:3 (December 2009) 196.

28. Piekut, "Race, Community, and Conflict," 192.

29. Fred Ho, "How Does Music Free Us? 'Jazz' as Resistance to Commodification and the Embrace of the Eco-Logic Aesthetic," *Capitalism Nature Socialism* 22:2 (June 2011) 60.

30. See Dessen, *Decolonizing Art Music*, 62-3, and Peter Cherches, "Downtown Music IV: Loft Jazz, 1972-1979," *Downtown Music, 1971-1987: An Overview and Resource Guide*, available at: http://www.nyu.edu/library/bobst/research/fales/DowntownMusic/cherches8. html, 2007, accessed May 6, 2013.

31. "About Jazz Forum Arts," *Jazz Forum Arts*, available at: http://www.jazzforumarts.org/whoweare.htm, accessed on May 6, 2013; Jason Byrne, "Lost Jazz Shrines Celebrates Jazz Forum, Jazz Gallery & Jazzmania Society!," *All About Jazz* (April 25, 2008), available at http://news.allaboutjazz.com/news.php?id=18096#.UYf3tYJAtiY, accessed May 6, 2013. An even earlier loft scene was cultivated in the late 1950s and early 1960s by photographer Eugene Smith at his loft on Sixth Avenue, a popular late-night hangout for many influential jazz musicians, writers, and artists. See *The Jazz Loft Project*, available at http://www.jazzloftproject.org, accessed on April 1, 2012.

32. Leroy Jenkins quoted in Lewis, *Power Stronger Than Itself*, 325.

33. Lewis, *Power Stronger Than Itself*, 325.

34. Gendron, "Rzewski in New York (1971-1977)," 565. Garrett List, artistic director of The Kitchen from 1975 through 1977, frequently presented African American avant garde musicians, such as Cecil Taylor, Archie Shepp, the Art Ensemble of Chicago, and others. This is not surprising given List's involvement with the Creative Music Studio. See Dessen, *Decolonizing Art Music*, 59-60.

35. Lewis, *Power Stronger Than Itself*, 332.

36. Mandel, "Jazz lofts as they used to be."

37. George E. Lewis, "Experimental Music in Black and White: The AACM in New York, 1970-1985," in Robert G. O'Meally, Brent Hayes Edwards, and Farah Jasmine Griffin, eds. *Uptown Conversation: The New Jazz Studies* (New York: Columbia University Press, 2004) 51.

38. Dessen, *Decolonizing Art Music*, 107.

39. See Kyle Gann, *American Music in the Twentieth Century* (New York, Schirmer Books, 1997) 352-86.

40. Lewis, "Experimental Music in Black and White," 52.

41. John Rockwell, "Jazz: Two Braxton Programs," *The New York Times* (April 23, 1982) C23.

42. Homi Bhabha, *The Location of Culture* (New York: Routledge, 1994) 66.

43. John Rockwell, "Recordings: As Important As Anyone in His Generation," *The New York Times* (February 21, 1988) 27.

44. John Rockwell, "Avant-Garde Series Pairs Zorn and Braxton" *The New York Times* (June 24, 1984) 47.

45. George E. Lewis, "Afterword to 'Improvised Music after 1950': The Changing Same," in Daniel Fischlin and Ajay Heble, eds. *The Other Side of Nowhere: Jazz, Improvisation, and Communities in Dialogue* (Middletown, CT: Wesleyan University Press, 2004) 166.

46. Quoted in Don DeMichael, "John Coltrane and Eric Dolphy Answer the Jazz Critics," *Down Beat* 29:8 (April 12, 1962) 21.

47. Bill Milkowski, "One Future Two Views: Conversation with Wynton Marsalis, Conversation with John Zorn," *JazzTimes* (March 2000) 35.

48. Shoemaker, "Bill Shoemaker on Avant-Garde," 60.

49. Quoted in Carlos Figueroa, "De Murray's Nouveau Gutbucket Swing," liner notes to David Murray, *Sanctuary Within* (Black Saint 1201452, 1991), CD.

50. See Yusef Lateef (with Herb Boyd), *The Gentle Giant: The Autobiography of Yusef Lateef* (Irvington, N.J.: Morton Books, 2006) 111-12.

51. Shoemaker, "Bill Shoemaker on Avant-Garde," 60.

52. See George E. Lewis, "Gittin' to Know Y'all: Improvised Music, Interculturalism, and the Racial Imagination," *Critical Studies in Improvisation / Études critiques en improvisation* 1:1 (2004) 3-4.

53. Siegfried Schmidt-Joos, "Weil viele Dinge geändert werden müssen: Ein Gespräch mit Peter Brötzmann," *Jazz Podium* 4:XVII (1968) 128-29. See also Lewis, "Gittin' to Know Y'all," 2.

54. See Lewis, "Gittin' to Know Y'all," 7.

55. See Lott, "Love and Theft."

56. Stanley Crouch, "The Genres: Stanley Crouch on Mainstream," *JazzTimes* (September 2000) 57.

57. James Newton, "Bobby Bradford @ 75," *Point of Departure: An Online Music Journal* 24 (August 2009), available at http://www.pointofdeparture.org/PoD24/PoD24BobbyBradford.html, accessed 16 May 2013.

58. Crouch, "The Genres," 57.

59. Salim Washington, "'All the Things You Could Be By Now': *Charles Mingus Presents Charles Mingus* and the Limits of Avant-Garde Jazz," in Robert G. O'Meally, Brent Hayes Edwards, and Farah Jasmine Griffin, eds. *Uptown Conversation: The New Jazz Studies* (New York: Columbia University Press, 2004) 28.

60. Shoemaker, "Bill Shoemaker on Avant-Garde," 60.

61. See Szwed, *Jazz 101*, 83-4.

Notes on Future Perfect

Sara Marcus

I still want a girl avant garde.

We *have* them, again and again.

And still there's that urinal sitting in the gallery, altar of standup manhood.

Vaginal Creme Davis / Alice Gerard / Billy Tipton / Julie Doucet / Yayoi Kusama / Eileen Myles —Le Tigre

Some canons seem to have just happened. Others wear the stretch marks of their creating.

• • •

I still want a girl avant garde. That's retrograde, but they all are. It's like Gershom Scholem said about messianic thinking: even the inclination to an unknown future, to the ineluctably new, can't help but reach toward a faraway past. An Edenic original state; a historical refusal.

If I want a girl avant garde (not to *have*, just to see it, to know it's there, maybe to pitch in for the others), I want it like I had as a girl. Like I was.

But back then I wanted it because—or I *knew* I wanted it because, could read my want of it because—it was like this newsletter commune I'd read about from earlier, women in dungarees with mimeos in a row house in DC. And that commune got juice from its links to what'd come before.

We're always fallen, already. And as we well know, there was no refusal in Eden.

Our out-front feelings are never immune from nostalgia. Even from being founded on it. Even before we're looking back from after, we're looking ahead to looking back. Will-have-been. And this itself is far from new.

I met many people who had saved their letters, flyers, zines, not just to have them but out of an understanding that these objects needed to survive.

• • •

The girl to girl underground is about to be a video game. I saw this on Google last month.

It's what they call a narrative game. Nothing to kill, nothing to gather but artifacts. In this game, the girl is already gone.

You, the player, are searching through clues in a house whose family has vanished. You have cassette tapes to listen to, with hand-drawn labels. A girl gave the tape to another girl: bright baton in a vanished relay race. Now only the tape remains.

• • •

As remains, these objects recombine in the after of the culture's dreaming.

They're mobile and fungible, but they have their codes at the heart. The beliefs of ones and manys, durably congealed in objects—tangible, sonic, spectacular.

Even a song is an object.

They're what we're left with. They're what we arrive at when we seek to take off.

dear miss davis

I hope this letter finds you well and I hope you are loving your life in Berlin. Even though we've been in touch before, I've never had the chance to tell you how I found out about you and how your work makes me feel. The first time I got to see you perform was in 2006 or 2007 in Olympia, Washington at HOMOAGOGO, but I'd probably known about you since 2000. I want to say that your being one of the many names listed off in that Le Tigre song "Hot Topic" brought you to my attention, but I have a feeling I'd heard of you before that. The point is, you weren't anything more than a name

and maybe a picture or two off the Internet for me for years. But I held onto your name, keeping it safe in my memory for so long because you were the only queer black punk I knew

con't →

Osa Atoe, *Dear Miss Davis*, from shotgun seamstress: a zine for black punks, March 2010.

246

Julie Doucet, *Non*, 2008. Collage, 15 x 21 cm. Courtesy of the artist. Text: us, we're against art we don't like it we show our asses to art we hope for the end of this masquerade that's lasted long enough. that's enough down with artists we know them we know what it's all about their actions are useless so let them croak. we want to torch all those scribblings put the axe to all that scrap and artists we do them in – the end.

The Avant Garde Subsumed in a Tangled Web

Cosey Fanni Tutti

I am inclined to regard 'avant garde' as an historical term that has little significance in present culture.

Having had my own Art and music referred to as 'avant garde' in the past, which at the time in 1975, was understandable in part, particularly as I and Throbbing Gristle members founded the new genre of 'Industrial' music. And I also accept the description of my art actions as avant-garde as they were in keeping in approach with fellow contemporary avant-garde Artists in standing apart from established Art practice. However, the abundance of experimental works (but not notably innovative) in the past 30 years has tended to negate the term 'avant garde,' not least because of the sheer quantity of interesting 'left field' work but most significantly due to the meteoric rise of the Internet and the phenomenal capacity and speed at which it facilitates the dissemination of information. There is little in the way of activity and ideas that can hide or stand in direct opposition to the mainstream. Consequently, anything 'other' has a brief amount of time in which to challenge the norm and present anything in the way of what could be considered as pushing any existing boundaries. The time frame in which anything is recognized as being actively innovative and the time frame in which it is subsequently assimilated as 'the norm' is getting shorter and shorter resulting in more of a shifting co-existence than an oppositional position to the mainstream. I don't necessarily regard this as a positive situation. The boundaries are redefined and shift quickly—maybe too fast to allow for a meaningful understanding of the works or indeed any repercussions (and new ideas) they may provoke.

Which brings me to conclude that at best the avant garde can possibly exist today, albeit transiently.

November 2012

Cosey Fanni Tutti, *Marcel Duchamp's Next Work – Mail Art*, 1974. Courtesy of the artist.

Asunder Ray

Thanos Chrysakis

To be an artist is to fail as no other dare fail… —Samuel Beckett

In a cultural setting in which the supreme paradigm is instrumental reasoning, utilitarianism, desacralization and apathy, it is not surprising that Art has almost completely surrendered to these same forces. The transformational and transfigural capacity of art is almost always operating as a field of resistance, responsibility, liberation, renewal and understanding of our inner and outer worlds. It seems, though, that through a slow and consistent process of appropriation, artistic praxis has been forced into and tamed by sterile professionalization and corporatization.

Long gone are the days when someone like Asger Jorn could send a Guggenheim award and its corresponding cash prize to hell. It seems, rather, that what the art critic Brian Holmes has described in the visual arts as the "gallery-magazine-museum-collection" circuit, and in a similar vein the "academy-competition-prize-concert" circuit in music, provides the structures for what the culture industry offers in quickly interchangeable normative abundance: neo-and/or post-somethings at the same time. So what is the artist's position in a social life that chews everything up, as Morton Feldman once sharply observed?

The position of the artist seems to have degenerated to a great extent into mere careerism. The biggest postwar art movement comes with the name *careerism* and still holds strong and develops even further. Of course, there is no problem with a career per se, but there is one, when it becomes a major movement and cultural setting, as it happens. The most eloquent description of this art movement, that I'm aware of, comes from the painter Dushko Petrovich:

> The scene seemed wild, but there were simple rules all along. You were given a white room in a Big Art City for a month. You had to do something in that room to generate attention beyond that month. You had to be written about, bought, or at least widely discussed. Then you would get to have the white room again for another month, and so on. If you did this enough, you had what was called a career. This generated what is perhaps this century's biggest art movement: careerism.[1]

In music and the sonic arts one can observe a similar movement and mentality. Safe commissions, state or corporate funds, competitions and awards, degrees and more degrees dictate the fate and further growth of this almost global artistic movement. The proliferation of PhDs in music composition and performance in recent years shows another trace of that horrific "art movement": the growing number of composers, poets and painters working in universities. Are we talking about a social malady, a malady of the human spirit, or just a survival strategy within biocapitalist governance?

Ultimately, the notion of the avant garde is not what it used to be. If it still exists, and if it is not entirely appropriated as another marketable genre, it exists as an *asunder ray* of the still creative and imaginative artistic forces that fissure the deeply financialized culture of secular power and its corporate values. Those creative artists who make and project that asunder ray are perceived as misfits or gladiators. We should not be surprised by the verdict as this is not something entirely new.

Actually, they are none of the above; they are just pathfinders or snipers of the unknown! (Not an easy target, indeed. So, dear enemy … mind you!)

Almost everyone could agree that in our mass pseudo-democracies we live to a great extent between narcissism, conformism and spectacle, and the art world not only contains, but also encourages and promotes these attitudes. Rilke's words never sounded so pristine and true: "And we, spectators always, everywhere, looking at, never out of, everything!"[2] Where does the artist stand in this flood of voracious eyes and ears? Where, especially, stands the inquisitive and daring artist?

As a composer and musician, I believe that an avant garde of today needs to break through the self-congratulatory aspect that is contained in any scene, any closed hub and group mentality; it needs an affective artistic opening to the

Raymond Gervais, *Samuel Beckett: Piano Solo* (Les Disques Oboro, 1989). Courtesy of the artist.

world and at the same time must abolish networking for genuine artistic contact and relation—a split from the sterile satisfaction with the merely 'interesting' and the forced single-minded compulsive career building. It should have and should develop its own way out of the conventional and the conventionality of the unconventional—an avant garde that takes the initiative to (re)discover those aspects that make good, powerful art, finding again music's *autaxia* and its special strengths of the intimate and the transfigural, developing ourselves to the level of our art, as Cecil Taylor genuinely pointed out.[3]

Music should make us aware again of the pulsing breath of time that exists beyond the quantifiable criteria of the marketable and saleable aspects of time. Because we are sculpting sound and time music should create time beyond mere utility and certainty, and in that sense, emphasize our own fragile temporality. Creative music transcends listening and points to the elements of transformation, renewal, the transient, the perpetual, an awakening of the carnal human spirit.

It is crucial that an avant-garde artistic praxis of today should not be self-conscious of itself, but only self-aware of its relation to a heavily manipulable reality, a reality that changes too quickly to see, to perceive, that another kind of change is needed, another kind of thinking and affective mode, another kind of dissent and working attitude outside the confines and codifications of our own artistic field and discipline.

Finding our own personal genealogies is equally important, tracing back, even beyond modernity and the notion of the avant garde and its recent past, for exquisite expressions and artistic gestures that defy our present, heavily mediated and organized lives—both social and private—by and within informational techno-systems.

We should enable ourselves to see the notion of the avant garde in diachronic terms, liberating it from its narrow twentieth-century historical origin and framework. The quest for newness is completely shallow if it is not accompanied by a quest for the profound, the mysterious, the elusive and the fertile.

In that sense, a renewal of thought and its affective dimensions contains a rediscovery of the classics. It is not surprising when the artist Robert Wilson points out that the task of the avant garde is to rediscover the classics.[4] True subversiveness exists in places that are not advertised, not marketed as such, or profit from their own supposedly—usually well funded—subversion.

The subversive aesthetic autonomy of the avant garde has either been appropriated or devalued by administrative forces, commercial interests, and corporatization. Therefore, given the deformed mindsets in our societies where economic value is the ultimate value, we should remind ourselves that subversion starts with/within ourselves. Truly artistic praxis equals generosity as it offers a chance for society to reflect upon itself and examine its course and self-understanding.

In a deeply saturated reality that is based on motivated communication, we are accustomed and culturally programmed to search for knowledge only outside ourselves, while at the same time we are unable to see the potential psychic and moral poverty that this attitude contains. In a public sphere that has internalized safe and marketable experiences, it is unlikely that we would have an inkling for experimental and experiential forms of artistic expression. The site of truly artistic resistance in the twenty-first century is the rediscovery of human obscurity and dignity amidst a heavily regulated, codified, and financialized social life.

What is that lucid manifold asunder ray? What is that plenitude of joy?

Notes

1. Dushko Petrovitch, "A Practical Avant-Garde: Toward a Manifesto," *n+1* (April 25, 2006), available at: http://nplusonemag.com/a-practical-avant-garde.
2. Rainer Maria Rilke's "Eighth Elegy" in the *Duino Elegies*, trans. David Young (New York: W.W. Norton, 1978).
3. See Lloyd Peterson, *Music and the Creative Spirit: Innovators in Jazz, Improvisation, and the Avant Garde* (Lanham: Scarecrow Press, 2006).
4. See Erika Fischer-Lichte, *The Show and the Gaze of Theatre: A European Perspective* (Iowa City: University of Iowa Press, 1997) 201.

The Avant Garde as Aeromancy

Kim Cascone

A mysterious cluster of clouds hovers on the horizon. A silver-gray outline frames a distinctive pattern, but on closer inspection, a streak of gray in the vaporous expanse foretells of something ominous about to happen.

Shape, texture, volume, size, color, speed of travel—all intersect on the plane of subtle forms, a projection or a shadow cast from another realm.

These clouds serve as oracles by forecasting future events and providing a method of divination. Only a handful of cowled graybeards—the mystics—have the ability to decipher their secrets.

They interpret the clouds, revealing events arriving from beyond the horizon. These "futures" weave themselves into the daily lives of the community and build a communal pool of wisdom distilled from past experience.

The mystics work in the community as priests, artists, builders, alchemists and healers. Gifted in the art of divination, they possess a spiritual unity with nature that allows them to read her much the way a scholar reads a book.

The townspeople are mostly unaware of the clouds, casually noticing them as sky scenery—the cause of modulating sunlight or a warning of an approaching storm.

The people leave it to the ones with special knowledge to advise them as to the hidden meanings contained in the clouds and to prescribe appropriate courses of action.

Time flows languorously, like a stream flowing from the future into the past under the guidance of the hooded mystics. The village relies upon the mystics' oracles as a means of survival, but also as a way of living in accordance with nature.

Over a distant range of hills a cabal of dark-path wizards, huddled over a jumble of fuming crucibles and burbling flasks, accidentally discovered a formula for making clouds.

The clouds manufactured by these greedy puffers, worth more than gold, were uncanny replicas of the *real* clouds, but neither the mystics nor the populace could distinguish the wizard-made clouds from the clouds sent by nature.

Knowing that the clouds held total sway over the populace, the wizards embedded their own messages into the clouds and waited for the mystics to decipher and deliver them to the people.

The messages were plodding and predictable; mostly recycled artifacts from the past cleverly transformed to appear new, yet somehow felt familiar. Predictability is the handmaiden of control. The faux clouds no longer forecast a future but perpetuated an expired past—keeping things as they were for those in power.

And the puffers extracted their gold not from base metals but from the pockets of an unsuspecting populace.

The clouds that nature sends, serving as messages from imminent futures, no longer exist. Over time the divining mystics gradually lost their intuitive connection to nature; their ability to channel the future atrophied.

The past has become embedded in the future, reducing what we experience as "the present" or "now" as simulacra— a plastic bauble bouncing upon an infinitesimal fulcrum where two streams intersect. One beckons from the past, the other seduces from the future.

The plastic bauble of "now" is all that exists today. All of time is trapped inside of it, containing a chimeric environment constructed from a trick of light, a sleight of hand, the conflation of a nostalgic past with a tantalizing future.

For a real avant garde to exist—again—we need to re-establish a "long-view" perspective, recover from our collective amnesia, and locate ourselves in the larger historical landscape.

By moving outside of this manufactured environment and allowing the stream of time full passage through our psyches, we can return to an intuitive process of artistic divination.

For it is only by a process of "imagination-intent-creation" that we can reshape our past into artifacts from a possible future.

Seb Janiak, *Fear* (from the series *The Kingdom*), 2011. Courtesy of Seb Janiak and Fred Torres Collaboration, New York.

Towards Indisposition

Marc Couroux

All science would be superfluous if the outward appearance and the essence of things directly coincided.
—Karl Marx, *Capital Vol. III*, part 7, chapter 48.

All media work us over completely.—Marshall McLuhan

Once thought by McLuhan to be the only one who could face the present (and the future already contained therein), the artist is now radically fragmented, ceaselessly abutting against one perceived endgame after another, so beaten down by competing rhetorics—all equally disempowering—that the question of art's revolutionary potential simply ceases to arise. At one end, the subsumption of artistic practices under the deleterious purview of the *creative class* amounts to their political neutralization; strategies once destined to interrupt unbridled consumption now function as (unpaid) research and development for the corporate world.[1] At the other extreme, which is really the other side of the same coin, the new orthodoxies of social practice demand ethical immediacy, saddling artists with the onuses of practical solutions, shouldering responsibilities that the state has long ago divested itself of. (Not to mention that this other instrumentalization all too often operates according to the same flexible, decentralized modalities which characterize the globally financialized phase of capitalism we now find ourselves in, resulting in the proliferation of palliative frameworks doubling as alibis for art institutions eager to appear socially relevant.)[2] In this context, agonistic, alienating strategies of disruption (proper to any self-respecting avant garde) are rejected as anti-social (if they haven't already been détourned by predatory advertising and branding) while the vistas opened up by the Internet promise democracy but frequently end up feeding what Jodi Dean terms "communicative capitalism," where contributions not only substitute for direct action but worse, constitute so much value-laden content directly informing real-time profiling, monetizing and datamining operations, ensuring an even more comprehensive, microscopically-attuned capture of general intellect and affect.[3] The neoliberalization of everything has become steadily normalized via the modalities of the möbius strip, the slip to the other side only retrospectively knowable. The artist is caught in a system immanence (Hullot-Kentor)[4], preempted at every turn, unable to see/hear his/her own embeddedness. As Eric Cazdyn points out in *The Already Dead*[5], our culture is characterized by a new chronic mode, replacing the terminal—in which foreseeable limits can be contested, overturned, abolished—with a medicalized, "capitalist realist"

stasis that is in keeping with Kafka's notion of *indefinite postponement* (eminently reflected in computer technologies which perpetually defer completion, its products always changeable, remixable, versionable).[6] It's a world of unending, equivocal short-terms, with the only revolutions one can count on being those of the rapidly refreshing news cycles that can circulate such traumas as the Abu Ghraib prison abuse scandal out of actionable range (something the right wing has long ago understood).

What productive roles can art still fulfill, given the seemingly unlimited capacities of rapacious capital to metabolize the resistant into more precise, pervasive modes of abduction? A radical separation is proposed here, wherein the artist becomes (at least) double: on the one hand, patiently exposing the corrupt forms and frameworks through which late capitalism operates through long-term elaborations of indigestible models (which deliberately thwart the categorical imperatives of art institutions and their curator-managers); on the other, defeating the atomizing, competitive exigencies of the art market and the divide-to-conquer individualism mandated by hyper-consumption by stealthily, anonymously, collectively operating under the radar, applying some of the resultant *modi operandi* in physical and virtual fields of action, according to quotidian, tactical, rapid-response, opportunistic logics divested altogether from the category of art. The efficacy of such strategies is considerably bolstered through the foregrounding of various *secondary processes* (Freud) by which each individual differentially ratifies, completes, co-creates the structures of domination which impede any conceptualization of political action. The ensuing discussion of four creative works—vectors of speculative, potential praxis—revolves around the following, while keeping in mind that no single strategy can ever be sufficient in and of itself and that one always runs the risk of overestimating the obsolescence of any particular approach (an automatic reflex endemic to the ahistorical flattening of resistant options capitalism is adept at promoting): by which contemporary modes is an individual *disposed* to normalized, preemptive predation and by which consequent methods might an active *positioning* against clarified targets take root?

Structural Adjustment, Perpetual Oscillation

Noam Chomsky has pointed out how the relatively short duration of the sound bite requires concise articulation that can only but reinforce conventionally held viewpoints, demanding neither defense nor elaboration.[7] One only has to utter a heretical position within this temporally restrictive format to be immediately consigned to the insane asylum of history: necessary explanations are mechanically preempted by tacit, unacknowledged structural limitations. The normative forms of entertainment media (the most powerful wing of the propaganda machine) operate in this fashion. *The Following* (full title: *The Following, Episode 1: Modified Limited Hangout (special guest star Robert Webber)*), a 2009 single-screen video, reproduces (while overheating) a seemingly untrammeled diversity of narrative events, oblivious to its standardized undergirding: the one-hour television drama-form. It was constructed through the overlay of 18 TV dramas (1971-1979), each featuring a guest appearance by actor-cipher Robert Webber and comprised only of fragments (left in their original position within the timeline of each episode) in which the actor is present acoustically and/or visually (both modes functioning independently throughout). While an impossibly dense viewing/listening experience appears guaranteed, the work is in fact eminently digestible: it's not so much that the predictabilities of the form legislate the nonsense of rambling non-sequiturs into cohesive sense (though this repeatedly occurs), but that the activity of viewing is itself abnormally weighted to the machinations of form and its concomitant manic-depressive curvatures, regardless of content (reduced to a subsidiary status). The rhythms and flows that are native to the form in question annul difference and semiotic contradiction, leveling all materials onto the same plane (much in the same way that news tickers abolish hierarchies between the catastrophic and the ridiculous). Unlike the (ostensibly) decommissioned appropriative practice of montage, which once derived its energetically liberating powers from the juxtaposition of surface heterogeneities, yielding indigestible supplements, *The Following* operates *from below*, propelling to the epidermis temporally-lodged splinters that foment tensions between micro and macro levels, refusing to resolve into straight signification (even of a critical nature). Detonations no longer occur on the level of the traumatic cut (slackened into equivocation), but over a distended temporality gradually revealing generalized, "under-arching" conditions.

The fact that this work is meant to be viewed *as if* it were but another conventional drama automatically activates preconceptions that invalidate the necessity to don the mask of "experimental viewer." Moreover, *The Following* departs from a too-close identification with generic conventions by employing frequent image overlays, drastic edits amplified by tangible changes in grain, "wrong" dubbing, the incorporation of black space within the acts themselves and the almost constant flow of speech in a singular

Marc Couroux, Stills from *The Following, Episode 1: Modified Limited Hangout (special guest star Robert Webber)*, 2009. Single-channel video. Courtesy of the artist.

voice (among others). These divergences are maintained in order to clarify even further the generalized neutralization of disruptive modes by the secondary processes impelled in each viewer by formal imperatives. "The reality of living in an inconsistent, meaningless world is, at least for the majority of people, experienced as unbearable … the subject does the difficult job for this order, proving its case, legitimizing it, tying the loose ends together."[8] (As filmmaker Owen Land put it, "This is a film about you, not about its maker.") A successful system of domination provides the apparent tools of its own undoing, escape routes that confirm its tolerance of discrepant challenges, while stealthily ratifying its fundamental unassailability: recall the cartoon satirizing "balanced media," in which both "left" and "right" factions occupy (the right) half of a discussion table, the left-hand side remaining empty.[9] The simulation of agency, free to latch onto "alternatives" without coercion, effectively occults the operative cognitive and perceptual regimes which determine in advance what can be said, shown, or sounded within a given cultural context. (This is the province in which much so-called "interactive" work resides: participatory lip service masking airtight control of all parameters). This realization should convince the viewer that any content, no matter how contestational, can be depoliticized through its incorporation into a standard form (media formats as well as other highly codified rituals, such as that subtending the classical music concert), highly tendentious but eluding scrutiny.[10] In perfect harmony with late capitalism, these recessive containers constantly regurgitate an unending array of riches, differences, varieties, which are nevertheless declawed of any deeply engrained, irreconcilable alterity: you may fall asleep during one episode and awaken with another, with no sense of anything having substantially changed.

Antagonisms of Sound and Image and the Infra-Legible

The viewer's perpetual oscillation between molar (invariant global form) and molecular (irreducibly local surface) levels is in no small part fueled by the always uncertain relationship between sound and image. While Webber's run-on speech linearly unfolds on the surface of a möbius strip, its function with regard to image is constantly flipping, from omniscient voice-over to internal monologue to bad dub—at times in the space of a single (composite) sentence. The puzzlingly normative slavishness of sound in its trustworthy support of image comes to seem rather artificial and contingent.

In an ongoing online "TV series" entitled *We Know What You're Looking For* (2011-), the set durations (30 or 60 seconds) of the commercial, intact since the late 1960s, make it possible to convulsively swap sound and image tracks and by the same token foreground the (usually covert) functioning of form, with its expedient distribution of structural

stresses. The presence of both actual and virtual (implied but absent) audio-visuals allows for the making-adjacent of incompatible content, which recasts the message being ferried (through tight collusion). Meaning-making observes alternately centripetal and centrifugal movements: tightly delimited physical gestures and image-regimes are alternately amplified and defused, while various levels of artifice leak out uncontrollably. Through recombination, one becomes aware of the various compacts by which sound and image collapse together into one entity, those which enable one to think them separately (as much as this is possible), and the shadowy middle-grounds that refuse resolution into either. However, while a particular coupling might "liberate" a visual gesture from its sonic underpinning (laying bare latent contradictions and staging), this movement also occasions fresh suppressions, which is why it is necessary to emphasize the process itself as an unresolving praxis over any final result, however temporarily reassuring.

In contrast to the more labor-intensive construction of *The Following*, the simple sound-image swap can be readily actualized by any individual with the means to download/record commercials and perform basic video editing. While the retrospectivizing that snaps into place to rationalize incongruities is made nakedly plain, the resulting constructs are not always successful, failing to efficiently signify, remaindering resistant concatenations that can potentially de-reify the prevalent orthodoxies violently submitting image and sound to mutual reinforcement. These indeterminate spaces of vague resonance operate at a pre-signifying level, before language and categorization snap into place. Like jokes, these (frequently side-splitting) hacked commercials make possible an envisioning of heretofore dormant modalities, by punctually revealing discrepancies between structural rules and their local application. If one is still unconvinced by the indoctrinating powers of the entertainment industry, consider the profound binding of sound and image enacted by "mickey mousing"—continuous short-term, taut correlation of musical and visual tropes, so effectively ingrained during childhood that one only has to listen to the soundtrack of a typical Bugs Bunny cartoon (most often by Carl Stalling) to generate an appropriate set of accompanying images. As Mark Fisher points out, "an ideological position can never be really successful until it is naturalized, and it cannot be naturalized while it is still thought of as a value rather than a fact."[11]

What Michel de Certeau might have termed "secondary production" is enacted in these two works under the cover of *infra-legible* procedures: the recasting and repurposing of materials intended for consumption (or to stimulate the same) into unstable entities that perform slow, structural, semiotic guerrilla warfare, seeking to undo—*from within the logic of commodity flows*—the finely woven twine of ideology and technics, the compact between surface and sed-

iment, making it more difficult for propaganda to operate without being more readily foregrounded in the future.[12] An *infra-legible* approach provisionally assembles a set of mechanisms into a parasitic response to a specific, singular context, dismantled when the job is done. Like noise, it is purely contingent—not theorizable "in-itself," assuming a new guise at each occasion, undetectable as such—yet it does not flag itself as oppositional from the get-go. It splits things from each other over time (content from form, content from other content, sound from image), coaxing (through a kind of fractalization) the targeted material to destratify, distend, digress, slip around and haunt itself, engineering a surface duplicity that gradually makes conscious the subject's cognitive and perceptual role in validating the effects of predatory media (the dark underside of Duchamp's *co-creative* viewer). It suspends capture by actively courting it—like an antidote that contains a modicum of the offending poison—refusing to settle into a unitary (legible) contestation, proliferating contradictory modalities while taking place as if conventions were still operative. Rather than coming to the sudden (yet comforting) realization that only a wholesale rejection can offer deliverance—a heart-on-the-sleeve righteousness proper to much experimental work—the listener-viewer of an infra-legible situation is short-circuited into performing a temporary de-reification, a separation requiring a finely tuned ear to the ground. The pitfalls of the Trojan horse principle are well known; the ease with which its subversive tactics might be served up as innovative methods to even further cement compliance makes imperative a constant state of delirium in uncovering blindspots, coupled with a lack of attachment to any particular mode of intervention (which does not exclude recovering some of the excess use-value occulted in historical artworks by the contingent frameworks prevailing at the time of their enactment).[13]

Broken In On Too Many Times (Instrumental Music #1)

Douglas Kahn underlines the fearful predictions made (most notably by Thomas Edison) on account of the just-invented phono-graph (sound-writing), especially regarding the consequences of its capacity to separate sound from its source, rendering any sound available to endless duplication and circulation, inevitably submitted to the "contaminating realms of writing, society and afterlife."[14] R. Murray Schafer coined the term *schizophonia* (split sound) to refer to the condition produced by this separation, both temporal and spatial, which makes possible the control and management of sound, its perpetual reformatting, remixing, re-editing, now immediately available to anyone with basic technology at their disposal.[15] The infamous video of Democratic contender Howard Dean, captured in the wake of a third place (!) win in the 2004 Iowa caucuses testifies to the recent usages of schizophonic magick. Two recorded versions exist of this particular event, both available online.[16] A video shot from the crowd *in medias res*

depicts a febrile Dean, stirring his troops, responding in kind to their enthusiasm which at times engulfs his words. The better-known version, which quickly metastasized across broadcast and cable networks tells the radically different story of a candidate severed from reality, preaching to what sounds like a marginal gathering, rattling off a paroxysmal wish list of states-to-win culminating in a primal, ostensibly unmotivated yawp. The "Dean Scream" is pure ideological manufacture: networks had access to the direct feed from Dean's microphone, the output of which technicians rebalanced in relation to the context, exacerbating the separation between the candidate and his supporters, forcefully confirming a condition of emotional instability and unsuitability for high office. Dean's candidacy was destroyed by a pre-YouTube instance of viral circulation and obsessive reiteration (the scream was broadcast 633 times in the four days following the speech), demonstrating through *real, material effects* the perpetual blowback potential of that which has been detached from the conditions of its production.[17]

Recording technology also irreversibly transformed music, now discretely objectified, altering the modes by which it could be accessed on the one hand, and instrumentalized on the other, deterritorialized from the "concentration machine" of the concert hall, divorced from its social ferment.[18] Adorno (early on) lamented the manner in which the listener is absolved of the responsibilities of *structural listening* through newfound abilities allowing ingress to a unified work *outside* of its linear (irreversible, ephemeral) unfolding, resulting in its fragmentation into islands of "sensual pleasure torn away from the functions which give them meaning"; the greater concern being the depletion of the individual's ability to patiently construct a long-term narrative by negotiating discrepancies, contradictions, polarities.[19] Indeed, the actualized atomization of the "good bits" maintains the listener in a constant present, suppressing the flow of cause and effect and inertial time which would allow for a dialectical reading and an attendant complexifying and thickening of thought. (Leaving aside the fact that in an age of "complete electric definition," in which listening is almost always "radically partial and precariously coherent," the idea of a recoverable *whole* constitutes a supreme fiction.)[20] The externalization of memory in the hypomnema of the recording engenders, as with any new technology of extension, the inverse effect of amputating native capabilities (dixit McLuhan).[21] Moreover, as the composite aural picture of a work is irremediably, grotesquely distorted by these new capacities, obsessive, piecemeal repetition spawns the pathology of earworm, an involuntary aural fixation with no particular goal except its own internal reenactment. ("Prior to the invention of mechanical recording, references to the now commonplace phenomenon of a tune-running-thru-the-head appear absent from literature." (Paul DeMarinis))[22]

The privileging of unrelated, fetishized surfaces to the

detriment of memory and history is naturally of enormous use to systems of indoctrination, which adopt and refine the idea of the hook, a synecdochal handle divorced from its sedimental motivation, by which a song and its attendant associations can be instantly conjured. The emergence of *tune detectives*, curios like *The Flying Saucer*—a 1956 embedding of snippets of then-popular tunes into a game-show-like conceit—and the enormously popular TV show *Name That Tune* all testify to the new modalities of aural cognition.[23] In an episode of the sitcom *WKRP in Cincinnati*[24], two DJs fail in their painstakingly-edited attempt to foil the fragmented listener, underestimating the latter's now native abilities in micro-perception, confirmed some years later by the ease with which the splintered sources of John Oswald's *Plexure* (1993)[25], a mutant collage of 1980s pop, could be identified on the fly despite their minimal airtime. These new aptitudes leave the individual vulnerable to be "broken in on" (Hullot-Kentor) by market interpellations, extending Louis Althusser's notion of hailing, in which an individual confirms, before conscious thought intervenes, his/her inscription into an ideological system.[26] In effect, *sonic branding* hijacks the listener's skill in latching onto bare traces—compressed concatenations of melody, harmony, timbre and affect—now implanted with brand identities comprised of manufactured, virtual, *unlived* associations, which can be anamnestically summoned at any time.[27]

On the Fetish Character in Music and the Regression of Listening (2006), realized in collaboration with Juliana Pivato, attempts to *détourn* and make productive use of this splintered, distracted listening which characterizes contemporary life. A computer accessing a large database of popular music from a 40-year period selects three-second segments from anywhere within four randomly chosen songs. Two performers must learn these fragments on the spot and slowly string them into a smooth, placid whole, imitating the flattened-out, boiled-down quality of Muzak. The enactment of these simple instructions is anything but straightforward, bringing into play the performers' abilities to replicate music by ear (mind-body connection), to memorize the shards as they are learned, to struggle with defining the manner in which they are to be grafted onto each other and distorted to ensure a seamless flow. As such, the performers are perpetually caught oscillating between two predicaments: on the one hand, legitimizing the (oft-maligned) condition of distraction for the new type of creativity which it makes possible, in which heretofore unsuspected connections can be made by virtue of the psychedelic proximity of criss-crossing signals; on the other hand, implicated in the gradual building of a continuity that requires a de facto betrayal of irreducibly singular detail through a simplified gloss analogous to the technique of spin (manufacture of superficial, surface decoys to forestall deeper penetration) and the sound bite form. The broader, extra-artistic implications of these conundra invariably color the complex, ongoing, in situ negotiations; indeed, the verbal exchanges between the musicians as they

develop suitable *modi operandi*, while uncomfortably flirting with a too-easy acceptance of the rules of the game, are part and parcel of the work itself.

All the while, despite these immanent minefields (which can never be totally dispensed with), a gradual re-embodiment is taking place, a repossession and re-materialization of the externalized memories of predatory hails—forced to submit (for a change) to longer-term development—establishing a concerted, subjective position which trumps a tacit (subliminal) disposition to invasion. In the end, the *Fetish Character in Music* provides a framework, a method rather than resolving into a clearly bounded artwork, however ravishing the resulting concoctions might turn out to be. As such, it is meant to encourage constructive approaches towards disabling sonic intrusions, through the short-circuiting of feedback loops between technological systems and the bodies in which their emanations are radically reterritorialized, bearing in mind that procedures of genetic debilitation through capturing, splicing, relocating and recirculating are only effective inasmuch as they remain cognizant of the ever-evolving modes of aural domination and are irreducibly grounded in the material apparati which induce and leverage the dispositions in question.

Occupy the Background! (Instrumental Music #2)

In 1920, the iconoclastic French composer Erik Satie, with the help of a small, spatially-distributed ensemble, performed fragments of *Musique d'ameublement* (furniture music) that he had written for the intermission of a play at a Paris gallery.[28] This "instrumentalized music" was intended to function much like wallpaper, "heard, not listened to," ambiently conditioning the space, encouraging social lubrication while covering up awkward conversational pauses. Despite his invocations to talk and move around, attendants nevertheless stopped what they were doing to listen, deferring out of habit to the representative agency at the source of the sound, an impediment cast aside only a few years later thanks to the development and improvement of technologies of sound reproduction and transmission.

The Muzak Corporation (founded as such in 1934, though its activities were already well underway) was tasked with the development of new functions for music enabled by schizophonic separation, at first in relationship with Fordist assembly-line production.[29] The almost-out-of-earshot soundtrack was organized according to the technique of *stimulus progression*, a parallel narrative carefully mapped onto the rhythms of the workday to minimize strain and inertia, its intensifications, slackenings and periodic gaps calibrated to the streamlined gestures perfected by Taylorist Time and Motion studies. As the disciplinary model of society began shifting to one rooted in control and hyper-consumption—characterized by the incorporation of *general intellect* and communication as essential com-

ponents of *flexible* labor—Muzak changed its tune, no longer concerned with regulating work, but with an ontologically prior manipulation of mood, via *quantum modulation*. Under this regime, a constant flow of compressed tunes donates the impression of surface variety while subtended by affective continuity (same tempi, timbres, rhythms etc.), enabling a pervasive control of a given space, while disappearing into it. Music is experienced peripherally, atmospherically, *as* environment.

Brandon LaBelle asks whether "Musak (might) be actually heard to uncover the background itself, as such a forceful and signifying elemental feature within the modern environment."[30] To occupy the background would mean tuning in to the register where the stealthy structuring of social activity takes place, out of the range of conscious perception (and therefore inaccessible to counter-action). (When engineering an audio mash-up intended to credibly suspend disbelief, it is imperative to attend first to maximal background continuity, where sloppy cuts can be immediately discerned.) It is also the zone where the *infra-ordinary* (Perec) unfolds its quotidian, recursive rhythms, which only a politics of noticing can do justice to: habits, twitches, micro-deviations, muscular memories ceaselessly operating under the radar.[31] Though one might argue that even the everyday has been successfully coopted by the ever-famished art market (the more anti-aesthetic, the better the capture), the background nevertheless remains a murky terrain, festering with underlying, pathological continuities while also constituting the repository of a rich groundswell of opaquely signifying molecular singularities. Or, paraphrasing the militant sound collective Ultra-Red, it is the unmapped territory where infra-legible desire lurks waiting to be uncovered by an extended period of sustained listening "beyond the echoes of our need," to the dark matter eclipsed by too-quickly-articulated demands.[32]

Adumbrate 57 (2012) (*subtitled infra-legible training music for the late capitalist subject*) is a background music installation that operates by restlessly resituating the listener spatially and temporally. Despite the absorption of glitch (once an eminent signifier of malfunction) into the toolbox of contemporary electronica, a stuttering CD (or its simulacrum) still has the capacity to radically, momentarily interrupt, punctually foregrounding what had been there all along. Though secondary processes may quickly engage to retrospectively occlude the offending cleavage, the latter's effects are unmistakably real. Like Cildo Meireles' *Insertions into Ideological Circuits*, this work operates in the same space reserved for background music, meant to be mistaken for it. (It is therefore imperative to form alliances with members of the precariat who occupy coffee shop, book and clothing store jobs, for this intervention to function successfully).

Adumbrate 57 was first intended as a speculative program for dislodging a stubborn earworm—the opening title

theme of the 1962 version of the *Manchurian Candidate* (itself a film about psychological training and brainwashing)—through the generation of 57 "deaf" variations. While preserving the exact distribution of thematic and accompaniment parts as per the original arrangement as well as the same rhythms and tempo, I proceeded to record subtly varied versions of each line, one at a time, respecting the general contour and range of both melodic (top line, bass, middle parts) and harmonic structures, while muting every other existent track, thereby suppressing as much as possible the urge to deliberately forge an inherently memorable gestalt. Taking advantage of some of the standard operations of a CD (or DVD) player—rewinds and fast-forwards at various discrete speeds, always audible—the variations were submitted to a *temporal* framework simulating an individual's obsessive back-and-forth scanning through the original theme, which in normal circumstances would practically ensure the emergence of a robust *musique fixe*. In this case, however, each time the scan lands on a particular segment, the music re-enters exactly where expected, precisely indexed to its proper location on the original timeline, but in a different version of itself; a nightmare adumbration, in which the object under scrutiny perpetually refashions itself, avoiding seizure. Indeed, going through the motions of repetition without it occurring *as such* remainders a curiously slippery, inscrutable sensation, colored by machinations taking place below the level at which conscious distinctions can be made (except perhaps by those with phonographic memory). Moreover, the familiar sound of scanning provides further bait, eliciting involuntary, normative, embodied associations with the everyday mnemotechnological interface of the remote-control, evoking the operations of *interested perception*: conscious, deliberate searching for a section to replay. Because of this entrenched prior relationship, the switch to new music on each landing is doubly occluded: it must be the same bit I just heard.

In contrast, two other types of interruptions—stutter and cut-out—work to resituate the listener *spatially*, both rendering the background temporarily available for consideration: stutters (sometimes as long as one minute) violently suspend the "ambient purr of control" (Goodman), while cut-outs (or drop-outs) withdraw sound completely, leaving embarrassment in their wake: a momentary and surreptitious confrontation with one's disposition, before the secondary process (as well as the music) takes over to mask—and discard—potentially gleaned insight, as if the schism never occurred. Both procedures are external to the realm of interested perception and erupt at irregular intervals, recalling Skinner's emphasis on the *variable ratio schedule* as the most efficient protocol for pulling you into a given system (think about the way in which emails, news alerts, Twitter feeds never arrive when you expect them).[33] Both types of bifurcation momentarily dis-tract: a soundtrack nominally operating to sub-tract you from your surroundings morphs into the means by which the latter can

be nakedly accosted. Nevertheless, the sameness of the music, its placid steadiness, quickly and repeatedly induce a withdrawal of attention. The cut-outs—sorely lacking in the contemporary era of 24/7 horizontal media—are intended to make the listener aware of his/her capacity to be entrained, to take on the rhythms of the music, to gradually develop a feedback relationship with it. When the music cuts out, it still continues in your mind, which recalls McLuhan's invocation to read every other page of a given text, in order to instigate more distant cognitive connections (and to avoid falling into hypnotic seduction by an apparently seamless flow of argumentation—an idea taken up by Martha Rosler in *If It's Too Bad to Be True, It Could Be DISINFORMATION* (1985), which fades the soundtrack of a news broadcast in and out at regular intervals, leaving code words dangling, deprived of their secure implantation in an ideological continuum).[34] *Adumbrate 57* is an attempt to establish the potential coordinates of a *defensive listening*, by denaturalizing one's complicity (via internal latching) with the abduction in progress, severing mnemonic processes from machinic enslavement. (The best way to defuse background music might be to listen to it, or even further, to actively embody, re-singularize it through discrepant humming and singing.)

• • •

These words have only sketchily outlined ongoing practices that harbor dormant valences and ineffable idiosyncrasies necessarily exceeding the consolidated, functional usages discretized in the above-mentioned works. The broader ferment of theory and practice evolving across multiple fields of action is above all intended to galvanize other artists into undertaking long-term collaborative investigations into the local, irreducible specifics of their own perceptual and cognitive mobilization by capital. Given the neuroplastic rewiring of the contemporary subject, the explosive proliferation of rabidly inconsistent modes deployed in the murky zones of indetermination where orientations are sealed in advance constitutes a necessary first level of disentanglement. A preemptive withdrawal from hallucinatory eternal presentism requires the embodied reactivation of deep-rooted continuities, history and accumulative memory, fostering conjunctions that stick in the craw and require delayed and protracted digestion. A sustained, speculative program of un-training through febrile, schizoid, parasitic, de- and re-couplings can force registral shifts liberating uncertain qualities no longer containable by a streamlined agenda, while opposed at every point to quick resolution and intimately cognizant of (its own) potential methodological complacencies and insufficiencies. Any possible future emancipation from the throes of capitalist control can only take root from within a concerted struggle that joyfully seizes opportunities provided by unsuspected rifts and aporias pried open daily in the rapid-moving stasis characterizing the present, a monumental undertaking for which the artist and his/her practical expertise, labor and peripatetic inventiveness is ideally equipped.

Complicating thought strengthens the impetus of an active or energetic confusion—delirium—against the reactive forces whose obsessive tendency is to resolve and conclude. Rebelling against the fundamental drift of philosophical reasoning it sides with thought against knowledge, against the tranquilizing prescriptions of the "will to truth."[35]*—Nick Land*

Notes

Thanks to Lendl Barcelos, Eric Cazdyn, David Cecchetto, Victor Cirone, Katrina Burch Joosten, eldritch Priest and especially Juliana Pivato for valuable insights. All works are available for viewing and listening at couroux.org.

1. See Eric Cazdyn and Imre Szeman, *After Globalization* (Chichester: Wiley-Blackwell, 2011) 77-99.
2. See Marc James Léger, *Brave New Avant Garde: Essays on Contemporary Art and Politics* (Winchester: Zero Books, 2012).
3. See Jodi Dean, *Democracy and Other Neoliberal Fantasies* (Durham: Duke University Press, 2009) 19-48.
4. Robert Hullot-Kentor, "A New Type of Human Being and Who We Really Are," *Brooklyn Rail* (November 2008), available at: http://www.brooklynrail.org/2008/11/art/a-new-type-of-human-being-and-who-we-really-are.
5. See Eric Cazdyn, *The Already Dead: The New Time of Politics, Culture and Illness* (Durham: Duke University Press, 2011).
6. See Mark Fisher, *Capitalist Realism: Is There No Alternative?* (Winchester: Zero Books, 2009) 21-30.
7. Noam Chomsky in Peter R. Mitchell & John Schoeffel, eds. *Understanding Power: The Indispensable Chomsky* (New York: The New Press, 2002) 325-6. See also footnote 7 from Chapter Nine, available at: http://www.understandingpower.com/AllChaps.pdf.
8. BAVO, "Always Choose the Worst Option: Artistic Resistance and the Strategy of Over-Identification," in BAVO, ed. *Cultural Activism Today: The Art of Over-Identification* (Rotterdam: Episode Publishers, 2007) 18-39, available at http://www.bavo.biz/texts/view/45.
9. Jeff Cohen, "TV's Imposters," *Extra!* (July/August 1990), available at: http://fair.org/extra-online-articles/tvs-imposters. The cartoonist is Matt Wuerker.
10. Marc Couroux, "Introductory note to le contrepoint académique (sic)," *Le Merle* 0:0 (Fall 2011) 49-52.
11. Fisher, *Capitalist Realism*, 16.
12. See Michel de Certeau, *The Practice of Everyday Life*, trans. Steven Rendall (Berkeley: University of California Press, 1984).
13. See Tony Conrad, "Is This Penny Ante or a High Stakes Game? / An Interventionist Approach to Experimental Filmmaking," (2004), available at http://tonyconrad.net/highstakes.htm
14. Douglas Kahn, "Death in Light of the Phonograph," in Douglas Kahn & Gregory Whitehead, eds. *Wireless Imagination* (Cambridge: MIT Press, 1992) 93-4.
15. R. Murray Schafer, *The Soundscape: Our Sonic Environment and the Tuning of the World* (Rochester: Destiny Books, 1994) 88-90.
16. The "crowd" version of "Howard Dean's Scream" is available at: http://www.youtube.com/watch?v=-3Meg3CEyUM, while the broadcast version can be found here: http://www.youtube.com/watch?v=D5FzCeV0ZFc.
17. Lisa Parks, "The 2004 Presidential Election and the Dean Scream" (February 4, 2005), available at http://flowtv.org/2005/02/the-2004-presidential-election-and-the-dean-scream.
18. A term coined by composer-theorist eldritch Priest.
19. Theodor Adorno, "On the Fetish Character in Music and the Regression of Listening," in *The Culture Industry: The Selected Essays on Mass Culture* (London: Routledge, 1991) 29-60.

20. See eldritch Priest, *Boring Formless Nonsense: Experimental Music and the Aesthetics of Failure* (London: Continuum, 2013).

21. Bernard Stiegler, "Memory," in W.T.J. Mitchell and Mark B.N.Hansen, eds. *Critical Terms for Media Studies* (Chicago: University of Chicago Press, 2010) 64-87

22. Paul DeMarinis, "Essay in lieu of a Sonata," in Carsten Seiffarth and Ingrid Beirer, eds. *Buried in Noise* (Heidelberg: Kehrer Verlag, 2010) 219

23. Douglas Kahn, "Where Does Sad News Come From?" in Kembrew McLeod and Rudolf Kuenzli, eds. *Cutting Across Media: Appropriation Art, Interventionist Collage, and Copyright Law* (Durham: Duke University Press, 2011) 94-116

24. The episode entitled "The Contest Nobody Could Win" first aired January 29, 1979.

25. John Oswald, *Plexure* (Avant Records (AVAN 016), 1993).

26. Robert Hullot-Kentor, "Right Listening and a New Type of Human Being," *RES: Anthropology and Aesthetics* #44 (Autumn 2003) 196.

27. See Steve Goodman, *Sonic Warfare: Sound, Affect, and the Ecology of Fear* (Cambridge: MIT Press, 2010) 141-8.

28. Mary E. Davis, *Erik Satie* (London: Reaktion Books, 2007) 127-8.

29. See Robert Sumrell and Kazys Varnelis, *Blue Monday: Stories of Absurd Realities and Natural Philosophies* (Barcelona: Actar, 2007) 100-31.

30. Brandon LaBelle, *Acoustic Territories: Sound Culture and Everyday Life* (London: Continuum, 2010) 185.

31. See Georges Perec, *Species of Spaces and Other Pieces* (London: Penguin, 1997).

32. See Ultra-Red, "Some theses on militant sound investigation, or, listening for a change," available at: http://inthemiddleofthewhirl-wind.wordpress.com/some-theses-on-militant-sound-investiga-tionor-listening-for-a-change/.

33. Sam Anderson, "In Defense of Distraction," *New York Magazine* (May 17, 2009), available at http://nymag.com/news/features/56793.

34. Available at: http://www.ubu.com/film/rosler_disinformation.html.

35. Nick Land, "Shamanic Nietzsche," in *Fanged Noumena: Collected Writings 1987-2007* (Falmouth: Urbanomic, 2011) 203-28

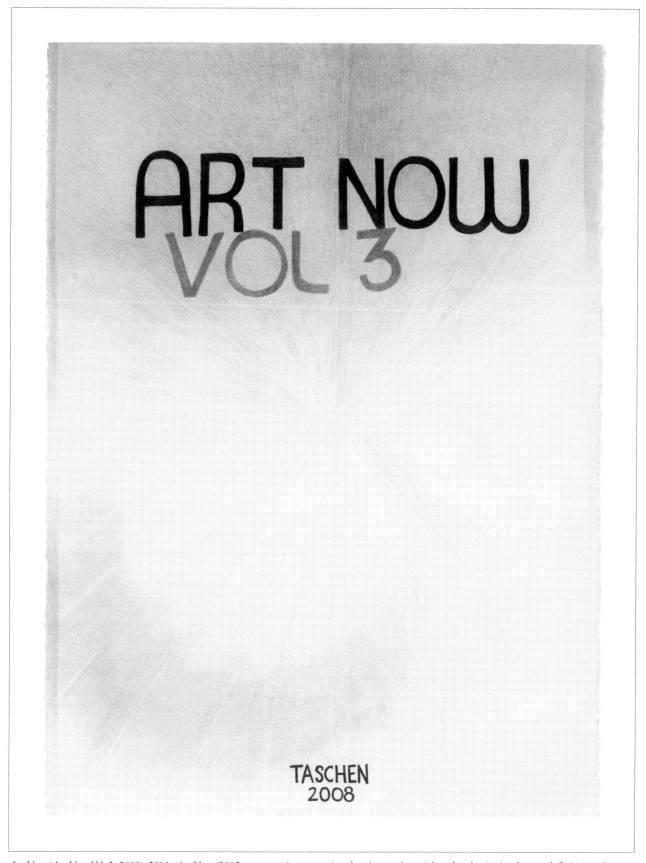

Art Now (Art Now Vol. 3, 2008), 2011. *Art Now (2005 to present)* is an ongoing drawing project with a clear beginning but no definitive end. There are approximately 80 drawings to date, each of them is graphite on paper and 55.9 x 76.2 cm (22 x 30"). Each drawing references an art book or catalogue cover with the word 'now' in its title, publications that mark the new—a new approach, a new idea, a new relationship. An open system, *Art Now* can assume any aesthetic, any sensibility, any time, any place: it signals only difference, like a comma.

Six Years: The dematerialization of the art object from 1966 to 1972: a cross-reference book of information on some esthetic boundaries: consisting of a bibliography into which are inserted a fragmented text, art works, documents, interviews, and symposia, arranged chronologically and focused on so-called conceptual or information or idea art with mentions of such vaguely designated areas as minimal, antiform, systems, earth, or process art, occurring now in the Americas, Europe, England, Australia, and Asia (with occasional political overtones), edited and annotated by Lucy R. Lippard.

Art Now (Six Years: The dematerialization of the art object … occurring now in the Americas, Europe, England, Australia, and Asia, 1972), 2011.

The Arts
Under Socialism

Being a lecture
given to the Fabian Society
with a postscript on

WHAT THE GOVERNMENT SHOULD DO
FOR THE ARTS HERE AND NOW

TURNSTILE PRESS
10 GREAT TURNSTILE, LONDON, W.C.1

1947

Art Now (The Arts Under Socialism, being a lecture given to the Fabian Society, with a postscript on What the Government should do for the Arts Here and Now, 1947), 2006. Collection of the Leonard & Bina Ellen Gallery, Concordia University.

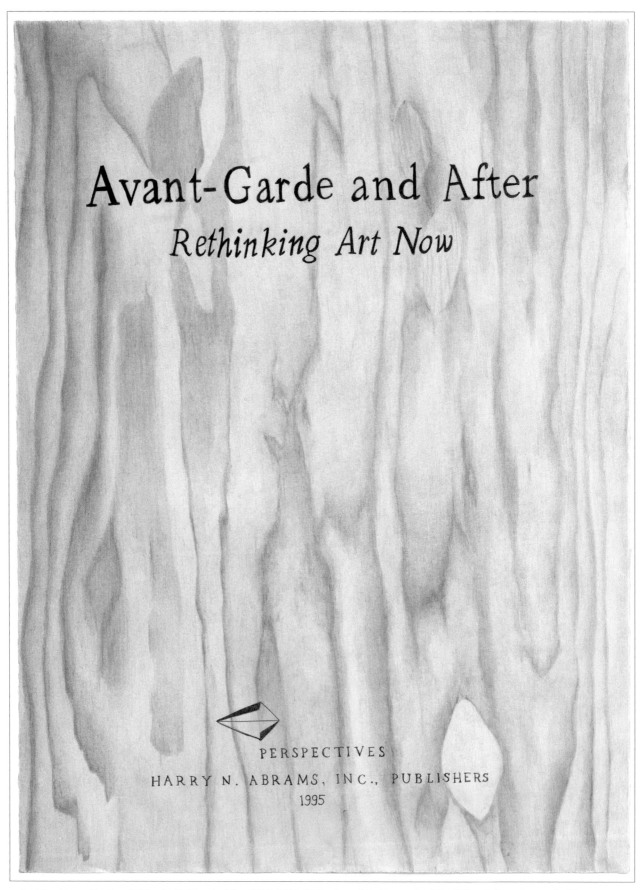

Avant-Garde and After
Rethinking Art Now

PERSPECTIVES
HARRY N. ABRAMS, INC., PUBLISHERS
1995

Art Now (Avant-Garde and After: Rethinking Art Now, 1995), 2010. Collection of the Leonard & Bina Ellen Gallery, Concordia University.

266

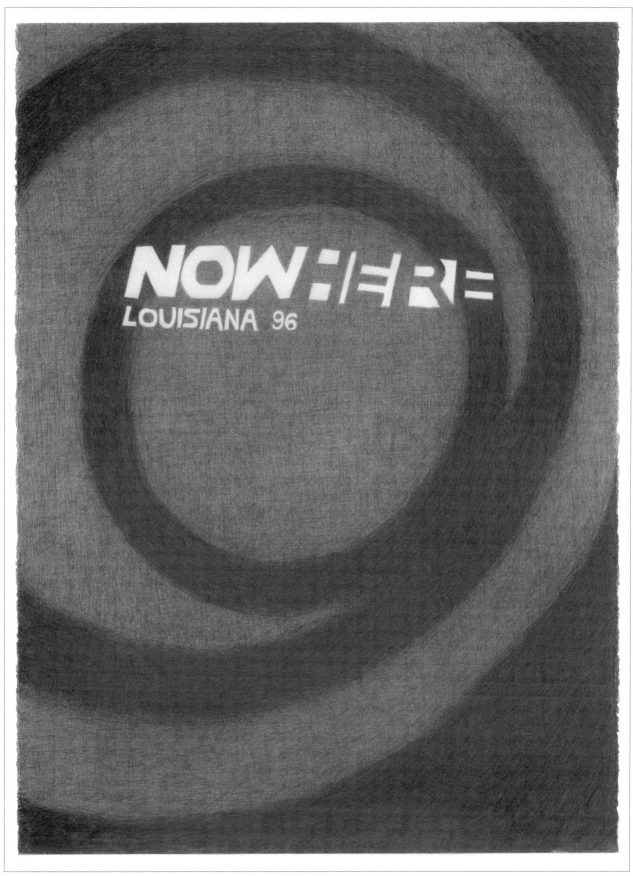

Art Now (Now Here, 1996), 2009.

l'art
d'aujourd'hui
et son public

collection
vivre son temps
les éditions
ouvrières
1967

Art Now (l'art d'aujourd'hui et son public, 1967), 2007. Collection of the Leonard & Bina Ellen Gallery, Concordia University.

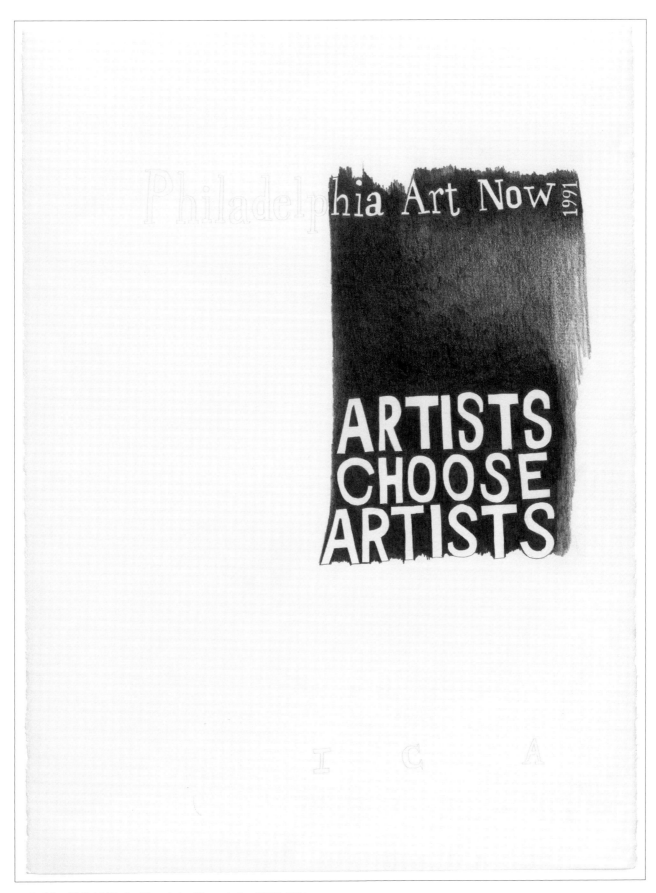

Art Now (Philadelphia Art Now: Artists Choose Artists, 1991), 2011.

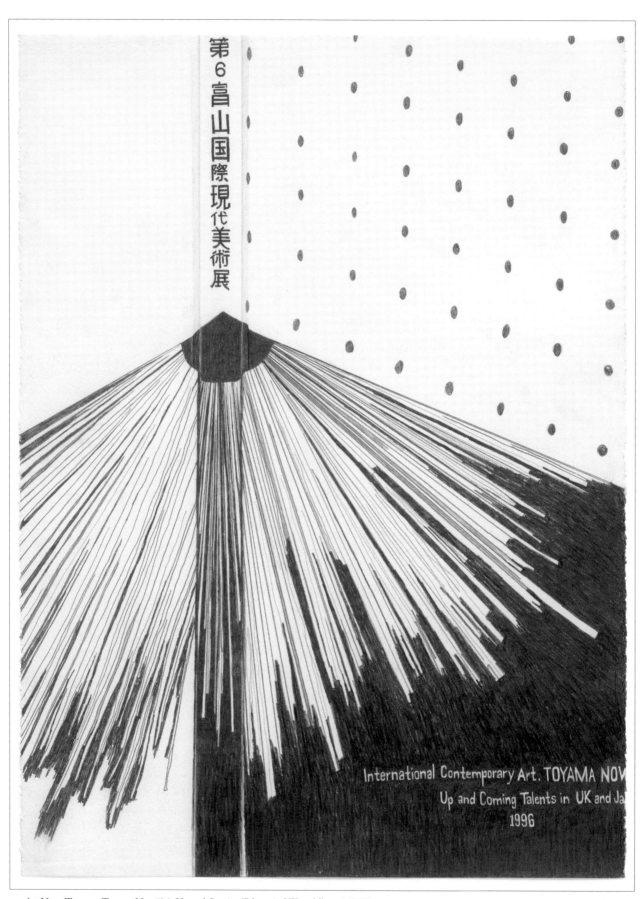

Art Now (Toyama: Toyama Now '96: Up and Coming Talents in UK and Japan), 2007.

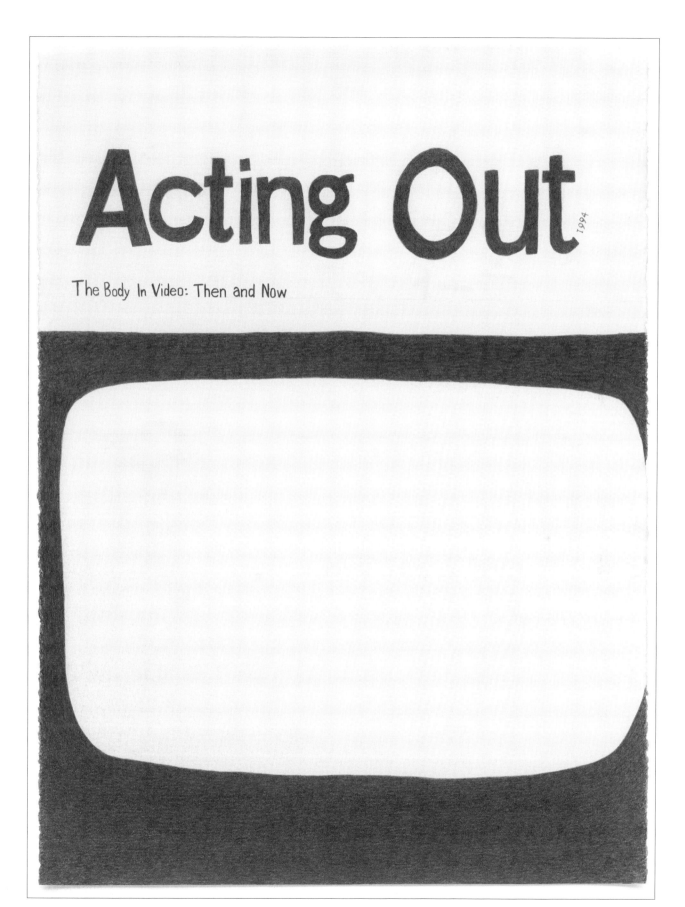

Art Now (Acting Out: The Body in Video, Then and Now, 1994), 2011.

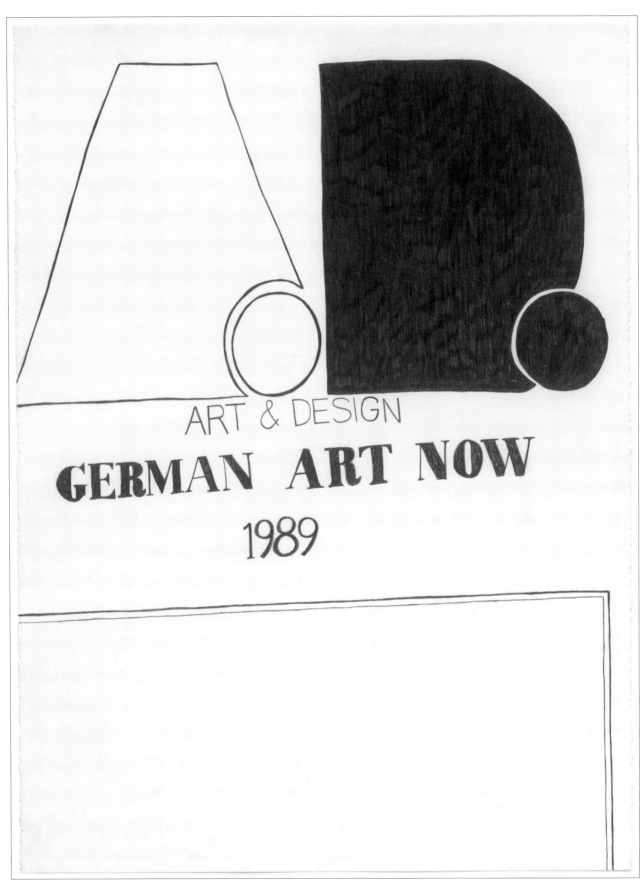

Art Now (German Art Now, 1989), 2007/2011.

In a Critical Condition

Chrysi Papaioannou

It has been 50 years since German poet and intellectual Hans Magnus Enzensberger highlighted the paradoxical temporality of the idea of the avant garde and declared the avant garde dead. Lamenting the demise of the avant garde's 'original' counterpart, which had by then already acquired the name 'historical' avant garde, Enzensberger dismissed the avant garde of his day as the solipsistic gesturing of experiment for experiment's sake: "Today's avant-garde deals in a future that does not belong to it. Its movement is regression. The avant-garde has become its opposite: anachronism."[1] Enzensberger was certainly not alone in viewing the avant garde with skepticism. A number of critics, from different political camps and different parts of the western capitalist world, came to the same conclusion. For those on the right, the artworks, writings, and performances of the 'neo-dadas' were shallow and skill-less fads. For those on the left, they were a sign of the victory of the culture industry. But the diagnosis nonetheless retained the form of an open question: Is the avant garde dead? What does the avant garde mean today?

In our present moment, contemporary art discourses may be keen to incorporate issues of politicized praxis and the naturalized-reified avant-gardist topos of 'art into life,' but they somehow shy away from the avant garde as idea. To ask the question of the avant garde's meaning today is simply not done. By returning to this question in such an explicit manner, the present publication re-opens the issue of the paradox of a contemporary avant garde and thus challenges the supposed redundancy of debates over its meaning.

The question of the avant garde's death or, otherwise put, of the avant garde's contemporaneity, is inextricably linked to the very notion of *the* avant garde, of the avant garde as a particular discursive formation. This formation ought to be understood as distinct from an older, more popular, formulation of the avant garde as vanguard (implying a group of individuals being 'ahead' in unison), or from what is now the dominant art-historical understanding of the term as shorthand for the plethora of modern art's radical 'isms,' an A-Z that spans decades and continents: from Constructivism to Lettrism to Zenitism, etc. Therefore, what is at stake is not work that has been regarded as daring and categorized at different points in time as 'avant garde.' Nor is it the kind of cultural production that can be called 'avant garde' in the sociological Bourdieusian sense of a restricted field of production that brings high returns of cultural capital. These understandings of 'avant garde' (note the absence of the definite article 'the') cannot appropriately respond to the question of the idea of the avant garde because they regard all historical moments as equally capable of producing avant-garde work (or rather, they *disregard* the varying significance of different historical moments in such production). By extension, they cannot attend to the proposition that today is a particularly apposite moment for a 'new' avant garde. So what is really at stake is the idea of the avant garde as a contemporary discursive formation and its relation to the specificity of the present historical moment. The avant garde as a discursive formation has by now developed its own (art) history. To become contemporary, it must negotiate its responsibility to the present moment with the recognition of the weight of its history.

We have been accustomed to viewing the avant garde through the lens of Peter Bürger and his much-discussed 'theory.'[2] This has led to a widespread acceptance that there are two key eras of avant garde activity which are identifiable as 'historical avant garde(s)' and 'neo-avant garde(s)' and which are all-too-neatly ascribed to two distinct art-historical periods separated by the war years of 1939-1945. Furthermore, it has meant an association of the idea of the avant garde with negation: firstly, a negation of the bourgeoisie and its culture (a culture which, for Bürger, culminates in the ideology of aestheticism and is then corrected by the anti-art gestures of the historical avant garde(s)); secondly, a negation of the bourgeois conception of the institution of art. Bürger's notion of the institution of art owes much debt to Walter Benjamin's idea of 'apparatus' and his Brechtian essay "The Author as Producer."[3] This is why the institution of art in Bürger ought to be understood as *art-as-institution* (note Bürger's compound noun *Institutionkunst*), and the avant-gardist negation as a negation of art as such—*not* as a critique of the *institutions of art*, as it has been widely misinterpreted, and even less as a critique of art institutions narrowly conceived (namely, as museums). It was not institutional critique that Bürger had in mind, but the negation of the bourgeois (read: capitalist) mode of production. Bürger's hegemonic presence over all matters 'avant garde' has meant that his adoption of the periodizing categories 'historical' avant garde and 'neo' avant garde is rarely questioned.[4] What is more, this periodizing tendency has now been extended to include a third stage in the 'key periods' of politicized aesthetics: 'historical' stands for the 1910s/1920s/early 1930s; 'neo' for

the 1950s/1960s/early 1970s; 'contemporary' for the late 2000s/early 2010s. (Needless to say, these periods mark moments of economic and political 'crisis.') What this means is that the idea of the avant garde must confront not only its art-historical equation with a series of 'isms,' it must now also come to terms with a serialized version of itself. That is to say, it must come to terms with the temporality at work in historiographical accounts that posit a first, second, and third avant garde.[5] Even though the battle to legitimize the second avant garde (read: 'neo') was fought and won some time ago, such a serialization implies the canonization and acceptance of the 'historical avant garde' as original, hence upholding and reinforcing its 'firstness.'

A serializing tendency may suit an empirical approach to the study of radical art movements, since it can help situate a particular movement within a broader avant garde lineage. However, if we are to advocate the avant garde as a radically temporal concept, serialization creates considerable obstacles. The issue identified by Peter Osborne as "the complacency of the sociological category of modernity" is precisely what is at stake.[6] This complacency results from viewing modernity in progressivist terms, namely, as the latest stage of historical development. The idea of the avant garde is worth defending today so long as it breaks away from a progressivist logic and disrupts the complacency of what has now become an avant garde tradition (and, despite claims to the contrary, an avant garde tradition remains a tradition). The serialization of the avant garde is a regression into tradition, which—buttressing a progressivist, developmental logic—obscures the complexity of the relationship between the avant garde as temporal concept and the sociological category of modernity. As a result, the avant garde appears in three different versions of itself, temporally locked into a linear narrative of peaks and troughs of radicalism.

It has become something of a commonplace in recent years to point to the polyvalent meanings of 'the critical.' Not only does every single research institute within academia now designate itself as 'excellent,' there is an abundance of various 'critical' angles to what are otherwise deeply reactionary intellectual projects. To be critical is to exercise one's critical judgement, but as we have been repeatedly reminded since the global financial crisis, the word's etymological roots also point to another meaning: *Krisis* is crisis as well as judgement; and so, to be critical also denotes a way of relating, responding or belonging to, a crisis.

In her historiographical account of the avant garde as critical concept, art historian Johanne Lamoureux remarked that all theories of the avant garde presuppose a notion of criticality. For Lamoureux, the avant garde must be understood in relation to a critical project, even if the target or purpose of that project is not always clear or agreed upon. What these diverse discourses share is an acknowledgement of criticality.[7] There is not much to argue with in such a

remark: criticality is here simply the nominalization of the adjective 'critical' and there is nothing unexpected in associating the avant garde with a critical project or a strategy of opposition. Nevertheless, the choice of the term 'criticality' and its preference over that of 'critique' is telling since the replacement of critique with criticality is indicative of the discursive parameters within which the idea of the avant garde's contemporary meaning is to be articulated. That is to say, such replacement is symptomatic of a broader reluctance on the part of cultural commentators and art critics today to explicitly associate a critical project, which may sometimes take the form of or act in the name of 'the avant garde,' with an unqualified critique of neoliberalism.

Criticality has been famously defined by art theorist and curator Irit Rogoff as the most recent phase of cultural theory, connected to a "cultural inhabitation that performatively acknowledges what it is risking without yet fully being able to articulate it."[8] According to Rogoff's formulation, criticality is juxtaposed with the notions of criticism and critique, and is presented as having replaced and superseded both notions. Criticism is seen by Rogoff as "allocating blames" (sic), whereas critique applies the same logic of analyzing through finding fault.[9] Criticality thus stems from critique but introduces an element of uncertainty towards one's own convictions. It seems to indefinitely defer critical judgement, replacing such judgement with a performative acknowledgement of the subject's own position. For Rogoff, critique replaced criticism when the post-structuralist turn brought with it a re-evaluation of hitherto-naturalized values and standards. Now that we have reached the period 'after theory,' it would seem to be high time for criticality to replace critique.

So where does this shift from critique to criticality leave the idea of the avant garde? The intention to do away with a mode of critical analysis that is more concerned with validating and less with questioning its own position is no doubt justified. However, Rogoff is rather too quick to replace critique with criticality, especially as her dismissal seems to originate in a misconception of what constitutes critique in the full sense of the term. This misapprehension lies in the common-sense assumption that critique equals self-affirmation, rather than self-negation; that in critiquing the other, one affirms oneself; that critique does not evolve an act of self-effacement. As a result, the critical subject (meaning, the discerning and necessarily judging subject) emerges victorious, beyond and above ideology. And this brings me to what is most problematic in this formulation of criticality: namely, the absence of a critique of ideology. Since, to rework my earlier reference to Lamoureux, there can be no theory of the avant garde that does not contain a critique of ideology, it begs the question whether criticality can be a useful theoretical tool for advancing the avant garde as a radical concept.

274

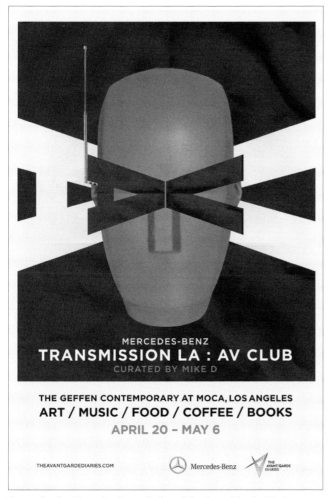

Poster for the Mercedes-Benz platform The Avant/Garde Diaries. 2012. Agency: REVOLVER; Creative Design: Vincent J. Ficarra. Courtesy of K-MB Creative Network, NY.

But why shouldn't we get rid of the idea of the avant garde? Hasn't the avant garde become too co-opted to have any critical function? After all, even the so-called 'creative industries' and their corporate sponsors are deploying the notion to their own profitable ends.[10] In reality, the issue is not that the avant garde has now become co-opted. As several scholars have observed in relation to various artistic manifestations in the postwar as well as interwar periods, the avant garde has been co-opted since its formation.[11] In his collection of polemical fragments inspired by Walter Benjamin, Terry Eagleton writes of the relationship between the bourgeois academy and revolutionary criticism: "For the problem of a 'revolutionary criticism' is not that it now risks incorporation into the bourgeois academy; it is that it was always already partly incorporated from the outset."[12] The same is also broadly true for the formations that we now identify with the discursive category of 'the avant garde.' Yet like 'revolutionary criticism,' like 'the left' (which is always dying yet somehow never dead), 'the avant garde,' despite its co-optation, continues to offer the possibility of articulating a project that works against neoliberal ideology. Though it is incorporated (and note how

Eagleton carefully inserts the word 'partly' into his assertion), it cannot be contained within the kind of institutionalized, art-historical discourses where the critique of neoliberalism is obfuscated. Neither can it be replaced by a post-postmodern notion of criticality where criticality is critique in its self-reflexive, timid guise; a parody of critique, a critique ashamed of itself.

If the avant garde is the name for an aesthetico-political project that rescues critique from criticality, its task today is to be critical in the double sense of the word: to be discerning and to be constitutive of a crisis. As a discursive formation at the intersection between representation, analysis and praxis, the avant garde is necessarily critical, and its task becomes more and more urgent as our condition becomes more and more critical. As the serialized avant garde lapses into the temporality of ever-the-same and into the repetition of modern art's historicism (innovation after innovation after innovation…), the avant garde as a radically temporal concept strives to wrest tradition away from the conformism of innovation that is working to overpower it.[13] Whereas serialization affirms the avant garde as tradition, the radical temporality of the idea of the avant garde disrupts the homogeneous empty time of western historicism. A stagist logic that submits the idea of the avant garde to a first, second, and third variant anticipates a fourth avant garde to emerge in the year 2050. A heterotemporal logic that allows the idea of the avant garde to carry within it 'early' and 'late' manifestations of radicalism undoes such anticipation. Instead, it problematizes the avant garde's relationship to a discourse of modernization and makes an intervention in the present possible.

The form this intervention will take is not yet recognizable as avant garde. It will certainly not be designed according to Situationist, Dada or other such templates. Things will not put on their 'true Surrealist face.'[14] Just because the avant garde is twice again historical, that is not to say it will not continue its critique of an ever more pervasive form of neoliberalism. Lest we forget, at the same time Enzensberger was declaring the avant garde dead, Asger Jorn was drawing a moustache on a little girl surrounding her image with the words: '*l'avant-garde ne se rend pas*' ('the avant garde doesn't give up').

Notes

1. Hans Magnus Enzensberger, "The Aporias of the Avant-Garde" (1962), in Michael Roloff, ed. *The Consciousness Industry: On Literature, Politics and the Media* (New York: The Seabury Press, 1974) 41.
2. More an extended essay than a fully-fledged theory, Peter Bürger's *Theorie der Avantgarde* has dominated critical discussion since its original publication in 1974. At the time of writing it has been translated into more than 14 languages, including Arabic, Croatian, Hebrew and Korean. For the English edition, see Peter Bürger, *Theory of the Avant-Garde*, trans. Michael Shaw (Minneapolis: University of Minnesota Press, 1984).
3. Walter Benjamin, "The Author as Producer" (1934); see for instance the version collected in *Walter Benjamin, The Work of Art in the Age of*

Its Technological Reproducibility and Other Writings on Media, ed. Michael W. Jennings et al. (Cambridge, MA: Belknap Press, 2008) 79-95.

4. For an exception to this rule see David Cunningham, "The Futures of Surrealism: Hegelianism, Romanticism, and the Avant-Garde," *SubStance* 34:2 (2005) 47–65.

5. See for instance the way in which the historical and neo-avant gardes are presented as a pre-history of contemporary participatory practices in Claire Bishop, *Artificial Hells: Participatory Art and the Politics of Spectatorship* (London: Verso, 2012), or—even more explicitly—the way in which the idea of the avant garde was framed in the roundtable discussion "Third Avant-Garde? Art Today," in *Weighs Like a Nightmare: Ninth Annual Historical Materialism Conference* (London, November 8-11, 2012).

6. Peter Osborne, *The Politics of Time: Modernity and Avant-Garde* (London: Verso, 1995) 2.

7. Johanne Lamoureux, "Avant-Garde: A Historiography of a Critical Concept," in Amelia Jones, ed. *A Companion to Contemporary Art Since 1945* (Oxford: Blackwell, 2006) 207.

8. Irit Rogoff, "What is a Theorist?" (2004), in James Elkins and Michael Newman, eds. *The State of Art Criticism* (New York & London: Routledge, 2008) 100.

9. Rogoff, "What Is a Theorist?" 99.

10. The website of 'The Avant/Garde Diaries,' a creative initiative by Mercedes Benz begun in 2011, characterizes "the present moment" as one of "unprecedented change, opportunity, and innovation" and includes its very own Q&A video on the topic 'what is avant-garde?' The answer takes various forms, with the most telling collage of responses being "whatever everybody else is doing, you're doing it better" followed by "and don't think too much of other people." See www.theavantgardediaries.com, accessed April 2, 2013.

11. Studies on this topic are too numerous to mention, but for a succinct summary of the phenomenon of the parallel institutionalization and consolidation of these formations as 'avant-garde,' see David Cottington, *The Avant-Garde: A Very Short Introduction* (Oxford: Oxford University Press, 2013) 16-21.

12. Terry Eagleton, *Walter Benjamin, or Towards a Revolutionary Criticism* (London: Verso, 1981) 82.

13. I am myself nodding to Walter Benjamin and his Thesis VI from "Theses on the Philosophy of History," available in *Illuminations*, ed. Hannah Arendt, trans. Harry Zohn (London: Jonathan Cape, 1970) 247.

14. Another reference to Benjamin, this time from convolute N [N3a,3] in *The Arcades Project*, ed. Rolf Tiedemann, trans. Howard Eiland and Kevin McLaughlin (Cambridge MA: The Belknap Press, 1999) 463-4.

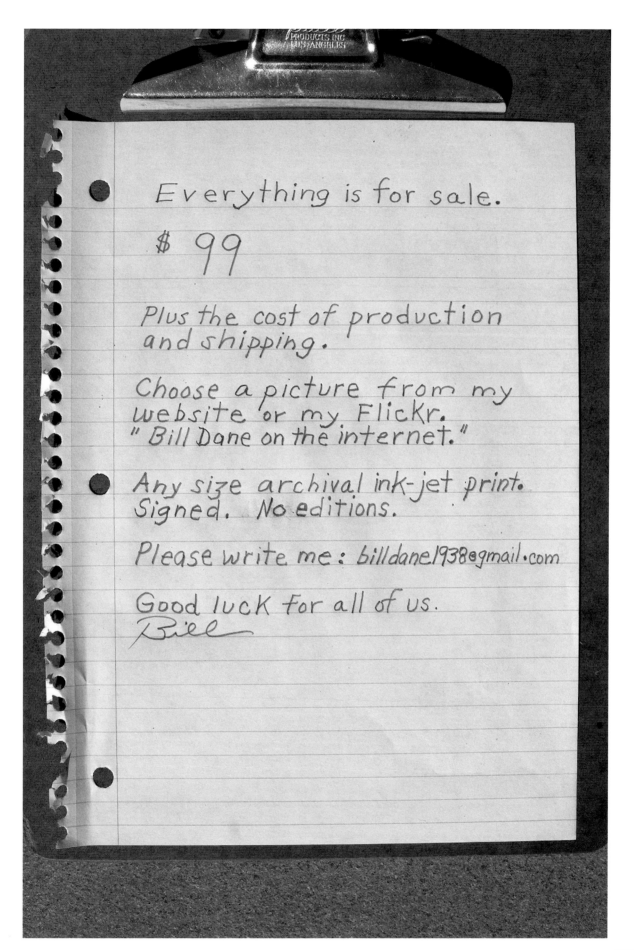

Contributors

MOE ANGELOS has collaborated with Marianne Weems and The Builders Association as a performer and writer since 1999 and has appeared in several Builders' productions. Since 1988, she has worked with The Five Lesbian Brothers, which has received a Bessie, an OBIE and other honors. She has worked at the WOW Café since 1981 and has appeared in the work of many downtown luminaries, including Carmelita Tropicana, Anne Bogart, Holly Hughes, Lois Weaver, Kate Stafford, Brooke O'Harra, Half Straddle and The Ridiculous Theatrical Company, to name a few. In 2012 she adapted and performed in *Sontag: Reborn*, a Builders Association show based on the first volume of the journals of Susan Sontag.

BAVO is a research collective consisting of Gideon Boie and Matthias Pauwels, who are both trained in architecture and philosophy. Their work focuses on the political dimension of art, architecture and urbanism. BAVO has organized several debates, symposia and conferences and published many articles in a diverse array of media. They were guest editors of *Andere Sinema* #176, titled *Spectres d'avant garde* and published the books *The Undivided City and Its Willing Executioners* (2003), *Cultural Activism Today: The Art of Overidentification* (2007) and *Urban Politics Now: Re-Imagining Democracy in the Neoliberal City* (2007). Boie and Pauwels live and work in Rotterdam and Brussels.

ZANNY BEGG is a Sydney-based cross-disciplinary artist, writer, curator and organizer. She is currently the director of the Tin Sheds Gallery. She has participated in residencies in Hong Kong, Indonesia, Chicago and Barcelona. Her recent exhibitions include *Emeraldtown, Gary Indiana* at Artspace, Sydney, *What Keeps Mankind Alive* at the Istanbul Biennial, Taipei Biennial and Sharjah Biennial, *Have the Cake and Eat It Too* at the Kunsthalle Exnergasse, Vienna, and *Self-Organization* at the National Centre for Contemporary Art, Moscow. She has also produced films, including *What Would It Mean to Win?* (2008 with Oliver Ressler), *The Bull Laid Bear* (2012 with Oliver Ressler), and *Emeraldtown, Gary Indiana* (2012).

BILL BROWN was born in New York City in 1959. In addition to being a founding member of the Surveillance Camera Players, he is the publisher of *NOT BORED!*, a Situationist journal that was founded in 1983 and went on-line in 1996. These days he is at work translating Situationist and post-Situationist texts into English. An anthology of his translations of texts by Gianfranco Sanguinetti will be published sometime in 2013.

KIM CASCONE studied electronic music at the Berklee College of Music and privately at the New School in Manhattan. He founded Silent Records in 1985 and has released more than 50 albums of electronic music on Silent, Sub Rosa, Mille Plateaux, Raster-Noton, Störung and Monotype. Cascone has performed with Merzbow, Keith Rowe, Scanner, John Tilbury, Tony Conrad, Pauline Oliveros and worked as assistant music editor on two David Lynch films. He founded the .microsound list in 1999, has written for MIT Press and *Contemporary Music Review* and is an advisor for the audio culture journal *Interference*. His writings are included in many books on sound art.

THANOS CHRYSAKIS is a composer as well as a performance and installation artist. He has produced several recordings and has performed at events in many countries, including France, Germany, Russia, Hungary, Spain, Portugal, the U.S. and the U.K. He has recorded/performed with many improvisers, among them Wade Matthews, Dario Bernal-Villegas, Jerry Wigens, James O'Sullivan, Philip Somervell, Jamie Coleman, Chris Cundy, Zsolt Sörés, Sebastian Lexer and Artur Vidal. His work was amongst the selected works at the 2005 Compétition Internationale de Musique et d'Art Sonore Électroacoustique de Bourges and received an honorary mention in 2006 at the 7th International Electroacoustic Competition Musica Viva in Lisbon. Since 2007 he operates the record label Aural Terrains, focusing on electroacoustics, composed and improvised music.

BEATRIZ COLOMINA is an architectural historian and theorist who has written extensively on questions of architecture and media. She is the Founding Director of the Program in Media and Modernity at Princeton University, where she is also Program Director of Graduate Studies at the School of Architecture. In 2006-2007 she curated the exhibition "Clip/Stamp/Fold: The Radical Architecture of Little Magazines 196X-197X" at the Storefront for Art and Architecture in New York and the Canadian Centre for Architecture in Montreal. Her books include *Architectureproduction* (1988), *Sexuality and Space* (1992), and *Privacy and Publicity: Modern Architecture as Mass Media* (1994). She is co-editor of *Cold War Hot Houses: Inventing Postwar Culture from Cockpit to Playboy* (2004).

MARC COUROUX is a Canadian interdisciplinary artist and a contemporary music pianist. Acclaimed by Musicworks as the "Glenn Gould of contemporary music," he is recipient of the OPUS Award of the Conseil Québécois de la Musique, a prize he won for his work in disseminating Canadian piano music internationally. He is co-founder of

ASOUNDER, a sonic tactical collective, and with Michael Oesterle of Ensemble KORE, a group dedicated to recreating a living relationship between composer and listener. A guest of Holland's Amsterdam Festival in 2000, Couroux complements his career as a pianist with teaching, writing and composing. He has taught classes in Canada, the U.S., Europe and the U.K. and is presently Associate Professor in the Department of Visual Arts at York University.

CRITICAL ART ENSEMBLE is a collective of tactical media practitioners of various specializations, including computer graphics and web design, film/video, photography, text art, book art, and performance. Formed in 1987, CAE's focus has been the exploration of the intersection between art, critical theory, technology, and political activism. The group has exhibited and performed at diverse venues internationally and has written six books. Its writings have been translated into eighteen languages; these include: *The Electronic Disturbance* (1994), *Electronic Civil Disobedience & Other Unpopular Ideas* (1996), *Flesh Machine* (1998), *Digital Resistance: Explorations in Tactical Media* (2001), *Molecular Invasion* (2002), and *Marching Plague* (2006).

CHRIS CUTLER is an English percussionist, composer, lyricist and music theorist and lecturer. He is best known for his work with the English avant-rock group Henry Cow as well as Art Bears, News from Babel, Cassiber, The (ec) Nudes, P53, The Science Group, Pere Ubu, Hail, The Wooden Birds and Gong/Mothergong. He has collaborated with many musicians, including Fred Frith, Lindsay Cooper, John Rose, Lutz Glandien, Shelly Hirsch, Zeena Parkins, Iancu Dumitrescu, Peter Blegvad and The Residents and has appeared on over 100 recordings. He created and runs the British independent record label Recommended Records and is the editor of its sound-magazine *RēR Quarterly*. He is author of *File Under Popular* (1984) as well as of numerous articles and papers published in 14 languages.

BILL DANE is a California-based still, straight, street photographer best known for pioneering a way to subsidize his public by sending his pictures as postcards. He has mailed over 69,000 picture-postcards since 1969. As of 2007 his method of making his pictures more accessible shifted from mail art to the Internet. In 1971 he worked with Diane Arbus, Lee Friedlander, eventually exhibiting is such places as the MoMA, the Barbican, Tate Modern, SF MoMA and the Getty Institute. His publications include *Bill Dane Photographs Outside and Inside America* (Provincial Museum of Grenada, 1992) and *Bill Dane's History of the Universe* (Fraenkel Gallery, 1992). His work is available through Bill Dane on the Internet at www.billdane.com.

THOMAS ELSAESSER is Professor Emeritus at the Department of Media and Culture of the University of Amsterdam. From 2006 to 2012 he was Visiting Professor at Yale University. Besides publishing over 200 essays in journals and collections, he has authored, edited and co-edited some twenty volumes on film history, film theory, German and European cinema, Hollywood, New Media and Installation Art. His books have been translated into German, French, Italian, Polish, Hungarian, Hebrew, Korean and Chinese. Among his recent books as author are: *Terror und Trauma* (2007), *Film Theory: An Introduction Through the Senses* (2010, with Malte Hagener), *The Persistence of Hollywood* (2012) and the forthcoming *German Cinema: From Mastering the Past to Guilt Management in the Present* (2013).

THE ERRORIST INTERNATIONAL was founded in 2005 in Buenos Aires and is composed of members from Argentina, Brasil, Bolivia, Chile, Columbia, Venezuela, Mexico, France, Italy, Spain, Germany, Australia, Switzerland, Canada, Romania, Croatia, the United States and Japan. Errorists use the word (T)errorism for the symbolic weight and danger that it represents. Errorists and their actions are supported by an international community of activists who spread their ideas and philosophy. The group is often (not) represented through their spokesperson Federico Zukerfeld. The Errorist Kabaret was presented at the 11th International Istanbul Biennale in 2009. Other installation works have been shown internationally: *The International Errorist* at the SMART Project Space in Amsterdam, and *Welfare State of Exception* at the Kunsthalle Charlottenborg in 2011.

HAL FOSTER is an American art critic and historian. He taught at Cornell University from 1991 to 1997 and has been on the faculty at Princeton since 1997. In 1983 Foster edited *The Anti-Aesthetic: Essays on Postmodern Culture*, a seminal text on postmodernism. In *Recodings* (1985) he promoted a vision of postmodernism that engaged its avant-garde history. In *The Return of the Real* (1996) he proposed a model of historical recurrence of the avant garde in which each cycle would improve upon the failures of the previous. He has worked as an editor for *Artforum, Art in America* and *October*. His other books include *Compulsive Beauty* (1995), *Prosthetic Gods* (2006), *Design and Crime (And Other Diatribes)* (2011), and *The Art-Architecture Complex* (2011).

ANDREA FRASER is a performance artist known mostly for her work in the area of institutional critique. Her work has been shown in public galleries, including the Philadelphia Museum of Art, the Kunstverein München, the Venice

Biennale, the Whitechapel Art Gallery, the Los Angeles Museum of Art and the Centre Pompidou. A retrospective catalogue of her artwork, *Andrea Fraser, Works: 1984-2003*, was published by the Kunstverein in Hamburg. Her theoretical and critical writings are collected in *Museum Highlights*, published by the MIT Press. She is currently a member of the Art Department faculty at the University of California, Los Angeles.

CHARLES GAINES's work investigates affect as the result of cognitive disruptions that are produced by works of art. Through the use of language and systems Gaines explores how arbitrary relationships become meaningful. He has had over 65 one-person shows and several hundred group exhibitions in the U.S. and Europe. He was included in the Hammer Museum Invitational (Los Angeles, 2010), the Venice Biennale (2007) and the Whitney Biennial (1975). He is in the collection of all the major museums in the U.S. and is the recipient of a Guggenheim Foundation Fellowship (2013). Gaines teaches at the California Institute of the Arts.

BORIS GROYS is an art critic, media theorist, philosopher, and a pioneering theorist on socialist art. He is currently Global Distinguished Professor of Russian and Slavic Studies at New York University and Senior Research Fellow at the Karlsruhe University of Arts and Design. He has taught at several schools, including the University of Pennsylvania, the University of Southern California and the Courtauld Institute of Art, London. He has published numerous books, including *The Total Art of Stalinism: Avant-Garde, Aesthetic Dictatorship and Beyond* (1992), *Ilya Kabakov: The Man Who Flew into Space from His Apartment* (2006), *Art Power* (2008), *The Total Enlightenment: Conceptual Art in Moscow 1960-1990* (2008), *The Communist Postscript* (2010), *History Becomes Form: Moscow Conceptualism* (2010), and *Introduction to Antiphilosophy* (2012).

OWEN HATHERLEY is is a writer based in Woolwich. He is the author of *Militant Modernism* (2009), *A Guide to the New Ruins of Great Britain* (2010), *Uncommon: An Essay on Pulp* (2011), *A New Kind of Bleak* (2012) and an e-book, *Across the Plaza* (2012). His PhD thesis was on Americanism and the interwar avant garde.

LYN HEJINIAN is an American poet, essayist, translator and publisher. She is often associated with Language poets and is well-known for her work *My Life* (1980), as well as for her book of essays *The Language of Inquiry* (2000). She has published more than a dozen books of poetry and between 1976 and 1984 was editor of Tumbra Press. From 1981 to 1999 she co-edited (with Barrett Watten) *Poetics Journal*. She is currently co-editor of *Atelos* and Professor of English at the University of California at Berkeley. She has worked on collaborative projects with painters, musicians and filmmakers and has received grants and awards from the California Arts Council, the Academy of American Poets, the Poetry Fund, the National Endowment for the Arts and the Guggenheim Foundation.

DEREK HORTON is an artist, writer, publisher and teacher. With Chris Bloor he established a ground-breaking undergraduate program in 1997 at Leeds Metropolitan University, designed to encourage students with few formal academic qualifications. He was subsequently a Principal Lecturer and head of Research in Contemporary Art at Leeds Metropolitan University until 2007. In 2005, he co-founded the online journal /seconds with Peter Lewsi and in 2009 began publishing the online magazine *Soanyway*, which he co-edits with Lisa Stanbise. *Soanyway* is a site that brings together words, pictures and sounds that tell stories in the broadest possible sense of the term.

MITCHELL JOACHIM is a leader in ecological design, architecture and urbanism. He was a founding Co-President of Terreform ONE in 2006 and is an Associate Professor at New York University and the European Graduate School. He has won the Zumtobel Group Award for Sustainability and Humanity, the History Channel and Infiniti Excellence Award for City of the Future, *Time* Magazine Best Invention of 2007, and the Victor Papanek Social Design Award. He was chosen by *Wired* Magazine for "The 2008 Smart List," by *Rollling Stone* for "The 100 People Who Are Changing America," and by *Popular Science* as visionary for his work "The Future of the Environment." His project Fab Tree Hab has been exhibited at the Museum of Modern Art and widely published.

ALEXANDER KLUGE is a German fiction writer, cultural theorist and film director. He worked as a legal counsel for the Frankfurt Institute for Social Research and with the encouragement of Theodor Adorno began to investigate filmmaking in the 1960s. A signatory of the Oberhausen Film Festival, Kluge became one of the leading fimmakers of the New German Cinema, achieving critical acclaim with such films as *Yesterday Girl* (1966), *Artists Under the Big Top: Perplexed* (1968) and *The Assault of the Present on the Rest of Time* (1985). Among his theoretical works, he is best known for *Public Sphere and Experience: Toward an Analysis of the Bourgeois and Proletarian Public Sphere*, which he co-authored with Oskar Negt in 1972. For the last few decades he has produced innovative programs for German television. In 2008, he released *News from Ideological Antiquity. Marx – Eisenstein – Das Kapital*, a 9-hour film that explores the contemporary relevance of Marx through the lens of Eisenstein's plans for filming *Capital*.

VITALY KOMAR is a Russian born painter and performance artist. In 1967 he graduated from the Stroganov Art School in Moscow. He began working with Alexander Melamid in 1973 and collaborated with him until 2003. As Komar & Melamid they founded the "Sots Art" movement, a conceptual Pop art practice based on Soviet visual propaganda and Socialist Realism. In 1974 they participated in the famous "Bulldozer" outdoor art show, where his work, together with other nonconformist artists, was destroyed by government authorities. They collaborated in various conceptual projects, ranging from painting and performance to installation, public sculpture, photography, music and poetry. From 1994 to 1997 they worked on "The People's Choice" series, creating "Most Wanted" and "Least Wanted" paintings based on statistical numbers. In 1998 they went to Thailand to teach unemployed elephants to paint, generating support for the elephants and their keepers. Their work has been exhibited by the Musée des Arts Décoratifs (Paris), the Museum of Modern Art (New York), The Metropolitan Museum of Art (New York), the Guggenheim Museum (New York), Ronald Feldman Gallery and at Documenta 8 (Kassel) and the Venice Biennale (1997, 1999). Komar currently resides in New York City and has had solo shows at the Moscow Biennale and the Galerie Sandmann in Berlin.

RICHARD KOSTELANETZ is an American artist, author and critic. He came onto the literary scene with essays in quarterlies like *Partisan Review* and *The Hudson Review*. He has produced literature in various forms: audio, video, holography, book-art, computer-based installation. He has also produced political criticism, memoir, music criticism, cultural history, literary criticism, radio plays, silkscreen, phtotography, drawing, visual fiction, documentary film, among other achievements. He turned against the literary establishment with *The End of Intelligent Writing* (1974) and *SoHo: The Rise and Fall of an Artists' Colony* (2003). His radical fiction has appeared in such books as *Visual Language* (1970), *In the Beginning* (1971), *Short Fictions* (1974), *Wordworks* (1993) and he also edited the anthologies of writing *Breakthrough Fictioneers* (1973) and *The Literature of SoHo* (1981). He is author of *A Dictionary of the Avant-Gardes* (1993, 2000).

BRUCE LABRUCE is a Toronto-based filmmaker, writer, director, photographer, and artist. He began his film career in the mid-eighties making a series of short experimental super 8 films and co-editing a punk magazine called *J.D.s*, which began the queercore movement. He has starred in and directed several feature length films, including *No Skin Off My Ass* (1991), *Super 8½* (1994), *Skin Flick* (2000), *The Raspberry Reich* (2004), *Otto, or, Up with Dead People* (2008), and *L.A. Zombie* (2010). His premature memoir is published as *The Reluctant Pornographer* (1997) and a book on his work has been published as *Ride Queer Ride* (1998). He has also directed theatrical productions, dance performance and opera, written for magazines, produced porn and fashion photography, and directed documentaries featuring Harmony Korine and Gaspar Noe, and Beatrice Dalle and Virginie Despentes.

MARC JAMES LÉGER is an artist and writer living in Montreal. He has exhibited work in Canada, the US and the UK. He has published numerous essays, including pieces in *Afterimage, Art Journal, C Magazine, Canadian Journal of Film Studies/Revue canadienne d'études cinématographique, Creative Industries Journal, Etc, FUSE, Journal of Aesthetics and Protest, Left Curve, One+One Filmmakers Journal, Parachute, RACAR* and *Third Text*. His essay on the aesthetic theories of Henri Lefebvre was published in Andrew Hemingway's edited volume *Marxism and the History of Art*. He is editor of *Culture and Contestation in the New Century* (2011) and author of *Brave New Avant Garde: Essays on Contemporary Art and Politics* (2012) as well as *The Neoliberal Undead* (2013).

CATHERINE LESCARBEAU is a Québecois artist with a background in fine arts and art history. She has participated in the production of several art projects, including *Une exposition merveilleuse* in 2008 and *OFF-Biennale de Dare Dare* in 2009. Her work deals with the notion of systems and its implications for artists in society. She is on the administration board of the Montreal artist-run center DARE-DARE and works for the Montreal Museum of Fine Arts.

JUDITH MALINA is a German-born American theatre and film actress, writer, and director. She is one of the founders of The Living Theatre, a radical political theatre troupe that rose to prominence in New York City and Paris during the 1950s and 60s. She studied theatre with Erwin Piscator at the New School for Social Reasearch and was greatly influenced by Brechtian principles of "epic theatre." Her work is discussed in several books, including *We, The Living Theatre* (1970), *The Enormous Despair* (1972), and *The Diaries of Judith Malina, 1947-1957* (1984). She has received several awards, including an honorary doctorate from Lehman College, the Grand Prix du Théâtre des Nations and the Prix de l'Université de Paris.

SARA MARCUS' first book, *Girls to the Front: The True Story of the Riot Grrrl Revolution*, was published by Harper Perennial in 2010. Her criticism and prose appear in publications including *Artforum, Bookforum, The Nation, n+1, Los Angeles Review of Books, Slate, Salon*, the *San Francisco Chronicle*, the anthology *Dreaming in Public: Building the Occupy*

Movement, and a forthcoming collection of the writings of the late feminist critic Ellen Willis. Her poetry has been published in *Encyclopedia, EOAGH, With + Stand, Death, The Art of Touring*, and elsewhere.

THÉRÈSE MASTROIACOVO's work is about art itself as an idea, and artistic process as methodology. It is about the precarious relationship art has to its own definition, open, half open, or slightly open for reclassification at any given time. The varying degrees of openness create space in-between, a space that gives way to meanderings, processes, and procedures. Her work is situated here, in a space of potential created in the middle of existing structures. It is this—this large, large thing stated so, so plainly—that makes her work both familiar and unknowable.

EVAN MAURO completed his PhD at McMaster University in Hamilton, Ontario. His dissertation, *Fables of Regeneration: Modernism, Biopolitics, Reproduction*, examines the politics of life in the early modernist period. His work has appeared in *Mediations* and *Reviews in Cultural Theory*. He teaches cultural studies and twentieth-century literature in the University of British Columbia's Coordinated Arts Program.

JONAS MEKAS was born in Lithuania and moved to New York City in 1949 as a war refugee. He has since then been involved in American avant garde film and in 1954, together with his brother, started *Film Culture* magazine. In 1958 he began working as a film columnist for the *Village Voice*, and in the early 60s founded the Film-Makers' Cooperative and Film-Makers' Cinematheque, which grew into the *Anthology Film Archives*, one of the world's largest repositories of avant-garde cinema. He has published more than twenty books of prose and poetry, has taught at several schools, including the New School for Social Research, Cooper Union, NYU and MIT. His films have been awarded several international prizes and he has also exhibited film installations in international museums. In 2007 he completed a series of 365 short films released on the Internet, one film for every day. That same year, the Jonas Mekas Center for the Visual Arts opened in Vilnius, Lithuania. He currently resides in Williamsburg, Brooklyn.

ALEXEI MONROE is a London-based independent cultural theorist. He is author of *Pluralni monolit Laibach in NSK* (2003) and *Interrogation Machine: Laibach and NSK* (2005), Programme director of the *First NSK Citizens' Congress*, and editor of the *Congress documentation in State of Emergence* (2011). His research interests include the aesthetics and politics of industrial and electronic music and the stag as a cultural symbol. His work has appeared in several publications, including *Contemporary Music Review, Central Europe Review, Kinoeye, Maska* and *The Wire*. He blogs on several sites, including http://pluralmachine.blogspot.com.

RABIH MROUÉ is a Beirut-based actor, director, playwright, and a contributing editor to both the Lebanese quarterly *Kalamon* and *TDR* (New York). He is one of the founders and executive board members of Beirut Art Center association (BAC) as well as a fellow at the International Research Center "Interweaving Performance Cultures." His works include: *Riding on a Cloud* (2013), *The Pixelated Revolution* (2012), *33 rpm and a few seconds* (2012), *Photo-Romance* (2009), *How Nancy Wished That Everything Was an April Fool's Joke* (2007), *Make Me Stop Smoking* (2006) and *Who's Afraid of Representation* (2005).

NIKOLAUS MÜLLER-SCHÖLL is chair of theatre studies at the Goethe University in Frankfurt/Main. His PhD dissertation, advised by Hans-Thies Lehmann, was on the work of Walter Benjamin, Bertolt Brecht and Heiner Müller. He has also worked as a freelance dramaturg, journalist, translator and critic. His publications include *Das Theater des 'konstruktiven Defaitismus.' Lektüren zur Theorie eines Theaters der A-Identität bei Walter Benjamin, Bertolt Brecht und Heiner Müller* (2002), *Politik der Vorstellung* (co-edited with Joachim Gerstmeier, 2006), *Schauplatz Ruhr* (co-edited with Ulrike Haß, 2007), *Was ist eine Universität? Schlaglichter auf eine ruinierte Institution* (co-edited with Ulrike Haß, 2009), *Heiner Müller sprechen* (co-edited with Heiner Goebbels, 2009) and *Performing Politics* (co-edited with André Schallenberg and Mayte Zimmermann, 2012).

LAURA MULVEY is a British feminist film theorist. She is currently professor of film and media studies at Birkbeck, University of London. She is best known for her essay "Visual Pleasure and Narrative Cinema," which appeared in her collection of essays *Visual and Other Pleasures* (1989) as well as numerous other anthologies. Her article is one of the first major essays that helped shift the orientation of film theory towards a psychoanalytic framework and to link this to feminism. She is also a prominent avant-garde filmmaker. With Peter Wollen she co-wrote and co-directed *Penthesilea: Queen of the Amazons* (1974), *Riddles of the Sphinx* (1977), *AMY!* (1980) and *The Bad Sister* (1983). In 1991 she co-directed *Disgraced Monuments* with Mark Lewis. Her publications include *Fetishism and Curiosity* (1996) and *Death 24x a Second* (2005).

OSKAR NEGT is a German philosopher and social scientist. He studied law and philosophy at the University of

Göttingen and the University of Frankfurt am Main as a student of Theodor Adorno, and was an assistant of Jürgen Habermas at the Universität Hannover. He is Professor of Sociology at the Universität Hannover. He has published several books, most notably, with Alexander Kluge, *Public Sphere and Experience: Toward and Analysis Of the Bourgeois and Proletarian Public Sphere* (1972), which was published in English in 1993.

CHRYSI PAPAIOANNOU is a doctoral candidate in the School of Fine Art, History of Art and Cultural Studies at the University of Leeds, where she is writing an intellectual history of the concept of the avant garde in European and North American art criticism and cultural theory from the 1960s to the present. She is a co-convenor of the London-based seminar *Marxism in Culture* and lives in London.

MARJORIE PERLOFF is an American poetry scholar and critic. Her family escaped Nazi persecution and moved to the U.S. She has taught in several universities, including The Catholic University of America in Washington, D.C., Maryland, South Carolina, and Stanford. Her work is concerned with experimental and avant-garde poetry, especially the major modernist and postmodernist writers. She has worked on Language poetry and Objectivist poetry and significantly opened up the "Official Verse Culture" to criticism. Some of her books include *Radical Artifice: Writing Poetry in the Age of Media* (1991), *The Futurist Moment: Avant-Garde, Avant-Guerre, and the Language of Rupture* (2003), *Differentials: Poetry, Poetics, Pedagogy* (2004), and *Unoriginal Genius: Poetry by Other Means in the New Century* (2010). She is currently scholar-in-residence and Florence Scott Professor of English Emerita at the University of Southern Califiornia.

JEAN-HERVÉ PÉRON / Art-Errorist / FaUST founder member / 1949 born in Casablanca / 1951-67 raised in Cherbourg, school and music / 1967-68 highschool in Schenectady / 1968-70 busking beatnik, on the roads of Europe / 1969-72 krautrock in Hamburg, Faust in Wuemme / 1972-80 Faust tours, children, odd jobs, travels / 1980-90 set builder, up and down Germany / 1990-2007 Schiphorst / 1994-97 You Know Faust, Faust tours / 1997-2004 no Faust years / 2004-07 art-Errorist , Avantgarde Festival Schiphorst, Faust tours with Zappi Diermaier and Ulan Bator / 2007-13 Faust collaborations with Steven Stapleton, Geraldine Swayne, James Johnston, Amaury Cambuzat, solo works and tours with Andrew Liles, Nathalie Forget, Zsolt Soeres, Amaury Cambuzat.

ADRIAN PIPER is a first-generation conceptual artist and analytic philosopher who was born in New York City. She has exhibited her artwork internationally, introducing issues of race and gender as well as Vedic imagery and concepts into the vocabulary of conceptual art and minimalism. Her sixth traveling retrospective, *Adrian Piper since 1965*, closed at the Museum of Contemporary Art of Barcelona in 2004. Her two-volume collection, *Out of Order, Out of Sight: Selected Writings in Meta-Art and Art Criticism 1967-1992*, is available from MIT Press. She also has a PhD in Philosophy from Harvard and has taught in various schools, including Georgetown, Harvard, Michigan, Stanford and UCSD. Since 2005 she has lived and worked in Berlin, where she runs the APRA Foundation Berlin and edits *The Berlin Journal of Philosophy*.

MIKKEL BOLT RASMUSSEN is Associate Professor in the Department of Arts and Cultural Studies, Copenhagen University. He is the author of four books, most recently *En anden verden* (2011), and editor of seven books, including *Totalitarian Art and Modernity* (2010) and *Expect Anything, Fear Nothing: The Situationist Movement in Scandinavia and Elsewhere* (2012). He has published numerous articles on activism, the avant garde, contemporary philosophy, the revolutionary tradition and totalitarianism in such journals as *Multitudes, Mute, Oxford Art Journal, Rethinking Marxism, Texte zur Kunst, Third Text* and *Variations*. He is co-editor of the journal *K&K* and *Monsieur AntiPyrine*. Together with Jakob Jakobsen he runs the publishing house Nebula.

GENE RAY is a critic and theorist living in Berlin. A member of the Radical Culture Research Collective (RCRC), he writes frequently for the journals *Third Text* and *Left Curve*. He is author of *Terror and the Sublime in Art and Critical Theory* (2005), and editor of *Joseph Beuys: Mapping the Legacy* (2001). Along with Gregory Sholette, he co-edited *Whither Tactical Media?* (2008), a special issue of *Third Text*.

JOHN ROBERTS is an English writer, critic and curator. He has taught and lectured throughout the UK and overseas, and has completed major curatorial projects in London, Venice, Hamburg, and Liverpool. His publications include *Postmodernism, Politics and Art: A Critique of Postmodernism* (1990), *Art Has No History!: The Making and Unmaking of Modern Art* (1994), *The Philistine Controversy* (2002, with Dave Beech), *Philosophizing the Everyday: Revolutionary Praxis and the Fate of Cultural Theory* (2006), and *The Intangibilities of Form: Skill and Deskilling in Art After the Readymade* (2007). He is currently Professor of Art and Aesthetics at the University of Wolverhampton, School of Art and Design.

JASON ROBINSON is an American jazz saxophonist, electronic musician, and composer. His work draws on post-1960s jazz experimentalism, post-bop, and electronic music technologies. In addition to an extensive career leading his own groups and performing solo, Robinson co-founded the acclaimed collaborative avant-jazz group Cosmologic and Cross Border Trio. He has also performed in reggae and jam band scenes, most notably with the group Groundation. Robinson is an Assistant Professor of Music at Amherst College and holds a PhD in Music from the University of California, San Diego. He has published articles and reviews in *Ethnomusicology*, *Jazz Perspectives*, and *Critical Studies in Improvisation/Études critiques en improvisation*.

GREGORY SHOLETTE is an artist, activist and author based in New York. He co-founded two artists' collectives: Political Art Documentation and Distribution (1980-88) and REPOhistory (1989-2000). He is the author of *Dark Matter: Art and Politics in the Age of Enterprise Culture* (2010) and co-editor of *It's the Political Economy, Stupid: The Global Financial Crisis in Art and Theory* (2013), *Collectivism after Modernism: The Art of Social Imagination after 1945* (2007), *The Interventionists: Users' Manual for the Creative Disruption of Everyday Life* (2004). He is an Assistant Professor of Sculpture at Queens College, City University of New York (CUNY), a visiting faculty member at Harvard University, and teaches an annual seminar in theory and social practice for the post-graduate research program at Geneva University of Art and Design.

SANTIAGO SIERRA is a Spanish artist who lives in Madrid. His most well-known works involve hiring laborers to complete menial tasks. These works are meant to elucidate the nature of work in capitalist society as well as political issues such as immigration and the isolation of economic classes. His most famous works have involved paying a man to live behind a brick wall for fifteen days, to wear protective clothing and be coated in polyetherane, to block the Lisson Gallery with a metal wall on opening night, and to sealing the entrance of the Spanish Pavilion at the Venice Biennale. He has exhibited internationally, with solo shows at MoMA PS1, New York, the Galeria Helga de Alvear, Madrid, Lisson Gallery, London, the Queensland Art Gallery, Brisbane, and the Sammlung Falckenberg, Hamburg. He work is presented in *Santiago Sierra: 300 Tons and Previous Works* (2005).

DAVID TOMAS is an artist and writer whose multimedia and photographic works explore the culture and transcultures of imaging systems. He has exhibited in Canada, the U.S. and Europe. He has held visiting research and fellowship positions at the California Institute of the Arts, Goldsmiths College, and the National Gallery of Canada. He is the author of several books, including *Transcultural Space and Transcultural Beings* (1996), *A Blinding Flash of Light: Photography Between Disciplines and Media* (2004), *Beyond the Image Machine: A History of Visual Technologies* (2004), and more recently, *Escape Velocity: Alternative Instruction Prototype for Playing the Knowledge Game* (2012). Tomas is Assistant Professor in Visual Arts at the Université du Québec à Montréal.

VICTOR TUPITSYN is a cultural critic and theorist living in New York City and Paris. He has published numerous essays on Russian art and co-authored many catalogues along with Margarita Tupitsyn. He is author of *The Museological Unconscious: Communal (Post)Modernism in Russia* (2012) and is on the advisory board of *Third Text*, London.

COSEY FANNI TUTTI is a performance artist. Her diverse and comprehensive practice includes the seminal "Magazine Actions" of the late 1970s, performances with COUM Transmission (1974-76), sound experimentation with Throbbing Gristle (1976-2011) and continuing musical exploration, solo as well as under the aegis of Chris & Cosey and CARTER TUTTI. Her work has been featured in institutional exhibitions around the world for over three decades. More recently, this includes Tate Britain's new collection display, *Has the Film Already Started?* (2011), *Pop Life: Art in a Material World* at Tate Modern (2009), *Panic Attack* at the Barbican, London, *Wack! Art & The Feminist Revolution* (2007) at MoCA, Los Angeles, and *It's Time for Action* (2006) at the Migros Museum, Zagreb.

DMITRY VILENSKY is an artist, writer, and founding member of Chto Delat?/What Is to Be Done?, a platform initiated in 2003 by a collective of artists, critics, philosophers and writers with the goal of merging political theory, art and activism. Vilensky is also editor of the *Chto Delat?* newspaper. Chto Delat?'s exhibitions include: *What is to be done? … The urgent need to struggle* at Galerie Nova, Zagreb and Institute of Contemporary Art, London, BAK, Utrecht, 2010; *Principio Potosí*, Museo Nacional Centro de Arte Reina Sofía, Madrid, 2010; the 17th Biennale of Sydney, 2010; and the 11th Istanbul Biennale, 2009. Vilensky lives and works in St. Petersburg.

MICHAEL WEBB was born 1937 in Henley-on-Thames in England, and studied architecture at the then Regent Street Polytechnic (now the University of Westminster). *Visionary Architecture* (1961), a project he designed during his fourth year at the Polytechnic, found its way, due to a curious set of circumstances, into an exhibition at the MoMA in New York. The following year, his thesis project for an entertainment center in the middle of London repeatedly

failed. Nevertheless it became widely published, and was featured in November 2009 at the *First Projects* exhibition at the Architectural Association School of Architecture in London. In 1963, he was invited by Peter Cook to be part of an assortment of young architects who referred to themselves as the Archigram group. Webb has taught at Virginia Tech, the Rhode Island School of Design, Columbia University, Barnard College, Cooper Union, SUNY Buffalo and Princeton University.

CHRISTINE WERTHEIM is author of +l'*me'S-pace*, editor of the anthology *Feminaissance*, and with Matias Viegener co-editor of *Séance* and *The n/Oulipean Analects*. In 2004 she was awarded a grant from the Annenberg Foundation to organize a series of conferences on contemporary writing: *Séance* (2004), *Noulipo* (2005), *Impunities* (2006), *Feminaissance* (2007), *Untitled* (2008), *Untitled NY* (2009). Her poetry appears in numerous anthologies, including *Against Expression*, *The & Now Awards: The Best Innovative Writing*, *I'll Drown My Book*, and *The LA Telephone Book*. She regularly writes critical pieces on art, literature and aesthetics, including for *Cabinet*, *X-tra*, *The Quick and the Dead*, *Walker Art Center cat.*, and *Patarcitical Interogation Techniques*. With her sister Margaret, she co-directs the Institute For Figuring, for which the sisters received the 2011 Theo Westenberger Grant for Outstanding Female Artist from the Autry National Center. Her new book *mUtter-bAbel* is forthcoming from Countertpath Press. She teaches at the California Institute of the Arts.

TRAVIS WILKERSON makes films in the tradition of "third cinema," wedding politics to form in an indivisible manner. His best-known films are *An Injury to One* (2002), an agit-prop essay on the lynching of the *Wobbly Frank Little*, *Accelerated Underdevelopment* (1999), on the filmmaker Santiago Alvarez, and *Who Killed Cock Robin?* (2005). He recently presented his first ever performance art at the Sundance Film Festival with *Proving Ground* (2009), a live multimedia rumination on the history of bombing. His work has screened at festivals worldwide, including Toronto, Rotterdam, Marseille, Buenos Aires, Vienna, and Yamagata. He is Assistant Professor of Film Studies at the University of Colorado, Boulder.

KRZYSZTOF WODICZKO is Professor in Residence of Art, Design and the Public Domain at the Harvard Graduate School of Design. He is renowned for his large-scale slide and video projections on architectural facades and monuments. He has realized more than eighty such public projections internationally and has also designed nomadic instruments and vehicles with homeless, immigrant and veteran operators. He has had many retrospectives and has exhibited at Documenta and the Paris, Sydney, Lyon, Venice, Whitney, and Kyoto Biennales. His work has been the subject of numerous publications, including *Critical Vehicles: Writings, Projects, Interviews* (1999), *Krzysztof Wodiczko: Guests* (2009) and *City of Refuge: A 9/11 Memorial* (2010).

WU MING, sometimes also known as Luther Blisset, is a collective of guerrilla novelists based in Italy and author of several books of non-fiction and more than a dozen novels, including *Q* (1999), *Manituana* (2004-2007) and *Altai* (2009). Their work has been translated into several languages, including English, Spanish, German, Dutch, French, Portuguese, Danish, Polish, Greek, Czech, Russian and Korean. Depending on how it is pronounced, "Wu Ming" is a Chinese word that means either 'anonymous' or 'five names.' This name, a tribute to dissidents, represents a refusal of the celebrity-making process. Besides novels, Wu Ming also co-wrote the screenplay for Guido Chiesa's movie *Radio Alice* (2004). Copyleft and Creative Commons licenses have been at the core of the group's activities since 1996.